# Professional 3D
# with
# Electric Image
# Universe

# PROFESSIONAL 3D WITH ELECTRIC IMAGE UNIVERSE

LANCE EVANS

CHARLES RIVER MEDIA

CHARLES RIVER MEDIA, INC.

Hingham, Massachusetts

Publisher: Jenifer Niles
Production: Tolman Creek Design
Cover Design: The Printed Image
Cover Image: Lance Evans

CHARLES RIVER MEDIA, INC.
20 Downer Avenue, Suite 3
Hingham, Massachusetts 02043
781-740-0400
781-740-8816 (FAX)
nfo@charlesriver.com
www.charlesriver.com

This book is printed on acid-free paper.

Professional 3D with Electric Image Universe.
Lance Evans.
ISBN: 1-58450-244-4
Printed in the U.S.A.

Library of Congress Cataloging-in-Publication Data

Evans, Lance, 1963-
  Professional 3D with electric image universe / Lance Evans.-- 1st ed.
    p. cm.
  ISBN 1-58450-244-4
  1. Computer animation. 2. Computer graphics. 3. Three-dimensional
display systems.  I. Title.
  TR897.7 .E93 2002
  006.6'9--dc21
                        2002012652

Printed in the United States of America
02 7 6 5 4 3 2 First Edition

CHARLES RIVER MEDIA titles are available for site license or bulk purchase by institutions, user
groups, corporations, etc. For additional information, please contact the Special Sales Department
at 781-740-0400.

# Contents

# CHAPTER 13  RENDERING                         375

# ACKNOWLEDGMENTS

Writing a book is the process of learning a subject we thought we already knew.

The process was not done alone. It is safe to say that this book would not have achieved as many of its goals had it not been for the tireless efforts of Sara Sprague, who acted as equal parts technical advisor and editor.

I also wish to thank Mark Hannon, Blair M. Burtan, Jean-Christophe Erny, Matt Hoffman, Himanshu Gothel, Brad Parscale, Jay Edwards, Ernest Rowe, and Bear Weiter for their various contributions along the way.

# AUTHOR BIOGRAPHY

As creative director and principle of Graphlink Studios in New York City, Lance's commercial accounts have included 3D work for Miller Beer, Absolut Vodka, Merck Pharmaceuticals, Trojan Brand, EDS, and a host of advertising and publishing companies.

In the 3D community, he is the founder of 3dNY.org. With thousands of members, it is one of the largest associations of 3D artists in the country. It hosts live seminars, and an active online community with articles, forums, and software. When not busy developing a variety of software and educational titles that are available through 3dNY and other retailers, Lance can often be found answering questions in 3dNY forums.

# FOREWORD

Electric Image Universe is one of my favorite tools. When first exposed to Version 1.0 in 1991, I was immediately impressed by its speed and power. Anybody who has to produce animation on a deadline appreciates a fast renderer, and Universe is as fast as it gets. The real secret to getting great looking images is iterative refinement. Look, react, make changes, look again. The faster you can render out an image or animation, critique it, make improvements, and run it again—the better it can be made before you run up to your deadline. All artists want more time to make their work better, and Universe's speed effectively gives it to you.

What do you do with that extra time? What parameters need to be changed to make your images look better? 3D is a complex and technical art form. Its sophisticated tools give the artist a great deal of control, but come with an often bewildering collection of sliders or worse, just numbers in boxes. "My gold object looks like yellow plastic. Which of the hundreds of numbers need to be changed to get it to really look like gold?"

In this book, Lance Evans discusses what the manuals do not, how to use the power that Electric Image offers to make great-looking images. Where the manual tells you what a given parameter is, this book teaches why you will want to set it to a particular value to get the best results. If you strive to make realistic images, you'll learn why one setting produces a realistic result and another does not.

John Knoll
July 2002

(Original creator of Photoshop, John Knoll is the Visual Effects Supervisor at Industrial Light & Magic for *Star Wars Episodes I* and *II*, *Star Trek*, *Mission to Mars*, *Mission Impossible* and others, for which he has received multiple Academy Award nominations.)

# PREFACE

A little perspective: Painting and sculpture are thousands of years old. Photography and moving images have been around for about a century. And although Disney's 1982 movie *Tron* introduced the technology to the world—professional 3D tools have only been available for a little over a decade, and the power to run them efficiently, less than half that time.

Despite this infancy of 3D, it has already saturated our culture's activities in passive events like TV and movies, and active events such as Web browsing, video gaming, and virtual reality parks. Professionally, 3D/CAD has taken over all areas of industrial and product design, previsualization, and to a large degree has replaced traditional cell animation. Museums and galleries across the country have showcased the new technology as art. Compare this to the 40-plus years it took people such as Steiglitz and Adams to gain such acceptance for photography.

While most other areas of creative tool development have reached a plateau, 3D developers seem to just be warming up. One need only look at the marked jump in quality Pixar Studios made between *Toy Story 1* and *Toy Story 2*, released just a few years apart. A string of stunning 3D films have followed, but perhaps of greater importance is the commonplace use of 3D treatments now occurring in the broadest range of films. The polish that this digital work can give a film—any kind of film—is becoming a staple in the industry.

As 3D artists, we are certainly attracted by the powerful tools and the opportunities they offer, but there is more to it than that. 3D is one of the most enabling mediums ever invented, and I believe this is largely the reason for its quick acceptance. How many other mediums allow either a single individual or large groups to integrate on the same project? What other tool can be used for fine art, illustration, animation, games, effects, design, architecture, and multi-media? Which other medium welcomes

the talents and experience of sculptors, scenic and lighting designers, artists, photographers, directors, writers, choreographers, animators, video editors, designers, and others?

I can think of no other medium with such broad entry points. It is a testament to the many talented people who have labored to advance this new art form to where it is today. And as we are all both practitioners and lifelong students of this medium, we need to discover where we will take it from here.

## About Electric Image Universe

Originally founded as a visual effects studio in 1987, the team developed 3D animation and rendering software to create digital special effects for film. Although rudimentary by today's standards, they were able to optimize the rendering software—called the **Camera**—to amazing speeds. Running on a consumer Macintosh computer, it easily out-paced workstation-class software/hardware systems. Dubbed Electricimage Animation System (EIAS), it went on to single-handedly define professional 3D animation on the personal desktop for many years.

EIAS continued breaking new ground and render-speed records, and was used for stunning effects in *Terminator 2*, the *Star Trek* movies, *Mission: Impossible*, *Star Wars Episode 1*, countless broadcast effects, and commercials.

While render speed is very attractive to anybody working in production, EIAS rendered beautiful images as well, eliminating "interlace sizzle" and other problems common in much of its competition. And where most applications choked on 50-100,000 polygons, EIAS was routinely used for projects having well over one million! This was a great boon for architects and many industrial designers.

A few years ago the EI team decided to start fresh and get rid of old code built up over the years. Rewriting mature software from scratch is a huge undertaking, but the benefits can be great. Re-christened **Electric Image Universe**, the new suite of software now runs on Mac OS9/OS X and Windows NT/2000/XP. Any seat of Universe comes ready to network-render your projects across all of these platforms at the same time—even across an Internet connection!

The new Universe suite of tools has also added a full-featured resolution independent modeling application, full support of OpenGL, a fast and customizable Raytracing engine, and many other features on top of its already stellar list of functionality.

## Who Is This Book For?

Since 3D tools encompass so many areas of interest, *Professional 3D with Electric Image Universe* has a broad appeal to many people in the graphic and motion graphics fields, those doing multi-media, product design, architecture, and many others. Although this book is certainly directed at those interested in learning more about Universe, most of the theories and procedures described are applicable to other 3D packages and related products. In this book you will:

- Find a closer examination of many powerful features.
- Learn production tricks to streamline and enhance your projects.
- Learn how to create a large number of truly spectacular and useful effects.
- See how to integrate other software packages into your EIU workflow.
- Find information about plug-ins and Universe's third-party developers.

Of greater importance perhaps, will be the discovery of new ways to approach old problems, and a better understanding of the methods to use in solving future obstacles.

In producing this work, we were fortunate to have the publishers of Electric Image Universe allow us to include their complete set of manuals on our CD-ROM. Having this valuable reference available allows us to take this book a great deal further than would have otherwise been possible.

Because of the professional slant to this book, it is not meant to all be consumed in a few sittings or read-throughs. Instead it is meant to offer valuable information to the user at any level, and act as a reference for topics that animators often need greater clarification on.

# INTRODUCTION

## UNDERSTANDING THE UNIVERSE

### How to Approach 3D on Your Computer

Just like the artist staring at a blank canvas, or the writer gazing cross-eyed into the word processor's empty screen—the 3D artist can sit with a handful of polygons and not know what to do next. Being an artist is not easy, some overflow with ideas while others get writer's block. (Tip: If the former, write the ideas down, because at some point you will have the latter!)

Whatever your art, it all starts with a story. An illustrator tells a story in 2D (even if using 3D tools!) and animators tell their stories in 2D over time (which is often called the 4th dimension). All artists need to be directors at heart, and this rings even more true with animation programs that have things called cameras and lighting. As a director, you must come to the table with ideas and a vision on how to execute them, making hundreds of stylistic and creative decisions along the way. Of course, if you work on commercial projects for advertising or broadcast clients, then you have the difficult task of bringing other's creative ideas to life.

Like a real-world director shooting in an empty Hollywood sound-stage, you start from scratch. Assuming you have your script and storyboards already done, it is time to call in the *set builders*. In the digital world, this is called modeling, and is accomplished in Universe's Modeler. Finished models are brought into the Animator application and the *set dressers* (read: texture mapping), *lighting designer*, and *director of photography* are all called in.

The point is that there is very little that you do in digital applications that can't find a counterpart in the real world. This is great because it allows you a broader understanding of what needs to be accomplished. The truth is that most people who come to 3D have done so via other mediums first. This may be because 3D is still so new, or it may just be the nature of its complexity.

## Basic Concepts of Working in 3D

The creation of digital 3D objects with our current level of interaction is a very unnatural act. Understand it this way: We exist in a true three-dimensional world, our mesh models and scenes exist in what we call a **virtual** 3D environment. This is all fine until we remember that there is a strictly two-dimensional wall blocking these two environments. We call this wall our monitor!

Imagine how nice it would be to model digital mesh with your hands, or step into a virtual woodworking shop to create your models. This is actually coming down the road at some point. In the meantime your best method for dealing with this hurdle is to learn the tools and techniques that are designed to help you navigate the software. In both Modeler and Animator, the default layouts have Top, Front, Side, and Perspective (called **ISO** in Modeler and **Camera View** in Animator) window views—much like architectural plans with elevations. Learning to keep these windows strategically focused on where the animation or modeling is active will net great productivity gains in your work.

While we are at it, we're stating something now that is important enough to be restated throughout the book: Organize! This means name your models properly, label your lights identifiably, create logical selection sets, and anything else that will streamline the production and provide better visual feedback. These are good habits that you will be happy to have when the screen gets blurry at 3 a.m. while working on a deadline. Easy to understand files are also important when they must be handed off to other animators, or re-worked at a later time.

Readers that have done 3D or drafting work are familiar with the way 3D space is defined as X, Y, and Z planes or axes. This can seem a bit confusing at first until you think in terms of a simple ruler. In the case of 3D we merely have three rulers, each going in a different direction. When looking from the front view, the X-axis measures in the left and right directions just like measuring across an 8-1/2" piece of paper, as seen in Figure I.1.

The only difference is that instead of starting to measure from left to right, 3D worlds start from the center—like a traditional newspaper layout is measured from the spine. Measurements to the right are in positive numbers, and those to the left are called negative. With only one axis we are only one dimensional, so let's add more.

In Universe's world the Y-axis is the vertical measurement, and when we combine both X and Y axes we get a *plane*. This would be called the X/Y plane, of course! Now with two axes we are...you got it, two dimensional! See Figure I.2 on the next page.

Let's add one more—the Z-axis goes from front to back, and we now have our 3D world as you can see in Figure I.3 on the next page.

This style of coordinate system comes in a few variations, but the particular system that we will be working with in Universe is referred to as **Y-up**, simply because Y is pointing up. Other software programs, like auto•des•sys's powerful modeler form•Z, flip the Y and Z axes and use a **Z-up** coordinate system. Animator easily converts models imported from other systems. People often ask why two different systems exist. It really has to do with the original intent of each of the software packages. Where an animation program is designed to mimic a theatrical or horizontal viewing experience, a program like form•Z was created with drafting in mind, which mimics sitting at a table and looking *down* onto the drafting board. In both cases the viewer is facing the same X/Y plane.

## HOW THINGS WORK IN UNIVERSE

The Electric Image Universe (abbreviated as EIU) suite of applications includes the following:

- **Modeler (EIM)**: Modeling application
- **Animator (EIA):** Scene building and animation application
- **Camera:** Multi-platform rendering application
- **Renderama**: Network rendering application

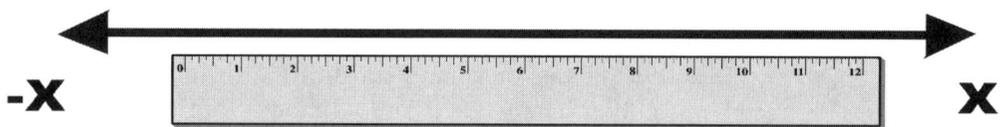

**FIGURE I.1**  A plain ruler measuring across the X-axis.

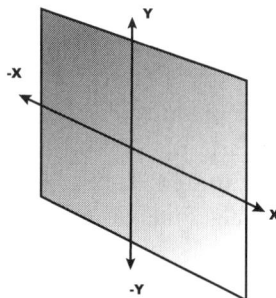

**FIGURE I.2**  With the X- and now the Y-axis, we have defined a plane—the X/Y plane.

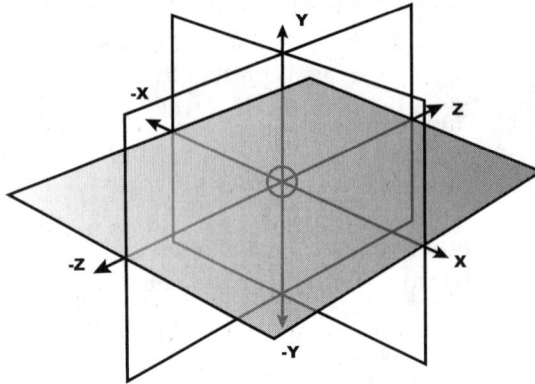

**FIGURE I.3** The 3D world coordinate system with all three axes and planes. This is known as a Cartesian coordinate system.

Each of these programs is a standalone application that runs independently, with the exception of **Camera**, which is hot-linked and controlled by Animator. Take a brief look at these applications so that you see how they work.

## MODELER (EIM)

The newest addition to the line-up, Modeler is referred to as a "hybrid" system that allows work to be done with both solid and surface models, as well as interaction between the two. Shapes can be created with surfaces, solids, NURBS, or ÜberNURBS (subdivision surface modeling).

Because it is based on splines and NURBS, the entire toolset is completely resolution independent and all models can be individually adjusted to raise or lower either the working or the output resolution. This allows going back to a model at any time and upping the resolution for film and print work—or lowering its resolution for games and Web applications. Although Modeler is resolution independent, it offers a limited ability to import polygonal models to use as a template for your work.

Its Boolean tools are based on the ACIS Geometry Engine and are fast and accurate. Other features include surface beveling and rounding tools, unlimited undo's, Surface Laws, which generate models based on input of algebraic formulae, EPS file import, and a limited collision detection ability.

Although Modeler has a number of export formats, to work with Animator and the rest of the Universe system, you will want to export to EIU's native FACT format.

### ANIMATOR (EIA)

This is where it all comes together. The Fact models are added to the project, the scene elements are set up, texture mapping is applied, and lighting is arranged. If you are doing still imagery without any motion, then simply place your camera view appropriately. If you are doing a full animation, then you will be working with the timeline's project window setting up animation keyframes and controls.

EIA offers real-time OpenGL previews, which include previewing single layer texture maps, motion blur, fog, light flares, and more. Full test-renders are available quickly at the touch of a button located at the bottom of the camera view window.

The Raytracing engine is integrated in such a way that the user need never really turn it off, and it only gets applied to items that would benefit from its use. All other items are Phong rendered as before. This, of course, speeds rendering which only takes a hit where Raytracing is really needed and turned on. The quality of the raytraced reflections, refractions transparencies, and shadows is excellent across the board.

Universe comes with an extensive list of plug-ins that adds great versatility and effects. It also comes with a long list of shaders, which are mathematical mini-applications used to generate volumetric textures. Below are just two of the new plug-ins that ship with the program:

- **ÜberShapes**: can create all sorts of geometric, mathematical, and organic shapes in a few seconds. Its geometry is resolution independent—this is the only method to using resolution-independent models in EIA at this time, all other geometry is polygonal.
- **Power Particles Basic**: A slimmed-down version of third-party developer Triple-D Tools' *Power Particle Pro*. It is a versatile particle generator that includes advanced collision detection, a great new interface with OpenGL support, and many other parameter settings for great effects.

### CAMERA

The Camera application is the actual rendering engine in the suite. Other than a few interface controls (pause/resume and quit), all features are controlled and set up in Animator. While it is rendering, Camera displays a wide range of scene data and render estimates that offer valuable feedback.

Camera is well known as the fastest rendering engine available, and the quality it produces is second to none.

Copies of Camera running on Mac and Windows (NT/2K/XP) are included at no extra charge with each seat of EIU. Camera can render out images as large as 32,000 pixels square—even at high resolution print quality (300 ppi), that works out to almost a 9-foot square image!

## RENDERAMA

Renderama is the network rendering application that can be used as either a spooler or render queue for a single machine, or to manage dozens of render boxes across many networks (even over TCP-IP!), regardless of operating system. A common scenario is a studio doing its authoring on its workstations, and sending the file to Renderama to manage the job over a renderfarm. In this way, animators can continue to work on their workstation while the Renderama continually optimizes and oversees the job or producing the animation.

# EIU MODELER

Modeling in 3D has often been referred to as a specialty within a specialty. This idea was fostered for a number of reasons, including the fact that in the traditional stop-motion world, animators and model-makers often came from different camps with very different training. The reason for this is simple: despite the Siamese-like bond between modeling and animation, the two endeavors don't really have much in common.

As the digital world was growing, many of the early modeling and animation packages were produced as separate applications. This allowed specialists in each area to work at their trade without the unnecessary overhead of toolsets that would not be used. There is much to be said for this logic even with today's powerful computers, and many packages operate with either separate applications or modules for the two toolsets.

In more recent years, the old-school notions of separate camps has given way to the more pragmatic idea that everyone should be able do a little bit of everything when sitting down with an animation package. Though there will always be hard-core specialists, you will find that the Electric Image Universe suite of applications makes it easy to jump into each area and produce exciting work.

Part I of the book covers the Modeler. It starts with an overview that offers many building block concepts, and then quickly moves on to more specialized and professional-level tutorials.

# 1

# AN INTRODUCTION TO MODELER

A s a recent addition to the Electric Image suite of tools, most would agree that Modeler has quickly grown into an elegant modeling solution.

Modeler is nonpolygonal, which might be new to those of you who have spent years pushing triangles and counting vertices. It is based on the very powerful ACIS 3D software engine used in a variety of higher-end CAD/CAM systems. Building on this, Electric Image has developed a program with a wonderful range capabilities and a working interface that is instantly comfortable to both new and seasoned users.

## A WORLD WITHOUT POLYGONS

The Modeler is dubbed a *hybrid modeler* because it seamlessly integrates wireframe, surface, and solid modeling functionality without the limitations of interoperability often encountered in other applications. Unlike the polygon modelers of yore, the ACIS 3D engine generates its geometry using elements such as Beziér lines and NURBS surfaces, which stay fluid and resolution-independent during construction and editing (see Figure 1.1). This is an important concept to understand because it means that the operator can take an object and generate low-density meshes for game development and then take the same object and output a high-density mesh model for film or print work.

A polygon modeler, by comparison, allows presetting a mesh density before each step but has a hard time modifying that density once created. This is not to say that polygon programs are without merit, for this is not the case at all. You can think of it in much the same way a digital artist

**FIGURE 1.1** Polygons begin to look more twentieth-century compared to hybrid modeling.

decides to use either Adobe Photoshop (pixels = polygons) or Illustrator (Beziér = Beziér); both have their good uses. In fact, because Animator is a polygon-based animation system, the last step within Modeler is always to export the model to Universe's polygonal Fact format.

## A MODEL INTERFACE

Few programs are as instantly comfortable as Modeler. It has a smooth professional feel and fluid ergonomics that belie its powerful toolset (see Figure 1.2). Unlike most programs, which have somewhat static interface elements, Modeler's windows and tool palettes are more modular and can be set up to give you a variety of information and visual feedback.

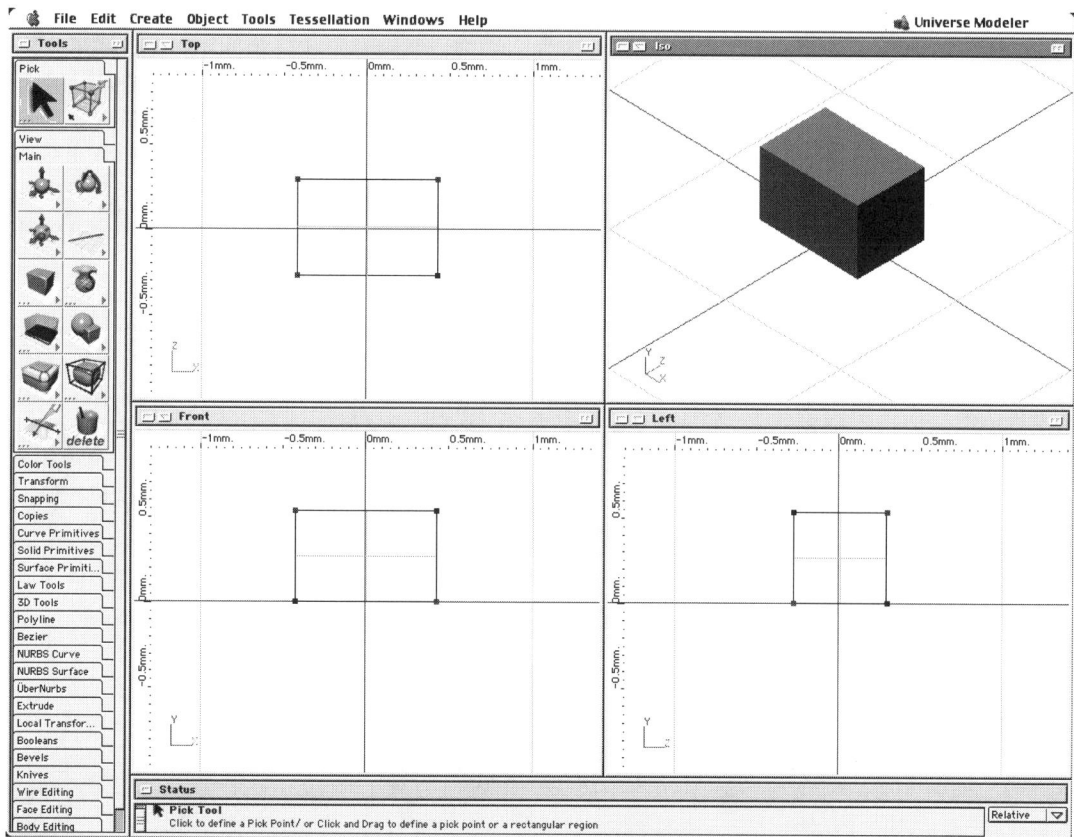

**FIGURE 1.2**    Modeler's default interface.

## Modular Windows

Tucked into the upper-right corner of each of the four default windows—referred to as **Modular Views**—is a tiny pop-up menu called the **Layer View** (see Figure 1.3) that controls which display mode the window is set to. Other than their 3D views, the windows can be set to three other options, all of which can also be displayed in their own proprietary windows from the **WINDOWS** menu or a key command. Accessing them through the modular 3D views offers convenience and efficient use of screen space.

### World View (Default)

Like its sibling, Animator, Modeler defaults to three elevation views and one isometric. You do not need to work in 3D very long to have the experience of moving elements around in one view, only to change views and be aghast at the havoc these simple moves can cause. If you have multiple views open at the same time, monitoring what is going on is easier because the other views are showing you in real-time the effect your actions have.

The three elevation views, Top, Front, and Side, each allow you to monitor just two axes at a time. For example, the Front view allows you to see and move things in the X-axis (left and right) and the Y-axis (up and down). However, because you are dealing with three dimensions, you can see how having at least one other window can help.

The fourth window on the upper right is set to ISO view, which is an oblique three-quarter angle that gives the operator a sense of the entire object. Realize, though, that all these views default to a **Parallel** setting, which means that there is no recognition or displaying of natural perspective, that is, converging lines. This is a good thing for the elevation views, and it is also all right in the ISO view as long as you understand that objects might look different when viewed through the camera in Animator.

**FIGURE 1.3**   The pop-up menu offering various views for each default window.

This is just a case of "objects might be closer than they appear," and you will quickly adjust to it. To get a better idea of how the object will appear in Animator, the Window Options menu allows you to change to a preset **Perspective** view. You might find that it exhibits too much wide-angle effect, but this can be diminished by moving the view out.

### Layer View (Cmd-L)

Layer view changes the window to display the *layers*, or hierarchical structure of the scene (see Figure 1.4). Its top element is a folder named **World**, within which all other items exist—other items being modeled objects, lights, and layers. Layers are also displayed as a folder icon that is used to organize all other elements, even other layers, via simple dragging. This offers good organization while working within the program and can also be used to group items upon export.

Along the far left are the Lock and Visibility toggle flags. These can be set by individual element, by layer grouping, or universally by using the icons at the top of the flag column. The user can also click and drag down the list to flip multiple objects at once. These tools become invaluable when projects begin to grow beyond the basic and you want to lock down finished objects for safety or turn them off to improve the work view. It also comes into play when you want to use the **Export Visible Only** feature in the **Preferences... Export** tab. Double-clicking any item opens its **Info Properties** window. **Object** names can be edited by first highlighting the name, and then hitting the Enter key.

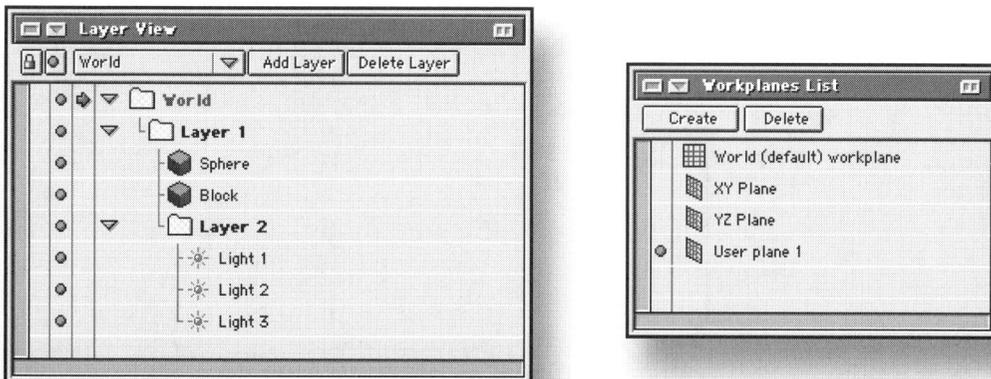

**FIGURE 1.4**    The Layer View mode (left), and the UCS View/Workplane mode (right).

### UCS View/Workplanes (Cmd-U)

UCS View displays and manages the workplanes within Modeler (see Figure 1.4). Workplanes are an important part of 3D modeling, but often a difficult concept for users to grasp. They are based on the fact that we are all working on 2D monitors and, for all intents and purposes, can work in only two axes, that is, one plane at a given time.

In programs such as Photoshop or Illustrator, you never think of such things because the workplane is simply the flat document, just like a canvas or sketchpad. An architect or engineer will be quick to remind you that this flat surface is actually your X/Y plane in disguise (or X/Z, depending on the view). When you draw or create elements, the program has to know where in space to place them. Because your mouse instructions to the program can convey only two axes of information (up and down, left and right), what is the program to do? What it does is default to the most logical preset plane. For example, if you select the **Surface Sheet** tool (found in the **Surface Primitives** Toolbar tab) and use it to draw a rectangle in the **Front** view window, which is an elevation view, you are controlling the X and Y coordinate information. Along the Z-axis, the program will automatically place all points at zero. You can see this happen in the ISO view, shown in Figure 1.5.

If you do the same thing from a nonelevation view, by changing the window's angle or using the ISO view, the model element behaves differently and attaches itself to whichever workplane is currently active. This is where using the USC View window becomes important and where creating

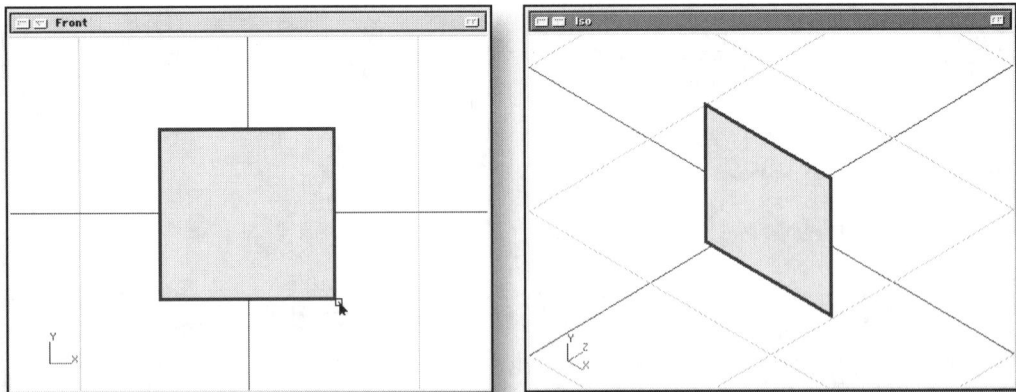

**FIGURE 1.5**   When drawing in the Front view window, elements default to a coordinate of 0.0 along the Z-axis.

custom workplanes gives you enhanced power and speed. This information applies to moving items, as well as creating them.

To streamline many of these issues, Modeler allows you to begin an operation in one window and complete it in another, thus enhancing the interactive workflow.

### View Manager (Cmd-G)

The View Manager allows you to store and retrieve different window views. Being able to reproduce an exact viewing position is a really good idea, but can be next to impossible, so generating valuable work angles as a project progresses can help speed it along later.

## Navigating World Views

Knowing where you are in the world and where you are viewing from is very important, so Modeler helps by first displaying the view's name at the top of each window. You do need to be careful with this because it is not always accurate. For example, if you set a window to Left view and then rotate the viewing axis—even by dramatic amounts—the title bar still states that it is displaying the Left view.

The second visual cue you are given is the tiny XYZ axes line at the lower-left corner of every window. Not only does it tell you what your two- or even three-axes view is, but it also rotates around in real time as you modify your view angle.

Moving around in the World views is surprisingly easy. The three actions involved are the Pan, Zoom, and Orbit controls. These can be accessed by their icons in the Toolbar's View tab, but most of the time you will want to be more productive than that and use the following keyboard commands:

- **Pan**: Spacebar
- **Zoom**: Command-Spacebar
- **Orbit**: Press either the letter O key or Cmd-Shift-spacebar
- **Fit to window**: F-Click

In addition, you can zoom into specific areas of the image by holding the **Option** key and **dragging the mouse** to marquee the desired area. Between all these commands, which take only a few minutes to file into memory (yours, not the computer's), the level of production goes way up, as does the level of enjoyment.

These commands apply to both the elevation and ISO windows.

## Window Options

Coast the cursor over any of the World view windows, and **Control-click** to bring up an extensive pop-up menu, replete with subtabs (see Figure 1.6). This is the Window Options control, which allows you to change many settings quickly without having to dig into the Preferences. You should be aware that most of these items are not available through other dialogs, only here. Some options are applied only to the selected window, and others are global changes.

You will find yourself using the two items at the top on a frequent basis:

- **Orientation**: For choosing any of the elevation views, the ISO view, or the Workplane view to be displayed in a specific window.
- **Draw Level**: For setting the level of preview for the individual window selected, from wireframe through Smooth Shaded (see Figure 1.7). Modeler's screen previewing is based on OpenGL (OGL), so the better your OGL card, the swifter your screen responses. It is common practice to set the ISO window to Smooth Shade and the other views to a lower and more efficient level. Wireframe modes are beneficial not just for processor efficiencies but also for working when you want to see and manipulate the control lines. These views are also essential for understanding the structure of your model and previewing tessellation.
- **Immediate, Complete, Single View, and All Views**: If the workstation is fast enough, you can have all windows update with the complete model (instead of extents) by setting these two options to **Complete** and **All Views**.

## Moving Objects in World Space

Now that you know how to move your view around, how about your scene elements? The Toolbar has three main tool icons: **Free Move**, **Free Rotate**, and **Free Scale** (see Figure 1.8). Each of these has subtools that restrict the action to a specific axis; as well as a few extras under Free Rotate.

Okay, time to experiment. Open a new Modeler file and put a simple cube into the center of the ISO view, using the Block tool found in the Toolbar's Main tab. A prepared file is provided in the corresponding folder on the book's CD-ROM, just in case you need it.

**ON THE CD**

Now switch to the **Free Move** tool found in the same tab, and using the ISO window, start dragging the block around. You see that it stays on

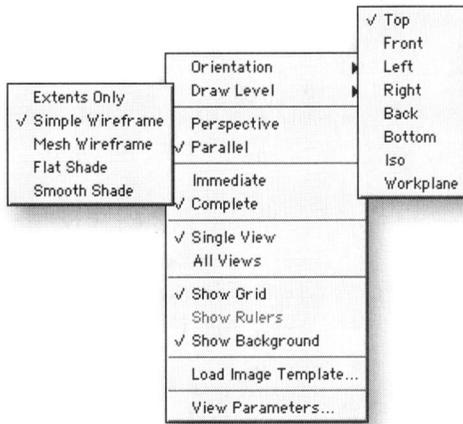

**FIGURE 1.6**    The Window Options pop-up menu.

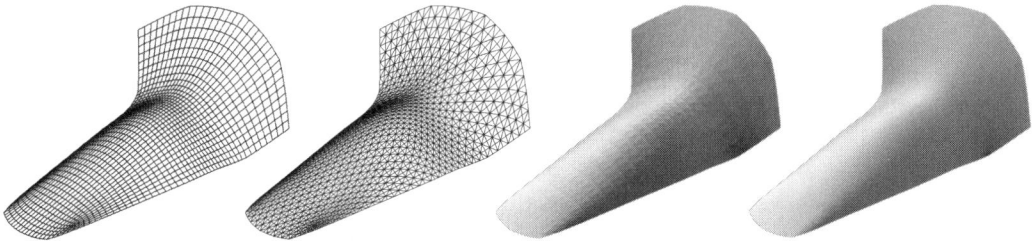

**FIGURE 1.7**    Shade levels: simple, mesh, flat, smooth.

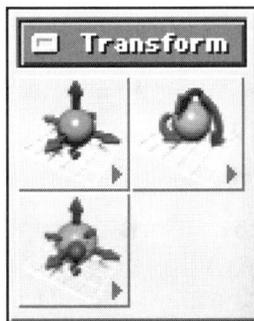

**FIGURE 1.8**    The Transform icons for Free Move, Free Rotate, and Free Scale.

the X/Z plane because that is the default workplane (keep in mind that a workplane is a stage, a Workplane View is a view of the stage), but you have little control of where on that plane it goes unless you switch to one of the elevation views. This is where the subtransform tools come into play, allowing you to work in a nonelevation view and still constrain the transformations to the X, Y, or Z-axis. Better still, don't go up to the Toolbar; instead, use a modifying key with the main Transform by holding down the X, Y, or Z keys while you move, rotate, or scale the elements. Look at the speed and freedom these few keys can give you. Do note, however, that in this example the Free Move tool constrained to the Y-axis results in no movement. This is because the Y-axis is off the workplane—except at that one location where the model currently sits.

### Mousing Around

The mouse actions are different than expected in some situations. For example, if an object is highlighted and you want to deselect it, the natural reaction is to click in an empty (*null*) area. This usually does not work. Instead, try holding the Shift key and clicking either the model or null space. Another option is simply to select a new tool, although this is not universal. Double-clicking in a null area works to deselect objects when in a Transform tool but can invoke a command when other tools are active.

As with other modeling programs, there is both a Pick tool and a Move tool. The functionality is correct, but the ergonomics are different than in most other applications, often resulting in confusion. A related issue is that many tools deactivate after use, returning the user to a default tool. If the mouse is not performing as expected, confirm that the correct tool is selected.

Another mousy problem that occurs is a failed attempt to Transform one model in a scene with two or more objects. A feature called *Collision Detection* is the likely cause and can be turned off by holding the F3 key. When turned on, this Collision Detection is very useful at automatically making sure that objects do not intersect.

### Single-Window Options

After you learn to control how a model is moved in and around the world space, there is less need to have four windows always displayed and taking up that much real estate. In fact, many experienced modelers prefer to do much of their work within a single window. Other modeling programs, such as form•Z by auto•des•sys, default to a single window interface, which can speed up the process for the more experienced operator.

On Modeler, click the window expand button on the upper-right corner to fill the screen. Click again, and it goes back in place to make your work mode fast. Using one window requires more nimble fingers for key commands, a bit of effort to remember them, and a clear awareness always to check the scene from various positions. When these things become second nature, the productivity returns can be substantial.

## The Toolbar Interface

The toolbar on the left is as malleable as the windows and can be moved to a more convenient location if preferred (maybe off to a second screen):

- **Control-click**: Brings up a pop-up menu to change the size of the icons and deal with custom palettes.
- **Option-click**: Alternates between icon and text-based display of the Toolbar. Icon mode is faster when you know the icons, and Text mode is faster when you don't.
- **Tab-drag**: Allows convenient placement and easier access for items used frequently, through tear-off tags.

The Toolbar's interface is quite good and flexible; the only issue is that several tools have less than catchy names that are quite long. This can make them hard to remember and hard to read in text mode. Instead of relying on the ToolTips, which are great but slow you down, you can combine a couple of the preceding options. If you first convert a tab to text format and then tear it off, you get a nice floating-text palette whose width is scaled to fit the longest name. No more guessing.

## The Status Bar

Tucked just below the four windows is the Status Bar. It is so unobtrusive that many people don't even notice it until they use the program for a while. This is a shame because it offers a wealth of information, especially for those just starting out.

The very first thing you should know is that the Status Bar is the only place that displays the project's file name. In general use, the prompts it gives when selecting and using any of the tools are so helpful and to-the-point that it saves you many trips to the reference manual. However, the title bar is not just for hand holding; it also displays error information, and depending on the tool that is selected, additional edit boxes appear that allow the operator to type in absolute numeric values instead of using the graphic interface. This is the case with one of the most-used set of tools, the Transform's **Move**, **Rotate**, and **Scale**. The values in these edit boxes can be

stated as **Relative To** the model's current data (positions, rotation, and the like) or **Absolute**, which uses world coordinates as the reference.

## ZEN AND THE ART OF MODELING

You must have a certain mental approach for any art form, whether 2D or 3D. All art strives for a sense of mass and space, and the decisions you make along the way help define these aspects of your work. A sense of mass can be quickly defined by using a pen and paper, which is what most traditional sculptors have always done—think of Rodin's drawing studies. Playing with your shapes on paper not only helps you design them but also helps you simplify their form. Herein lies the secret to 3D modeling—the simplified form.

Looking at a shape that needs to be modeled and being able to break down the shape mentally into its more primitive components is the real trick. There is almost always more than one way to approach building an object's shape, and determining which way will be easiest, truest to its form, and the most reliable for animating makes this trick more challenging, to be sure.

Some people are more intuitive at this than others, but practice and experience absolutely make a world of difference. Expect to bang your head in the beginning—everyone does.

### Where Do Shapes Come From?

As a general work process, shapes start out simply and gain complexity as they are further developed. This is not always the case (exceptions can be found), but models that evolve in a more progressive fashion tend to behave better in the long run and have fewer texturing or shading problems.

The following is a generic list of object categories, from simple to complex (not to be confused with *topology*, which is specific to Modeler's ACIS technology):

- **Wires**: These are the basis of life, in the 3D world, at least. There are also vertices, but we will view them as a subset to wires because they are rarely used independently.
- **Faces and surfaces**: These are basically enclosed wires and are the first level that can be seen in a fully shaded rendering.
- **3D derivative objects**: These are more complex forms created by applying some type of action, extrude for example, onto wires and/or faces. They do not have to be a true solid but usually have a distinct three-dimensional mass.

- **Compound structures**: This is the category most complex models fall into, being a combination of multiple derived objects.

## How to Approach a Model

To better understand the ways in which a given model's construction can be approached, you will take a shape and explore four ways to produce it using cross-sections and Skinning, Revolves, the Birail tool, and Boolean methods.

Although the primary point of this exercise is to gain a better conceptual understanding, there are also tools and steps to be learned along the way. All project files are included on the CD-ROM in the associated folder.

**ON THE CD**

Start with the conceptual sketch of a vase, shown in Figure 1.9 on the left. The sketch must be adapted for your use, so we created the vase profile template shown in Figure 1.9 on the right. Templates and background art can be saved as TIF, JPG, GIF, PICT, PNG, or Electric Image **IMAGE** format (by using Photoshop natively or with the plugin that comes with EIU). We used the IMAGE format and imported it into the **Front** view window in Modeler, using the **Window Options** control (Control-click the Front view window). Images in Modeler are automatically placed on something of a virtual plane, which can be sized, moved, or rotated, as shown in Figure 1.10. Open the **Layer View** window (via a modal 3D view window or by holding Cmd-L), and lock the image in place. Now that the file is set up, you can get to work. The base file with imported template is on the CD-ROM and ready for your use. It is named *Vase START file.eim.*

**ON THE CD**

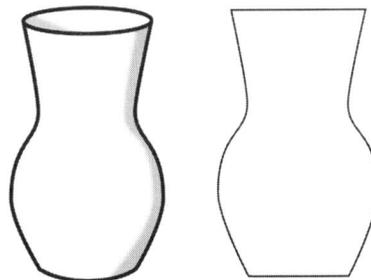

**FIGURE 1.9**　A simple shape that, nonetheless, can be approached many ways. A concept sketch (left) and working profile (right).

### THE CROSS SECTION METHOD

The cross section method uses wires, in this case, circular-shaped wires, to create the vase's cross-sectional structure to then use with the Skin tool.

1. Select the **Create Circle** tool in the **Curve Primitive** tab. In either the Top or ISO view, click the center of the grid (at World Zero) and drag out. If this is done in the ISO view, the template can be viewed at the same time, allowing the circle to be reasonably sized from the start.

2. Click the **Copy Mode** tool (on the Copies tab) to make it active. A check mark appears. Then double-click to open its options window. For **Number of Copies**, enter 6. Toggle the **Divide Total Transformation** option on. The amount you transform an object (by Move, Scale, or Rotate) will now be divided by the number, and a copy of the model will be created and placed at each division point.

3. In the Transform tab, click and hold on the Free Move tool to open the suboptions. Select the **Move Y** tool. In the Front view, click the circle you just made, and slide it upwards until it is in line with the top of the vase template. A duplicate is created for your new position, and five more are deposited in between, as shown in Figure 1.10. The original circle may be obscured by the grid line, which can be turned off.

4. Turn off the **Copy Mode** by clicking the icon again. The check mark should disappear.

5. Select the **Uniform Scale** tool (on the Transform tab), and in the Front view, resize each circle to match the width of the vase template behind it (see Figure 1.11).

6. Select the **Skin** tool (on the 3D Tools tab). This tool is used to put a *skin*, or surface, across selected wire objects. To do this, you select each of the

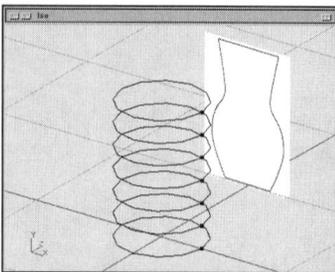

**FIGURE 1.10**   The wire circle has been vertically duplicated. Note the virtual plane for template images toward the back.

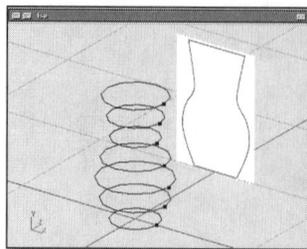

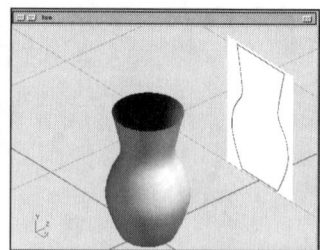

**FIGURE 1.11**   The wireframe circles scaled to the template (left) and the final Skinned model with top face removed (right).

wireframe circles, this must be done in a progressive order because the tool correctly interprets the order in which items are highlighted. In a convenient window, select the circles from top to bottom, or vice-versa. Just don't jump around haphazardly. When done, double-click in a blank area of the window where no model exists. A skinned model should appear over the circles. Note that the circles still exist, and if you are happy with the new skin model, go to the Layer View window, put the circles in a folder (a.k.a. a *Layer*), lock them, and make them invisible. They will be available if you ever need them again but are also out of your way.

7. The last step is to remove the top **End Cap** to create an open-top vase (shown in Figure 1.11 on the right). You could have set the Skin tool not to generate end caps in its **Settings** window, but you want one created for the bottom of the vase. In the **Face Editing** tab, you can use either the **Uncover Face** tool or the **Remove/Delete Face** tool to accomplish this. The difference between the two is that the Remove Face tool also removes the associated co-edge wire information that Uncover Face leaves behind. You might have some trouble using either tool as you click around the top of the vase; this is because you need the mouse to click one of the **isoparm** lines. These are the grid-like lines seen in the Simple Wireframe mode, as in Figure 1.12. Switch to wireframe view if necessary.

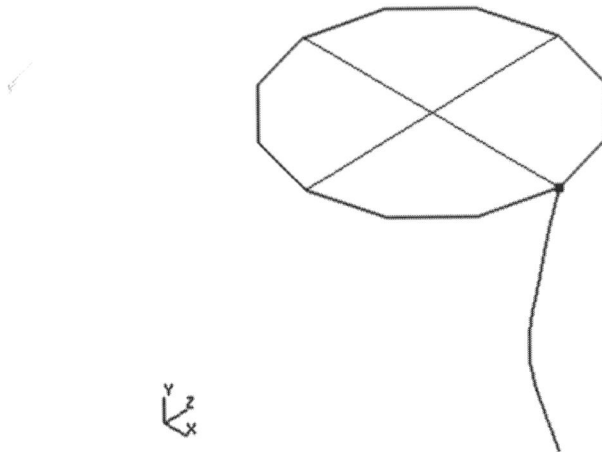

**FIGURE 1.12**   The isoparm are the grid-like cross lines that represent a surface. Face Editing tools must be clicked directly on some part of these in order to work.

## The Revolve Method

The revolve method uses the Revolve tool and a wire profile model.

1. Start by tracing half of the profile template. Select the **Create New Beziér Curve** tool in the Beziér tab. You will be working in the Front view window, which is much easier if it is made larger to fill the screen—click the window resize button in the upper-right corner.
2. Using the Beziér tool just as in an illustration program, outline only the left half of the vase but do not include the top horizontal line, as you want the vase top open. This can be accomplished by four clicks from top to bottom and then the last one horizontally to the centerline, as shown in Figure 1.13 on the left.
3. Select the **Revolve** tool (on the 3D Tools tab), and click the Beziér line. This lets Modeler know that you want to revolve this line, but around what? You have a few options. You can pick another model—a straight wire or edge, to use as the axis of Revolve. Instead, click the red Y-axis centerline, drag straight down vertically, and let go. Your now familiar vase should appear on screen (see Figure 1.13 on the right). This could, of course, be done at a very different angle and position, and the results would be quite different. Try a few, but know that if you set an angle that will cause the model to overlap itself, an error will be displayed.

## THE BIRAIL METHOD

The Birail method combines elements of the preceding two examples, as the Birail tool uses profiles like the Revolve tool, but like the Skin tool, it does not mandate symmetry in its results. You must create three wire objects, left and right profiles (where the term *bi-rail* comes from), and a cross section. Because you have created these before, this will go fast.

1. Select the **Create Circle** tool (on the Curve Primitives tab). As you did before, go to the ISO view, click in the center, and drag outwards to create a reasonable-size wire circle.
2. Select the **Universal Scale** tool (on the Transform tab). In the Front view, scale the circle, which should be lined up with the bottom of the vase, until its width matches the template.
3. Select the **Create Beziér** tool (on the Beziér tab). In the Front view window (which you might want enlarged), again draw the left profile of the vase. This time, do not include the top or bottom horizontal sections, only the wavy side.

4. In the Transform tab is a tool named **Reflect**. With it, you click the Beziér line to highlight, and double-click to indicate that the selection is complete. Now Modeler needs an axis of reflection, so give it one by going to the center red line (Y-axis) and dragging straight down. When you release the mouse button, a mirror image of the Beziér line appears on the right side. You now have both rails and a cross-section, as shown in Figure 1.14.

5. Now comes the time to use the **Birail** tool (on the 3D Tools tab). This tool is finicky about how close it is (or isn't) to other items in the world. The cross section needs to be within the set tolerance distance of the primary rail (the first one clicked). It also can't have other items within that same tolerance zone. The cross section can be moved using a snap filter to ensure that it is right on the rail, or you can just zoom way in from two or more views to adjust it. Double-click the icon to open the Settings window. There is an **Intersection Toleranc**e edit box that defaults to 0.001 but needs to be changed to 0.1 in our files on disk to work. Also notice that the **Cap Ends** toggle should be on.

6. With **Birail** selected, click the primary rail, then the secondary rail, and then the circle. Now double-click in an empty area of the World view to set the tool to work. If an error appears, read and act on it. The error comments are written in human terms, a nice change of pace.

7. After the vase is generated, the top face needs to be removed as before, using the Uncover Face tool. The final model appears in Figure 1.14 on the right.

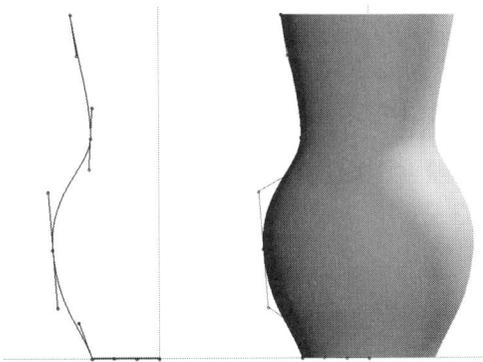

**FIGURE 1.13**   The Beziér tool is used to create the vase profile. A vertical reference line is added down the Y axis (left). The final revolved vase (right).

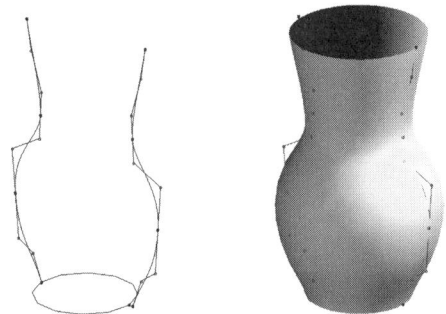

**FIGURE 1.14**   The primary and secondary rails and the cross-section circle (left). The finished Birail model after the top face is removed (right).

## THE BOOLEAN METHOD

We have introduced several tools from the 3D Tools tab already, so the last method for generating a vase uses some other techniques. You will use NURBS, Knives, Revolve, and Boolean tools. Understand that this is not the most direct way to make this particular shape, but this approach is applicable to other situations and teaches yet another way to look at form and shape.

1. Select one of the **Create New NURBS Curve** tools, either the top-left icon, which creates a NURBS line from **Knots**, or the top-right, which creates it from **Control Vertices** (CVs). In the **Front** view window, create the vertical wave portion of the profile only. You will probably find that using the **Knots** implementation makes obtaining the desired shape easier, but the **CV**-based tool might be less confusing to start with. Both are certainly different from the Beziér curves most artists are accustomed to, but offer advantages discussed later in the book. Because this is an exercise, take the time to try both tools and see how true to the shape you can get. Because you need only the side curve and not the top or bottom horizontal lines, aim to limit creation of the shape to no more than four clicks (control points).

*The Knots-based tool allows you to click and drag the mouse for enhanced control. The CV-based tool does not.*

2. Select the **Surface Sheet** tool (on the Surface Primitives tab), and draw a rectangle on top of the NURBS curve, in the manner shown in Figure 1.15 on the left. Make sure that the NURBS curve extends just above and below the rectangle.

3. Select the **Wire Knife** tool (on the Knives tab), and double-click to open its Settings window. You are going to use the NURBS curve to modify the rectangle's shape. The Settings option lets you choose whether this action is executed as a **Split**, which retains both halves, or a **Cut**, which keeps the portion of the rectangle you click and deletes the rest. Select the Cut option and click OK. In the Front world view, click any portion of the rectangle to the left of the NURBS curve—this tells Modeler which part to retain. Then select the NURBS curve (not its blue Hull lines), and the right portion of the rectangle disappears. Open the Layer View window (Cmd-L), and turn off the NURBS curve.

4. Change to the Mesh Wireframe preview level, and you will see that your new shape has a lot of cross hatching going on in the middle. This will interfere with a clean Revolve operation, so select the **Uncover Face** tool

(on the Face Editing tab), and click the object. All internal structure disappears and leaves an outline, as shown in Figure 1.15 on the right.

5. Select the **Revolve** tool (on the 3D Tools tab), and double-click to open its settings. Select the **Solid** option, because you want to generate a solid instead of surface model. Leave the Angle of Revolution at **zero degrees**— this tells Modeler that you want a smooth surface. Click the **Knifed Body** to highlight, and drag a vertical revolve line down the centerline Y-axis. In a moment, a model appears that might best be described as an inverted vase, as shown in Figure 1.16 on page 22. You will be using this model to do a Boolean subtraction from a cylinder model to create the outer shape of the vase.

6. Double-click the solid **Cylinder** tool (on the Solid Primitives tab and as a subtool in the Main tab) to open its Settings window. The cylinder needs to be shorter than your solid Revolve model, which will be used as the subtraction shape. However, its radius needs to extend past the negative vase shape and into the revolved mass. These requirements can be achieved by creating the cylinder manually and editing as needed or by creating it numerically for more precise control. In the corresponding project file on the CD-ROM, the following values were used to generate the cylinder:

**ON THE CD**

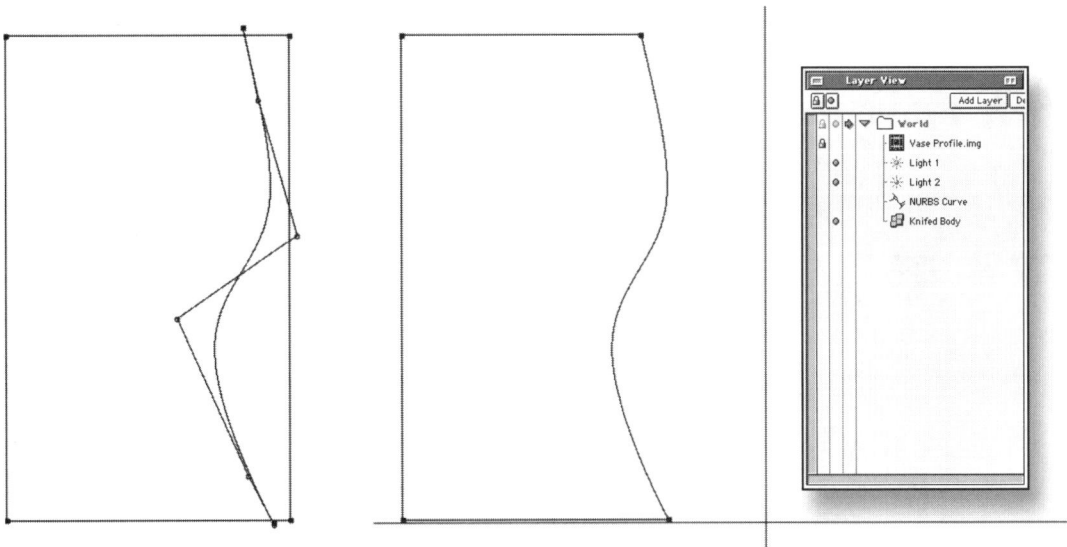

**FIGURE 1.15**  The NURBS curve with the Surface Sheet rectangle, before the Wire Knife operation (left) and afterwards, with the curve turned off in the Layer View window (right).

| | | | |
|---|---|---|---|
| **Base Center** | X: 0.0mm | Y: 0.015mm | Z: 0.0mm |
| **Base Radius** | 0.4mm | | |
| **Height** | 0.9mm | | |

The correctly generated cylinder model is shown grayed out in Figure 1.16.

7. Select the **Boolean Subtraction** tool (on the Boolean tab), and click the Cylinder model first, then click the Revolve model so both are highlighted. Now, off to the side in an empty part of the world space, perform a double click. The result is a vase model.
8. Again, use the **Uncover Face** tool (on the Face Editing tab) on the top of the vase to open it.
9. To finish, select the **Shell** tool (on the Body Editing tab), and double-click to open the settings. Change the default of 0.01 to a thicker value; the sample file uses 0.03mm. Click the vase model, and in a moment, its thin-edged opening has a more realistic thickness, as shown in Figure 1.17.

**FIGURE 1.16**    The Revolve model represents the vase's negative space, which will be Boolean-subtracted from the cylinder, which is gray in this Front window view.

## THE TOOLS

Not counting duplicates, the Toolbar is home to more than 200 tool icons, of which more than 50 have submenus for additional options and settings. You do not have to learn them all overnight. When facing any large amount of material to learn, breaking it down into a more logical and digestible form is helpful.

To accomplish this, look at the toolset in terms of the building block categories discussed earlier: **wires**, **surfaces**, and **derivative** shapes. In the following two chapters, you will take a hands-on approach with both ACIS modeling and ÜberNURBS.

### The Main Palette for Speed

Located at the third tab slot down from the top, is the **Main** palette (see Figure 1.18). This is a generic, custom palette pre-made with some of the most frequently needed tools. If you were to leave just one tear-off menu out all the time, this would be it.

The secret to the Main palette's speed is that beneath each tool's icon are all the other tools from their respective palette categories. For example, tucked under the **Revolve** tool icon as subicons are the **Sweep**, **Skin**, **Loft**, **Blend**, **Profile Skin**, **Coons**, **Net Surface**, and **Birail** tools. There are similar situations for most of the other icons, so you can see how this can save you trips to the ever-scrolling Toolbar.

### Lines and Wires and NURBS, Oh My!

As they are the building blocks of most other structures, take a look at Modeler's tools to create lines, wires, and edges (see Figure 1.19). These are divided into one general palette and three discrete palettes.

**FIGURE 1.17**  The final Boolean vase with the Shell tool applied.

**FIGURE 1.18**  The Main palette offers some of the most often used tools in one convenient location.

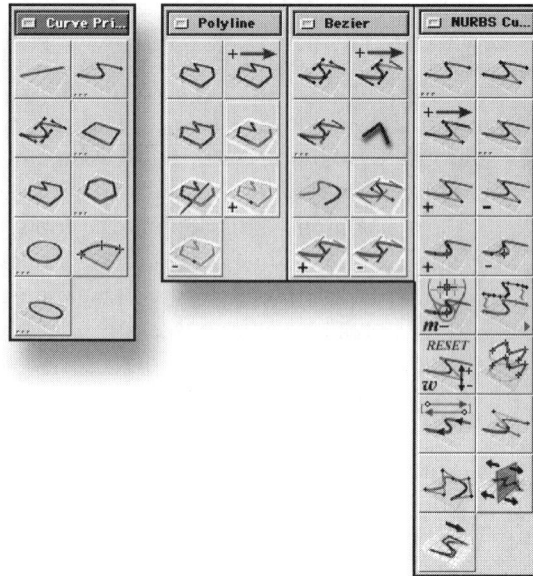

**FIGURE 1.19** Modeler's various line, wire, and curve creation palettes.

### Curve Primitives Tab

This general palette offers both primitive wire tools and access to most of the Beziér and NURBS via subicons, à la the Main palette. Unique to this grouping is the **Rectangle**, **Line**, **Circle**, **Regular Polygon**, **Arch**, and **Ellipse**.

### Polylines Tab

Polyline tools take the sophistication level a step further with more involved tools for splitting, joining, and otherwise editing straight lines.

### Beziér Tab

Just like the comfy Postscript Illustration program that has been on your computer for ten years, this palette has all the basics you want. This is one of the few 3D applications I have seen with such good implementation.

## NURBS Curve Tab

This palette of tools is Modeler's most basic foray into the interesting world of NURBS. Here you find tools that are as significant a leap of sophistication over Beziér curves, as Beziérs are over Polylines. As you saw in the vase-modeling experiments, the NURBS curve can be created using

either a **Knots-driven** system or one based on **Control Vertices**, each method having its own strengths.

### NURBS Curve from Control Vertices

This tool certainly seems to be the junior player of the two NURBS curve options. Its lines are of noticeably simpler form than the Knots version, and it does not have additional settings. Despite this, there is a free-flowing quality to it that is fun to work with.

Being designed to have the mouse deposit CVs instead of Knots means that the operator can only "best guess" where the lines are going to appear. As you can see in Figure 1.20, the only two predictable points of control are those created by the first and last clicks.

Even more difficult to deal with is that as you extend a line and continue creating new CVs, the entire line readjusts its shape with each click. You can see in Figure 1.20 how the first five CVs are the same in both lines, but the three corresponding line segments differ because one NURBS curve has additional CVs. This is very similar to a Natural Cubic path and can be used where an organic and unpredictable quality is desired. It is not for precision work.

### NURBS Curve from Knots

When clicking to create knots, controlling the general shape of the line is easy. This tool even allows a click-drag motion, like our old friend Beziér, and is almost as user-friendly, with practice. As you look at Figure 1.20,

**FIGURE 1.20**    The NURBS Curve from CVs is unpredictable and hard to control (left), compared to the NURBS Curve from Knots, which is easier to predict and more like Beziér.

placement of additional Knots does not have any great effect on previous curve sections. When comparing the two lines in the image, the first two curve segments are identical, and the third only slightly different.

However, when doing a click-drag, this tool's action is different from that of Beziér curves because of a different pattern of biasing. A Beziér click-drag creates a more or less equal effect on each side of the click point, whereas this tool offers a heavier weighting to the front-side (post-click) length of the curve. The main workflow difference is that for the Knots curve to take advantage of the click-drag, the operator must make a confirmation click. If you don't, the next click overrides it. In this sense, the drag action is acting as a preview for the position of the next click. Double-click to finish the operation.

Editing is done by selecting the Edit NURBS Curve tool and highlighting the curve. This puts Modeler into NURBS curve edit mode, where other items can't be edited until the operator exits with a double-click action. The edits themselves are applied to the **CVs** or **Control Lines** (**Hull**). Elements can be pre-picked by marquee or clicked on directly. The curve is very easy to edit in this mode, as shown in Figure 1.21.

### Weighting

NURBS CVs, on either curve or surface objects, have the ability to modify the weight of their associated edge. What this does, in essence, is determine how much you want to cheat the Knot closer to the CV. In doing this, you are taking a shape that started as a smooth curve and adding some amount of pull, or tension. The positioning of the curve also changes as it moves closer to the CV. You can see this working in the examples in Figure 1.22, where there is increasing weight along the top row and a dual weighted line below. This is accomplished by holding down the W key and click-dragging on the CV. More than one can be edited at a time. Note the tiny footnote weighting numbers displayed as the mouse is dragged.

Be aware that this is a very delicate control and the effects are not always as stable as you might like, especially when creating derivative shapes later. This should be used only when all other manipulation options are exhausted. The **Reset NURBS Curve Weights** tool is used to remove any weighting adjustments from a curve automatically.

### Why Use NURBS Curves?

The reason so much emphasis has been placed on the development of NURBS is that it offers a much more efficient curve than the Beziér does. Beziérs are known as *piece-wise* curves, meaning that each curve is structurally

**FIGURE 1.21** The Knots curve is easy to edit. Here, just the bolded CV was moved to create various shapes.

**FIGURE 1.22** The top row shows (left to right) no modification, moderate weighting, and full weighting. The two bottom examples show no modification (top) and the two center CVs weighted (bottom).

a separate edge of the same wire. This is why importing EPS files into any number of 3D applications is always more trouble than you expect.

Modeler does a fine implementation of Beziér curves, and their basic use is no problem, until you start using them to build derivative and other complex 3D objects. At this point, the operator can begin running into two limitations: lack of unified editing and higher than necessary tessellations.

To see some of these limitations, make a wavy Beziér curve, and then Revolve it. Now select the **Edit Surface** tool (on the NURBS Surface tab) to edit the **new revolve** object. Click the object, and lo and behold, most of it disappears. This is because you have access to only one "piece" of the wire at a time (see Figure 1.23). If you double-click to exit the edit mode, the entire model returns. If, on the other hand, you do any edits, the rest of the model is removed from the scene.

Now look at the problem of higher tessellation and complexity. To do this, examine the simple wires you created for the vase: one Beziér and the other NURBS. As you can see in Figure 1.24, the Beziér curve contains three edges, compared to the NURBS single edge, even though both are only one wire apiece and produce the same shape. In fact, all NURBS curves are single edged. This is why a NURBS curve used in a Revolve

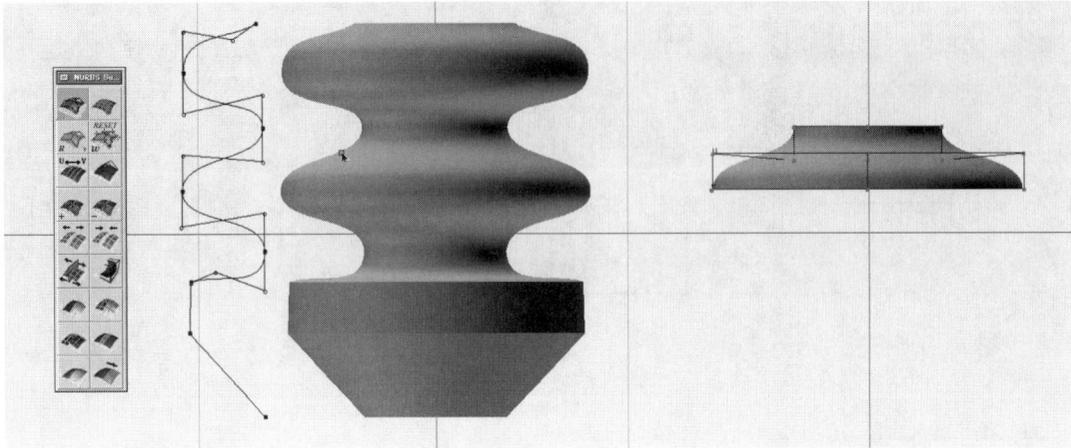

**FIGURE 1.23**    The Beziér curve (far left) is Revolved to create your model (center), but when the Edit Surface tool is used, only the activated edge-revolve survives the process (right).

would not do what you saw in Figure 1.23, and why they produce more efficient models at export time.

The good news for Beziér fans is that you can actually work with your preferred tool and then select the **Convert to Single Spline** tool (on the Wire Editing tab) to change it over to a NURBS curve. There are some limitations, however, and the results might not always be as good. These are reasons to become handier with NURBS curves. Also, be aware that if a NURBS curve is activated with the Edit Beziér tool (on the Beziér tab), it will automatically be converted.

## Surface Structures

The next level up the 3D food chain is surfaces. In Modeler, it is safe to say that *all surfaces go to NURBS* because regardless of how the surface is created, editing is accomplished with tools from the NURBS Surface tab.

### Creating Surfaces

Any number of variations exists, but most methods of creating a surface boil down to pre-made, derivative, and derivative wire surfaces.

**FIGURE 1.24**    Even in this simple shape, the Beziér curve contains three times as many edges as the NURBS curve, leading to more complex derivative shapes and exports.

### Pre-Made Surfaces

Several tools generate a closed and filled face, which is the essence of a surface. These include tools from the Curve Primitives tab, as well as the Surface Sheet from the Surface Primitives tab. Clicking these with the Edit Surface tool converts them to NURBS bodies, which can be edited with any of the NURBS tools. Notice, though, in Figure 1.25 that the nonrectangular shapes do not survive the conversion. The same thing happens with Knifed objects.

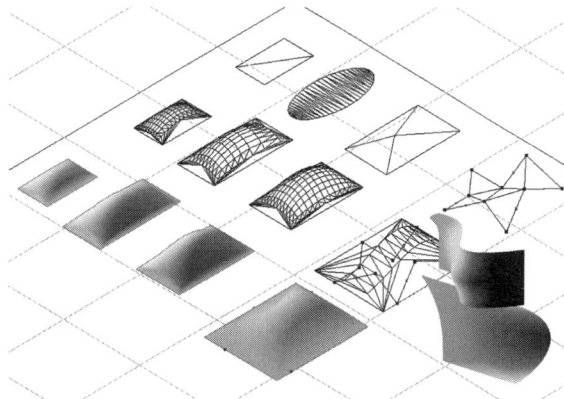

**FIGURE 1.25**    Pre-made surfaces from the Curve and Surface Primitives tabs can be converted and edited in NURBS Surface.

### Derivative Surfaces

Use any of the derivative tools set to their *surface* option. This includes many items from the 3D Tools tab, such as Revolve, Skin, Extrude, Birail, and Sweep, as shown in Figure 1.26. After any of these operations are complete, the Edit Surface tool can perform any needed alterations.

You might run into a snag with the editing of some derivative surfaces. For example, the Extrude tool does not add any cross divisions, so what happens in the NURBS editing mode is that the operator drags the Hulls or CVs to create a new shape and then exits the edit mode. Upon exiting, the model drops back to the original shape (or some hybrid shape). In some situations, the Subdivide Surface or Add Isoparm tools may do the trick. In the case of an Extrude, the problem is that the model is too simple and you need to use the **Degree Elevate** tool to allow the model to contain more complex shapes (see Figure 1.27).

### Derivative Wire Surfaces

The Derivative Wire Surfaces category includes the Coons and Net Surface tools, which are used to create a wide variety of surface shapes (see Figure 1.28). Both offer a greater level of precision than the other methods, with Net Surface offering even more than Coons. The downside is that both tools are picky about what they work with and require precise alignment of the intersecting points. Using the Snapping controls is almost mandatory. Net Surface has a tolerance setting that can be used to lessen the demands for precision.

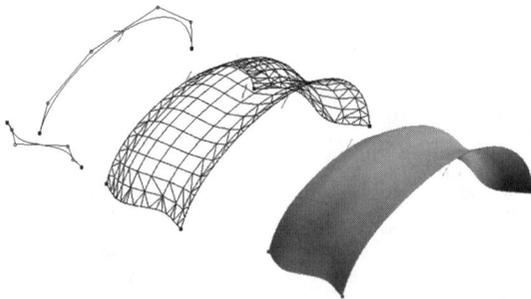

**FIGURE 1.26**   The Sweep surface derived from two NURBS Curves (left).

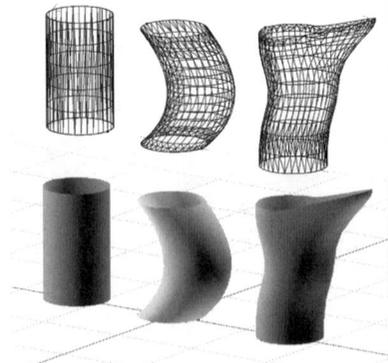

**FIGURE 1.27**   The Extrude model originally (left) and after converting it to NURBS and applying the Degree Elevate tool (center and right).

Here are some tips for Coons and Net Surface success:

- Coons Surface requires exactly four wires, and Net Surface needs four or more wires—larger numbers of wires offer more exacting shapes, but are more tedious to manage.
- Always use Snapping, either to Grid or to Point.
- Stay with NURBS curves, because they work better.
- Activate the lines in an orderly fashion.
- For Coons, go in a clockwise or counterclockwise direction, and for Net Surface, go from one line to the next, in order.
- Although point tolerance is tight for the perimeter, Net Surface does not require it inside the mesh. Wires must touch, but points (CVs) need not.
- U and V wires need not be at pure 90-degree angles, but their Control Hub lines must not be parallel or the process will not work.
- Try to keep the lines simple while still producing the needed shape. Overly complex configurations often fail to meet the tools' needs.

### Solid Structures

Solids are created with some of the same tools talked about in the Surface Structure section. The differences are that a derivative's tool settings need to be set to solid and, in some cases, wires may need to be closed. Figure 1.29 shows a simple experiment with a circle shape and **Extrude** to see what generates a solid.

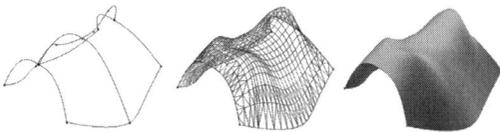

**FIGURE 1.28**  A simple horse's saddle created with six wires using the Net Surface tool.

**FIGURE 1.29**  What makes a solid?

The back row has two open wires and two filled wires. Extrude was applied to all of them, one with the **End Cap** option and the other without. The results are in the middle row, where you can see that the open circle extruded without end caps is a surface object. The others are hard to tell, so they were duplicated and had a Knife cut them in half (the third row). As you can see, you can create a solid model by either extruding a filled wire or extruding an open wire with the End Cap option enabled. The model at the far right would not allow the Knife to function. This is the model that used a filled wire and the End Cap option. You can see in its Properties tab that it has an extra Loop and Face, compared to the other well-formed models.

Just to test the test, one of the solid models was taken, and the Shell tool applied. This was then Knifed, to confirm that a Knife would show the inside of a hollow object.

In many situations, a surface object can be converted to solid by using the **Cover Circuits** tool (on the Body Editing tab). This works with more structured objects that are likely to have the necessary underlying elements, as shown in Figure 1.30.

## 3D Derivative and Compound Models

*Derivative models* are simply those derived from other, usually simpler, models. The derivative toolsets include those that build shapes, such as Revolve, Extrude, and others in the 3D Tools tab. This category also includes tools that you might think of more in terms of editing existing models, such as Rounding and Knives. Both NURBS Surface and Über-NURBS are also derivative tools.

Few models can be made with just a single shape, and today's sophisticated models must be assembled using a variety of parts to create a Compound model. These models need not always be attached; they can sit next to one another in the scene—after all, you don't have to worry about gravity. When more complex interactions are needed, you can turn to tools such as Booleans, which can create perfect-fitting elements.

When creating models at this level, it is very important to always be aware of any future texture mapping needs. In fact, the mechanical mapping requirements should be figured out as early as possible to prevent modeling that is logical but inappropriate for scene-building needs. Figure 1.31 shows an example of a wooden stand whose top part was Boolean-Unioned to the bottom, making the texturing process much harder.

**FIGURE 1.30**   A surface is made solid with the use of the Cover Circuits tool. It is then Shelled and cut to confirm, as with the test in Figure 1.29.

**FIGURE 1.31**   Compounded models (left) can be hard to texture-map. By keeping objects separate within the file, the texturing process is simplified.

### TUTORIAL

### ÜBERNURBS MORPHING: SACK OF FLOUR

For the Morph Editor (see Chapter 9, "Morph Editor") to work properly, the **Anchor** (base) model and all its **Target** models must have identical polygon and vertex information. This is achieved by using the **Uniform** tessellation option, which is available only for ÜberNURBS models. ACIS models must use the other setting, called **Adaptive**.

As with most things ÜberNURBS-related, this process is fairly straightforward. ÜberNURBS mode tends to get out of the way and let the operators do their thing. You will step through building the relatively simple model of a sack of flour, creating a morph target for it, and then exporting for Animator. Start, final, and intermediate project files are provided on the CD-ROM, along with the Morph project set up in Animator, and rendered out as a QuickTime file.

**ON THE CD**

1. Open the **START-Sack of Flour.eim** project file on the CD-ROM. This file has a template and a basic ÜberNURBS object already in place.
2. With the **ÜberNURBS** edit tool selected, clicking the object automatically brings it into Über edit mode.
3. Select the **Add Edge** tool, and drop in a new **edge** on the side panel at the very top and very bottom. These **corner control edges** pull at the corners to give a more rectangular shape. While you are here, add another two edges farther from the corners, about 20% from the top and bottom. These are **shaping edges** and will help you later. Add the same edges to the opposite side panel, and add just the **shaping edges** to the top and bottom panels, as shown in Figure 1.32 on the left.

4. Switch to a side view, and with the **Edit** tool, drag a marquee around the front or back panel (doesn't matter which) to select the CVs. While holding the **Z** key to restrict motion to the Z-axis, click and drag in an empty part of the screen (a null zone). The selected parts of the model should follow the movement. You are creating the stitched part of the bag, so you want the sack to be made very thin (see Figure 1.32 on the right) but not paper-thin. Shift-click in a null zone to deselect the model.

5. Double-click the **Edit** tool to open its **Settings** window. Set the **Vertex Chop Ratio** to **0.9**. This controls the location of new loops when using the **Loop** tools. Guess what's next? Select the **Inset Loop** tool, and click the **center point** of the front panel. A new loop is inserted within the front panel, which is just slightly smaller.

6. Open the **Edit** settings again, and change the Vertex Chop Ratio to **0.98**. Perform the same operation as in Step 5, by clicking the center point of the front panel resulting in another loop being placed. Now, select the new loop with the **Edit** tool, and while holding the **Z** key, drag it inwards a bit, almost halfway into the model's thin depth. This creates a lip around the sack's stitching (not a reference to the Stitch tool). Don't go too far. A little is fine, and too much will be a headache later (speaking from experience).

7. For the last time, open and change the **Edit** tool's **Vertex Chop** setting to **0.85**, and make one more loop. You should know that these numbers

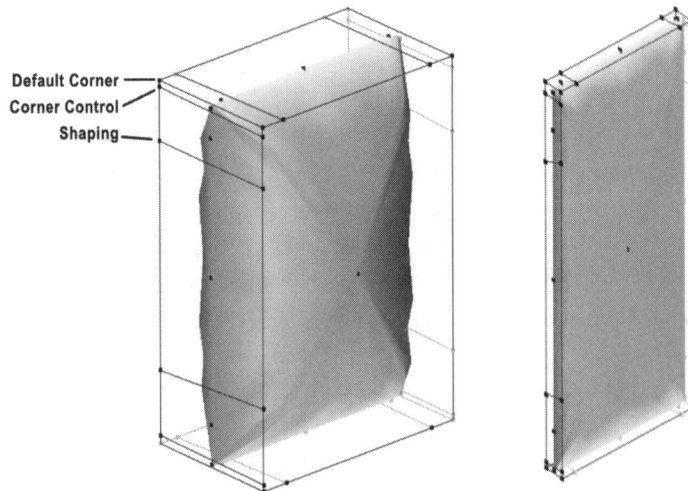

Default Corner
Corner Control
Shaping

**FIGURE 1.32** Add edges, four to each side and two to the top and bottom (left). Then reduce the model's z-depth (right).

came from a bit of trial and error and are not based on anything but visual feedback. You can see the results of these steps in the first image of Figure 1.33.

8. Corners are often a problem area and can have creasing issues. Because ÜberNURBS likes having **four-sided** cage elements, you want to change the corner structure by removing a few edges and putting two new ones in their place. Working in the **Front** view, do this for all four corners, following the steps in Figure 1.33. Then add two more edges that go across the large loop, as shown in the center image of Figure 1.34. Clicking the **Tab** key hides the mesh and makes editing the cage easier.

9. Repeat Steps 5 through 8 for the back side of the model.

10. Make the **template** image visible in the **Layers** window. Working in the **Front** view with the **Edit** tool, manually move the corner Hull and CVs on the model to match the template, as shown in Figure 1.34 on the left.

11. The top and side groupings can be marquee'd and moved as units, as highlighted with gray in the center image of Figure 1.34 on page 36. Move the top group first, as moving the side first can interfere.

12. With the **Edit** tool in **Iso** view or another off-axis view, select the large center loop and drag it outward while holding the **Z** constrain key. This gives the model dimension, and it starts to look more like a sack that has contents. You can toggle the mesh on and off to see how it is looking. Now do the same for the opposite side of the model.

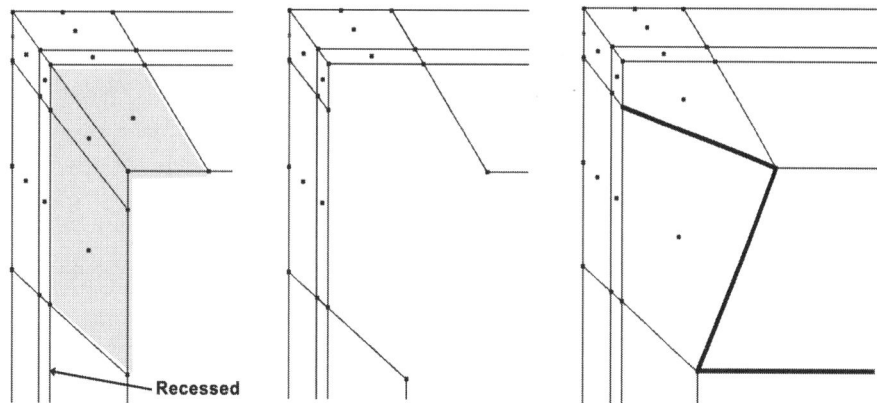

**FIGURE 1.33**   The Front view of the upper-left corner, at the end of Step 7 (left). Note the varying loop sizes created from the Vertex Chop setting. Delete the edges in the grayed area (left and center), and add two back in (right). Don't forget to add the edges across the main loop (partially seen in the right image).

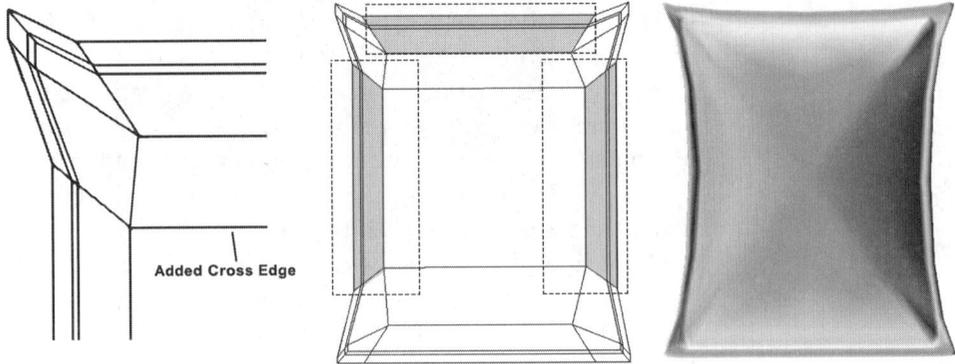

**FIGURE 1.34** Modify the cage corners to match the template (left and center) so that the model looks like the smooth-shaded image (right).

The main model is now done. Double-click the Edit tool in a null area to exit the edit mode. Save the project file, and then export the model to Fact format, which is the optimized model format for Universe. For morph export, the default settings work very well.

Duplicate the model and make one copy invisible. With the ÜberNURBS Edit tool, select the new model, and begin changing its form to look more like a sagging sack that was just dropped on the counter. Broaden the loops at the lower half while thinning the upper sections. Put subtle organic touches all around, but be careful—overdoing it can cause excessive creasing. Use the provided final project file as a guide (see Figure 1.35). When done, exit the edit mode, and export the model to be used as a target. Note that Anchor and Target models are exported the same way; they are just loaded into Animator differently.

Keep in mind that Target models are created by moving the CV and Hull on the model. You cannot add or delete edges or other elements in their creation. If modification is needed, it must first be done to the Anchor model and then that can be pushed and pulled to create the Target. Any modification in the ACIS environment (aside from a Transform) would also interfere with the morph working properly.

## MANUAL TESSELLATION

The technology of leaving the model's dicing until export can be very liberating. The tradeoff is your direct control over the process. In many situations, neither the Uniform nor the Adaptive options can hope to figure out your needs.

**FIGURE 1.35**  The Target model resting on the ground in an animation scene constructed in Animator.

A perfect example of this is modeling the human body. These are very complex models, and you always want to lower the polygon count whenever possible. It is common to keep the mesh density low in areas such as the upper or lower arm and then go for a higher mesh density around the elbows and other areas that need to be deformed. However, there is no way for the tessellation engine to know this, despite its elaborate settings. The trick is to dice those sections manually by inserting additional divisions. Fortunately, Modeler gives you a few ways to do this:

- **Surface and Boolean Imprint**: A surface is positioned to intersect with the model. The Boolean Imprint tool is used, and excess objects are deleted. Your original model now has extra articulation points.
- **Knife and Boolean**: Use any of the Knife tools to **split** a model in some way, then use the Boolean Stitch or Join tool to bring them back together. The trick is that these Boolean operations do not remove the Knife line, so you end up with additional articulation points.
- **Project Wire on Body**: Buried in the Wire Editing tab, this tool allows you to "project" a wire onto your model. Make sure to change its settings to the **Make Face** option to work. This is a great option because it gives you depth control on the face creation, it does not require an additional rejoining step, and you can reuse pre-made wire grids, such as the one provided in the project file on the CD-ROM. The only limitation is that it needs to be a one-piece wire, so just zigzag it, as shown in Figure 1.36.

**ON THE CD**

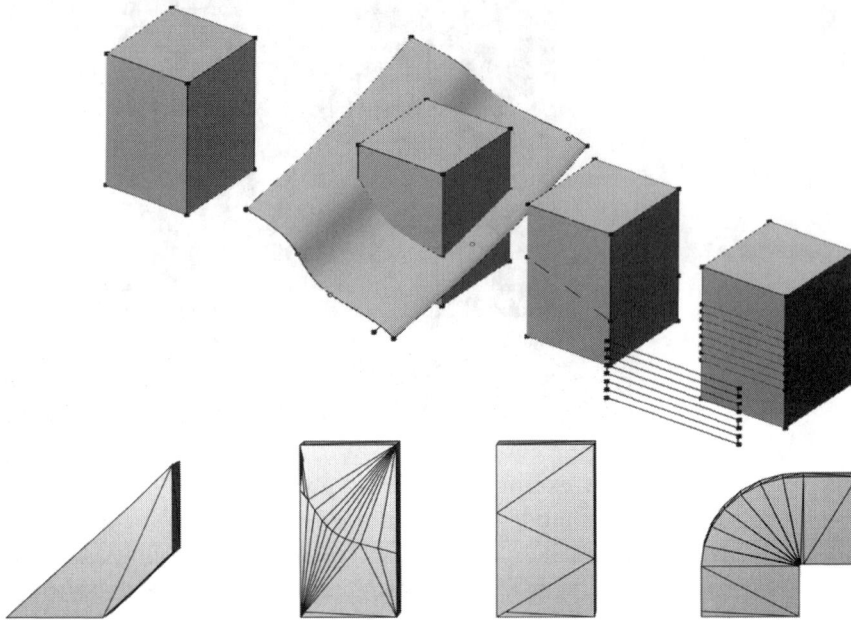

**FIGURE 1.36**  Constructed in Modeler (top row) and rendered in Animator with Polygon outlines for emphasis (left to right): The original box, Surface and Imprint, Knife and Stitch, Project Wire on Body. Note that the first and last models in Animator were set with a 90-degree Bend Deformation.

*NURBS Surface editor has some tools to do this, also, as mentioned earlier, but they are not as easy or as flexible as these three methods.*

# 2

# ACIS MODELING

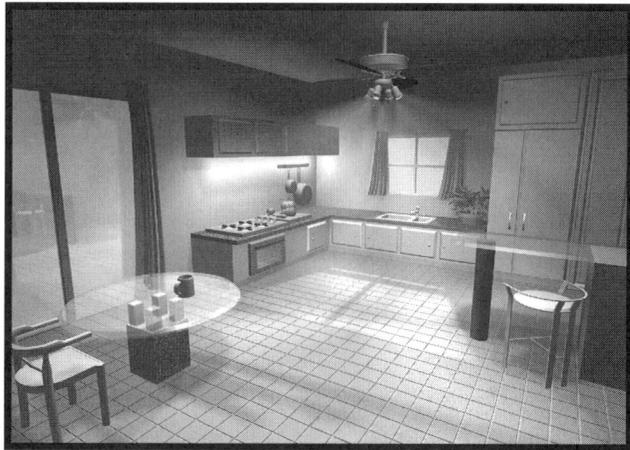

M ost of Modeler's controls exist within the ACIS 3D environ-
ment. These tools are used for a style of modeling often re-
ferred to as *hard body* modeling—the comparison being to the
more organic *soft body* approach of ÜberNURBS' subdivisions. In this
chapter, you will take advantage of this extensive toolset's precision to
produce a complex scene that contains elements of drafting, architecture,
and product/interface design. You will be reproducing the modern
kitchen.

Note that Start, Final, and incremental project files are provided on
the CD-ROM, should you need to refer to them. Anticipate needing a few
work sessions to complete this project, and consider using the different
sections as logical dividers.

**ON THE CD**

A final version of the room you are about to build appears in Figure
2.30. There is also a color image and a QuickTime fly-through on the CD-ROM.

## MODELER AS A DRAFTING TABLE

Before jumping into creating 3D shapes, you need a floor plan for your
kitchen. You could use a dedicated drafting program or even Adobe Illus-
trator, but why not use Modeler itself. It has all the control you need for
light drafting.

In the **Document Settings > Grids/Units/Rulers/Snap** tab, set
the following:

- **Distance between major lines**: 1 foot
- **Distance between minor lines**: 3 inches
- **Grid Size**: 30 feet
- **Snap Distance**: 3 inches
- **Snap Aperture**: 21 pixels
- **Snap Angle**: 0 degrees
- **Length**: Foot
- **Angle**: Degree
- **Internal Length**: Foot

Open the **Top** view to fill the screen, and make sure that **Grid** and
**Grid Snapping** are on. The Grid color can also be modified.

## TOOLS FOR DRAFTING

In drafting work, there is a handful of particularly useful tools, so this is a perfect opportunity to create a Custom Palette. These are easy to make and can be saved to disk. You will find a copy of the one used here on the CD-ROM, which you can load into your copy of Modeler by going to **FILE> Tool Palettes > Open Custom Palettes . . .** The tools chosen are for basic shape making, modification work, and general utility. Figure 2.1 shows the Modeler à la drafting table, with the Custom Palette loaded.

ON THE CD

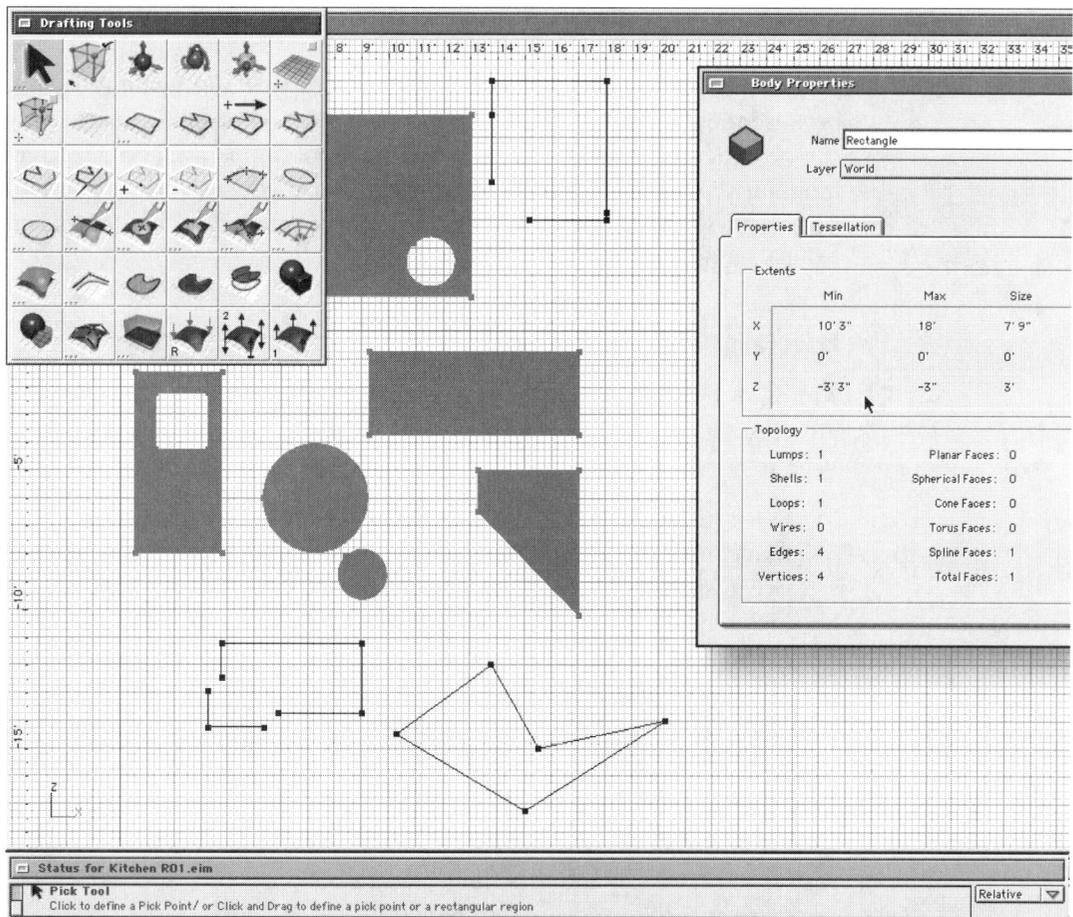

**FIGURE 2.1**   Modeler arranged for drafting work, with the customized Drafting Tools palette and Snapping Grid.

The **Curve Primitive** tab offers a nice range of shapes that can be generated as either wires or filled shapes, and can have **Scale**, **Boolean**, and **Knife** operations applied. The **Polyline** tab tools are very important here as well, with the limitation of working only with unfilled wires.

### Modifying Drafting Shapes

To change an object's dimensions, you have a few options, the best choice being the **Polyline** toolset, which works on unfilled wires, either opened or closed. These are versatile tools, and it is often worth uncovering a face to gain access to them. The **NURBS Curve** tool can also be used to modify unfilled curves (although covering them later can be a bit of work).

To work with filled surfaces, you can work with the **Scale** tools, but because their actions are based on a center point, controlling exact sizing can be difficult. The **NURBS Edit Surface** tool can be used on filled rectangular shapes. However, keep in mind that it converts the object to a **Spline** body, which must have its face uncovered before any extrusion can be applied.

### Knives and Boolean in Drafting

Although mostly thought of as 3D tools, the Knives and Boolean tools are very helpful with 2D surface work as well. Here are a few rules to keep in mind:

- Filled surface objects need to be two-sided for use with Knives.
- Boolean Union and Subtraction operations should be performed between surfaces of matching side counts. Mismatched objects result in incomplete operation or poorly formed objects (more on this later).
- A reversed face direction can also lead to incomplete operations.

---

**TUTORIAL**

## STEP ONE—FLOOR PLANS

Just as in real life, creating a floor plan to build upon is the best way to approach an architecturally based project.

1. In your enlarged **Top view**, start by dragging the **Rectangle** tool (Unfilled) from **world zero** (0,0,0) until it creates a shape that measures 20 feet along the X-axis and 16 feet along Y.

2. In the **Layers** window, name it **Ground Plane** and make four duplicates of it. Make all but one invisible.

3. Select the **Offset Planar Wire** tool, and set it to 5 inches. Clicking the rectangle generates a new, smaller rectangle that is 5 inches inset all around—about the thickness of a wall.

4. Select both rectangles with the **Fill** tool. Isoparms should appear.

5. With the **Boolean Subtraction** tool, select the outer and then inner objects; then double-click in a null area to perform the operation. The result should be a **5-inch** filled frame. Because this is the frame of the wall, rename it **Frame**.

6. Make a new **rectangle** (Filled and 1-Sided to match the ground plane) that overlaps **25%** of the frame, and then subtract it with the **Boolean Subtraction** tool, as shown in Figure 2.2. Lock the item.

7. Make another ground plane copy visible, and make it **2-Sided** (the tool is in the Face Editing tab). Turn off **Snapping**. Using the **Straight Knife** tool, select the object, and draw a line using the frame as a guide. This action cuts off the lower-left corner (refer to Figure 2.2). The Knife must start and end just beyond the object to work. This is why Snapping needs to be turned off; you do not want to be forced to another grid increment (refer to Figure 2.2).

8. Make three new rectangles which are 10 feet wide (x-axis), and whose dimensions along Z are:

- **Countertop**: 30 inches
- **Under-counter Cabinet**: 27 inches
- **Kickplate**: 24 inches
- **Over-counter Cabinet**: 18 inches

It is easier to create them from the ruler's zero mark and then move them into place afterwards. Place them as seen in Figure 2.3, in the upper right hand corner of the room.

**FIGURE 2.2**   (Left to right) The new rectangle over the frame, Boolean Subtraction, the ground plane with Straight Knife applied (Frame as template only), Frame and Ground Plane results.

**FIGURE 2.3**  The template is coming together, with the line work for the counters and snack island in place.

9. Select the counter objects made in Step 8. With the **Copy Mode** set to **1**, **Rotate** them 90 degrees, and then move them into place (refer to Figure 2.3). You will edit them later.

10. For the snack island, select the **Rectangle** tool (make sure the Fill Curve Primitives is not selected as you do not want the item filled) and create an object that is **2 feet** along **X** and **5 feet** along **Z**. Move it into place (refer to Figure 2.3).

11. With the **Fillet Edge** tool set to **6 inches**, apply it twice to create the outline for the snack island (refer to Figure 2.3).

12. The refrigerator and pantry are **3 feet** and **1 foot 11 inches**, respectively, (put **1 inch** between them to make it an even 5 feet) and match the **30-inch** counter depth. They need to fit in the lower-right corner, but the counter is too long to allow that. You could forgo the 'fridge, after all, if a digital character is in a virtual kitchen, does it eat? (Think about it, this could be the essay section on the midterm.) Instead, cut the counters down by drawing a line along X in the appropriate location and using the **Wire Knife** tool. The countertop and other objects need to be made **2-Sided** to work with the Knife. Do one object at a time until all four are complete, then make the line invisible, or Delete it (see Figure 2.4). This way of editing ensures that all the objects end at exactly the same place.

13. The other side of the counters needs adjusting, also. Both the kickboard and the under-counter cabinet need to be extended to match up with the other kickboard and counter. The best way to do this is to Uncover and use the **Polyline Edit** tool (Figure 2.4).

14. Create another **Rectangle** (with Fill) that measures **X = 23 inches, Z = 33 inches**. This will be used later to Boolean Subtract a hole from the countertop to make room for the sink. **Move** it into place (refer to Figure 2.4).

15. Create another filled **Rectangle** where **X = 36 inches**, and **Z = 24 inches**. This will be used to create the stovetop later. For now, move it into place (refer to Figure 2.4).

16. The snack island can't float, so add a **Rectangle** for a storage cabinet measuring **X = 24 inches** and **Z = about 20 inches**. With the **Circle** tool, add a **6-inch** diameter circle, placed as shown in Figure 2.4. Remember, each of those grid lines should be 3 inches if your system matches our setup instructions. That means that this Circle's Radius is only one gridline.

17. The far wall needs a pot hanger next to the stove. Create its top profile with the **NURBS Curve from CV** tool. One of two styles can be made: a more contemporary curve or the traditional flat front (see Figure 2.5). To constrain the line to a flat line, place two CVs at the locations marked in the image. When done, place the profile line against the wall under the overhead cabinet (refer to Figure 2.4).

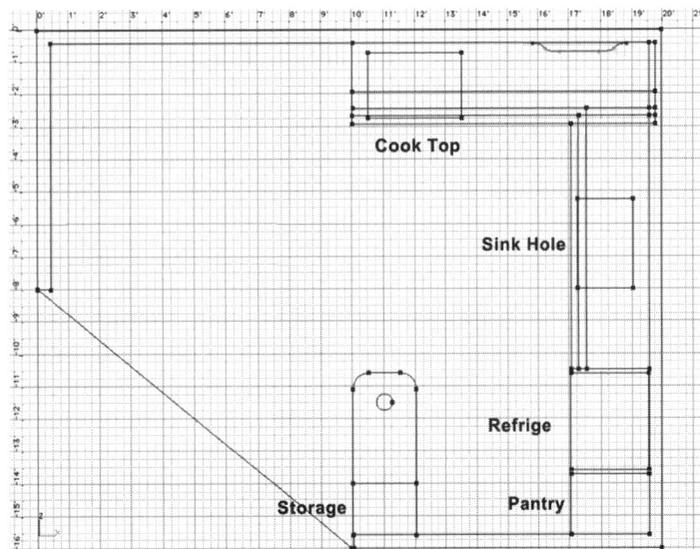

**FIGURE 2.4**   The stovetop, sink, refrigerator, pantry, and other starting shapes are dropped in.

**FIGURE 2.5**   The pot-hanger profile can be a contemporary swoop (top in both examples) created with 6 clicks or the traditional version, created with one additional click at either end of the flat line.

18. In the breakfast area, draw a **Circle** with a diameter of **48 inches**, centered as shown in Figure 2.4. Use the **Rectangle** tool to create a square that is **1 foot** in the **X** and the **Z** axes, and centered on the same point as the 48-inch circle. Finally, create four more squares that are all one grid line in X and Z, or **3-inches square**. Place them just inside the larger square (refer to Figure 2.6).

In the **Layers** window, create a new folder and name it **Template Layer**. Put all the elements in there, except the ground plane items and lights.

**FIGURE 2.6**   The breakfast table with center supports centered around the world position of X = 5 feet and Z = 5 feet.

If you had any problems with this section, refer to the Template file on the CD-ROM.

**ON THE CD**

**TUTORIAL**

## STEP TWO—TILE FLOORING

Tile flooring is optional but adds a great finished look to the project. Even the fastest computers, however, can find creating all these tiles very taxing. To streamline the project, try to keep the Draw Level set to Extents whenever practical. You may also want to produce and export this section separate from the rest of the project. The final Modeler file and exported Fact model are on the disk. When imported into Animator, the size of the tile model should not be an issue.

1. Turn off every object except the Knife Cut **Floor** (5-Sided). **Duplicate** it to keep a backup, and tuck it away, visibility off.
2. At **World Zero** (**0,0,0**), click-drag to start making a filled **Rectangle** that is **6 inches** square. (2 grid units in each direction). The mouse should be re-leased at **X = –6 inches**, **Z = 6 inches** so that the square is not on top of the floor (see Figure 2.7).
3. In **Iso** view, **Extrude** the tile up by **0.25 inches**, End Caps off. If it extrudes down, the face will need to be reversed (refer to Figure 2.7), and the step redone.
4. Enable the **Face Filter** (on the Pick tab), and highlight the Tile's top face. Note that only the isoparm selects.
5. Set the **Round** tool (on the Bevel tab) for 0.15 inches, and double-click in a null space to execute operation (refer to Figure 2.7).

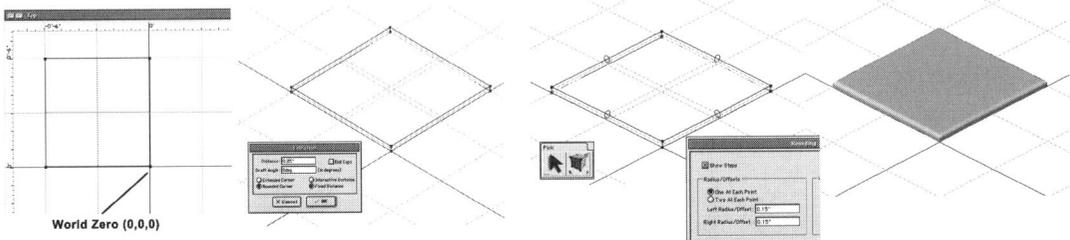

**FIGURE 2.7**    (Left to right) Create the Tile's profile, extrude, round the top edges, and view the final shaded preview.

6. With the Tile profile selected, double-click the **Copy Array** tool to bring up the settings. This tool is wonderful for filling in large areas with multiple copies of an object. You would use it for tiling the whole floor, but a by-product of this operation is that as the number of copies goes up, the process slows down—it is very taxing on the system. Other programs have a similar Achilles' heel. The solution is to break up the action into smaller steps, which ends up being much faster. Fill in these settings:

- **X-Offset**: **6.2 inches** (6-inch tile plus gap for grouting)
- **Y-Offset**: **0**
- **Z-Offset**: **–6.2 inches**
- **X/Y/Z Scale**: **1** (you do not want to change the size)
- **No. in X**: **5** (creates five copies in the X-axis)
- **No. in Y**: **0**
- **No. in Z**: **5**

Click **OK**, and it quickly generates 25 tiles in place (see Figure 2.8).

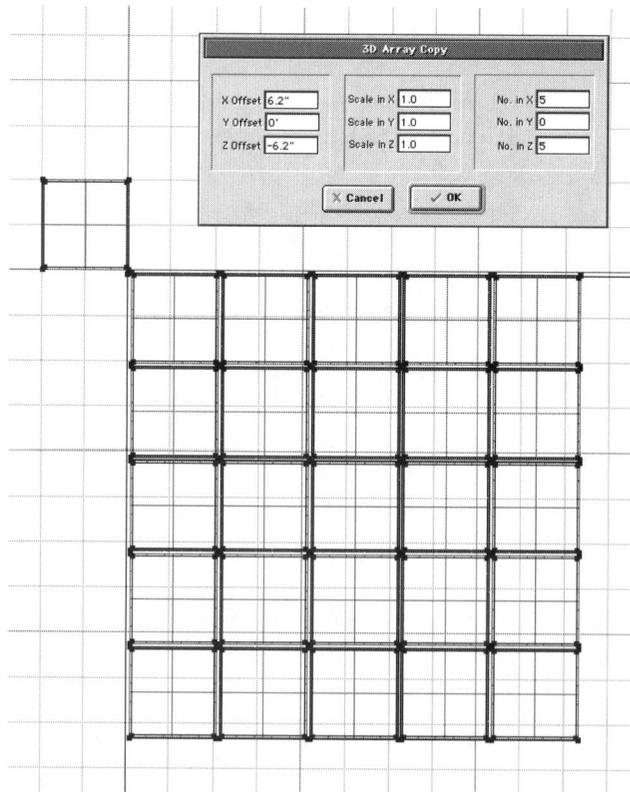

**FIGURE 2.8**   The results of the Copy Array.

7. Select the 25 tiles and perform a **Boolean Union** on them.
8. Select the new **Boolean** object, open the **Copy Linear** settings, and set them as follows:

- **Translation X-Axis: 31 inches** (6.2 inches per tile, five tiles)
- **Constant Offset**: Toggled off
- **The next four settings**: 0
- **Scale**: 1.0
- **Number of Copies**: 7

   Click **OK**, and again **Boolean Union** the results (see Figure 2.9).
9. One more **Copy Linear** operation: **Translation X = 0, Y = 0, Z = –2 feet 7 inches**, **Six Copies**. The entire floor area should now be covered with tiles.

*The shipping version of Modeler had a software hiccup at this step, so the Array tool's Z–axis was used instead.*

10. **Boolean Union** all tile groupings. Because this step can be very taxing on the system, it should be done in stages—joining two groups, then another two, and so on. Save between operations.

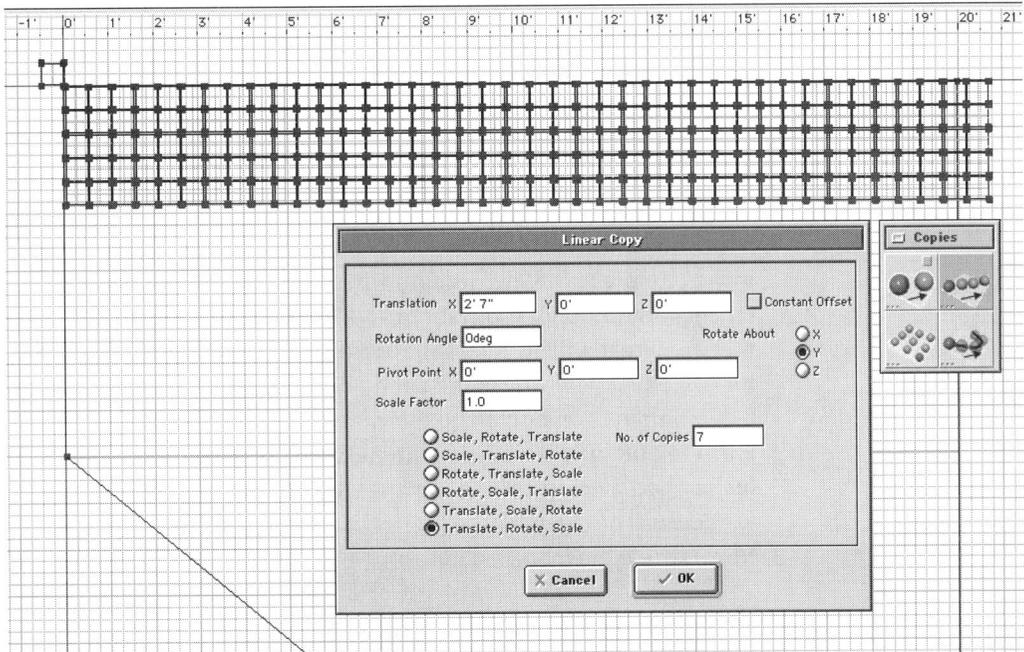

**FIGURE 2.9**    Copy Linear duplicates the group across the X-axis and then later the Z-axis.

11. The final step is to trim the excess tile. You would normally use the Floor with a Wire Knife, but because of the multiple body structure of the tiles, the results will not be what you want. Instead, you must create a negative Boolean object and use it with the Subtraction Boolean tool to remove the unwanted areas. Use the floor's wire object as a guide. Figure 2.10 shows the last steps.

**FIGURE 2.10**  (Left to right) All tiles copied and Boolean Union applied, a negative Boolean object to use with the Boolean Subtraction tool, and the final object.

**TUTORIAL**

## STEP THREE—EXTRUDE AND PLACE

With the template finished, it is time to begin moving the project into the 3D realm. To do this, change the view to a convenient Iso perspective. As you go through extruding, remember that wires that are extruded are left untouched, whereas a filled wire (face) is converted into the new shape. Therefore, you may want to duplicate your **Template Layer** folder of items to ensure that you have a backup to return to if necessary.

1. Start with the cabinet's base, or **kickboard**. This should be **Extruded 4 inches**. Before extruding, confirm whether an object is a wire or a face (Element Info window). You want to add **End Caps** to wires, but not to wires that are already filled (faces) because that causes poorly formed structures. If objects extrude in the wrong direction, you can undo and reverse face/wire direction or change the extrusion value to negative or positive.
2. **Extrude** both **under-counter cabinets** and **over-counter cabinets** to **30 inches**, and all **counters** to **2 inches**. Delete the cabinet over the sink; a window will go there.
3. Now Extrude the following items:

- **Snack island counter:** 1 inch
- **Snack island cabinet and support pole:** 34 inches
- **Breakfast table's center support:** 15 inches

- **Breakfast table four smaller supports:** 27 inches each
- **Circular tabletop:** 1.5 inches
- **Pot hanger:** 2 inches
- **Pantry:** 8 feet
- **Wall frame:** 9 feet
- **Floor base (5-sided):** 2 inches downward

4. Missing from that list is the refrigerator, because it will require a bit of work. **Duplicate** its wire/face object **twice**. **Extrude** one of them to **2 feet**, as a cabinet that will be placed above the refrigerator. Take the **second** one, and using the **Polyline Edit** tool, bring its **front** face back so that it aligns with the other under-counter cabinets. This will be used as a base for the refrigerator. **Extrude** it **4 inches**.

5. From the **Top** view, you are going to make two simple alterations on the shape of the other refrigerator rectangle to reflect the recess that should be seen around the door. Make sure that it is a wire (Uncover Face tool if needed), and use the **Polyline** tools to create the two notches shown in Figure 2.11. Then **Extrude** it **68 inches**.

You will leave the sink and stovetop elements alone for now. After everything else is extruded, begin to lift all the elements up in the **Y-axis** to where they belong, using the **Y-axis Move** tool and the **workplane** in **XY mode**. Move the objects as follows:

- The counters stack with the kickboard on the ground, the under-counter cabinets sitting right on top, and the counters on top of them. This should bring the top of the counter to 36 inches. The over-counter cabinets are "hung" with their base at 5 feet.

**FIGURE 2.11**    The refrigerator wire edited with just two notches that make it look more realistic.

- The refrigerator is placed above its base, and the cabinet on top of it should roughly level off with the adjacent pantry cabinet, which is already in place.
- Raise the snack island and circular table to sit atop their supports, none of which need to be moved.
- Raise the pot hanger to a reasonable height on its wall.
  When finished, the scene should resemble Figure 2.12.

**FIGURE 2.12** The set after Extrude and Place are complete. For clarity, the kitchen is shown without its walls.

TUTORIAL

## STEP FOUR—FINISHING WORK

Before tackling the appliances, you have a fair amount of "finishing work," as they call it in construction. As you work, use the Layers window to turn off interfering items; this improves the visibility of objects being worked on.

### THE PANTRY DOOR

You will begin the pantry door, proceeding as follows:

1. With the **Loop Filter** setting (on the Pick tab), select the **Convert Loop to Wire** tool (on the Wire Editing tab), and click on the front face or Loop of the pantry door area. This creates a wire to work with without disturbing the model.

2. Create a **Circle Primitive** off to the side that is about 3 inches diameter. Open the setting window for the **Sweep** tool (on the 3D Tools tab), and set it for **Orient Sweep** and **Move the Cross-Section to Path**.

3. Set the **Offset Planar Wire** tool to **–4inches**, and apply it to the wire to create a smaller duplicate. Now **Sweep** this wire as well. Partial results appear in Figure 2.13.

4. Apply a **Boolean Union** to both Sweep objects, and using the **Boolean Subtraction** tool, remove their shape from the Pantry object. The final pantry appears in Figure 2.13 on the right. Handles could be added, but often are not, with heavy molding like this.

### REFRIGERATOR DOORS

5. There are two doors, and each one needs to have Rounding applied. Set the **Rounding** to **0.25 inches**, and using the **Loop Filter** setting, highlight one of the two doors. Double-click in a null area to execute. Repeat with the next door.

6. To generate the handles, use the **NURBS Curve from Knots** tool to draw two lines that will be used as rails with the Birail tool, as shown in Figure 2.14. Make sure that both starting and ending vertices rest on the same plane with the front of the fridge.

7. A custom workplane needs to be created to match the face of the fridge doors. Select the **Add Workplane** tool (on the Workplanes tab), and click a horizontal and then a vertical wire to activate. The workplane should be added to the Workplane window, where it can be named appropriately and activated.

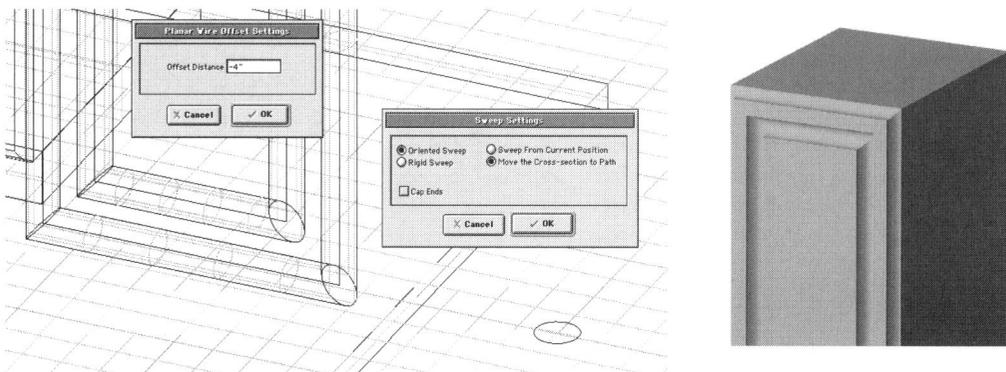

**FIGURE 2.13**    The two wires with Sweep applied. Boolean operations are then applied to create the final Pantry model at the right.

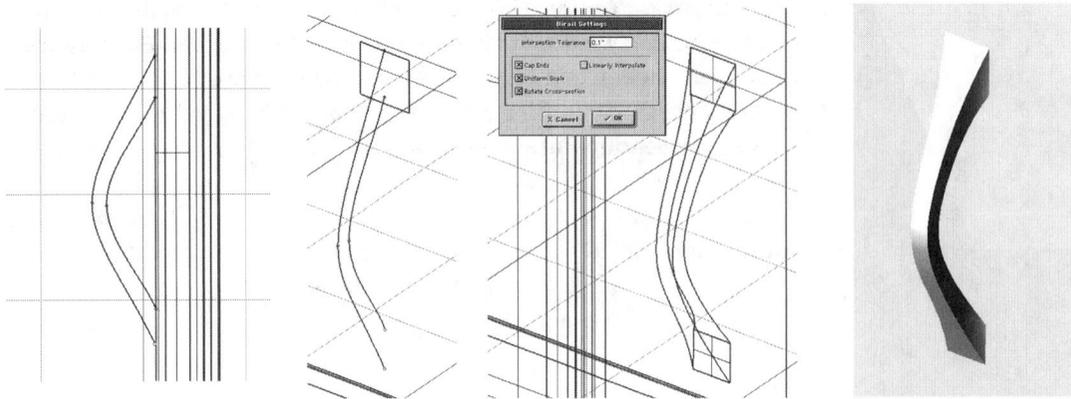

**FIGURE 2.14**   Two NURBS Curve wires drawn in Front view, a square Rectangle drawn in Iso view on the custom workplane, and the resulting Birail handle shown in Wire and Shaded views.

8. In a Side or Iso View, use the **Rectangle** tool to draw a small **1.5-inch** square on the new workplane. It should be situated to intersect with the starting vertices of the two wires (refer to Figure 2.14).
9. With the **Birail** tool (on the 3D tools tab), select the first wire, then the second, and then the outline rectangle, and double-click to generate the handle. This tool is sensitive to item location and spacing, so experimentation may be needed. The **Intersection Tolerance** used here was **0.1 inch**.
10. Place the handle at an appropriate location, and **Copy** it to the other fridge door.

### THE OVER-FRIDGE CABINET

11. The cabinet needs a door. Start with the **Convert Loop to Wire** tool to create a front wire, just as was done with the pantry. See Figure 2.15 for all these steps.

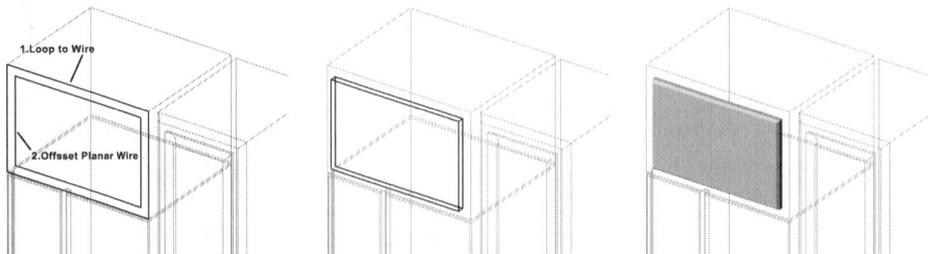

**FIGURE 2.15**   (Left to right) Convert to Wire and Offset Planar Wire, Extrude, and Chamfer.

12. Select the **Offset Planar Wire**, and set it to reduce the size of the wire by **2 inches**. When done, set the **workplanes** to **YZ** mode, and **Extrude** the wire away from the cabinet (into the room) by **1.5 inches**.
13. With the **Chamfer** tool (on the Bevels tab) set to **1 inch**, click the front **face** or **Loop**, and execute the operation.

## THE CABINET KNOB

Although a very simple model, the cabinet's doorknob illustrates an important concept in model construction (see Figure 2.16 for all these steps).

14. In the Front view, draw a filled circle not far from the front of the over-fridge cabinet. Make sure to center it on a grid line, which you will need later. It should be about **1.5 inches** in diameter (A).
15. Draw a filled rectangle overlapping the circle as shown in the diagram (B).

These two items will have a **Boolean Union** action applied, but if it is done carelessly, the results can easily be like image C, which shows a model with very bad geometry. Unlike a polygonal modeler, which might be able to push its way through this construction, however inefficient, the ACIS modeler will be more greatly hindered. This model would not be able to have a Knife operation applied, or an Uncover Loop, and so on. This problem is easily solved by making sure that both models are either single- or double-sided, using the tool in the Face Editing tab.

16. Apply a **Boolean Union** (D).
17. **Uncover Loop** (E).
18. Use the **Straight Knife** tool to **Cut** the object horizontally. Use the grid to determine the center (F).
19. **Revolve** the model around a horizontally drawn centerline (G).
20. View the final model in **Shaded** view (H).
21. Place the knob against the cabinet door in an appropriate position.

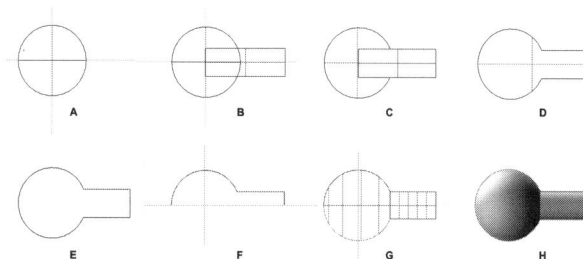

**FIGURE 2.16**   The cabinet knob. See steps for details.

### UNDER-COUNTER CABINETS

The under-counter cabinet next to the fridge has a room-facing length that measures about 94 inches wide by 18 inches tall. This allows for four cabinet doors measuring 20 inches wide by 15 inches tall.

22. (Optional) Create a new custom workplane from the surface of the cabinet, which will allow the creation of the objects to be done in place.
23. From a side view, draw one **Rectangle 20 inches** × **15 inches**, placing it about an inch and a half in from the side wall. Use the **Copy** tool set to **3** copies and **Divide Total Transformation**.
24. To create the beveled fronts of the cabinets, you will need to repeat Steps 12 and 13 for these objects. Then copy the cabinet knob and place appropriately.

### UPPER AND LOWER CABINET DOORS

The other set of cabinets has slightly different needs, but you can still reuse these doors.

25. In the **Layers** window, create a new folder (Layer). Highlight the four cabinet doors and knobs from above, and **Duplicate** them. These new copies are highlighted and can be dragged in unison into the new folder.
26. While watching the **Top** view, again highlight the new doors and knobs. Select the **Rotate Y** tool, and in the **Status** edit box at the bottom of the screen, type in **–90°**. The copies should swing into the correct orientation.
27. Put these four door sets in place for the overhead cabinet. You may want to add a bit more spacing in between them.
28. Copy two doors and knobs, and put them in place for the lower under counter cabinet. Slide them to the right of the cabinet; the oven will be on the left side.

### FURNITURE BEVELS

A few more Bevel operations are needed.

29. **Bevel** the front edges of the two work counters using the **Edge Filter**. This can be either a tiny **Chamfer** to represent a Formica laminate or a nice **Rounding** of 0.25 inches or more to represent a more luxurious marble. In either case, there will be a problem where the counters intersect, so the long counter needs to be **Split** with the **Straight Knife** (see the dashed line in Figure 2.17).

30. The round glass table needs a nice bevel. Using the Loop or Face filter, give it a 1-inch Chamfer.

31. The glass snack island is meant to match the table's Chamfer. This is done by pre-picking the edges indicated in Figure 2.17, using the Edge filter, selecting one of the edges with the Bevel tool, and double-clicking to generate.

## WALLS AND WINDOWS

You want to add a window over the sink counter and a sliding glass door behind the breakfast table. Both can be done in a few simple steps:

32. Make the extruded walls visible, and **Duplicate** a copy for safety's sake. From the Left or Right side view, draw a **4-foot wide** and **3-foot tall Rectangle** above the countertop where you want the sink window to be placed. **Extrude** the new shape, with **End Caps** if needed, and **Move** it to intersect with the wall.

33. Apply a **Boolean Subtraction** to knock out a window, as shown in Figure 2.18.

34. Switch to the Front view to make the **Rectangle** for the sliding glass door. It should be about **6 feet** wide and **7 feet** tall. As with the window, **Extrude** it, make sure that it intersects the wall, and perform a **Boolean Subtraction** (refer to Figure 2.18).

35. Use the original rectangles to generate a framework for the new window and doorway. It would also be a good idea to make the rectangles, convert them to two-sided, and place them in position to be used as the glass elements.

**FIGURE 2.17**   Sections of models marked for final Bevel operations.

**FIGURE 2.18**   Window and sliding glass door openings are knocked out with two Boolean Subtractions.

36. The final touch for the windows is drapery, which is surprisingly easy to create using the Birail tool. In the Top view, select the **Beziér** tool, and draw a squiggly line to represent drapery folds (see Figure 2.19). When done, use the **Convert to Single Spline** tool on it.

37. In a forward-oriented view (which is Front for the doorway and Side for the window), draw two NURBS Curves to define the vertical shape of the drapes. One must intersect with the squiggly line's first vertex, and the other with the last vertex. Zoom in to make sure that they intersect, and check from at least two elevation views. Use the Birail tool to generate the drapes as shown in Figure 2.19.

38. The one drape can be flipped to use on the other side or further modified with the NURBS Surface editor.

**FIGURE 2.19**   Creating drapes: The Birail tool needs a cross section and two guidelines. The results are on the right.

## STEP FIVE—CLEAN THE KITCHEN

If your project has gone well, you no doubt have a lot of object files listed in your Layers window. Now is a good time to clean it up before jumping into the next section. Create a Layer for all the old items that are not likely to be needed any more. This way, they can all be turned off.

Go through the remaining objects, and apply names that will be descriptive once inside Animator. For example, **Countertop** is much better than **Extruded Solid**. Grouping subfolders can also be very helpful. For example, putting all the under-counter items in one folder helps with organization.

**TUTORIAL**

## STEP SIX—MAJOR APPLIANCES

Quick-and-dirty sinks, stovetops, and ovens: This covers several techniques that can be used in making all sorts of item shapes.

### DOUBLE-BASIN SINK

This double-basin kitchen sink is a classic case of "explanation is more complex than operation." After you get through this, the door opens to many more complex creations.

*The Skin tool has a 50-50 shot at producing surfaces with normals that face in the desired direction. This is easy to fix by applying the Reverse Face tool (on the Face Editing tab) or making the model two-sided.*

1. Turn off all models except the second countertop.
2. Recall the rectangle drawn for the sink in the drafting section? Find it, turn it on, and trace it to make a new rectangle that lies on the custom workplane, on the top of the countertop. Then turn off the old version.
3. Select the **Workplane** tool, and make a custom workplane aligned with the top of the counter. Activate it, and **turn off the countertop**.
4. While in Top view, select the **Offset Planar Wire** set to **0.5 inches** (or negative 0.5 inches, depending on the direction of the wire); select the rectangle to generate a slightly smaller wire (Wire 2 in Figure 2.20). Note that if the wire is filled, **Uncover Face** will need to be used.
5. Use the **Fillet Edges** set to **1.5 inches** on all corners of both rectangles. Try to start at the same corner on each one, and go in the same clockwise or counterclockwise direction.

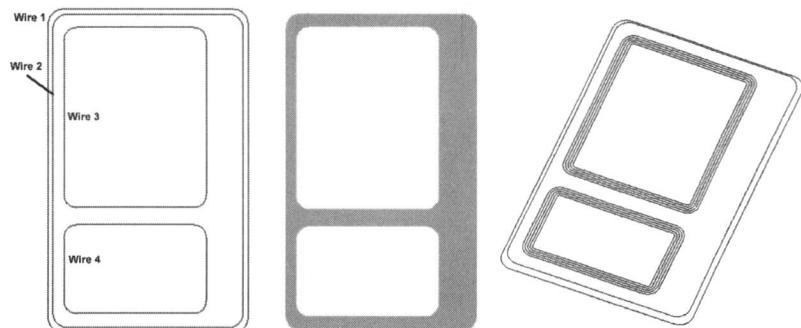

**FIGURE 2.20** The Top view with the first four wires in place. Note the extra space placed at the head of the basin (right side of the image) for future placement of the faucet (left). The top of the basin is created from wires 2, 3, and 4 and two Boolean Subtractions (middle). Extra wires created with the Offset Planar Wire tool (right).

6. Draw a new **Rectangle** that measures (X) 15 inches × (Z) 18.5 inches. **Move** it with **Copy** mode on, and then Scale or Polyline-edit the copy to 9 inches along the X-axis. These are the basin outlines, wires 3 and 4.

7. With the **Fillet Edges** set to **1.3 inches**, round the corners of the two new rectangles, and make sure that they are placed to look like Figure 2.20.

8. Take wires 2, 3, and 4 and raise them upwards by 0.5 inches.

9. With the **Fill** tool (on the Wire Editing tab), fill wires **2**, **3**, and **4.** This is a nondestructive act and generates three new objects. In the **Layers** window, turn off the four wires, leaving just these new filled objects visible. (Note that having Preferences set to Show Isoparm makes it easier to know whether a wire is filled).

10. Using the **Boolean Subtraction** tool, subtract the filled versions of wires 3 and 4 from filled wire 2. This is done in two steps. (If Boolean Subtract does not want to work, try to make all items either one- or two-sided or reverse face directions. Also, they may not be on exactly the same plane; Extrude 3 and 4 to ensure intersection.) The results should look like the middle image in Figure 2.20. This is the **basin top**.

11. In the Layers window, turn off the basin top, and turn on the four original wires (unfilled).

12. With the **Offset Planar Wire** tool set to **0.25 inches**, click **wire 4** to generate a smaller wire, and name it **wire 5.** Do this three more times—applied to each successive wire—to generate **wires 6**, **7**, and **8** as well. Then do the same thing to **wire 3** (wires 9 through 12). The results appear in the last image in Figure 2.20.

13. **Move/Copy wires 6** and **10**. Move the copies **down 6 inches**, and turn them off for now. Name them **6-B** and **10-B.** You will need them later.

14. You are going to work with **wires 4**, **5**, and **6** now. The idea is to apply a Skinning operation to create a curved shape that will seamlessly join the basin top with the vertical wall inside the basin. Leave **wire 4** where it is, and move **wire 6** down **0.5 inches** along the **Y-axis**. The question is where to place wire 5. Wire 5 can have its Y-axis changed, its size, or both. Figure 2.21 shows how doing a little of both offers the best option. When **wire 5** is correctly placed, use the **Skin** tool set to **Smooth**, by clicking **wires 4**, **5**, and **6** and then double-clicking to apply.

15. Now you will do two **Skin** operations set in **Linear** mode. **Wires 1** and **2** are skinned to create the lip around the sink. A Linear Skin is also applied to **wires 6** and **6B** (and when doing the second basin **10** and **10B**). Look at Figure 2.22, which breaks the whole project into a schematic-style diagram.

16. Next is another curved skinning with the **Smooth** setting. This uses **wires 6B**, **7** (which needs to be customized as wire 5 was), and **8**. The difference is that the curve swings the opposite way this time. **Wire 8** first needs to be **moved 0.5 inches** below **6B**, and adjustments need to be made to wire 7 (refer to Figure 2.22).

17. Create a **Circle** that is **3 inches** in **diameter**. Center it in the basin, and lower it about **0.5 inches** below **wire 8**'s position. Perform a **Linear**-mode **Skin** operation between the two. Make sure to toggle on the first four settings' option buttons. They are needed here to correct the greater variations in shape.

18. A **drain** can be fashioned with a simple profile shape that is **Revolved** and put in place. Actual holes can then be created using Boolean Subtraction, although a texture map will probably suffice, depending on the project (refer to the right image in Figure 2.22).

**FIGURE 2.21** Wire 5 can be placed and sized differently to generate various curves when wires 4, 5, and 6 are skinned. The Front views show the wires forming a straight line, which generates a Skin that looks like a Chamfer (left). By raising wire 5 and making it smaller (about 98% here), a nice curve is generated (right).

**FIGURE 2.22** A diagrammatical explanation of the sections involved, with associated wire numbers. The sink (left) and an enlarged drain profile (right).

19. When the first basin is complete, do the same operations on the second basin. When all parts are complete, they can be combined using the **Boolean Join**. If, on the other hand, the sink is going to be very reflective—for use in a stylized detergent commercial perhaps—keeping the straights and curves separate offers the control needed for reflections. Figure 2.23 shows the final image.

    Set the Extrude tool to a few inches, and apply it to wire 2. Turn the countertop back on, and move the new extruded model to intersect. Then apply a Boolean Subtraction to ensure that the countertop does not interfere with the sink. Boolean the under-counter cabinet as well.

### BUILDING AN EXOTIC FAUCET

Water faucets have become very exotic, but a sleek contemporary model can be generated without much effort. The following instructions reference Figure 2.24, which is a Front view.

20. The vertical base is a line at a slight angle that is **Revolved**. In Figure 2.24, it is represented as line **1**, and its centerline of revolution is represented by **1R**. The main neck of the faucet is done the same way, seen as **2** and **2R**.

**FIGURE 2.23**   The final double basin sink.

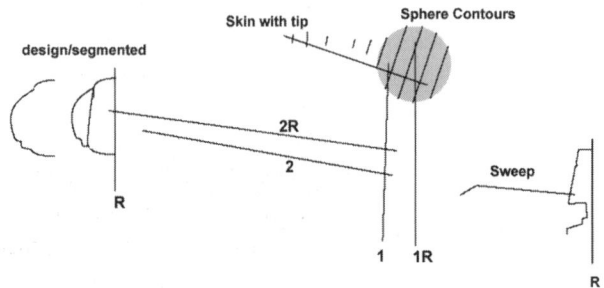

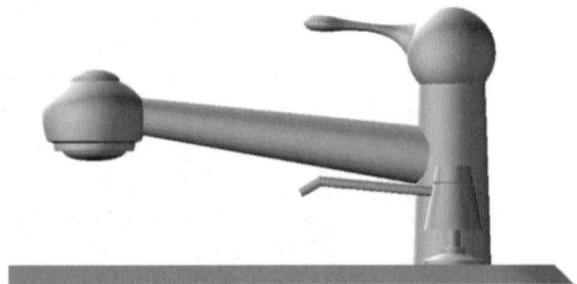

**FIGURE 2.24**   The final faucet construction diagram and soap dispenser.

21. A **Sphere** from the Solid Primitives tab is placed at the top of the Base model (seen in gray), and the **Contour** tool is used to generate five contours. You will use the far-left contour (the others can be deleted), along with a **Copy/Move** action set to **5** and **Divide Total Transformation**, to create the wires to the left. These wires are then Scaled down universally, and then more in the Y-axis. They are then positioned as shown in Figure 2.24. A line is added to use its point in a **Skin with Point** operation, which allows a point to be the final selection object in a skinning operation. The Point filter needs to be enabled just before the point is selected.

22. The Spray Head model is created as a **Revolve**. The far-left profile in Figure 2.24 is the original, but upon revolving it, the edges are not sharp enough. By breaking the profile into three separate pieces, it is easier to get a crisper rendition for the final model.

23. The soap dispenser is another revolved profile, and its spout is a Sweep.

## THE STOVETOP

You must keep something in mind as you jump into the last leg of this tutorial. Wherever practical, all items reproduced here are based on real-world measurements. This makes the workflow smoother, and the results more realistic.

24. Take the **stovetop** rectangle created in the drafting section, and drag it to sit right on the countertop above it. Make sure that it is a wire and not a face. With the **Move** tool set to the **Y-axis** and **Copy Mode** on, drag the rectangle up two more times, first, about **1 inch** high and, second, at **1.5 inches** above the countertop.

25. Select the **Offset Planar Wire** tool, and set it to **1.5 inches**. Click on the top wire just created to generate a new, smaller wire.

26. With the **Skin** tool set to **Smooth** and **End Caps**, click on the wires from low to high, and then the smaller inset wire. Double-click to execute the skinning. As you can see in Figure 2.25 on page 64, the extra wire in the vertical line helps keep the sides flat. This is just like adding extra controlling Hulls in ÜberNURBS to force-create edges.

27. In the top view, create a **9- to 10-inch Circle**. **Duplicate three** more, and put them in the proper positions for burners, leaving excess space on the right for control knobs.

28. With the **Offset Planar Wire** tool set to **0.5 inches**, select one of the circles to generate a smaller circle. Then select the smaller circle to generate another. Change the tool's setting to **1.5 inches**, and click the smallest circle to create another one. Do this to each of the four burners (refer to Figure 2.25).

29. Select the two smallest circles from each set, and **Move** them up about **0.5** an inch from where they are. Take the largest circles and move them to sit on the top of the stovetop's surface. Take the remaining circles (second in), and raise them to about **0.25 inches** over the top of the stovetop surface. These will be used to create a lip. When done, individually apply the **Skin** tool set to **Smooth** to all four sets.

30. Use the second largest wire to create an **Extruded** cylinder. (Duplicate the cylinder, as they are deleted during Boolean actions.) Use this cylinder to perform a **Boolean Subtraction** on the stovetop and the countertop. This makes room for the recesses. Do this for all four sets.

31. You need to conceal the area below the catch dish and gas pipe, so take the third largest construction circle this time, and **Extrude** a cylinder from it downwards. Use the **Cap Ends** feature and a preset **Distance of 2 inches**. When done, use the **Uncover Face** tool to remove the top face. This creates a kind of bucket shape that you can make black. Now copy this to all the other burners.

32. A central gas pipe can be fashioned with a Polyline profile and Revolve (see Figure 2.26).

**FIGURE 2.25**  The stovetop base with burner construction wires drawn.

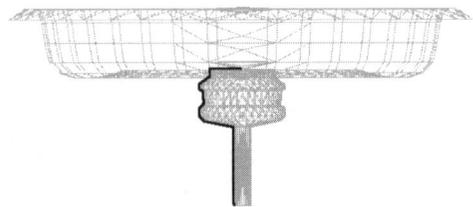

**FIGURE 2.26**  The gas pipe is a simple Revolve model, but its interesting shape makes it look more complex.

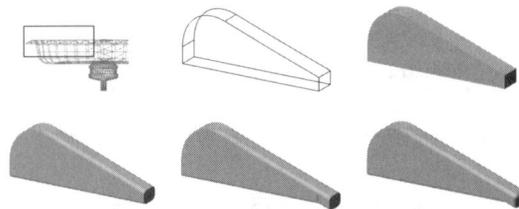

**FIGURE 2.27**  The burner supports were built from a rectangle and progressively shaped. Top row: Rectangle, Extrude, and Shaded. Bottom row: Round Edges, Extrude tip, and Round tip (Left to right).

33. To create the iron pot support, a Rectangle is drawn in the Front view (see Figure 2.27). This is then modified with the **Polyline Edit** tool and the **Fillet Edges** and then **Extruded 0.35 inches**. The four length edges are rounded by **0.1 inches**, using the **Pick Edge Filter** and **Round** tool. The tip is extended, using the **Extrude** set to **0.35 inches** and the **Pick Face Filter**. The new tip is then rounded, using the **Pick Face Filter** and **Round** tool set to **0.075**, as shown in Figure 2.27.

34. **Copy/Rotate** three more supports at **90**, **180**, and **270 degrees** around. Then use a **Boolean Join** to bring them together. No need to use Union— it takes longer, and its benefits are with intersections, which this does not have. Copy them to the other burners.

### CONTROLLER BASE AND KNOBS

35. To create the base for the knobs, draw a Rectangle (as shown in profile in Figure 2.28). This can be drawn right on the stovetop surface by enabling the **Snap to Face** feature (on the Snap tab). **Extrude** it by a small amount, and then add a **Chamfer**.

36. To create the control knobs, use the **Solid Primitive Cylinder**, and cut a notch out of each side using the wire knife tool, as shown in Figure 2.28. Add a bit of **Rounding** to the edges, and **Copy/Move** to create three more copies in place.

### OVEN

37. Turn on the under-counter cabinet, and with **Snap to Face** on, draw a **Rectangle** for the front of the oven. **Extrude** it into the room by about **1.5 inches**, and then apply a Chamfer.

38. To create a handle for the oven door, change to a side view, and draw a modified rectangle with the **Polyline** tool. **Extrude** the shape a bit less than the oven's width (see Figure 2.29 on page 66).

**FIGURE 2.28**    The knob was simply a Primitive Cylinder cut with a Wire Knife and Rounded.

**FIGURE 2.29**   The profile is created from the side and then extruded. A Wire Knife is then used from the top view to create the handgrip recess.

39. In the Top view, draw a **Rectangle** that will be used to do a **Boolean Subtraction** and finish the shape.
40. Drop another rectangle, centered on the front of the oven, to act as its "window."

## Taking It Further

ON THE CD

When all the modeling is complete, it is time to **Export** the models to **Fact** format. The exported Fact files provided on the CD-ROM were saved from the main file, using the default Tessellation settings provided by Modeler. The tile floor was produced separately and exported with the **Normal Tolerance in Degrees** increased from its default of 15 to 30. This lowered the polygon count from more than 80k to 30k, and it could have been brought down further.

The files were brought into Animator, and a well-finished scene was constructed with a few lights, shaders, and the inclusion of several supporting models from the **Fact Model Disk**.

This Animator project is included on the CD-ROM and appears in Figure 2.30. The CD-ROM also has a full color version of this image that you should look at, as well as a fly-through animation of this scene in QuickTime format.

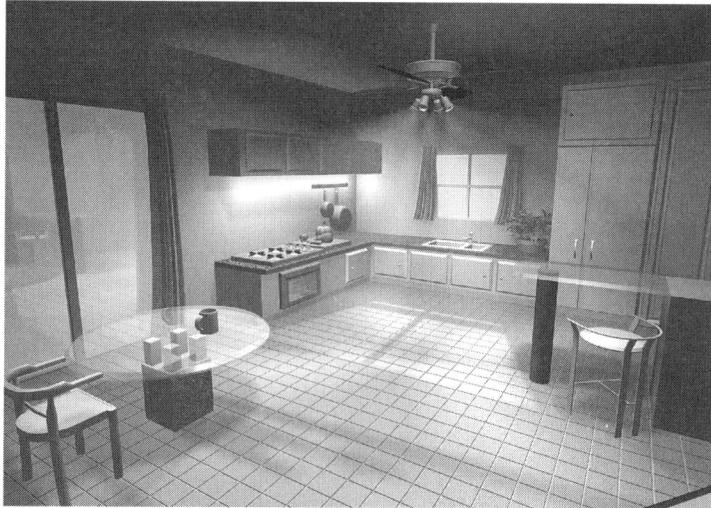

**FIGURE 2.30**    The final project brought into Animator and set up with a few additional models from the Fact Model Disk. The image was produced using Phong rendering.

# MODELING A HEAD IN ÜberNURBS

By Mark Hannon *(figure2productions.com)*

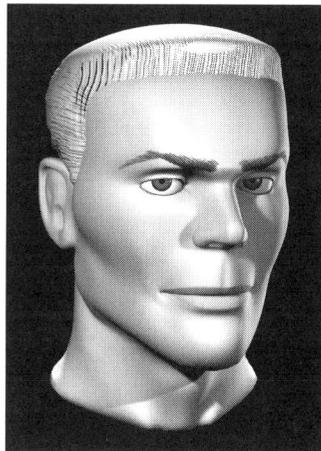

There are many approaches to modeling a head in 3D. Some artists like to develop a model directly on the screen, and others prefer to plan a character on paper. This tutorial uses the second method. The head created on the pages that follow was developed through a series of sketches. When the character began to materialize, two templates were drawn for the front and side views, which you will see as you follow along.

For this tutorial the model is based on two sketches of a very macho-looking guy. This character could be a superhero, a super villain, a thug, or even a secret agent. Just like actors, your characters assume the roles you assign them.

If you want to create your own characters but do not have an art background and are not confident about your drawing skills, you can also use photographs. Friends and family members are a good place to start. You may also want to check out Images and longdesc, a commercial disk of photos set up especially for 3D artists (see the CD-ROM folder that contains the "Resources").

**ON THE CD**

## LOADING THE TEMPLATE IMAGES

**Ctrl-click** in the **Front view** window, and choose **Load Image Template**. Select the location of your front-view template, and the chosen image will appear in the center of the Front view window (see Figure 3.1). **Repeat** the process in the **Left view** window for the side-view image.

Use **Command-L** to bring up the **Layer View** window. You will see a list of the template image names (see Figure 3.2).

**Double-click** each template image's name to open its **Properties** window. You need to offset the position of the images to make room for the model you will build.

In the Properties window, use a **positive value** in the **Z** field for the **Front view** image to push it backwards and a **negative value** in the **X** field for the **Left view** image to move it off to your left. Depending on the size of your template images and model, these values can be higher or lower. **Lock** both images by clicking in the column to the right of the visibility dot in the Layer View window. An icon of a lock will appear.

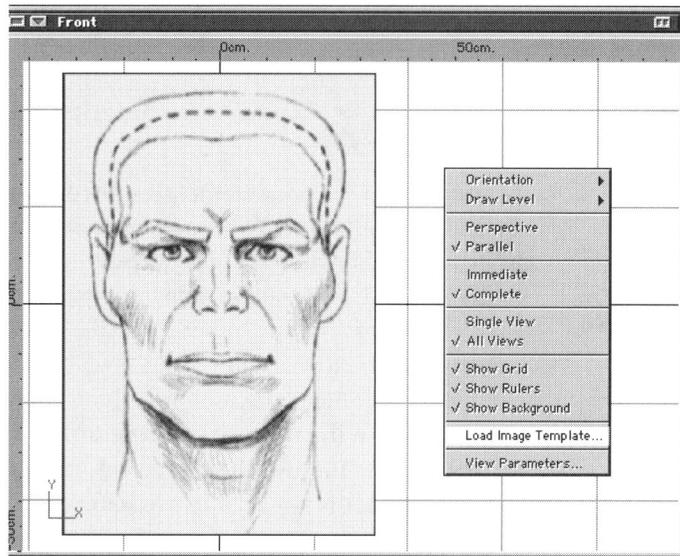

**FIGURE 3.1**    Loading the first template image.

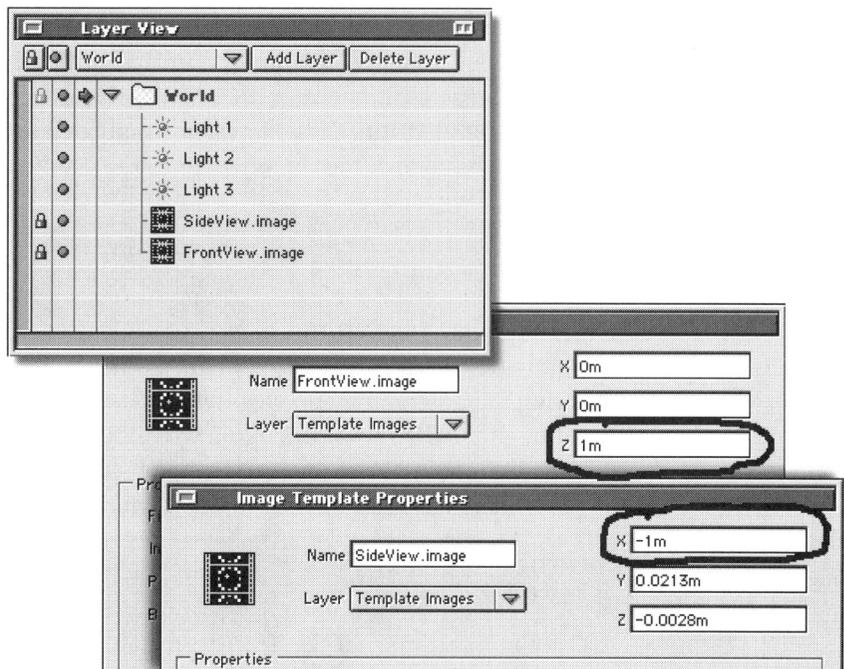

**FIGURE 3.2**    The Layer View window.

*When making your own template drawings, the key features should line up in all views.*

### Lining Up the Sketches

The front- and left-view templates need to be at the same level so that key features of the face will be in the same place and at the same level regardless of which view you are working in.

Electric Image Modeler does not have window guides but you can make your own. Try this trick. Select the **Line** tool from the **Curve Primitives** tab in the toolbar, and draw five horizontal lines in the Front view window. Using the **Move** tool, line them up with the top of the head, the eyes, the base of the nose, the mouth, and the bottom of the chin.

**Shift-click** the five line objects in the **Layer View** window so that all are selected. Click and hold the **Rotate** tool in the Transform tab, and choose the **Rotate Y tool**. In the lower-right corner of your screen, you will see a text field. Enter the number **90** in that text field. The five line objects will turn and become visible in the Left view window.

**Lock** all the line objects, and **unlock** the **side-view template** image. Select it by clicking its name in the Layer View window. Select the **Move** tool in the Transform tab, and working in the **Left view**, position the side-view image by clicking and dragging outside the image area in the **Left** view window. Position the image so that the lines pass through the same areas as they did in the front-view image. When you're done, **turn off the visibility** of the lines, or simply delete them. They won't be needed again. Relock the side-view image.

## CREATING THE MODEL

To create your ÜberNURBS object, you need to start out with a block primitive. In the Solid Primitives tab, select the **Block** tool, and start by drawing a square in the Top view window. Next, click near the top of the head in either the Front or Side view windows to set the block. There is no need to worry about the size of the block at this point; you'll be scaling it to match the size of your template more closely.

### Sizing the Block

Using the **Scale** tool in the Transform tab, click on the block. You adjust the block's size relationship to the template by holding down one of the three modifier keys: **X**, **Y,** or **Z**. In the Front view window, **constrain** the scale operation to **left** and **right** by holding down the **X** key,

scale up and down by holding down the **Y** key, and use the Left view window to scale the block in the back to front direction by holding down the **Z** key. When using the Scale tool, dragging to the **right increases** size, and dragging to the **left decreases** size. Scale the block to the size of the head only; the neck will come later.

*When using any of the Transform tools, click the object only once to select it, and then drag the mouse in empty space to use the tool.*

Use the **Move** tool in the Transform tab to adjust the block's position. Turn off the visibility dot of the front template image so that the grid is visible, and in the Snapping tab, pick **Snap Planar**. Click on the block once with the **Move** tool to select it. Then drag in empty space in the Front view window to move the center plane of the block over to the centerline of the grid. Turn the front template image's visibility back on, and adjust its position if necessary. In the Left view, position the block over the side template image while holding down the Z key (see Figure 3.3).

**Converting the Block**

Click the ÜberNURBS tab, and **double-click** the **ÜberNURBS/Edit Cage tool**. The tool's Settings window will appear.

In the upper-left corner of the window, click the option **Generate ÜberMesh**. Leave everything else at the default settings, and then click **OK** to close the window. ÜberMesh creates a much smoother surface than ÜberNURBS and is generally more forgiving when working with loops that have fewer or greater than four edges.

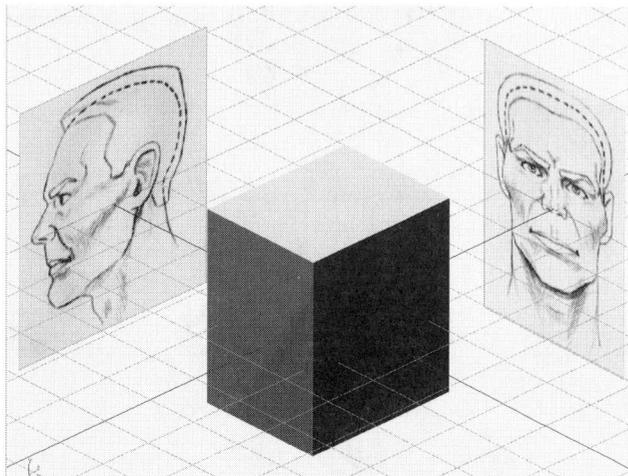

**FIGURE 3.3**  Positioning the block and the template drawings

*The ÜberNURBS cage is made up of a network of lines or edges that interconnect to create patches or loops. Loops must have at least three edges, ideally four, but can go higher. Although three-edged loops can be used, they generally cause creasing and should be avoided. Loops larger than four edges should be divided into smaller four-edged loops.*

Using the **ÜberNURBS / Edit Cage tool**, click once on the block. The block will be replaced by a more organic, egg-like shape inside a cube-shaped cage (see Figure 3.4, Step A). This cage has only six loops, which isn't enough for creating a more complex shape, so the number of loops needs to be increased before you begin to shape the object.

Click the **Subdivide Globally** tool just to the right of the Über-NURBS/Edit Cage tool, and click the ÜberMesh object twice. You should now have a more complex cage (Figure 3.4, Step B). Switch back to the **ÜberNURBS/Edit Cage** tool.

*The small dots at the intersection of each edge are Control Vertices (CVs). These are what you use to manipulate the shape of the cage. The best approach to doing this is to work with large groups first, then smaller groups, and finally individual CVs.*

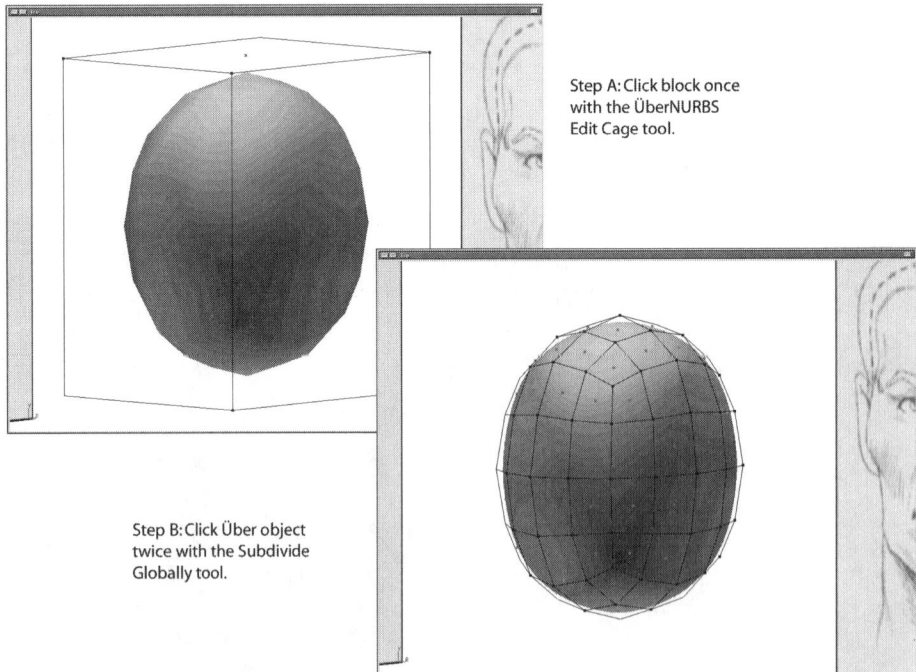

Step A: Click block once with the ÜberNURBS Edit Cage tool.

Step B: Click Über object twice with the Subdivide Globally tool.

**FIGURE 3.4**    Starting the ÜberMesh object.

### Understanding the Behavior of Control Vertices

CVs can be selected individually by clicking them with the Über-NURBS/Edit Cage tool, or in groups by drawing a box around the bunch you want to select. You can add or remove CVs from a selection by holding down the Shift key and drawing a box to deselect groups or clicking to deselect individual CVs. Groups of CVs can be shaped quickly by dragging, scaling, or rotating them.

*Selected CVs have to be deselected before you work with the next group, or unexpected changes will occur to your model.*

When dragging CVs, *avoid working in the Iso window*; the results can be unpredictable. Use the **X**, **Y**, or **Z** modifier keys to constrain the drag or move. Holding down X constrains the move to left or right, holding down Y constrains the move to up or down, and Z, back to front.

To scale a group of selected CVs, hold down the **S** key while dragging right to enlarge or dragging left to decrease size. Holding down the modifier keys (X, Y, or Z) with the S key constrains the scale operation to that direction.

Holding down the **R** key rotates the CVs. For more reliable results, you must use the same modifier keys when rotating. (X, Y, and Z). When working with selected groups, do not directly click the object when doing any Transform operation. The group will deselect. Instead, choose a point outside the object to drag, and implement the Transform operation. Individual CVs, on the other hand, can be directly scaled and moved. After you use the Scale or Rotate operations to get the shape of your Über object close to where you want it, the shape can be further refined by pushing and pulling individual CVs.

As this head model becomes more complex, more explanation will be necessary. To save space and a few trees, the process referred to in the preceding few paragraphs will be called **shaping**. Come back and read through it whenever you feel the need. If at any point you exit Über-NURBS mode, you can get right back in by clicking the object with the ÜberNURBS/Edit Cage tool.

### Building a Head

The preliminary steps are out of the way, your templates and basic shape are set up, and it is time to start roughing out your head. The first steps of this process are illustrated in Figure 3.5 on the next page.

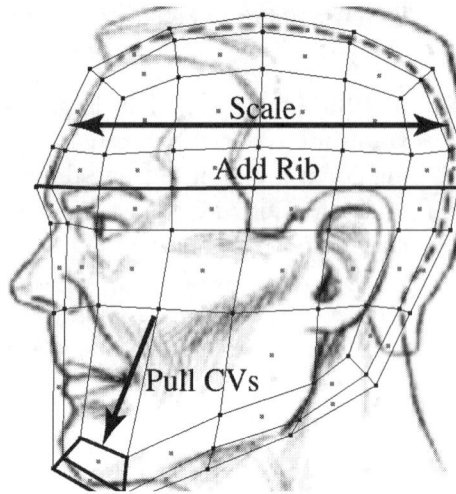

**FIGURE 3.5**    The first steps in shaping the head.

1. Select the figure by clicking it with the **UberNURBS/Edit Cage tool**, and press the **Tab** key to hide the shape inside the cage.
2. Select the center horizontal rib by drawing a box around it with the ÜberNURBS/Edit Cage tool. Click and hold, holding down the **Y** key, to move the rib up or down until it passes through the center of the eyes. **Deselect** the rib by clicking a single CV; then Shift-click that same CV.
3. In the **Left view** window, select the **Add Rib** tool, and draw a line that starts just in front of the head and passes out the back at about the level of the brow protrusion.
4. Staying with the Left view window, switch back to the **Über-NURBS/ Edit Cage tool**, and select the CVs for the top of the head. **Scale** and **move** them in the **Z** direction until their shape conforms more or less to the template image. Do the same with the horizontal brow rib.
5. **Deselect** the brow, pull the four loops on the lower left of the egg shape, and move them down to form the chin. **Move** the CVs closest to the jaw line to shape the jaw. Then move the horizontal rib above the chin to rest at the base of the nose.

Whew! That was a lot for just getting started, but the general shape of the head has been established. **Double-click** in **empty space** in any window to check your progress. When you are ready to continue, click the object again with the **ÜberNURBS/Edit Cage** tool to activate it.

More resolution needs to be added to the cage in the cheek, nose, and brow areas. Two more **ribs** need to be added in the Left view with the **Add** Rib tool and shaped with the **ÜberNURBS/Edit Cage** tool to give the cheek bones definition. The eye socket must also be started by pulling back the **indicated CV**. In the Front view, the **Add Edge** tool should be used to establish the base of the nose area and further define the brow (see Figure 3.6, A and B). To use the Add Edge tool, select it from the ÜberNURBS tab, click a CV or an edge segment to establish the start point, and then click an adjacent CV or edge segment to complete the new edge.

*Before using the Add Edge tool, it is advisable to use the Visibility tool to hide parts of the cage that could be accidentally affected. For example, if you are working on the front of a model, hide the back to prevent the Add Edge tool from placing an unwanted CV on one of the back edges.*

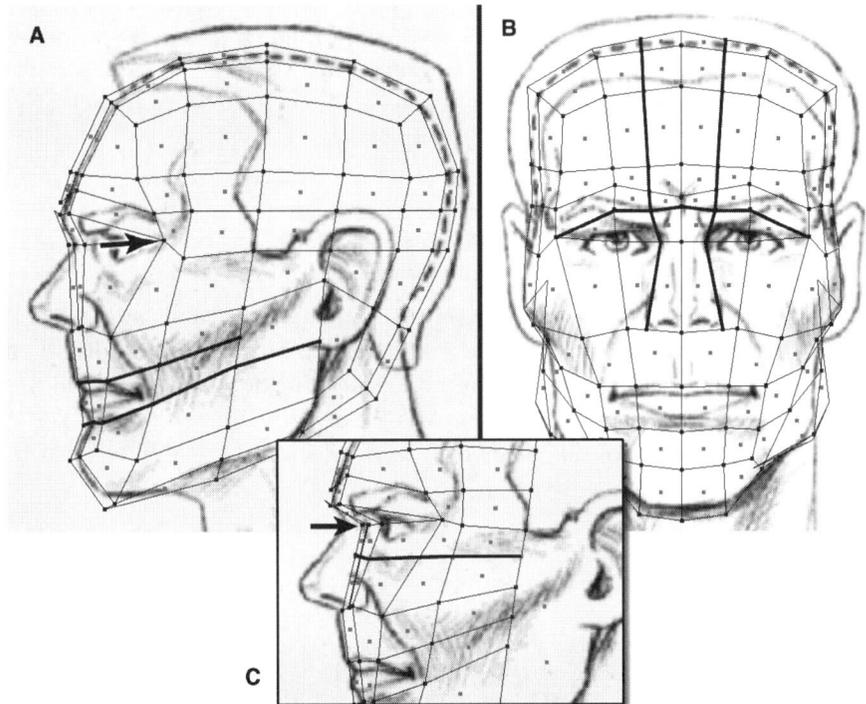

**FIGURE 3.6**  Using the Add Rib and Add Edge tools to increase mesh resolution, and forming the eye sockets and brow.

### The Brow and Eye Socket

Giving your Über-lump a forehead and a well-defined brow will bring out the first hint of human features. Using the **ÜberNURBS/ Edit Cage** tool, in the Left view window, select the CVs just in front of the eye in the template image, and push them **back** in the **Z** direction. To create the lower boundary of the eye socket, add a Rib with the **Add Rib** tool about halfway between the eye and the base of the nose (see Figure 3.6C).

Before moving on, you will do some shaping. Switch back to the **ÜberNURBS/Edit Cage** tool, and in the **Left view** window, select the group of CVs that form the chin. In the Front view window, **scale** them inward in the **X** direction by holding down the **S** and **X** keys, and dragging to the **left**. Tweak the shape by gradually selecting smaller groups and individual CVs where needed. When you are done, follow the same procedure for the back of the jaw, the cheekbones, and the top of the head.

In the **Left view** window, pick the **Visibility** tool from the bottom of the ÜberNURBS tab, and draw a box around the **back** of the model to hide it. If you hide too much, holding down the Shift key while drawing a box makes hidden edges and CVs visible again.

In the **Front view**, pick the **Add Edge** tool, and add two edges between the eyes, going across the nose.

Starting on either side of the nose, add edges that form a semicomplete circle that goes just outside the corners of the mouth in the template image and across the depression of the chin and back up. The new edges appear as dark lines in Figure 3.7, A and B.

Pick the **ÜberNURBS/Edit Cage** tool, and select one of the CVs that fall inside the edges forming the boundary of the base of the nose. Shift-select any other CVs also inside that area to add them to the selection. Pick the **Delete Vertex** tool from the ÜberNURBS tab, and click one of the selected CVs. All edges and CVs that were inside the nose area should disappear.

### The Nose

Pick the **Extrude Loop** tool, and click the **small dot** in the center of your new, empty nose loop. You will notice in the Left view window that the extrusion pops out like Pinocchio (see Figure 3.8, A on page 80). Switch back to the **ÜberNURBS/Edit Cage** tool. Working in the **Left view**, select small groups of the CVs in the new extruded loop, and **move** them in and out in the **Z** direction so that they follow the slope

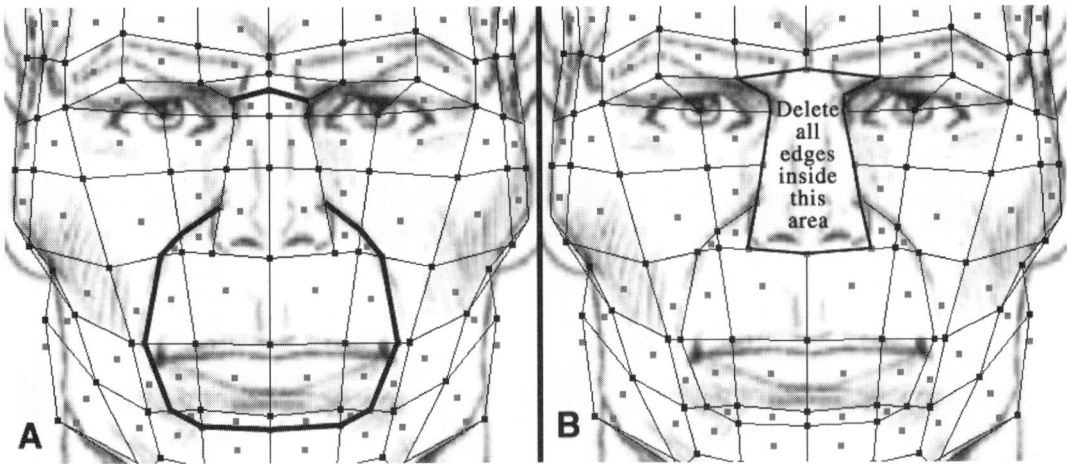

**FIGURE 3.7**    Adding edges for the bridge of the nose and outer mouth area, and deleting the nose edges.

and shape of the nose (see Figure 3.8, B). In the **Front view**, click the loop's center dot to select it; then **scale** it inward in the **X** direction. Tweak individual CVs if needed (see Figure 3.8, C). When you are happy with the shape, you need to subdivide the open complex loop into smaller groups of four-sided loops. Switch to the **Add Edge** tool, and looking at Figure 3.8, D, connect the horizontal edges, first going all the way across. Next, work your way from the top to the bottom, connecting edge to edge and following the imaginary centerline of the face.

### The Mouth

You will come back to the nose shortly, but for now, move on to the mouth. The mouth will be formed from a series of concentric rings, like the rings inside a tree. You made the first of those rings when you surrounded the mouth (refer to Figure 3.7). To clear the way for the mouth, you need to get rid of the edges and CVs that are inside that first ring. If it isn't already, *make sure that the back of the head is hidden,* by using the **Visibility** tool. Use the **ÜberNURBS/Edit Cage** tool to **Shift-click** all the CVs inside the first mouth ring to select all of them. Be sure not to include any of the nose CVs or edges. If you accidentally select an unwanted CV, you can Shift-click it to deselect it. Pick the **Delete Vertex** tool, and click one of the selected CVs inside the mouth ring to delete them all. Switch to the **Add Edge** tool, and add the single edge to the front of the cheek to break the 5-point loop into two 4-point loops (see Figure 3.9, A).

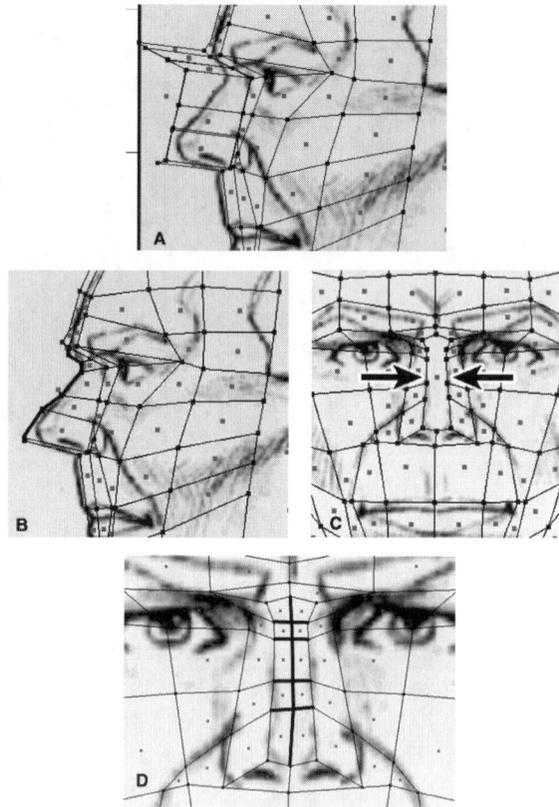

**FIGURE 3.8**   Shaping the nose.

Staying with the Add Edge tool, add some edges to round off the sharp corners near the nose, to make the mouth ring smoother. Break up the 5-point loop at the bottom right, and add three new edges, starting from the nostril flare and then going across the front of the nose. It should look like Figure 3.9, B after a bit of tweaking.

From this point on, you will be concentrating on the **right** side of the head model. Eventually, you will mirror the right half of the head over to the left so that you won't have to model the features for both sides of the head.

Remember the concentric circles discussed earlier? Well, here they come. Pick the **Inset Loop** tool, and click the loop center dot inside your newly prepared outer mouth ring. A new inset loop will appear (see Figure 3.10, A). Switching to the **ÜberNURBS/Edit Cage** tool, click the loop's center dot to select it, and use the Scale operations to shape it. **Move** individual CVs when necessary. **Add** two **edges** from the upper lip to the base of the nose; then **inset** again (see Figure 3.10, B). Shape

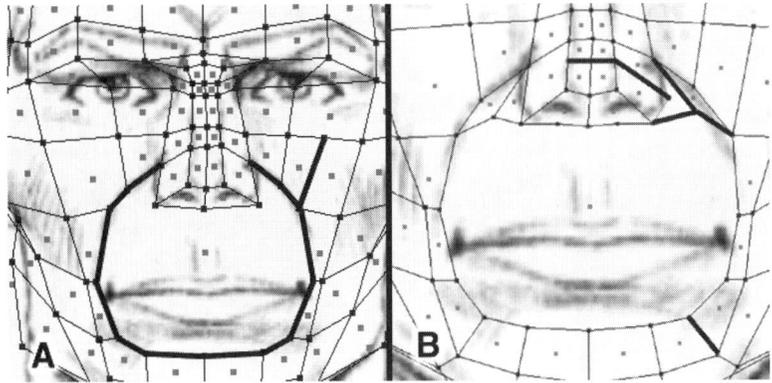

**FIGURE 3.9**  Preparing the mouth area and breaking up a 5-point loop. The outer nostril and upper mouth.

this new loop so that it follows the outer lines of the lips. Use the Front and Left views to guide you (see Figure 3.10, C and D).

Double-click in empty space in any window to deactivate the cage and show your progress. As you can see, the model is starting to become very head-like (see Figure 3.11, page 82). This is also a good approach to drawing and sculpting: "Rough in" the basic shapes before you add the detail.

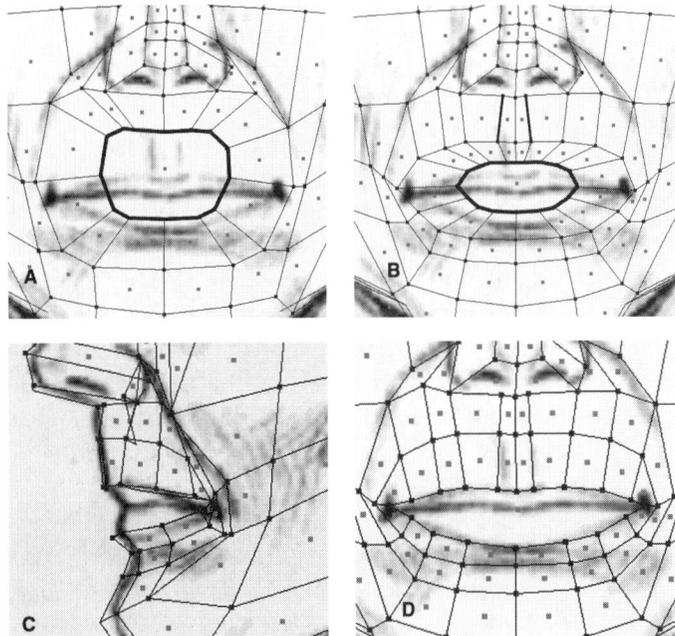

**FIGURE 3.10**  Forming the outer mouth.

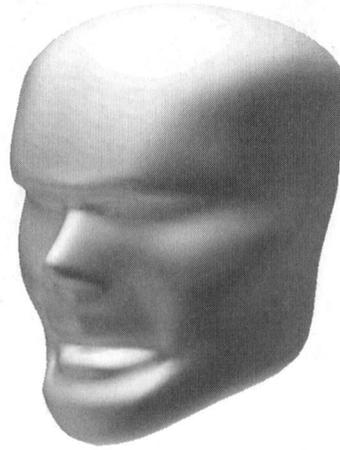

**FIGURE 3.11** Checking your progress in Smooth Shade mode.

### The Lips

Pick the **Visibility** tool, and hide everything except the last two loops of the mouth area. Switch back to the **ÜberNURBS/Edit Cage** tool. Following the same procedure as before, **inset** the outer lips loop, and **scale** and **shape** it two more times to form the curve of the lips. Be sure to use the Front and Left view windows to adjust the shape (see Figure 3.12).

### The Mouth Cavity

This part can be tricky. You may need to magnify the windows quite a bit to see what you are doing. Using the **Inset Loop** tool, inset the thin loop that forms the mouth opening (see Figure 3.12, A). Go back to the **Über-NURBS/Edit Cage** tool, and click the loop's center dot to select it. This may require some trial and error because the center dot for this new loop may be hard to see. In the Left view window, push the new loop back into the head in the **Z** direction (see Figure 3.12, B). In the **Top view** (see Figure 3.12, C), **scale** and **shape** the new loop in the **X** direction to the width of the mouth.

*When using any of the Transform operations with loops, do not click and drag any part of the model. You will deselect the loop, and only the part you clicked will be selected. Transform ÜberNURBS selections by dragging in empty (null) space.*

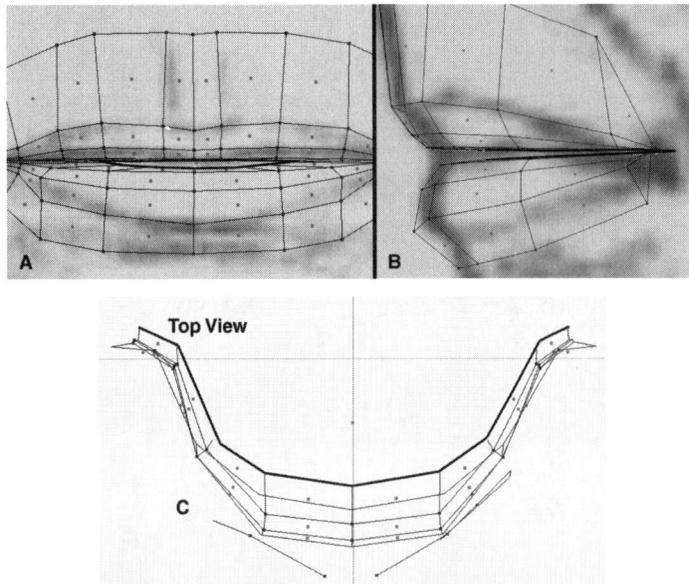

**FIGURE 3.12**    Modeling the lips and beginning the mouth cavity.

Use the **Visibility** tool again to **hide** everything but the loop you just dragged inside the mouth. You need to inset this loop again, but the new loop would be so small that it would be almost impossible to select. As an alternative, use the Extrude Loop tool to send your new loop to a different location so that you can work with it. Pick the **Extrude Loop** tool from the ÜberNURBS tab, and click the center dot of the mouth-opening loop. The new loop should appear out in front. Pick the **ÜberNURBS/Edit Cage** tool. Select the new loop by clicking its center dot, and begin to **scale** it in the **Y** direction to open it up. **Scale** slightly in the **Z** direction, and then **move** the loop back in the **Z** direction so that it is slightly behind the mouth-opening loop (see Figure 3.12, C).

Inset or **extrude** the loop from Figure 3.12. Shape the CVs and edges to form the first loop of the mouth cavity. While working with the mouth cavity, use the Iso view to position the loop center into better view. Be sure to go back to the Front and Left views to apply any of the Transform operations, such as Move or Scale. Using either **Inset Loop** or **Extrude Loop**, continue to form four new loops. **Scale** and **shape** the loops as needed, and **move** them back in the **Z** direction to form the mouth cavity (see Figure 3.13, A on the next page).

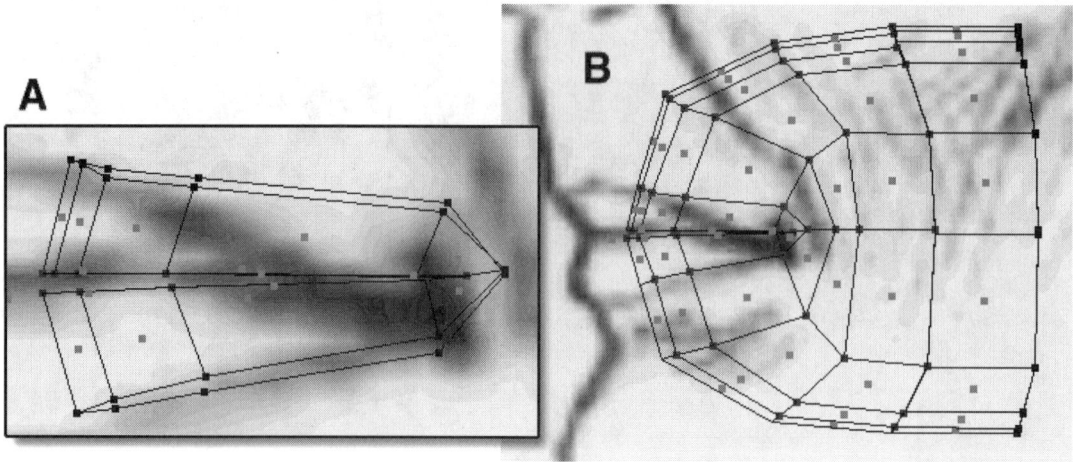

**FIGURE 3.13** The mouth cavity starts taking shape.

Repeat the steps from Figure 3.13, A to create the inner mouth cavity (See Figure 3.13, B). Figure 3.14 is a suggestion of how to divide the last loop of the mouth cavity into smaller 4-point loops. Use the **Add Edge** tool, and create the long horizontal centerline as the first edge. Connect the vertical edges next, and if necessary, use the **Delete Edge** tool to break up the double 3-point loops on either end into single 4-point loops. If you end up with a few 5-point or 3-point loops, don't worry about it; the inside of the mouth usually remains hidden from view. In the **Left view** window, pick the **ÜberNURBS/Edit Cage** tool, and pull the CVs along the horizontal center edge back in the **Z** direction to curve out the back of the mouth.

### The Eye

With the mouth finished, you can now start to refine the features of the face. Moving to the eye, select the CVs inside the edges of the outer eye socket, and use the **Delete Vertex** tool to delete them (see Figure 3.15, A). Using the **Inset Loop** tool, make a new loop inside the eye socket loop. **Scale** and **shape** it so that it is slightly larger than the eyelid in the template image (see Figure 3.15, B).

To give a better shape to the eye, a few more CVs will be needed along the top of this loop. Here is a nice little trick for increasing edge resolution: Using Figure 3.16 on page 86 as a guide, **inset** the loop that forms the underside of the brow. Switch to the **Delete Edge** tool, and delete the two vertical edges and the three edges underneath that they

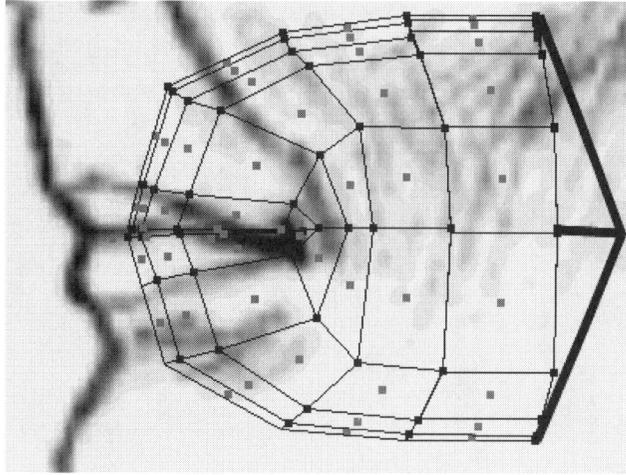

**FIGURE 3.14**    Closing the last loop of the mouth cavity.

had been connected to. Be sure not to delete the top edge of the eyelid loop. Using the **Add Edge** tool, connect the two remaining CVs left from the inset to the top of the eyelid loop. The two additional CVs break up a long edge and make shaping the eyelid much easier.

With the added flexibility of the eyelid loop, you can now start to form the eyelid curve. **Inset** the eyelid loop, and **Scale** and **shape** it using the Front and Left views (see Figure 3.17, A and B on page 87). Follow the shape of the eyelid in the template image as you shape the loop. To create the ridge of the eyelid (the area where the eyelid

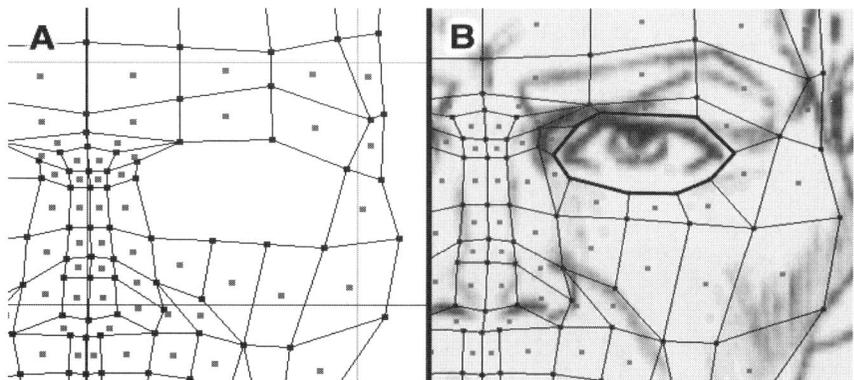

**FIGURE 3.15**    Starting the eye socket.

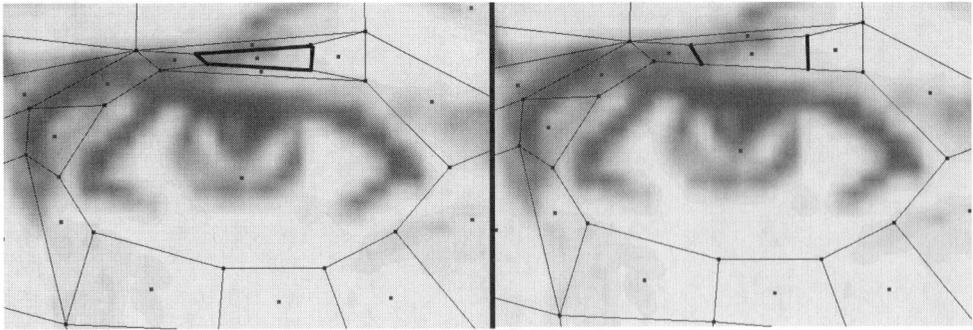

**FIGURE 3.16**    Increasing the edge resolution around the eye.

curves around to go inside the head), **inset** the loop once more, and **Scale** and **shape** it so that it is just inside the preceding loop (see Figure 3.17, C and D).

You are going to cheat a bit when you create the inside of the eyelid. Rather than create a cavity that follows the surface of the eyeball, simply **inset** the eyelid and **push** the loop in the **Z** direction back into the head (see Figure 3.18). When the eyeball is in place, you won't know the difference. This next step is strictly optional: **Add a rib** just in front of the back of the eye socket, and delete the CVs behind it with the **Delete Vertex** tool to simplify the loop's shape.

With the **Subdivide Loop** tool, click on the center dot of the last loop of the eye socket to close the shape.

If you haven't done so, double-click in empty space to check your progress. It should look like Figure 3.19.

### Finishing the Nose

Without nostrils, your hapless character won't be able to smell anything, so you will correct that now. Figure 3.20 shows the first four steps for finalizing the nose.

1. **Add edges** to increase the edge resolution of the nose shape (see Figure 3.20, A on page 88).
2. In the **Left View** window, select and **delete** the vertex at the center of the nostril flare (see Figure 3.20, B).
3. **Inset** the Nostril flare loop. **Shape** the back two edges and CVs with the **ÜberNURBS/Edit Cage tool** (see Figure 3.20, C).
4. Use the **Add Edge tool** to divide up the complex loop into four 4-point loops (see Figure 3.20, D).

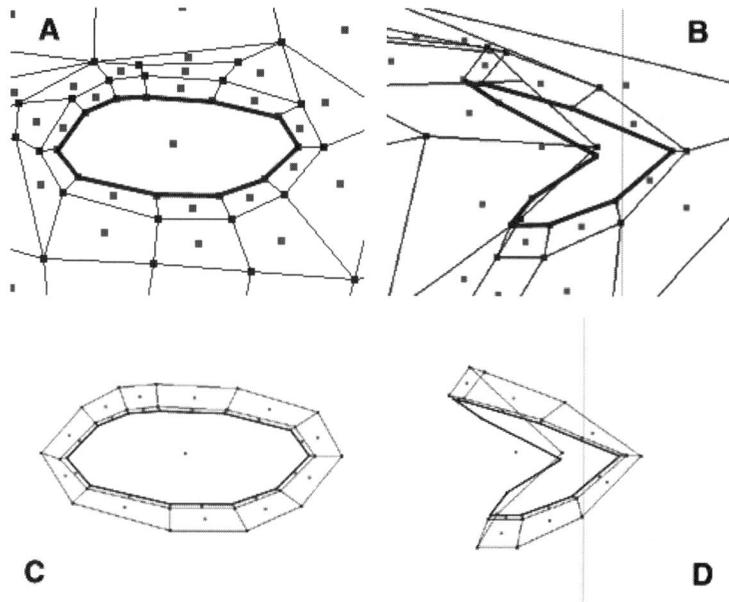

**FIGURE 3.17**    Forming the eyelid.

**FIGURE 3.18**    Creating the inside of the eyelid.

**FIGURE 3.19**    Checking the model's progress.

**FIGURE 3.20** Finishing the nose.

5. Go back to the **ÜberNURBS/Edit Cage tool**, and Shift-click the two back edges of the last loop you inset to select them. You may also need to Shift-click the CV in between them if it becomes deselected. Hold down the **X** key, and **drag** slightly to the right to pull out the back of the nostril flare (see Figure 3.21, A).

6. Pick the **Delete Edge tool**, and get rid of the edge on the underside of the nose.

7. **Inset** the underside nose loop. **Scale** the loop, and **move** CVs as needed. Don't forget to switch back to the ÜberNURBS/Edit Cage tool (see Figure 3.21, B).

8. **Inset** the nostril loop, and push it just slightly upwards into the nose. Repeat this step, but this time, push the loop much further inside the nose (see Figure 3.21, C).

Now is a good time to check your progress. Double-click in empty space to deactivate ÜberNURBS mode and view the model. When you are finished looking and are ready to continue, click the model with the **ÜberNURBS/Edit Cage** tool to reactivate the cage.

**FIGURE 3.21**   Modeling the nostril.

### The Ear

It would be nice if the ear only looked complicated and was actually deceptively simple to model, but that's not the case. Modeling the ear can be as challenging as the entire head. The good news is that if your character is cartoon-like, you can take some liberties with the shape of the ear.

You can use either the **Add Edge** tool or the **Add Rib** tool to increase the edge resolution of the side and back of the head (see Figure 3.22 on the next page). The ear, like the mouth, will be shaped from a series of inset loops, and these added edges you put in now will give you more flexibility to shape the ear.

It would be a good idea at this point to use the **Visibility** tool to hide the left half of the head in the Front view. In the Left view, pick the **Add Edge** tool, and lay in a series of edges that form a somewhat lopsided circle. Keep it outside the ear in the template image. If any 5-point loops are created, add an edge to split them into two 4-point loops. Select all CVs inside the circle with the **ÜberNURBS/Edit Cage** tool, and then delete them with the **Delete Vertex** tool (see Figure 3.22, A).

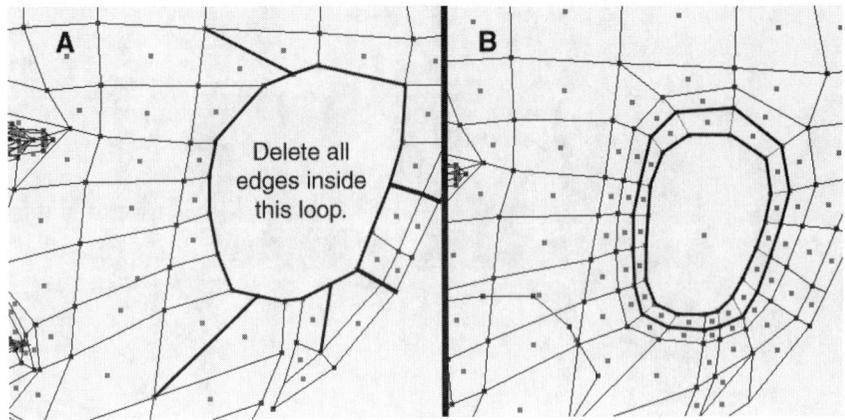

**FIGURE 3.22**    Preparing the area for the ear, and inserting ear loops.

**Inset** the loop, **scale** it out, and **shape** it. Then repeat the process with a second loop (see Figure 3.22, B). You may want to spend some time checking the model in the Iso view. If this area looks lumpy, smooth it out by pushing and pulling CVs with the ÜberNURBS/Edit Cage tool.

*At this stage, the ear construction starts to get tricky. With all the overlapping loops and edges, the process can become visually confusing. If at any point you get lost and can't tell which edge belongs to the current loop, click the loop center dot with the ÜberNURBS/Edit Cage tool. The current loop will highlight, making things clearer. Make good use of the Visibility tool to hide sections of the model that you aren't working on.*

### The Base of the Ear

**Inset** the current loop and with the **ÜberNURBS/Edit Cage** tool, **scale** the new loop out in the Left view while keeping the left side of the loop inside the previous loop. (See Figure 3.23, A) Push the right side of the loop out slightly past the previous loop by dragging individual CVs. In the Front v**iew**, **Ctrl-click** and hold to bring up the pop-up menu. **Select Orientation > Back** to switch views. In the Left view, select the CVs along the back edge; then, in the Back view drag them out away from the head one at a time (see Figure 3.23, B). Switch back to the Front view.

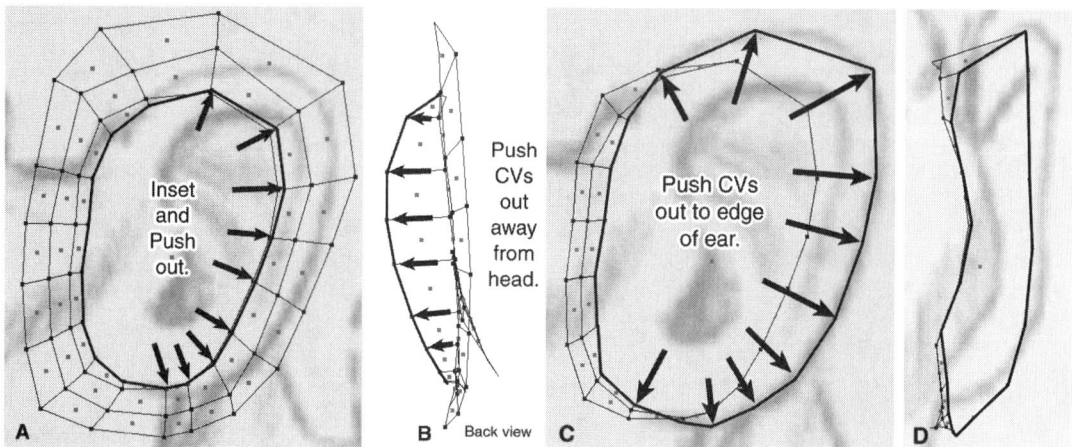

**FIGURE 3.23**    Creating the base of the ear, and starting the ear shell.

### The Ear Shell

**Inset** the ear base loop. Just as before, keep the left side of the new loop inside the preceding loop. With the **ÜberNURBS/Edit Cage** tool, drag the CVs along the back edge out to the edge of the ear in the template image (see Figure 3.23, C). In the Front view, drag the CVs out toward the outside of the ear, but stop slightly short of the edge (see Figure 3.23, D). This loop forms the underside of the ear shell.

Now you can give the ear some thickness. In the Left view, pick the **Extrude Loop** tool, and click the ear shell's loop center. The extruded loop will pop out away from the head. With the **ÜberNURBS/Edit Cage** tool, select the loop center in any view where it is visible. In the Front view, drag in toward the head until the back edge more or less lines up with the outside of the ear in the template image. Start dragging individual CVs to line up with the ear template image. Shape the CVs around the front of the loop so that they blend in to the head and cheek bones (see Figure 3.24 on page 93).

In Figure 3.25 A and B, you begin to create the structure of the outside of the ear. Can you guess the next step? That's right! **Inset** the loop. **Scale**, **shape**, and **tweak** the CVs so that the top and back of the loop follow the outer edge of the ridge where the ear forms a slight cup.

**Inset** the outer loop; then **Inset** the new loop. Switch back to the **ÜberNURBS/Edit Cage** tool, and **scale** and **shape**. Push the CVs along the top and upper sides, up and under the preceding loop into the ear. Shape the lower part of the loop around the ear canal (see Figure 3.25, C).

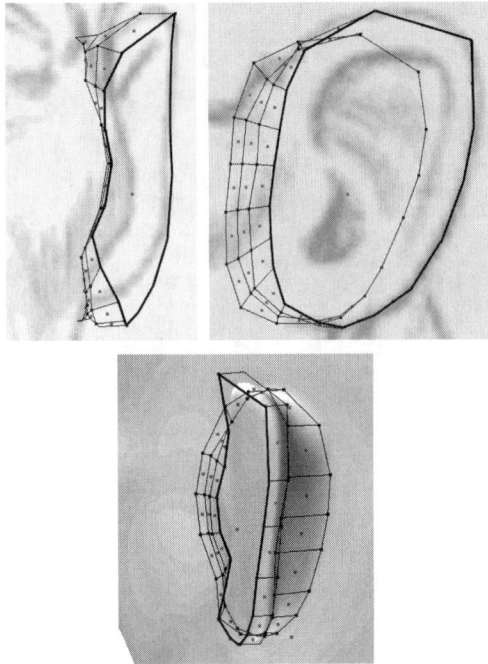

**FIGURE 3.24**   Giving the ear thickness.

### Finishing the Inside of the Ear

The inside of the ear can be finished with a few steps that you should be familiar with by now:

1. **Inset** the loop (see Figure 3.26, A).
2. **Scale** and **shape** the loop. **Add edges** to split the loop into top and bottom sections (see Figure 3.26, B).
3. **Inset** the top loop, and **delete** the edges in the bottom loop to prepare for the ear canal (see Figure 3.26, C).
4. **Add edges** to divide up the top loop, and **inset** the bottom loop (see Figure 3.26, D).
5. **Inset** the bottom loop once more, and push it inside the head with the ÜberNURBS/Edit Cage tool (see Figure 3.27).
6. Divide up the inside ear canal loop with the **Add Edge** tool (see Figure 3.27 on page 94).

When you are satisfied with the shape of your ear, double-click outside the model to preview your progress and see whether you need to go back to add more detail.

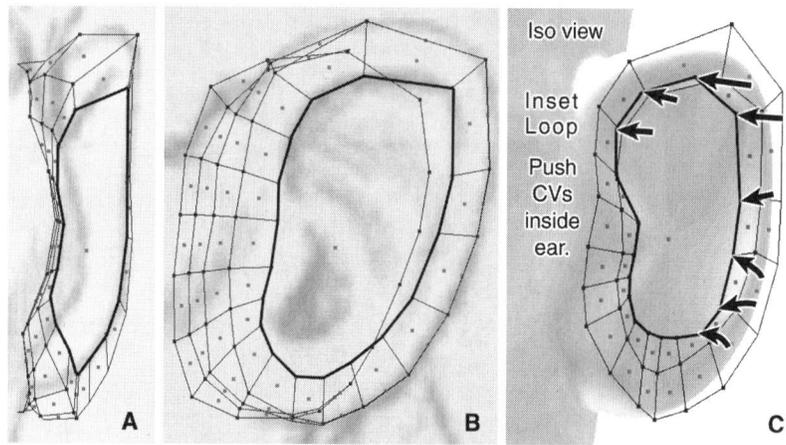

**FIGURE 3.25**    Beginning to shape the outer ear, and refining the shell.

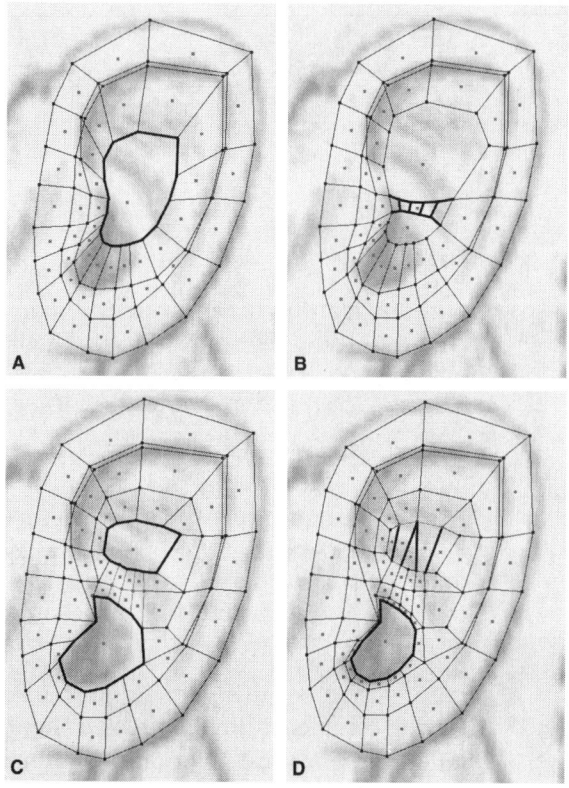

**FIGURE 3.26**    Adding detail to the inside of the ear.

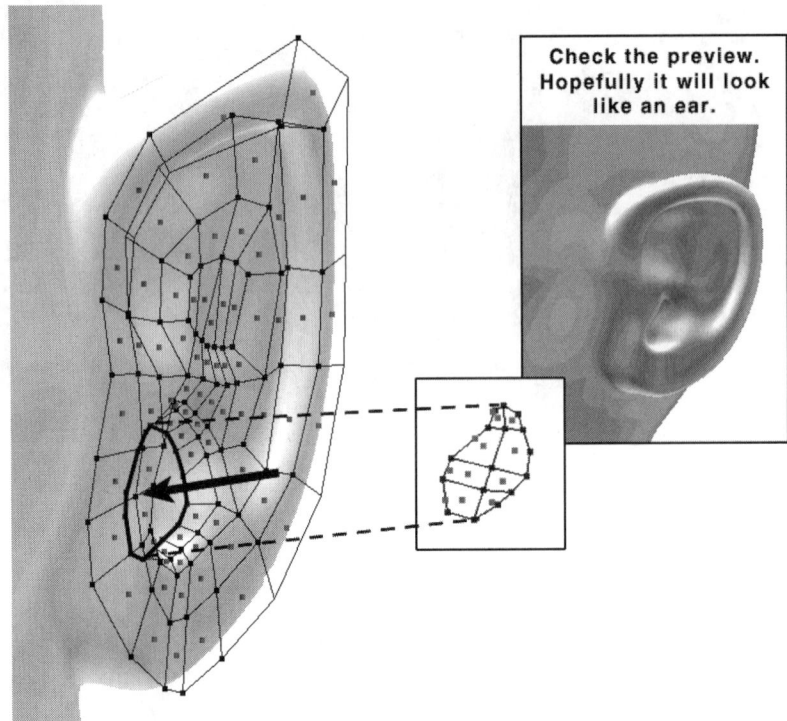

**FIGURE 3.27**   Pushing the loop in to form the ear canal.

### The Neck

With the features of the head finished, you need to give this guy a neck. **Delete** the edges from just under the jaw line to the base of the back of the skull (see Figure 3.28, A). Use the **Extrude Loop** tool to start the first section of the neck. **Scale** and **shape** the loop, using the template image as a guide (see Figure 3.28, B). **Repeat** the process four times to finish the neck (see Figure 3.28, C).

It is certainly acceptable to keep the edge configuration as it is for the neck, but later on you may want to suggest the muscles of the neck. Figure 3.28, D offers a suggestion of what you might try.

### Finishing the Head

Having completed the features on the right half of the head, it is time to reflect those features over on the left half.

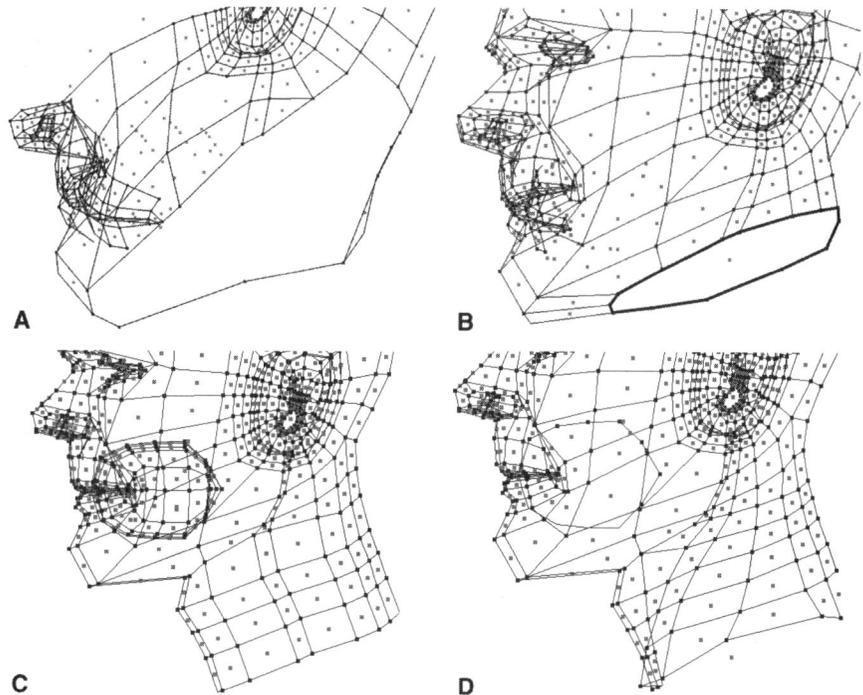

**FIGURE 3.28**   Extruding the neck.

### Preparing the Model

The first step in preparing the model for the Reflect operation is to add an **edge** to the bottom of the neck. The Join Loops tool you will be using shortly needs to have a continuous center loop to get good results. With the Add Edge tool, connect the bottom center CV at the front of the neck to the bottom center CV at the back of the neck. Use the **Iso window** to get a better view, if you need to (see Figure 3.29, A on the next page). The next step is to check that all CVs along the centerline of the model are lined up on the center grid line. Pick the **ÜberNURBS/Edit Cage** tool, go to the Snapping tab, and click **Snap Grid**. Starting at the top in the Front view, zoom in very close, and check that all CVs are lined up on the center grid line (see Figure 3.29, B). If the front template image's visibility is on, turn it off. If you have to adjust any of the CVs, Snap Grid makes the task easier by pulling the CV to the grid line like a magnet. When you are done in the front, Ctrl-click and hold in the **Front view** window. From the **Orientation** submenu, select **Back View**. Check all the CVs along the center line from the back view to make sure that you got them all.

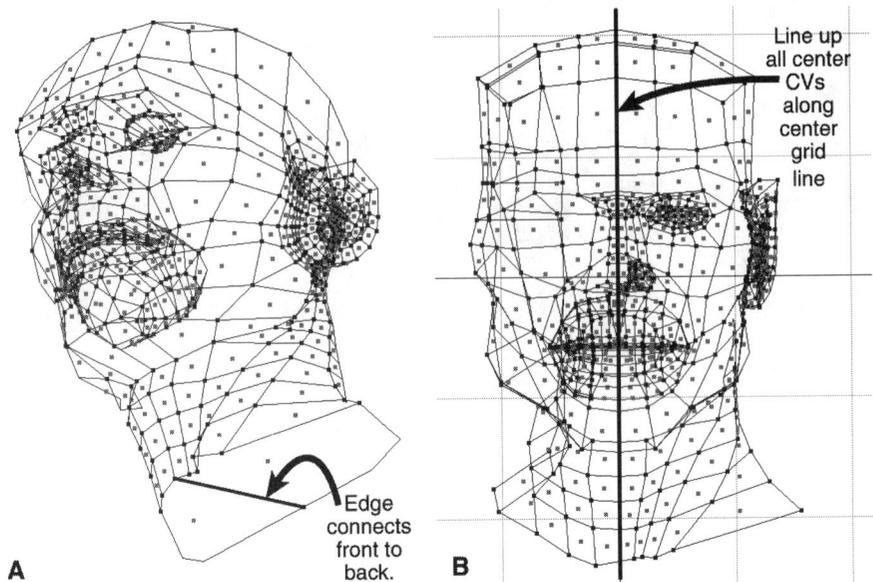

Line up
all center
CVs
along
center
grid
line

Edge
connects
front to
back.

A                    B

**FIGURE 3.29**    Preparing to mirror the right half.

While still in the ÜberNURBS/Edit Cage tool, draw a box around the left half of the model to **select** those CVs, but *do not include the center CVs in the selection*. While the left half is selected, pick the **Delete Vertex** tool and click any of the selected CVs to delete them all. There should now be only half a head left.

### Reflecting the Model

Double-click in empty space to exit the ÜberNURBS tool. From the Transform tab, pick the **Reflect** tool. The status bar at the bottom will prompt you on how to use the tool. With the Reflect tool, click the half-head model to select it, and then draw a vertical line just to the left of the center grid line. A mirror image copy of the half head will appear (see Figure 3.30, A). Depending on where the mirrored half is, you may need to pick the Move tool from the Transform tab to shift it a bit to the left. You will need to see both loop centers for the next step.

### Joining the Halves

Pick the **ÜberNURBS/Edit Cage** tool, and click the right half head to activate the cage. Holding down the **M** and **R** keys, click the left-half head to merge the selections. In the ÜberNURBS tab, pick the **Join Loops** tool. Follow the prompts at the bottom of your screen as you click the

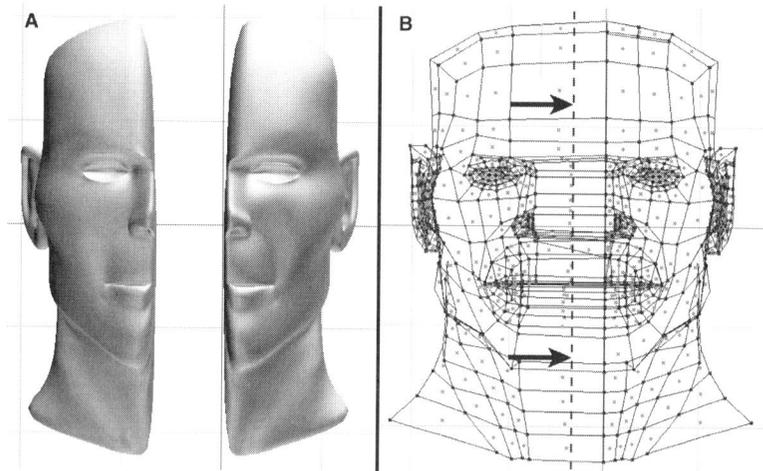

**FIGURE 3.30**   Mirroring the halves, and dragging the left half into position.

inside loop center on the right half, the inside loop center on the left half, an edge on the right half, and a corresponding edge on the left half. The two halves will be joined. **Delete** the leftover half-head by picking it in the Layer View window.

Switch back to the **ÜberNURBS/Edit** Cage tool. Draw a box around the left half, not including the centerline, to select all the CVs in the left half. Drag your mouse to the right, out in null space, to pull the selected CVs in toward the center. Make sure that the CVs and edges on the left side are the same distance from the center as the corresponding CVs and edges on the right (see Figure 3.30, B).

Add some **spheres** for eyes from the Solid Primitives tab and a macho haircut, and he is ready for texturing (see Figure 3.31), which we will leave to your efforts. For more information on texture mapping, including UV mapping, see Chapter 11, "Material Editor."

The final project file can be found on the CD-ROM.

**ON THE CD**

**FIGURE 3.31**   The finished head.

# EIU ANIMATOR

In the pursuit of your animation goals, you will likely spend most of your time in Animator. This is the application where all of the elements come together—models, texture maps, audio, motion data—and where these various parts are choreographed into an animation. This does not just happen, of course. It takes the skill and patience of a good animator/director to produce the final product. Your goal then, is to make Animator's tools work for you the way a dedicated painter makes his brushes sing. As with all art, this takes time.

In animation, details of content and timing often count for more than in film. Chuck Jones once said that an animation's success can often hinge on a single frame. And while details are important, the often-heard advice to spend 90 percent of your time working on the most important 10 percent of the project is also true.

Determining your artistic goals helps to keep this balancing act from toppling over. Occasionally, stop to ask yourself—if only for a moment—what is it you want to do with this medium, and what are you trying to achieve? Whatever the answers may be, Animator offers the tools that allow it happen.

Part II of this book is by far the largest, and covers the widest range of topics. In it, you will find in-depth coverage and tutorials on every major function in Animator, Camera, and Renderama.

# ANIMATOR'S INTERFACE

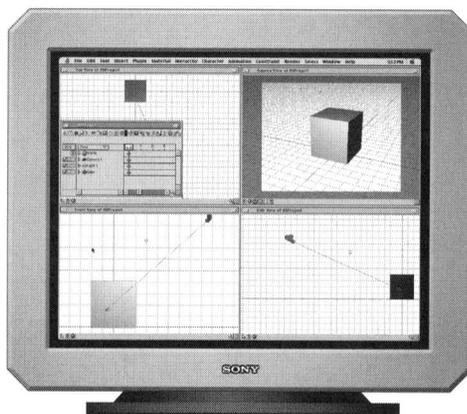

The release of Universe has brought many enhancements and features. Its interface is more powerful and streamlined with a variety of new controls. The following is a short list that gives you an overview of the new items in the program:

- A new screen-drawing system featuring full OpenGL (OGL) support
- Raytracing for transparency, reflections, refraction, occlusions, and shadows
- A reorganized drop-down menu structure
- New Bones and Inverse Kinematics systems
- A new geometry Skinning system
- New 3D Paint-On Weight Maps
- A new Constraints system
- Motion Blur previews
- A new Global Illumination system
- New Icons and ToolTips throughout

## INTERFACE TOOLSETS

The entire interface has been given a facelift, and items are now placed in a more logical order. The old Object floating palette has been removed in Universe, and the icons throughout have been updated to be more functional and visually appealing (see Figure 4.1). Almost everything you roll your cursor over has a **ToolTips** pop-up label letting you know what it is. This is great for new users and even for getting veterans up to speed with the new tools and icons. When you learn them all, they can be turned off in the Preferences menu's **Viewer** tab.

### The New Menus

There are now 13 drop-down menus (not counting HELP) across the top, with titles that make finding what you need very easy. With few exceptions, you will find the order of the menus tends to work from left to right in tandem with how an animation project might progress. For ex-

**FIGURE 4.1**   The new floating toolbar with updated icons and tools.

ample, the file management and import/export categories are on the far left. These are certainly the tools you need when beginning a project. PLUG-IN, MATERIAL, and HIERARCHY controls that help build the scene are in the middle of the screen, and the more advanced Character setup tools follow. After this come the ANIMATION and CONSTRAIN menus and, finally, the RENDER controls, which are logically to the far right. The only menu item that seems oddly placed is the SELECT menu, which might live better between TOOLS and OBJECTS. The WINDOWS menu is at the end, which is a traditional location for a WINDOW menu. This expanded menu layout promotes a more logical workflow, and can be seen in the "Animator Menus.jpg" file on the CD-ROM.

**ON THE CD**

### Monitor Setup

With all these windows and effect interfaces, don't expect to be running this on your old 14-inch monitor! The minimum screen real estate you want to work with tends to be $1024 \times 768$, and this is best done on a 17-inch or larger monitor. Smaller screens have also had problems with the numerous menu items running off the right side of the screen. You can see a standard screen setup in Figure 4.2.

Unlike some other applications, Animator is very well suited to working with dual monitors. There are generally two schools of thought

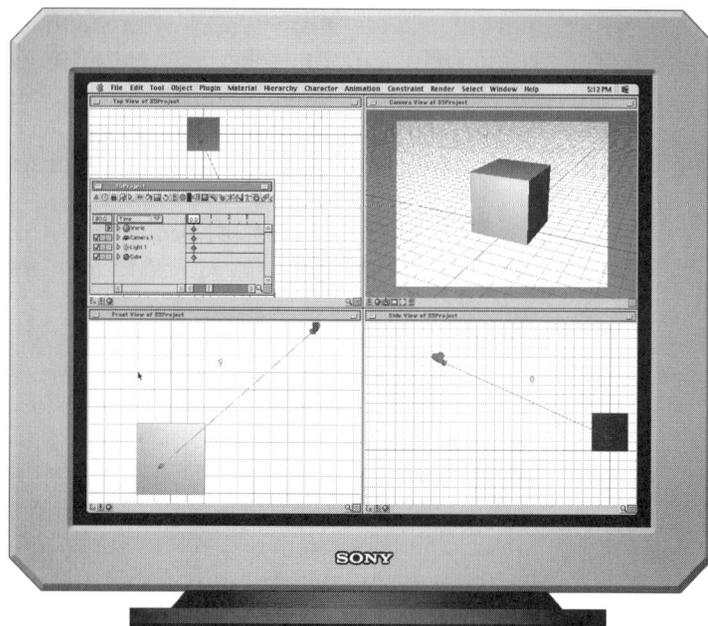

**FIGURE 4.2**    A standard configuration on a single monitor set to $1024 \times 768$ pixels.

on how to set this up, which apply to Animator, Modeler, After Effects, and other similar programs.

**Method one** is to keep your four main windows (Top, Front, Side, and Camera) on your main screen. Then set up your Project/Timeline window on the second screen, using its full width. This can be set to use the full screen for complex animations or to share it with a variety of other palettes and interfaces.

**Method two** is to move your Camera View window to the main screen and keep the other views and palettes on your secondary screen. When real-time playback cards were introduced for nonlinear editing, this setup became popular because you could put a full-size NTSC window on your playback monitor. Although this setup can be useful to you, a 3D artist's needs can differ from those of a video editor. Four windows generating 3D imagery need a lot of graphics horsepower, and few people can afford to have two workstation-class video cards. That said, this can be a very productive arrangement with the right hardware installed.

## Organized Screens Mean Fast Work

An important factor in how you ultimately arrange your screen real estate is which method helps you keep it better organized. If your layout is confused and you cannot figure out what is going on in that 3D world of yours, mistakes will be made and time will be lost. The manager of a large animation studio shared a trick with me that he used with new employees to see whether they had the "chops" to work in his shop. He would take a stroll by their office a few times across the day and examine the screen. Workers with screens poorly organized for the specific work being done produced a lower level of product consistently.

*If you find your screen all messed up from having moved and resized your windows past the point of recognition, go to the WINDOW drop-down menu and select Reset Windows.*

If you are new to 3D, let me explain why keeping track of things is so much harder compared with other disciplines. Just as we live in the real 3D world, our creations in Electric Image Universe (EIU) live in a fully 3D world. Someday, when our technology takes a few more leaps, we will be able to take great advantage of this similarity. However, right now, communication between these two 3D worlds must go through a very 2D interface—your monitor! 2D monitors are already the weak link in the system, so you can see why keeping them organized is so important.

## POWER USER INTERFACE NOTES

The following sections cover the general interface. When you learn most of this, you will find that everything moves along with far less effort.

### Keyboard Shortcuts

No self-respecting power user could live without using many keyboard shortcuts to pop windows open and closed, chomping through work and impressing all who come within screen view. You will find keyboard commands scattered through the book, and a full and up-to-date list is included in the appendix of this book. Learn it, live it, and use it. Tattoo these commands on the palm of your hand, and replace them as your mantra . . . or not.

### World and Camera View Navigation

Finding your way around in 3D is harder than in any other environment, except maybe the New Jersey Turnpike. This is why 3D traditionally uses the three elevation views and the perspective (camera) angle. It was already stressed that you should keep all pertinent windows focused on the models and work you are doing, but updating your views is a pain until window navigation becomes second nature to you. There really are not that many commands you need to learn, and using them will save you scads of time.

### World View Navigation

When you want to move around a World view (Top, Front, and Side), please don't tell me that you go to the floating **Tools** palette and select the **Drag** tool "Hand", because this is a major waste of time. Simply hold down your **spacebar** with your thumb, and let go when done. Much faster! You can make ten start/stop moves this way in the time it takes to go to the Toolbar once.

*The spacebar key used to activate the Hand or Drag tool was borrowed directly from Photoshop, so you can use it there also.*

The floating toolbar's **Zoom** tool is another bad one. These tools are there so that on Thanksgiving you can teach your parents to use Universe, instead of watching the parade for the millionth time. They are not

there for you—the professional!—to use. The exception is if you have a disability that prevents your using your non–mouse operating hand. Holding a very strong cup of coffee in your free hand also gets you a temporary pass.

*These things are partly said in jest, and only from the power user's mentality. Navigation icons are great to fall back on, but your productivity and free flow of creative ideas will benefit from your reduced dependence on these tools.*

When you want to zoom in and out, Animator has given you much better tools. At the corner of every World view window is a Zoom magnifier tool:

- **Click it**: Zoom out.
- **Click+Shift:** Zoom in.
- **Click+Option:** Fit window to scene. This is a great timesaver when you are lost because it is often easier to do this and then zoom into where you need to be.
- **Click/hold+drag Left/Right:** This gives you a smooth zoom in and out. Super fast and functional and a lot of fun to play with while waiting for renders.
- **Click+Option+drag marquee:** Used to zoom into a specific area on the screen by marqueeing the selected area.

The **Window Resizing** control is at the lower-right corner and lets you drag to resize. The **Resize** button is on the upper-right corner of every window and pops the window to full screen and then back again. Both of these are very useful (see Figure 4.3).

**FIGURE 4.3** A screen grab of the Front World view window.

The **Axis view** control is the small icon at the window's lower-left corner that displays two axes to inform you which view it is currently set for. If you click it, you can quickly change views to a different projection. Even faster, if the window is active, you can simply press the **1**, **2**, or **3** **keys** to change the axis.

*Here is the payoff when using the 1,2, or 3 keys: Close two of the World views leaving only one World view and the Camera window open. This cuts down on your computer's update energies and enables you to get faster screen draws on the windows left open. Just select the view you need as you need it, with a quick press of a number key. In many working situations this is wonderful, and in some, having all windows open is preferred. Your call.*

The tiny filmstrip icon is the **Animation Preview.** The ability to see your models animate from each of the World views is a great diagnostic tool. Click to play, **Control-click** to set preferences, and **Option-click** for motion blur settings and preview.

**Shading Preview** (the Blue Ball) settings allow you to choose the quality of the preview level from lower quality (but faster!) levels such as Wireframe, to Gouraud or Phong. See the Universe 3.0 manual, page 9, for a full description of the preview levels. This control also lets you turn the hardware OpenGL engine on or off (see the "OpenGL Hardware Previews" section) and cull backfaces, which is actually telling the computer not to preview to screen any polygons whose normals are facing away from your viewing direction. This can speed previews and can also help correct reverse shading problems with the previews of some models. **Cull backfaces** is only a preview option and does not affect final renders in any way. This command also exists in every model's Info Shading tab, as well where it does affect rendering. However, renders from the **Camera** application are generally devoid of any problems that this might fix, so it is hardly ever an issue.

### Camera View Navigation

The Camera view window operates differently than the World views and behaves like a camera, as might be expected (see Figure 4.4 on the next page).

First, let's quickly go over the four extra control icons at the bottom of the Camera view window:

- **Snapshot**: For quick renders. See more information in the "Previews and Test Renders" section.

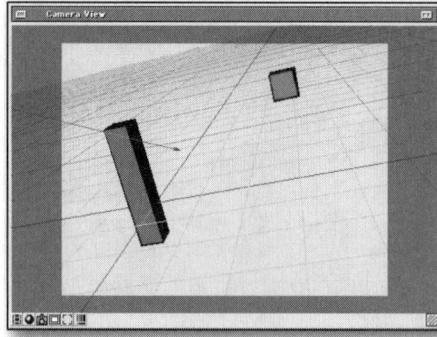

**FIGURE 4.4**    A screen grab of the Camera view.

- **Field Chart**: Paints various guiding lines on the screen for alignment use and for broadcast action and title safety. Click for on and off; Control-click for settings.
- **Rotoscope**: Turns on a preview of images placed in the camera's Roto/Comp tab.
- **Camera Control:** Changes your cursor to their function, when the drop-down icons are clicked, until you reset it by clicking back. They work only on the Camera view window. They are also very slow because you always have to jump between them quickly—so don't use them! Use their keyboard shortcuts instead. The following key commands are to be cast to memory; they are that important. No brushing your teeth until you know them, okay?

*An easy way to remember these keyboard shortcuts is that they all work off the spacebar. Remember that, and you have only one more thing to learn for each control. Not too bad!*

- **Spacebar = Camera Tracking**: Moves the camera and reference point in tandem.
- **Spacebar+Command = Orbit:** Rotates the camera around its reference point.
- **Spacebar+Option = Pan:** Rotates the view by moving the camera's reference while the camera stays stationary.
- **Spacebar+Control = Dolly:** Moves the camera body farther out or closer in along its reference line. Technically, this is a dolly-in or dolly-out move.

- **Spacebar+Shift = Zoom:** Changes the angle of view, like using a wide-angle to telephoto zoom lens on a camera.
- **O = Orbit**: Mimics the feature in Modeler.

Learning these navigation controls is really important and will change the way you work. If you promise me that you will, I will let you go brush your teeth now. (Gargle while you are at it, okay?)

There is one more control, which you will never find if we don't cover it here, unless you read about it in the manual. (But, hey, nobody reads manuals, right? That is why you bought this book.) While holding the **Control key** down **click the Camera view window's title bar**. You will see a hidden pop-up menu listing all the project's cameras and spotlights. Selecting an item changes the Camera view window to display the scene from the viewpoint of that item. This is how you select which camera is the active rendering camera. Remember this because you will be using it later.

*In upcoming versions this is likely to be replaced with a control at the bottom of the Camera window.*

## Model Navigation

It is nice that you now know how to move around in the different windows with ease. The next thing you must learn is how to move your models, lights, and cameras around in their space. Universe Animator has added a variety of industry-standard controls to help you accomplish this much more easily than before.

Animator now has **Manipulators** (referred to as *controllers*, *widgets*, *gnomes*, or *those things*), which you can see in Figure 4.5. Manipulators help you control how items are moved, by constraining their motions. When an object is selected in a window, it becomes highlighted and displays a Manipulator in its center. The Manipulator's axis controls are color-coded so that R, G, B = X, Y, and Z, respectively. The system defaults to the Translate Manipulator.

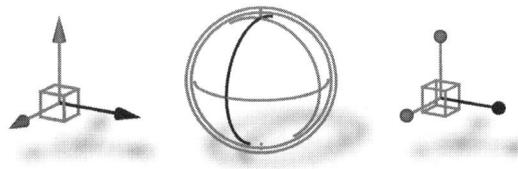

**FIGURE 4.5**  Shows the Manipulators for Translate, Rotate, and Resize (left to right).

- **Translate (T)**: This is the overly confusing word that really means *move*. Click-dragging any of the arrows constrains the object's movement to the axis that arrow represents. Clicking in any other location allows free movement.
- **Rotate (R):** Selecting a rotation control "wheel" limits any rotation to that axis. Selecting between wheels allows free rotation.
- **Scale (S)**: Selection of an axis control handle allows scaling of a specific axis. Any other click-drag location results in a proportional scaling of the model.

All three of these options are available in the TOOL menu, with axis-specific options for Transform and Rotate. This eliminates your need to grab the correct handle on screen, which can be harder in complex scenes.

*You can quickly make axis-restricted rotations, regardless of whether you are currently in the Translate, Scale, or Rotation mode, by holding the following modifier keys and clicking any object icon in the World View or Camera View windows. Just make sure to click outside any controller's center frame or handles.*

- **Control+Option** = X-axis rotation
- **Control+Command** = Y-axis rotation
- **Control+Command+Option** = Z-axis rotation

## Display Edit

All the new screen elements, including the manipulators, lights, and cameras, are drawn using OpenGL (OGL) and are adjustable in the Display Edit window, which is under the EDIT drop-down menu listing. Here you can tailor these items for personal taste. You can also make items such as manipulators or lights smaller to get them out of your way or larger to allow easier access.

## Non-modal Dialog Windows

Animator's *non-modal* windows sometimes confuse new users. In most desktop programs, you open a dialog, make your adjustments, and then select an exit key to finish and go back to normal editing mode. These dialogs are called *modal* because they put you in a different work mode when active. Animator has very few of these and instead uses non-modal control interfaces whose settings take effect as soon as you input a value.

There is no need to finish the operation with an OK button, and you are never restricted from going to other parts of the program, even though these windows remain open. Whether they stay open or closed is up to you and is more an issue of screen real estate than anything else. This creates a much more interactive workflow experience.

*When you input a value into non-modal windows, there is actually a one- to two-second delay, which can be annoying when you want to work fast and see your results. Pressing Enter or Return after an edit updates your scene immediately and streamlines production.*

### Setting Global Object Edits

While we are on the subject of different editing windows, here is an almost hidden feature of Animator for selective global editing.

Often, you edit a setting of some sort and wish that there was a way to apply it quickly to many other objects in the scene as well. Well, there is, at least for the toggle boxes and a good many drop-down menus in the non-modal windows. Here is how it works:

1. Make your edit.
2. Press the Control key (Mac).
3. Click the toggle or drop-down you edited in Step 1.
4. A pop-up menu appears with eight main options (see Figure 4.6).

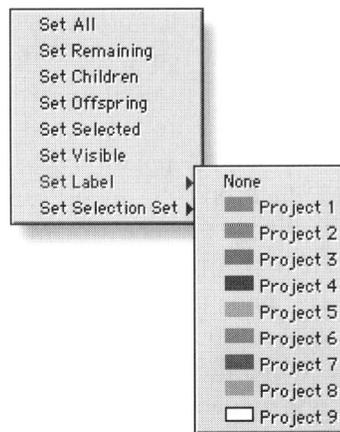

**FIGURE 4.6**   The global edit pop-up menu.

This feature can be used with most or all toggle and drop-downs in the Material, Joint, and Info (model, light, bone, IK handle, and so on) windows.

## PREVIEWS AND TEST RENDERS

Many users are confused regarding previews. It is easy to get confused because there are so many types of previews to choose from that people are not sure what is what.

You can choose from still **Snapshots** or animated previews. Generally speaking, the animated previews are low-quality visual roughs, whereas the still preview Snapshots can be set to generate any level of quality up to and including finished render quality.

The first level of preview quality is what you see on your screen. The specific level of quality can be set using the Blue Ball, as already discussed.

The **Preview** button in every window is intended to be an animation preview. When clicked, it either immediately previews the animation to the **screen** or saves the animation to disk by first asking you to name it. If previewed to screen, it changes the window to preview mode, offering greater feedback with a frames-per-second playback read-out, time code, a frame counter, and VTR style controls. Most important, it provides a **scrub** slider to allow dragging back and forth to examine your animation (see Figure 4.7).

The **Preview Settings** dialog allows you to choose a feature called **Drop Frames**. The idea of this used to be to allow frames to be dropped while playing back on slower computers, so that you could get a feeling for the motion. Today, computers are so powerful that you can actually use this feature turn-off to slow down playback! Many scenes now play back at 50 or more FPS, which is impressive but does not provide you with the 30 FPS motion feedback desired. Disabling Drop Frames locks this to the **FPS** of the project's settings (set in the **Render Settings Timing** tab or the **Project** window).

Preview Settings is also where you choose to output to the screen or file. The animation file can be saved to multiframe IMAGE or QuickTime and is useful for sending to others, for analyzing, and for bringing into your compositing program to begin roughing a project together. This feature was used more often when computers were slower and could not attain the reasonable playback speeds they are better able to give us today. The settings interface also allows you to choose the shading level you

**FIGURE 4.7**   The Camera View window in animation Preview mode. Note the additional controls and read-outs that are added. World View windows gain similar controls when in Preview mode.

want a preview displayed in. However, remember that this Preview feature is completely generated within Animator, using either hardware or software rendering (set using the Blue Ball) and never goes out to the Camera rendering engine for higher quality.

*If you ever press the Preview button expecting an animated playback and just see a static image, either you have not animated anything yet (duh!), or the **Render Setting's Timing** tab has the **Render** option set to **Current Frame**. Just change this to **All**, or select the range you prefer.*

The **Snapshot** command in the camera window is a well-designed tool that allows you to generate quality renderings quickly without needing to trot over to the Render Settings window. This control actually sends out to the Camera rendering engine to do the work and can return to you a full-quality final render, if the Render Settings are appropriate and you choose the **Full Size** option. Invoking Snapshot does not quit the Animator application the way a full render tends to do, and with the price of computer memory, there is little need to do this today for a still

rendering. Frankly, I hardly ever go to the render window anymore for generating stills because Snapshots are easier and faster, and when the render is complete, Animator automatically opens the final image for inspection. The only thing procedurally faster is the **Render Project . . .** menu option because it directly saves the file to disk. However, this also induces Animator to quit before rendering.

The real timesaver with Snapshot is to use it during the testing stage. Rendering at the camera window's **Window Size**—full-frame or precropped selections of the image—is very fast. These options make doing dozens of test renders a snap. Because this takes its rendering settings from the Render Settings window, you can go in and speed up things significantly by turning off whatever is slow and may not need to be on for testing (Bump/Displacement, Transparency, Reflections, Anti-Aliasing, and so on). Just make sure to turn them back on when ready for your final renderings.

*Anti-aliasing is one of the largest drains on rendering power and can very often be kept off during much of the testing stages to speed up test renders significantly. Turn it off to do your hundreds of test renders and then back on when you start getting close to your goal. Most imagery works well with this technique, but some can be dramatically altered by turning off anti-aliasing, so sporadic tests with it on are a good idea.*

Other programs have a variety of real-time or interactive feedback previews, and they are very nice. However, Electric Image is still, after all these years, the fastest rendering system on the market. Guess what, so is its previewing system. Most scenes rendered with a window-size snapshot and anti-aliasing turned off pop open in just a few seconds. In fact, unless you are getting close to final tests, you should consider turning off any elements that do not directly influence the elements of your test preview. This way, all your testing stays quick and responsive until you near the end.

## OPENGL HARDWARE PREVIEWS

Both Modeler and Animator use OGL for previewing. It is the only choice in Modeler, but Animator also lets you revert to its older software mode if needed. OpenGL is a wonderful technology developed by the pioneers at Silicon Graphics and adopted as the industry's standard for professional 3D graphics previews, as well as game interfacing. Most modern

video cards offer at least some degree of OGL acceleration today, but as a professional, you are likely to want one that offers more powerful screen drawing than the average consumer card. That said, many of the newer video cards originally designed for high-end gaming are being pressed into professional use as well, with great results at lower prices. If you are running a fast OpenGL accelerated card, turning on the hardware engine (under every Blue Ball controller and altered globally in the **Preferences**) can give you a substantial speed boost in screen rendering and work flow.

Because OGL is an evolving technology, it is not perfect, and every card has the capability to (mis)interpret the scene information differently. Sometimes a card's interpretation results in previewing that is not satisfactory, and reverting to the software engine may be preferred because it delivers a preview that is closer to the final render you will get. This is one argument for buying those more expensive professional video cards; they are said to provide more accurate results for the CAD/ CAM/3D pro. This is probably true, but it will cost you. Understand that for all the time and money spent on OGL, it only affects **previews** while working inside the applications (both Animator and Modeler). OGL has no effect on your final renders, which are handled by the proprietary Camera application, producing a much higher-quality render at a much slower speed. (For more information on optimizing final render speeds, see Chapter 13, "Rendering.")

Throughout the history of 3D development, high-end OGL cards have been available only for Windows NT/2K and workstations. This is changing with the adoption of OS X, and a number of new 3D developers for the Mac. Mac 3D artists currently have access to the high-end consumer cards discussed before. Fortunately, Electric Image is very well optimized and performs well with these cards under OS 9 and even better under OS X.

The other alternative is to run Electric Image under Windows 2K or XP, which, of course, opens the door to all varieties of available 3D hardware. The developers have done an excellent job of retaining the same look and feel of Universe between both platforms, and most third-party developers have cast their support by porting their products.

# THE PROJECT WINDOW

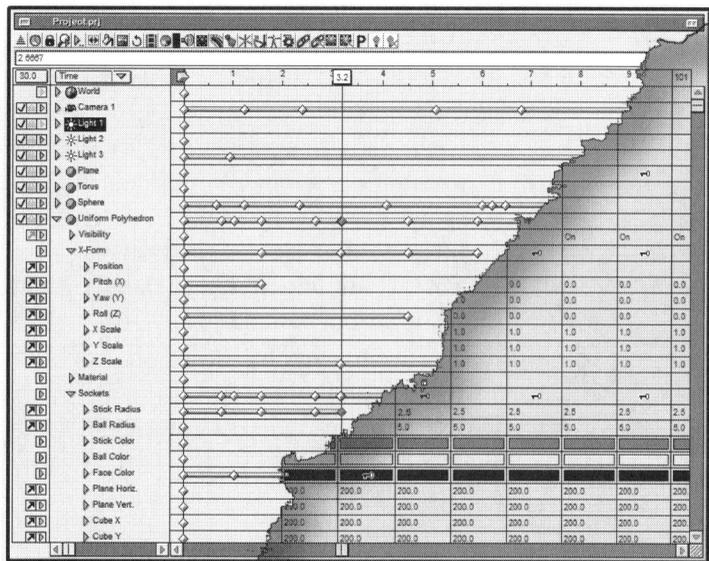

Along with the World and Camera views, the Project window is usually the most used interface. It is a powerful window that opens the door to the underbelly of the animation channels that make Animator so versatile. You should take the time to scrutinize and learn it well. The Project window is laid out as a timeline, and its general style is often referred to as a *dope sheet* in the industry (see Figure 5.1).

Although other programs have a similar interface, many users of these programs tend to use a simpler timeline palette in conjunction with other palettes, such as a curve editor, to produce the animation. Similarly, Animator offers the Time palette (Cmd-hyphen), which is a basic strip palette where you drag to set the time you want to be in. One can make a number of good arguments for the Time palette–style of animation. First, it is simpler and easier for the mind to deal with. It also lends itself to being a freer and more interactive creative process at times.

A good experiment would be to create an animation using the most basic interface and see how it affects the decisions you make. Having just the Camera window and the Time palette open, see what you create using navigation commands! Figure 5.2 shows this alternative work setup. You may love working this way, and that is fine, but you will quickly run into limitations.

Most long-time Electric Image users tend to prefer using the Project window because it is an interface we are accustomed to and because of all the extra control it offers under the hood. With it open large on a screen,

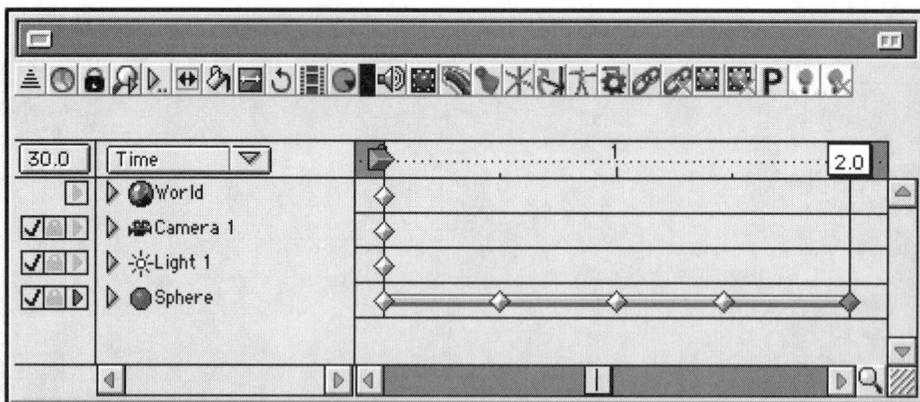

**FIGURE 5.1**   The Project window, with a single model named Sphere that has five diamond-shape keyframes.

**FIGURE 5.2**   A basic working interface, with just the Time palette and Camera window.

you can see at a glance what is going on with every object, model, light, and camera across the entire animation. You can easily make broad changes to many or all keyframes, or you can go into a single channel of one single model and change its color for just one frame! This is the kind of control that has attracted so many professional animators for so many years.

If you have ever used a video editing program or something like After Effects, the Project window should seem straightforward to you. Every object or element that is added to the animation is listed in this window along the left side. The timeline runs from time zero at the left and progresses chronologically in time as you move farther right—easy enough so far.

*A little-known fact is that the Project window's timeline does not stop at the zero mark. Instead, you can animate into the negative time zones as well. Why would you do this? It is not generally how you would intend to set up an animation, but as an animation expands, elements are often added to the beginning, and this option may be an easier and faster solution. Plug-ins such as Mr. Nitro also require lead-in time to work, so you can set it up at -2 seconds and have the effect occur at the proper time.*

The idea of setting up an animation is that at certain points in time, certain things happen. At these points in time, you add what is called a *keyframe* (KF) to the animation to mark the event. You create keyframes attached to the object involved in the event that is happening. For example, if you have a bouncing ball animation, you add one KF to the ball at the point where it hits the ground and another at the point where it is peaking at the height of the bounce, and so on. Animator displays KFs as small red diamonds along a pale purple time bar (refer to Figure 5.1).

## ENABLING ANIMATION

Without multiple KFs, there can be no animation (although you can arrange static scenes for illustration work). To create a KF for an object, you have to make its animation channels active with the Enable Animation toggle switch, which is the little green triangle to the left of the item entry in the Project window (it is a very light purple before it is activated). The other way is to highlight the object and then select the Enable Animation option at the top of the ANIMATION drop-down menu. Be warned that everyone forgets to do this at some time, only realizing this after going to play back a great animation sequence they *thought* they had set up. The reason for having this is that many items in a scene are never animated (floor, walls, and the like), but the Camera rendering engine needs to poll each item for every frame to see whether it is static or animated. Turning off animation for a static object can save rendering time.

*You can avoid this problem by turning on the Default to Animating When Creating New Objects toggle in the **Preferences > Keyframe** tab—but then you must remember to turn off non-animated items or risk slightly longer render times.*

*This switch can also act like a fast eraser tool if you decide that you don't like the way an individual channel (or entire object) is animating. Just click the green triangle off, click OK at the warning message, click it back on, and start from scratch.*

After the animation is enabled and you move the time thumb to a new time, almost anything you do besides making a sandwich will create a new keyframe automatically. This keeps the animation process moving forward at a nice clip. Now let's get under the hood.

## WHAT IS A CHANNEL?

The concept of channels can be confusing. Because literally everything in Animator is based on information stored in channels, it is important to grab hold of the concept.

If you have a bank account, you can understand what a channel is. Think of what happens when you take your monthly balances and put them into a chart, maybe in Excel or Quicken, or just on a piece of graph paper. However you do it, you have the option of displaying this data in a few ways, the simplest being a ledger.

| MONTH | J | F | M | A | M | J | J | A | S | O | N | D |
|-------|-----|-----|-----|-----|-----|-----|-----|-----|-----|-----|-----|-----|
| $BAL | 500 | 534 | 601 | 234 | 412 | 419 | 556 | 150 | 723 | 892 | 901 | 56 |

**FIGURE 5.3**    The same data presented as a line chart.

This data can also be presented as a basic graph (see Figure 5.3).

Here you have every month and your balance for each. Guess what? That row of balances is the same thing as a **channel** in Animator, a set of variable values recorded over the variable of time. You can think of each month as a keyframe, which, in the Project window, need not be in a uniform interval like the months. Say that instead of your balance, you make that channel the position data for a model that is moving. You get the idea—but it gets better.

What if you say that this balance line is really a total balance of various accounts you have in the bank: a checking, a savings, an IRA, and maybe a portfolio of investments (3D tech stocks, perhaps?). You would then have many channels of data to deal with. Well, the same is true for an object in Animator, which has its top level of KF information and then opens up to all the channels underneath.

Open up the sample project, Channels.prj, in this section's folder on the CD-ROM, or look at Figure 5.4, and you will see a typical model ob-

**ON THE CD**

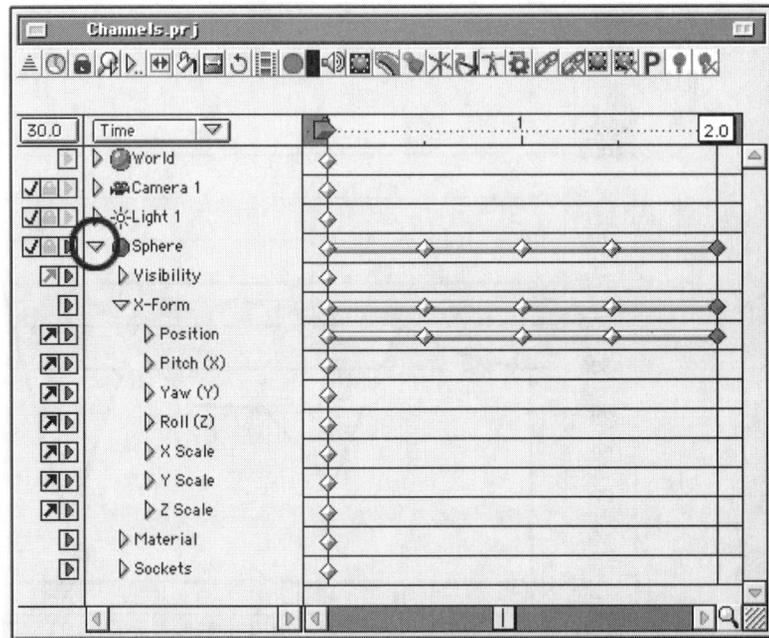

**FIGURE 5.4**    A typical model object displayed in the default Time View, with subchannels opened using the Display Channel icon (circled).

ject displayed in the default **Time view,** with some of its channels displayed by opening its **Display Channel** icon (the disclosure triangle, like you see on Mac desktop folders). The first level down, you will see a few categories, each one of which also opens with a disclosure triangle to show still more channels that represent almost every single control in Animator. Every animatable control in the program (which is most!) has a corresponding channel. Please re-read that two more times, and when you *think* you get it, read it once more for good measure.

As you start to understand the concept of channels and how they work, you may notice that all you see here are keyframe diamonds that represent an action (which you can determine by opening the subchannels to see which one has a KF attached) but you don't have any value information about that action—as though your monthly bank statement told you that a withdrawal was made on a certain date, but neglected to tell you the amount. Thus, you see that this **Time View** mode can be used to change the time of a KF but not its value. To do this, you need to use it in conjunction with either the World and/or Camera windows, or other control interfaces, such as the **Info window** (see Figure 5.5).

There are a number of control interfaces, such as the Deformation, Material, Info, Morph, and other interface windows that are used to edit animation settings. Whereas the Project window can show you *all* the channels in the animation, these other windows take a specialized view, each dealing with only a select group of channels. Also, they are optimized to enable you to make the most use of that data, just as a variety of banking tools might be used to specifically view investments, mortgage, or other financial "channels."

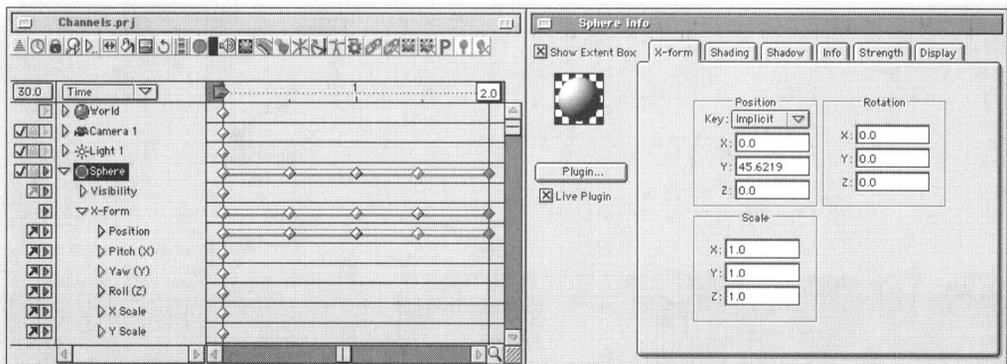

**FIGURE 5.5**   The Project window working in conjunction with the model's Info window.

The Project window is a very powerful multipurpose channel viewer, however, and Animator allows you to change its view mode to three other settings, all of which look much more like the banking spreadsheet example. The other options offer various ways to work, and you can change into them using the **Edit Mode** pop-up, located at the very top of the Channel Name list. These other modes are **Keyframe**, **Frame**, and **Key Index**.

## Keyframe

Keyframe displays a column for every frame in the animation yet behaves like the Time setting in that it shows you which frames are keyframes. If you change a setting in any cell, that cell is converted into a keyframe, which will influence neighboring values. KFs are bold for easy identification (see Figure 5.6).

## Frame

The Frame mode looks the same as Keyframe except that KFs do not exist in this mode and, hence, are not bold. If you modify a frame's value, it affects only that particular frame and does not create a new KF. Instead, it creates what Animator calls a **Custom Frame**, which is displayed with an underline.

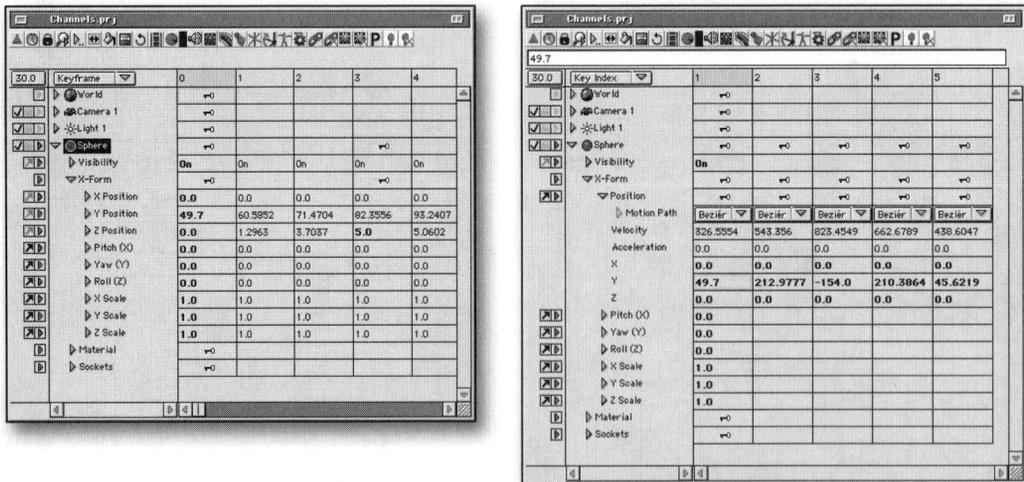

**FIGURE 5.6** Left: The Keyframe display mode in the Project window. Notice the KF icons and boldface frames 1 and 5. Right: The Key Index display view.

### Key Index

The Key Index option displays only the keyframes and ignores what is referred to in traditional animation as the **in-betweeners**. In this view, the numbers across the top do *not* represent frame numbers, as in the other cases. Instead, they represent a keyframe number. Under column 1, you have all the first KFs from every channel, under column 2, you have the second, and so on, regardless of where those KFs reside in time. This is great for going in to make broad keyframe value changes across a channel or two, because it takes up a lot less screen real estate than having every frame displayed. This is really used as an alternative to the Keyframe view for editing existing frames. It does not allow creation of new KFs (see Figure 5.6).

All these views offer easy editing by just clicking to highlight a cell of data, going up to the Value Edit field at the top, putting in a new number, and pressing Return/Enter. In Figure 5.7, see what happens when you put the bank values into the Y-axis position keyframes. You get a line graph! For this to work, you also have to move the model across the X-axis to get it moving left to right. Otherwise, the model would only be moving up and down.

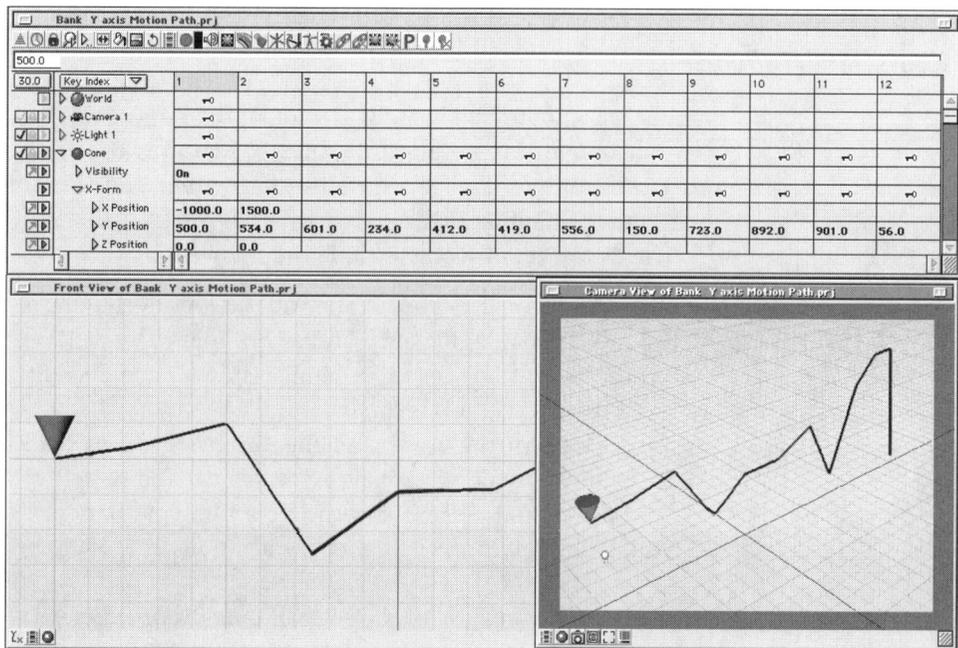

**FIGURE 5.7**   Inserting the sample banking records into the Y Position channel creates a 3D financial presentation.

Here are a few commands to speed you along:

- **Click-drag**: Selects multiple cells of information to edit. You can also Shift-click to select cells across and up and down.
- **Cmd-click a channel:** Quickly highlights an entire channel of data.
- **Spacebar**: Makes active the Tracking "Hand" used to scroll the list vertically.

Here are a few time-shifting commands that work across the entire program:

- **Cmd and left/right arrows**: Changes the time by one frame.
- **Cmd-Shift and left/right arrows:** Changes the time by 1/3 second.
- **Cmd-Ctrl and left/right arrows**: Moves the time to the beginning or end of the animation.

Having this level of access to individual cell data increases your opportunity for data manipulation. It was very popular with Electric Image power-users years ago to copy and paste strips of this data into Excel, do some manipulations, and then pop it back into an animation channel. Luckily for us, the developers of Animator have been slowly adding this calculation capability to the program.

## PROJECT WINDOW TOOLS

Tucked unobtrusively along the top of the Project window is a row of very small icons. Some are duplicates of items on the Tool palette, but others are unique. Figure 5.8 shows the names and locations of these tools, and their submenus.

The Organization Tools include the following:

- **Project View**: Lets you arrange all the top-level items in the list differently, by name, by label, and so on. Hierarchy is the default.
- **Time View:** Changes the time display between Seconds, Timecode, and Frames. Seconds is the default.
- **Project Channel View** and the **Channel Open tool:** These two tools control which channels are displayed and how the subchannels are opened and closed. This can be a time and patience saver when you have a few hundred models with thousands of channels.

*Very important*—*the Channel Open tool contains the **Show/Hide Children** command, which you will use frequently. The keyboard shortcut is **Cmd-H**. When a parent object is selected, this either opens or closes the children objects. This command is also found in the main HIERARCHY menu.*

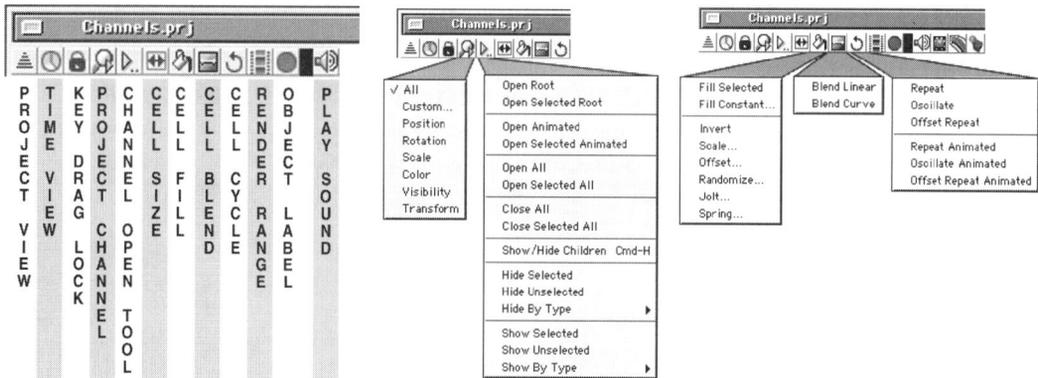

**FIGURE 5.8**    The Project window's organization and data manipulation tools. Left: Overview with tool names. Middle and right: Tool submenus.

- **Cell Size**: This is a tiny item but a real helper. All it does is let you change the width of the cells. This enables you to fit twice as many cells across the width of your screen and saves you tedious scrolling.
- **Object Label**: This adds a color-coded label that allows you to select by label in the Select menu and sort the listing by label using the Project View tool.

Data manipulations include the **Cell Fill**, **Cell Blend**, and **Cell Cycle**. These are great tools that surprisingly few users seem to know about. They comprise a host of effects on your animation channels that make them feel like Photoshop filers for sequences of 3D data. Just a few of the effects include a variety of fills, inverting values, utility scales and offset of data, jolt and springing effects applied to objects, blending and smoothing data, and a variety of step and repeat style options. (Read the Animator 3 manual, Section 11.4, starting on page 297, for a full breakdown of the tools.)

### The Value Modification System

Animator allows you to select a range of data cells and plug in simple mathematical formulas to mass-modify them. To accomplish this you do the following:

1. **Highlight a range of cells**. These can be regular frames or KFs selected in the Key Index mode.

2. **Open the Fill Constant tool**. Plug in the formula you want, and press Return. The data cells update accordingly.

**The formulas are input in this form**: @ *symbol amount*. The @ tells Animator that a formula is about to follow. The symbol is a math symbol you choose, and the *amount* is the value of the operator.

Plugging in @+5 adds 5 to each cell selected, so 25 becomes 30.

The recognized symbols are:

- +       Add
- –       Subtract
- *       Multiply
- /       Divide
- ^       Exponential
- %       Percent
- !       Convert positive numbers to negative, and vice-versa
- #       Return an absolute value (so –5 would return a value of 5)

## MANIPULATING TIME

Now, go back to the default Time view, where you see the diamonds for keyframes. After all the great things we just said about the other views, you might wonder why anyone would use the Time View option. The answer is that it is an easier way to view a project, especially when you are viewing a lot of animation. Getting into the nuts and bolts of a channel is not something you need be doing every second of the day, and most work involves what might be described as a broader choreography of digital events. The Time view allows you to control more easily the overall movements of one model, as well as its interaction with many others. It does this by not bogging you down with all the extra data and by allowing you to drag keyframes freely where you want them.

There are a number of ways to do power-moves on the keyframes:

- **Drag on pale purple bars**: To move an entire path.
- **Drag to highlight:** To highlight a block of KF diamonds at one time, click-drag a marquee around them.
- **Click or Shift-click to select** or **deselect a KF:** To add more KFs to an existing selection or to remove any from the existing selection set.
- **Click anywhere in the timeline:** To deselect all KFs.
- **Click-drag on KF:** To move the selected KF and change its point in time.

- **Option-click-drag on Keyframe:** To duplicate. Great for doing step and repeat or sequence cycling.

    **Also**, when any keyframes are selected, you can go to **ANIMATION > Delete Keyframe**.

*If you use the Delete key to remove a highlighted keyframe, your model may be deleted instead. Keyframes are best removed through the menu command.*

- **Cmd-K**: Adds a keyframe, but does so **to every single channel** of the model selected. This is confusing and can interfere with future animation edits, so it should only be used in simple animations that will not be bothered by this action. For adding a single KF to a single channel, you must go to that channel's editor (the Info window, Material Editor, or wherever else it may reside) and change the value at the time you want a KF added. Then change it back to the original value, and the KF will remain (KFs are added automatically, but not removed that way). Yes, adding a null KF should be easier, but how is Animator supposed to know which channels you want KFs added to? Besides, because most KFs are put in automatically when you produce an action of some sort, this is not that much extra work.

*Some of the techniques mentioned may not support the **Undo** function, so please do a quick save before attempting any nonreversible actions.*

*It is a good idea to get into the habit of using some type of sequential naming so that you can save multiple copies and revisions of a project along the course of production. In this way, you should* never *lose more than a half or full day's work, and preferably much less. I have seen very exotic examples of how people do this, but let's keep it simple with an addition to the file name at the beginning or end. An example is* Widgets R-03.prj, *where the name* Widgets *is followed by an R that signifies the following number as a revision and then the revision number, which has two digits to keep all files in proper order, from revision 1–99. If you go over 99 revisions—and that is not hard on large projects—you can start again at* R-01B, *or whatever suits your taste.*

- **Control-click-drag on the Time Thumb**: To scrub through the animation. Scrubbing is being able to see a preview while dragging at its controller. This works on the Project window, Time palette, and FCE and lowers the need to select the preview control. Adding shift

to the command (Ctrl-Shift-click-drag) limits the scrubbing to just the Camera view, but because the World Views do not get the fluid real-time updating anyway, there is no noticeable advantage.

Next is a time stretch/crunch technique that can save you a lot of hair pulling when your intricate animation runs too long or short. This can be applied to sections of an animation or across the whole thing.

1. This adjustment requires that the time area be highlighted and that all keyframes wanting to be shifted must be selected. To highlight the area of time, go up to the Time Selection area (where the Time Slider is), and highlight the band of time that you want to expand. This is done by a **Cmd-click** and **dragging** across the numbered time area at the top. That area will turn a darker purple and extend down through the data panel area.

2. Now select the KFs you want affected, by dragging a marquee around them. Additional KFs can be added or deselected by Shift-clicking. Most of the KFs should be within the purple highlighted area, but you can have some off to one side, just not both sides (see Figure 5.9).

3. To begin the move, hold down the Control key and click-drag on a KF. It is visually easier to work with the move if you pick a KF that is at either the far-left or far-right side (the far-right KF is used in the figures). The KF you pick automatically becomes your dynamic reference, and the KF that is the farthest on the other side (and is within the highlighted areas) automatically becomes the anchor reference (see Figure 5.13).

4. **Cmd-click** in the Time selection area to deselect the dark purple selection area.

Let me forewarn you that although it does support Undo, it has long had a bug or two that can get wacky at times. However, it is consistent and thus avoidable. You may need to play with it, but you can get what you need. The setup is more complex than it should be, but the process is much simpler than it sounds.

## THE PROJECT WINDOW FLAGS CONTROLS

The three columns along the far left of the project window are called **Flags**. They are Visibility, Lock, and Animation. Some fast ways to control them include:

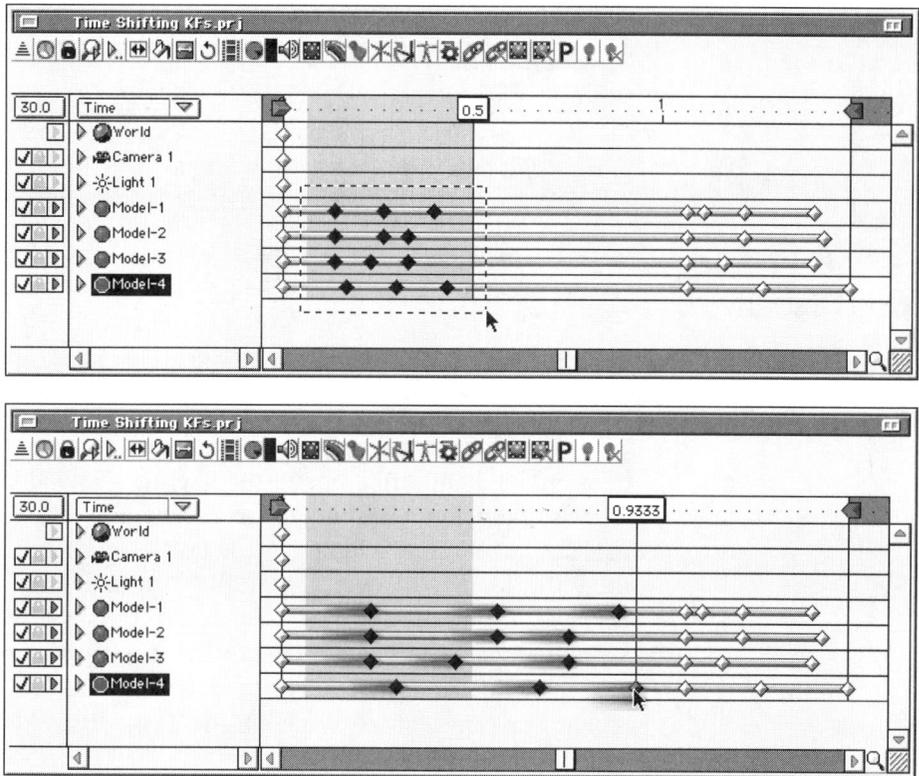

**FIGURE 5.9**    Top: Keyframe Time-Shifting setup, with time and active KFs selected.  Bottom: Hold the Control key and click-drag to enact the move.

- **Option-click**: Quickly enable or disable many items at once. This inverts the selection of the item you click, and then it converts every single item below it on the list to the same setting! This can be very helpful, but not as selective as you may want. If you have a large group of items to turn off, use this command. Then go to the next items beneath the group—which were turned off inadvertently—and turn them back on.
- **Cmd-Option-click:** Click a parent object, and all offspring are switched to match. This is like the preceding command but much more selective.
- **Multiple selection-click:** If you have any number of specific objects selected (you can use the Select menu to quickly select by label or type, and the like), click the flag for one of them, and they will all

change to that same setting. This is a fast way to turn off or lock down a few hundred tree models in a scene, for example.

*The Lock flag locks only the World and Camera views, leaving the Project and other interface modifications open to accidental editing. Keep this in mind when you think that you have locked an object and that it is now immune from your fiddling (or others').*

## OBJECT VISIBILITY

An object's visibility is an interesting thing and is handled different ways in different programs. Animator gives you a few options:

- **Flag**: The check mark visibility flag is a quick-and-dirty way to turn off a model, light, camera, and the like. It is a good idea to turn off models that will not be rendered in a scene, because it speeds rendering. This is also how a light is turned off—remember this when you leave the room! However, this is also a static setting and cannot be changed during the course of animation. Children with the Inherit Visibility toggle checked are referencing this flag's setting.
- **Material Editor settings:** For models, you can also use the Transparency or Clip settings to modify their visibility. This gives you the added creative control of having various levels of opacity. If fully invisible is what you want, though, this option adds to your rendering time because of both the geometry that is not eliminated and the addition of transparency calculations.
- **Visibility channel**: If you set the Project Window mode to any of the spreadsheet-style settings (any but **Time** view) and flip open the Channel View icon, you will notice a channel named **Visibility**. Its cells are filled with the word **On** or **Off**. This refers to the item's visibility, of course, and you can modify this to your heart's content. As you plug in a setting, it auto-fills to the right until the end of the animation or until it hits another keyframe. This setting does not support anything other than fully on or fully off.

## IMPLICIT VERSUS EXPLICIT: WHAT ARE THEY TALKING ABOUT?

A few versions ago, we saw a tiny drop-down menu show up on our information window's Position settings, and we heard a collective gulp

from the user base. As an ex-president might have said, "There you go again!," using words that scare us all off.

The terms *implicit* and *explicit* sound like a reference to some complex trigonometric equation, but they are not. *Implicit* just means *implied*, or *assumed*, and *explicit* just means *specific*. What they are referring to is how you want the program to interpret an object's motion in its XYZ space. Most of the time, you move an item around the scene, and you don't care how it gets to where you put it, just as long as it gets there. Most likely, it has been moved from one set of crazy number coordinates, such as X = 103.6, Y = 232.4, and Z = 15.8, to another equally abstract set of coordinates.

When you make this move, you are actually making *three moves*—one in each axis. Well, I should say that the computer is, so that you don't have to deal with it. Can you imagine having to make three separate operations for every single move? You would never finish your projects.

ON THE CD As you can see in the Implicit-Explictit.prj sample file on the CD-ROM and in Figure 5.10 on the next page, there are two moving Cylinder models; one is set for the default of **Implicit** and the lower copy in the project window was changed to **Explicit**. The **Implicit** system knows that we are lazy and takes care of all the work for us. You can see that when you open the position channels, X, Y, and Z, all share the same non-editable motion path. Even though the way it is displayed in the Project window makes it appear that each axis has its own editable animation channel, this is not the case. If you move any one of them, the others follow suit. They are locked together, and in most cases, this makes your life much easier. The **Explicit** channels, by comparison, can be dealt with individually, allowing for much more control but at the same time shifting some of the automation onto your shoulders. Think of it as having both an automatic and a standard shift car. Automatic is better for stop-and-go city traffic, but you know that you want the added control of the stick on those nice open roads.

When in **Implicit** mode, Animator offers one of my favorite tools, a Beziér control like the one from the Illustrator and Freehand drawing programs. However, these are even more powerful because they are attached to the motion control path in the 3D space. When you use this Beziér, you have the ability to edit all XYZ paths at the same time. Coming from one of the other programs just mentioned, this is an awful lot of fun.

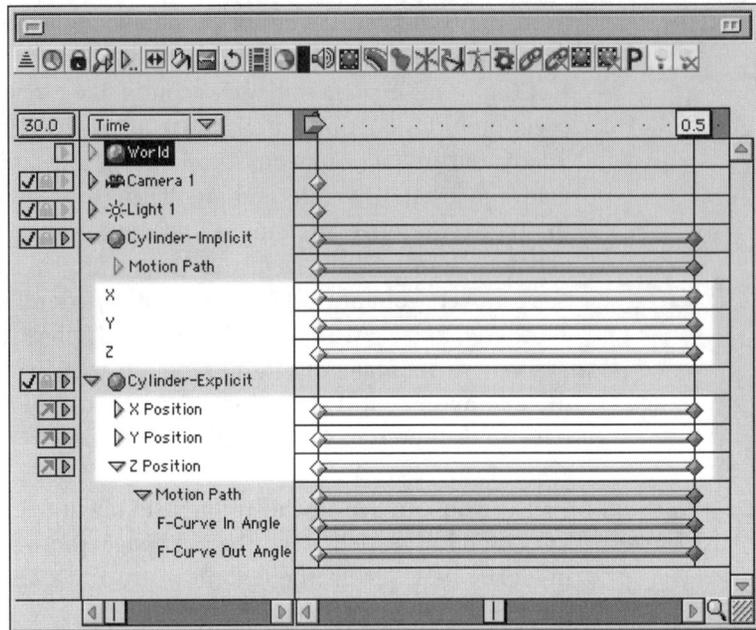

**FIGURE 5.10** Two models with their position data channels displayed. The top is set to Implicit mode, and the bottom is set to Explicit mode.

When you switch to **Explicit** mode, you lose these Beziér controls and, instead, are given what are called *F-Curves* control, which you manipulate in the **Function Curve Editor** (FCE) discussed later. As already mentioned, there is a trade-off because your on-screen interaction is not as powerful, but you now have almost infinite control of each separate XYZ channel inside the very powerful FCE. Channels set to the **Implicit** mode cannot be added to the FCE and must be switched to **Explicit** first.

One common way animators address this is to use the **Implicit** setting for as long as possible. When it can take you no further—or when continuing in **Implicit** would require creating too many keyframes—switch to the **Explicit** setting, and continue your project. When you become more familiar with the differences, you will know which mode suits your needs best. The Preferences settings offer either option as the default for new objects.

**Implicit** is available for only position channels; all others that deal with the coordinate system are locked in **Explicit** mode.

## SETTING YOUR PATH

While poking around in the channel views, you may have noticed that, in the spreadsheet viewing modes, each channel has a setting named **Motion Path**. Oddly enough, this offers a small pop-up menu with the options Linear, Natural, Hermite, and either Beziér or F-Curve. If you look in the ANIMATION drop-down menu, you will see the same options. The difference is that the menu drop-down options apply only to an object's **Position** channels, whereas the Project window offers the option to Set Path type on many channels. This is an important feature for the animator, as you will see.

In both cases, you are offered four choices: Linear, Natural Cubic, Hermite, and Beziér or F-Curve. What are these? They are different styles of curves, each with its own advantages to the animator. Lucky for us, Animator lets you choose which you want to use. Unlucky for us, Animator makes you stick to your choice for the length of the animation, unlike a few other programs. You can see this when you change one of the pop-up menus and the entire channel changes as well. However, this is very livable because the more advanced paths give you great control. The options, in ascending order of sophistication, are described in the following sections.

### Linear

Linear is the simplest type of path and takes an animated object from one keyframe location to the next in the shortest possible line. This can be used for a ball dropping straight down or the hard ricocheted first bounces of a billiard ball. In truth, life has very few absolute straight lines, so this option may more often be used for establishing a mechanical feel to your animation. There are no additional controls for this path.

### Natural Cubic

The Natural Cubic path provides a natural-looking motion for your object and is simple to use. The downside is that any editing of the path you do has the chance of affecting the entire path along the length of the animation. This may not be a problem for most applications, but keep it in mind when exacting results are needed. This can add a natural organic feel to your motion. There are no additional controls for this path.

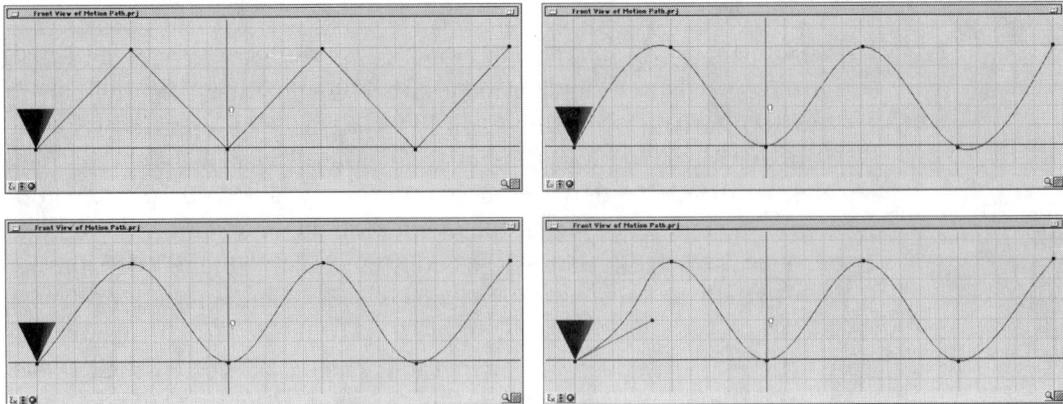

**FIGURE 5.11**  The four available animation path (clockwise from upper left):  Linear, Natural Cubic, Beziér, and Hermite.

## Hermite

(Charles Hermite, 1822–1901) The Hermite style of motion path seems very similar to Natural Cubic at first look, but you will notice that it is more exacting even in its default curvature. More importantly, any editing of it affects only local curves and not the entire spline, as with Natural Cubic. Hermite offers three additional curvature controls: Tension, Bias, and Continuity. These values can be altered throughout the animation to create exacting results. Although more time-consuming, this is a powerful option.

- **Tension:** This controls how sharply or smoothly the curve passes through the control point (or KF). The default value of zero looks much like the Natural Cubic. −1 bows out, making a more gradual curve, and +1 duplicates a linear setting with no curvature.
- **Bias:** This offsets the curve with a swing- or Beziér-style manipulation, positive numbers shifting the curve later in time and negative earlier.
- **Continuity:** This breaks the line's continuous feel with a sharp bend. Positive numbers create a concave feeling, and negative values a convex one.

### Beziér

We are all familiar with the 2D version of this from our Postscript-based drawing programs. Although based on the work of the Russian mathematician Sergei Bernstein (1880–1968), it is Pierre Beziér (1910–1999) who is credited with the actual graphics implementation of this math in the 1970s while in the employ of the carmaker Renault. (A little history never hurts, and again, it puts into perspective how young this technology is). The Beziér path's on-screen control handles allow for an ease of use that is hard to match and is preferred by most animators. Notice that when you switch to Beziér, it inherits the shape of whichever path you switched from. Beziér is available only if the channel is in Implicit mode. Pressing the **Control** key while manipulating the handles restricts their radial movement, allowing the animator to push and pull the handles longer or shorter.

### F-Curve

The F-Curve option is available only if the channel is in Explicit mode. The actual curves behave much like Beziér's but can be edited only in the Function Curve Editor (see Chapter 7: "The Function Curve Editor" for more information).

## THE WORLD ICON

At the top end of the Channel List panel, you see the World icon. Double-click this to open a variety of settings. It is easy to forget about this, despite its being at the top of the Project window, but don't. This is the only place to edit global settings for Ambient light, Reflection maps, Fog, and a few other handy items.

## IMPORTED MODELS

When you import a model into Animator (**OBJECT > Import Object**) and look at the Project window list, you might almost think that it was imported two or more times, but this is not the case. Just below the World icon listing, you see all your imported models listed. This list has the name of the model file as it appears on your hard drive and has a model icon (looking like an Oscar) in front of it. Farther down on the list, just below the cameras and lights (if you are in the default Hierarchy view), you see your imported model listed again, this time with a simple gray ball icon in front of it (see Figure 5.12 on the next page).

**FIGURE 5.12**    An imported model is seen both in the import list and as an object in the scene list, where you see that this model has two associated objects.

Why is this? The top listing (the "Oscar" icon) is a model import list, where all imported model files are listed. The lower listing (the gray ball) is where all objects in the scene are listed. Models can have (and can import) any number of objects in them; there are two in the example, and you can see that they carry the names they were given in Modeler.

On a practical level, the model list items can be used as **Morph anchors**, thus allowing morphs across many objects at one time.

## THE PARENT-CHILD RELATIONSHIP

For animation purposes, and even sometimes just for organizational purposes, you will usually want to set up your models in a hierarchal system. This certainly means that the shin bone should be connected to the thigh bone for character animation. However, it can also mean that the walls are parented to the ceiling or that the 200 lampposts are parented to a single lamppost or to an **effector**. This allows you to use that wonderful **Cmd-H** (from the HIERARCHY menu) keyboard shortcut to hide many child objects out of sight "under" their parent. It also allows you to set the children to inherit many attributes automatically so that you need not manually change the same setting on 200 or more objects.

To create a parent-child relationship, do the following:

1. Highlight all of the objects you want to become children of a single parent. You can select these items in the window views or in the Project window and they can be Shift-clicked to be added or removed from the set. These can be model objects, effectors, and even cameras or lights.
2. With the objects highlighted, activate the Parent tool by selecting it in the Hierarchy menu or clicking its icon in the Tool palette or Project window (the icon looks like a chain link).
3. A dialog box opens, asking you to select a parent. Do this by clicking the object you want to be the parent in either the Project window or the World or Camera views.
4. You can add more this way or you can remove children by selecting the Remove Parent tool instead.
5. You can continue this to create many levels of parent-child hierarchies that can become very complex if they need to be. However, keep it as simple as will work for your needs.

## BRINGING UP OTHER DIALOG INTERFACES

While working in the Project window or any of the World and Camera views, you often want to call up a variety of dialog interfaces to create and edit the project. Animator allows easy access to these dialog boxes through the following actions:

- **Double-click**: For the Info window
- **Cmd-Double-click:** For the Material Editor
- **Cmd+Option-Double-click:** For the Joint/Link Editor
- **Ctrl+Option-Double-click**: For the Plugin Editor

TUTORIAL

## A BASIC ROOM SET IN 10 EASY STEPS

When you first run Animator, you are confronted with a blank canvas that needs to be filled. Today you may be doing flying logos that do not need an environment or **set**, but at some point, you will sit down to a project where one is required. There are a number of ways to do this. Some people are more comfortable with the drag-it-into-place method, and others are at home with a more structured approach.

There are advantages to both. The dragging technique that uses the Translate (Move), Rotate, and Scale tools can be fast and easy to set up. If this comes at the expense of accuracy, though, it may not be worth it. Take a look at this method for putting up a basic one-room setting that is fast, accurate, and yet still very easy. This tutorial is deceptively simple in that when you *get* it, you will have learned a lot about controlling objects in your 3D space.

For this tutorial, you will be using the Project window, the Joint Editor (also called the Linkage window), and the model's Info window.

1. Start a new project, and bring up the **ÜberShapes** plug-in found in the PLUGIN menu. Select **Plane**, and make it 200 by 200 units along the **X-Y plane**. Be sure to click off the Auto Name toggle, and click OK. (Auto Name causes the object to revert to a default name, and you want to custom-name the models.)

2. Open the model's **Info** window, and change the **Position Y** edit box to 100. This moves the model so that it is sitting properly on top of your virtual ground-plane grid.

3. Open the **Project Window**, and name the model *Back Wall* by clicking it and editing the name above, pressing the **Return** key to finish. Then duplicate it (**Cmd-D**) and name the new model *Ceiling*.

4. With Ceiling selected, go to HIERARCHY> **Joint Editor**, and click the **X-Form** tab. You want to move the model's **Manipulator**, which is used as the pivot or rotational center of a model. The **Manipulator** is represented in Animator with a yellow box and the Translation/Rotation/Scale controls. Go into the **Position Y** edit box, type *100*, and press Return. You should see the **Manipulator** move to the top edge of the model, because the model is 200 units tall and measurements originate in the center. Close the Joint Editor.

5. Change the Camera window view to a 3/4 angle so that you can get a better perspective of what you will be doing. Feel free to modify it as you need to throughout the tutorial. You can also add extra cameras for additional views.

6. Open the model's Info window, and take a look at the **Rotation** value boxes. What you want to do here is to rotate this Ceiling model 90 degrees around its **pivot point's** new location. Which axis do you need to change? If looking from the **Front** window, you know that you want to have the virtual "hinges" on the left-to-right axis, which the little icon on the lower left tells you is the **X-axis**. Now you know that you need to plug 90 degrees in to the **X-axis**, but should that be positive or negative? If you forget which direction is which, it is easier to just try one, and if it is not correct, you know that it is the other! In this case, it was just positive 90 degrees. Figure 5.13 shows the various steps just described.

7. Go back to the Back Wall model, and duplicate it again. Call this model *Left Wall*, and again open the **Joint Editor** window to move the model's **Manipulator**. This time, you want to move it to the left side, which happens to be located at **Position X = –100**. Close the **Joint Editor**.

8. Open the **Info** window. Now you want to rotate this model along which axis? The "up and down pony" one for those with toddlers, so that it will rotate like a hinged door. This is the **Y-axis**, of course, so plug 90 degrees in to the Y rotation. Are you getting the hang of this yet? You should now have two walls and a ceiling up, as shown in Figure 5.14 on the next page.

9. Everyone loves shortcuts, so instead of going to the Back Wall again, just duplicate your Left Wall, and rename it *Right Wall*. Then open its **Info** window, and you can just move it over to where it should be on the other side by changing that –100 in the **Position X** edit box into a **positive** 100. Boom! Look what happens. You have another wall up. Easy stuff!

10. That was so easy that you need to do it again. Select the Ceiling, **duplicate** (Cmd-D) it, and rename it *Floor*. Now open the floor's **Info** window and change the position-Y to—can you guess? It's almost a trick question, so a

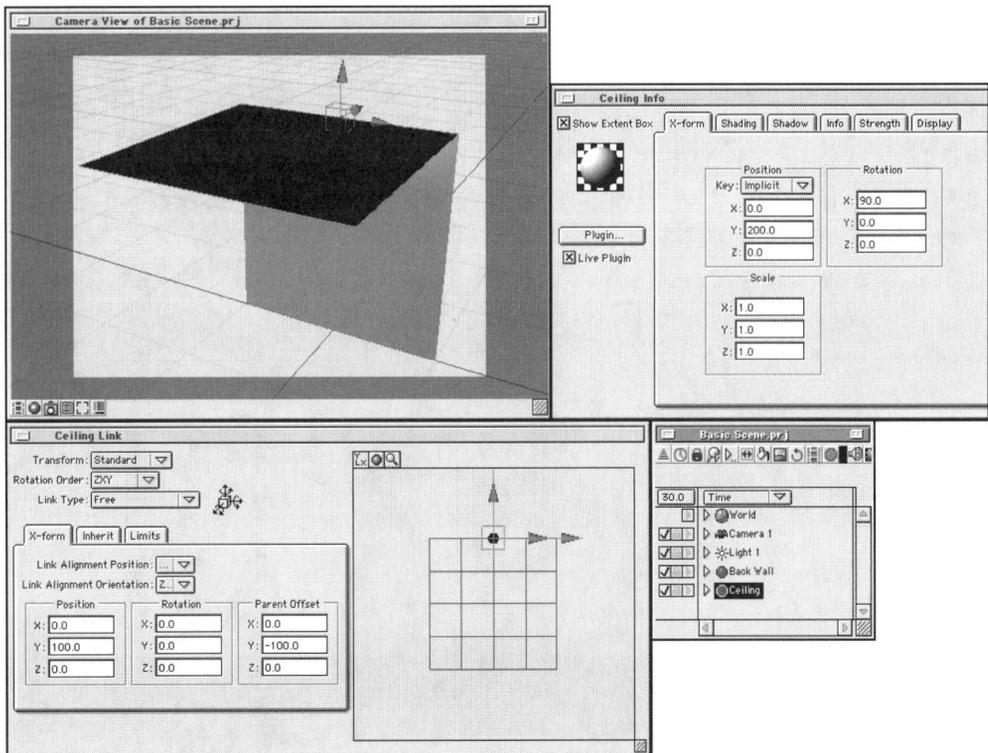

**FIGURE 5.13**    Working on the Ceiling model in the Project, Joint, and Info windows.

hint is that the answer is not –100. Remember that you moved the original Back Wall up by 100 just to get it sitting on the ground plane grid, which put you off center vertically? You need a **zero** in the **Position Y** edit box to make it work and give you the final box you see in Figure 5.15.

Ten easy steps that did require some thought (but not that much), and in return, you saved a lot of time that would have been spent futzing around and nudging the models if you had done it manually. Also, you saved yourself a lot of time later, having to fix imperfections that might show in an animation, such as light gaps in the corners and oddly angled walls. In addition, you have gained a better understanding of a few new control windows and how they can be used effectively. The final version of the project can be found on the CD-ROM in the **Project Window** section.

**ON THE CD**

**FIGURE 5.14**    The Left wall model gets "hinged" and rotated into place.

**FIGURE 5.15**    The final box, assembled accurately and quickly with just a little thought and basic math.

**TUTORIAL**

## THE BOUNCING BALL

The bouncing ball tutorial is about as clichéd a 3D exercise as you can come up with, but this is because it is very effective in familiarizing you with the way the **Project** window works. To make this terribly realistic, you would also be using velocity curves or similar controls in the Function Curve Editor. For now, just take this to a reasonable point and maybe add some characterization along the way. The start file can be found on the CD-ROM as Ball Bounce.prj, in the **Project Window** folder. The final version of the project and a rendered Quick-Time movie are located in the same place.

1. Add a ground plane to your project, using the ÜberShape plug-in found in the PLUGIN menu. Make it at least 20,000 units in **Width** and **Length** so that it goes off to the horizon, and select the **X-Z Plan**e option.
2. **Enable** animation for the Sphere model by clicking its Enable Animation flag in the **Project Window**. The model should already be set with a **Linear** motion path.
3. Now focus your attention on the **Front World** window. What you want to do is just rough in some keyframes at 1-second intervals. In my version, for every 1-second keyframe, I moved the ball two grid lines over to the right (along the X-axis) and almost three grids up or down (along the Y-axis), as you can see in Figure 5.16. Your version need not be exact; close is just fine.

To set up these keyframes, do the following

a. **Change the Time slider in the Project Window or Time palette**. Remember that you are doing 1-second intervals, and create your main keyframes at 0, 1, 2, 3, 4, and 5 seconds.

**FIGURE 5.16**    The Front World View window, where the ball animation gets animated.

   b.   **Move the model**. As you do this, take note of the red diamond keyframes automatically placed in the Project window.

   c.   **Change the Time slider**. Continue until you have roughed out all keyframes.

4. With the model selected, go to the HIERARCHY> **Joint Editor** window. Click the **X-Form** tab, and in the **Position Y** value entry box, type –35. As you do this, notice two things: The center point for the preview image at the right drops to its base, and the motion path on the screen gets lower. What you just did was simply change the model's **Manipulator Point**, bringing it down to the base of the model. You will see why shortly. The Manipulator Point is the point of rotation when rotating the model, and the point of scale when scaling as well. It often needs to be in places other than the center for certain things to work the way you want.

5. With the model still selected, go up to the drop-down menus ANIMA-TION> Set Path To > **Hermite,** and see the motion path change to a smooth curve. If you preview the animation in the Camera window, you will see something that looks more like a roller-coaster ride than a bouncing ball, so you have more to do. The next step requires that you manipulate the motion path in a way that can be done in either the Hermite or Beziér modes. Because you should know both options, this project will be split up. This makes the instructions more confusing, so pay attention and you will learn twice as much.

### EDITING HERMITE PATHS

6. Switch the Project window to the **Keyframe Index** mode, and open the **Channel View** icons to reveal the **X-Form > Position > Motion Path** channels. You see value entries for Hermite Tension, Bias, and Continuity. Go to the third KF (at the first bounce), and click in the **Tension** box to highlight. Then go up to the editing area near the top of the Project window, type in a 1.0, and press the Return key. You see in Figure 5.17, on the next page, how the third KF has changed to look more like a bounce. You have added tension here, and as you can see, the line path does look more "tense."

7. Now that you have done one, go in and finish the first curve by poking in a 1.0 for the first KF's Tension, as you just did. You see a slight arching up.

8. Keyframe 2 is where you can have some fun. The top arch needs to smooth out, so type –1.0 in its **Tension** edit box. By putting in a negative number, you remove tension—the path does look less tense, right? This

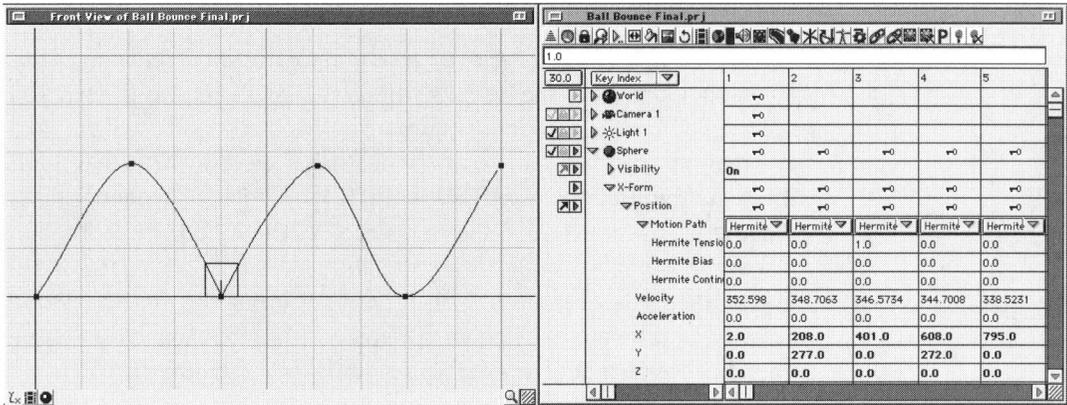

**FIGURE 5.17**    Editing the Hermite path.

number varies, depending on the arch of the ball desired, which is a factor of the height and space between bounces. I settled on −1.2, but your eye might prefer a different value.

9. Finally, add a touch of **Bias**. (Yes, this sounds like a cookbook! Parallels can be drawn, but I leave it to you to draw them.) As the name implies, Bias swings the curve to favor one side over the other. By putting in **0.4**, you give the ball's bounce more of an "attack" (see Figure 5.18).

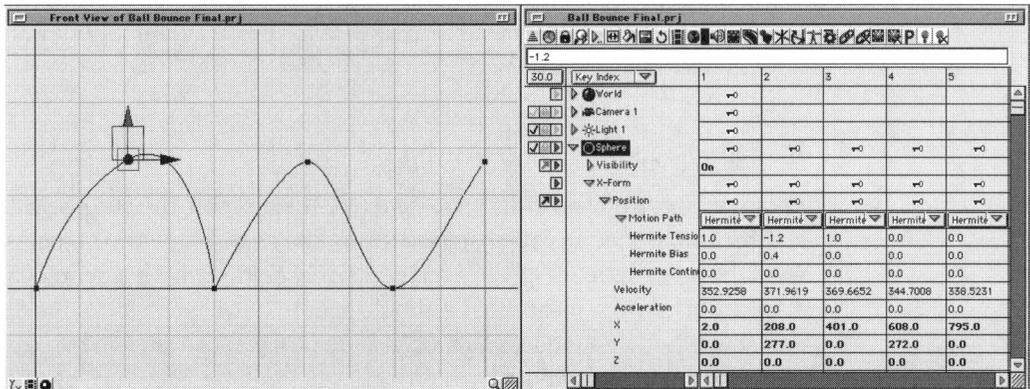

**FIGURE 5.18**    The finished Hermite path bounce.

### Editing Beziér Paths

10. You are going to use the Beziér path setting for the remaining part of this animation. Just above the Hermite controls edit in the previous steps, you see the path mode pop-up menu going across the Project window. Click and drag that to change the path to the **Beziér** selection. Note that this is the same thing as going to the ANIMATION> Set Path To menu, except that there it uses the term **F-Curve** instead of **Beziér.** Both are similar and use control handles, but Beziér is an option only with Implicit data, and F-Curves are available only for Explicit channels inside the Function Curve Editor. The program is being casual and referring to them as the same thing here, even though they really substitute for each other.

11. If you click the second KF again, you will see that Beziér handles appear. This is just like the one you want to create at KF 4. Do this by clicking KF 4 and then click-dragging its handles out and at an angle to match. Now do the same thing to KF 6, which will have just one handle. You will find this to be much more interactive than using the Hermite controls. However, if you have  multiple identical bounces to do, plugging in the Hermite data is faster and more accurate, right? It becomes a matter of learning which tool sets to use for which situations.

12. Go down to the fifth KF. You need to get rid of the curve where it hits the ground. Holding the **Control** key while dragging on the Beziér handles will constrain their movement to a straight line, either in or out. **Control-drag** the handles to the center of the KF, thus adding Tension, as you did earlier with the Hermite setting. If the handles disappear and you need them back now or later, change the path to Hermite, and then back again (but this does lose your Beziér editing!).

13. Play a preview of your animation, either from the Front view or after moving your Camera window to a good vantage point. Figure 5.19 shows my Camera view at this point.

## The Ball Goes Squash

Recall when you moved the Rotation point to the bottom? The purpose was to add realism, or better yet, character, to the ball's bounce. Any object with enough spring to bounce like a ball is probably going to have a good deal of elasticity in it, which means that it should squash down when it hits the floor. Scaling is based on a model's Manipulator point. If you had left it in the middle of the model, scaling would have brought the lower geometry up, as well as the upper geometry down. By moving the point to the bottom, all of the geometry scales come downwards.

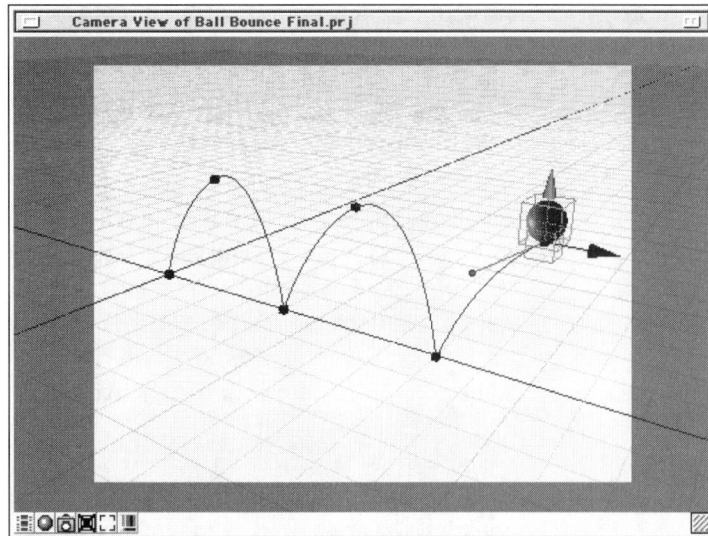

**FIGURE 5.19**    The Camera view after finishing the basic editing with Hermite and Beziér.

The easiest way to set this up is to go to the KFs that hit the floor (3 and 5) and scale the ball's Y-axis down. What happens, though, is that you end up with a scaling action that starts way too early at the preceding KF and ends too late at the next KF. For example, if you scaled the Y-axis at KF 3, that scaling move would start at KF 2 and end at KF 4. What you need to do is put in a few controlling or *holding* KFs to act as digital bookends around each scale action.

1. Switch the Project window back into **Time** mode because the rest of this will be working with the KF diamonds.

*I have, on rare occasion, noticed that switching from **Key Index** to another mode mucks up the KF ordering and my ability to select the correct one. This is a new and, hopefully, passing glitch that is easily fixed by saving and reopening the project. It appears to be only a display-related problem and is not saved with the file.*

2. Go to KF 3. You want the scaling to start before it actually hits the ground. This might not be true-to-life, but it makes for better animation. You can move to an earlier time by dragging the Time slider, but because you just

want to go a few frames over, it is more accurate to use the **Cmd+arrow** keys and press the left arrow three times. This puts you at 1.9 seconds on the Time slider read-out.

3. You need a KF here, but if you use the command to **Add Keyframe**, they will be added to every channel. Instead, open the ball's **Info** window, and in the **Scale Y-axis** edit box, change the 1.0 to 1.01. Then remove it (click, type *1*, and press Return, Delete, and Return. Done.) You now have a KF in just the Y scale channel, and very dexterous hands!

4. Now you need to do the same thing after KF 3. The spring effect is bigger post bounce, so you need to make this bookend KF occur later on. I decided on 6 frames after KF 3, which puts you at 2.2 seconds. Do the same edit dance with your fingers to get another KF in the **Scale Y-axis** channel here.

5. Going back to KF 3, you can safely edit the Scale Y-axis down to a lower number. Smaller numbers make the ball seem very soft and spongy, like a squash ball. Larger ones exude rigidity, like a bouncing ping-pong ball or billiard ball. I used 0.6, but feel free to do your own thing. Cutting the size to 0.5 or less makes for a very cartoon-like action.

6. Guess what, you have to go do all of that again for KF 5—or do you? If you change the Project window one more time into the **Keyframe mode**, you can do this with a simple copy/paste. Open the window to fill the screen, and go to frame 60, listed across the frame numbers along the top. Locate the **Scale Y** channel, and you can see that frame 60 is a KF with a value of 0.6, three frames earlier is a KF of 1.0, and again at six frames after. You can drag to highlight these 3 KFs and in between data, **copy** them. Then go to frame 120, which is KF 5, click in three frames earlier, and **paste**. If done correctly, you now have these new KFs in the right locations.

7. Change back to Time mode, and play another preview to see whether it looks right. The squash effect is probably subtle, but you should be able to tell whether it was done right. If you go back and make the squashing extreme, it will be easier to check the effect's timing. Figure 5.20 shows the way the Project window should look and a tight close-up of the ball at a bounce keyframe. Note that the motion path does not show a KF symbol for the Scale KFs, which are in frame view (take my word for it), only for Position data.

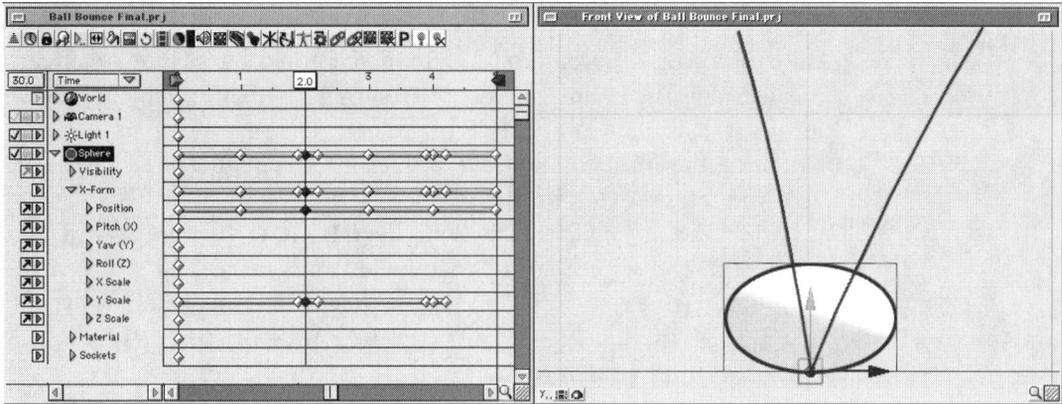

**FIGURE 5.20**    The Project Window and Front View close-up after the Scale edits.

## TIMING THE BOUNCES

Although we said that we would not go into real velocity curve editing, there is a quick-and-dirty way to feel as though you have.

As a rubber ball bounces, you notice that it loses acceleration as it climbs up its arched path and often appears almost frozen in mid-air at its peak position, for just that fraction of a second. On the way down it gains speed, but it is really just after the bounce that the ball has its greatest burst of energy.

With this in mind, the most important visual would be to *increase* the ball's speed between the bounce at keyframes 1, 3, and 5 and the arch peaks at keyframes 2, 4, and 6.

*This is a perfect example of why you don't use the **Add Keyframe (Cmd-K)** all the time. If it had been used it earlier to set your Scale Y axis with the squashing ball, you would have troubles with extra KF in your position channels now. But you don't because you did it the right way.*

The easiest way to *increase* the speed of a traveling object in animation is simply to **decrease** the amount of time in which it happens. You take the arch peak keys (2, 4, and 6) and shift them earlier in time by about 10 frames, or about 1/3 of a second. The result is a slight slowdown as the ball falls, but in return you get a good dramatic emphasis after the bounce, with a much snappier springing upwards. Again, all that is done is to drag the diamonds for KFs 2, 4, and 6 over to the left a little. You can see in Figure 5.21 how it was done.

## Adding Sound

Animation work is often produced to match audio tracks that are already finished. This is certainly the case with any lip-syncing character animation, as well as many other kinds of projects. The best way to produce this is to bring the finished audio file or files into Animator to use as a template and reference for your work.

Adding an audio file is easy. Go to the **OBJECT> Import Sound . . .** menu item, and select the AIFF audio file you want to load. It appears in the project list near the top, and you will see a very small audio wave displayed across the timeline. If you open the track's **Channel View** icon, it displays a larger version of the audio wave, which is easier to see. If you double-click the item to open its **Info** window, you will see Animator's audio interface. Refer to the manual for more information on using the **Audio Info** window. You can see all of this in Figure 5.22, and notice that the bounce waveform lines up with the bounce of the ball. Yes, we planned it that way. Animator can load mono- or multi-channel audio tracks.

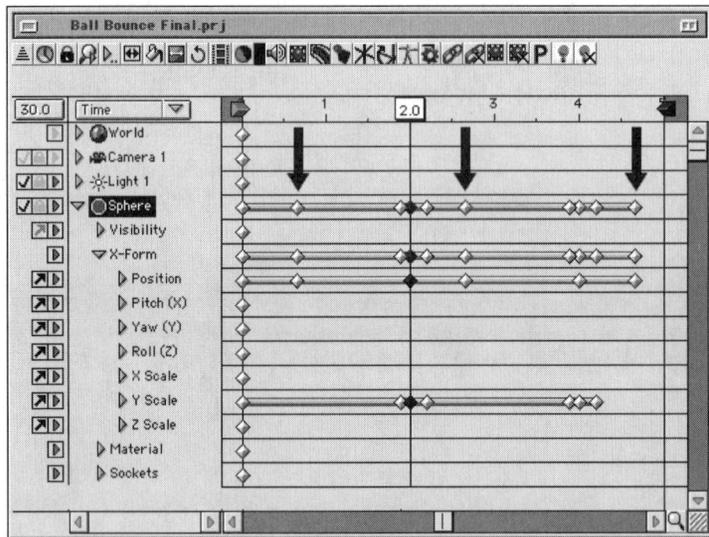

**FIGURE 5.21** The keyframes for the bounce peaks (indicated by arrows) were dragged left, earlier in time.

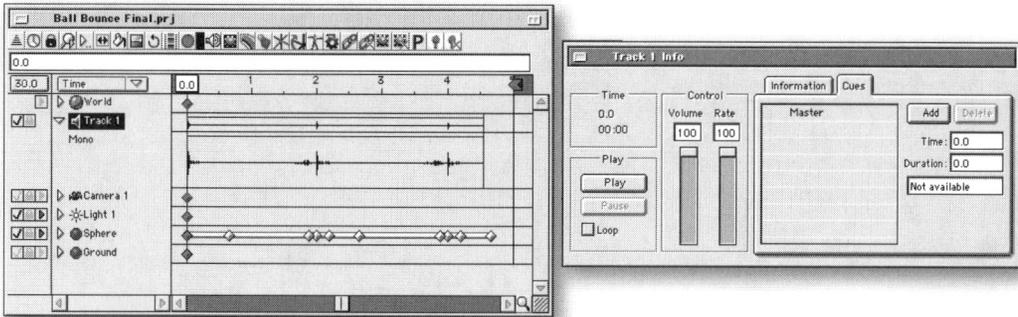

**FIGURE 5.22**    An audio track loaded and its Info window open.

When using audio in Animator, you can play back an entire clip with the **Play** button in the **Info** window or highlight smaller sections for playback by dragging across the waveform graphic in the **Project** window. You can set **cue points** for the audio and use the waveform as a visual guide to set your animation.

Electric Image's IMAGE format does not support audio tracks. But the **QuickTime Preview** export feature does support an audio track, and this is a great way to test an animation's timing.

# 6

# THE SELECT MENU AND SELECTION SETS

Many people don't realize how important a feature such as **Selection** and **Selection Sets** can be to 3D animation or illustration work. It is so valuable that an entire menu category is set aside for it that contains a host of options designed to make your animation life easier (see Figure 6.1). Sorry, it won't do a thing for your personal life.

When you are doing basic projects, these tools can fade into the background and seem less valuable. As the complexity of your animation work grows, though, your need for these tools increases. The options in this menu are powerful and very well thought out, offering a wide range of selection criteria. You can select all models or all lights. You can get more esoteric and select just hidden items or only Inverse Kinematic (IK) handles. You can select by label and then **Invert** your selection. If none of the presets do it for you, you can even do a customized **Find**, **Find Again**, or **Find All** with full wildcard character support (see Figure 6.2).

Leaving the best for last, we come to **Selection Sets.** These are saved groups of selected items that can be used again and again and are cleverly integrated into many other areas of the program to offer a lot of control.

Here are a few areas where the Selection tools are indispensable:

## Selection

In its most basic application, the tool set is used for selection. Quickly select all models that are labeled **Red** (By the way, label names are editable!), or when working on that centipede model, quickly select all the

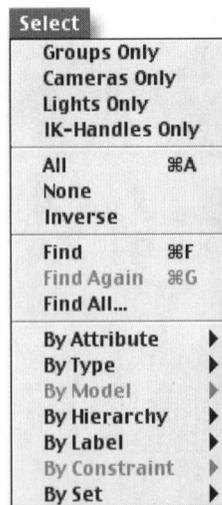

**FIGURE 6.1**   The Select menu.

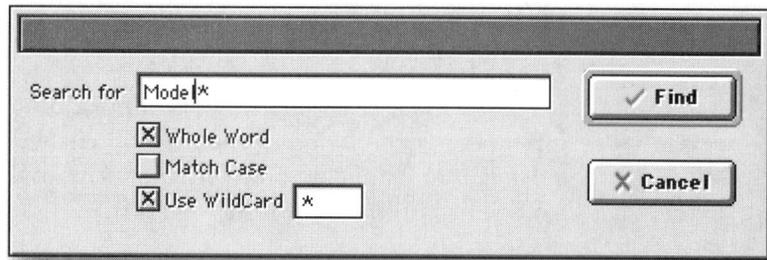

**FIGURE 6.2**    The Find and Find All dialog boxes look the same.

legs' IK handles. One of my favorite productivity boosters is to select a top-level parent model manually, and then use **SELECT > By Hierarchy > Children of Selected**, which automatically selects any number of nested children (not offspring) without having to even open the hidden items. Then just **Shift-click** to reselect the parent, as it naturally gets deselected with that action.

### Find and Find All

The Find features help you locate one or many objects. This is a tool that becomes very helpful if you have hundreds of model objects that may be hierarchally nested and difficult to find on screen or in the Project window.

The **Find All** dialog box is also great for selecting items you want to add to a Selection Set. For example, searching for *centipede leg-left-* * with a **wildcard** character selects all your centipede's left legs and omits the right legs. The wildcards allow it to ignore the variables of the legs' numbering system so that objects centipede *leg-left-01* through *centipede leg-left-99* can all be selected. Then all of these can be added to a Centipede Left Leg selection set at once.

*Find the needed object. Set the Time thumb to the frame you want to edit the item, and open its **Information** window (**Cmd-I**) or other dialog box. Now edit! To do this, you need never actually see the object selected in the World or Camera views, or buried in a subfolder in the Project window. The trick here is that many times you know what needs to be edited and don't have to see the object to do it. For example, you know that a light needs to be made 50% brighter or a model needs to be enlarged 20%; these things can be done quickly by letting the search function do the selection for you in complex scenes.*

## Selection Sets

Aside from simply customizing the selection of predetermined groups—which, in itself, is a valuable tool—this feature has been integrated into many other sections of the program. This enables you to do things such as tell a light to illuminate only certain models of the scene. This allows for a much higher level of control than offered in real life.

## Selection Set List Boxes

These are found in the **Lighting Info** window (Illumination List, under the Properties tab), in **Bones Info** (under the Action tab), and in the **Render Settings** window (under the Glow Layer tab). Each has it own implementation and use, with the Illumination List often the most useful. (See Chapter 10, "Lighting" for techniques that make use of this feature.) Figure 6.3 shows the Illumination List box in the **Lighting Info** window.

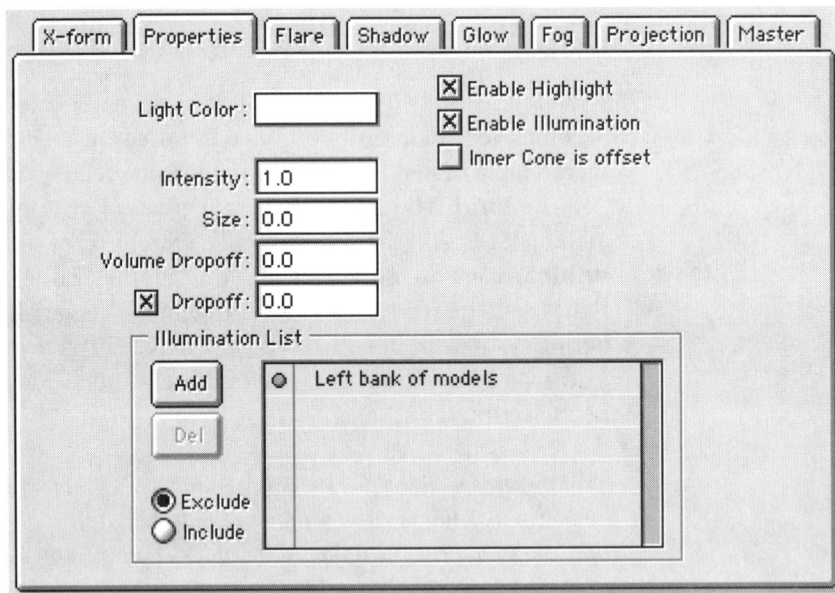

**FIGURE 6.3**    The Lighting Info window's Illumination List box at the bottom of the Properties tab.

# 7

# THE FUNCTION CURVE EDITOR

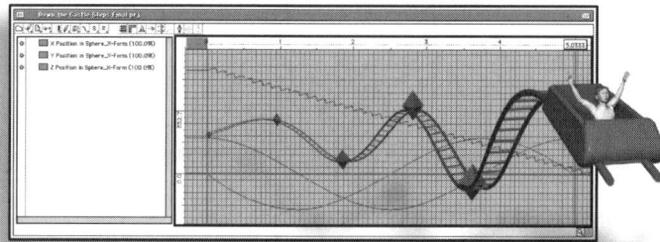

he **Function Curve** is a name that might sound more imposing than it really is, because these curves are simply another way to look at your data. At the same time, function curves offer different and sometimes better ways to control your data.

One significant capability of the **Function Curve Editor** (FCE) is that you have the option of adding all kinds of data to it. In that respect, it is a general-purpose editing interface like the Project window, as opposed to the Morph or Deformations editors, which are very channel-specific. In addition to the variety of channel data, the FCE is equally adept at editing the more elusive Velocity curves.

All animatable channel data can be added to the FCE for editing; the two exceptions being **Implicit** channels and color channels. Implicit channels can, of course, be easily converted to **Explicit** in either the AN-IMATION menu or the object's Info window X-Form tab.

The FCE is opened by either selecting it in the ANIMATION drop-down menu or using the **Cmd-`** key combo (see Figure 7.1).

## ADDING CHANNEL OR VELOCITY DATA TO THE FCE

The FCE adds *either* **Channel** data *or* **Velocity** data, not both at the same time. Most of the time, you will want to add channel data from specific channels.

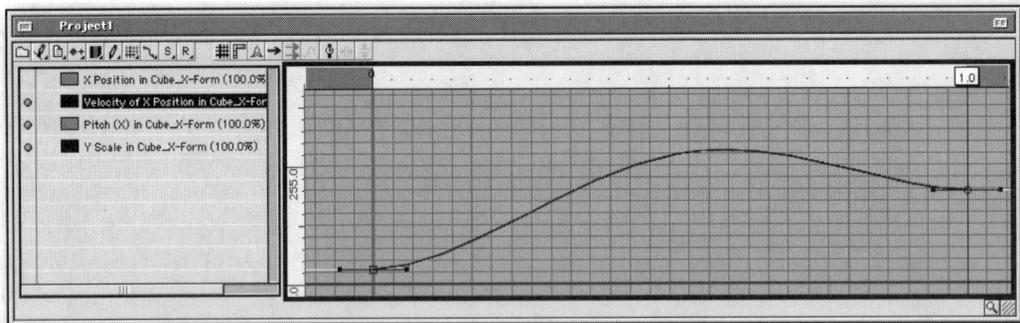

**FIGURE 7.1**    The Function Curve Editor window.

### Existing Channels

Channels that already exist in the project can be added to the FCE by either **double-clicking** them in the **Project** window (you must open the **Channel view**'s disclosure triangle) or using the **Add Channel** command in the FCE, which allows you to add many channel selections at one time. In either case, you see the channels instantly appear in the FCE's list—unless the channel has **Velocity Controls**, which you are asked to remove if you want **channel data** to be used.

### New Channels

Both **Preferences** and the **Morph Edito**r have options to add all new channels automatically to the FCE and thus save you from having to do this manually.

### Velocity Controls

When you add a channel that has a **Velocity Control** to the FCE, you are asked what you want done with it. Many, but not all, channels have Velocity Controls, although you tend to think of them mostly in relation to X-Form type of data.

To see whether a channel has a Velocity curve, open the **Channel view**'s disclosure triangle in the **Project** window, and then open one of the subsections, such as the X-Form. In the **flag panel** along the far left, you see that the **Lock** flag now shares its space with a funny-looking arrow pointing up at 45 degrees; this is the Velocity Curve icon.

**Velocity** is a set of data that tells you the rate of change over time, like a car's speedometer. By comparison, **channel** data is more absolute, such as actual coordinate information. Obviously, these two sets of data are closely related and can often be used interchangeably—but they are not the same thing.

Remember that train going from Boston to New York on your old math tests? If the train is traveling 300 miles and the trip takes 3.5 hours, $300/3.5 = 85.71$ tells you that the **average** speed of the train was about 86 miles per hour. When you set up an object to animate from one location to another, the associated Velocity Control data is created at a constant and even rate, like that train. However, it need not stay that way and you will, of course, want to change this often.

Where is this **Velocity Control**? Before the FCE was added to Electricimage 2.9, there was a Velocity Editor window (since eliminated). In Universe, if you want to edit an object's velocity, you must first add its

data to the FCE. If you double-click an **Implicit** channel, you end up adding its Velocity curve to the FCE, if it has one. If you **double-click** an **Explicit** channel, you are asked what to do with the Velocity data, remove or keep it. This is really asking whether you want to add a Velocity curve or channel data to the FCE.

*If you want to add Velocity data from a channel that has its Velocity Curve icon turned off, simply click it to turn it back on.*

Back to that train that is going 86 miles per hour. In real life, nothing is constant, and the goal in animation is often to look more real, so you can use this Velocity curve now in the FCE to manipulate the ebbs and flows of the varying train speed. Take a look at the "Velocity.prj" project in this section's folder on the CD-ROM. In it, you have two sphere models animated identically, moving from the left to the right. Both have had their Velocity curves added to the FCE (see Figure 7.2).

**ON THE CD**

*When you click a channel in the FCE, the graph area automatically adjusts to the curve. This can drastically change the scale of the values along the vertical axis and can make a virtually flat path **appear** very dynamic. Always take a look at the value scale along the left to confirm its real characteristics.*

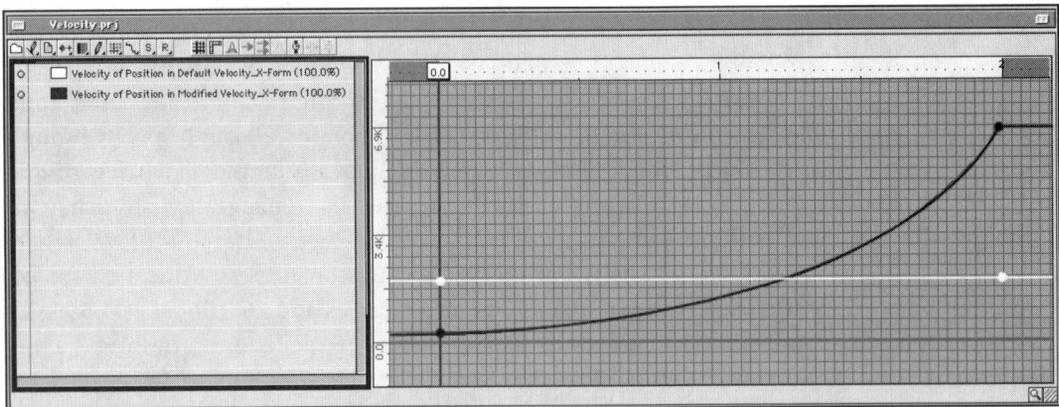

**FIGURE 7.2**   Two models with their Velocity curves added to the FCE. One is left at the default (the white flat line) and the other is edited (the curved black line).

*Fit* to Window (**Opt-click magnifier**) *works in the FCE, also.*

If you look at the default Velocity curve (the white line), you can see that it is flat, indicating a *constant velocity*. The second sphere's curve has been modified to start off very slow—at almost no velocity—and then accelerate to a very high speed to catch up and finish the race at the same time (reminiscent of *The Tortoise and the Hare*). See "Velocity.mov" QuickTime preview on the CD-ROM. When you watch the movie, also try setting the player to Loop Back and Forth, and take a look at the cycling patterns you have set up. Although moving horizontally, the red sphere looks like a bouncing ball. Remember this because it is used in one of the tutorials.

ON THE CD

**TUTORIAL**

## BOUNCING BALL MEETS VELOCITY CURVE

Now go back to the Ball Bounce tutorial that didn't have any real velocity controls added, in Chapter 5, "The Project Window." You remember that the final version of that had KF time shifting added to create some velocity control, but you will do it the right way now.

ON THE CD

1. Open the file "Ball Bounce with Velocity.prj" on the CD-ROM, which has had the time shifting removed. Open the **Channel view**, and **double-click** the Implicit **Position** channel to add it to the FCE as a **Velocity** path.
2. Open the FCE, and select the path's name to highlight it and view it in the grid. You may need to use Fit to Window to see it better (**Opt-click-Magnifier** icon).
3. The very simple idea here is that the higher the path goes up the graph, the faster the model is traveling. As discussed in the Ball Bounce tutorial, you want the ball to be moving its fastest right after the impact of the bounce and to have that speed decay as it climbs the arch. At the peak of the arch, the ball can almost seem to stop for a brief moment before it begins to accelerate again as it falls back to earth.

This seems like quite a complex bunch of moves for you to represent with this curve, but it isn't when you get the hang of it. Go ahead and play with it, and we allow you the "misfortune" of peeking at our solutions in the "Ball Bounce with Velocity.prj" file on the CD-ROM. You can see the curve in Figure 7.3. Notice how the bounce effect is exaggerated. Remember that there is no perfect solution and that many factors go into creating a realistic ball bounce. Have fun!

ON THE CD

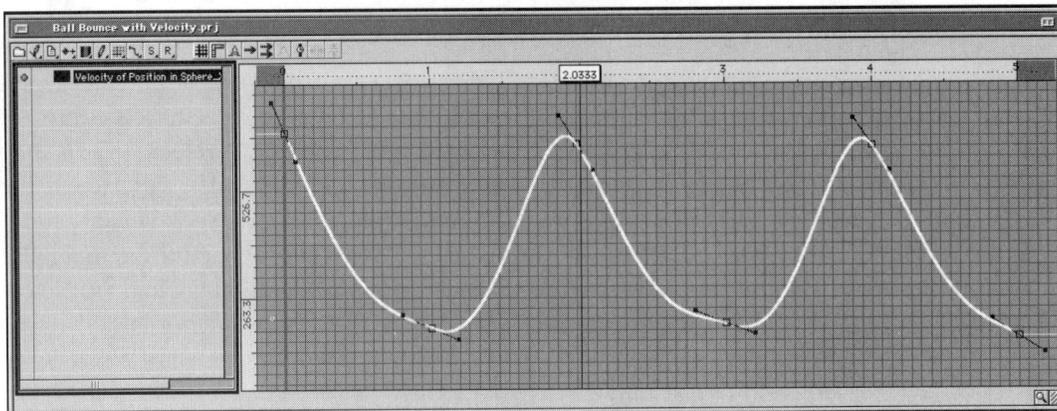

**FIGURE 7.3**    The Ball Bounce project with its Velocity channel added and edited in the FCE.

*Use the **Tab** key to change your cursor into a constrained **vertical-**, **horizontal-**, or **diagonal-only** controller.*

### Channel Data

The more common type of path data to bring into the FCE is channel data. This is the result when you opt to **Remove Velocity Controls** in the dialog box discussed earlier. Channel data can be added only from **Explicit** data channels.

The first thing you notice when you bring in a channel of data is that your once **Beziér**-encrusted motion paths on screen are now without their control handles. This control has been removed from the screen and, instead, placed inside the graphs of the FCE. If your paths are set to **F-Curve**, they will still have the **Beziér**-like controls, but these will only be 2D manipulators, instead of the 3D variety you had before. There are trade-offs, so jump in and see where some of the perks are.

## TUTORIAL

### BASIC MOTION EFFECTS IN FCE

Go back to the banking example from Chapter 5, where you set up the data like an Excel spreadsheet. You already saw in that chapter how you can get a 3D graph when you put the bank information into the **Y Position** channel in the **Project** window.

You were very happy with this ability until the client called to say that the data actually represents six months, not the year he told you—could you squish it down? Manipulating this data as separate keyframes would be slow and not very accurate. If the client came back with more changes, you would again have the same arduous task before you. If you don't know it yet, learn it now—clients ask for many changes, so it is your job to make these edits easy on yourself.

Rather than edit the keyframe data in the Project window and World views, you can take that **Y Position** channel into the FCE, which is what is done for you already in the "FCE Bank Data.prj" on the CD-ROM. The new **graph** view you see in the FCE matches the path you see in the World and Camera windows for the model (see Figure 7.4). It also matches the graph you produced in Excel (refer to Figure 5.3 in Chapter 5).

*ON THE CD*

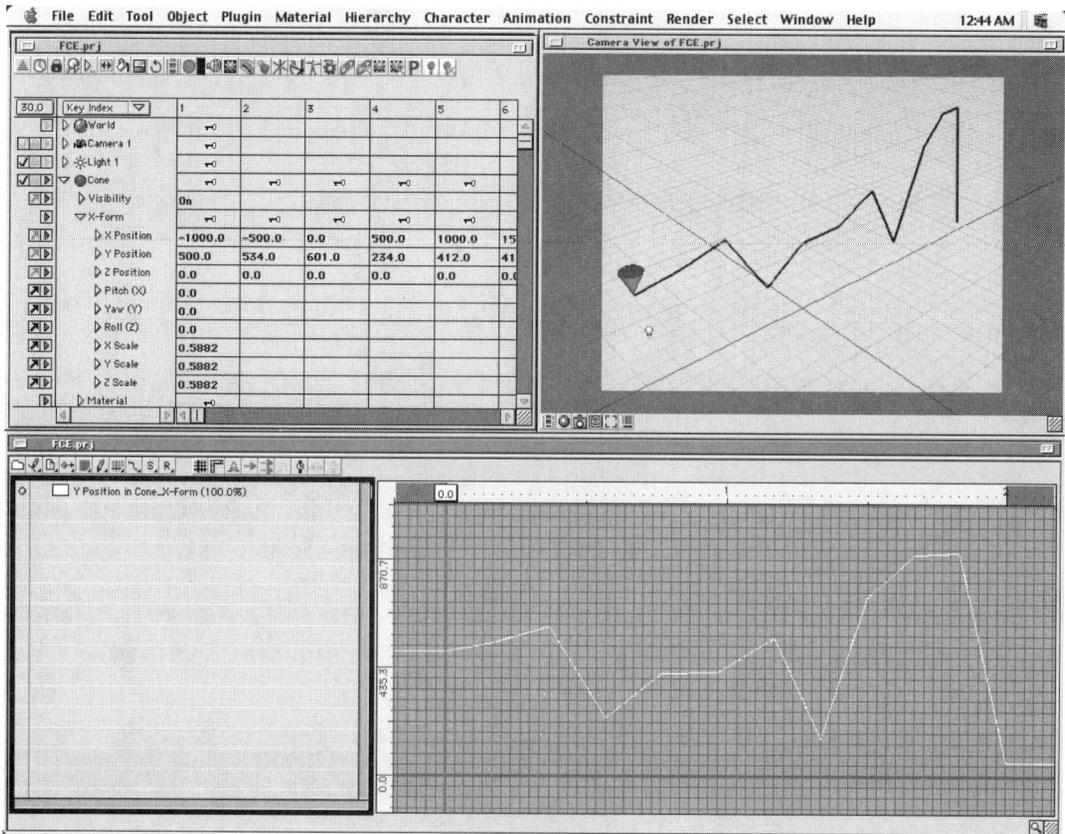

**FIGURE 7.4**    The Y Position channel (bank data) from the Project window is added to the FCE.

Before you try to solve the client's problems, you should explore the FCE tools for a minute. Go to the F-Curve's graph window, and move any of its control points. You see the same move reflected in the World environments as well. You can still go into the World and Camera views and move the model around, of course, if you want to, but you will not have access to Beziér controls.

Now you want to open the **Path window** (this is what the ToolTips calls it, yet in the Animator 3.0 manual, on page 249, it is referred to as the **Key Channel window**). This is done by either double-clicking the **Y Position in Cone_X-Form (100%)** path in the **channel list** or going to the eighth tool in the FCE toolbar, which has a squiggle icon. This is a great tool with many options you need to learn. For now, simply go to the **Motion Type** selector, and change the curve style to **Natural Cubic**. See how the F-Curve window and the World and Camera views update with a smoother curved path. Now change it to the F-Curve setting, and notice that your graph now has the Beziér curves. If you go back to Linear and then switch directly to F-Curve, you see that the Beziér-style controls are all split handles. These can be made solid by **Cmd-clicking** each (which also splits solid controls) or just going back through one of the other modes. Fun stuff.

### CONTROLLING F-CURVES

Now let's go back and solve the client's problem:

1. In the **Project** window, **double-click** the **X Position** channel to bring it into the FCE.
2. Highlight the new channel path, which should be named *X Position in Cone_X-Form (100%)*, and if need be, fit the view to the window. It should look like a straight line sloping up to the right (see Figure 7.5).
3. Press the Tab key, and notice that when the FCE window is active and the cursor is over the graph area, it cycles through horizontal, vertical, and diagonal and then back to the normal cursor. Set it to the vertical setting to constrain your cursor's editing motion.
4. Put your vertical cursor over X Position's second KF, which is at the upper-left corner of the grid, at about the 2-second and 1.5k intersection.
5. Click and drag this KF down to the main line at the zero mark, and let go. See in the World and Camera views how the motion path has become much shorter. It did so while keeping all the KFs in proper proportion! This can be seen in the "FCE Finish.prj" on the CD-ROM and in Figure 7.6.

**ON THE CD**

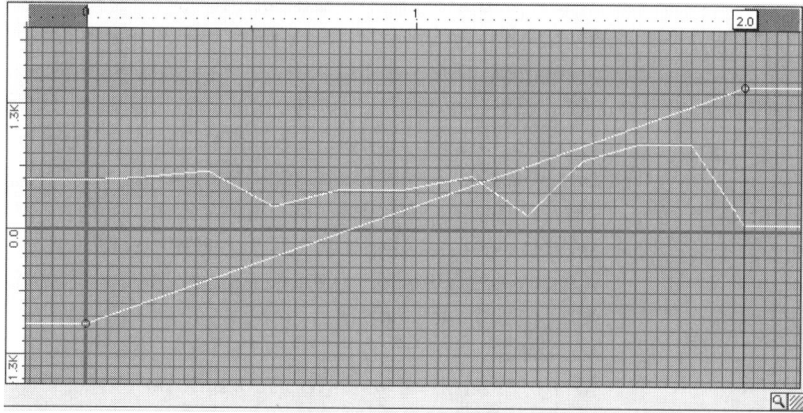

**FIGURE 7.5**    The X Position path is the angled line.

Here is another one. This time, you will bring the last axis into play so that you can see how they all work together. This is just another variation on the same "FCE Bank Data.prj" file. The finished version of this on the CD-ROM is named "FCE XYZ.prj."

*ON THE CD*

1. Open the "FCE Bank Data.prj" file, and add the **Z Position** data channel to the FCE.
2. Highlight the channel in the FCE, and fit it to the window. As you can see, it loads as a straight line because there is currently no motion data in it.

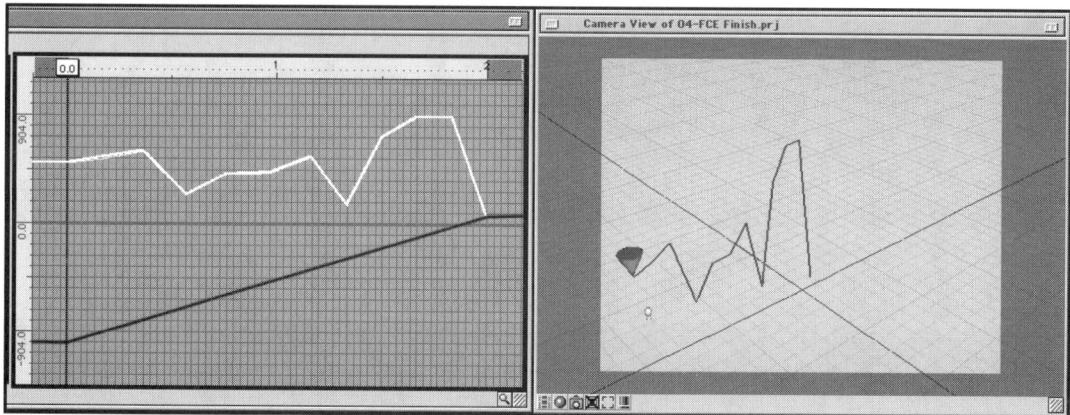

**FIGURE 7.6**    The FCE Finish project after the X Position move. Notice that the path was shortened in proportion.

3. In the **grid** area, **clicking** a path while pressing the **Option** key adds a keyframe. You want to add a KF at the very **end** and at the **middle** of the animation. That would be at the 1-second and 2-second points. Do that now, and you should have a horizontal line with a KF at the start, middle, and end. Precision is not necessary because you will clean it up soon.

4. Go to the path names listed on the left, and double-click the Z-axis to open the **Path Editor** (or **Key Channel** window, depending on who you believe). You see these three KFs listed. When you click one of them, its Time and Value data is displayed on the right side (see Figure 7.7).

5. As you click the keyframes in the Key List, they can be edited on the right to read **0/0, 1/0,** and **2/0** (Time/Value), respectively. Then go back into the KF 1.0, change its value to 2500, and see how the path changes in the graph and World views.

6. With the 1.0 KF still selected, go up to the Motion Type selector on top, and change it to **Hermite** and then to **F-Curve**.

Your entire path has now been curved to follow the **Z Position** path (see Figure 7.8). You can see how you can have great and independent control over every axis with the FCE. This was a lot to understand in one swoop, so feel free to go back and repeat these exercises again and to play around more with the

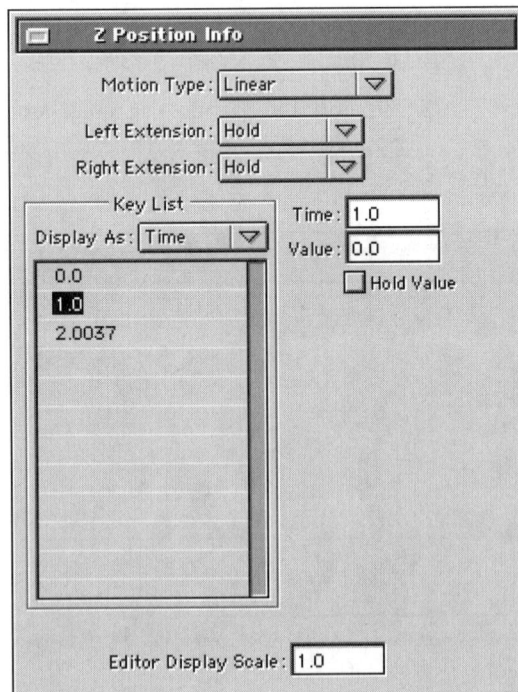

**FIGURE 7.7**   The powerful Path Editor.

FCE. The next tutorial asks you to flex some real FCE muscle. The basic concept you should walk away with from this is that in the Function Curve Editor, every channel is treated separately, offering tremendous control.

### Navigation in the FCE

Highlighting a path's name in the **channel list** on the left displays the path in the **graph window** on the right side. If it is not well centered for viewing, you can do one of the following:

- **Option-click the Magnifier icon**: This forces a Fit to Window.
- **Click-drag the Magnifier icon**: This works as it does in the World windows except that here, the X-axis and Y-axis of magnification are independent of each other, giving you more control.
- **Spacebar**: This creates a **Tracking** hand to move around the grid space.

### List View

The following controls are used to control items in the List view:

- **Shift-click**: To select or deselect list items.
- **Drag:** To rearrange items in a list.

**FIGURE 7.8**    The Z Position path adds extra control over the model's motion path.

- **Create a folder**:(using the New Folder icon on the tool FCE tool-bar). To organize groups of channels. This helps make sense of work that becomes very complex.

### Controlling the Data Paths

The following controls are useful in manipulating the F-Curve paths:

- **Marquee control point:** For selection.
- **Click-drag on a point or line:** To move and change values
- **Opt-click:** To create a new control point (KF).
- **Opt-Ctrl-click control point:** To delete a CP. Clicking the line deletes the CP on either end and restructures the path without.
- **Cmd-Ctrl-click control point:** To join or break a Beziér into two teeter handles. (If the teeters are split and you join them, slightly moving one updates the screen and pops it back into shape.)

**TUTORIAL**

## DOWN THE CASTLE STEPS

Now you will tackle a hard one. Although parts of this tutorial could be accomplished by other means, you will learn how to push the limits of this valuable tool. You are going to push your limits as well. A finished file is provided for you to pick apart, and a start file that you will use to follow the instructions.

**Here is the object**: Get your blue ball to make its way around a castle tower's outside staircase. This means that the ball has to move in a circular path and then you have to make that path descend from the roof to the ground. To make matters more difficult, you want the ball to look as though it is bouncing down the stairs (see Figure 7.9)!

You want to make the FCE do the work for you, which means that you are looking for a more global solution instead of getting stuck with a lot of frame-by-frame handwork. The advantage to this, as you saw earlier, is being able to do a cleaner job and have a setup that can be more easily edited for client changes. Take a look at the finished QuickTime movie on the CD-ROM to see

**ON THE CD**

what you will be creating; it is named "Down the Castle.mov."

1. Open "Down the Castle Steps-Start.prj," and you will see the model referred to as the **Castle**. Sitting on top of its staircase is the Blue Ball model. You will also see a motion that is already partly set up for you—but don't think that this will be easy! By clicking one of the **Preview** buttons in the

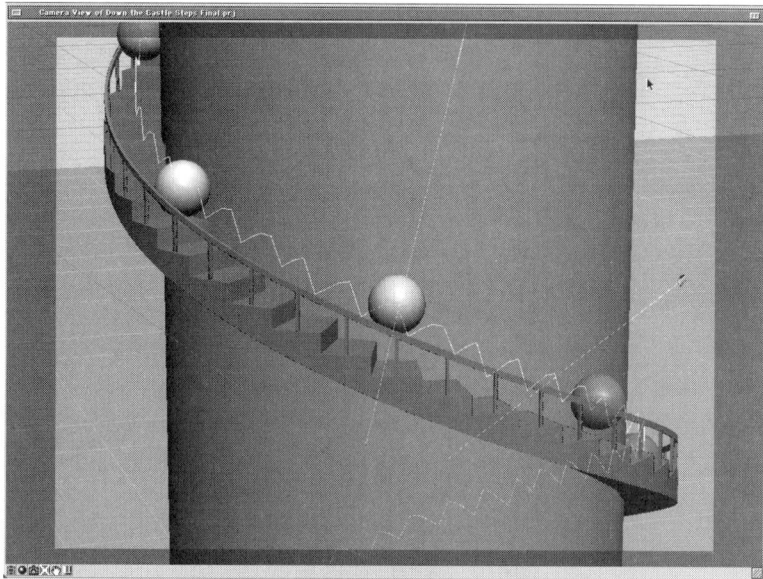

**FIGURE 7.9**  Camera window view of Down the Castle Stairs. Note the stair-stepped motion paths.

**Top** or **Camera** views, you can see the square motion path that is already there. Why square? Because this brings the ball into each sector—a good starting place from which you can then smooth the paths.

2. Go to the **Project** window, **double-click** to add the Blue Ball's **X, Z**, and **Y Position** channel data to the FCE, and then open the Function Curve Editor. Use the **Fit to Window** command if you need to. By clicking the paths, you see that both the X and Z linear motion paths are being used to create the ball's square animation. You can also see that they have the lowest number of keyframes necessary to accomplish this task.

How do you know where these KFs should be placed? Use a combination of a common sense and basic math comprehension. But when these resources fail you, simply drop the model in the approximate positions (using Top view in this case). The resulting KF data will usually clue you in to what needs to be done. Taking time to understand how the two paths work in tandem to move the ball around will give you a broader understanding of motion paths. Moving the Timeline to various locations helps.

3. In the FCE, double-click the **X Position** path to open the **Path editor**. There are four KFs displayed here, and the path is set to **Linear.** It is a good idea to click the KFs and make sure that their **Time** and **Values** are correct (see Step 4). This is especially important with an exacting project like you are doing.

4. You need to start converting this path into a circular shape, so change the **Motion Type** to **Hermite.** The Time and Value should already be set, but you must put in the following Tension values. Also, make sure that the **Linear** toggle is off.

| TIME | VALUE | TENSION |
|------|-------|---------|
| 0.0 | 0.0 | -1.0 |
| 1.25 | -200 | 1.0 |
| 3.75 | 200 | 1.0 |
| 5.0 | 0.0 | -1.0 |

5. Now do the same thing for the **Z Position** path, which has only three keyframes. Set it to **Hermite**, and its data values should read as follows:

| TIME | VALUE | TENSION |
|------|-------|---------|
| 0.0 | 200 | 1.0 |
| 2.5 | -200 | 0.0 |
| 5.0 | 200 | 1.0 |

6. Step back, and recognize that you just created two **sine waves** (see Figure 7.10). Also, notice that the motion path has become circular! Click Preview to see your new circular animation. Recall that you did not add any keyframes, but merely adjusted the settings for the few you had.

7. Now you need to have the ball animate down along its Y-axis, from its starting height of about 560 units to the ground level. You can do that easily by clicking the **Y-axis** (remember to use **Fit to Window** if you need it), adding a KF at the 5-second mark, and then dragging the KF down to zero. Try this, and you will see a good-looking motion path in the Camera window when you play it. It does not, however, take the castle steps into account. This would be fine if you had a ramp but looks odd with stairs. If you did add a KF at 5 seconds to try this quick solution, delete it now because you won't need it for the more advanced solution coming next. To delete, select it by clicking, or dragging a marquee, and then select **Delete Keyframe** in the ANIMATION menu.

8. So what is the advanced solution? Good question. In the **Path Editor** are the options Right and Left Extensions. These offer effects such as Repeat and Oscillate. They also offer the **Accumulate** setting, which is basically an additive version of a repeat function. For the Y-axis, you need to set its **Right Extension** to **Accumulate.**

9. Go to the beginning frames of the Y-axis path, in the upper left of the grid. Add two KFs (**Opt-click**), both very close to the beginning of the line. You are going to use them to create a single stair step shape. If you drag them into that shape now, you will see how the **Accumulate** feature works.

How can you get this stair-step shape to match the stairs on the model? How do you know exactly where the KFs should go? You could keep guessing, but that is time-consuming. A bit of math can help you out.

Take a moment to gather together the information already at your disposal. Doing so often makes a challenging project easier to solve.

- You know that the top of the Castle is about 560 units high. You could check that with the **Location palette** (the WINDOW menu) if you don't know it. (The path starts slightly higher—at the ball's center. It also ends slightly higher than the ground plane, so the Castle's height is equal to the distance of the ball's vertical travel.).
- I will tell you that there are 40 stairs in the castle, but that is something you could count in 2 minutes.
- You already know that the animation runs 5 seconds.

As you can see, no information is secret, and that is all the information necessary to find your **Time** and **Value** settings for those keyframes:

- **Time**: You need to know how long each step should take. You can find that value in time or frames, so 5 seconds × 40 steps = **0.125 seconds per step**.
- **Value**: Value is really the height of each step riser, of which you have 40, so 560 × 40 = **14 units for each riser**.

Based on this information, you can set the KFs as follows:

| KF | TIME | VALUE |
|----|------|-------|
| 1 | 0.0 | 580 |
| 2 | 0.125 | 580 |
| 3 | 0.125 | 566 |

When you plug in these numbers, you will get a motion path that is very usable and close to perfection (see Figure 7.10). The process took me less than 30 minutes to figure out and produce. It is unlikely that one could have done this animation by hand in that amount of time—and this solution is far more editable.

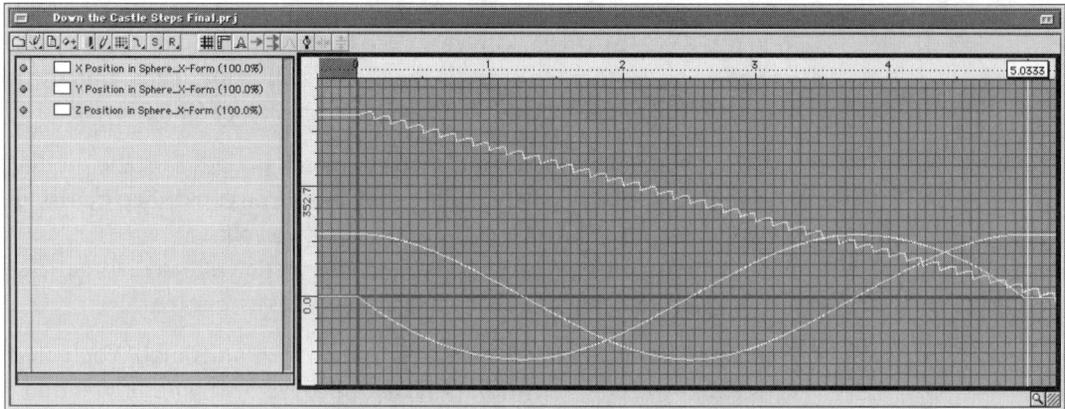

**FIGURE 7.10** The X and Y Position paths creating two sine waves, and the final F-Curve path for the ball descending down the staircase

Getting it to work perfectly is just a matter of editing a few values at this point. You can see in the final version that the value of the second KF is increased to create the feeling of more bounce, and the **Y Position** path is changed from **Linear** to **Hermite** so that you can add some arching and make it look more like a bouncing ball.

When you understand this exercise, you are well on your way to making good use of the Function Curve Editor. View the final QuickTime version on the CD-ROM; in which a few extra bouncing balls were added, along with a flourish or two.

*ON THE CD*

## EDITING VELOCITY OR CHANNEL DATA?

This evokes curiosity. Certainly, a Velocity channel is not the same thing as a data channel, so I wanted to see what would happen if the same model and animation were added to the FCE twice. Once using its **Velocity** channel, and a second time using its **Position** channel.

As you can see in Figure 7.11, it is very possible in at least some situations to use the two different types of path data in much the same way. See the accompanying QuickTime movie, which shows the two models animating almost identically. The file "Velocity vs Channel.prj" can be found on the CD-ROM.

**ON THE CD**

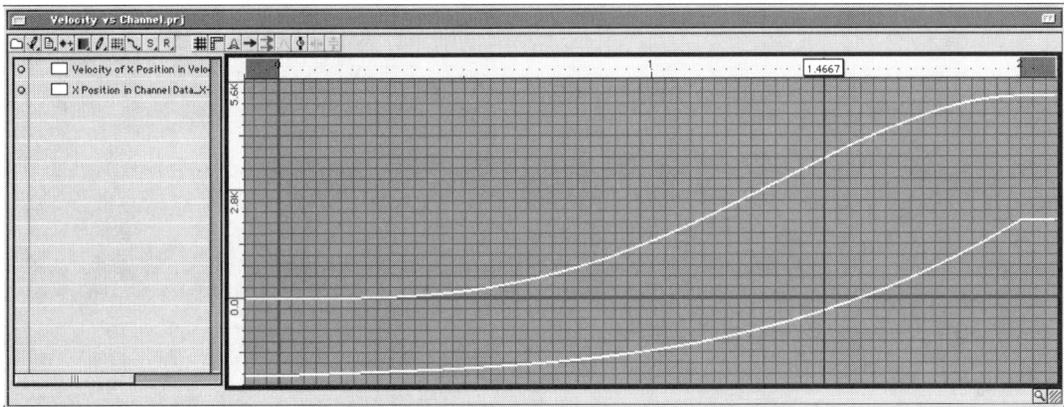

**FIGURE 7.11**    The FCE graphs look similar and have similar effects, even though one is velocity and the other channel data.

# 8

# THE DEFORMATION EDITOR

Very few animation tools are more creatively satisfying, and challenging, than deformation controls. These tools (as shown in Figure 8.1) let you apply a wide range of distortions to a model's geometry.

As of last count, Animator offers 12 deformer styles, and each one of these further offers an even wider range of customization options and refinements.

The current deformation options are:

- **Scale**: Very similar to using the Scale dialogs in a model's Info window, this also scales along the X-, Y-, or Z-axis. It is also very important to note that if you need to scale a model that you will later deform, using this scaling tool instead of the Info window's is better because the latter can create conflicting data sets and unreliable results.
- **Shear:** This option allows positional shifting between two opposing sides of a model, similar to the 2D shears of Adobe Illustrator and Photoshop.
- **Twist:** This is a rotation along the length of the chosen axis, creating a corkscrew effect when pushed to the extreme. (See the UV Mapping tutorial in Chapter 11, "Material Editor.")
- **Taper:** This allows a narrowing or expansion of the model's dimensions along one end of the chosen axis.

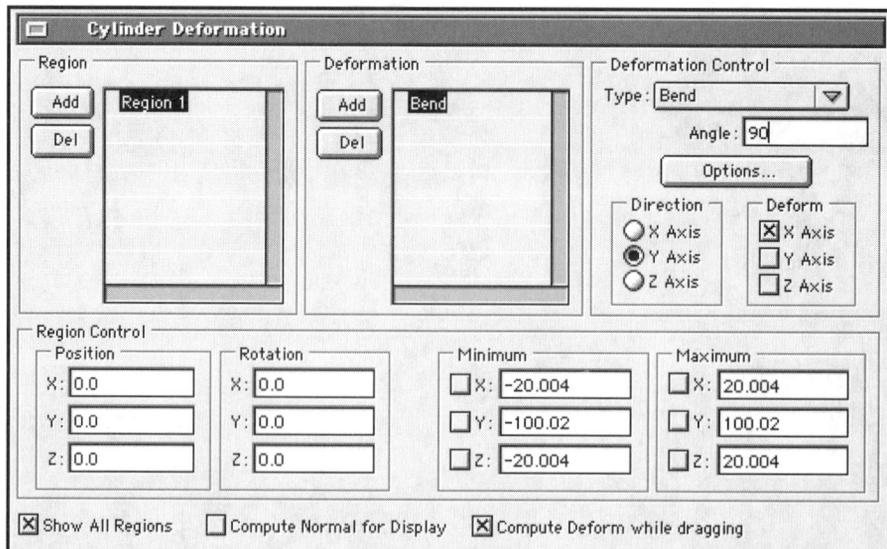

**FIGURE 8.1**    The Deformation Editor window.

- **Bend:** This allows the model to be bent in any direction chosen, along any axis. You can also choose to have the center pivot of the bend either along the base or the model's center. This is one of the most often used deformations and comes in handy all the time. It is great help for simulating a wide variety of organic movement for hair, trees, leaves, fabric, and other effects.
- **Bulge:** This is used to spread or contract the center areas of a model. It can be used in a linear fashion or set to use the Fillet option, which puts an extra flourish into the deformation.
- **Linear Wave:** This is excellent for creating quick sine wave–shaped models and can be used to create snakes and similar wavy effects.
- **Circular Wave:** This is similar to the linear version, except that the waves emanate from the center of the model. This is the setting used to create those almost clichéd 3D water ripple effects on a large flat Plane model. A sample of this is included on the CD-ROM, and you should note that the height of the wave is controlled by the height of the deform region settings (which are described on the following page). The taller the region, the taller the wave. Not just for use on flat plane models, this deformer can be used on other shapes to create nice undulations, and other graphic effects.
- **Stretch:** This allows for a more abstract or organic deformation. This style of deformation tends to get less use than the others, partly because its use is more abstract. Despite this, it is interesting and may give you the effect you need when others can't. A sample "Stretch.prj" is on the CD-ROM. The trick is to set the region to cover the mesh you want to deform and select the Capture Vertices button in the Options section. You then interactively move the region in world space.
- **Beziér:** This adds two sets of Beziér control handles that allow the animator to create a free-flowing and more character-like movement—a lot of fun to use and produces very creative results. The Options button opens extra controls, including a reset.
- **Beziér II:** This is a more advanced option that allows up to four control handles, placed up and down the chosen axis of the model. It's great when more complex control is needed but not always better than the simpler Beziér.
- **Bones**: This is more of a holdover from the way bones used to be added to a model to set up character riggings. In this method, you add the bone effectors in the World views, and you take bone 1 and its children and parent them to the model. The model is then activated in the Deformation Editor, using this Bones setting. This still works well but is not as flexible as the newer procedures, discussed in Chapter 14, "Character Animation."

## SETTING THE REGION OF DEFORMATION

When you begin a deformation, you first create a new region by clicking the **Region Add** button. You are asked to name your new region. The name you choose then appears in the Region list box at the left, and a colored bounding box appears around your model. This box is the region that defines which part of the model will be affected by any of the deformations applied to this one region. Logically, it defaults to the model's extents, but you can modify it at any time.

If you look at the bottom of the window, you see the **Region Control** area, which has edit boxes for **Position**, **Rotation**, **Minimum**, and **Maximum**. These settings modify the Region, based on the model's coordinates, and determine which sections of the model are affected by the deformations. Keep in mind that these values are completely animatable.

*The relationships of scale, rotation, and position between the model and its deformation regions are not affected by alterations in either the Link or Info windows. For example, if you apply a deformation, close the dialog, and then rotate the model, its deformation region rotates along with it. If this didn't happen, you would end up with unwanted effects.*

Deformation Regions serve two functions: Each region maintains its own list of deformation styles assigned to it, and it also defines the areas of the model where these deformers will be applied. Each region can have any number of deformations added to its list—practicality usually limits the number before the program does. Each deformation in a given list is, of course, applied to the same area. If deformations need to be placed on the model differently, additional regions have to be set up.

## SETTING THE DIRECTION

Any deformation you set has to be defined for the program by setting a minimum of two axes: a main **Direction** axis and one or more **Deform** axes, as shown in Figure 8.2. These might best be described as the *active* and the *action* axes, respectively.

The **Direction**, or active, axis is the base axis from which the deforms work. Your choices are **X, Y**, or **Z**. The **Deform** axis must have at least one toggle selected but often has two or all three toggles activated at the same time. Desired results are most often obtained when only one or two **Deform** toggles are selected and when they are not the axis selected for **Direction**.

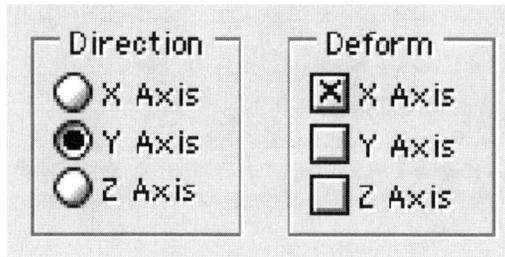

**FIGURE 8.2**  The Deformation control's axis settings in the Direction and Deform sections.

## INTERACTIVE EDITING

After you enter the basic settings in the Deformation Editor, you can proceed to any of the World or Camera views and click-drag on the model to edit the current deformation region settings interactively. What this means is that as long as the Deformation Editor window is still open, all your actions with the **Transform**, **Rotate**, and **Scale** manipulators are applied to the Deformation Region instead of the model, as would be normal. You can see the **Region Control** values update in real time as you do this. Your ability to do this moves the creative process along much faster.

*Keep in mind that this interactive editing is functional whenever the Deformation window is open. So remember to close it when you are done with your deformation editing, and return to normal mode. It is easy to forget this and find yourself making unintended deformation edits.*

## POLYGONS, MESHES, AND DICER

When using the Deformation Editor on models, the experience is often so fluid that it is easy to forget how dependent the process is on a model's mesh count. Although the interface allows for complex actions, the basic concept is that deformations are applied along the vertices of a model. The higher a model's mesh resolution, the more malleable and friendly it is to the process. Figure 8.3 shows the effects of varying a model's mesh resolution on the deformations applied to it.

Notice how smooth the deformation is with the highest-meshed model. As the mesh count goes down, the telltale polygon angling along the model's profile becomes more pronounced. In image D, the model

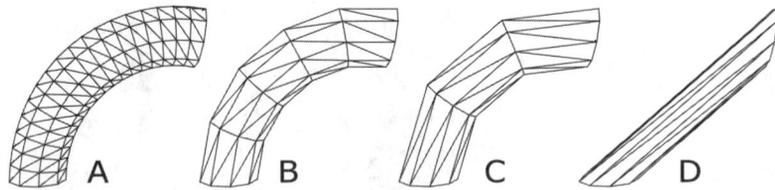

**FIGURE 8.3**    A basic Bend deformation applied to a model at various mesh resolutions. (A) a very high mesh resolution, (B) a moderate mesh count, (C) a low polygon model, and (D) no deformable mesh.

has only the minimum number of vertices required to produce its shape and has had no extra meshing applied to it. You can see that, because of this, the Bend deformation has no vertices or bend points with which to work and the result is not what you want.

*If you set up a deformation and it either does not work at all or is working in un-expected ways, suspect your model's low mesh count as a possible cause.*

There are basically three ways to get your models to become appropriately meshed:

- The method that gives you the highest level of control is to prepare your models in a polygon-based modeling program such as Form-Z. A polygon modeler gives you exacting control to do things such as add much higher mesh counts at specific bend points while keeping meshes better optimized where the extra polygons are not needed (see Figure 8.4). In addition, a good polygon modeler enables you not only to add a face but also to triangulate and orient it in a manner that allows for the best deformation later on. A model need not be created in a polygon modeler to take advantage of its features. You can create your models in EI Modeler up to whatever level of development is appropriate and then export it to a polygonal format, like the Fact format. Then you bring it into Form-Z or a similar application for final editing.
- Electric Image Modeler offers tremendous control of a model's tessellation. The only drawback is that the settings are generally uniform across a given object, so it is harder to increase the mesh selectively at a specific bend point. The notable exception to this is when using the ÜberNurbs toolset, which can make this easier.

**FIGURE 8.4**    The uniformly meshed model on the left contains many polygons that are not needed for the deformation, whereas the optimized model on the right has less than half as many polygons with no compromise to the quality of the Deformation.

Despite the advantages of a polygon modeler, you can easily find a good working balance for your tessellation settings in Modeler, one that gives you an appropriate polygonal resolution for your deformation work.

*For a neat trick on getting around the automated Tessellations in Modeler, see the section entitled "Manual Tessellation" in Chapter 1, "Introduction to Modeler."*

- The plug-in **Dicer** that comes with Animator can be used to mesh an existing model on the fly without any extra modeling efforts. This is a great timesaver and has been in the program for a long time. Although it is not as ideal a solution as obtaining a "more perfect" model, it solves many mesh problems quickly.

*Use Dicer on a model, and then save the model to disk under a new name. Import the new model, and use it instead of the original. This eliminates Dicer needing to recalculate at every frame.*

*Although Dicer adds mesh that smoothes the model during any future deformation work, it does not remove any angularity that already exists in a model.*

There is yet another approach to get appropriately meshed models: Create them within Animator by using the ÜberShapes plug-in with the Deformation Editor. This technique, which has been referred to as *Deformation* or *Parametric* modeling, offers great potential for certain needs. It also opens the door to some exciting animation techniques.

## STACKING DEFORMATIONS AND REGIONS

As you add more **Regions** and **Deformations**, you will see that they can be reshuffled in their list windows by simply dragging on the item's name. As you change the order, you will also see that this can often change the final results of the model. Take care when deciding in what order things are applied.

To understand why changing the order of deformations alters the outcome, think about how changing the order of a simple mathematical equation can alter the results:

(5 X 5) + 2 = 27, but 5 (5 + 2) = 35

The same is true for deformations. Take a simple Cube model from the ÜberShape plug-in—making sure that it is well meshed—and apply both a **Taper** and then a **Bend** deformation to it. You can see the progression of setting this up in the upper examples of Figure 8.5. Because the Taper is applied first, the Bend is applied to an already tapered model. The result is just as you would expect. However, in the lower examples, the order in which the deformations are applied has been swapped, and the results are not attractive.

## MODELING AND REMODELING WITH DEFORMATIONS

The Deformation Editor is most often thought of as being used for special effects, but it can also be a very valuable tool for modifying existing meshes.

Because graphic projects require a wide range of models, you are always looking for easier and faster ways to produce them. In many situations, it is much easier to create a model by reducing it to a more primitive form and using deformations to finish the job. Although Modeler offers a Cage tool, this tool does not compare to the control available in Animator's deformations. In fact, I have frequently brought models from other modeling programs—with competent deformation capabilities—into Animator for the greater control it offers.

You will explore this concept in the next tutorial.

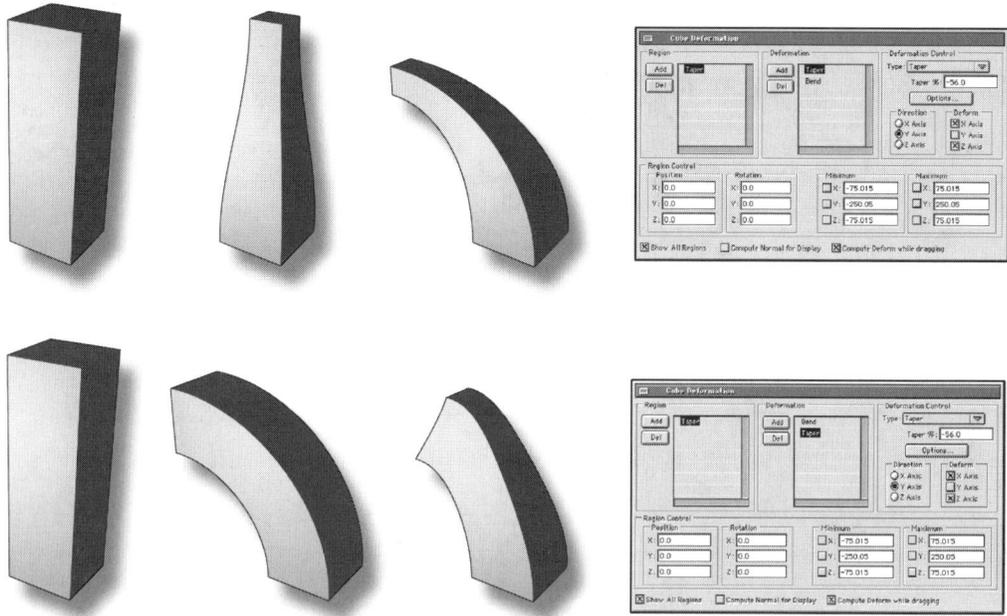

**FIGURE 8.5**   Top: Beginning with the base model, Taper is applied, and finally the bend deformation. Bottom: Base model, the Bend deformation is applied, and Taper last. The results are very different, even though only the order of application has changed.

**TUTORIAL**   **TWISTED TUBES**

This is a very simple deformation modeling job that takes only a few seconds to accomplish. Without deformations, this simple project could be much harder to create. The twisted tubes you will make are a good example of how you might make braided hair, twisted electrical wires, and a variety of medical/science models such as DNA. Figure 8.6 shows both the imported twin tube model and the final deformed model.

**ON THE CD**   The "TwistedTubes-Start.prj" file is in the folder for this section, as is the final project file for reference. The starter file has the model already loaded for you.

1. **Select** the model and open the **Deformation Editor** window.
2. **Add** a **Region**, and then change its default **Deformer** to **Twist**.
3. Set the **Direction** of this deformer to the **Y-axis**, because you want it to work on the model's vertical axis.

**FIGURE 8.6**   On the left, you see the "TwinTubes.fac" model as it was imported, and on the right, after some easy deformation modeling.

4. Toggle on both the **X-** and **Z-axis** toggles in the **Deform** section. Leave the Y-axis off—you do not want to twist that axis.

5. Set the **Amount** of the **Twist** to **720%**, which is two full revolutions (360×2). This can be set manually in the dialog box or interactively in the Camera or World windows.

6. The last step is to reduce the **region's** dimensions in the **Y-axis**. The **Minimum Y** defaults to about **−324**, but you want to raise that. Change it to **−200** instead. Do the same thing to the **Maximum Y**, bringing 324 down to **200**.

You are done! If you want this as a static model, you can go to the **OBJECT> Export Object . . .** menu item and choose which format you want to export it to, probably Fact, and then re-import it. This saves the program from having to re-calculate the deformation at every frame, which slows the system's performance.

## ANIMATION TUTORIALS

Deformation is great for modeling, modifying, and all kinds of effects for illustration work or static objects in an animation. However, animated deformations offer even greater capabilities—and complexities.

The next few tutorials deal specifically with animation. Before you begin, it is helpful to get an overview of the three ways deformations can generate an animation:

- **Value Deformation:** By changing the values in the deformer's edit box (usually expressed as a percentage or angle), over time, you can create an animation. This is the most obvious (and a simple) extension of what you have already learned.
- **Animated Regions:** The Region can be moved over time to deform the model. This is easy to do by either changing the **Position** and **Rotation** values for the Region or manually dragging the Region in the World views.
- **Static Region**s: Here, the regions remain in the same position—static—and only the models move. This is harder to set up, but can offer a more realistic animation and much more freedom for the animator.

TUTORIAL

**VALUE DEFORMATION**

ON THE CD

You will jump into this topic with a fun project that uses a well-meshed Hammerhead Shark model from the Fact Model Disk Collection (see "Resources on 3dNY.org" in Appendix A). All the files, including starting and finished project files, are in this section's folder on the CD-ROM.

1. The start file has several items set up for you so that you can jump in faster. The model is already imported and parented to a **Null Effector** found in the drop-down menus **OBJECT > Add Null**. A **Null Effector** is a nonrendering object set up as a parent object and aids many animation moves that can often be managed better if not applied directly to the model. As you will see, the Shark model will be loaded down with deformation keyframes, so instead, you will let the **Effector** deal with its overall movement in world space. The **light** and **cameras** are placed in position, and a **background** image has been added to the Camera's **Roto/Comp** tab.

2. **Select** the **Shark** model, and make sure that its animation **flag** has been enabled. Open the **Deformation Editor** window, and **Add** a new **Region**. Change the default deformer to a **Bend** setting; set its **Direction** to the **Z-axis** and its **Deform** to the **X-axis**. This will let you bend the Shark *from the Z-axis* and deform it in the X-axis.

3. Click the **Options** button, and enable the **Bend from Center** toggle switch. This way, when you deform the model, it will add a bend to the front of the Shark, as well as to the tail section. You can now plug a value

into the deformer's **Angle** edit box or interactively drag at the **region** in the World views to see it work. Be sure to zero out any changes you make.

4. If you plug a large number in to the **Angle** box (I used about 100 for testing) and view the model from the **Top World** view, you will see that it is bending from the center, as you told it to do in Step 3. Unfortunately, fish do not wiggle in such a symmetrical fashion from front to back. Instead, the tail end sways far more than the head, and the easiest way to adjust for this is to modify the **Region's Minimum Z** from the default of about **75 units** (the model's extent) to a larger number. Figure 8.7 shows the default **region** on the left (with a **Minimum Z** of about **–75**), compared with the **modified** version on the right, where the **Minimum Z** is increased to **–150**. Notice how the Shark's head now has less deformation and the tail end has more.

5. In your final version, the number for the **Minimum Z** edit box is adjusted down, from the test of –150 to a value of **–140**, so input that number now. In the **Deformation control's Angle** box, put a value of **–50**.

6. Move the time to **1.0 second**, and replace the **Angle** value with a **positive 50**. You will see the Shark's body swing in the opposite direction now.

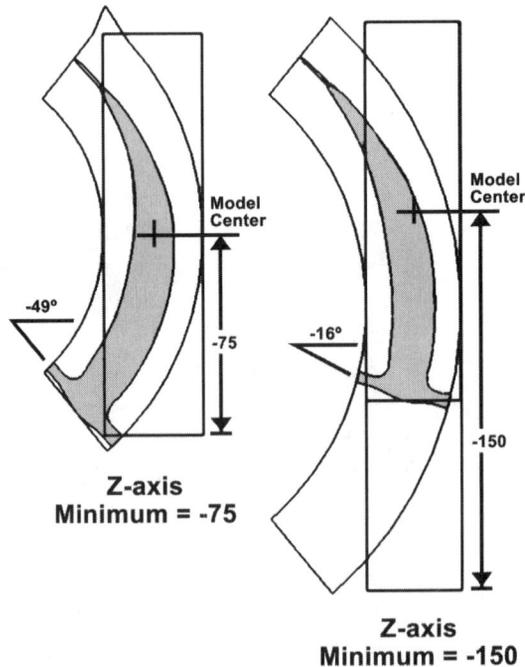

**FIGURE 8.7** The Top World view on the left shows the default Region setting and its resulting Deformation. On the right is the modified version.

7. Again, change the time setting to **2.0 seconds**, and put a **–50** in the **Angle** box. Continue this, alternating at every second across the remainder of the animation's six seconds. The values you put in need not be –50 and 50. Varying the numbers improves the look of the animation. Your final file varies between an absolute value of 35 and 70. When done, slide the time back to the zero mark.

8. In the **Deformation Editor** window, click the **Add** Region button again, and set the new **Deformer** to **Bend** as well. This time, set the **Deform** to the **Y-axis**, because you are going to be deforming the model vertically this time.

9. Because you do not want the vertical motion to be as obvious as the horizontal, you are going to apply a slower oscillation effect by altering the value every 2 seconds instead of every second, as you did before. Varying the numbers is important for a sense of realism, and your final project file has absolute values that range from 20 to 60. Feel free to experiment until you find what you like and have finished this second pass on the timeline.

*In the final project file, you will see that the keyframes are not set to the exact 1-second increments instructed here. I did a little shifting to improve the animation's pacing.*

10. Be sure to close the **Deformation Editor** window when you are finished.
11. If you **preview** what you have done so far, the shark should appear to be swimming in place. It will probably look funny standing still, but this will change in the next step.
12. To add positional motion to the model, you apply the moves to the **Effector**. Again, make sure that its animation **flag** is enabled. You can now drag the Effector around to set up any type of animation move you want. In the final version, I have set the **Effector's Position** values in the **Info** window to the following:

* **First frame: X = 90, Y = 0**, and **Z = 537** puts the shark at the upper-left corner of the Camera view and far enough away to substantially decrease its size.
* **Last frame: X = 26, Y = 12**, and **Z = -214** places the model almost behind the Camera view and on the lower right of the screen (see Figure 8.8 on the next page).

13. When you **Preview** the animation now, it looks convincing. You can go back and make more adjustments to improve the look further.
14. Your last step is to make the **Background** image visible in your **Camera View** window and active in your final render. Because the image was already loaded into the Camera's **Roto/Comp** tab for you, you need only make it active in the Camera window by clicking the **Rotoscope**

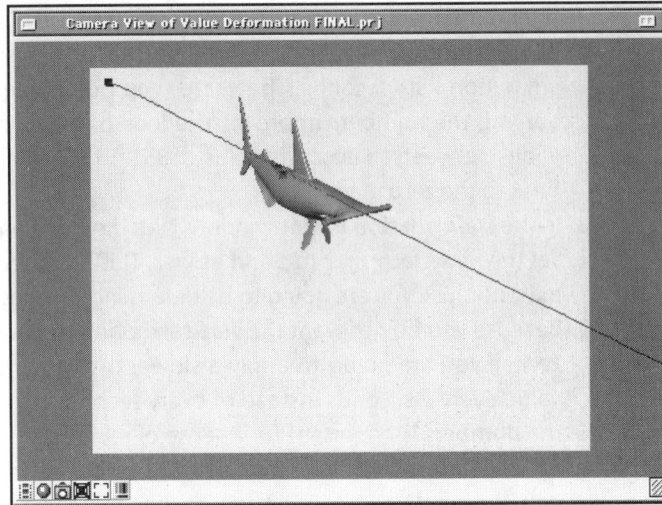

**FIGURE 8.8**   The Camera View window shows the motion path line of the Effector and Shark animating across the screen from a distant upper left to a near lower right.

icon/menu at the bottom of the window. It is the icon at the far right that looks like NTSC color bars (see Figure 8.9). Click it, select the "Water.img" option, and the image appears behind the model.

15. Now open the **Render Settings** window. The final project file has this already set up, but you can render this out however you want. The final QuickTime movie is on the CD-ROM and named "Deform Shark Attack.mov." Figure 8.10 shows a Snapshot render with the background image.

**ON THE CD**

Aside from the movement with the Effector, this character animation is accomplished in just a few minutes by simply changing the deformation values. With more work, you can certainly make it look even better.

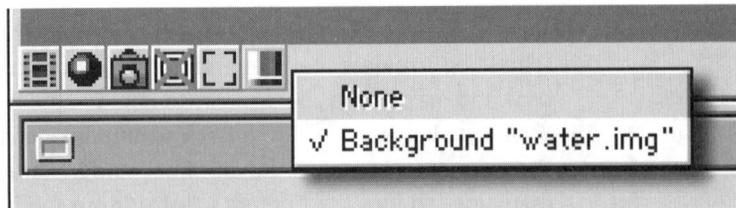

**FIGURE 8.9**   The Rotoscope icon looks like NTSC bars.

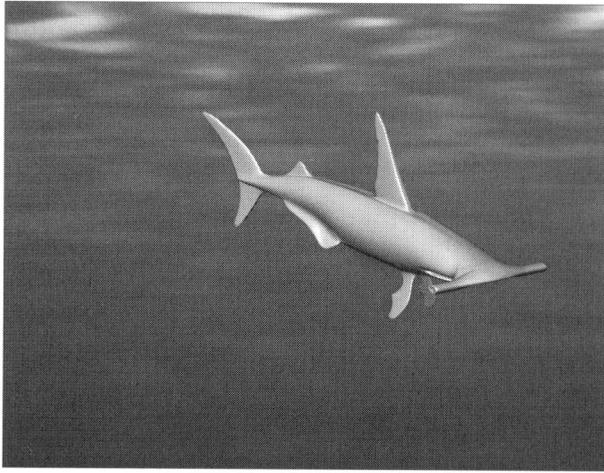

**FIGURE 8.10**   A Snapshot rendering taken from the final animation.

## ANIMATED REGIONS—BASIC

You will start simply by setting up an easy deformation movement. In this section's Basic folder on the CD-ROM you will find a starting project file and a completed version to have as a reference. The starting file has a simple **Über-Shape Plane** model placed in the center of the scene. It is created to have an elongated shape and is well meshed to allow smooth deformations.

1. Select the **Static Plane** model, and open the **Deformation Editor** by going to the drop-down menu **ANIMATION> Deformation Editor** or by double-clicking the model while pressing the Ctrl-Cmd keys.
2. **Add** a new region, and name it if you like.
3. **Add** a new **Deformation** to this **Region**. It will be added as the default **Bulge**, but you will change it to the **Linear Wave** selection.
4. The settings for the **Linear Wave d**eformation should be set to the following:

   * **Amplitude**: Mine is set to 15; yours should be close to this.
   * **Direction**: The Y-axis.
   * **Deform**: Only the Z-axis.

5. Your Deformation window should look very similar to Figure 8.11 on the next page. You can also see that the default dimensions for the Region match the model's extent ranges, as seen in the Info window. The model should now be displaying the new deformations clearly in the Camera's obliquely positioned window view (see Figure 8.12 on the next page).

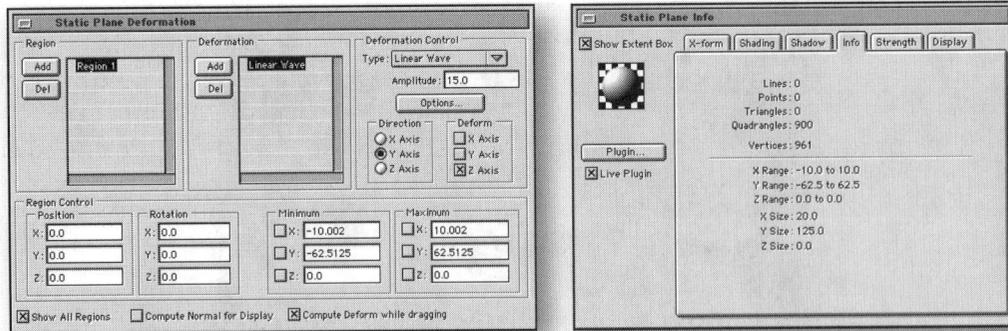

**FIGURE 8.11**    The Deformation window and Info window. Notice how the Region dimensions match the model's extents.

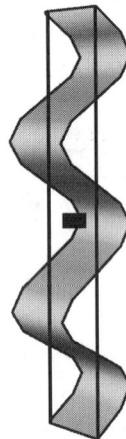

**FIGURE 8.12**    A close up of the view that should now be visible in the Camera window. The model should now be taking on the deformations.

6. Now let's have some fun. Enable the animation flag at the left side of the Project window.

7. In the **Deformation** Editor's **Region Control** area, highlight the **Position Y** edit box, and put in a value of **125**. In the Camera window, you see that the bounding box representing the **Deformation** has now moved to sit just above the model and that the model itself is no longer deformed.

8. Slide the **Time** thumb to the **5**-second mark. Go back into the same **Position Y** edit box, and this time type in **–125**. The deformation box is now sitting just below the model, and a keyframe diamond is automatically added to the model's timeline in the **Project** window.

9. Now, when you **Preview** the Camera window to screen, you have an animation showing the model in a static position, but with the Deformer Region passing through it to create the animation. You can see this in the **QuickTime** movie named "StaticModel.mov" on the CD-ROM.

*ON THE CD*

10. Here's a quick interactive variation on this. Highlight the region's bounding box in the Camera window (or select the region in the Deformation Region list box). You will see that the region highlights with its own **Manipulator** handles.

*It is hard-to-impossible to tell whether Manipulators are those of the Deformer or of the standard variety by looking at them. The only way to tell is by knowing whether the Deformation Editor is open or closed.*

11. Click and drag the **green Y-axis Transformation** handle. As you drag it up and down, you see that the **Deformer** is easily passed through the model. As it does, the model is squeezed into shape like toothpaste through the tube's opening. You can also hold the **R** key for **Rotate** or the **S** key for **Scale**, as in normal world transformations, only here it acts on the **Region's** orientation and size instead of the model's.

---

**T U T O R I A L**

**ANIMATED REGIONS—ADVANCED**

Here you are going to combine the preceding two tutorials and take the Deformation Editor one important step further. By moving both the Region and model at the same time in opposite directions, you can create many sophisticated effects. You will work with the Shark project again. Both the starting and final project files can be found in the Advanced folder on the CD-ROM.

*ON THE CD*

When you open the starting project, you see that I have already imported the model and positioned the lights and camera. The Shark model has a simple forward-animation movement applied to it, and you are no longer using the **Effector** to move the model. The reason is that you are going to be creating only two keyframes with this technique, so moving the model directly is much more manageable now. If you Preview it, you will simply see a move that looks like the previous exercise but without any deformations on the model.

1. Make sure that the timeline is set to the first frame. Select the **Shark model**, and open the **Deformation Editor**.
2. **Add** a **Region**, and change the default **Deformation** to **Linear Wave**. Set its **Direction** to the **Z-axis** and the **Deform** to the **X-axis**. This deforms the model in only the X-axis, as you did in the preceding tutorial.

3. You need to set the **Deformation control's Amplitude** to a value that can be seen but is not overbearing. After some fiddling, I settled on a value of **5.0**.

4. If you look at the model in the Top view window (see Figure 8.13, A), you see that a curve has been added to it, but it is still a few steps from being animated. Click the **Options** button, and in the **Waves** edit box, replace the default 2.0 with **10.0**. The Top view should now show a fish with many curves (see Figure 8.13, B).

Unlike the preceding tutorial, which has many edits, you are only three steps from finishing. You need to enlarge the Region to give the Shark a larger area to swim through the deformation. Then you need to animate that enlarged Region in the opposite direction from the one the Shark is swimming in, so that they pass through each other in a progressive fashion.

5. To enlarge the **Region**, go to **Maximum Z**, and where it is set to the default of about 75, change it to **700**. You should see the region's size get much longer in the **Z-axis** in the Top World view.

6. If you Previewed it now, the **Region** would merely follow along the model, and you would see no deformation. You need to offset the **Region's Position** in the **Z-axis** by replacing the default of zero with a value of −700. You should now see the Region displayed across the Camera view along the Shark's animation path.

7. (Last step) Move the timeline to the last frame, and in the same Region Position Z-axis you just edited, it will probably have the −700 you input at frame 1. At the last frame, you want it to become 0.0, so plug that in now.

Preview your animation. It looks better than your first shark attack and was easier to produce after you learned some basic steps.

Add the background image as before.

### TUTORIAL EXTRA CREDIT

Observant readers will have noticed that when the Shark model is animated as described in the preceding section, you get an apparent elongation of its Z-axis as an unwanted by-product. What is happening is that you are getting this stretching in the X-axis (the axis you have the deformer on), which makes the model look as though it is bending. Whenever something bends, its length shortens, except, of course, in the Computer Graphics (CG) world, so your brain tells you that the model became longer *because it didn't become shorter!* Quite funny, and easily corrected by adding an extra **Scale Deformation** placed **before** the Linear Wave.

**FIGURE 8.13**  Both images are taken from the Top World view. Image A is the default waves setting of 2.0, and B is after you change the value to 10.0.

1. **Add** a **Scale Deformer**, and in the **Deformation List** window, **drag** it above the Linear Wave. Set its **Deformation** to the **Z-axis**. With the Scale deformer, the direction setting seems not to matter, and you only enable or disable an axis using the Deformation toggles.
2. Because you just want to accomplish a bit of corrective surgery here, you do not want to add too much reduction, so the final file has the **Scale %** value set to −15%. The model's position will shift, which you can correct for, if you like. The final rendered QuickTime animation is on the CD-ROM and is named "Moving RegionModel.mov."

**ON THE CD**

---

**TUTORIAL**

**STATIC REGIONS**

The preceding tutorial's setup is fine for many situations, but its limitations become more obvious when you want greater control and freedom of movement for your model within its world space and deformation regions. What you really want is a way to do the opposite of what you have been doing: Rather than move the **Deformer** around freely, you want to move the **model** in and out of the Deformer's space.

You are going to solve this problem by setting up *independent* deformation regions, using parent Effectors. Because these deformation regions are independent, their positioning in the world space is not controlled by the model's position. This may sound like good news for the deformers, but it is especially good for the model, which can now come and go as it pleases, with no more need to *counter*-animate the deformers. You will again turn to the trusted Shark model.

The **start project file** for this tutorial only has the model imported and sitting at world zero. The camera and light are set up, but elements are less critical here, so you can move things almost anywhere you want.

1. Go to the drop-down menu **OBJECT> Add Null**, and click to place the **Null Effector** close to the center (again, not critical).
2. Highlight the **Effector**, and open the **Deformation Editor** window. **Add** a **deformer**, and change it to **Linear Wave**.
3. Set its **Direction** to the **Z-axis** and its **Deform** to the **X-axis**.
4. Set its **Amplitude** at about **5.0**, and under the **Options . . .** button, put a value of **50.0** in the **Waves** box. Both of these can be altered to suit your taste.
5. Now go down to the **Region's** size settings, and put a **–2000** in each of the **Minimum** edit boxes and a **positive 2000** in each of the **Maximum** boxes. The idea here is to make the deformation Region large enough to extend to any part of the world you may want to animate the shark within. Close the Deformation window.

*The number of deformation* **waves** *you set in Step 4 will be stretched out over the large* **Region** *you just created. This is why you need to put in a higher than normal* **wave** *frequency. You can see just how large your new* **Region** *is in Figure 8.14.*

6. Set the Effector's **Lock flag**.
7. Select the Shark model, and open the *Joint/Link Editor*. In the **Inherit** tab, make sure that **Inherit Deformations** is toggled on and all other toggles are off (this can vary, depending on other needs, of course). Also check that **Link Type** is set to **Free**.
8. **Parent** the Shark to the **Effector**, and you are finished with the setup. Painless!

Now, wherever you move the model—up, down, back, or forth—it will ripple through the deformation waves (along the X-axis, as set) without your needing to make any other adjustments. You will find it extremely liberating to avoid much of the technical rigging that normally bogs you down when you want to spend your time being creative. Spend a few minutes playing with the setup, and then try setting up an animation.

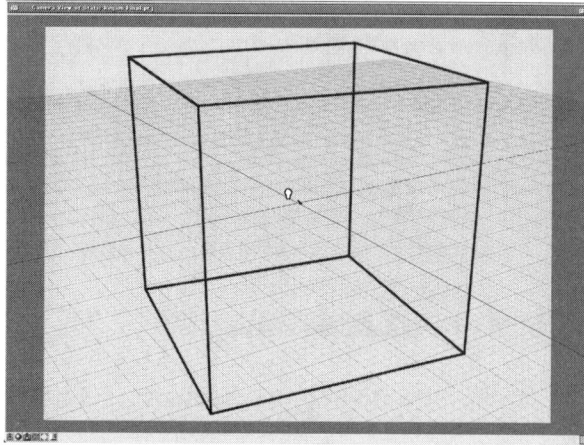

**FIGURE 8.14**    This is a Camera view of the world. The Camera's position has been dollied way back, so it is not a view you will see. Note how large you have made the Deformation Region and how small the Light and Shark models are in the center.

### STATIC REGIONS AND MULTIPLE MODELS

After a static Region is set-up and a model is added, it becomes easy work to duplicate the model and to create any number of instances of that model in the scene.

*Geek Note: The term* Instance *in 3D refers to situations in which a virtual model or* **alias** *is placed in the scene, instead of actual geometry. This can improve system response when working on a scene in which hundreds or thousands of copies of a model are used. The word has come to be used much less specifically to mean a* duplicate. *EIU does not offer true instancing capabilities, but its native system runs very efficiently nonetheless.*

After a child model of an Effector is duplicated, the child can also be duplicated, thus saving you a few steps. You then must offset the extra model in some way to differentiate it from the original. This can be done by either time-shifting its keyframes in the Project window or repositioning it in world space—or you can do both.

On the CD-ROM, you will find both a project and a QuickTime file named "School of Sharks.mov" that shows an example of this technique with positional adjustment applied, as shown in Figure 8.15 on the next page.

**ON THE CD**

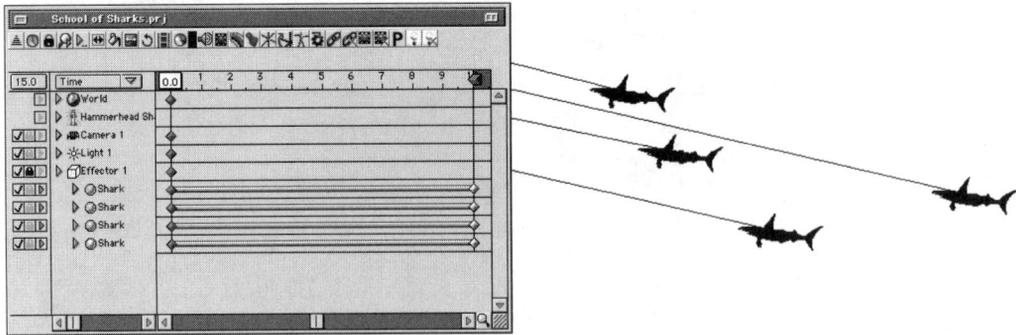

**FIGURE 8.15** The Project window shows how the duplicated models merely fall into place below the deforming Effector parent object. And how the Shark models are offset along the Z-axis to allow for variations in the deformations applied.

In this animation, the duplicate Shark models are moved into other positions in the World views. Special care is taken to offset each of the models from the other in the Z-axis, as shown in Figure 8.15. This is done because the deformer's **Direction** is set to the **Z-axis**, and if the models were animated shoulder to shoulder, they would very obviously be moving in the same deformation path and look unrealistic, which you do not want here. In other situations this would, of course, be a desirable effect.

There is another alternative here. Rather than duplicate the child model, you could duplicate the parent Effector with its child. This would enable you to set different deformation attributes to each model and not worry whether they are swimming two or more abreast. Even though it is more work to set up, this approach also offers you the ability to apply a different personality to each Shark model. You could have one that tends to wiggle more than the others or another that takes longer waves.

One last thought on this is to remember that you need not use multiples of the same model. For example, you could just as easily put in models of different fish.

*On the CD-ROM, you will find a QuickTime movie named "Shark Animation .mov" that shows an example of a work-in-progress using the exact scene you created earlier. The specific project file for this movie is not included on the CD-ROM. Instead, you are urged to take the scene you made and develop your own animation.*

**ON THE CD**

*Note that the Function Curve Editor was brought into play with a number of data tracks, for better control of this project.*

TUTORIAL

## STATIC REGIONAL MODULES

When you have the concept of static Regions under your belt, you can take it much further by setting up Regional Modules that can do some amazing animations.

In the previous examples, you created Deformation Regions that, for all practical purposes, extended across the entire virtual world. What if you were to take this concept and, in a sense, *minimize* it by reducing the size of the Region so that it covers only specific zones in the world's space? What you would have is a modular block of deformation that the model(s) could move not just through but also in and out of. Like any modular blocks, they can be stacked to create additive (or subtractive, or multiplied, and so on) effects. The folder for this topic contains both starting and final project files.

**ON THE CD**

1. The **Start** file has an ÜberShape Cylinder model placed in the scene and parented to an **effector**.
2. Select the **effector**, and open the **Deformation Editor**.
3. **Add** a **region**, and change the **deformer** to **Bend**. Then plug in the following values:

- **Angle**: 90.0 degrees
- **Direction**: X-axis
- **Deform**: Y-axis
- **Minimum** X, Y, and Z: –80
- **Maximum** X, Y, and Z: 80

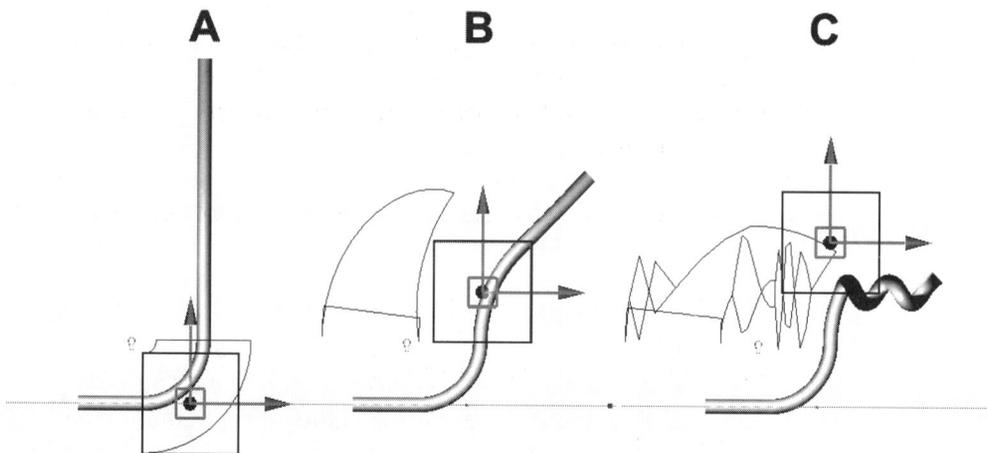

**FIGURE 8.16**    Images A, B, and C show how the model looks after adding each of the three regions in this project. The heavy lined box in each image is the actual region.

The model should now look like Figure 8.16, A, in the Front view window.

4. **Add** a second **region**, and again change the **deformer** to **Bend**. Then plug in the following values:

- **Angle**: 45.0 degrees
- **Direction**: Y-axis
- **Deform**: X-axis
- **Minimum** X, Y, and Z: –80
- **Maximum** X, Y, and Z: 80

The model should now look like Figure 8.16, B, in the Front view window.

5. **Add** a third **region**, and change the **deformer** to **Bend**. Then plug in the following values:

- **Angle**: 720.0 degrees
- **Direction**: Y-axis
- **Deform**: Z-axis
- **Minimum** X, Y, and Z: –80
- **Maximum** X, Y, and Z: 80

6. The model should now look like Figure 8.16, C, in the Front view window.
7. Close the Deformation Editor.
8. Make sure that the **Cylinder** model has its animation file enabled.
9. Set the time slider to **frame 1**, and in the Cylinder's **Info** window, place a value of about **–500** in its **Position X** box in the **X-form** tab.
10. At **3 seconds**, put a value of **700** in the same edit box.
11. Preview the animation, which should look like the QuickTime file in the project's folder.

You can see how easy it really is to daisy-chain a few deformers in a row and open the door to new effects. There are a few things to keep in mind as you create your own:

- Keep your thoughts on where the actual Deformation Regions (the black boxes in Figure 8.16) are placed, and virtually ignore the Editor's screen representation of the deformer's shape (the squiggly lines in Figure 8.16). This is because this preview was designed for one deformer at a time, and as you can see in the image, Figure A's 90-degree deformer outline is accurate, but B's and C's will only confuse the situation.
- Creating stacked deformations worked logically when the order that the model passed through them matched their order in the Region list box. When this was not the case, the results were unpredictable, and some Deformers simply refused to cooperate at all.

- Working in order, as you did in this tutorial, also lets you see what you are building as you go. However, this is not always an option. Your model was long enough to reach all your deformers; not all projects will be like that.

  Animator does not always do a good job of correcting the model's normals when multiple Regions are stacked. You can see this in your Preview movie. In a final rendering, though, this problem does not exist.

- When the Deform window is closed and you go to move the model through the Deformation Regions, it will not update in real time as it does when only a single Region is applied. You need to release the model and allow it to update.

- Not all Deformer styles are as friendly to this type of application as Bend is, so you need to experiment and see how each one can meet your needs. Sometimes there are alternative ways of doing the same thing. For example, if you want a Deformer to enlarge a model, you can use the Scale, but you may find the Bulge works better in some situations. Experiment!

- Because Deformation is inherited, you can create several levels of Parent/Child Deformations to enhance the effect or merely to enable you to affect several models at once.

- It is easy for this type of work to become very involved. A complicated project does not always need to be done in one swoop. Many moves can be broken down into a few individual renderings and composited together in post production.

## FEATHERING REGIONS

There is a caveat to using modular deformation Regions, which you didn't see in the last exercise. Although some deformations lend themselves to having a model enter into their air space—such as the Bend deformer you used—others create a much too harsh ripping effect on geometry as it enters or exits the Region. These can compromise the success of the effect.

A good example would be one of the earlier tutorials you did in this section, "Animated Regions—Basic." This has a Plane model standing still and the Deformer flying into its space to deform it. If you look closely, you can see an abrupt transition where the deformer's edge hits the Plane. It is reproduced here using a Cylinder model, and you can see the similar edges in Figure 8.17 (left) on the next page.

What if you were to take a few regions, instead of one, and gradually build the effect incrementally? Much like an image that is posterized in

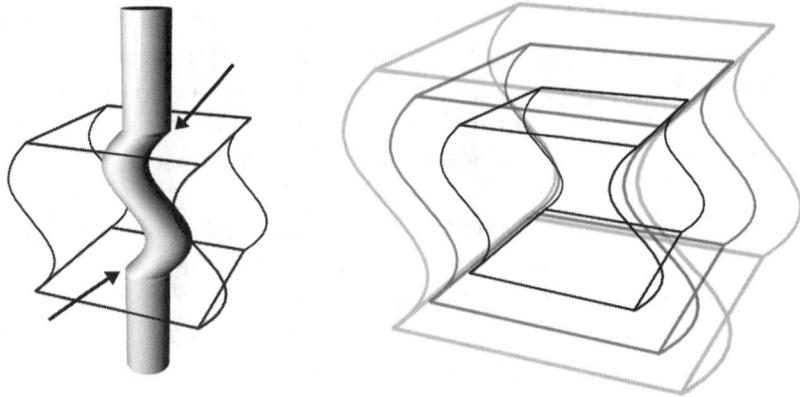

**FIGURE 8.17**   Left: A Cylinder model with a simple Linear Wave Deformation Region applied. You can see the harsh edges where the region begins and ends. Right: Stacked feathered deformation regions (presented as an illustration since Animator's preview of stacked regions is not clear). Each progressively smaller region has a stronger deformation value.

Photoshop, if there are enough steps, the eye and brain do not readily see the stair stepping occur. Figure 8.17 (right) illustrates the concept of stacking Regions that are increasingly smaller in dimension but set to increasingly higher deformation values. If the numbers are entered correctly, you come out with a smooth transition.

**ON THE CD**

In the project files in this section on the CD-ROM, you will find two feathered projects. The first, "Feathered Blocks.prj," is designed for a model to fly through. It has been set up similarly to Figure 8.17, with feathering above and below the central section. When the model is passed through the Deformers, it looks like the model you see on the left side of Figure 8.18.

You can see in Figure 8.18 that the level of increased deformation is relatively smooth, even though you have used only five Regions to build the effect. Less critical projects could get away with as few as three. On the right side of the image, you see a model that was included as a control subject to give you a frame of reference for what is happening here. This model on the right has had the same number of Linear Waves applied to it as the largest Region of your feathered model, and it has the Amplitude value set to match the sum of all five Regions in the feathered assembly. Presented this way, you can see how severe a deformation it really is and now appreciate how good a job the feathering on the left is doing. Figure 8.19 shows the Deformation Editor for this setup.

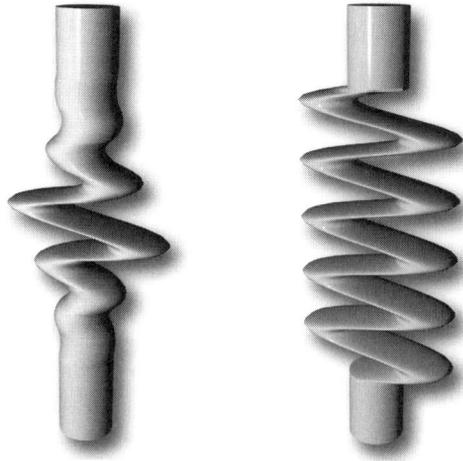

**FIGURE 8.18**    A Cylinder model passed through the block of feathered Deformation Regions on the left. The right side image is the same Deformation without feathering.

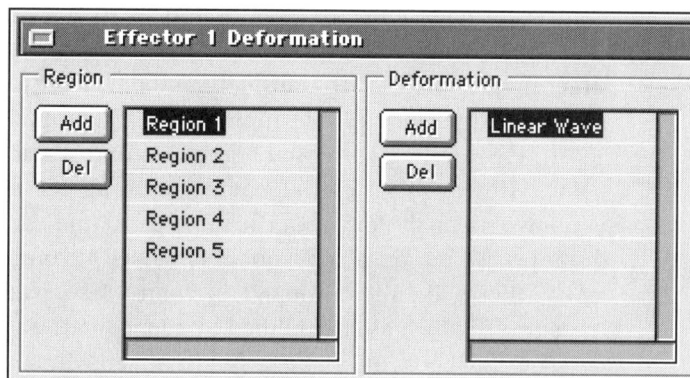

**FIGURE 8.19**    The Deformation Editor with the various regions set up to create the feathered effect.

I will let you open the file and dissect it, rather than go step by step. Here are a few notes on the setup, to help you out:

• Each Deformer has its own particular needs, and in the case of Linear Waves, you can see that you have every alternate Region's Amplitude value set to a negative number. As an alternative, you could set the Phase to 180 degrees. We won't go into the math as to why this is needed; suffice it to say that it is and it works.

- Unlike having the Regional blocks next to one another, as you did before, Deformers nested within one another seem not to care in which order they are applied, giving you greater freedom in setting up your work.
- The real trick to getting this to work is to make sure that the waves in each Region line up properly. This is done with some simple math. In your sample file, you can see that a Region with a Y-axis dimension (the only important axis in this project) of 160 units (−80 to 80) has a Wave Frequency of 8.0 and a Region with half its Y-axis dimension has half the frequency rate, or 4.0. Because all are centered on world zero, any alignments are taken care of automatically.
- The Amplitude settings determine the maximum Deformation and, in combination with the region's dimensions, also determine the slope at which the feathering occurs. In your example, each successively larger region has had its Amplitude Value cut in half. Remember that this number is cumulative across all the Regions.

Remember, that you have two feathered project files in that folder? Well, the second file, "Feathered Blocks+Zone.prj," is probably more useful because it does *half* as much as the preceding example. The last feathered Deformation Region was set up to have both an increase and a decrease in Amplitude, with a peak in the middle. This sample is a one-way street that can be used to transition a model either into or out of (depending on the direction) a static, nonfeathered Deformation Region.

To create this transitional region, you must stack Regions as you did before. However, instead of having them all centered on one another, you have them all starting at the same point and each extending different distances. When an actual model is passed through the transitional region, it looks like the left image in Figure 8.20. Notice that it only has a transition applied, as exemplified by the icon art on the left.

The model on the right has both a transitional Region and a simple static Region, which is placed above, as shown by the icon art to its right. In both cases, you have gone from a straight cylinder model at the very bottom and smoothly transitioned into something else as you moved upwards. The fact that it can work so cleanly with a solid block really has to inspire an animator's creativity.

## ATTENUATED REGIONS

There is one other way to solve this problem with hard-edged Deformation Regions, and that is to animate the Deformation Value after the model has entered its air space. What this means is that a model is ani-

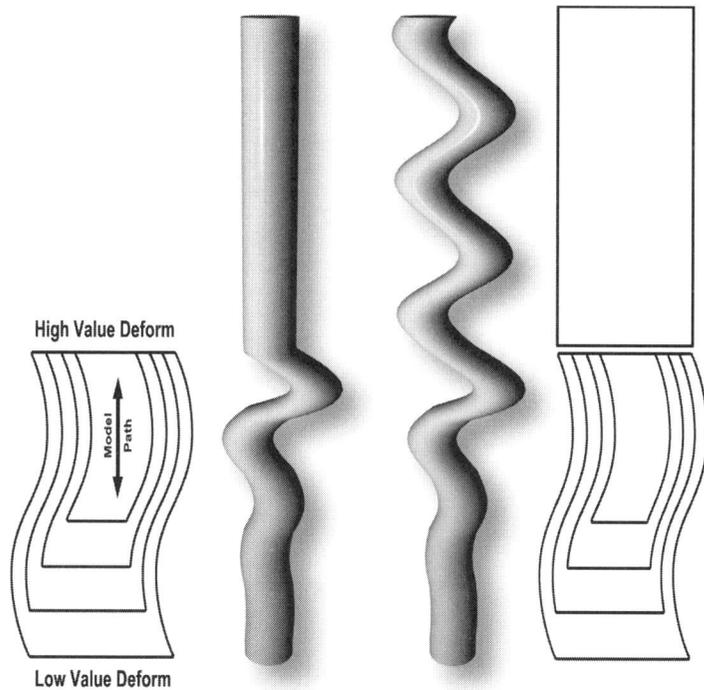

**High Value Deform**

Model Path

**Low Value Deform**

**FIGURE 8.20**    A transitional region setup that provides a transition when a model is going to, or coming from, a static deformer block. The image on the left is the model passing through a transitional Region. On the right, the same model is passing through the same transitional Region and also an adjoining static Deformation block.

mated to fly into a deformer's Region while the deformer's Value is set to zero. Sometime after the model is inside the Region, the deformer's Value can be animated to a higher strength. This would operate something like what you see in Figure 8.21 on the next page.

This technique has some good points and some bad. The good is certainly that it offers perfectly smooth transitions and does not require extensive setups with stacked regions. On the negative side, unlike the transitional technique where you can see a model pass through into the new region, this method applies the effect to the entire model at one time—a stylistic difference you may or may not care about.

Another drawback to this way of doing it is that it is not as automatic as the transitional and instead requires that the animator hand-set the

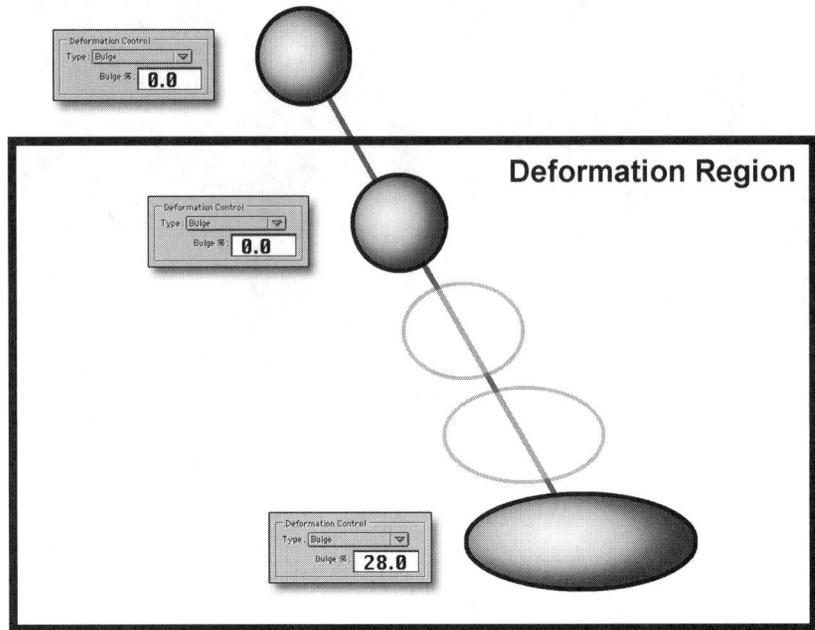

**FIGURE 8.21**    The Deformation Region's Strength value is kept at zero until after the model enters its zone. Then the value can be animated up to full power.

timed animations. If the model's timing changes, the animator must make manual corrections to the effect. Finally, you are limited to using this with no more than one model per region, unless they all convert at the same time, of course. If you have multiple models that must convert at different times, you need to set up each one with its own region and hand-tool the timing of each one. Now, I am not making this out to be a bigger deal than it is. I am merely suggesting that the transitional stacked region method offers a lot of automation and might relieve the animator of additional work when changes come around.

*The Deformation Amount Value, which is obviously animatable, is a channel that can be added to the Function Curve Editor. Controlling these edits from the FCE can make the job much faster moving than having to open the Deformation Editor each time and select the correct region and deformer.*

**ON THE CD**    In this section's folder on the CD-ROM, you will find two files that exemplify this technique. The first is a very basic sample of how to set this up and make it work. The name of the file is "Attenuated Regions.prj."

The second project is considerably more involved and great fun. It is called "Rotten Tomatoes," and you will find the project file, model and Modeler files, and rendered QuickTime movie on the CD-ROM. This project is a cute little animation showing a bunch of rotten tomatoes being thrown down onto the ground one after the other and going *splat*. Figure 8.22 shows a few rendered frames from the QuickTime movie. Note that this entire effect was generated only using the Deformation Editor. There is no mapping or plug-in use in the project (except for ÜberShape, which was used for the ground plane).

**ON THE CD**

In this animation, each tomato is assigned a separate Effector parent, which has two different Scale deformers attached. When each Effector's assigned tomato model gets within a couple frames of impact with the ground, one Scale deformer enlarges the model in the Z- and X-axes, while the second deformer squishes the model along the Y-axis. Together, the two simulate the tomato compressing on impact and then spreading. No, it was not able to create a tomato breaking in half with its innards flowing out. For this, you would need other treatments. However, for a fast and very plausible cartoon-like animation, this was perfect. (Because this is not a commercial job, we will let the problem with the green leaves slide—just this once.) Open the file, and play with it to get a better understanding of how it works.

**FIGURE 8.22**    A few frames from the Rotten Tomatoes QuickTime movie on the CD-ROM.

# 9

# THE MORPH EDITOR

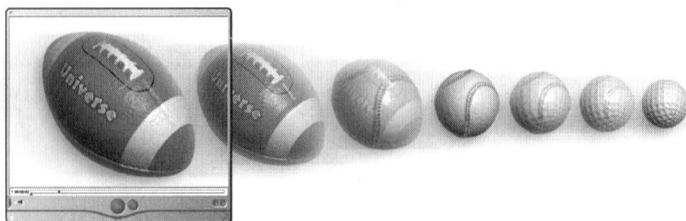

The Morph Editor (ME) can be thought of as a close cousin to the deformation controls in Animator. The basic difference is that, whereas the deformations are applied from a predefined library with broader brush strokes, morphing takes a customized and more *micromesh* approach. Morphing excels at animating small details of the mesh, giving exacting control over each individual vertex if so desired. It is this level of control that has enabled it to be so successful with facial animation, lip sync work, and many other areas of animation.

Most people first became familiar with the 2D morphing that was all the rage in the graphics world after Michael Jackson's *Black or White* video with facial morphing came out. "Wouldn't it be cool if you could do that in 3D?" you would see posted in the early 3D forums online, and, of course, it did not take long for developers to oblige. The first 3D morphing techniques used a keyframe-to-keyframe approach, which let you set a key for model A and then a key for model B. The computer would map a path from A to B in the allotted number of frames, as long as the model meshes matched (a restriction we functionally still live with today).

This key-to-key approach was a breakthrough, and for about 15 minutes, we were all very happy to have it. Then the limitations began to set in, and we realized that we were stuck having to build a separate model for each and every keyframe. Ugh! But it worked for us until something better came along, in the form of weighted morph targets, shown in Figure 9.1 in Animator's Morph Editor.

Think of this evolution in terms of audio for a minute. First, we had mono, and life was simple because all we needed was a volume control. Then some yahoo with two ears invented stereo, and we were all in trouble, until another bright fellow came around with a balance control, and life was good again—unless you were a professional in the music field, in which case, you put everything through your mixing board.

Okay, working with one model is, of course, the same as monophonic sound in this analogy, and keyframe-to-keyframe is akin to running a stereo signal. If you are a professional, you need to run many audio (or Target!) channels through the system at the same time to be able to crank some up and turn others down. This is just what Animator's Morph Editor window and its weighted morph technology allows you to do. The Morph Editor acts like a mixing board for your Anchor model and its many targets.

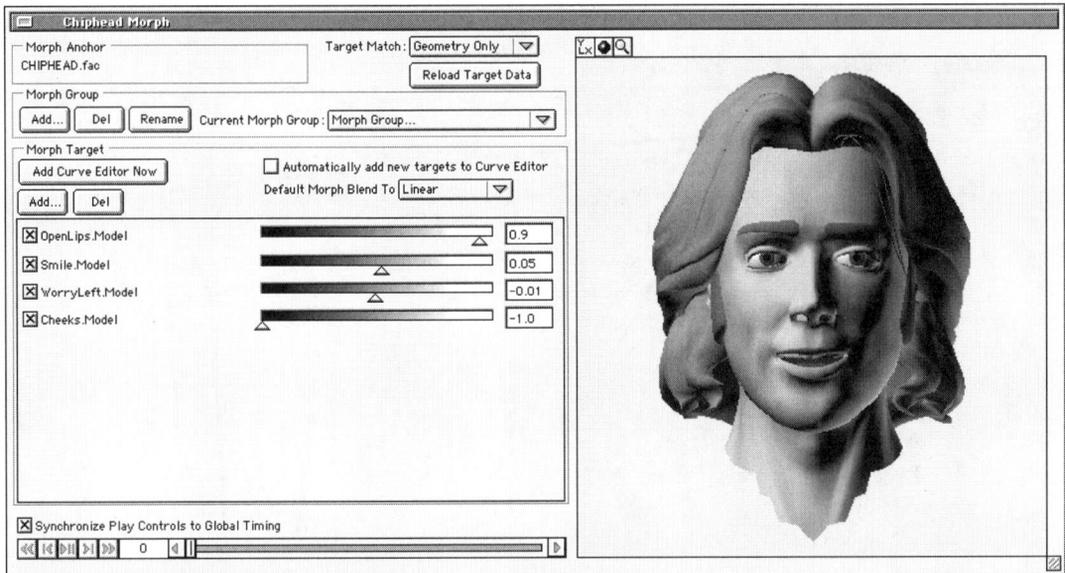

**FIGURE 9.1**   Animator's Morph Editor window.

## HOW DOES MORPHING WORK?

I will take a step back now and explain just how the morphing technology works, so that you can better understand how to make the most of it and avoid any pitfalls.

Morphing is based on a system of differential coordinates, another product from the makers of "Sounds Worse Than It Is." What this system does is make comparisons between your original base model, which Animator calls the **Anchor** model, and any morph **Target** model. It does this by reading a vertice's local coordinates and then reading the coordinates of the Target's matching vertex. For example, assuming that the target vertex has moved more than 20 units in the X-axis, morphing enables you to have the base vertex move from its original position to the target vertex—or any point in between. In reality, the vertex is likely to have shifted in all three axes, as you can see in Figure 9.2 on the next page. The corner vertex (labeled *A* in the diagram) is from the original Cube model, or the Anchor model. The vertex labeled *B* is from the Target model that the Anchor will want to morph into. These corresponding vertices will be morphed from one to the other along the shortest line between the two points, represented here by the dashed line. When this is set up, you can use the slider in the Morph Editor to move the vertex to any position along that line.

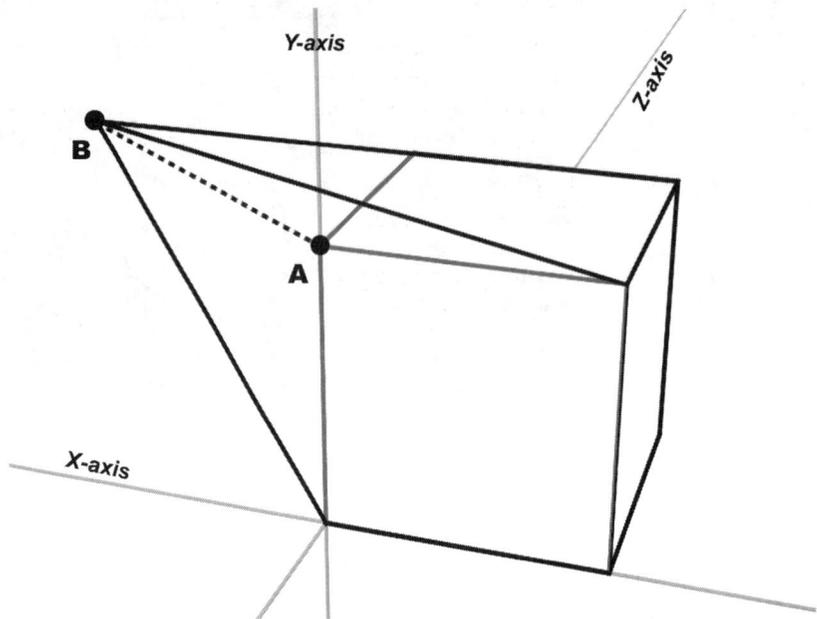

**FIGURE 9.2**   Morphing allows you to move vertices between the original location and the target.

Now, in real-world use of the Morph Editor, it is more likely that hundreds or even thousands of vertices will be shifted at the same time during a morph, which makes more work for the computer. In addition, if you are using a weighted system and mixing a few target models at the same time, the workload on the computer can increase exponentially, slowing down both your screen draws and rendering. The morph effects are so impressive, though, that they are worth it.

---

**T U T O R I A L**   **BASIC MORPH TUTORIAL**

---

**ON THE CD**

To get your feet wet, you will set up a straightforward morph. You will be morphing the Anchor model directly to the Target model, which will be using the ME in a **key-to-key** style of morph. If you are new to the ME, it would be a good idea to follow along. If you are already familiar with the Editor, you may simply want to read through this tutorial. In this section's folder on the CD-ROM, you will find a project called "Basic Morph." Both the Start and Finished versions are included.

1. The Start file has the **Anchor** model already loaded. It looks like a green sphere-like object placed in the center of the world.
2. Go to its Animation flag, and enable it.
3. **Select** the **Anchor model**, and open the **Morph Editor** by going to the Animation drop-down menu **ANIMATION> Morph Editor**.
4. Like other editors in the program, the Morph Editor organizes its targets into groups.

      In the **Morph Group** area at the top of the window, click the **Add** button to create a new Morph Group. Each Morph Group can have as many as 10 targets added to it, and you can have virtually as many groups as you want. You are asked to name your new group, and the name is added to the **pop-up menu** at the right.
5. At the very top of the window is a pop-up menu labeled **Target Match** (more on this in the "Importing Tips" section, later in this chapter). For now, simply set it to its **First** setting.
6. Now you have a Morph Group to add a Target to. In the **Morph Target** area (which is just below the Group controls), click the **Add** button, which opens an Open dialog box. Select the morph Target named **Spokes**.
7. When the Target is successfully loaded, you see a **slider control** appear next to its name in the **Target list box**. There is also a value-editing box right next to it, and one or both methods can be used to input the morph values desired. Note that the slider **defaults** to the middle setting of **0**. Normal operation has the slider going in the **positive direction**, which is to the right. If you move the slider to the right, you see the morph action interactively taking place in the preview display at the far right. Releasing the mouse button is required to update the **World** and **Camera** views. Although you can drag the slider to the left of center zero, you do not do that now because this particular model does not lend itself to the technique. Instead, click in the edit box, and put in *0* to bring the slider back to dead center.
8. At this point, you need to change the animation's point in time to the last frame. You could do this with the **Project** window, but the Morph window also offers you a time slider at the bottom. It is less accurate but still very usable, with both a frame count readout and even **VTR-style play controls**. These controls can speed your work along and help with diagnostics when troubleshooting complex animations.
9. After the time is set to the final frame, you can move the **Morph Target slider control** all the way to the right so that the edit box shows a value of **1.0**. All views of the model should show the spokes sticking out (see Figure 9.3 on the next page).

**FIGURE 9.3**    The Morph Editor set up with the target fully dialed in at the last frame of the animation. Note the edit box set to 1.0, which represents 100%, and the time slider and frame count at the bottom of the window.

10. Close the Morph Editor.
11. In the **Camera** window, click the **Preview** button to confirm that the animation is correctly set. It should show a sphere at the start and then the spokes gradually pushing out to create the prong-like item you see in Figure 9.3. If you have anything different, go back and check your steps.
12. Although the morph is done, perform one more step to add a flourish to the animation. While still in the last frame, open the model's **Info** window, and plug a value of **360** degrees into the **Rotation Y** box. This makes the model spin on the Y-axis while the morphing is taking place. **Play** the **Preview**. The final rendered QuickTime movie is located in the project's folder on the CD-ROM.

**ON THE CD**

---

**TUTORIAL**    **MORPH RELAY RACES**

Let's take this keyframe-to-keyframe style of morphing and make it interesting. Instead of merely going from one model to the next and leaving it there, what if you wanted to have your model morph from one, to another, and then another, ad infinitum? There are many applications for techniques like this, such as the opening sequence of a sports show on TV. You have seen these effects before, when the football morphs into a baseball and then into yet another

item. Usually, though, these effects are accomplished in 2D instead of 3D. Here, you are going to do this in 3D and benefit from the extra depth, camera angles, and overall versatility it offers you over the 2D approach.

You will find a start project file named "SportsMorphStart.prj" in this section's folder on the CD-ROM. This file has only the camera and lights set for you so that we can begin on the same page. In the same folder, you will also find a copy of the final project file to look at as a reference to this tutorial, as well as the rendered QuickTime movie from this project. A drop shadow and timing shifts were added in After Effects to make it easier to view, but all other effects are from the Animator file.

*This tutorial has three models (one Anchor and two Targets) that are a bit on the heavy side, with almost 33K polygons each. If your system runs slower than normal, that is to be expected.*

1. **Open** the **start** file, load the "Football.fac" model into the scene, and **enable** its **Animation flag**.
2. In the **Football's Info** window, change its **Rotation X** to **80** degrees. It is now better framed in the Camera window (see Figure 9.4).
3. With the Football model selected, open the **Morph Editor**, and **Add** a **Morph Group**.
4. For these models, leave **Target Match** set to **Full Match,** which is a rare situation but fine for these models.
5. Now **Add Morph Target**, and load both the "**Baseball.fac**" and the "**Golfball.fac**" **Target** models. These models appear in Figure 9.4.
6. The sliders and model preview should look like Figure 9.5 on the next page at the first frame, 0 seconds.

**FIGURE 9.4**    The Football, Baseball, and Golf Ball Target model. Note that the striations on the Football are a by-product of the modeling technique used, and will be covered up with texture and bump maps.

**FIGURE 9.5**    The slider settings and preview at the first keyframe.

7. Change the time to **1.0 seconds**, using the **timeline** or the slider at the bottom of the Morph Editor.
8. Set the "**Baseball.fac**" **Target**'s slider control value to **1.0**. This turns the football into a baseball (see Figure 9.6).
9. Change the time again, now to **2.0 seconds**.
10. Move the **Baseball** slider back to its original **0.0** value, and now change the **Golf Ball** Target slider to **1.0** (see Figure 9.7).
11. The Project window now shows three keyframe diamonds for the "Football.fac" model.
12. Close the Morph Editor, and click the Camera window's Preview icon to see what is happening.

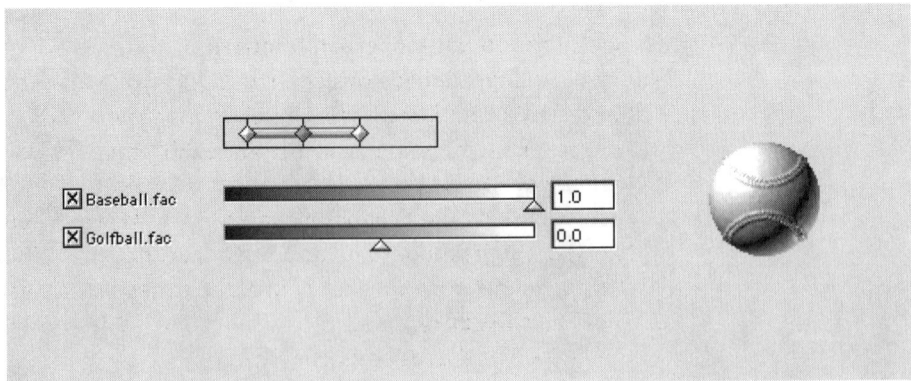

**FIGURE 9.6**    The slider settings and preview at the second keyframe.

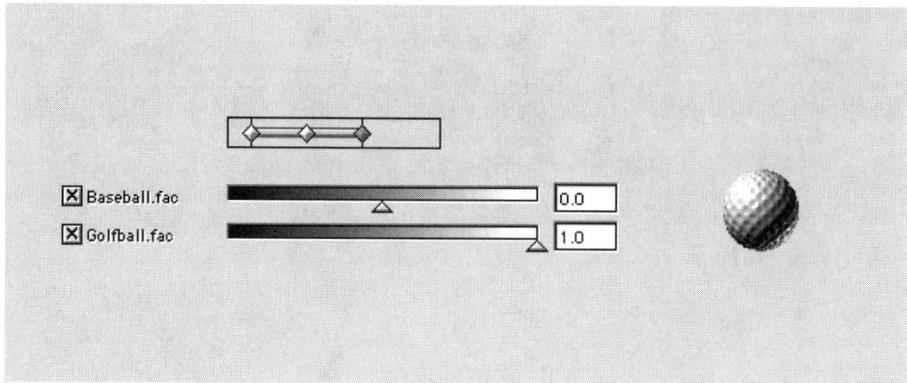

**FIGURE 9.7**    The slider settings and preview at the third keyframe.

You should be seeing a smooth morph from the football to the baseball and then to the golf ball. If all looks good, make this look professional with some mapping.

*This part assumes a familiarity with the Material Editor and gives a swift overview of the steps. Because we have not covered these tools yet, you can, of course, skip this section and return to it at a later time if you prefer.*

### THE FOOTBALL MAP

The following steps take you through the process of adding the first texture map to this project:

13. Select the Football model at **0.0 seconds.**
14. Open the **Material Editor** window, and in the **Diffuse** tab, click **Add** to load the "**Football.img**" (see Figure 9.8 on the next page).
15. Double-click to open the map's **Texture Editor** interface.
16. In the **Projection** tab, set the map to the **Cylinder** projection. Make sure that it does not **Tile** in either direction. Set its **Wrap** to **360** degrees to go fully around the model, and add just a sliver of extra height to make sure that the model does not sneak out at the edges. I used a value of **1.01**.
17. The map's **Rotation** needs to be set to **0.0**, **–7.0**, and **180 degrees** for the **X-**, **Y-**, and **Z-axes**, respectively.
18. In the **Filter** tab, the map should be set to use only its **RGB** channels. Close the Texture Editor window.

**FIGURE 9.8**   The "Football.img" and "Baseball.img" texture maps and Alpha channels.

19. Back in the Material Editor, select the map in the **list** box, and **copy** it. You can now go to the **Bump Map** and **Specular list** boxes and **paste** it in. In both cases, you set the **Use Channel** selector in the **Filter** tab to use only the **Alpha** channels. For Specular, click the **Invert** toggle as well.
20. Finally, in the top section of the **Specular** tab, lower the Specularity **value** to about **0.3** and its **size** to about **25.0**.

### THE BASEBALL MAP

To add the second texture map, this one for the baseball model, follow these steps:

21. Change the time to **2.0 seconds**.
22. Add the "**Baseball.img**" map (as shown in Figure 9.8) to the "Football.fac" model, and set **Projection** to **Spherical**, no **Tile**, **Wrap** to **360 degrees**, and Band to **180 degrees**. Set its **Filter** tab to use only the **RGB** channel.
23. **Copy** and **paste** the map into the **Bump** and **Specular list** boxes, and change both from **RGB** to **Alpha Only**, as you did with "Football.img."

### MATCHING MAPS AND MORPHS

After the maps are loaded and set up, go to each of the three keyframes and set the map's **Transparency** or **Strength** value appropriately. This Strength slider control is found in each map's **Texture Editor**, under the **Filter** tab.

The logic behind setting these is very straightforward:

- At **frame one**, you want all three **Baseball maps** (Diffuse, Specular, and Bump) to have a **Strength** setting of **0**. You want all the **Football** maps turned up to their **maximum** settings (which may be less than full strength, of course).
- The second keyframe at **1.0 seconds** reverses the preceding settings, so you see that the Baseball maps are applied to the Baseball model and the Football maps are now turned down.
- Your **third keyframe**, which is at **2.0 seconds**, should have both the Baseball and Football maps turned down. Because the **Golf** Ball has no texture or bump maps, you have nothing to turn up at this keyframe.

Animator previews only the texture map located at the top of the **Diffuse** list box, so do not expect to be able to preview the mapping accurately from within the program. Instead, make a small frame preview render, and see what it looks like. Take a look at the "SportsMorph.mov" QuickTime movie on the CD-ROM. The final animation looks like Figure 9.9.

**ON THE CD**

**FIGURE 9.9**   Excerpts from the rendered movie.

## THE NEXT LEVEL OF MORPH EDITING

The real power of the Morph Editor comes into play when you start adding more than one target at a time. Take the example of morphing a character model's head. **Anchor** models intended to work with multiple

targets should generally be designed in a more neutral fashion, as shown in the facial expression of the first image in Figure 9.10. The **Target** models are then dialed in, to add the expressions, which, in this case, could be a smile or lifting eyebrows. When adding the **Smile** and **Brows** in the Morph Editor, Animator averages the differential coordinates and allows you to use both targets at the same time, as shown in the remaining images of Figure 9.10. This is much better than the key-to-key style of morphing, which restricts you to going from one model to another and does not allow the multiple model mixing you have here.

It gets even better. In the example, both targets are affecting different parts of the Anchor model, the brows and the mouth area. However, Animator allows you to combine targets affecting the *same vertices at the same time*. You could add both **Smile** and **Mouth Open** targets and have it look completely natural. See how this is done, in Figure 9.11. What the Morph Editor does here is that, rather than average the positional data for two models as before (the Anchor and Target), it now averages them for three models (Anchor, Smile Target, and Blink Target). Now things get interesting because this means that you no longer have to create every single pose as a new model. Instead, you can combine targets to create new facial expressions on the fly.

**FIGURE 9.10**    The Anchor model (left), with the Smile Target dialed in (center), and both Smile and Brows Targets (right).

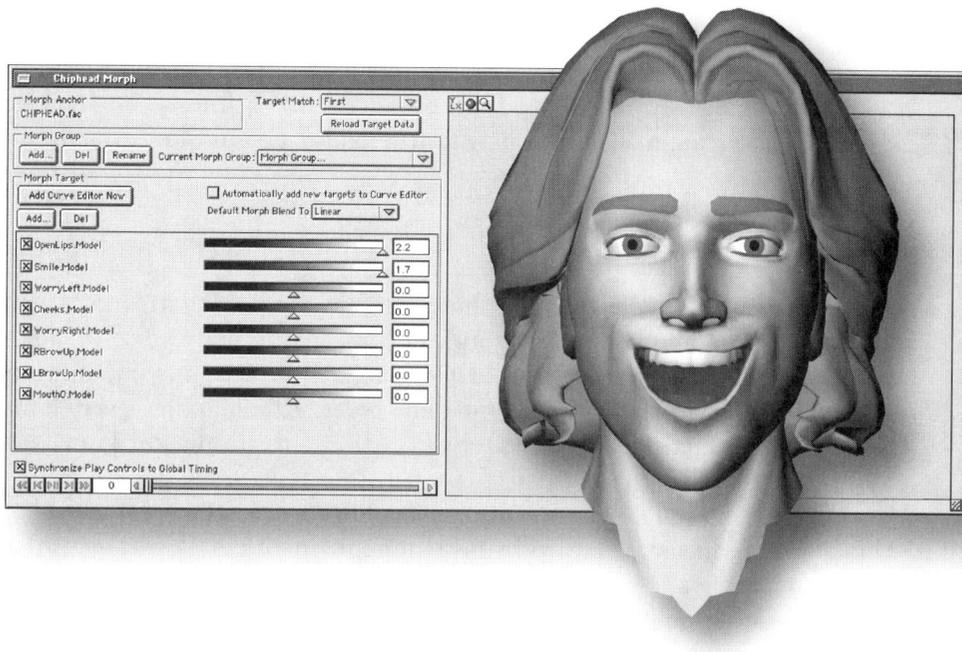

**FIGURE 9.11**    Note that both the Smile and OpenLips Targets are dialed way up. Despite the fact that both affect the same areas of the Anchor model, they are successfully applied in a complementary fashion.

The practical ramifications of this are that you no longer have the need to create as many models as you once did. It relieves you of the burden of producing a model for every conceivable combination of targets. This is a very good thing, especially because the realities of producing a character with a full range of expressions still demand a project of daunting scale.

## Modeling Anchors and Targets

Because the ME does not have any preset library like the Deformation Editor, all your real control comes from how the models are designed and built. Although this may put an extra burden on you, there is almost no limitation to what you can create. It also means that you need to be much more creative and resourceful with your modeling options.

In Chapter 1 of this book you will find the section "ÜberNURBS for Morphing," which explains how to generate Anchor and Target models for the morphing process. In this section you will explore a few alternative

ways of accomplishing this task, using other tools. These tools include a polygon modeler, the choice here being auto•des•sys's form•Z (FZ), deformations, an invaluable Photoshop plug-in called *Cybermesh*, and Electric Image's own Amorphium product. Each of these offers a wholly different approach to building functional Anchor and Target models.

## POLYGON MODELING

In building models for morphing, you have to play by its rules. The current limitations of most morph technology are that every Anchor and Target model must be created with *identical* mesh counts and the vertices must be written in exactly the same order. Although this is very limiting for the modeler and the process, how else can Animator know which vertex points to match up?

Unfortunately, many of the modeling tools you have come to depend on are incompatible with the requirements of building Target models. Booleans, Knife Slicing, and other drastic modeling tools ruin an ordered mesh count, change the vertices around, and result in Target models that do not work. The tools that are generally acceptable for use with morph modeling are scales, transforms, and deformations, because they do not change the database of existing vertices.

*These limitations apply to how a Target model is derived from the original Anchor, but* not *to how you create the original Anchor model, which has no construction restrictions.*

Because of these limitations, Target models have traditionally been created by hand-moving vertices in a polygonal modeler. For example, look at a morph sequence that starts with a square box and has a recessed area appear in one of the sides (see Figure 9.12).

Rather than cut a hole with a Boolean tool—which you know would not work—you manually move the model's vertices and polygons to get the shapes you want, as shown in the screen shots taken from form•Z in Figure 9.13.

When creating your Anchor model, you have to think ahead and determine what extra geometry will need to be put in place for any Target models you will be making. Obviously, all that extra geometry in the forward face of the Anchor model is not necessary for its own shape. It is needed for you to be able to drag the center square polygon backwards into the body of the model to create your Target shape.

This example has very simple geometry, but it is easy to see how this type of modeling can be very time-consuming with complex models.

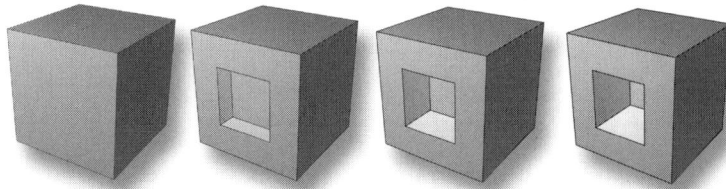

**FIGURE 9.12** This morph sequence starts with the Anchor model on the left and ends with the Target model on the far right. The stages in the middle show the animated progression.

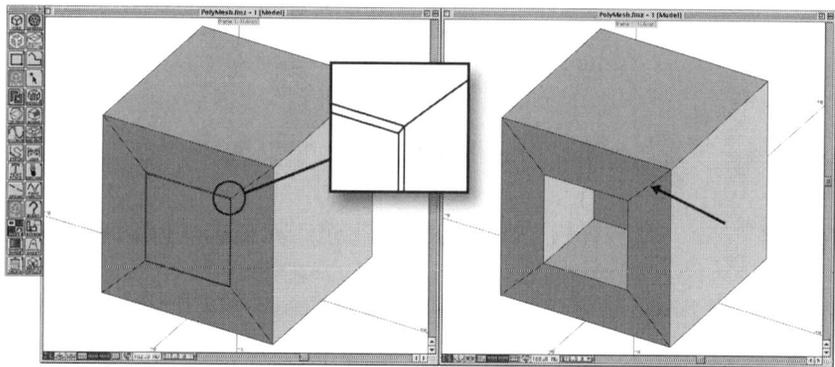

**FIGURE 9.13** Creating the Anchor model (left) involves laying in "construction" geometry that later allows the creation of your Target model (right). Also note the manual additional of line segments.

Even though there are few shortcuts, you can find some tricks to help move things along faster. For example, in the preceding examples, you could make the Target model *first*, using the Boolean tools. Then, when you duplicate the model to create the Anchor, you only have to bring the center square polygon forward. Like the chicken and egg, it doesn't matter which came first.

*Although the morph process makes it tempting to create a highly detailed model, more moderate meshes that are well designed create a much lighter load to carry when animating and rendering.*

Depending on which polygon modeler you are using, there are a variety of workflow parameters to jump through. It is impossible to be exhaustive on this subject here, but the following is a short hit list of things

to be aware of in any program, with an emphasis on the use of the very popular form•Z program.

## Triangulation

It is very important that none of the faces of your model have more than four sides. Anything more complex is simplified either by FZ's Fact export or through Universe's import or render stages. When this happens, your models run the very high risk of no longer having the same vertex count and order. Even though quadrangles are technically acceptable, they tend to fall off perfect planarity during model work, so you will find that the safest path is to triangulate your final Anchor model fully before creating the targets. The downside to this is that working with a fully triangulated model can greatly slow production.

## Smooth Shading and Combining Coordinates

Both these options are very helpful in general modeling and animation work, but when used with Anchor and Target models, they can create all sorts of havoc. Having a pristine vertex count and order is of the greatest importance in morphing, yet both these tools muck with your model's vertices. Have you ever brought a model into Animator, using a variety of export/import options, and seen that it displays or renders differently in each case? Or you may have noticed that when **Smooth Shading** or **Combine Coordinates** settings have been varied, so too does the model's technical data listed in the Info window's Info tab. You will see that the Vertices readout can change dramatically, sometimes even without any telltale visual differences in the model.

What all of this is about is that a vertex at the corner of a model, say, a cube, can be made from a single vertex, or quite often it can be made up of as many as three—one for each of the polygons converging at that corner. When a model's polygons have separate vertices, those polygons are shaded with a hard edge. If the polygons share vertices, the Camera rendering engine smooth-shades those particular polygons. In Figure 9.14, you can see how this happens.

When you stop to think about this, it makes perfect sense because shared vertices are the structures you have in any mesh that is expected to shade smoothly, such as a sphere. Without any indication of an **edge**, the Camera renders the cube model the same way it would a sphere, despite the fact that the cube looks hard-edged and pointy cornered to your eyes. You may notice that this style of rendering looks very similar to imagery from Curious Labs' Poser. However, when you have a defined edge

**FIGURE 9.14**    Both cubes are lit by the same Radial light source. The top set shows what happens when a standard eight-vertex cube is imported without any manipulation and rendered smooth. Below, you have a cube with a full set of 24 vertices that renders with hard edges.

in a mesh, as you do in the lower image, the Camera knows to apply appropriate shading. You can tell what is going on by looking at the vertex count for both cubes, where you see that the lower model has 24 vertices, three times the number of the top model.

The problem is that you want to leave all your morph-related models untouched, but you run the risk of having morph models that will not shade properly. One of several solutions to this problem is to smooth-shade models manually in the modeling program, thus sidestepping the use of haphazard import/export tools such as Smooth Shade or Combine Coordinates. A program like form•Z has a smooth-shading tool that can be applied to individual faces or the entire model, or it can be set universally upon export. Alternatively, vertices can be manually laid in by splitting a model's mesh and then reassembling it again, using the Join tool. Unlike the Boolean operation, which resolves vertices and other geometry, the Join tool simply combines models intact and thus allows you to create customized arrangements. Another option is to use a program

**224**    Professional 3D with Electric Image Universe

such as UVMapper, which has a Split Vertices feature that can be applied to the entire model in one fell swoop. Whatever you do, remember that you must treat all targets in the same manner you do the Anchor model.

In many situations when generating morph targets, these issues never arise, and you may float for years without any concern. When models become more complex and your needs more demanding, though, you are more likely to run into these issues.

## Exporting and Importing Preferences

As with other modelers, form•Z has a wide range of export options to choose from. Because you are exporting to Electric Image Universe, save your models to the Fact format. The Fact format has changed specifications as it has evolved, so form•Z offers exporting to either a Fact 2.8 or Fact 2.9 format. Although each one has pros and cons, thus far I have found the older option to work better with Universe. Other animators differ on this, which can probably be attributed to the great range of models and applications, each with specific needs.

Take care when triangulating at the export stage rather than doing it manually when modeling. You have no control and may or may not get lucky. Including normals when exporting is usually a good idea. Despite this, you will find that the Camera rendering engine is uniquely good at rendering normals properly, even if Animator has had problems with previews.

In earlier versions of EI, it was often necessary to take models from form•Z and pass them through EI by importing and exporting them and then use the newly saved versions. This was said to "align" the vertices in a way EI preferred. Universe has, thankfully, eliminated that need. Should you have problems, though, such as exploding morph models, it would be good to try passing the models through either the older 2.9 version, the standalone Transporter application that comes with Universe, or Animator.

*One of the best ways to start troubleshooting problems is to keep an eye on the model's information windows in your modeling program and in Animator's model Info display. The vertex counts are the most revealing data, but other items can sometimes affect your success.*

## MORPHING BY DEFORMATION

At first glance, it might seem like a strange idea to use the Deformation Editor to generate Morph Targets. "Why not just add a deformation directly to the model and be done with it?" you may ask. The answer is that

deformations can become complex and, by converting them to a morph, you are freed up to animate easier.

Another issue is the difference in style between Deformation and Morphing in animating a model. Although many deformers put a model through a predetermined path, such as the arc of the Twist deformer, morphing takes a direct approach that might be more appropriate for the project. Morphing also allows you to take a variety of complex, compounded deformation poses, export them as a few Target models, and then painlessly move between them, something that could be impossible within the Deformation Editor.

For example, if you have a model that has a **Bulge**, **Scale**, and **Twist** applied in frame one, you can't easily go through the timeline, dialing the three deformers up and down in unison. You have to modify each deformer individually and figure out the amount of value change necessary to keep a uniform look. The process is very slow moving. If the model from frame one is exported as a Morph Target, you can breeze through that timeline with all your edits in no time.

On the production end, you will find creating morph targets this way to be fun, quite easy, and very likely to work without the need for extra tweaking. If you keep the creation projects, everything is very easy to reproduce and modify as needed.

The downside to this is that you are, of course, more limited in what you can do, compared with working within a real modeling program.

## MORPHING WITH CYBERMESH

If you were wondering how in the world I was able to create the models for the SportsMorph tutorial, Knoll software's CyberMesh Photoshop plug-in is the answer. In Figure 9.15 on the next page, you can see the maps that were created for each model. In addition to letting you quickly create a wide variety of models—many that would be very time-consuming if done traditionally—Cybermesh has a special place in the morpher's toolkit because it is guaranteed to work. Unlike most other methods of generating targets, which run the risk of vertices not matching up properly, as long as you keep the canvas the same size and export to the same style of projection, your targets will morph to your Anchor.

The other major upside is that if you take the grayscale image used to create your model, convert it to RGB, and scale it up, you have the world's "most perfect" template to create any texture maps for that model—guaranteed perfect fit! When you bring the map into Animator, just apply it with the same projection you made the model with in the first place. For example, if you exported from CyberMesh using the Spherical

**FIGURE 9.15**   From left to right are the maps used to make the Football, Baseball, and Golfball models for use in the SportsMesh tutorial.

projection (see Figure 9.16), use that same style when mapping the model. You can, of course, map these models just as you would any other model.

The downside to using CyberMesh for morphing is that because these models are far less efficient than traditionally created meshes, your computer can run much slower and your preview updates noticeably lag. This is especially true if you start to use multiple target models.

## AMORPHIUM PRO

Amorphium is another program published by the good folks at Electric Image, and as you might guess, it integrates very well with their flagship product. Although Amorphium inherited a few technologies from Animator, it has quite a number of capabilities unique in the graphics world. Chief among them, for your purposes here, is its capability to deform models with clay-like ease. Amorphium enables you to manipulate the mesh like a pile of Silly Putty, pushing and smoothing it as you go, offering an extensive range of work modes and a large selection of tools in each mode (see Figure 9.17).

The Tools mode offers Brush, Smooth, Smudge, Pinch, and other tools to move the mesh where you want it. Compared with EIM—and any other modeling program, for that matter—Amorphium feels the least like you are working on a computer program. It also offers some interesting texture mapping and painting options, animation, and some of the best export to Flash available.

The clean way Amorphium manages the mesh, even after all the pushing and pulling you may do to it, keeps all the vertices in line. Because of this, you can import a model, export a base Anchor version to Fact format, do your modifications, and then export the new version to Fact format as well. The results are completely morph-friendly. This enables you to create models in minutes that would be impossible or painfully time-consuming with other programs.

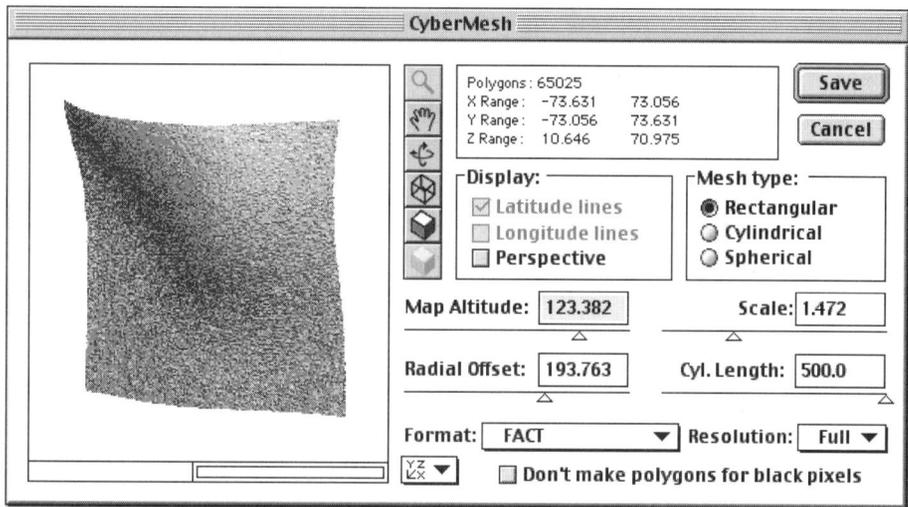

**FIGURE 9.16**    The interface of the CyberMesh export plug-in.

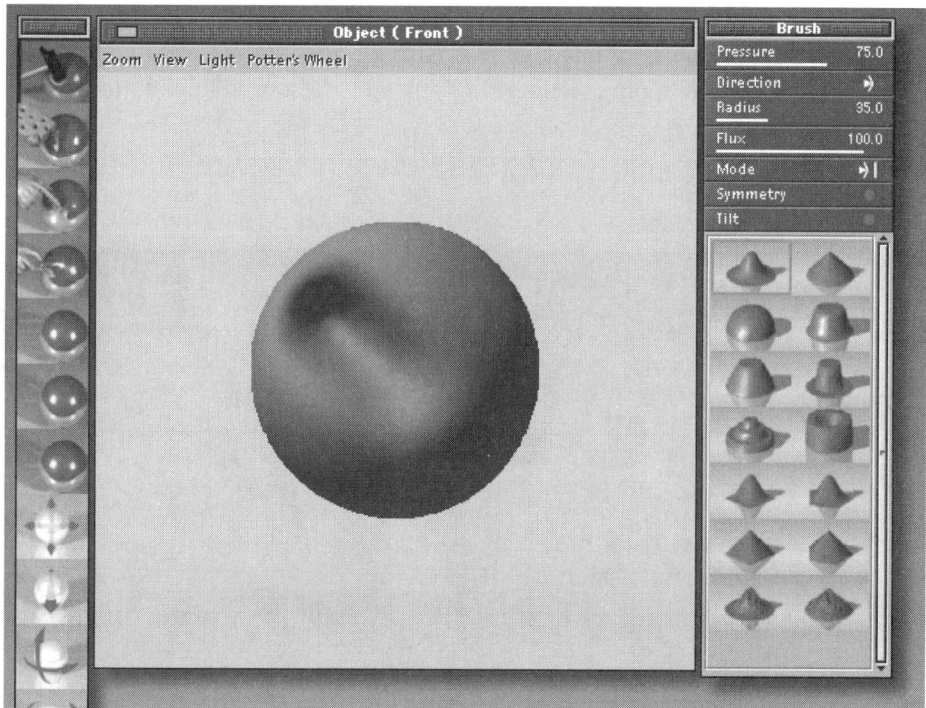

**FIGURE 9.17**    Amorphium's Tools mode, which offers interactive clay-like modeling.

Even though you can use Amorphium to create your models, it lends itself to modifying existing meshes.

## TEXTURE-MAPPING MORPHS

A common misconception about morphing is that it requires setting up both Anchor and Target models with texture maps and other attributes. This is not the case because the only model that is ever seen and rendered is the **Anchor** model. Target models are never swapped into the scene as people think. Instead, their vertex data is merely read and applied to the anchor. When you texture-map the anchor, you are good to go.

Here is another little gift from the makers of Animator: Any texture mapping is moved along with the distortions created by morphing the model. For example, if you texture-map red lipstick onto a model's face and then apply a Smile Morph Target, the texture map follows along for the ride and stays with the lips, just as when doing a deformation. The reason for this is that much of the technology behind morphing and deformation is basically the same; merely the implementations are different (see Figure 9.18).

Anchor models can take advantage of UV mapping as well, which can be very effective in creating a heightened level of realism. (See the UV mapping section in Chapter 11, "Material Editor," for more information.)

**FIGURE 9.18**    Mapped lipstick follows the mesh when Morphing is applied. (Image ©Graphlink Studios 2000.)

## ANIMATING MORPHS

The Morph Editor and morph animations in general have a few extra workflow particulars that, if understood, can enhance your projects. The following sections point out some of the most interesting and useful items.

### Keyframes

Every time you edit a slider in the Morph window, you are creating a new keyframe. A free-flowing session can end with more KFs than you have ever seen before. This may be considered a by-product of this type of project workflow because trying to minimize large numbers of KFs can be hard with the ebb and flow of facial animation. This is not necessarily a bad thing, at least until you have to go back in to do additional editing.

Because the ME does not display KF information, keeping the Project window open with the Morph channels exposed allows you to see the KFs you are creating on the fly and enables easy editing.

### Value Ranges

The standard range of a morph is 0 to 1, which represents the direct translation between the Anchor and Target models. However, nothing stops you from taking that differential data and using it in reverse, which is done by making use of the 0 to −1.0 range. This is great because it can functionally double-duty many of your existing targets. A smile can also be used to generate a frown, and mean eyebrows can be reversed to give you a submissive or frightened set as well. When making phonemes, the building blocks for lip sync animation, you can use a Mouth-M from the lip biter category in reverse to make the lips pout. Great to use for that 3D love scene!

You are not limited to staying within the range of −1.0 to 1.0 and can extend that to any reasonable number by using the edit box to input your desired value. The slider range updates to include your new value. As a very general rule to be taken with a pound of salt, you can usually go from a bit less than −2.0 up to a bit past 2.0. Doing this extrapolates the differential data and projects it past the Target model and into what can be very exaggerated results. If the results are too extreme, back off until it feels acceptable. Keep an eye out for models falling apart with gaps or tearing mesh. It is also more common to see problems when using negative morphs, because the targets were generally not made for such use. If tearing or overlapping occurs in the process of reaching the facial expression you want, corrective rotoscoping on a few frames can quickly solve the

problem. Also realize that extreme poses tend to be used for a very brief emphasis, so perfection may not be necessary for what amounts to two or three frames of expression.

## Channels and FCE

Every morph target model you add is actually a new channel and, as such, can be set to any of the motion path styles Animator offers. There is even a pop-up menu that allows you to choose the default motion path for your imported targets. The options are:

- **Linear**: This would not be good for facial animation but may be appropriate for other, more mechanical projects.
- **Natural Cubic:** This is a good choice for facial animations because it gives a nice and naturally curved path that seems to respond well to this type of work.
- **Hermite:** This is a good alternative to Natural Cubic that offers a "tighter" curve, which might be appropriate for animating more serious characters.
- **F-Curve**: Excellent for more exacting work, this is a good choice when further editing in the FCE is expected. It offers superior refinements to what can be done in the Morph Editor.

Like all channels, Targets are automatically added to the Project window, where you can do further editing. Probably more beneficial is adding your target's path to the Function Curve Editor. There is even a toggle setting in the Morph window that adds all new Target models to the FCE automatically, a great idea because the FCE is so well suited for controlling many types of morph animations.

## PREVIEWING MORPHS

Animator can give you almost real-time feedback in the Morph Editor's preview window as you edit the sliders. Notice that as you drag the sliders, the morph preview window is continuously updating, compared with the World and Camera views, which update only after you release the slider.

To kick the animation process into high gear, you can close all the World and Camera views and just view the animation in the Morph's preview window. Closing the other windows relieves your computer system of much work and can significantly increase your screen updates. You can use the timeline control at the bottom of the window to shift to new times.

The ME's preview window offers an extremely valuable feature that most of us unconsciously take for granted. No matter where you move or how you rotate your model in the world space, the Morph preview window always shows it from your preselected view. This is a great asset in that it always allows you to have a clear view of your model for animating. Assume that you have a character animation with a model that is talking and moving about—this saves you from having to create an extra camera to track your model to get a clear view of the facial action needed for lip sync work. The ME preview is editable at any time, allowing you to choose from Front, Side, Top, or Orbit. With Orbit selected and **Spacebar-Cmd** pressed, you can interactively drag the view window to orbit the model and customize the view. You may find that facial animations are better judged from a slight angle, rather than from the default Front view.

The preview also has its own light source, so again you are freed up to do as you want in the world setting and still have ample light to edit your morphs. Whether your scene is in darkness or otherwise poorly lit for viewing the model analytically, the ME preview still shows your model with its classic 3/4 keylight and backlight setup.

Speaking of analytical views, you should recognize that the preview window shows the model in something of an extreme orthographic view (see Figure 9.19). This tends to make the model look different than it

**FIGURE 9.19** The Morph Editor's preview window on the left, compared with the Camera view on the right.

does in the World or Camera views and affects how you interpret the settings you choose. Try to keep this in mind as you work, and check the Camera view as needed to confirm your choices. When your mind makes the adjustment, it should not be a major issue. A by-product of this is the fact that a character model viewed from the Front view does not appear to be looking forward, even though in the Camera view you will see that it is.

As an alternative work setup when animating with the FCE interface, you may want to close the World and Camera views and keep only the Morph Editor open to make use of its preview window. This can be an effective arrangement, but note that you will not get the live updates you get when working with the morph sliders.

## IMPORTING TIPS

When importing target models, you must set the **Target Match** pop-up menu appropriately. By default, it is always set to **Full Match**, which generally refuses to accept all but the most stringently produced targets. For this reason, I hardly ever use this setting and, instead, prefer the **First** or **Geometry Only** options because they are far more accepting and produce the morphing results I need.

Some programs do not write the Fact model format correctly, or at least as correctly as Animator and Transporter do. As noted earlier, if you are having problems with targets creating "exploding" morphs, try running both Anchor and Target models through Transporter and saving them out as new Fact files. When saved, remove the original models from the project, and start anew. This can often clean up the vertex order and solve the problem.

The Morph Editor requires you to create Morph Groups to which you add Target models. Although these groups are limited to 10 targets each, you are not limited in how many groups you can add to the project. When creating groups and adding targets, try to do it in an organized fashion, by keeping similar targets together. For example, you can keep the standard phoneme targets used for speech in one group and other expressions in a second group. This makes animating and editing much easier later on. Once added, targets do not allow their position to be moved within the set or to different sets, so care must be taken when loading. See the section on lip-syncing with HeadGames in Chapter 14, "Character Animation" for more information on these subjects.

# 10

# LIGHTING

There is an old approach in both painting and photography that says that you work up from darkness by adding lights to your subjects. It is possible to make or break an image merely through the pattern and quality of illumination chosen, and this is why lighting design is such an important topic of study. Even after designing lighting for stage, still photography, and traditional art for years, there is still more to learn. Continue to learn the aesthetics of light and to seek out more studies beyond this book.

In addition to possibly making the scene attractive, lighting also holds the important job of helping to make the shot look more realistic. Unlike lighting photography, film, or stage, which have realism already built in, both 3D and paintings must rely on good lighting techniques to take the project to a higher level. Good illumination helps create that extra level of snap in the image that makes it pop off the page or screen and feel more tangible. It is becoming more common to look at a 3D project and not know if it is 3D or real. "Hmmm," we say to ourselves, "could they maybe have trained that chipmunk to drive a car?" No, it was 3D. But the effect would not have been pulled off successfully if the lighting (and all other elements!) was less than top notch. Most large 3D productions have an entire staff just for the digital light rigging—it is taken very seriously.

The most interesting irony is that in order to get "realistic" lighting, we often have to set things up in ways that could not possibly exist in real life; like having one light illuminate a model, but not the model right next to it, and other digital sleights of hand. This comes under the heading of "whatever gets the image in the can at the end of the day."

For a full breakdown of the tools, see the Animator 3.0 manual section 4, page 117. Figure 10.1 shows a standard lighting Information window.

## LIGHTING OPTIONS

Animator offers six distinctly different **Light Types**, which are selected in the light **Info** window, and are listed below. In addition to these, we also have the World object's **Ambient** setting, which is a global command, and the new **Illuminator** lights. Glows, fog, and other effects do not actually give off any light to surrounding objects.

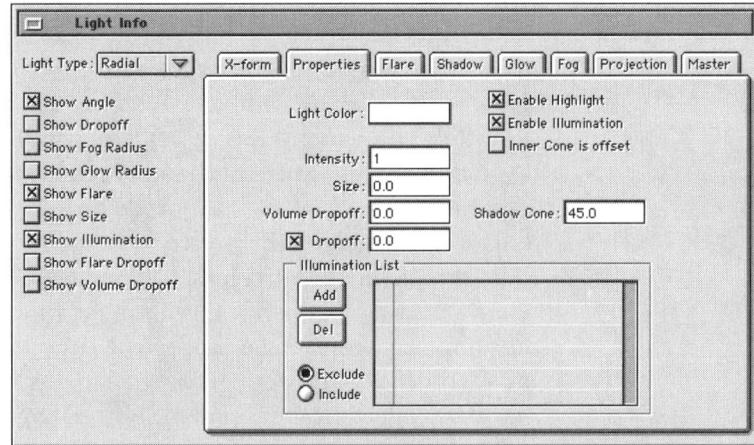

**FIGURE 10.1**    The standard lighting Information window set to the Properties tab.

*When choosing and setting up a light source, it is often difficult to see what some of the settings are doing in a busy scene. Using a test model, or even a separate project to try out different lighting experiments will better allow you to see what is happening with your lights. You will find the project file called "Lighting Types.prj" on the CD-ROM that is a simple wall with a Stucco shader texture, which allows you to quickly diagnose what your light is doing. This was used to generate the images below.*

**ON THE CD**

## Lighting Types

The following is a breakdown of the main lighting fixture options available to standard lights. Note that no shadows were enabled for these images, but are available for Radial, Spots, Parallel, and Camera lights.

- **Radial**: Like a standard light bulb, this setting has light emanating from all directions. This is the default light, it gives a nice soft and natural feeling to most scenes. It can be used for a key light (which means the main light), or as a fill (see Figure 10.2). This light offers **Dropoff**, **Shadows**, and other controls. Its **Shadow Cone** feature in the **Properties** tab only appears when shadows are enabled, and determines the field of view of the Buffer shadow map in degrees.

This control is needed because even though the light is omnidirectional, the shadow mapping is limited to less than 180 degrees, and practically speaking, somewhere in the 100- to 150-degree range is a more reasonable high end to avoid great distortions.

- **Parallel**: This can be used to represent the sun in an outdoor shot. Even though the sun is truly a radial light source, only a fraction of its rays hit the earth, so they appear to be parallel. Laser beams are the only other parallel light source. It is rare that you would use more than one of these lights in a scene, except for some special effect. The Parallel light generates its illumination on a global scale, so you need to only set its angle properly. Neither the icon's **Position**, nor its **Light to Reference Distance** settings in the **X-Form** tab will have any effect on illumination. Both **Dropoff** and **Shadow Cone** controls are available.

The visual effect of this light is harsher than some of the others, and you will notice that there is less falloff of shading on a model when this light is illuminating it (see Figure 10.3). This effect is simi-

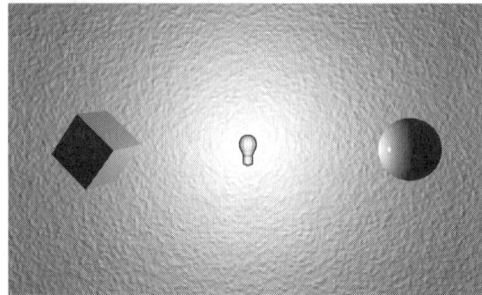

**FIGURE 10.2**   The Radial light (default) with icon.

**FIGURE 10.3**   Parallel lights create a harsher and analytic atmosphere.

lar to adjusting a model's **Falloff** setting in the **Diffuse** tab to a number lower than the default of 1.0.

- **Spot:** These are the most versatile lights and offer the greatest range of control. **The Inner Cone** and **Outer Cone** edits boxes control the light's diameter, with **Factor** and **Inner Cone Offset** controlling the relationship between them. The **Dropoff** effect works exceeding well with this light and is wonderful for adding puffs of light here and there. Although a control to change the shape from circular to elliptical would be nice, this can be accomplished as it is done in real life by swinging the lamp to an oblique angle from the model, or using **Projection** maps.

  In addition to being very useful, Spot lights are a lot of fun to work with. They can be set wide and used for bright scenes, or narrowly to help create a lot of drama in a film noir–style setting. They make good **key** lights and **fills**, and are often the best choice for **rim** or **back** lights (see Figure 10.4).

  Although they preview in **Gouraud** in the **Hardware** mode, the previews when in the Software/Phong settings are far more accurate and pleasing. (You will note that while in Gouraud mode a model's mesh density will affect the preview quality, whereas in Phong mode a lower density mesh creates little or no degradation.) Inner and outer cone, Dropoff, and shadow mask preview lines can all be displayed on screen giving the animator tremendous feedback.

  Spots lights are pointed using their reference points at the tip of the light beam, but final adjustments and more accurate framing of the models is obtained by using the Camera window set to preview the lights view (as discussed later in this section).

- **Camera:** Imagine an animation with the camera mounted on the hood of a car, headlights shooting forward, well that is just what

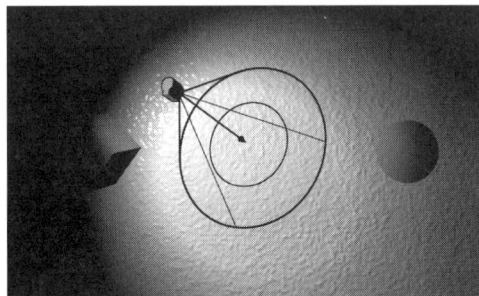

**FIGURE 10.4**   The Spot light is the most versatile fixture and offers great control.

these lights do (see Figure 10.5). A Camera light is also good for simulating the point of view of a miner wearing a hardhat with a light, or a medical animation with the viewer flying up the inside of an artery. It is also very similar to "ring" lights that wrap around a camera's lens—these were very popular in fashion photography in the 1970s. Camera lights are good for certain effects, although most artists will probably not use them that often.

- **Ambient:** Like the global ambient illumination in the **World** settings window, Ambient light adds a base level of light that affects darker areas more than lighter ones. Unlike the global version, this can have its light intensity modified (with positive or negative values), in addition to its color. Most of the other controls are non-functional with this light. When a light is set to this type of fixture, no World object icon is displayed, thus it cannot be moved in the World/Camera windows. But that's fine because its illumination is global and moving or rotating it would have no effect.

Ambient light does not produce any specular reflections and is mostly used to light the geometry's Diffuse colors. In fact, if you lit a scene with this light, diffuse colors would be the only visible attribute. In Figure 10.6, we have added a dimly lit second light source on the left side to help give some form to the scene, because with only Ambient light, the all white scene would have no definition.

**ON THE CD**

On the CD-ROM, you will find an animation that takes this scene and scales the Ambient light from an intensity of 0.0 through a full 1.0 setting. This will give you the best concept of how ambient light adds to a scene.

Ambient light must be used carefully because there is a very fine line between enough, and too much.

**FIGURE 10.5** Striking head-on lighting effects with the Camera light.

**FIGURE 10.6**   Ambient light source cuts contrast and must be used carefully. (There is a second light in this scene, see text.)

- **Tube:** These look a lot like the shape of light coming from fluorescent fixtures, and are often found along the ceilings of 3D office scenes. They are wonderfully able to produce an elongated shape of light that is hard to simulate with a Spot. This can be used for a variety of situations including soft fills, back or side lighting, and the many obvious places where narrow lighting is needed, under cabinets, billboards, neon signs, or florescent fixtures (see Figure 10.7). It is also a good choice for an internal light source when many points of light would otherwise be needed. For example, if you had a building with hundreds of window openings that needed light coming out from inside, one or two Tube lights could greatly simplify your task at hand. The advantages here are, of course, much easier setup, but also the fact that one Tube light will render much faster than the larger number of lights it replaces.

  Until the introduction of Illuminator lights, Tube lights were the only real implementation in Animator of what is known as a soft light.

**FIGURE 10.7**   Tube lights are often an overlooked resource with a wide range of uses.

## A Basic Lighting Rig

Take a look at a simple studio light rigging that would be used to do a portrait shot. This is ideal for character work, but the concepts hold true for products shots and many other situations. You will learn what the job of each light is, the name of that particular job, and what it looks like on the model and in the scene.

Our talent agent, *Left-of-Central Casting*, sent Chip over as our model. Strolling in 20 minutes late and looking like he didn't know about this early morning shoot until far too late last night. You know these actor types.

Fortunately he has time to wake up as we set up the lighting. In Figure 10.8, we haven't set up any studio lights just yet, but you can still see a little bit of what is going from the **Ambient** light sneaking into the room through doorways and such.

Once the backdrop is in place, we set up the **Key** light first. This is the primary light that you see in an image. It is a brighter and more obvious light than any others and by its nature, goes a long way to setting the tone of an image. In an outdoor scene, the key would be the sun, in an indoor setting, it would be a main light. In our studio portrait session, we are going to add a light at the classic portrait angle, which is just above and to the left of your shoulder if you are the photographer standing at the camera position. This was often called "Rembrandt" or 3/4 lighting. Figure 10.9 shows the screen grab where you can see the Key light's guidelines, and a **Snapshot** with just the Key light on.

**FIGURE 10.8** Before we get the lights on, the Ambient light shows us the way.

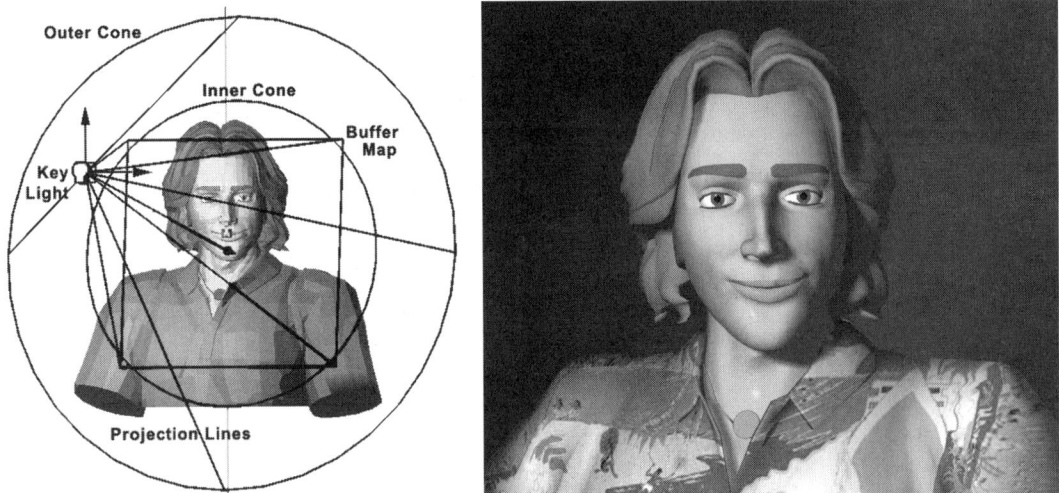

**FIGURE 10.9** A screen grab shows the Key light's guidelines (left). Chip with the Key light turned on and in place (right).

The idea in placing this Key light is to find an angle that creates pleasing light on our model's face. We are not trying to get rid of all shadows with this light, in fact, using the light to create nice shadows gives the face a better shape. This light is set to **Spot** so that we can have nice control over its direction, and can feather the light's intensity all around. The cone settings are left at their default settings because they work alright, but the Intensity is upped a bit to 1.15 because we want the Key light to have a bit more kick. A **Dropoff** of 150 is also added. Why? Because we don't want the Key light falling onto the background wall.

You can solve this background issue by creating a lighting **Exclusion** set, but using **Dropoff** has the advantage of abiding by the **Inverse Square Law** (see that topic later in this chapter). A Buffer shadow is also added to this light to create more realism. "Why?" you ask, "We don't see it casting any shadows." Actually we do—it is casting shadows onto itself. The hair casts a shadow onto the forehead, and the head casts one onto the neck and shoulders. The **Buffer** map does not need to be sharp and won't be covering a large area, so the size is kept on the low side, which also keeps the rendering fast.

Once we are happy with this light, we add a second one to our right, just a bit off camera. This is going to be our **Fill** light, which we will leave at the default **Radial** setting because this creates a relatively soft light. Figure 10.10 on the next page (left) shows a top view screen grab where you can see the

**Top View**

**Side View**

**FIGURE 10.10**    Top view screen grab shows the X/Z plane placement of the lights (left). Side view screen grab shows the placement and elevation of the lights (right).

positioning of our new light. We placed it at about the same height as the model's head, but because this is a softer light without shadows, the placement is not as critical as with the Key light.

The **Fill** light is generally not used to eliminate shadows either, but simply to soften them and even the lighting a bit. It is also not intended to compete with the Key, so its **Intensity** is brought way down to 0.4 and its **Enable Highlight** toggle can be turned off. It is also given a **Dropoff** of 150, and a **Buffer** shadow. Even though a Radial light is nondirectional, its shadow buffer (which is really just a projected texture map) is not omnidirectional. So be careful to aim it correctly or you may not get the shadow you expect. Figure 10.11 shows a **Snapshot** using both the **Key** and **Fill** lights.

Our next light is alternately called a **Rim**, **Hair**, **Edge**, **Ridge**, or **Back** light. By any name, the point of this light is to give accent to the edge of your model and help bring it out from the background. It is usually fairly bright in order to slightly overexpose the edge; in this case, its **Intensity** was set for 1.8. In a portrait style setup like ours, it is placed behind the model pointing forwards and down at the back of the cranium. In real life, a photographer would need to make sure it is placed out of camera view and probably also add **barn doors** or **snoot** to make sure stray light stays out of the camera's lens. These are not

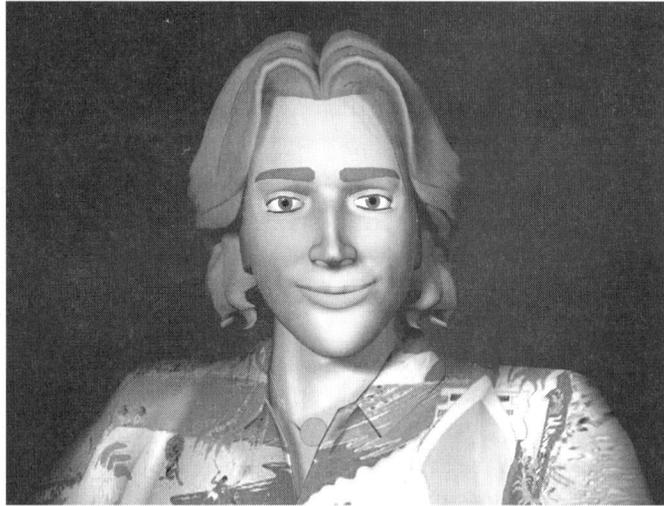

**FIGURE 10.11** Snapshot using both Key and Fill lights.

concerns of the 3D artist, but still are things you need to be aware of if you are striving for any level of realism in you work. You can see its placement in the side view screen grab in Figure 10.10 (right).

No **Dropoff** was set for this light because it was not pointing to the back and it is not used for subtle lighting that would benefit from the Inverse Square Law. One last thing to take note of about our Rim light is its placement on the right side of the model. This is not happenstance, rather it is by design. Had we placed it on the left side, it would be competing with the Key light and need to be even brighter. Worse yet, the image would feel lopsided. So it is placed on the right to act as a visual counterweight and help balance the whole shot. See the Snapshot in Figure 10.12.

Our last light is the **Background** or **Back** light. This is used to illuminate our textured backdrop that was made with an Über Shape placed in the Y/X axis with a Cloud shader applied. We just want a typical soft light pattern here and can use either a Radial or Spot. But as mentioned earlier, a Spot gives us nice feather control so we go with that. It is set so it is light and airy around his head, and gets a bit darker toward the side and top of the frame of the image. Why? It is an old painter's trick to fool the viewer's eye and **frame** or **contain** the image on a more emotional level. Photographers use this trick also, when they **burn-in** the edges of a print in the darkroom. You can see the finished image in Figure 10.12, and in full color on the CD-ROM.

ON THE CD

This is a very simple setup and a very good place to start. You will find the completed project file on the CD-ROM named "Basic Lighting Set-up.prj". Run through this tutorial once or twice to make sure you understand what is going on. If you like, try setting the same thing up in real life to see how they compare. Get a different model, though, Chip is less than reliable.

Once completed, start playing with it yourself and take the light rigging to new places artistically. Try to create a film noir mood, or one from a horror flick. Change the lighting fixtures, and their settings. See what a Parallel light would look like as a Key light, or perhaps a Camera light. We can go on for pages suggesting different ways to play with this. Change the lights' colors; add Ambient or Subtraction lights (any light with its Intensity set to a negative value). As you go, keep learning more about lighting in general, and lighting inside Animator, in particular. Most importantly, learn that building a large and complex scene is really just a matter of building up all the little things you learned from playing with this simple rig.

**FIGURE 10.12** The final rendering with the Key, Fill, Rim and background lights in place. Notice how the Rim lighting helps bring the model off of the background on the right side.

## A Few Notes on Realistic Lighting

Realism is the Holy Grail for many 3D artists. If this is not the case for you, then you should be thankful because despite the great technical strides, realism is still very hard to attain. As one graphics researcher put it, most realism found in 3D today is more a credit to the artist than the software developer.

There are many things that make an image come to life: Contrast, sharpness, color, focus, texture, an "edge" to the objects, and specularity are just a few. What is hard for us to get a grip on sometimes is that it can be the contradictions that look most realistic. For example, sharpness helps make an image look real—this is partly true. But if an entire image were tack sharp it may not look terribly real, and worse, it may not look very interesting. Having your foreground object remain sharp while the background elements defocus is often more real to our mind's eye, and also more pleasing.

When it comes to light, we often want to play a visual dance by not lighting everything evenly—letting some elements become more prominent in the scene simply from the way they are lit, while others can be left to recede into the background. This is why, unless there is a specific reason to use a Parallel light source (like an outdoor or planetary scene), using the feathered edging and size controls that a Spot light offers is preferable.

Another technique that creates depth and realism is having multiple lights, because few environments have just a single light. Even if a scene is meant to look like it only has a single light, you will almost certainly need a bit of Ambient light or a puff of Radial light in the shadows for balance. If you have ever done photography or film work, you know how complex it can be to make a scene look simple. Complex simplicity—it sounds like an oxymoron, but it's the truth.

Specular reflections are very important and are controlled by the lights in conjunction with the Material Editor. Even objects that we do not think of as having specularity often do, and placed well, it can help pull the object off the page just a bit more.

### Inverse Square Law and Realism

Sometime in your sophomore year of high school, your Earth Science or Physics teacher told you about the **Inverse Square Law of light falloff**. If your adolescent mind was on other things, now's a good time for a recap.

The Inverse Square Law states that if you double the your distance from a light, it will drop to 1/4 the intensity rather than the 1/2 most would naturally assume. For example, using a light meter take a light reading 10 feet from the source, then another 20 feet away and you will find that the intensity actually **drops to 25%** of the original value! For those that care, the formula goes something like (Distance)2 = Intensity/4, where doubling the distance yields 1/4 of the light's intensity. This law also applies to gravitational, electrical, and other natural forces as well.

This happens because when you move the light back twice the distance, the same number of light rays now needs to cover **4 times** the area (X times Y= Area, so if X=200% and Y=200%, the area of the light has increased to 400%). See Figure 10.13.

It is this severe loss of light intensity that causes your camera's flash to quickly become useless past 8 or 10 feet, and is the reason professional photographers and filmmakers spend so much money on powerful lights.

So how does this relate to you and the 3D artist? With the singular exception of the sun, our eyes always expect to see the Inverse Square Law at work; if it isn't, we get the feeling that something doesn't look quite right. The makers of Animator know this and have given us the ability to edit a light's **Dropoff** value in the **Info window > Properties tab**. The **Dropoff** value is simply a radius measured from the light source (using the same world units seen on the rulers, **Cmd-M**), which sets the light **Intensity** to zero at any distance you choose. Being 3D, we get to have a lot more control over this effect than in real life, and to save us a few rounds of test renders, Animator does a fairly good job of previewing it for us with both wire-bounding lines and model shading.

In Figure 10.14, we have compiled five test scenes, each consisting of a standard **Radial** light set at an **Intensity** of 1.5 and placed at the world

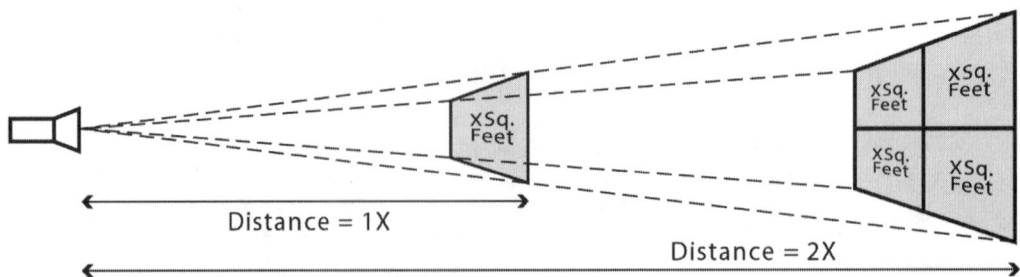

Distance = 1X

Distance = 2X

**FIGURE 10.13**    The mechanics of the Inverse Square Law.

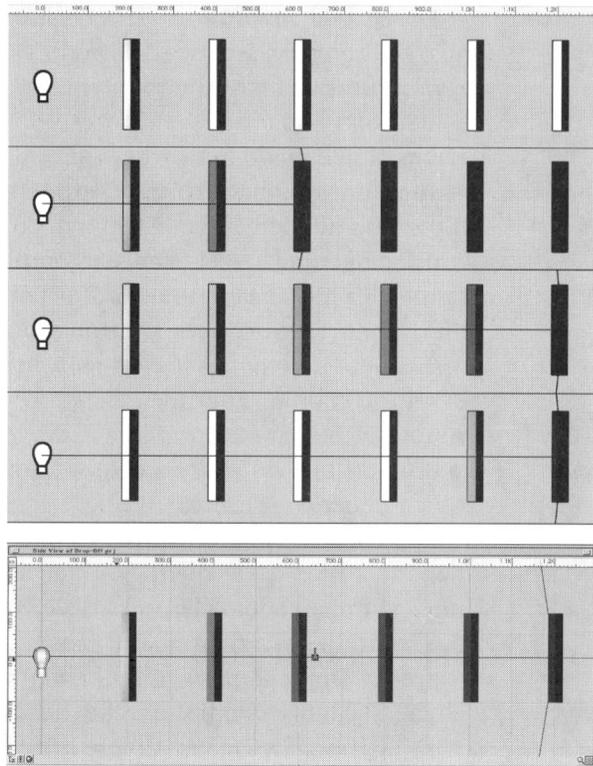

**FIGURE 10.14**   The five rows show variations in the lights Dropoff rate setting. See the text for a complete description of each test scene.

origin (0, 0, 0). The test scene has a series of 6 pillars lined up along the Z-axis off into the distance at 200 unit intervals. You will see just how the illumination diminishes as it moves further from the light. The square pillars were all rotated 45 degrees so that we can see the front surface of each, and no shadows were applied to the lights. The top four are full quality-renders and the last is a screen grab. The project file "Drop-Off.prj" is included on the CD-ROM if you wish to look at it or set up your own tests.

ON THE CD

The top row does not have any **Dropoff** applied. See how every single pillar has the same bright white shading on the left side, the side that faces the light source. This is because the light stays at a constant illumination level (we set it at 1.5), and if a pillar were placed a million units away, it would still be lit in the same way.

The second row has had the **Dropoff** turned on to a value of 600 units; you can see a section of the radial **Show Dropoff** guideline at that distance (note rulers at the top). This means that the light is brightest at the bulb, and gets progressively darker in a linear fashion until it reaches a radius of 600 world units where its intensity equals zero.

The third row has had the **Dropoff** setting increased to a radius of 1200 units and there are now enough pillars for us to see a clear pattern of the light getting darker. Notice that Animator has the **Dropoff** behave in a more or less linear fashion, instead of nature's choice of exponential. Although not natural, having the intensity drop linearly makes lighting a scene easier and requires fewer lights. In the fourth row, the **Dropoff** is still set to 1200 units but the light's Intensity has been increased to 5.0. You can see how putting in more extreme Intensity values seems to alter the drop-off rate a bit. The last row shows how the on-screen preview looks, a rather good estimate.

Now, take all this new knowledge and apply it to a more practical example. In Figure 10.15 (left), you see an office cubicle set with a desk lamp and three under-cabinet spots. No **Dropoff** has been applied to the lights, resulting in a room that is harsh, bright, and not very pleasing to the eyes. More importantly it is not very realistic looking.

The second example, on the right, has **Dropoff** applied to the lamp's light, which creates a more believable lighting environment. Attenuating this lamp's illumination radius allows you to see the under-cabinet spots without having the lamp light wash them out. And even though the first example seems much brighter, the light in that scene is actually set a bit lower than in the second example, so expect attenuated lights to need some adjustments.

**FIGURE 10.15**   Left: The lights in this image have no Dropoff applied, creating a harsh image. Right: The second image has Dropoff applied to the desk lamp and looks much more realistic.

Below are some valuable Dropoff tips:

- Remember that the **Dropoff** number tells Animator the location where you want the light's **Intensity** to equal **zero**. Because the drop-off of light is linear it will take a bit of distance for the light to increase to meaningful and usable values. For example, if the **Dropoff** is set to 500 and your model is sitting at 450 units from the light, don't expect it to be very well lit. In fact, if you put that model at 250 units from the light, it will only be receiving half of the light's intensity.
- The smaller the **Dropoff** value, the less bright the light will *appear* to be because it will be putting out less illumination to surrounding models. Boost the light's **Intensity** a bit to compensate, and feel free to play with the numbers until the scene looks right.
- Enabling **Dropoff** costs you little if any rendering time, so you can add it to many lights in a scene to enhance realism.
- The sun is exempt from the Inverse Square Law due its distance from the earth.
- Obviously, any cast shadows will also be lessened by **Dropoff**, just as in nature.

## Calculating Dropoff Exposure

Because the **Dropoff** works in a linear fashion when you have the light set to 1.0, it is easy to figure out how much light is being used to expose your models by using this formula:

### 1.0-Distance/Dropoff = Actual Exposure Intensity

where **Distance** is measured between the light and the model, and **Dropoff** is the value you select yourself for the edit box.

For example, if we use our example from above where **Dropoff** is set to 500, the **Intensity** is set to 1.0; when we put our model at 250 units from the light, then we have: **1.0-(250/500)**, which tells us that our model is being exposed with an intensity of 0.5.

Do one more, and change the model's **Distance** to 150 units: **1.0–(150/500) = 0.7**. This is helpful because it gives you a quick way to know the exposure of any Dropoff-enabled light and model combination. You can then figure the compensation value needed for the light, or where to put the model.

*If you shift a single light's Intensity value by 0.2, it will shift a mid-toned model (50% gray diffuse reflectance being the ideal) by 10% density in the final render. Thus adding 0.2 to a lights value brings a 50% model to 40%, adding 0.4 brings it to 30% (very predictable).*

### Enable Highlight/Enable Illumination

In the light **Info** window's **Properties** tab you will find two toggle boxes named **Enable Highlight** and **Enable Illumination**. These are the on/off switches for the light's **Specular** and **Diffuse** lights. Separating the two gives you a lot more control of the final renders:

- **Enable Highlight**: Turning off the highlight means the light will not create any **Specular** reflections in the scene. This is helpful for situations where the light is being used as a fill and you do not want to call added attention to it, or for creative reasons.
- **Enable Illumination**: There are situations where you may be using a light for effects other than illumination and wish to turn it off. These effects can be additional Specular highlights, or Glow/Fog lights.

### Selective Shadows

Generating shadows is a lot of work. Even when you are not using the RT engine, Buffers applied to even a few lights can start adding noticeable render times to your scenes. So, when you're not using them, turn them off! Animator allows you a number of ways and places to turn the shadows on and off. Keep in mind that all of these must be properly turned on to get shadows working, and by default most of them are. The **Enable Shadow** toggle in the light's Shadow tab is the only setting that needs to be changed from its default.

For a full understanding of where the various controls are located, here they are, from macro to micro:

- **Globally**: In the **Render Setting's Render** tab there are actually two discrete global on/off toggle boxes for **shadows**: One is just for Buffers which is simply labeled Shadows, and the other just for **Raytrace Shadows**. They can be set independently, and they both act globally.
- **Per Light Source**: In each light's **Shadow** tab is the **Enable Shadow** toggle box that controls the shadow for that individual light, whether it is set for Buffer or RT.
- **Model Specific**: Each model's **Info** window has a **Shadow** tab that contains a shadow on and off toggle, plus this interesting assortment of shadow-related controls:
- **Cast Shadow**: Controls whether the model can cast shadows onto other scene elements.
- **Receive Shadow**: Controls whether the model will receive shadows.

- **High Precision Shadow:** Results in shadows cast upon the model looking a bit sharper, and under some circumstances, the density of the shadows appears to increase as well.
- **Generate Shadow Mask:** Transfers the shadow that is projected onto the model to the render's Alpha channel instead of the standard RGB channel. This gives a clean shadow mask (or Alpha) for post-production effects.
- **Shadow Object Only**: Makes the model invisible in the RGB channel's render, but allows its shadow to render correctly.

*When you have large ground planes or similar sets, make sure to turn their **Cast Shadow** toggle off, because you will not derive any artistic benefits from it, and it could eat into your render overhead.*

There are also creative and design reasons to turn a lights shadow off. Our mind's eye likes to see a consistent direction to light, and shadows casting haphazardly can interfere with that. This is why real photographers spend so much time trying to remove the trace of extra telltale shadows—we need only to turn them off.

The images in Figure 10.16 show you the results of various options. You can see that in Image A, we have a problem with the shadows going dark, so a second light is added from the opposite/back side. If this second light (Image B) is allowed to cast a shadow, it creates a visual confusion you may not be looking for in your imagery. Image C shows the light left

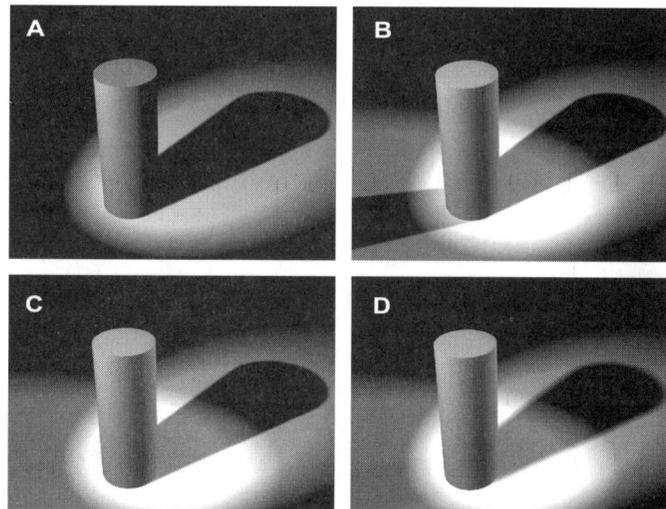

**FIGURE 10.16**   A) Basic single lighting setup with shadow. B) A second light is added to bring up the shadows and act as a "ridge" light. C) The ridge light's shadow is turned off to streamline the image. D) A compromise setup where the ridge light has a shadow enabled but has its presence in the scene de-emphasized.

on, but its shadow turned off. Even though this is not lighting seen in the physical world, it is a lot less chaotic looking and our mind accepts it as plausible. An alternative to this is Image D, which has the second light's shadow enabled once again, but they have been de-emphasized in the image with large amounts of **Softening** and **Darkness** adjustments (see the section on Buffer shadows later in the chapter).

### Light Illumination Lists

A light's **Illumination List** is found at the lower half of the **Properties** tab. It is a simple **Add/Delete** list that allows you to tap into the power of the **Selection Sets** tools found in the **SELECT** drop-down menu.

When a Selection set is **Added** to the list we are offered the option to **Include** or **Exclude** that **Selection Set**. This allows us to set up a selection set of scene objects that we want illuminated, or a set of those we do not.

In the project "Illumination Lists.prj," we have a scene that continues the shadow-related problem we discussed earlier in the "Selective Shadows" section. Using Illumination Lists, we can add another possible solution to the problems encountered there. As you saw in Figure 10.16, the cylinder needed a second light source to help open up the shadows on its right side. Adding a second light solved that problem but created some new ones as well.

In this project, we have created a Selection Set appropriately named "Please illuminate me," and added it to the second light's list. The only item in this set is our main cylinder model. Notice that if you toggle between the **Include** and **Exclude** radio buttons the Camera view will preview these changes rather accurately. You can also click on the on/off icon (the blue ball in front of the list name) and that action will be updated in the Camera View window.

By giving this light a list of which items to include, we are also telling it to not include any items that are not on the list—in this small project that would only be the ground plane. By doing this, we have eliminated most of the problems of the extra casting shadow we had in the other section. To be clear, notice in Figure 10.17 how this solution not only eliminates the extra cast shadow, but also any additional light casting onto the ground plane. Because there is no light falling onto the ground model, our eyes no longer expect to see its companion shadow.

This looks pretty good and solves some problems, but is not as believable as we want. Why? Using Illumination Lists gives you a control that is not natural. This can be fine, as long as we keep it *believable*.

**Define the problem**: Totally eliminating the light and shadow from touching other models makes the edge lighting on the cylinder appear too harsh, especially toward the bottom, where it dips into what should be all shadow.

**Solve the problem**: Add some **Dropoff** to the second light, as seen in Figure 10.17. In this image the cylinder has a much better sense of integration with its environment.

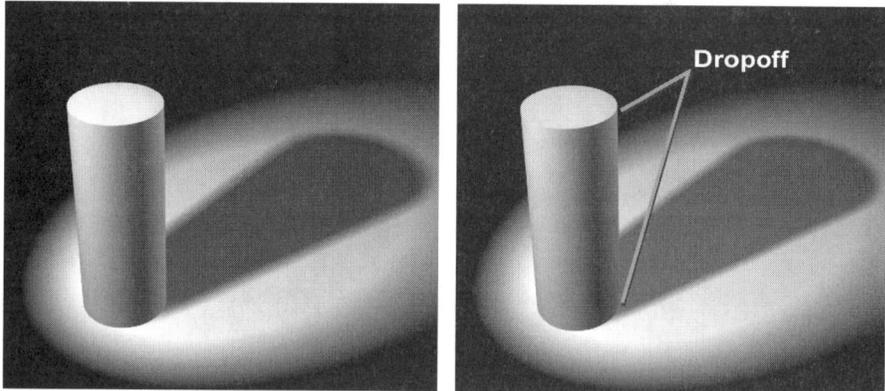

**FIGURE 10.17**    Left: Selection Sets allow the second light to only illuminate the cylinder—without additional light or shadows on the ground. Right: Dropoff added to the second light helps to integrate it back into the scene's environment.

### A Light's-Eye View

If you go to the Camera window's **Title Bar** at the top of the screen and hold the **Control** key while clicking on it, you will be rewarded with a drop-down menu that lists every camera and pointable light source (Radial, Parallel, and Spot). You can use this in conjunction with the camera window's navigation controls to help arrange the light much faster. It is also used to set up Buffer shadows, discussed later in this chapter. See Figure 10.18 on the next page. (Note that later versions of the program are likely to implement a less-cryptic way to set the Camera window's view setting).

## DEPTH BUFFER SHADOW MAPS

Shadows make the world go round. Well maybe not, but they can make a 3D world feel round and real. They give objects a sense of body and mass, and a feeling of placement in the scene. They also take extra time to render, which is why they get enabled on a light-by-light basis, and default to off. Only turn on the shadows for lights that need them.

### How Buffers Work

**Buffer** shadows (also called **depth maps**) are the fastest method of creating shadows in Animator, the other main option being **Raytracing**

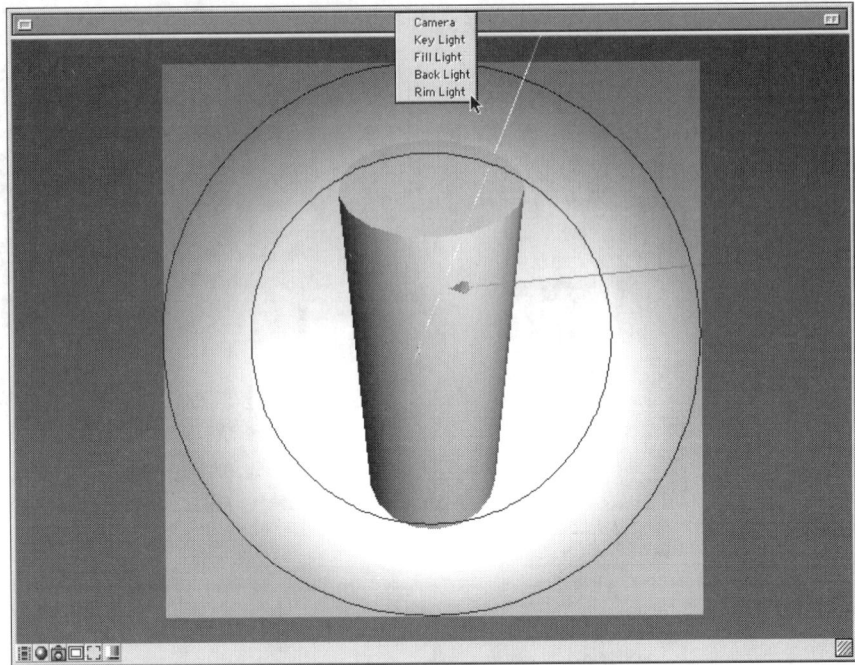

**FIGURE 10.18**   Using the Camera window to get a "light's-eye view." Note the hidden drop down menu selector.

(see the section on RT in Chapter 13, "Rendering"). Although RT is more accurate, it comes with a price tag of rendering times that are usually more than we like to spend for animation work. Because of this premium, you only need to use RT when other options cannot produce the effects needed. In truth, Buffer shadows can be made to provide for most of our needs. You will find its controls in the Light **Info** window under the **Shadow** tab (see Figure 10.19), where you will see it is set to the **Buffer** option by default. Aside from the two toggle boxes located on this tab control section, all the settings are capable of being fully animated.

Buffer shadows work by generating both a texture map of shadows from the light's point of view, and the scene's **Z-Depth**, which enables one object behind another to retain correct shadow mapping. This data is generated for every light that has shadows enabled. The size of the shadow map is set in pixels by the **Buffer Size X** and **Y** edit boxes, where you can see the default is always set to 1280. Larger sizes offer greater detail but slower rendering and require more memory. Only the areas of the scene that can be seen through the light (by using the "View light as camera" technique discussed earlier) will be mapped with the shadow

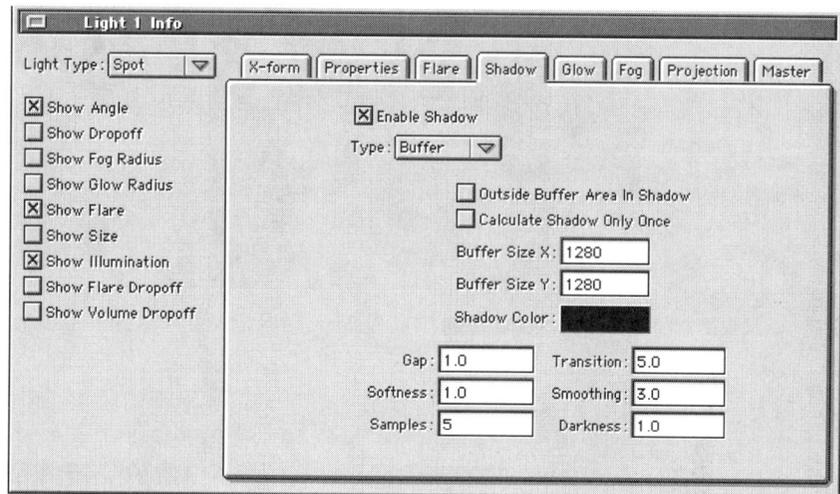

**FIGURE 10.19**   The Depth Buffer shadow controls found in the light Info window.

buffer image, and thus appear to generate a shadow. The projected maps aspect ratio is determined by the Buffer X/Y values, and the actual height and width of the map's projection is determined by the various **Cone** settings in the Properties tab.

## Making Buffers Look Good

Unlike Raytracing, Buffer shadows don't have a lot of real-world physics to fall back on. This is good in that it means we have a lot of controls over the final look, but bad in that we need to manually set these controls. Animator's defaults are good place to start, and will satisfy your needs in some situations, but you need to learn more to get the most out of Buffers.

### Smoothing the Hard Edges

**ON THE CD**

Look on the CD-ROM at the basic lighting scene "Buffered Shadows-Ball.prj," a sphere model sitting on a plane, illuminated by a spotlight. In Figure 10.20, on the next page, we see this setup rendered with both a **Buffer** and with **RT** lighting. If any visual differences exist, they are certainly hard to see, but the RT took three times longer to render at our sample size of 1024 X 768. In larger resolution renders, you would see the RT times drastically increase compared to only moderate increases for the Buffered renders.

**FIGURE 10.20**   The Buffer render (left) looks indistinguishable from the Raytrace rendering (right).

The obvious question one asks is if the two images look so similar, why bother with Raytracing? The truth is that much of the time it is not needed. We include Raytraced examples here for the sake of comparison.

When you look at these images, you can see that the shadows are looking very severe. This is a surprisingly common mistake made not only by novice 3D artists, but by many long-time pros as well. If shadows are intentionally left with hard edges for stylistic reasons, that is fine. If the scene has a far-off light source or harsh spotlight that would generate a hard shadow in real life, then also fine. But remember that this is a very rare situation, and even objects in direct sunlight cast shadows that soften dramatically as they move further from the object.

Fortunately soft shadows are easily added to **Buffers** by going to the **Softness** edit box and putting in a higher value than the default of 1.0. Figure 10.21 shows examples of both images from Figure 10.20, but with their shadows softened.

*Remember that the value you put into the **Softness** edit box actually represents pixels, and can be thought of as the Gaussian Blur filter in Photoshop. But because it is pixel based, its effect will vary if you change rendering resolutions—something we often do between the testing and final output stages. So you may put in a value of 5.0 while testing at window size and it looks great, but when you do a final rendering at a larger image size, this value will generate a lot less Softness. Testing with the **Selected Full Size** feature can help. Also helpful is knowing that it works in a linear fashion, so if your 1/4 frame (320 X 240) looks good with a Softness setting of 5.2, then you know that your final full frame (640 X 480) render needs a setting of 10.4 to match.*

In this round of Buffer versus RT renders, you can see a qualitative difference in that the RT has delivered a smoother shadow with more

**FIGURE 10.21**    Buffered (left) and Raytraced (right) shadow render examples with their shadow edges softened.

natural gradients. By direct comparison, the Buffer shadow is a second runner-up, but how often do your clients or the viewers get to make such a direct comparison? Standing alone, the Buffer render still looks very good even to a trained eye, and it was done in 19 seconds. This level of softness in the RT shadow required a Light Radius setting of 80, and the render time for it was just over 12 minutes. In that amount of time, you could have had 38 Buffered frames rendered, so you really need to ask yourself if you require that slight quality enhancement.

When adding **Softness** to a shadow map, values of 3-10 are a good place to start for a nice and natural softness. Having it look natural to our eyes will depend on what our mind thinks it should look like given the type of light, the model, its distance from the objects, and other factors. The beauty of this feature is that there is virtually no extra rendering time involved. The exception to this is that if you notice a little bit of graininess around the edges of the feathering you may wish to remove it by increasing the **Sample** rate a bit, say from the default of 5 to anywhere from 7-15 or more if needed. You will get hit with a bit more render time for doing this, so only do it if you need to. In most situations the graininess will not even be noticed.

There is an alternate method to softening your shadows, and that is to drastically lower the pixel dimensions of your **Buffer** map in the **Buffer Size X/Y** edit boxes. Unlike the **Softness** effect, the softening added by this method does not vary with your testing or rendering frame size. It is also not subject to adding graininess to your scene. On the downside, you are losing resolution and the acuity of a shadows form, and if you push it too far (resolutions of about 100 seems to be the lowest you would want to go, but this will vary), you will start to get pixilated shadows. A tiny bit of **Smoothing** can easily correct this if needed.

### Shadow Density and Hue

Buffers can do some things that RT can only dream about. You may think that the images in Figure 10.21 look a bit dark in the shadows, and that is true. When we do artwork, we generally do not want elements to drop off to such a harsh black, except for a specific effect. It was done here for test purposes. But when you want to lighten the shadows up, the **Buffer** controls have a **Darkness** edit box at the lower right of the window. Its value range is from 0 to 1.0, which represents the shadow's density. With it, you can type in 0.5 and have the shadow density drop to 50%, or use any other value that suits your needs.

There is more. Notice the **Shadow Color** chip further up which allows you to set the color of the shadow as a separate parameter. When choosing a shadow color, remember that more realistic choices tend to be just slightly lighter than black and can lean to a hue that represents the **ambient** light of the environment. Figure 10.22 shows a shadow with lowered density and a few extra flourishes.

With these two controls, you have the ability to create most visual effects that are needed, create them quickly, and render them off just as fast.

*A (semi) transparent model is another time you would want to reduce a shadow's density. But it is also an opportunity to add a bit of knowledge that can improve your work. The Transparent/Opaque slider value from the Transparency tab in the model's Material editor should be used as the starting value for the shadow's*

**FIGURE 10.22**   The ball project set up with a Buffer Map shadow that has soft edges and a lowered density.

Chapter 2–Kitchen set built in ACIS toolset.

Chapter 15–Running water.

Chapter 7–Complex Function Curve animation.

Chapter 8–Shark animation created with Deformation tools.

Chapter 11–Using the *Solid Map* technique.

Chapter 16–Multi-pass renderings composited in After Effects.

Chapter 14–Character Animation of inanimate flour sack.

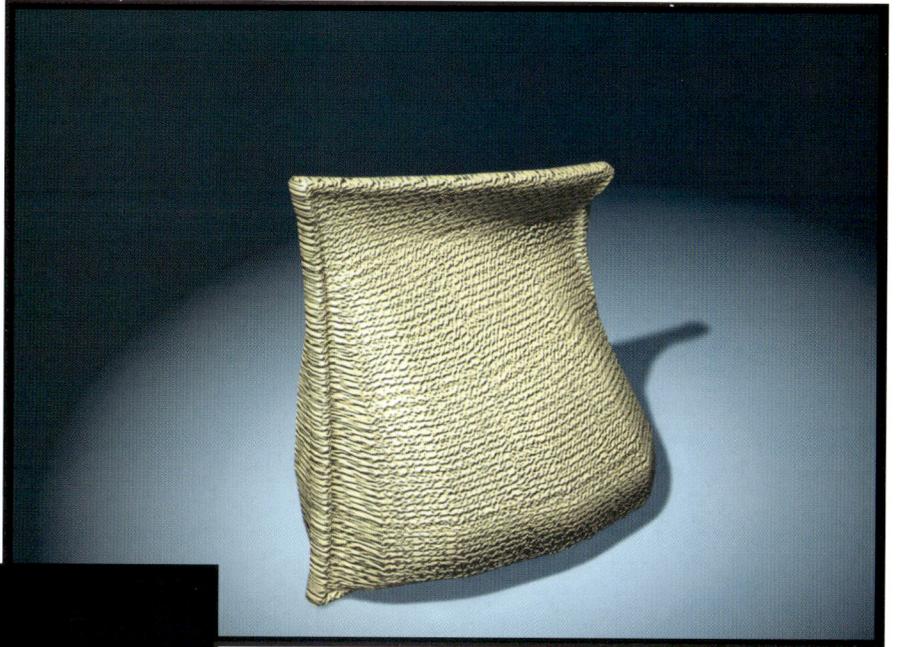

Chapter 14–Bones rigging with IK and creating an animated walk cycle.

Chapter 13–Head built in ÜberNURBS.

Chapter 15–Creating the open sea.

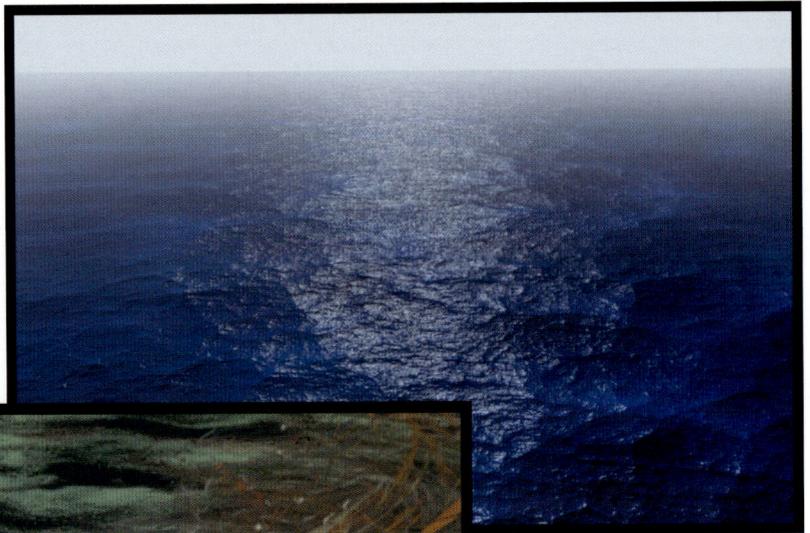

Chapter 15–Particle generated tornado.

Chapter 15–Creating fire and smoke with Dante.

*Darkness* density value. The reason is that the two values are directly related, and must remain so for the effect to read properly. You may also need to compensate for edge density if any was applied. The Diffuse color of the model is also a good place to start for the Shadow Color chip. Shadows from transparent objects are not based on black the way those from opaque objects generally are.

### Calculate Only Once Toggle

If you have a scene where models and lights are stationary throughout the animation, why should the shadow Buffer maps be recalculated for every frame? If **Calculate Only Once** is enabled, the shadow is calculated once at the first frame, and then saved to disk for the remaining frame renders to quickly use. Even though EIU is a fast renderer, this little switch can save you a bundle of time, especially with architectural-style fly-throughs.

The only other limitation is that the new **Renderama** network queue is not able to take advantage of this, thus you must set these renders manually. Inconvenient, but well worth it.

## Where Buffers Bog Down

Let's identify some areas where the Buffer does not hold up as well.

### Mixing Soft and Hard Edges

ON THE CD

If Buffered shadows were perfect, we would never have invented RT, but they are not. Look at the next test scene called "Buffered Shadows-Cone.prj" on the CD-ROM. It is much like the ball scene you were just using, but this time the model is an inverted cone with its narrow point at the ground plane.

Try to apply the same buffered shadow softening to this image that you did so successfully to the ball. Figure 10.23 on the next page shows the scene with (A) default settings, (B) with 18 **Softness** and 10 **Samples**, (C) same as B, but the **Transition** has been lowered to zero, and (D) our control subject, the raytraced image.

The default (A) is too hard edged, as was expected. But the Buffered shadow setup (B) that worked with the ball scene no longer looks so good; why? Buffered shadows tend to fall apart when you need to mix both hard and soft shadows in the same image. This is because, you will recall, that these shadows are actually projected image maps. When you ask Animator to add **Softness**, you are actually just blurring the map,

**FIGURE 10.23**   The cone scene, samples A, B, C, and D. See text for details.

and there is no way for it to know that the point of the cone should not be blurred as much as the rest. You can force a slight improvement by adjusting the **Transition** setting down (C), which will help bring the tip of the cast shadow a bit closer to the tip of the model. But there is no question that the RTed image here (D), which was set for a **Light Radius** of 60 and 12 **Samples**, is really beautiful and much better than anything the Buffer can achieve. Note its sharp and accurate definition at the point and how beautifully it softens further away. Also note it took over 12 minutes compared to the Buffer renders that were done in 20 seconds.

### Distance Dropoff in Raytracing

If you look at elongated shadows in the real world, you may notice that as they get further away from the object casting them they tend to become more transparent. What is happening is that the greater distance allows more scattered room light to sneak in and eat away at the shadow's density. Buffers have no way to simulate this, whereas the RT shadow control has a **Dropoff** (not to be confused with a light's Dropoff in the Properties Tab, which serves a different purpose) option that allows this effect to be added.

Although this setting does not add much time to the render (in RT terms, at any rate), it does not look good by itself, and usually needs to be combined with the **Soft Edge** effect, and longer render times. Though

there is no control for this in the Buffer settings, these effects can be simulated, as described in the "Fake Buffer Maps" section of this chapter.

### Very High Detail

If you were to need a map with highly detailed shadows, you might start running up against some shadow Buffer limitations. Remember that the Buffer map is a texture map image that is being projected onto your scene. Like all texture maps it has a finite resolution, so if you spread it over too large an area, it will look pixilated (see Figure 10.24).

The situations where you are most likely to run into this problem are:

- Imagine a very large fly-through with a single Parallel light acting as the sun. It is casting a shadow Buffer across trees and buildings and cars. Because of the large area and detail, you have already cranked up the Buffer maps X and Y resolution past the default of 1280 and all is looking good from a bird's-eye view. But when you start your descending fly-through and swoop down to street level, all the shadows look terrible. The reason is that your Buffer map still does not have enough resolution because a situation like the one just described is really very demanding. If your computers memory allows, try to further increase the Buffer, bringing your resolutions to 5,000 by 5,000 or more if needed. Fortunately memory is relatively inexpensive today and computers with a gig or more of memory are common. If this does not solve the problem, you may need to break the scene's lighting into two or more groups, one for the long shot and

**FIGURE 10.24**  An extreme close up of a Buffer map shadow whose resolution was not high enough for this tight a shot.

another for the close ups. This can be done with lighting and Selection Sets, or as two rendering passes and cross-fading one over the other in a post-production program. Another solution for this problem is provided in the **Subtraction Lights** section of this chapter.

- Check that the lights in question are aimed correctly. Do this by aligning them in the World views and then fine-tune by looking through the Camera window set to view as light. **Make sure that all objects that cast shadows or have shadows cast upon them, can be seen through that light source's view**. The actual map is placed on the inside of the boundaries marked by the light's guide lines as seen in Figure 10.25. If it is not aimed at the model, no shadow will be generated.
- Stretching the map too large by selecting very wide angles in the light's **Shadow**, **Inner**, or **Outer Cone** edit boxes can cause problems. Even though the **Cone** edit boxes accept values up to 179.9 degrees, it is not well suited to create a Buffer map at such an extreme, and distortions are to be expected. If you need to do this, you may have to break the effect into groups using two or more lights, or revert to using Raytracing.
- Multiple models at varying distances from the surface create a dilemma. As an object moves further from the surface that receives its cast shadow (usually the ground), we expect to see its shadow get more blurred. But if you have some models close to the ground and

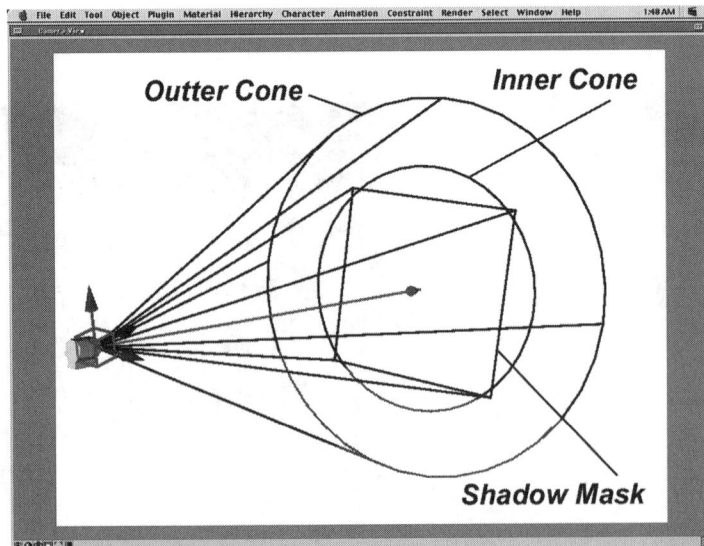

**FIGURE 10.25**   Light source guide lines.

others far away, which do you set the Buffer's **Softness** setting for? The solutions to this are that you find a compromise setting that you can live with, or you assign the objects to different lights using the Selection Sets Include and Exclude features.

## FAKE BUFFER MAPS

Is there no end to what we can fake? (No *When Harry Met Sally* jokes, please) The idea here is that once you understand how Buffer mapping works, you realize that you can do some of it manually and have more control.

**TUTORIAL**

### PROJECTION MAPPED SHADOWS

The concept is to use a camera to create and then project an image map of a shadow onto the scene. Although there are a number of steps, the concept is not really hard and well worth the time you invest to learn it. This technique offers the animator a great deal of flexibility.

### PART 1: TAKING THE PICTURE

1. Create a second camera (Cmd-D or **OBJECT > Add Camera**). Rename it in relation to the light you will associate it with, "Camera-light 1" for example.
2. Open the new camera's **Info** window X-Form tab.
3. Open the light's Info window X-Form tab.
   Duplicate all the light's **Position**, **Reference**, and **Angle** data to the camera as seen in Figure 10.26 on the next page. If done correctly, the new camera should now be in the same world space as the light.
4. Make sure that the light's **Shadow** is **Enabled** and set up the way you want it.
5. Go to the **Cone** model in the sample project, and open its **Info** window's **Shadow** tab. Enable **Shadow Object Only**. What this does is make the model invisible when rendered, but it will still cast a shadow. Very useful!
6. Set the Camera window to view as "Camera-Light 1." If you ran a Snapshot now, you would see the cone's shadow but not the Cone. Although you could probably use this image and clean it up manually, Animator goes even further to help you.
7. To get a clean image without all the extra shading in the scene, open the Plane model Info window's **Shadow** tab and **enable** the **Generate**

**FIGURE 10.26**   Copy the Position, Reference, and Angle data from the light to the projection camera.

**Shadow Mask** toggle. This takes the shadow that is projected onto the plane, and rather than mapping it onto the surface as it normally would, it transfers it to the **Alpha** channel. This means that any oddly shaped, obliquely angled cast shadow's shape can be automatically grabbed without hours of Photoshop fiddling, and you will automatically have a perfectly clean shadow Alpha. There is truly only one word for this: Neat!

8. Optional: We now have a perfect Alpha channel, but the RGB channels need to be made black (or whatever color you want your shadow to be). Once rendered, you can do these adjustments in Photoshop or After Effects for animations. Or you can go to the **Render Settings** window's **Render** tab and toggle off the **Diffuse** and (maybe) **Specular** options. Thus you will have a black RGB and a shadow-mapped Alpha channel.

Now, render your frame or animation and save it to disk, we named ours "Buffer render.img" and you can see it in Figure 10.27.

**ON THE CD**   This picture-taking Animator file is all set up for you on the CD-ROM and is called "01-Fake Buffer-Basic.prj." You can now open this saved IMAGE file in your favorite editor (remember this can be a still or a multi-frame file), make

**FIGURE 10.27**  The manually generated Buffer shadow map showing the black RGB plates (left) and the Alpha (right).

any brilliant alterations destined to win you that technical Oscar Award, and save it back into IMAGE format.

### PART 2: SETTING UP THE PROJECTION

1. Open the **Cone** model **Info** window **Shadow** tab and toggle off of the **Shadow Object Only** button. You want the cone to show in the renders again.
2. Similarly, toggle off of the **Generate Shadow Mask** button for the Plane model because you want the projected image to map normally.
3. Highlight the Plane model and go to **SELECT > By Set > New Set**… menu to create a new **Selection Set** that includes the Plane model. You will be asked to name it, so name it "Shadow" and click OK. You have just created a Selection Set and added the Plane model to it. When you set up the Camera's projection map, this will let you assign it just to the models in this list, which is of course just the Plane model.
4. Make sure the **Render Settings Diffuse** and **Specular** toggles are **enabled** again.
5. Make sure to **disable** the light's shadows, remember that you are replacing them!
6. Open the camera **Info** window's **Projection Map** tab and **Add** the "Buffer render.img" image to the List box.
7. Set the **Camera Map Applied As** to **Diffuse**, and in **Camera Map Applied To**, select your **Shadow** Selection Set. What all this does is take the image you created of the shadow and project it onto any models that are part of the Selection Set you created. You are also telling it to project the image into the model's Diffuse channel.
8. Now double-click to open the map's **Texture Editor** window and go to the Filter tab. Set the **Use Channel** to **RGB+Alpha**, and set the **Alpha** to the **Use as Mask** toggle selection.

9. Set the Camera window's view back to the original camera—the one you want to use to record the animation—and render. Ta-dah! See the final rendering looks exactly like the standard Buffer image in Figure 10.23 (A). Though it *looks* the same, the fact that it is a camera projection map and not a Buffer shadow will give us a lot of options.

### Pushing the Fake Buffer Envelope

"Okay," you say, "that was, interesting, but how does it really help me?" It helps you with many of the problems we talked about earlier, and it also gives you a *lot* of creative controls that you didn't have before.

Remember that softened Buffer render of the cone model that didn't look so good? How about we take our manually generated Buffer map, "Buffer render.img," into Photoshop for a little handwork and swap it out. It will look like Figure 10.28 (left).

The hard-edged Buffer map was gradually softened using Photoshop's tools (not as easy as it may seem, the PSD file is included on the CD-ROM for your benefit). It now looks like the RT image and will actually take even less time to render than the original Buffer file did because it no longer needs to calculate the Buffer.

Maybe you still prefer the look of the real Raytraced cone that took 12 minutes to render or just prefer not to do any handwork, you are in luck. This technique works just as well with RT shadows as it does with Buffered. Simply change the light's shadow setting to RT when making the Buffer map in Part 1 of the tutorial. This gives you an even larger benefit because Raytracing does not offer the Calculate Shadow Only

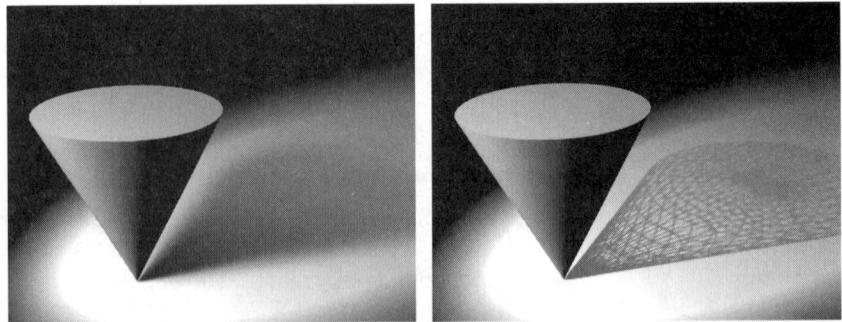

**FIGURE 10.28** Left: Projection map shadow, pre-retouched in Photoshop. Right: Solid model "casting" a wireframe shadow.

Once option. In the same way some programs allow you to "bake" their radiosity, this lets you have raytraced scenes with almost zero render hit. Now you can do that animation the way you want! The only render hit you will take is when doing the one-frame rendering to make the map.

Get creative and allow the shadows to have their own personality, or move in ways that are not in tandem with the model, a la the old Looney Toons animations. You can have a solid-looking model cast a wireframe shadow (see Figure 10.28). You can even take the shadow map rendering into a post-effects program and animate it.

### Multiple Distances

Recall the issue we had with multiple objects that were different distances from the ground plane and needed different amounts of softening? This is easily solved now that we can bring it into Photoshop and do whatever we need (see Figure 10.29). This technique can also be done with After Effects to adapt it for animation work.

*Remember that your projection map camera and your main camera are coming from vastly different perspectives, which can be disorienting. When modifying shadow maps in Photoshop or other post programs, it is sometimes easier to modify it once with orientation markings to see how they fall in the scene when rendered. After you are oriented, go back to the map and erase the markings in Photoshop, or use a garbage mask in After Effects.*

*In this file, the shadow projection map was set up differently in that it does not use the RGB channels. Rather, it inverts the Alpha to use the black area as the shadow projection. Its **Filter** tab was set to **Alpha Only** and **Invert** settings. This gives a bit less control, but removes the need to turn off the lights when you render the map.*

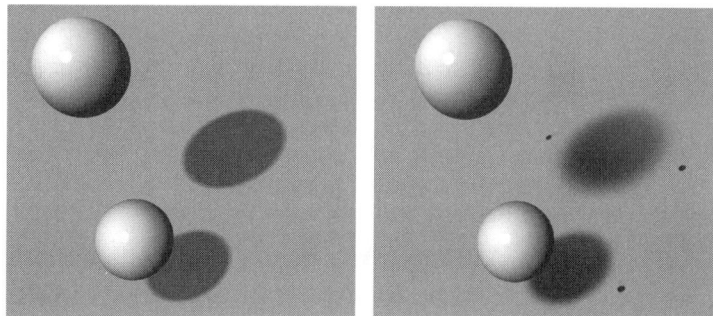

**FIGURE 10.29**  With standard Buffer maps (left) models at varying distances are still softened equally, but with custom maps they can be treated independently. Note the orientation markings in the shadows, see TIP for description.

*Remember that the **Filter** tab has a **Strength** slider that will allow you to dial down the maps opacity—this means that if you are using a RT image as a map, you finally have control of a Raytraced shadow's density. The **Blur** edit box will let you soften the map, and you also have a variety of **Blendmode** options in the **Filter** tab and the camera's **Projection Map** tab. You can also change the RGB color from black to other colors in Photoshop if you want to shift the shadow's hue.*

**ON THE CD**
Check out the variations included in the folder on the CD-ROM, which include the "Fake Buffer," "Fake RT," "Use RT Image," "Wireframe Shadow," "Multiple Distances," and "Multiple Objects," which is covered in the next section.

*CAVEAT EMPTOR: There is one major place where this technique falls apart, and that is if a model needs to cast a shadow onto itself. Traditionally, cast shadows are able to have models cast a shadow on themselves, but that is not possible when projecting shadow maps. The silver lining is that Animator does have the internal technology to overcome this and hopefully it will be implemented in a future release.*

## TUTORIAL — CASTING SHADOWS WITH MULTIPLE OBJECTS

Real Buffer maps have the luxury of using a **Z-depth** data file as mentioned earlier. A Z-depth file makes sure multiple objects that cast shadows onto each other do so correctly. Because we do not have this sophisticated data controlling our mapping, we need to rig it so that when one model is in front of another, each casts the right shadow. If not, the mapping would quickly get messed up. The Multiple Objects.prj file on the CD-ROM shows one example.

**ON THE CD**

### PART I: TAKING THE PICTURE

1. All steps are the same as the first tutorial, except here you apply the **Shadow Object Only** toggle to both spheres.

### PART 2: PROJECTING THE SHADOW MAP

1. This is just like in the earlier example, the Plane model is added to a Selection Set and this set is selected in the **Camera Map Applied To** drop-

down list. This restricts the camera map projection to only the Plane model. Set **Camera Map Applied As** pop-up to **Diffuse**.

2. Set the Plane model's **Receive Shadows** toggle to off in its Info window.

### HERE'S HOW IT WORKS

The sphere model closest to the light now casts a real Buffer shadow onto the second sphere, and you can give it just a touch of **Softness**. Both spheres appear to be casting their shadows on the ground plane, but it is really the projection map's doing. The camera's projection map was given a lot more softening with the **Filter** tab's **Blur** setting to make it look further away.

See Figure 10.30 for the final rendered result, and go dissect the file!

**FIGURE 10.30**   Multiple models combining both Buffer and Projection techniques.

## SUBTRACTION LIGHTS

You have to love the virtual world. Instead of having a light **add** illumination to a scene, we can set its **Intensity** to a negative number and actually have it subtract illumination!

This can be used to dim sections of a scene, or broad areas. Just about all the standard lighting controls work with this feature. It's often used to take illumination away from areas that may be overexposed from multiple lights—this can happen frequently if you have lights and models that are not set up to cast shadows, thus allowing the light to pass into areas that would be darker in real life. There are a variety of other uses including special effects, but for now, you will do a mini tutorial that uses subtraction lights to solve a common problem that many animators face.

## Projecting Shadows with Subtraction Lights

Buffer shadows are actually created using a texture map, as discussed earlier in this chapter. Most of the time this works very well, but there is one particular type of scene that causes Buffer maps and animators a great deal of problems. It is the very popular outdoor scene shot from way overhead and encompassing many models. Why is this a problem? Because these scenes are usually daylight which means they are lit by a single Parallel light source. This one light has a single Buffer that creates the cast shadows for every single object in the scene. Normally this can be fine, unless you run into one of these three problems:

1. The scene has many small models, but also a few that are quite a bit larger than the rest. The problem is that the small models only need a bit of **Softness** applied in the **Shadow** tab to look good. The large models, on the other hand, will require much more or their cast shadows will look harsh and hard-edged. If you give the large models the **Softness** setting they need, then the rest of the shadows in the scene can blur to the point of disappearing. There is no way to correct this disparity using s single light. (You could try using multiple lights instead of one parallel, but that has its own set of issues in trying to reproduce broad sunlight, and avoid overexposure.)

2. If your camera dollies in for a very close shot, the shadows may look terrible. Why? Because they are being created from a very small part of the Buffer map. The only direct solution is to increase the resolution of the Buffer map, but to be effective, the increase would likely make the map impractically large. There are directorial, editing, and compositing solutions to this, but if you need this to be one swooping shot, it can be problematic.

3. If for any number of reasons the models need to be illuminated differently from one another, you may run into conflicts.

Creative animators have often come up with the solution to light the key models separately, and isolate them from other light eco-systems using **Selection Sets**. The problem they run into is that both the masses of models and the key models need to cast their shadows upon the same ground plane! It needs to receive the light and cast shadows from both eco-systems, but then we are looking at an over exposed ground plane and other problems. Yes, there is a way to do it generating shadow masks and using post-production compositing, but solutions that can be accomplished from within the program are often mentally cleaner and certainly generate fewer files to keep track of.

T U T O R I A L

## SUBTRACTION LIGHTS COME INTO PLAY

Similar to Camera projection mapping, lights can be used as projectors also. They are often used to project various environmental effects and virtual colored gels onto a scene. Light from a stained glass window is the common example. This is done by using an image map placed in the light's **Projection** tab. This is often referred to as a **Gobo**, coming from theater and film terminology.

But what if we were to load a gobo into a light and then make the light subtractive? We would find ourselves with the ability to project shadows. And unlike projecting a traditional Buffer or RT shadow, we now get to do it without also having to project light at the same time! This is a very powerful technique with many applications, and can be used in large part to solve all the problems listed above. Now, you will step through a project that has some of the same problems. The finished project file is named "Subtraction Shadow.prj" on the CD-ROM.

ON THE CD

In this project is a city scene covering a large number of buildings. A **Parallel** light is added for the overall sunlight and made a little yellow. It is set up to cast an obvious directional light with a fairly hard-edged shadow. In addition to aiming the direction of its illumination, the Parallel sunlight had its Buffer map carefully framed over the scene's active area so as not to waste the Buffer map's resolution. Some Ambient light was also added and made a touch blue to represent the clear blue sky that affects outdoor shadows (see Figure 10.31 on the next page).

The hero of this scene is an airplane that will fly across the screen, casting its large shadow over all the buildings below. You will use a subtraction gobo light to create the plane's shadow because if you tried to use the main Parallel light, you would run into these problems:

1. The large Buffer map would need to be recalculated for each frame instead of being able to use the **Calculate Shadow Only Once** toggle. Calculating a large Buffer for every frame would be a heavy load for the rendering process.
2. The buildings have shadows that are kept mostly hard edged because they are relatively close to the ground compared to our distant viewing location. The plane, on the other hand, is high over the buildings and its shadow needs to be a lot softer. You can't do these with the same light.

**FIGURE 10.31**   A Still frame from the final animation of this Subtraction lights project.

3. The shadows cast from the buildings need to stay reasonably black because not that much **ambient** light is creeping in. But the plane's distance from the ground allows a lot more ambient light in, so the color and the quality of the shadows need to be different.
4. You don't need to do this here, but had you needed to adjust the shadow's location or size in any way, you could not have done it with the Parallel light without affecting the other models. Keeping it separate allows a lot more control.

### PRODUCTION STEPS

The following steps were taken to accomplish the subtractive shadow effect:

1. Once the **Plane** model was put into its basic position it was added to a new **Selection Set**.
2. A light was then added above, and in its **Info window X-form** tab, we plugged in the same **Yaw**, **Pitch**, and **Roll** values as were already applied to the **Parallel** sun. We did this because we want the shadow to look like it is coming from the sun.
3. The new light was then changed to a **Spot** light and its **Inner** and **Outer** cone values were made the same and brought down to a narrow number, ultimately **20 degrees**. Again, this was done to more closely mimic the parallel light of the sun. We replaced its **Intensity** value with a negative number; first we tried –1.0, but later changed it to **–0.6**.

4. The Camera window view was changed to view through the new Spot light. The light was centered on the plane and dollied way out to further increase its **Light to Reference Distance** value, and minimize the field of view. While still looking through the Spot's view a **screen grab** was taken of the Plane. We changed the Camera back to its normal view.

5. The screen grab was cleaned up, made into a black-and-white-only alpha-like image, and then inverted so that the Plane is white and the background is black. A few points of **Gaussian Blur** were added to soften the image and it was saved out in the IMAGE format.

6. This **gobo** was loaded into the **Spot** light's **Projection tab** using the **Add** button, and a healthy amount of **Blur** was added to it to increase its apparent distance from the ground. The Plane's **Selection Set** was added and set to **Exclude** because we did not wish to project the shadow onto this model.

7. In order to set up the projection shadow to look as accurate as possible, a few things needed to be adjusted to put us in something of a test mode. The city models were turned off because the shadow's distortions on the buildings would make any analysis difficult or impossible. A flat **Über-Shape** ground plane was put in its place. The **Spot** was turned off and a single test render was made using the **Parallel** light to cast a shadow onto the ground. Although we did not want to use it in actual production, it gave us a good idea of what we were looking to reproduce using the **Spot** light. Once rendered, the Plane's **Selection Set** was added to the **Parallel** light and **Excluded** so it will no longer see, illuminate, or cast a shadow for the Plane model.

8. At this point the plane had not yet been illuminated, so the **Parallel** light was **duplicated** and the Plane's **Selection Set** was changed from **Exclude** to **Include**. Other than **Ambient**, this is the only light that actually illuminates the Plane.

9. The Spotlight was turned back on and a test render was made to get a feeling of the "shadow" it casts. Although it was not bad, the proportions, size, and location weren't a reasonable match for our **Parallel's** sample quite yet. The **size** of the projection is controlled by the **Inner** and **Outer Cone** settings, so they were adjusted. The proportions of the image are controlled by the **Projection** tab's **Scale** and **Alignment** controls. Setting the **Alignment** to the **Fit Without Outer Cone** option changed the **Scale** to **X: 1.0** and **Y: 0.5176**. This was an immediate improvement as a few factors must have elongated the Y-axis, but it improved with this correction.

10. A few extra test renders were made to get the shadow density correct for both lights. The **Spot's density** is controlled by its **Intensity** value and that was scaled back from –1.0 to **–0.6**, as noted earlier. But the shadow color was too neutral and needed more blue in it than the **Ambient** light was casting. As the non-realistic buildings were already looking rather blue, we decided to add more color from the light itself. To do this, we changed the white light chip to a color. Because we were subtracting light instead of adding it, we used the inverse or complimentary color to the one we wanted. Blue's compliment is in the yellow areas so that is the color we added to the **color chip** in the **Properties tab**. The substitute ground plane was deleted and the city building models made visible once again.

11. After everything looked good, we had to get the animation working. The **Spot** needed to track along with the plane to work correctly. Using a follow-spot approach with a **Constraint Look At** would not look right. So we simply made the **Spot** a child of the Plane and set its **Link/Joint** editor to **Inherit Position**.

    The Plane model's **animation track** was **enabled**. The **Time** slider was set to **0.0** and the Plane model (along with the light in tow) was dragged off Camera view to the right, using the red colored **X-axis Transform arrow**, as seen in Figure 10.32. The **Time** was then set to **6.0** seconds and the Plane model was again moved using the **X-axis Transform** arrow to the other side of the screen and off view.

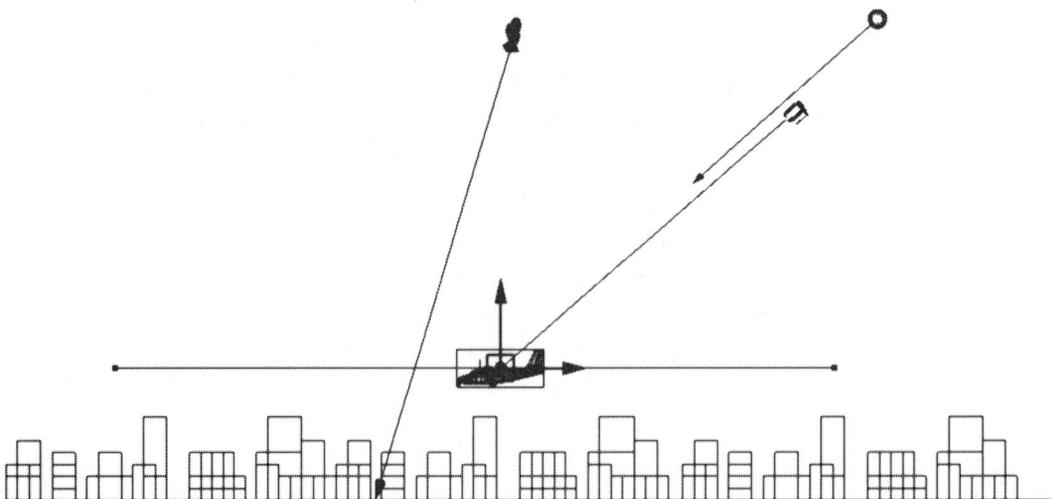

**FIGURE 10.32**  The Front view window of the animation being set up.

12. The animation was rendered out, and sound was synthesized (that's another book), and the two combined using **QuickTime Pro**.

*ON THE CD*    You can see the final version of the animation on the CD-ROM called "Subtraction Shadow Plane.mov," and notice how generally natural the effect turned out, despite the fact that this is certainly not a realistic scene. Open the project file and see how it is all put together. Also try various moves on the Plane model and watch as the **Spot** light follows along. Use both **Transforms** and **Rotations**.

## SOFT LIGHTS: SPOTS AND ARRAYS

In the never-ending search for the perfect light for the perfect job, there is yet another option that many dedicated 3D artists embark on to achieving realistically soft lighting: They manually build banks of lights. Although a bit more time consuming in the setup and rendering phases than using a default light, the payoff is a more realistic light and shadow pattern.

With a **bank** or **array** of lights, the shadows that are created behave more naturally in that they are sharper near the start of the object casting the shadow, and become increasingly defocused further away. By ganging a number of lights together, we are actually doing the same thing that the raytracing engine does when we tell it to turn on the **Soft Edge** feature. But unlike raytracing, which is made as slow as molasses with this option on, Buffer shadows are still fast enough for animation use.

We are going to look at two types of soft lights here, a **soft spot** light, and an **array** or **bank** light. Soft spots and arrays can be easily cause confusion with Animator's Illuminator lights (see that topic later in this chapter). This is understandable as many characteristics and potential uses overlap. Generally speaking, the differences are

• **Soft Spot**: Although technically a bank of lights, the term *Soft Spot* does a much better job of describing its design and intent. Its design still has all the lights in a tight cluster like a spotlight, and thus its main goal is to create a more realistic cast shadow and not change the quality of the lighting on the model. This is very different than the goals and mechanics of our arrays and Illuminators, which usually work at broadening the source of light as well as the softness of the shadows.

- **Bank Lights**: The bank lights we will build are also based on Spot lights, but in a much broader pattern that creates a softer lighting on the model. Although similar to the Box Illuminator, it does not engulf a model the way a Dome Illuminator does.

### Building Soft Spots

Building a soft spot is simply a matter of arranging some number of lights together in a controllable way, with these lights all generally pointing in the same or similar direction. A soft spot has already been created for you in the "Soft Spot.prj" file on the CD-ROM, you can see a screen grab of it in Figure 10.33. A sample rendering can also be seen in the same figure that shows the soft-shadowed results from this light rigging.

The entire soft spot rigging can be saved as a Fact file and re-imported into other projects. So you will find the file "Soft Spot Light.fac" also available on CD-ROM for your use. When importing this into a project, you will have to designate the Master Light because this does not survive in the Fact format. One other odd item is that saved Spot lights are not always able to preview their spot properly, even though they render without any problems. This will probably be corrected in an update.

There are a few parameters to be aware of when setting up bank lighting.

**FIGURE 10.33** A screen grab of the Soft Spot fixture (left), and a rendering of our Cone project using a "single" Soft spot. Notice how the shadow starts soft and gets progressively softer just like a raytraced image. Yet even with the 25 lights on this fixture, it still rendered in less than 8 minutes, close to half of the RT.

### Shape of Array

Lights can be arranged in almost any configuration, but the most common are circles or rectangles. Even within these shapes, many light riggers weight the dispersion of the lights a variety of ways, some like an organized pattern, while others prefer a stochastic approach. These variations often provide little tangible benefit, unless the number of lights is very low and needs to be dispersed more carefully.

### Size of Array

The larger the bank of lights is, the more defocused the shadows will become. This is the same as a circle of confusion in photography and optics (see Chapter 12, "The Camera" for more discussion of this). But, if the bank is made larger and there are not enough lights to produce a smooth pattern, you will begin to see very separated cast shadows instead of the smoother effect usually wanted. The light attributes can compensate for this to a large degree. *The size of the array is one of your main control factors when setting up this type of light.*

### Number of Lights

The more lights in a light bank, the smoother the shadow's **blur**—and the longer the rendering time. Fewer than 20 lights, and the amount of defocus that can be accomplished smoothly may not be worth the effort. Although some have used upwards of 100 or more lights, this can consume a lot of rendering time.

### Focal Point of Light

A focal point of a light is created by rigging all lights to point toward a target object that is placed perpendicular to the bank's Z-axis. This target can be placed at the subject of the scene, at a closer depth or one much further away. In all cases that we tested, there appears to be no appreciable benefit derived from the added efforts. More control is gained by changing the size of the array. (Note that Dome Illuminators are used to *engulf* the subject in light, thus gaining a benefit from a focal point that we do not get here.)

### Attributes of lights

Each light has its standard set of controls that will need to be set properly. This is best done by creating a **Master Light** (see the Animator manual) and using it to control all the others in the bank. The main items of concern in this type of rigging are

- **Intensity**: This setting will need to be brought way down because we are using so many lights. If you have 20 lights then you should set the master to 1/20, as a starting point of experimentation.
- **Shadows:** Turn the shadows on, and set them to Buffer (or why else are we doing this?).
- **Buffer X and Y:** As discussed in the Shadow Buffer section, there are two ways to induce a blur effect into a Buffer shadow, and for this type of rigging, it's best to reduce the shadow mask's X and Y dimensions because the results are more constant. Just beware of blockiness if they are set too low.
- **Physical hierarchy**: With so many lights, you need to set the hierarchy to allow easy manipulation of the bank. The easiest way is to create a base plate to parent the bank to, and set the light children to inherit both Position and Rotation from the parent. Because a Master Light is not a physical hierarchy, there is no conflict here.

## Building a Bank Light

Although softening **shadows** is an important aspect of using an array of lights, creating a broader/softer light on the **model** is also a concern. The Soft Spots did not address this, bank lights do.

Bank arrays are usually designed as large panels of light that broadside a model and create that look of someone sitting in front of a large picture window on an overcast day. Not as common in real life as in the movies, but nice imagery non the less.

When creating an array, the natural choice would be Animator's only real soft light, the **Tube**, but the results of our tests were not wonderful. They put out too much light at the ends, so the surrounding elements often get more light than the model. They also do not cast shadows, and they do not create a specular reflection. So Tube lights were ruled out. We reverted to using Spots over Radials because they can be made just as soft from the front and we gained more controls.

*ON THE CD*   The project file "Bank Lights.prj" on the CD-ROM contains a bank with 25 Spot lights arranged along an anchor plane as seen in Figure 10.34. A sample image of the bank light illuminating a 3D teapot is also seen on the right.

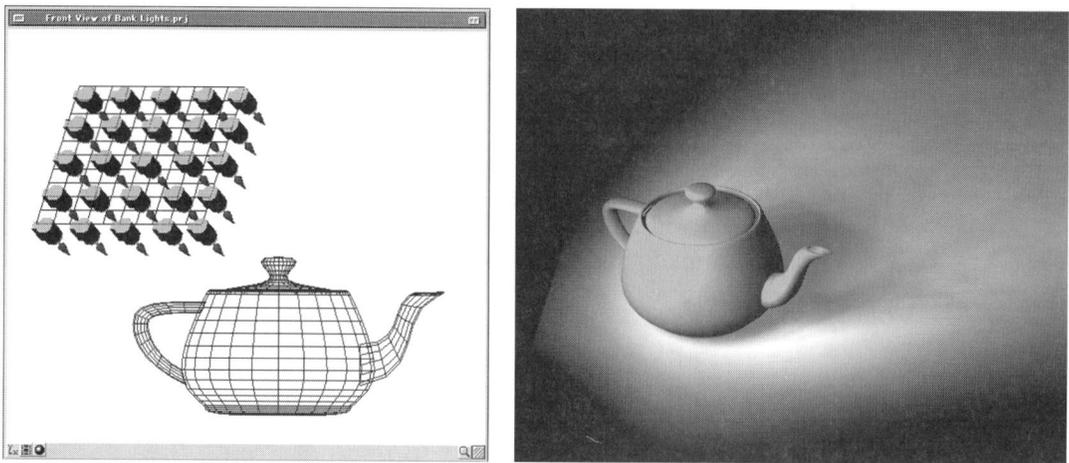

**FIGURE 10.34**  Left: A screen grab of the Front view window showing the bank's arrangement. Right: A sample rendering using only the bank light. Note how the model itself has a broader illumination, and notice the more real-world photo-studio look of the lighting's shapes. Rendering time was only a bit over 4 minutes.

### Notes on Using Soft Lights

Rigging and managing soft lights of any kind are more work, but they need not be that much. Here are a few thoughts to keep in mind:

- Take care not to manipulate a bank using individual lights—always use the anchor model they are attached to.
- The rigging is a bit less responsive to some navigations, but the widget manipulators/controllers work; so does using the X-form inputs in the anchor model's Info window.
- Viewing through the Camera window using the center light is okay to check, but don't use the Camera window's navigation as it will only move the one light. Instead view the Camera window while using other means to edit Position or Rotation.
- Use the **Constraint Look At** and apply it to the bank's anchor model. Have it **Look At** the model you want illuminated, and then wherever you move the bank to it will automatically face *exactly* the way you want it.
- The light Intensity does not always work as expected, and 25 lights set to 1/25 Intensity value is not the same as one light set to a value of 1.0. There are many factors going on that could cause this, so test and compensate.

- Bank lights specifically benefit from a realistic Dropoff applied as it adds to the soft quality.
- Don't forget to drop the Buffer Size X/Y down to keep the shadows soft and the render times fast.
- If a bank does not have enough lights there is no reason to start anew. Just duplicate your bank and shift it over a bit and you have doubled your lights.
- Turn some lights off during the testing period and back on for final renderings.

## ILLUMINATORS

This new class of lighting added in version 4.0 can create truly beautiful soft shadows and objects that feel so real you want to reach out and touch them. This is accomplished by setting up an array of lights in either a **Dome** or **Box** arrangement in Animator. In traditional photography, the same techniques are referred to as *light tents* (or simply *tenting*) and *bank lighting*. Just like in its 3D counterpart, these techniques are intended to move us away from the harshness of our pinpoint light sources. In photography, we would very often see bank lights used for beauty shots, and *tenting* is very popular for smaller items like expensive jewelry and hardware parts.

*Although sometimes called **Global Illumination** (GI), **Illuminators** are more accurately referred to as soft lights or bank/array lighting. True **Global Illumination** is actually not one particular technology, but instead more of a catchall category for a number of physical interactions that affect the way light behaves. Stanford University's Henrik Wann Jensen Ph.D., who pioneered the topic, defined it as: "The superset of radiosity and raytracing. The goal is to compute all possible light interactions to obtain truly photo-realistic images. The simulation of **all** types of light scattering in a model is called **global illumination**."*

Although the real-life and 3D tools are extremely similar, there is often a large difference in application. In real life, these tools are used to soften or remove most shadow. In 3D, where removing a shadow is as simple as turning it off, the attraction of Illuminators is the quality of the lighting and shadows they offer. When you see Illuminator samples they invariably exhibit a gorgeous and sometimes unearthly quality. See the difference between a parallel shadow, standard spotlight with shadow, and an Illuminator example set to a sample rate of 35 in Figure 10.35.

**FIGURE 10.35**   Three examples compared: Parallel/shadow (inset left), feathered spot/soft shadow inset right), and light from an Illuminator with shadow (at 35 samples).

Illuminators are added to the scene by going to the menu **OBJECT > Add Illuminator**. You will need to click in a World view, and drag the cursor out to size its stage area. Additional controls are found in the Illuminator's Information window; many you will know from the more standard light controls, but here are the few unique items.

## Stage Type

Illuminators offer the option of two types of stage, Dome or Box.

### Dome

A Dome Stage has the lights distributed across the area of a half sphere, engulfing the entire model from all sides like a photographer's tent light (see Figure 10.36 on the next page). This is the stage type that is used for the type of light we have come to think of when we hear Illuminator, or to a lesser degree, Global Illumination. It is soft and omnidirectional (which is different that non-directional), and it's weighted to have more lights distributed higher on the dome, and fewer along the horizon. One must assume this is to create a more natural feeling of outdoor lighting, and it works well. The one other element incorporated into this dome is that all lights point to the stage's center, so you would probably be less successful if lighting items outside of that area.

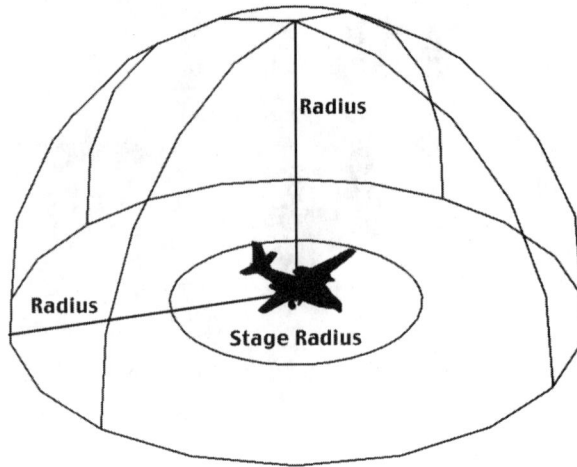

**FIGURE 10.36**    The Dome Illuminator control lines.

### Box

A Box has the lights distributed across a flat square plane (see Figure 10.37). This makes it extremely similar to the Bank or array lights discussed earlier in this chapter. Although this stage style defaults to being positioned directly over the head of the stage, the designers probably didn't expect us to leave it there because it does not produce an attractive visual effect. Because this light does not give the environmental or tent-

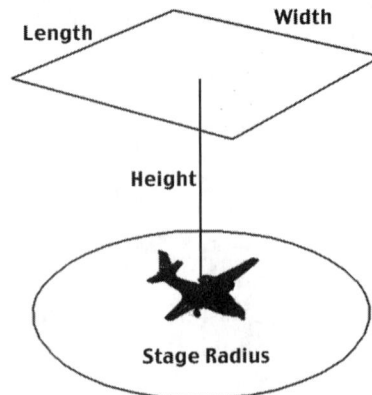

**FIGURE 10.37**    Screen grab of the Box Illuminator control lines.

ing effect of the dome, one is inclined to want to use it as one would use the home-built Bank lights. There may be a few caveats in doing that: Although it is a flat panel shape, it too seems to exert some kind of magnetic force on the lights to make them point more towards its center stage. This works wonderfully with the Dome stage, but can require a little more care and learning curve if you are trying to use this to replace your Bank light. The other problem with the Box was that the Constraint Look At did not work as it should, so this would mean that, for now at least, following a subject is a manual endeavor.

## Light Type—Radial or Parallel

In testing the Illuminator's Light Type settings, the **Radial** light gave a softer feel with a heavy light falloff further from the center of the Stage. The **Parallel** light provided broader coverage without the light falloff towards the ends of the stage exhibited by the Radial light. This is as expected. The Parallel was very analytical looking in its flat light, which was an interesting mix with very soft shadows when the Sample rate was set to a high enough value. Radial is certainly the one you will find more uses for in most types of projects.

### Radius or Height/Width/Length

These are best set to comfortably cover your scene and the items you wish to illuminate. Give your items enough room to breath, no reason to be cramped. Illuminators also seem to give a more relaxed and even lighting effect when enough space is between the lights and models. The flip side of this is that it is possible to generate some interesting abstractions of lighting if you bring the lights too close. Experiment.

### Stage Radius

The Stage Radius is actually the same thing as the Cone setting for other lights, it is the mechanism by which you determine the physical expanse of the Buffer map. And just like with other lights, you can make it very large and the shadows begin to get softer. If you make it too small it will begin to crop the map in strange ways. Setting it to approximately the same size as the overall Radius seems to be a useful rule of thumb.

### Samples Value in the Properties Tab

In order to create this array lighting Animator is doing basically the same thing you did in the last section, but doing it automatically. The number of lights actually put inside this Dome or Box light is determined by the value you put in the Samples edit box. So a value of 5 simply means you are assigning the Illuminator 5 lights. These lights then get automatically distributed around the Dome or Box—the more lights, the smoother the shadows. Of course it will cost you because the more lights you have, the longer the renderings will take. Take a look at the images in Figure 10.38 that show an increasing number of Samples, or lights. Notice how the shadows are the only part affected as Animator automatically adjusts for exposure. Although the lower sample rates produce nice results in their own right, it is not until you start getting into the higher sampling rates that you approach the creamy smooth shadows that you associate with Illuminators.

### Buffered or Raytraced Shadows

Like all lights in Animator, you have the option between their traditional depth buffered shadows and the raytraced variety. Raytracing is very slow when you have just one light, but when you start to have the large numbers we are talking about for Illuminators you are looking at long

**FIGURE 10.38** The increasing Sample values of a dome Illuminator light (clockwise from top left): 35, 75, and 150. Their rendering times were 9, 20, and 36 minutes, respectively, showing a linear increase.

render times. Because the benefits of RT only exist in a few areas, try and refrain from its use unless you are using it for still work, where render times are less critical.

## Tips for Using Illuminators

Here are some final pointers to keep in mind when using Illuminator lights:

- Sample rates of under about a dozen look rather like discrete and separate shadows—like an actor on stage with a few spots. Numbers above 20 begin to give a more passable representation of a smooth look.
- You can get away with lower Sample numbers by cranking up the **Softness** value in the **Shadow** tab. Keep in mind that this will only help to a point. Remember that this is resolution dependant so a window-size test snapshot will look softer than a full-size render does later. Test at actual size using a cropped snapshot.
- Lowering the X and Y buffer size under the Shadow tab will do two things for you: It will soften your shadows and it will shorten your render times. Like the tip above, this will help, but only to a point.
- At the time of this writing, the **Render Shadows Only Once** option did not work with Illuminators, but this is likely to change and if your object is not moving in such a manner that the shadows change in any way, then by all means use this feature when it becomes available. Renderama in its current form does not support this feature, so it will need to be rendered manually.
- Illuminators work with our fake Buffer map techniques just like all other lighting does. So you can render the scene once and apply the shadows as a map. This will allow you to turn the shadows off of your Illuminator array and save you a good deal of render time. Your Illuminator will still need to generate the many lights, but this is much faster than shadows.
- If your render time is more important and you can compromise on the look, it is possible to use a broad soft Spot light to simulate an Illuminator to a passable degree (see the file on CD-ROM "Fake Global Light.prj"). Not a great solution, but in a pinch it will help.
- Because the Dome Illuminators are designed to give a convincing outdoor environmental feeling, certainly use them that way. But realize that by themselves, they only create a dull overcast day—in a sense it is like a more realistic Ambient light. Combine it with a direct Parallel light used as the sun.

*ON THE CD*

Although we think of them in terms of the shadows, you can use Illuminators for soft lighting objects and let another light cast the shadows. This can be a very effective way to do product shots. Check the CD-ROM for additional imagery and test images. And look at the project file "Illuminators Test Stage.prj" on the CD-ROM, which is a good testing stage set up with both Dome and **Box Illuminators**.

## ANIMATED SHADOWS

Here is a fun one to finish the chapter with. It will let you combine things you've learned in other chapters with this one. You are going to pick up the bouncing ball tutorial from Chapter 5, "The Project Window" and add animated cast shadows. But probably not animated the way you are thinking.

This is short and sweet, so be on your toes:

1. Open the project "**Ball Bounce-Shadow.prj**" in this section of the CD-ROM, or pick up your project file from earlier.
2. Add a large **ground plane Über Shape** model to the set, make it large so that it goes off into the sunset, maybe **30** or **50,000** units in each the **X and Z axis**. Also make sure you have the plug-in set to give you at least **20-50 EI Divisions** on the mesh.
3. Make sure the light is placed high above the bouncing ball and change it to a Spot light with moderate **Inner** and **Outer** Cone settings.
4. Enable the lights **Shadow Buffer**.
5. With the light selected, go to the **CONSTRAINT > Look At** menu. It will ask you to choose an object to look at, so pick the **Sphere** model (the blue ball), and then hit **Cancel** to tell it you are done. If you wish to confirm it worked, highlight the light and go to the CONSTRAINT menu again, but this time the **Constraint Editor** option should be available. Select it and see that it is set to **Auto Look**, the **Sphere** is listed in the **Target** section, and all the toggles at the bottom are enabled. If you hit the **Preview** button, you should also see the **Spot** following the ball as it moves.
6. Now make sure the **Time** is set to 0.0 at the beginning, **enable** the Spot lights animation toggle, and open the **Shadow** tab in the light's **Info** window.
7. At **Time 0.0** make sure the **Softness** edit value is already set to 1.0.
8. Now slide the Timeline to the point where the ball bounces highest, somewhere just around 1.0 seconds or a bit before, depending how you set up your animation. Whatever you choose is not very critical.

9. Go to the **Softness** edit box in the **Shadow** tab, and this time put in a much larger value, like 10.0.

10. Move the Timeline to where the ball next hits the ground, which should be about at **2 seconds**. In the Softness edit box put the **1.0** back in. Are you catching on? Every place the ball is close to the ground plane we want the shadow to look sharp. But when the ball moves away from the ground it naturally gets defocused and more blurred.

11. Continue this through the end of the animation.

12. Although it was not done in the sample file, you could add other attributes that occur when one object is moving closer and farther from another. As the ball moves away from the ground, its shadow would naturally get a little larger from the spread factor. It might also get slightly more transparent.

13. When you are happy with the way it is looking, add a camera move to accentuate the animation.

14. Render it out and see what you get. A sample of the finished animation can be found on the CD-ROM.

# MATERIAL EDITOR

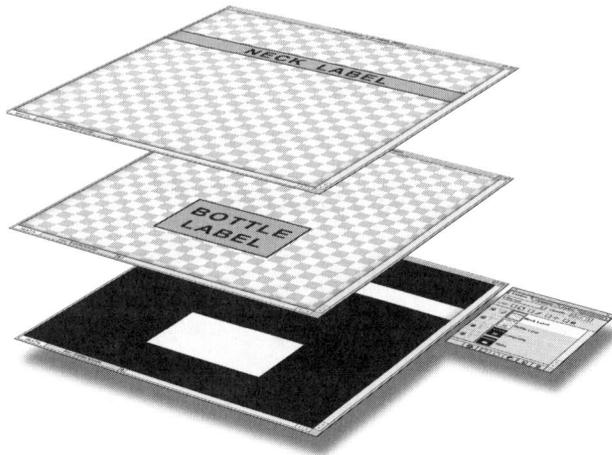

M ost topics in 3D can find their roots in the real world, but no such parallels exist for texture mapping. Rather, it draws aspects of its techniques from many sources, and relies on a variety of methods to accomplish its goals.

## ACCESSING THE EDITOR

To open the **Material Editor** (ME), double-click either on a model in a window or on its name in the Project window, while holding the Command key down. Alternately, you can select a model and summon the ME through the drop-down menus **Materials > Material Editor** or via its tool icons, located on the Toolbar, and also on the mini tool strip in the Project window.

## MATERIAL EDITOR AS A HIERARCHICAL STRUCTURE

The ME has a large number of sections and sub-sections. On the next page is a simple hierarchical chart that can help you understand just what is going on in the editor's interface, as seen in Figure 11.1.

## USING SUPER LAYERS

Hopefully, you are familiar with Photoshop and its multi-layering ability. What makes these layers so powerful is that they open the door to many options. They give you the ability to control transparency, masking, and layer interaction. In Photoshop's Layers floating palette, you can change the opacity and blending modes to create an unlimited number of variables with a just a few commands.

Although not a pixel editor like Photoshop, Animator's Material Editor also allows you to stack many layers of maps, each with its own alpha channel. It offers the same blending modes found in Photoshop so that you can create a variety of effects and visual imagery that would otherwise be impossible to do. Better still is the fact that it lets you do all of this in 3D! Layers are commonly used to build **glazed** textures (multiple transparent layers), adding grime layers on top of

## MATERIAL

This is the top structure, which contains all other bits of information within it. Think of this as a folder that simply holds all the related information in one place. You can also save Materials as a disk file and apply them to other models, copy and paste them to other models, or save them as a Master Material and subscribe any number of models to them.

## MATERIAL CHANNELS

(Also called Attribute Channels or Material Tabs) These are the tabbed sections you see when the ME is open, and they include **Geometry**, **Diffuse**, **Specular**, **Ambient**, **Reflectivity**, **Transparency**, **Luminance/ Glow**, and Transmission. These represent the principle visual factors that a 3D (or traditional) artist would deal with in order to attain the desired visual results. Each of these categories has both Attribute and Mapping control sections, which are located on the top and bottom halves of the tab, respectively.

### SHADING ATTRIBUTES

Each Material Channel has its own set of unique attribute controls, which are found in the upper section of the channel tabs. With less-demanding scenes you may find that many models can be set up with just a few simple modifications of these settings.

### IMPORTED MAPS

At the lower section of every Material Channel Tab you will see a section with List boxes that are used to import maps. These maps can be either **Image Maps** or **Procedural Shaders**.

#### IMAGE MAPS

Image maps are pixel-based images that are usually created or modified in Photoshop, and exported as Electric Image IMAGE files. These maps can be imported and stacked many layers high, each with different attributes applied through their individual Texture Editors.

##### IMAGE TEXTURE EDITOR

Double-clicking on a texture map in any channel's map list will bring up the Texture Editor with attribute settings for that map.

#### PROCEDURAL SHADERS

These are used in much the same way pixel-based image maps are, but shaders are actually mini-applications designed to generate a variety of visual effects and patterns.

##### SHADER TEXTURE EDITOR

Double-clicking on a texture map in the channel's map list will bring up the Texture Editor with attribute settings for that shader.

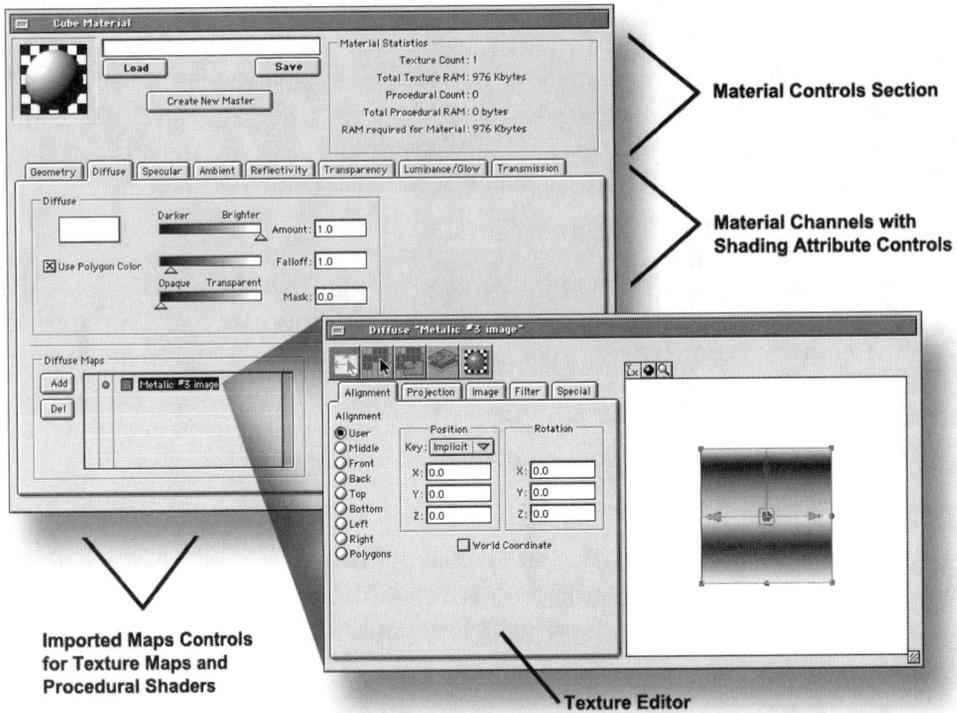

**FIGURE 11.1** The Material Editor with the Diffuse tab selected, and a Texture Editor window opened.

other textures, or applying irregularly shaped maps using an alpha channel as a mask. Although all the material channels offer this ability, the Diffuse channel is the one that offers far more opportunity to put it to best use.

As powerful as these options are, many users don't realize they exist because they are somewhat buried in the interface and not organized as logically as in Photoshop. Take a minute to identify the tools and compare them with their Photoshop counterparts.

The layers in Photoshop are, of course, comparable to the map lists at the bottom of the Diffuse Tab. This is where you load and delete image layers from the list, and where you can change the order of the list simply by dragging the items. Descriptive names are

helpful here because there are no icon previews like in PS's Layers. See Figure 11.2.

The other tools are found deep within the **Texture Editor's Filter Tab** (see Figure 11.3):

- **Strength Slider:** This control is the very same thing as the Opacity slider at the top of PS's Layers palette. Use it to control the map's opacity level.
- **Use Channel:** If the image loaded is an RGB+A file, this lets you choose which channels to load, the options being RGB, Alpha, or RGB+A. Note that loading an alpha channel does not automatically

**FIGURE 11.2**    At the bottom of the Material Editor, you see the Map List layers.

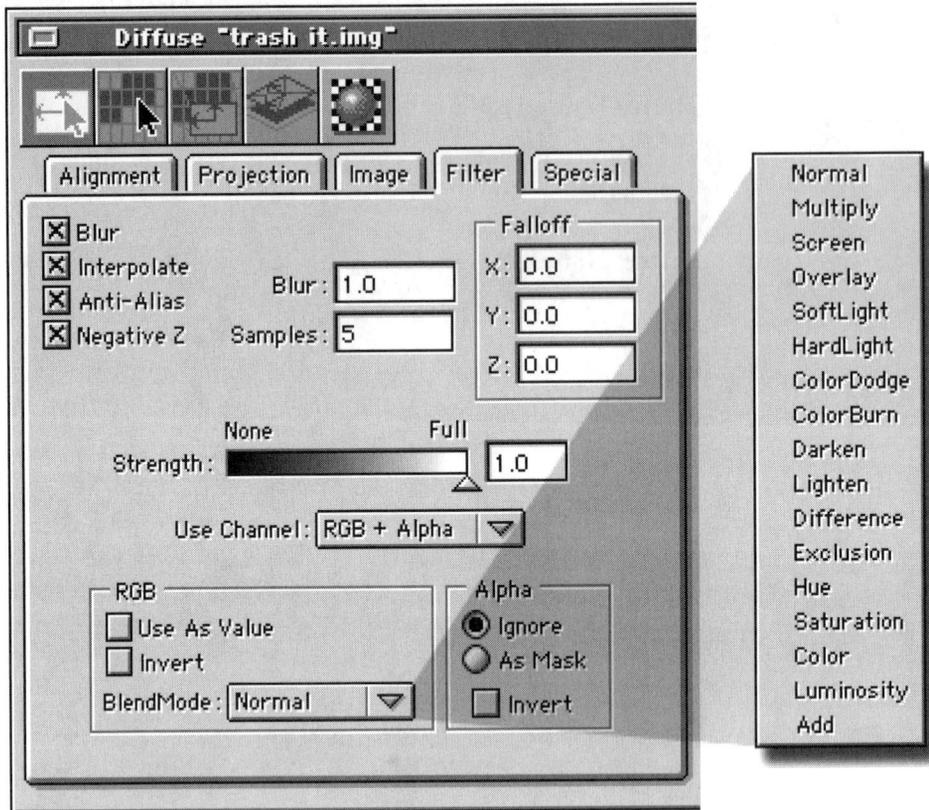

**FIGURE 11.3**    The layer controls are buried in the Texture Editor's Filter tab.

make it a mask, which must be done in the Alpha section below. (Although you can load a grayscale image if needed, you are less likely to do so in the Diffuse channel.)

### RGB

Here is a list of the RGB controls:

- **Use as Value:** When selected, this converts the RGB map to grayscale.
- **Invert:** This inverts the RGB colors to resemble a photographic color negative, or Black and White if being used when the Value button is activated.

- **Blend Mode:** This is the big one. As in Photoshop, this offers the following options—Normal, Multiply, Screen, Overlay, SoftLight, Hard-Light, Color Dodge, Color Burn, Darken, Lighten, Difference, Exclusion, Hue, Saturation, Color, Luminosity, and Add. The only two differences from PS's Layer palette is that Dissolve is missing and Add was added. Dissolve is a pixel-based effect, which may not be applicable, and Add appears to be a slightly brighter version of Screen mode. These settings do not preview in real-time and a test render is needed to see their effect.

### Alpha

The Alpha controls are:

- **Ignore/As Mask Toggle:** This control is similar to Photoshop's Enable or Disable Layer Mask control and activates the alpha channel to be used as a mask.
- **Invert:** Invert alpha is a real timesaver because it is easy to forget whether a value map should be positive or negative; this toggle offers an easy fix either way. This is really useful when loading your RGB+A map into a value-oriented channel.

### A Few Notes

- Except where mentioned otherwise, all of these settings give you real-time previews. The main exception is Blend Mode because Animator only displays one map at a time, and any blending requires more than one map.
- To save time switching between Texture Editor windows, jump directly from one TE to another using the hotlink **Source Editor** button. Of the five buttons at the top of the Texture Editor window, the Source Editor is the one on the far right. Use the Tool Tips pop-ups to find it.
- Another feature here that is also in Photoshop is the step-and-repeat function. But here it is much easier to set up. PS makes you define a pattern, select an area, and then Fill with pattern. In Animator, you just set **Tiling** in the **Projection** tab. It even has more options offering **None**, **Hold**, **Repeat**, and **Mirror**.

Unlimited layers with all sorts of blend modes is a powerful thing, it is great to have and invaluable when used properly—but do not rely on it too heavily. The first reason is the lack of real-time previews. The second reason is multiple layers take longer to render and will put additional demands on the system's memory. These seemingly small items add up when you are doing animation work, and your job as a production animator is to keep things moving along as efficiently as you can. Do the layer compositing in Photoshop, which will be faster anyway, and then use 1, 2, or 3 composited maps on your model instead of 20!

## SOLID MAPS

The Solid map technique is an important subject for material mapping in Animator, and will open the door to more control and a greater understanding of the Material Editor. This section is a brief overview of the concept, but it is recommended that you do the Power Mapping Glass Bottle tutorial to get hands-on experience with how Solid maps work in a project.

### What Are Solid Maps?

The concept of Solid maps is really very simple, and it is this simplicity that sometimes confuses people. They are just image maps with a black, white, or grayscale tone in the RGB and Alpha channels, which I call Solids here due to their similarity to Solids in After Effects. When added to various material attribute channels (Transparency, Luminance, etc.), they can be used to achieve greater control over the values of that channel. Because of their numerous applications, these simple maps can be used over and over in many projects to extend the capabilities of the Material Editor interface. In this book, these are called *Generic* Solids.

Although Solids only contain black, white, or shades of gray, single-channel grayscale IMAGE files are not granted access to all of the channel controls in Animator. RGB files are given more editing controls, and RGB+A have the greatest flexibility with full use of every control including the Blend Mode options. Obviously, this is the format you will usually want to use, and it is also the format referred to when the term "Solid Map" is used here.

### Custom Solids

Generic Solid maps are great, but since you often need to control specific areas of Diffuse maps, **Custom** Solid maps need to be made. The easiest

way to do this is to simply take the original Diffuse map that has an alpha channel, and in Photoshop, remove all color and texture from the RGB channel so you end up with RGB channels that contain either black, white, or perhaps a gray value, depending on your needs. Leave the alpha channel in place just the way it is because it will be used to mask the RGB. (See Figure 11.4.) Then save this custom Solid as another IMAGE file for use in the project. To keep projects well organized, it is a good idea to use the same name as the map it is based upon, and just add "SM" to designate Solid Map.

### How Do Solids Help?

**ON THE CD**

To understand how Solid maps are helpful, first try a simple project. Open the "Testing Solid Maps.prj" on the CD-ROM. If you were to do a test render right now, it would show a plane model on a checkered background, as seen in the left image of Figure 11.5. But what if you wanted to make part of that plane transparent? If you use the Transparency tab's attribute slider control at the top, the entire model becomes transparent (see Figure 11.5, middle image).

To gain greater control, you need to use a solid map. Locate the "whitewithalpha.img" at the bottom of the **Transparency Maps List** window, and toggle its **active** button on (second column, blue circle). Another test render should now look like the last image in Figure 11.5,

**FIGURE 11.4**   A normal RGB+A Diffuse map (top), and its corresponding Custom Solid map (bottom) RGB images are on the left and Alphas are on right.

which shows only the selected area made transparent. This was done using a custom Solid map that has an alpha channel with a circle.

As stated, this is a simple example, but you can see how it can be used in multiple channels to regulate a wide variety of attributes for Bump maps, Specularity, Luminosity, and so forth. It is also important to keep in mind that unlike a more traditional value map (in this case a transparency map), this solid map can be stacked in the List Box along with other solids to create cumulative results.

## Making Solids Work

The following list describes some of the controls that can be used to fine-tune Solid maps:

- **Attribute Placement:** Unlike using the main attribute sliders, which apply their properties to the entire model, Solids allow you to choose precisely where an attribute is applied. This is controlled by the placement of the map, using the settings in its Texture Editor's Alignment and Projection tabs. Solids generally affect the sections of the model that they are mapped onto, but they can also have control over areas they are not placed—I call these areas a map's **negative space**. This is done by extending a map's reach with the **Tile X** and **Y** controls also found in the **Projection** tab.
- **Invert Color:** By making use of the **Invert** toggle boxes for both **RGB** and **Alpha** channels, every map becomes four maps in one. A black RGB or Alpha can instantly become white, or the reverse. More interestingly, a 25% black tone in any channel becomes a 75% tone instead. All of this extends your ability to do fast mapping with delicate adjustments.

**FIGURE 11.5**   The default rendering (left). The Transparency Tab's attribute slider (center) is applied to the entire model, compared to generating transparency with Solid maps (right), which allow complete control.

- **Invert Alpha:** This option inverts the mask selection. Combine this with setting the **Tiling** to **Hold** for both **X** and **Y**, and you quickly end up with a Solid that allows you to control the map's entire negative space. Again, this means you just got two maps for the price of one! If you have a small map on a large model, this is a fast way to create a negative space map and it also takes up much less memory when rendering.

- **Strength Slider:** Now, look at the **Strength** slider, found in the **Filter** tab of every map. This is a great tool for dialing in the strength of a map with subtle variations. But be aware that this acts like a transparency slider for the map layer, and not a tone control. This means that sliding down the strength of a black map will give you a map that is progressively less black, not more white. Using the invert toggle will make it white, and then the slider works the same way. Think of this: you can use the slider to create a 50% transparent black map or 50% transparent white map. Neither of these are the same as having a 50% gray *opaque* map, but depending on your **BlendMode** settings and the map's use, some of these options may give the same results. Experimenting is the name of the game, so again, you begin to see the potential here. And it gets better.

  With stacked maps, the **Strength** slider allows you to dial in the value you want as a **wash** over lower maps. So a white map can be dialed in with the slider over darker maps, or a black map can do the same over lighter maps. All of this is being used to simply create tonal values that ultimately drive all of your attribute settings, all of which, happily, are animatable!

- **BlendMode:** By using an RGB or RGB+A file, Animator gives you access to the BlendMode options that offer endless stacking configurations. If you are stacking multiple map layers you can now blend them with the Multiply, Lightest, or other settings. Combine this with the Invert and Slider tools discussed above and you have a powerful arsenal to use in any channel your heart desires.

**ON THE CD**

You will find a folder on the CD-ROM full of RGB+A files that contain black RGB channels and have varying densities in their Alphas. I call all of these **generic** Solids and they are very useful for all sorts of quick fixes. You will see that they vary mostly in the Alpha channel, with different tones of gray, black, white, and a gradient ramp. Though small in size, most can be scaled up to any dimensions or aspect ratio without any visible degradation. This does not apply to the gradient, which has more practical limitations.

## Power Mapping

Since being redesigned in version 2.8, the Material Editor has had a versatile interface with many tools, but unlike the older version it no longer has the ability to independently set the shading attributes **per diffuse map layer**. What does this mean? One of the best examples is that of applying a label to a beer bottle (this comes from the author's work on a major beer account, not necessarily a personal penchant). In the old system, you could set all sorts of attributes to the model's geometry, like transparency for example. Then when you put a texture map on top of the model, you could set its transparency independent of the geometry's setting. The same was true for the next map as well (the software supported a max of 2 map channels at the time).

In the new system, all diffuse maps inherit **all** shading attributes. This means the bottle labels will automatically inherit the transparency settings made with the Transparency slider. So if you have a semi-transparent beer bottle and apply a texture map as a label, the label inherits the transparency from the bottle and it too becomes semi-transparent whether you like it or not. The technical term for this is "Bummer."

Below are three solutions to these problems. Solutions numbers one and two are common work-arounds and there are short tutorials on how to accomplish each one, along with full project files on the CD-ROM. The third tutorial is a more sophisticated solution that involves using Solid maps. Though it is more involved, it offers a number of advantages that make it much more efficient and versatile. All tutorials use the same glass beer bottle described.

ON THE CD

T U T O R I A L

ON THE CD

## Solution #1

This solution involves creating duplicate models that are then mapped independently.

1. Open the "Solution 1.prj " project file on the CD-ROM.
2. Duplicate the model of the bottle. The duplicate model remains in the exact same location as the original. One is labeled "Glass Bottle" and the other "Label Bottle." You probably need to make your "Label" model slightly larger than your "Glass" model, otherwise the label may get partially obscured by the glass material. As little as 0.5% or less can be enough to avoid any problems. You only need to scale the X- and Z–axis, as the Y-axis has no effect on this.

3. To the "Label" bottle, apply the label map in the **Diffuse** channel. The map's Alpha channels should **not** be active—this could result in double-masking after the Clip channel is added. See the RGB and Alpha maps in Figure 11.6. You can put multiple diffuse maps onto the "Label" model, especially if they have similar properties.
4. Copy and paste the map into the Geometry tab's Clipping channels. Set it to **Alpha** only. This will remove any part of the model where the Alpha map is set to black.
5. Set the **Tiling** X and Y to **Hold**. This will extend the Alpha's black perimeter pixels outwards in all directions, thus eliminating any part of the model outside the Alpha selection.
6. Now, to the second "Glass" bottle, apply all of the bottle's transparency and other surface properties, but don't apply any labels to it. See the results of both models in diagrammatical Figure 11.7.

When you render the scene it should all look right since you kept all of the elements and their properties discreetly separated. See Figure 11.8.

**FIGURE 11.6**    The RGB map (left), and its Alpha channel (right).

**FIGURE 11.7**    Label model (left) is clip-mapped, and Glass model (right) has no maps.

**FIGURE 11.8**    Final render of Solution #1.

### ADVANTAGES WITH SOLUTION #1

Logically speaking, this is a very "clean" solution, and easy to keep straight in your mind. It allows the labels to truly sit off of the bottle, which is potentially more realistic. And the Clip map gives you a cast shadow for the label.

### PROBLEMS WITH SOLUTION #1

It has the potential to add a great deal of geometry to the scene. Sure, in this example, you have only added a small bottle model, but in other situations, this solution could be forcing you into adding multiple copies of very large model files. When you need to animate them, this solution can further complicate your character riggings and slow production/rendering (turn additional copies off via the Visibility Flags while working to speed screen performance, and turn back on before rendering any final shots).

**TUTORIAL**

### SOLUTION #2

The essence of this technique is to map the entire bottle with one or more full-sized maps:

1. In Photoshop, Paste in a screen-grabbed image of the bottle model, adjust the width, and use it as a template to build your labels and surface property maps. See Figure 11.9.

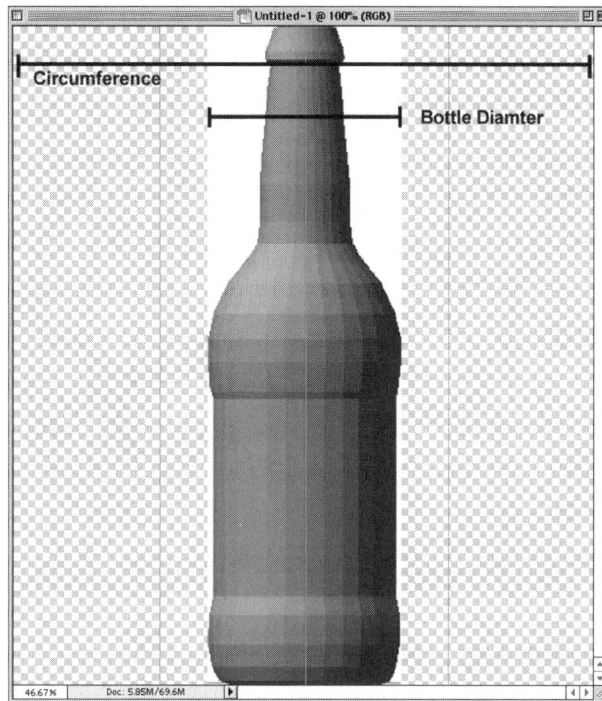

**FIGURE 11.9**    Screen grab of model from Front World view. Remember that the Circumference (template width) is equal to Diameter * Pi (about 3.14).

2. Create all of your maps on separate layers for ultimate control, and then load each one's transparency (**SELECT > Load Selection**) to create the Alpha mask channel. See the diagrammatical Figure 11.10 on the next page.
3. In this example, you will be working with just a Diffuse channel RGB+A file, but in a more elaborate setup, you could certainly add maps for other channels. See Figure 11.11 on the next page.
4. Add this map to the **Diffuse** channel list, and then change it to **Cylindrical Map Type**.
5. The **Wrap Angle** needs to be changed to 360 degrees so that it goes all the way around the model. This will sometimes leave a tiny gap at the seam, so **Tile X-Axis** should be set to **Hold** to avoid this problem.
6. The **Height** will likely default to the full height of the model, which should be 1.0. Remember that the idea is to cover the whole model with this map.
7. In the **Filter** tab make sure that both the RGB and the Alpha channels are loaded, and set the **Alpha** to **Mask**.

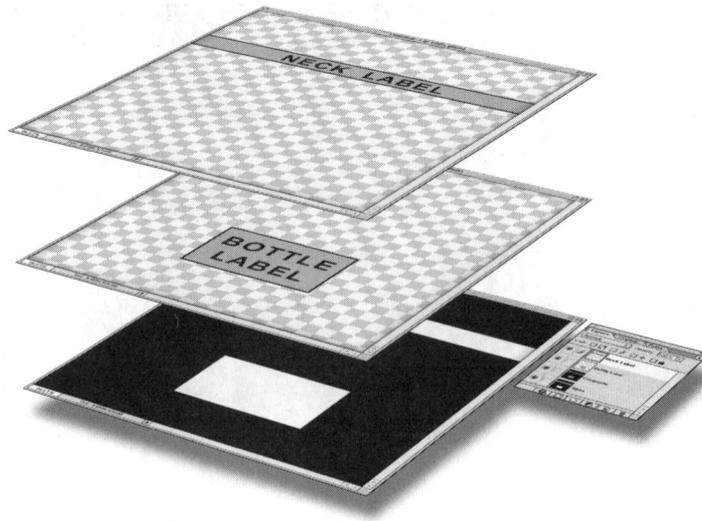

**FIGURE 11.10**    Creating the layered Photoshop file for generating the maps and alpha.

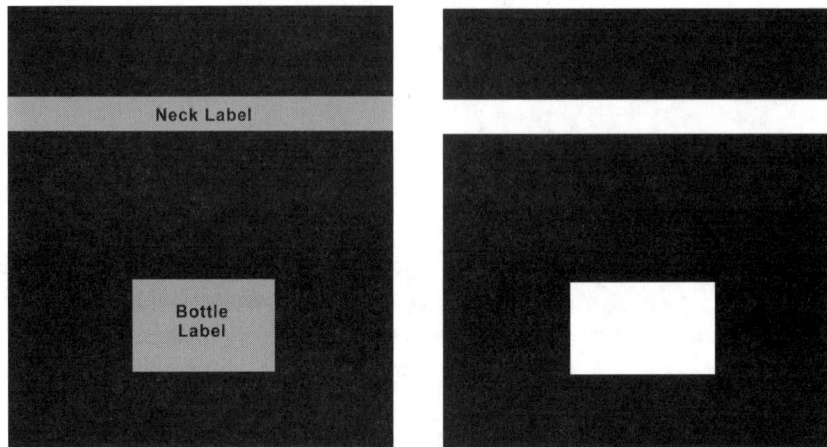

**FIGURE 11.11**    The full body RGB texture map (left), and its Alpha channel (right).

8. Now that this is set up and sized properly, you can go back to the **Diffuse Map List**, highlight the map and **Copy** it. Select the Transparency tab, click in the **Transparency Maps List** window, and select **Paste**, which deposits the same map already sized and positioned. Even though you don't really want to use this map for Transparency, pasting it here automatically scales and positions your real Transparency map.

9. Double-click on the map's name to open the **Texture Editor** and go to the **Image** tab. Click on **Replace Image** and select the "Transmap.img" which is a grayscale map that has had more details added, like seams along the sides of the bottle to represent the bottle's molding process, and a cloud mottling to give a bit of overall variation in the glass. Once this replaces the other file, it inherits the sizing and placement information so you are freed from having to repeat that process. This is a big timesaver when you're doing this with a number of channels. And because this is a grayscale map, you do not need to set the Use Channel—it will default properly. This map will now override any transparency Slider setting and make the glass very transparent, yet keep the labels opaque.

10. Even though the Slider control is now non-active, having been overridden by the full-body map, other attribute controls need to be set. In this sample, the mode is set to **Color Filter**, **Subtractive**, and **Custom Color**. These are the settings recommended for most normal situations. A light brown color set is what gives the bottle a brown glass look. For a bit of added realism, some extra **Edge** density is dialed in on the right. See Figure 11.12 for the final render.

*You will notice that this solution uses Transparency and the last one uses the Clipping channel. Though the Clip effect can give you a better shadow, it actually eliminates the geometry, which means you would not be able to apply the glass-like attributes used here.*

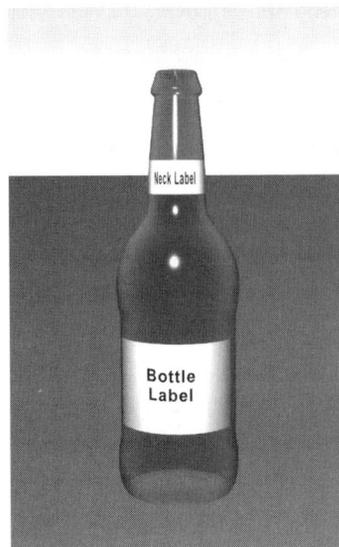

**FIGURE 11.12**    The final render looks good.

### ADVANTAGES WITH SOLUTION #2

What we have here is a technique that does all of the mapping in Photoshop—you could almost call it "pre-fab" mapping. This has a lot of plusses in that after we have the template correctly in place, it is easy to generate and align many texture and attribute maps quickly because it is all done in Photoshop. After the first map is loaded into Animator and aligned on the model (usually the Diffuse channel), it is easy to Copy/Paste this map to the other channels and **Replace Image** in the **Filter** tab to bring in any other attribute channels that are already aligned.

If a map artist at a large studio is handing off texture maps to the scene-building department, this will be a good option—it keeps much of the control with the map artist, and streamlines the workflow for the scene builder.

### PROBLEMS WITH SOLUTION #2

There are a few issues that boil down to flexibility and efficiency. What happens when you set up your entire model using this technique, and then need to change the size, shape, or location of an individual map? Or what if you need to vary an attribute level of one section of the model but not another? What happens is that you must go back to Photoshop and have ALL of your maps regenerated and swapped out for the old ones. Why is this? Because everything is locked together, and if you need to move the main label up an inch, you are locked into position with the upper label as well. You also have to move the Transparency and any other maps, which are also locked into this texture map eco-system. Hence, you have lost a great deal of flexibility and even the slightest design changes (can everyone say "client"?) will send you 50 yards back.

The second problem is one of system and rendering efficiency. Using a full model map can be very wasteful in many situations. Even in the example, you only have two small maps in the Diffuse channel, yet the full model map is covering much more acreage. Multiple channels of this can slow the working environment down a bit, and it will have an even larger impact on rendering speeds and the amount of RAM needed.

---

**TUTORIAL**

## POWER MAPPING: SOLUTION #3

Imagine if you could take the best of both of the previous solutions and come up with another option that allowed you to treat each map and attribute as a separate item—as it should be—and yet did not require you to create dead weight in the form of extra models or oversized texture maps. Drooling yet?

This technique is based on many of the layering and blend abilities of the Material editor that are discussed in the Super Layers and Solid Mapping sections. You will be using both generic and custom Solid maps in this exercise.

### LAYERING SOLIDS IN THE TRANSPARENCY TAB

Before jumping into this next tutorial, please take a momentary side-excursion into the world of the Transparency tab, if you will. When working with Solid maps and using their **BlendMode** and other settings, most attribute channels are well behaved. The Transparency channel, however, is unique in that it offers the user three ways to produce transparency (plus Raytracing). Each of these options goes about generating the transparency effect with a different set of rules, thus the results you get from using layered Solid maps can vary:

- **Filter**: This is the default mode and when you use layers and **Blend-Mode** settings with it, they behave as you would expect them to, much as they do in Photoshop. This can be used for a lot of quick setups with layering, and you will find it rather versatile using just the Diffuse map's alpha channel—saving you from creating special custom Solid maps. You will, however, still run into setups where you need to use Solid maps, and other situations where you miss the added controls offered in the Color Filter mode, or the better quality that mode can deliver. For this reason, this option is only recommended for doing quick and moderately simple layering projects.
- **Color Filter:** This is the preferred mode for transparency work, as it offers the best quality and the most versatile set of controls. The downside is that due to the way the Color Filter performs its calculations, the **Blend-Mode** settings for layers do not work as expected. You can remedy this if you create and use custom Solid maps instead of the Diffuse map's alpha. This only takes a few minutes to do and in the long run really allows for much more control. See Figure 11.13 on the next page.
- **EI Filter:** This option is similar to Color Filter, yet offers fewer controls so it is not recommended.

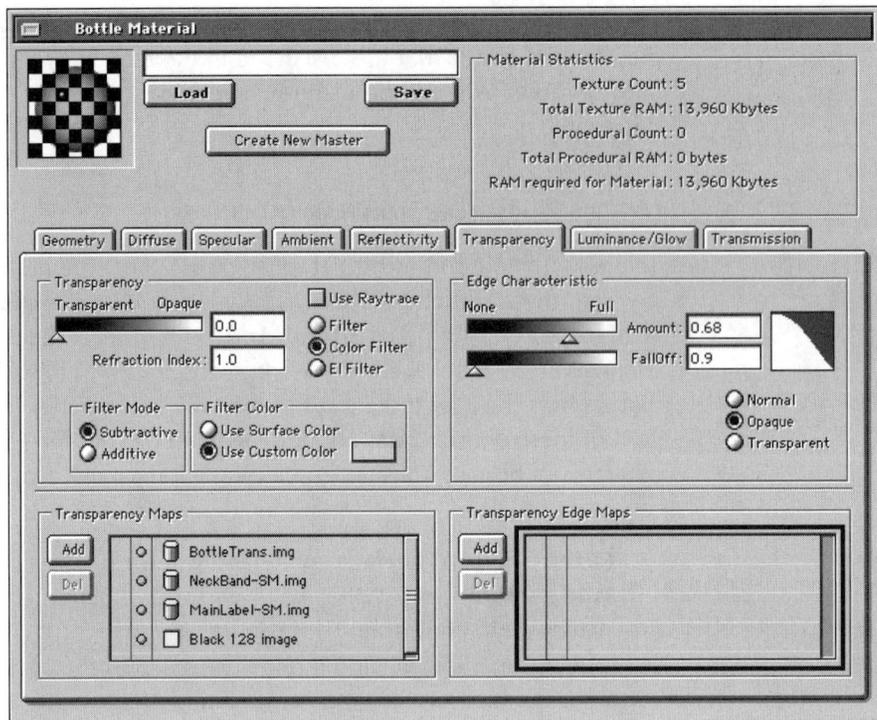

**FIGURE 11.13** Transparency tab set to Color Filter mode and its options.

## THE MAPS

The following is a list of the image maps to be used in this tutorial. They have already been created for you in Photoshop and saved out as IMAGE files on the CD-ROM:

**ON THE CD**

- **MainLabel.img**: The bottle's Diffuse main label. It is tightly cropped and has an alpha channel to mask its shape (see Figure 11.14). Although this is set up like a product shot, you could also add any dings, rips, or tears if the bottle needed a fatigued look .
- **NeckBand.img**: Diffuse map for the neck of the bottle (see Figure 11.15).
- **BottleTrans.img**: The glass bottle's transparency map. This grayscale map only addresses the opacity issues of the glass bottle, not the labels. This is how you want it to be, as it gives you the flexibility you seek. A slight mottling effect was added with Photoshop's Cloud filter to give a natural variation to the transparency. Extra opacity was added along either side to simulate bottle seams. The embossed logo area at the bottom of the neck had some extra opacity added, as well as an extra puff blown into the curve that swells just below the main label at the bottom. See Figure 11.16.

**FIGURE 11.14**    Main bottle label with its Alpha channel.

**FIGURE 11.15**    Label for the bottle's neck with its Alpha channel.

**FIGURE 11.16**    Full model Transparency map for the glass (emphasized for reproduction).

- **MainLabel-SM.img and NeckBand-SM.img**: These are the custom Solid maps (SM) to use with the two Diffuse maps. These look just like the maps above, except the RGB channels are white (not pictured).
- **LabelEmboss.img & NeckEmboss.img**: These are Solid maps based on the MainLabel and NeckBand maps. The Alpha channels have been customized to use these as bump maps to create an embossed effect on the two label maps. Figure 11.17 shows both custom Alpha channels.

### How to Put It Together

Although the emphasis for this exercise is on the powerful use of multi-layer mapping in the value channels and the use of Solid maps, a lot of other techniques and insights sneak in along the way.

**ON THE CD**

Open the "START Power Map.prj" file on the CD-ROM, which has the Bottle and basic scene elements in place for you.

### Bottle Glass

In Animator, you will start by setting up the glass bottle's attributes.

### In the Transparency Tab:

1. Add "BottleTrans.img" to the bottle's transparency map list, and then open its **Texture Editor** window to change the default Flat projection to

**FIGURE 11.17**  Custom Alpha channels for embossing the label maps.

**Cylindrical mapping**, and the **Wrap Angle** to 360 degrees. It should pop into almost the perfect size and placement when you do this, the only additional item you might want to change is to set the **Tile X** to **Hold** to avoid any seam in back.

2. Now set the Transparency attributes section to **Color Filter**, **Subtractive**, **Use Surface Color**. The Surface Color option works well for colored glass objects.

   **Edge Characteristics** should be set to Amount: 0.6, Falloff: 0.4. Make sure it is in **Opaque** mode.

### IN THE REFLECTIVITY TAB:

3. Bring the **Reflectivity** slider way up to about 0.6. Glass is not a mirror, but it is very reflective. Then make sure to set the color chip. Some testing showed that it looked best with the **Reflection Bias** toggled on. This takes the reflection imagery, and tones it to the hues of the model's Diffuse color.

*With both the Reflection and Transparency set to **Bias**, the bottle looks a bit dark. A short trip to the Diffuse tab to adjust the color chip a shade or two brighter (to **HSV 40/70/44**) does the trick, and bottle should visually snap into a nice sense of realism.*

4. Though called the **Edge Controls**, these really work to attenuate the middle sections of the model, so in reality they have absolutely no effect on the edges at all. Kind of funny. You want to tone the reflectivity down a bit in the middle, so set the **Amount** to 0.4 and the **Falloff** to about 1.0.

5. Now you need to give it something for the model to reflect, so add a panoramic texture to the **Reflection Maps** list. You can use the "pan 2.img" file found in the associated folder. Give this map a little extra **Blur** in its **Filter** tab, and make sure the **Use Bitmap Reflection** toggle on the right side is selected in the main tab area. The model now reflects the map around it. For basic backgrounds during testing and simple setups, the **World** object icon offers you the very handy **Backdrop** options, which can be turned on in **Project window > World icon > Backdrop > Sky/Ground**.

### IN THE BUMP & DISPLACEMENT MAP LIST:

6. Select the "BottleTrans.img" map in the Transparency Map List and Copy it. Then go to the **Bump/Displacement Map List**, click to highlight the

box, Paste the map into the list, and open its **Texture Editor** to the **Special** tab. After playing with a few tests renders, a **Bump** of 5.0 and a **Displacement** of 1.0 were settled on. The greatest effect here is on the emblem as seen in Figure 11.18.

The bottle still needed more variation in the glass to look real. Though the map above gave it an overall effect, it needed more variation on a **localized** level, meaning it's visible when looking at smaller sections of the model. The easiest way to do this is to add a subtle **Bump** map of noise. A procedural **Shader**, which maps the texture solidly and thus avoids any mapping distortion is perfect for this, so add "FractalNoise.shd" and do a bit of sizing. Since this is laying on top of the first map, be sure **BlendMode** is set to **Screen** so that both maps are used. **Lighten** would work also, and one or two others would give variations on a theme.

You want a very subtle effect, so the Bump can be cranked down until you just start to see some effect. In our testing, a setting of about 0.11 was too strong, yet the controls were not very responsive when dropped below that number. The solution is to leave it at 0.11 and simply dial down its **Strength** slider in the **Filter** tab until it feels right. See the overall shot of the model at this point in Figure 11.19.

### LIQUID MODEL

The Liquid model that sits inside the bottle is treated somewhat similarly to the bottle in many respects except one. Transparency with a hard edge is too harsh and does not look right, so instead of setting the Edge Characteristics to the **Opaque** mode, it is set to **Transparent** and the edges are feathered off. Open the file to see the details of this model.

**FIGURE 11.18**   Detail of the glass emblem area before Bump/Displacement (left) and after (right).

**FIGURE 11.19**    The glass bottle at this point, before labels are added (exaggerated for reproduction).

### BOTTLE CAP

1. The cap is mapped with a noise map in its **Specular** channel, and the **Specular Size** value is brought way down, which means the diameter of the specular reflection is made **larger** (because the numbers work the reverse of what you would think). Also, make sure to set the color to Diffuse Bias as metals' specular highlights are usually the same as their Diffuse color.

2. The settings described would normally result in a burned-out cap, except you can now go to the **Diffuse** channel and bring the Diffuse value to about half of normal. What you will end up with is a harsh fleck-like texture that has something of a sheet metal quality. Though caps don't really have this anymore (they used to!), it still reads well visually—people look at it and think "metal." Real caps are treated with many finishes to remove their metallic qualities, but such a surface might very well look less realistic than this one.

3. Change the **Diffuse** color to a yellow-gold and then map a white Solid to the very edge of the cap to create the unpainted edge caps always have. The Solid map is actually a black RGB, but that doesn't matter because you can click on the **Invert** toggle and turn it white very easily. See Figure 11.20.

**FIGURE 11.20** Detail of the metallic bottle cap.

## LABEL MAPS

Here you go, time to jump into actually adding the labels.

### DIFFUSE CHANNEL

1. Load up "MainLabel.img" into the **Diffuse** channel. Although **Flat** can be used and has the advantage of a correct X/Y aspect ratio, it also creates distortion you can avoid by using a **Cylindrical** projection. Cylindrical also eliminates the need to correct for negative-Z issues, so the map doesn't come out the back of the model in mirror image. The sizing of this map will need to be adjusted in the **Texture Editor**. You can either do it interactively by dragging at the map in the TE window, or using the scale, position, and rotation inputs in the **Alignment** and **Projection** tabs. Getting proper aspect ratio with Cylindrical mapping is more art than science because you are working with placement values that are based on the model and have little relationship to the map's real dimensions. Yes, you could figure out some formulas to do this scientifically, but good old-fashioned eye-balling is really the most practical solution.

2. In the **Filter** tab make sure that the **Use Channel** menu is set to **RGB+Alpha** and that the **Alpha as Mask** setting is checked. The label needs to be masked here because the geometry it sits on is not totally transparent—remember those cloud patterns in the "BottleTrans.img." The label map should now appear correctly sized, positioned, and masked in the preview windows.

### TRANSPARENCY CHANNEL

1. In the Diffuse tab's Map List select the "MainLabel.img" and Copy and Paste it into the **Transparency** Map list window. "MainLabel.img" map is now placed into this channel on top of the BottleTrans.img map with all parameters intact. Double-click on the map name to open its **Texture Editor**.

2. You don't really want to use "MainLabel.img" here, but it gives you all the scaling and positioning data with a simple Copy/Paste command. Now, you can go into the **Image** tab and select **Replace Image** to replace it with the Solid map named "MainLabel-SM.img" and retain the formatting. In the **Filter** tab, select **Use Channels RGB+Alpha**, and enable **Alpha as Mask**.

What have you actually done so far? **You have isolated the label's Transparency attribute settings from the rest of the bottle**. This allows you to change the strength of the transparency just over the label area, without affecting the rest of the bottle in any way. This is why Solids are so important!

### REFLECTION CHANNEL

1. You do not want the label to be completely reflective, so Copy the "Main-Label-SM.img" Solid map from the Transparency list and Paste it into the **Reflectivity Maps List** (the one on the left of the tab window).

2. White areas of a Reflectivity map are 100% reflective and black areas are non-reflective, so toggle the **Invert Color Value** button in the map's **Filter** tab. This will turn the RGB color from white to black and remove the reflectivity of the label. Most labels do have some amount of reflection, so dial the **Strength** slider down a bit to lessen the map's removal power.

### BUMP/DISPLACEMENT CHANNEL

You don't want the label to have quite as much bump as the bottle, so Paste the Solid map into the **Bump/Displace** map list on top of the previous two maps. You can do a few things here. You can click the **Invert Color Value** in the Filter tab to make it solid black and thus remove all Bump or Displacement from the label, or you can leave it white, which will **Bump** all of it evenly. This second option gives the label a slightly raised edge that picks it up from the bottle. The Strength slider can then be backed off a touch to allow a little integration of the lower maps. This is all very subtle and probably not noticeable in most shots, but you know its there. Besides, we are talking about theory here.

## LUMINANCE

If you were to do a test render now you would start to like what you are seeing. If this were a real-life product shot you would want the label to have a nice luminosity, so let's add it here. By adding the custom Solid map to the Luminance channel with the RGB set to white, you are brightening the label. It only needs a little, so you can dial in about 0.45 and set the attributes to the **Shade** option.

As an alternative, use the normal Diffuse map instead of the Solid white map. This will add contrast and more snap than using a solid, which tends to kill contrast a little. My model actually has a mix of both maps to achieve the balance of contrast and luminance I wanted.

## EMBOSSED LABEL BUMP CHANNEL

We all know *Universe Lager* is a premium brew, and you want it to look like one. So you have one more map to add to the mix. The "LabelEmboss.img" is a Solid map with a custom Alpha that you will place at the top of the **Bump/Displacement** list. Give it a decent-sized **Bump** value of 3.0. Figure 11.21 shows a close-up of the finished map with the embossing.

## NECKBAND LABEL

The **NeckBand.img** map is treated the very same way as the main label, except rather than figuring out the exact wrap dimensions to get the 360-degree Cylindrical wrap at the correct aspect ratio for the height, a shortcut is used.

Load the **NeckBand.img** map into the **Diffuse** channel and set it to a **Cylindrical** projection. Set the map with the right position, rotation, and sizing

**FIGURE 11.21**  Close-up of map with emboss effect.

so that it looks good, but here is the important part—**DO NOT** have it wrap around the full neck. In fact, if you try to get that to work it will never look right because the map was not made wide enough to reach. As you manipulate it, let the side ends fall where they may and don't worry. It will look natural this way.

When you are happy with the way the main elements look, go to the **Projection** tab and change the **Tile X** to **Hold**. This will extend the right and left edges of the map all the way around the neck of the model automatically! Make sure to do this with all of the Solid maps used for this, as well.

The second variation is due to the lighting situation. The neck label is closer to the light and on a more acute curve, so it catches more light and is a bit overexposed compared to the other label. Its custom Solid map was added on top of the **Diffuse** channel with the white RGB **Inverted** to black, and the **BlendMode** set to **Multiply** (though Darken or others could work.) The result is like turning down the Diffuse slider, but localized to just this map so the proper exposure is achieved.

### Shadows

If you intend to Raytrace the image, use the projection map trick (see Chapter 10, "Lighting") to save yourself a lot of rendering time. If you intend to use the Buffer shadows, then you should be aware that they are affected by the Transparency map. Any areas in the map that are darker than 128 (the 50% point) will result in areas that do not generate a shadow. The work-around is to duplicate the bottle and turn all attributes and maps off, and in its Info window's **Shadow** tab, turn the **Shadow Object Only** toggle to on. The final rendering is shown in Figure 11.22 on the next page.

### Advantages of Solid Maps

With Solid maps, Diffuse maps and their attributes can be moved independently of other items, without affecting the other map's settings. Just remember if you want to move "MainLabel.img," you will have to move all of its attribute maps as well and this will need to be done either manually by popping correct values in the coordinate sections, or by redoing the Copy/Paste/Replace steps we used above. Even though this method requires two maps—a Diffuse and a Solid—combined they are still much smaller than the large maps required by Solution #2.

Having a custom Solid map allows you much more control of the many attribute channels, and also gives you access to the BlendMode and other tools you might not have otherwise had with just a normal Alpha channel.

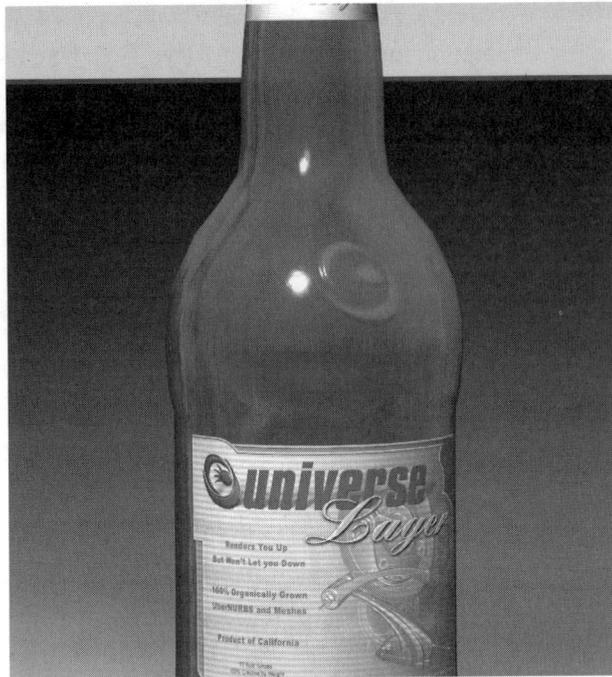

**FIGURE 11.22** The final rendering. See the image on the CD-ROM for a clearer view.

## UV MAPPING

UV mapping (UVM) is a fascinating technology that could fill a whole book by itself. The great amount of math involved with UV is beyond both the scope of this book, and the author's mathematical comfort zone (a sigh of relief heard all around!). Instead, this section will cover the most important aspects that relate to the artist/animator and give you enough information to lead you through at least a few *Lost Weekends* of experimentation.

### What Is UV Mapping?

UV is actually a coordinate system where the U and V represent coordinate locations something like the X and Y do in a Cartesian system. Where XY *mapping* is based on a rigid grid system, UV is used to map coordinate locations along complex curved surfaces—similar to the way longitude and latitude map the curvature of the earth.

The concept behind UV mapping is rather than trying to make the image fit the model, why not make the model fit the map? Or more precisely, make the model fit one of the standard mapping projections. The first step is to drastically simplify the model's geometry to allow the texture to be easily mapped onto it. This is generally done by unfolding the model's geometry into a flattened arrangement—looking like the old 2D World Atlas diagram of the earth seen in Figure 11.23. The model is then mapped using a Flat projection, and reassembled into its original shape pulling the texture along for the ride. All the vertices are used as mini anchor points with which to drag the texture.

Although an unfolded model with a **Flat** projection map is the most common scenario, the UV technique can support other standard projection options as well. You'll see this later.

### How Does EIU Support UVs?

As in the old joke, we have good news, and bad news. The good news is that EIU understands UV coordinates and image mapping in most respects. If you have ever mapped a model and then deformed it, you have seen the map follow along as if glued in place on the model. This is accomplished using UV mapping in a manner similar to that described above.

The bad news is the implementation needs to be further developed in order to make the animator's day go more smoothly. Animator can import Fact models with UV data, but not other formats. Fortunately there are ways around this.

**FIGURE 11.23**  The old style of flattening the 3D earth in order to make a 2D map is the conceptual basis of how UV mapping works.

## Creating UV Models in EIU

There are currently three ways to generate a UV-enabled model in EIU.

### Using Modeler

The first method is to create the model in Modeler. Yes, all Fact models generated in the Modeler actually have UV data. The fact that there are no user controls over their creation means you are restricted to using its default UV settings, however these are still valuable in many situations. Take a look at a complex block model that was created in Modeler by applying a Boolean Union to a few boxes, and then exporting it as a Fact file. When we bring it into Animator and apply a texture map using the Flat projection, we get the type of results we would normally expect to see. Figure 11.24 shows the Texture Editor interface and the corresponding Flat map rendering.

Hidden within every model's **Info Window > Shading** tab, is a section generically labeled "Texture" which has a main toggle called "Use UV Space" and then two sub-toggles you won't be dealing with now (playing with the two sub-toggles will get you a few interesting patterns, but nothing very usable). The main toggle is the on/off switch that tells Animator whether or not to use the UV data associated with the model (the toggle is unavailable if no such data exists). When you turn it on for the

**FIGURE 11.24**  The Texture Editor applying a standard Flat map (left), and the corresponding render (right).

sample you are now working with, you will see a few things change. The Camera window preview updates to show a pattern that looks more like Cubic mapping than Flat. This is actually the UV data moving the texture all around the model (UV mapping does not allow textures to pass through a model and create smearing as traditional mapping often does. This makes sense, since it is based on surface coordinates). You may also notice the texture's pattern seems enlarged, which is just a byproduct of changing coordinate space and can be modified with scaling controls in the Texture Editor.

The next thing you will see is in the Texture Editor's preview window—the model has disappeared! Well not exactly, but the geometry seems messed up and looks flattened like it has been hit by a steamroller (you may need to change the view to see the effect). This is normal, and how UV works. Any time you do UV mapping in Animator, the map gets applied to the model in the shape it was in when the creation software applied its UV data—usually this is done to a flattened model. A model like this can be very hard to make sense of, so when specific UV mapping is the goal, other programs should be used to help out. Since the model geometry has been converted to work with a Flat map, other projection settings will not work predictably, but feel free to experiment and see what you get. See Figure 11.25.

Just to show you one more sample, we took a block and a sphere and used the Boolean tool on them to make another model to import. In Figure 11.26 (top), you see the standard Flat map applied and then the UV map. You can see how the map follows a spherical pattern around the sphere, and a cubic pattern around the block. But don't forget that this is one solid model that only has a single Flat map applied to it. Pretty cool, huh?

### ÜberShape Plug-in

The ÜberShape plug-in is a great tool that offers the ability to create a wide range of models on the fly. These models are the only non-polygonal geometry supported by Animator at this time, and they also give you the option of creating UV coordinates. In the ÜberShape dialog interface, select the **Create UVs** toggle and then hit the OK button to exit. Remember to also turn on the Info Window's **Use UV Space** toggle and you should see the standard mapping change over to UV. If the preview and renders look funny, it may be that the model geometry size is reduced when UVs are turned on as you saw earlier. You may have to zoom way in, as the geometry can become very small in the Texture Editor window. Just go in and reduce the size of the map as much as needed.

**FIGURE 11.25** The model is set to UV mode in its Info window (top left), and Texture Editor now displays a flattened representation of the model (lower left). The model is shown with UV coordinates controlling the texture's placement (right).

To confirm that UVs are on, check that the geometry looks flattened in the Texture Editor preview window.

A Torus model generated with ÜberShape and rendered with and without UVs can be seen in Figure 11.26 (bottom). Again, notice how the map follows along the surface of the geometry in a manner that cannot be produced with standard mapping. Also included on the CD-ROM is a sample using the ÜberShape Rock option that does not generate proper UVs as we might hope it would (feel free to use the nice seamless rock texture that was made for it anyway!). Hopefully, this will be corrected in the future along with the Teapot whose UVs don't seem quite right either. Despite these exotic shapes, all of the more normal shape variations have worked just fine. An extra bit of information that should bring a smile to your face is that all UV data can be exported along with the model and saved to a Fact file.

**ON THE CD**

**FIGURE 11.26**   Top:  Another sample Modeler file. The first is rendered without UV(left), and the second has "Use UV Space" turned on (right). Bottom: The Torus model was generated by the ÜberShape plug-in and is shown rendered with both Flat projection (left) and with its UV space turned on (right).

## TUTORIAL

### UV'S FROM DEFORMATIONS

The Deformation controls incorporate the use of UV mapping coordinates in order to move any textures along with the applied deformations. You can tap into this power and use it to map models in great new ways.

Take a look at the Candy Cane example. A candy cane is certainly a simple form, but the spiraling red stripes wrap around not only the straight pole, but around the curved end of the cane as well. This would be a nightmare to map traditionally, but using UVs makes it easy work. This is how to do it:

1. Import the simple cylinder model "Cylinder.fac" and map a red and white stripe texture map named "Candycane.img" to it. Use the **Cylindrical** projection with a very narrow **Wrap Angle** of 45 degrees, and set its **X** and **Y Tile** to **Repeat** to create a straight stick with a number of straight red and white lines on it. When creating a model for this type of work, keep in mind that it will be deformed and make sure it has a high enough polygon

count where needed. Proper modeling is best, but the Dicer plug-in can be used, or you can increase the mesh count if using the ÜberShape plug-in (if you're using Über to generate the base model, you can eliminate a few undesired side effects that occasionally pop up if you output it into a polygonal Fact file and re-import it).

2. With the model selected and mapped, open the **Deformation** window. Create a new **Deformation Region** and apply the **Twist** deformation in the **Y Direction** to **Deform** the **X-** and **Z-axis** (see the included project file on the CD-ROM for details). Plug in a large amount of Twist—you can pre-view the results in the World view windows. In the sample file, the pole was twisted 650 degrees.

3. Now create a second deformation zone and apply the **Bend** deform to it. In the sample file the bend is set to about 200 degrees. Since you only wish to bend a section of the model, reduce the limit of the deformation zone by simply changing the **Y Minimum** value at the bottom of the window. Note that this setting does not become an active setting until you turn on the toggle next to it. Try 60 along the **Minimum Y-axis** so that the bend will only affect the top of the model.

4. While open, the Deformation window allows some nice interactive manipulations of the model in the normal Camera and World view windows by simply dragging the mouse around. It is also easy to muck up your work if you forget to close the Deformation window and start trying to work in the scene, so always close the Deformation window when you are finished with it.

5. You now have a finished and perfectly mapped candy cane in just two minutes of work! But this is not a portable UV model just yet.

6. Select the model and export it as a Fact file using the drop down menu **OBJECT > Export Object > Native Fact**. In the dialog box, select both **Preserve Deformation** and **Preserve Transformation**. The file is called "UV Candycane.fac" on the CD-ROM.

7. Close the current project file and open a new one. Make sure the "Candy-cane.img" texture map is in the same folder with this new model so it can find it and import this model and texture into the new project. With any luck, the model will pop into the scene looking perfect. (The author's version as of this writing requires you to toggle the **Use UV Space** switch off and on once to **reseat** the image, after which all is fine.) If anything looks wrong, check the map in the Texture Editor window—make sure the Position dialog under the Alignment tab has all fields set to zero. These extra steps may not be needed, but they're mentioned just in case.

If all was done correctly, you should have a UV mapped model that renders just like the deformed model did. (See Figure 11.27.) One thing you may notice is that unlike all other UV mapping that you have dealt with thus far, with **Use UV Space** on, this model does not display as flat in the Texture Editor window, instead it shows itself as the original cylinder model. If you toggle the UV switch off, then the TE preview changes to the candy cane shape. This is because when you turn the UV on, you are telling the model to go into the shape it was in when originally mapped, which in this case was a straight cylinder! Also note that the mapping parameters are the same as they were in the original file: Cylindrical with a 45-degree wrap and XY Tiling. As mentioned earlier, this is the exception as most UV mapping is done with a Flat format.

**FIGURE 11.27**    The candy cane model had its UVs created with the Deformation Editor and saved as a standalone model.

## Third-Party Programs for UVM

As time goes by, you can find more and more programs that support the creation of UV models. The short list of most likely suspects is Poser, Maya, Lightwave, Cinema 4D, Body Paint, Body Mesh, UV Mapper, and Painter 3D. Each of these programs handles things a bit differently and each has its own strong and weak points for various projects. What they all have in common though is the **inability** to write out to Fact format models. And although they write out to the OBJ format, which supports UV data and is recognized by Animator, Animator does not support importing the UV data from these files at this time. What to do?

### Object2Fact

To the rescue comes Ramjac Software with a wonderful utility called "Object2Fact," which does just what the name implies and converts Wavefront Object (OBJ) models into Fact format. In doing this, it offers the user a wide range of options that are very valuable and well worth the low price of this product. It should also be mentioned that the manual for this program was written by Jens Moeler, and is packed with information that offers a wonderful education in itself. This utility is simply a must-have if you wish to bring in UV models from other formats, and it is sold through *www.tripledtools.com*.

O2F's interface consists of just one screen that contains a rather straightforward set of options. The manual explains them all very clearly, but you will still want to experiment a bit and see what settings can improve on the workflow based on the application you choose to create the models in.

The OBJ format is very robust and offers the ability to contain a wide variety of data. In addition to the actual geometry data, OBJs can have an associated ".mtl" file which stands for **material**. Between the OBJ and .mtl files you can specify surface attributes, polygon colors, material settings, normals, UV map information, and more. O2F allows you to control a lot of these elements in its interface. The files needed to make the best conversion are: "modelname.obj," "modelname.mtl," and "model-name.img," and all need to be in the same folder. In any case, if some of these files are not present, O2F can go a long way in making things work anyway.

Figure 11.28 shows the O2F control screen that is displaying a sample preset for converting OBJ files generated in Poser. There is another version called Object2Fact Light, which is currently distributed for free.

### Using Body Paint 3D

Body Paint 3D is a relatively new program on the scene which picks up from where the likes of Painter 3D and others seem to have left off. A product from Maxon Computer who also makes Cinema 4D, there is no mistaking that this is a professional tool meant for real work. It has a powerful interface that will make Cinema 4D users feel right at home because they feel so similar and offers new users a taste of the deep toolsets found in Cinema 4D (see Figure 11.29).

**FIGURE 11.28**   The single-screen Object2Fact user interface belies the value it adds to your toolbox.

image by wen-kai chen

**FIGURE 11.29**   Body Paint offers some of the best tools for painting directly onto 3D models, and controlling every aspect of the process.

### The Basic Workflow

- Open a model up in Body Paint 3D.
- Create a new Material.
- Add whichever attributes and texture layers you will want to this material. Texture layers can stack much like in Photoshop and you can designate them for different channels like Diffuse or Specular.
- Make a layer active, grab a brush, and start painting. You can have both the 3D interface and the flat texture window open to paint on and edit with. It can be very helpful seeing both open at the same time.
- The way the map wraps the model, the way the model is unwound, and the way its UVs are generated are totally editable. This gives the user a lot of much-needed control that is hard to find in other programs.
- Export the model with its new UV coordinates, and export the maps to go with it.
- You now have an OBJ model and a Tiff or Photoshop file. Convert the image to IMAGE format and run the model through Object2Fact.

When you load them into Animator you may encounter two issues. The model may be inverted along the Z-axis. Remember that inverted is not the same as rotated 180 degrees. If a sock is sitting on a table and facing you, you can turn it around to face the other way by rotation, or you can turn it inside out—which is inverting it. If you invert it in Animator, it may not carry the mapping as you want so, the best bet could be re-converting the model and changing that Z setting in Object2Fact.

The other problem you may encounter is that of the OpenGL card or drivers not shading properly, this may be a fault of the way the model's normals are written. The image ends up being dark where light hits it, and light where it should be dark. If you turn hardware render off and switch to software preview render (using the Engine setting under the blue ball or use the Preferences settings), then the model will look fine. In either case, the model renders perfectly.

There is certainly a learning curve to be able to take advantage of the breadth of features in Body Paint 3D—its manual is at least as thick as Animator's—but the payoffs are there for you if your mapping needs warrant it.

### UVMapper: UVs from Thin Air

There are many otherwise excellent modeling programs that just do not recognize, or produce, UV mapping coordinates. To the rescue comes UVMapper.

UVM is a utility that has been in slow development for a number of years, and its developers have graciously given the betas away for free all this time. The final release of the commercial versions is just coming about as this book is being written, but for your needs the betas can do a fine job. For this tutorial, you will be using UVMapper beta 0.29 for the PowerMac. Though not tested, the version for Windows should work as well, though its interface may have some variations from what is described here.

**TUTORIAL**

## OVERVIEW ON HOW IT WORKS

- UVM loads a model's data set into memory and the user decides which way its geometry should be unfolded.
- The unfolded model is displayed on the screen for your inspection, and the geometry can be moved and modified in the window—to scale sections larger or smaller, and to make sure mesh does not overlap.
- Once you are happy with the layout, you can simply save out the model as an OBJ, and the preview screen as the map template.
- The map template can be brought into Photoshop and painted to your heart's content, then saved out as an IMAGE file.

Now that you have a basic understanding, actually go through it with real geometry, make a UV mapped model, and bring it into Animator.

### IN UVMAPPER

1. Run UVMapper and go to **MAP > Preferences**. You will see settings that allow you to preset the size of both the displayed template map on screen, and the size that it gets exported as. Setting these properly will make your workflow a bit smoother. The **On Screen Map** settings should not be larger than your monitor's resolution so you can see the whole image on screen. The exported image is what gets mapped to your models in Animator and will generally need to be larger. But getting this perfect is not needed because it is usually brought into Photoshop and painted; it can also be scaled up or down in the Image Size window at that time. If the export size is left small, then the template's resolution makes the polygon outlines very jaggy; this may interfere with precise work so choose a reasonable size. Also note that both the screen preview and export map's proportions are kept the same, but you don't need to do this. See Figure 11.30 on the next page.

**FIGURE 11.30**   UVMapper's Preferences dialog box where you set the preview and export dimensions.

2. Go to **FILE > Open** and load the "Testmodel.obj" file that is in the UVMapper folder. The model information will be loaded into memory and you can see its statistical readout at the top of the interface window.

3. Go to the MAPS drop-down menu, where you will see the many different methods available to convert the model from 3 dimensions into 2 dimensions. You will notice that these are the same or similar names to the standard mapping projection names, how come? UVMapper uses similar methods—but in reverse—to project 3D models into a 2D plane. Choose PLANAR with the settings shown in Figure 11.31, which also displays the resulting interface screen.

This model is very simple, but if you had a more complex one with multiple groups and materials, these could be selected individually by going to the SELECT menu. Once selected, these items appear with a marquee around them, and you can then drag them to new locations or make specific elements larger or smaller. See the Hot Keys under the TOOLS menu for a full list of con-

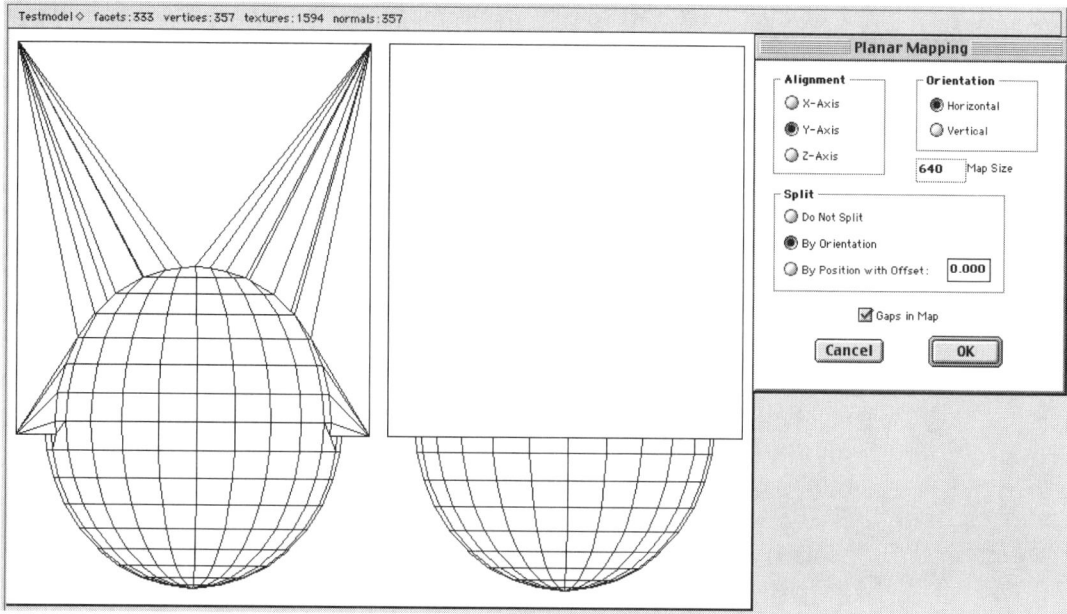

Testmodel ◇  facets:333  vertices:357  textures:1594  normals:357

**Planar Mapping**

**Alignment**
○ X-Axis
● Y-Axis
○ Z-Axis

**Orientation**
● Horizontal
○ Vertical

**640**  Map Size

**Split**
○ Do Not Split
● By Orientation
○ By Position with Offset:  **0.000**

☑ Gaps in Map

Cancel    OK

**FIGURE 11.31**    Planar Map dialog box and the resulting projection in the interface window.

trols. These controls are important because model groups often overlap each other, which makes mapping impossible. Selecting a group and moving it to another space solves this problem.

Another problem is choosing which projection/options are the best for your model as each involves some degree of compromise. The Planar projection chosen here is not without its own set of problems, which will be pointed out later. Like most things in 3D and life in general, make the choices with the fewest problems and then do your best to minimize the limitations imposed by those problems.

4. Go to the **FILE** menu and **Export Texture Map** and **Export Model**. Do not use the **Export UVs** option—it is not needed for what we are doing, as the UVs are already included in the model file. The model is saved as "Testmodel.obj," and the image as "Testmodel.pct" on the CD-ROM.

**ON THE CD**

5. Using either Photoshop or another program, open the "Testmodel.pct" image and do your thing making a texture map using the polygonal template as a guide. To be sure, this is not as sophisticated and power-user oriented as employing Body Paint 3D, but this method works well for many projects, and is more cost-effective. When you are done creating the art, save it out as an IMAGE file. For the sake of this tutorial, no master art was created, but instead the polygonal template was left intact.

6. Run Object2Fact to convert the model into a Fact file using the settings seen in Figure 11.28. It was saved to the CD-ROM and named "Test-model.fac." Notice that the **Make Texture Polygon** toggle is selected, this is covered later in this section.

Switch over to Animator where you can open up the file already set up for you called "UVMappers.prj." If you decide to create it yourself, just import the model and apply the texture. Make sure **Use UV Space** is selected (again, if there are any problems just toggle this off and on once to reset it).

In the provided project, the model is rotated around its X-axis for a better view. Take a look at the image and you can see the polygons in the image are mapped right on top of where they actually exist on the model. You can confirm this by switching the view to wireframe to see that it looks the same (just not shaded, of course). This is the stuff that keeps 3D junkies up late nights going, "Yeah!" Sad, but true. See the comparison in Figure 11.32.

When you set this file up yourself, the image should pop right into place because we added something in the O2F conversion—remember that toggle labeled **Make Texture Polygon**? It added a bounding polygon that becomes a

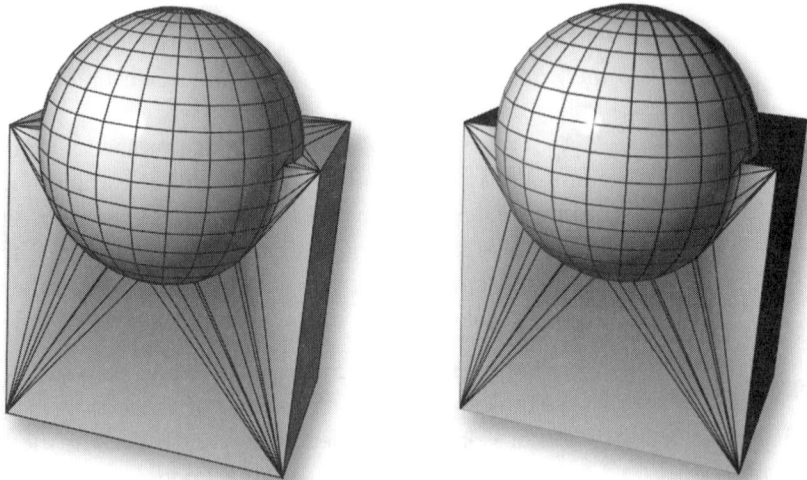

**FIGURE 11.32**    The image on the left has no map, but instead was created using the "Edge Outlines" option that outlines the polygons. The rendering on the right was a fully mapped render that uses the map we created. This verifies how accurately UVMapper can align a map to a model's varying surfaces.

placeholder for the exact positioning of the image map. You can see this in the Texture Editor window. If the map were to get moved at any point, you can always use the **Select Polygon** tool and then the **Fit to Selected Polygons** tool in the TE window to pop it back into place. Of course, simply setting the position and rotation of the map to zero all around usually fixes the problem as well, but this may not always be the case and so including the texture polygon is a good failsafe.

Another item you should be aware of is the seam that wraps around the sphere section of the model. You can see it best in either the top or side views in the project, and it appears looking like a darkened airbrushed band. If you examine the map, you will see that the polygons are severely foreshortened along these areas from the Planar mapping. Depending on your needs you might prefer to pick a different projection in UVMapper.

Lastly, you should remember that you can add maps to all the channels just like with non-UV models. So there is nothing stopping you from adding a specular or even a bump map to this model and creating something really spectacular.

# THE CAMERA

The word "Camera" is used in a lot of places within Electric Image's Universe—let's clarify them so that we are all on the same page:

- **The Camera Object Icon**: This is the non-rendering object in the World windows that represents the camera's position (as seen in Figure 12.2), and is used to interactively edit the position, angle, and rotation of the camera and its view. The results of these edits are pre-viewed in the **Camera view** window. Animator can add as many cameras as you want to a scene, but only one can be the rendering camera at a given time. Like all objects in the scene, the Camera icon is also listed in the **Project** window.
- **The Camera View Window:** This is the window in Animator's upper-right corner that represents the viewfinder of the currently se-lected render Camera. It is designed to feel like the user is looking through a real camera, with the ground glass borders and frame data. The darkened ground glass borders aid you in providing more envi-ronmental information to make proper framing easier. It also allows the animator to easily keep items just off screen until needed. The final framing seen in this view window is exactly what will be sent to the **Camera** rendering application to create the final single or multi-frame renderings.

    With just a few key commands the user can control almost all of the camera motion right from this window, although a combination of navigational edits both here and to the camera object in the World views is usually most efficient. These key commands are covered in the "Power Users Interface Notes" section in Chapter 4, "Animator's Interface" earlier in the book, along with most of the other control tools found at the bottom of the Camera window.
- **The Camera Application**: This is the program that is the rendering engine for Electric Image Universe. It will render what the user sees in the Camera view window. This application is covered in detail in Chapter 13, "Rendering."

You can see how all of these items that contain the name **Camera** are related to one another, but of course should not be confused. The context usually clarifies the intent.

*Many 3D artists do more print and photography than film, so we built an alter-nate 35 millimeter SLR camera model to use instead of the movie camera that An-imator ships with (see Figure 12.1). It's on this book's CD-ROM in the Camera*

**ON THE CD**

*section, and all you do is drop it into your EI Resources folder to replace the old one. Next time you launch Animator, you will feel a bit more at home! Keep a backup of the original file in case you want to return to the stock camera. The file name must be "IconBody_Camera" for Animator to use it, so you can't have both active in the folder at the same time.*

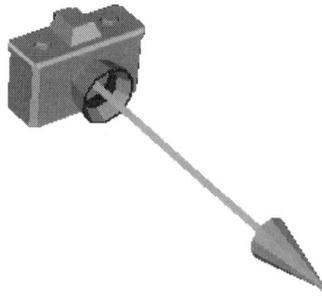

**FIGURE 12.1**   Alternate 35 mm SLR camera.

## USING THE CAMERA

When you look at the camera in the World views you will see that the model used to represent it is a classic movie camera. This is appropriate since as you go along you will see many of its controls mimic the way a camera actually works.

In the front of the camera you will see a long line and an arrowhead. The tip of the arrow is called the **Reference Point** or sometimes the **Focus Point**, and is used to determine the camera's aim. You can grab and drag the camera **body**, the **line**, or the **arrowhead** in order to change the position and orientation of the camera's view. The process is very intuitive and allows you to quickly jump between World views to adjust the camera from multiple angles (see Figure 12.2 on the next page).

When you drag the various camera parts:

- **Reference/Focus Point**: Changes the *angle* of view, but leaves the camera body in place. This is the same as using the Pan tool (Spacebar+Option) in the Camera window.
- **Line of Reference:** Moves both the Camera body and Reference point while changing the *position* of view. Leaves the angle intact. This is the same as using the Track tool (Spacebar) in the Camera window.

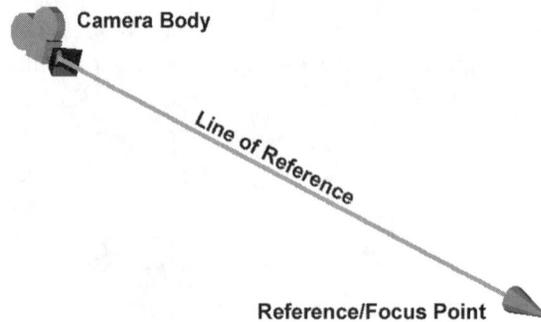

**FIGURE 12.2** The anatomy of the Camera icon, showing the Camera Body, Line of Reference, and the Reference/Focus Point.

- **Camera Body:** Changes the angle of view but leaves the Reference point in place. Thus, you can easily move the camera to a different point of view for the same subject. This is the same as using the **Orbit** tool (Spacebar+Command or simply holding the "O" key) in the Camera window.

  In addition, the Camera body can be dragged while holding down the **Control** modifier key to constrain the movement along the line of reference, and thus perform a **Dolly In/Out.** This can also be done to the Reference point, but you won't see any change in the Camera view, instead it will only affect **Depth of Field**, if enabled and set to **Reference** (see Figure 12.3).

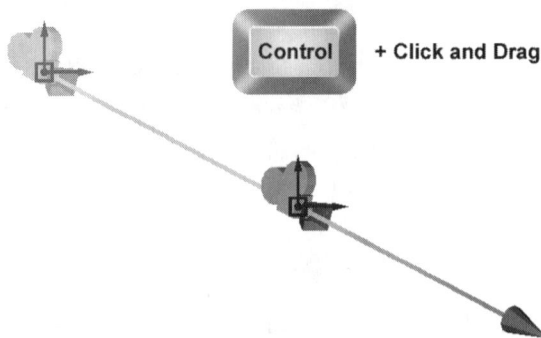

**FIGURE 12.3** The Camera's Body and Reference Point can have their motion constrained to the Line of Reference by holding the Control modifier key.

You can also constrain the Camera's movement along one of the axes using the **Translate** controller's arrowheads to constrain its motion, but you will find that it leaves the Reference Point behind. If you again hold down the **Control** key as a modifier, the entire unit will move in unison and give you a controlled **Track** motion along your chosen axis (see Figure 12.4).

## More Information, Please

When you modify the Camera object, it is very helpful to open its **Info** window and jump between the **X-Form** and **FOV** (Field of View) tabs as you proceed with the various moves and actions. Doing this allows you to see exactly which values are being edited and gain a greater understanding of how it all works together (see Figure 12.5 on the next page).

## Dolly Versus Zoom

Those without a film background may not know the difference between these two similar moves. They often appear to give us the same framing, so it is easy to confuse them. But they are actually not the same, and have important differences that you need to understand.

A **Dolly** move actually moves the camera body, as if you are pushing or pulling it on a Dolly cart with wheels. The camera lens' field of view (FOV) settings do not change at all, but the position of view is altered and

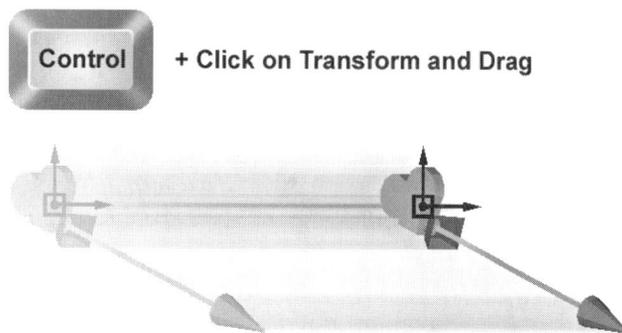

**FIGURE 12.4**   The Camera's Body and Reference Point can have their motion constrained to the chosen axis by holding the Control modifier key while dragging the Translator's axis arrows.

**FIGURE 12.5** The Camera's Info window showing the X-Form and FOV tabs.

creates what is called either a **Dolly-in** or **Dolly-out** move. This is a more realistic visual experience for most living creatures like we humans, as our eyes' FOV never changes. This is also why "blinders" were invented centuries ago—to change a horse's FOV and more narrowly focus their attention.

*Though our eyes' actual FOV never changes, our mental focus does alter what registers in our consciousness. If our mental focus is very narrow—like when trying to thread a needle—then our perceived FOV can be altered. Directors often take this into account when choosing how to shoot a scene.*

Having to physically move a heavy camera body in real-world filmmaking is costly and difficult. A classic example of this dolly technique pushed to the nth degree is the opening three minutes of Orson Wells's *Touch of Evil* that takes us across an entire town in one shot. As a virtual filmmaker, you do not have these constraints and can easily produce all types of creative moves. A simple "Dolly-in" move is shown in Figure 12.6.

**FIGURE 12.6**   A simple Dolly-in move. See "Zoom-Dolly.jpg" on the CD-ROM for more detail. First and last frames were matched as closely as possible to the zoom samples.

The **Zoom** tool is the same as using a zoom lens. Though the camera position and its angle of view remain unaltered, the **FOV** is made larger or smaller. This is a control that is usually set once per shot, and somewhat less frequently animated.

Outside of its early cinematic use in the '60s and '70s, when the zoom lens technology first became widely available, you often see it used in television in place of the more costly dolly shot. It can also be used for effect shots, but becomes cliché very fast (sometimes called "stylized" when wanting to be polite). Figure 12.7 shows a series of frames that reflect a camera zoom from a wide-angle shot, to a telephoto one.

On the CD-ROM, you will find a much more detailed visual comparison between the Dolly and Zoom actions, called "Zoom-Dolly.jpg." When comparing zooms with dollies in the CD-ROM samples, you can find a few interesting things:

1. We expect the FOV and perspectives to vary, and they do. This can be easily seen when comparing the last frames of the tests.
2. We also expect the zoom samples to look wide-angle in the early frames and telephoto at the end, as they do. The surprise is seeing that the dolly-in samples exhibit the opposite trait. Despite the fact

**FIGURE 12.7** A simple Zoom-in move, which starts with a 12 millimeter lens setting, and ends at 200mm. (Models from the Fact Model Disk.) Bolded frame is a "standard" lens length.

that the FOV does not change, the early frames *feel* telephoto, and the later frames moderately wide angle.

3. As you look at both tests, you will notice that the zoom transition occurs mostly in the early frames, with the last frames only showing minor variations. Though the 12mm to 200mm start and end settings are both 4X multiples of the "standard" 50mm lens (50/4, and 50 X 4), and are visually correct, the linear animation from one to the other does not work. If you do a zoom, better results can be obtained by modifying the acceleration curve in the Function Curve Editor (FCE).

4. The dolly-in transition is smoother, but still not visually linear. In this case, the results are opposite of the zoom transition. The early frames of the dolly show little change, with most of the transition occurring in the final few frames. Again, bringing the acceleration channels into the FCE will allow for smoother results.

---

**T U T O R I A L**   **HITCHCOCK'S DOLLY-ZOOM EFFECT**

We have all seen director Alfred Hitchcock's famous push-pull effect shot that plays a dolly move against an opposing zoom. He used this to create a sense of disorientation in *Vertigo* when Jimmy Stewart would look down from a

height, and at the end of *Psycho* when "Mother" gets thrown down the stairs. Though it is doubtful he was the first to create it, it certainly became well known as one of his many camera tricks (see Figure 12.8).

This effect is a lot easier to set up in 3D then it ever was for the real-life camera crews. The trick is to consistently frame the foreground subject so that it does not perceptibly move or change size. This fools your mind into thinking the camera is stationary, but the changing background and perspectives confuse your mind's eye, creating an uneasiness that conveys the mood of a darker scene. Final QuickTime animation is provided on the CD-ROM, but you may develop your own project files.

*ON THE CD*

1. At frame zero, place the camera close to the model, who in this case, is our old buddy Chip. Place a **25mm** wide angle on the camera. You can do this numerically in the Camera's Info window in the FOV tab.
2. Somehow, you must mark Chip's visual position in the frame for future reference. In real life, a marked sheet of acetate would be laid over the camera view. Today's cameras are often connected to a video display, similarly, so it would not be that crazy to lay the sheet over the top of your computer monitor. A soft marker can be used to outline the model.

**FIGURE 12.8**    The famous Hitchcock Dolly-Zoom effect is an easy setup in 3D.

*If you use this method, please take care not to put tape on your screen, only on the plastic sides, and pre-test to make sure the sheet does not allow the marker to bleed through to the screen. Treat your monitor glass as a photographer would his lenses.*

3. Another way to mark the position and sizes is to take a window size **Snapshot** and load it into the Camera's **Rotscope** tab.
4. Change the Camera window tool to the **Dolly** tool and retreat the camera back until the model begins to look rather small in the camera window. Do not move the camera icon in any of the World views.
5. Now change the Camera window tool to the **Zoom** tool, and use it to change the focal length of the lens by zooming in until the model once again fits the template outline. Ignore the background elements because they are not going to match. When you play back the preview, it should create an effect like the one seen earlier in Figure 12.8. To really appreciate the effect, view the QuickTime rendering on the CD-ROM.

*ON THE CD*

## CHOOSING THE RIGHT LENS

The 3D artists' freedom to choose any lens at any time is empowering, if it is used correctly. If misused, it can lead to a visually confusing experience for the audience. There is no such thing as just one *right* lens length for any particular shot, so it is sometimes hard to decide which will be the most appropriate. This is why even experienced directors and cinematographers routinely reshoot scenes using various lenses and camera angles. Once again, virtual filmmaking allows you to see your scene shot a number of ways and the price you pay for this is far less than that of your real-world brethren. It has even become common for live-action directors to "pre-shoot" sections of their real-world film using 3D mock-ups to inexpensively test their cinematography.

When initially setting up a scene, it is often easiest to set up the camera with what is considered a **normal lens** first, and after a bit of scene blocking, let the needs of the shot guide your decision process. For example, if you have a medical shot where your camera is moving through the arteries and traveling to the heart, the normal lens may have too narrow a FOV and not allow us to see enough of the walls as they pass. A wider-angle lens would do a better job here. On the other hand, when working on your next video game, the view from a racecar driver's seat might need a much longer lens with a narrow FOV to see straight down the racetrack. The point here is that a normal lens gives you a starting ground

from which to depart, if you decide to depart. Some artist/photographers and film directors have established their personal style by using nothing but a standard lens. Others have sworn publicly never to touch one, and live in only the wide angle and telephoto worlds. As with a painter choosing his brushes, these are the decisions that help define the artist's unique style.

## Lenses: Both Digital & Real

So just what is a *normal* lens, you ask? Laid out in very human terms, a normal lens for a given film format is one that will give us an image most closely resembling our own field of view. The requirement of just what size lens is needed to do this will vary, depending on the camera/film format being used—or in our case, emulated. For example, on a 35mm SLR still picture camera, the standard lens is considered to be the 50mm, which is why that's what comes in the box.

The rule of thumb is that the normal lens for a camera is equal to the film format's diagonal measurement (see the left image of Figure 12.9). This is easily measured from an exposed piece of film, or you can figure it out by knowing the format's height and width measurements and using the good old **Pythagorean Theorem**, which states $a^2 + b^2 = c^2$. For us, this translates to **height$^2$ + width$^2$ = diagonal$^2$**, and in the case of our 35mm SLR, it would look like:

24mm$^2$ + 36mm$^2$ = diagonal$^2$ or
576 + 1296 = 1872
And the square root of 1872 is about **43.3 millimeters**, which is your diagonal.

Feel free to use your calculator!

**FIGURE 12.9**  Left: The frame of a standard 35mm SLR still camera. You can see that a true "normal" lens should be 43.3 mm. Middle/Right: The image projection from a shorter lens (middle) does not cover the film as well as a longer lens placed farther away from the film plane.

As you can see, a 50mm lens on a 35mm camera is really a touch long, and in fact many years ago manufacturers used to supply lenses ranging from 35 to 50mm as "normal." The variations often have to do with the high cost of quality optics, and the ability of a lens to project an image that properly covers the area of the film. The farther a lens is from the film, the larger an area its projected image covers, as seen in the middle and right images of Figure 12.9. So a 50mm lens has an easier time providing proper coverage across that 43.3mm diameter frame, thus it is less expensive than the higher-quality 43mm lens that would be needed.

Why should virtual filmmakers care about such things? Animator's Camera toolset is based upon traditional real–world camera systems, and your ability to control them is based on your understanding of these tools. For example, when you first start a new Project, Animator's default settings for the camera, lens, and film are:

- **Aspect Ratio**: 35mm (Spherical)
- **Film Size (Horizontal × Vertical):** 21.946 × 16mm
- **Ratio:** 1.3715
- **Lens:** 32mm
- **FOV**: 36.8699

Have you ever stopped to wonder what all that means? As with many of the camera's settings, the **Aspect Ratio** setting is found in the **Render Settings** window. This pop-up menu allows you to choose an aspect ratio by selecting the type of camera and film format you want to match. How do you know what you want to match? Generally you will ask your client or output service what their needs are. The settings in this menu do NOT determine your output resolution, merely the horizontal to vertical ratio. The reason for this may become clearer as you browse the options found here, and see that they are almost all film related media, either motion picture formats or still camera formats. These formats are determined by the aspect ratio of the film, as compared to video formats, which are more often defined by their resolution.

The default selection of **35mm Spherical** (see Figure 12.10) refers to a 35mm motion picture camera that uses a Spherical lens—a more standard lens compared to the anamorphic lenses made by CinemaScope, Panavision, and others for special widescreen formats. 35mm Spherical's actual film frame size is 21.946 × 16mm. This information is provided for you from within Animator, it's just hidden a little. To get it, click on the **Aspect Ratio** menu and drag up to select **Custom . . .** when the dialog box pops up, it will have the information on the previous selection's horizontal and vertical dimensions, and the ratio between the two.

**FIGURE 12.10**    35mm Spherical movie film (left), and 35mm Full Aperture (right). The onlydifference is that Full Aperture does not reserve space for audio tracks, and can thus provide a larger area for slightly higher quality imagery. (Dimensions are rounded.)

Because you are given the frame sizes, you can apply your formula as above and get a diagonal measurement of about 28mm. If you open the **Camera Info** window and go to the **FOV** tab, you see that the default lens size is 32mm—just a touch longer as you saw earlier!

The **FOV** measurement you see in the next edit box down is your field of view. The number represents your current viewing angle in degrees, which is a factor of the film format and lens length. This value can get a bit misleading at times, due to the fact that different professions tend to use different measuring standards. Still photography lenses are often quoted based on their diagonal measure, whereas the film industry uses horizontal. Animator allows you to choose which standard to base the display on.

Why is all of this important? For a number of reasons:

- Even though Animator gives users a format's "normal" lens as a default, it may or may not be your definition of normal. As you have seen, normal is in the eye of the beholder and open to interpretation.
- By knowing what a normal lens length should be for your chosen format, it is easier to determine what lengths are telephoto or wide angle, and by how much.

- Despite Animator's long list of default options, new formats and requirements are always popping up and this knowledge enables you to better deal with them.
- The same is true when animating for multimedia, Web, and print projects that can have all sorts of nonstandard requirements that may not be covered in the list of defaults.
- Once you change your lens length (or the **FOV** which is hard-wired to the lens length) in the project's **Camera Info** window, the program does not remember the defaults any longer. It is easy for animators to find themselves "lost" in 3D space after some experimentation has changed settings. Knowing how to correct these settings and knowing how to read current settings is important to mastering the tools. (You can also close the file and open a new one to get the defaults, but of course that is slower).

**TUTORIAL**

## Setting Up for Print

Now take what you have just learned and put it to some practical applications for a printed illustration. Print-oriented projects take a few extra steps in Animator because the defaults are designed for film and video, but this is easy enough to remedy.

**Here is the assignment**: You have just received a call from an art director to produce a full-page illustration whose trim measures 8.5 × 11, plus a 1/4" bleed (also called safety) all around. The first thing you will want to do is set up your page size, which, with the bleed, is going to be 9" wide and 11.5" tall.

Go into the **Render Settings** window, and drag the **Aspect Ratio** pop-up menu to the **Custom . . .** option. Change the unit settings to **inches**, and then type in 9 in the horizontal and 11.5 in the vertical.

You now have a camera view that matches your page dimensions (see Figure 12.11), but it does not show the bleed lines. The Title and Action safe lines that Animator offers are designed for video needs, not print, so you have to look for another way to do this. One method is to incorporate these lines in a background template, if one is used. Do this in Photoshop by setting your image to its actual size in the **Image Size** dialog box (the resolution need not be greater than 72 ppi), and then dropping in the lines using the rulers and info palette as guides. This is functional, but there is a cleaner solution.

In the **Render Settings** window, go to the **Resolution** tab and activate the **Enable Crop** toggle. If you look closely, you will see a line box appear around the perimeter of the camera's view.

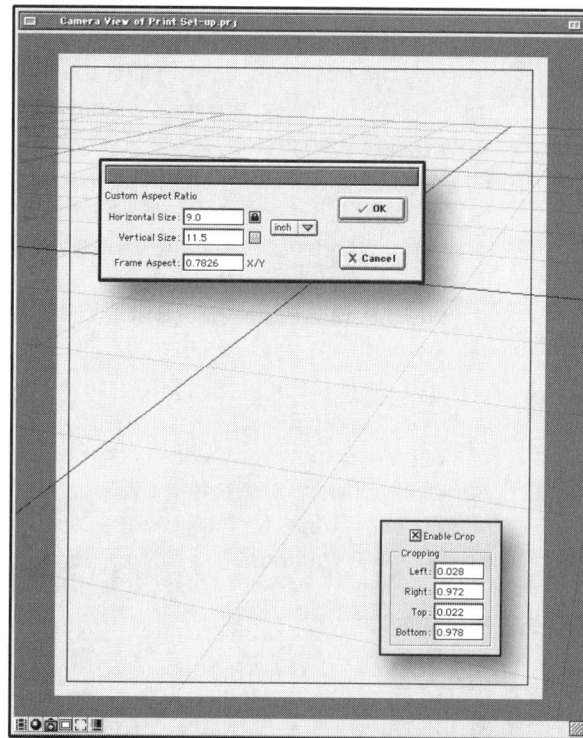

**FIGURE 12.11**    The Camera view window set up with a custom Aspect Ratio for a print job, and crop marks enabled. The related dialogs are also shown.

There are four cropping values listed just below, which are expressed as simple percentage values of our view (see the inset in Figure 12.11). Animator defines the view as 0% at the **Top** and **Left**, and as 100% (1.0) at the **Right** and **Bottom**. These four lines can be easily pressed into service to indicate your project's trim dimensions of 8.5 ×11 by converting the bleed into a percentage of the horizontal or vertical dimension.

- **Left**: Take the bleed, 0.25 and divide it by the full width of the view, 9.0". You get the percentage of 0.027777777, which you can round off to about 0.028 and put in the Left edit box.
- **Right**: This one is even easier, simply take the default value of 1.0 that is in the box, and subtract your 0.028 value. This gives you 0.972, which you plug into the Right edit box.
- **Top**: 0.25/11.5=0.0217, or rounded to 0.022.
- **Bottom**: 1.0-0.022=0.978

As you can see in Figure 12.11, the Camera window now has clean and accurate crop marks to indicate your project's final trim size. Because you set this up using the crop tools, you are also able to turn their display on and off when you need to. Even better is the fact that this turns the cropping on during test renders, and then off for your final renderings, allowing you to make your design judgments based on an image that closely matches the final trim. At the flick of a switch, you can turn off the cropping and generate your final rendering with the added bleed areas. Even page layout programs don't get this sophisticated.

What would be a normal lens for this new format? Animator gives you a value of 457.1991mm, but our math puts it closer to about 375mm. Either way, you are now in the right ballpark for setting up a scene with a lens that is safely in the normal range.

What you may not realize is that you have actually just built your own camera. Well, sort of. Creating this custom page size, safety zone, and determining lens settings for it is like designing a unique camera and film format. Is this how Nikon started?

## SPECIALTY CAMERAS & LENSES

Professional photography studios have a variety of tools designed to better handle specific projects and overcome limitations. 3D cameras do not have the same limitations, but it is a fact of life that most clients want our 3D projects to strongly resemble their real-world counterparts. This is to be expected, and often requires emulating traditional tools—even if that sometimes means emulating their flaws.

A humorous example of this was seen by photographers as they adopted Photoshop and were presented with plug-ins designed to Add Grain, Add Scratches, Add Lens Flare—all the things they had spent years learning to remove!

### PERSPECTIVE DISTORTIONS

Let's pick up on the print job project you just created above. Assume the assignment is an architectural rendering of a proposed building—a popular use of the Universe package. You will want to use a lens that is appropriate to the style of photography used for architecture, which will often mean using a slightly wider angle lens. With their larger FOV, wide-angle lenses allow a photographer to include more of the scene without needing to move back as far. This is important since there are often walls, buildings, or traffic that prevent their free movement. Aesthetically, using a wider lens also tends to add an enhanced feeling of dimension and grandeur, both nice qualities for this type of work.

In professional architectural photography, large format View Cameras—either 4 × 5 or 8 × 10—are used, which allow for the correction of perspective distortions by using the camera's **swing** and **tilt** functions. These distortions usually occur because of more extreme angles created by the camera's placement. The first thing you realize is that your virtual camera does not have these swing and tilt corrections, but it also does not have the placement limitations. Or does it?

If the goal is to create a realistic image that emulates a real photo, then you have more constraints than you might think. You want to use a wide lens to get a certain visual feeling, but in order to frame the image correctly while using this lens, you actually begin to find yourself rather constrained. Suddenly you do not have much more freedom than a photographer would. Sure, you can physically move the camera anywhere you want, but then you are also changing the viewer's perspective in the process. When you find yourself with perspective-distorted buildings that your virtual camera does not have the tools to correct, what do you do? You fix it in post, of course, which means Photoshop for still work, and a program like After Effects for animation. These programs offer wide and exacting range of perspective controls, so much control in fact, that many real-world architectural photographers rely on these tools, as well. Here are the steps for correcting perspective problems:

1. Your client wants a preview of what the building will look like from the street, so you set a camera up at about street level and shoot up. At this point, you don't worry about perspective distortion too much, though you will probably try to cheat the camera up as high as you can—street-level view for a very tall person (see on the left of Figure 12.12). When you finalize the framing, pulling back a bit gives a bit of extra image that may be helpful in post-production work. Always try to give yourself a little extra imagery to play with if you can—it is much faster than having to come back and redo the render.

2. This is a still illustration project, so open the rendering in Photoshop and prepare to correct the distortion using the **EDIT > Transform > Perspective** tool, as seen on the right in Figure 12.12 on the next page. Turn on the **View Grid** option, as vertical lines are a good reference for this correction. The buildings need not be made perfectly vertical; in fact, retaining a touch of perspective looks much more natural. You can see how much nicer the corrected image is, with a greater sense of immediacy and presence. You may also wish to add a bit of height to the image, as the Perspective tool can make the image look squatter than it did before.

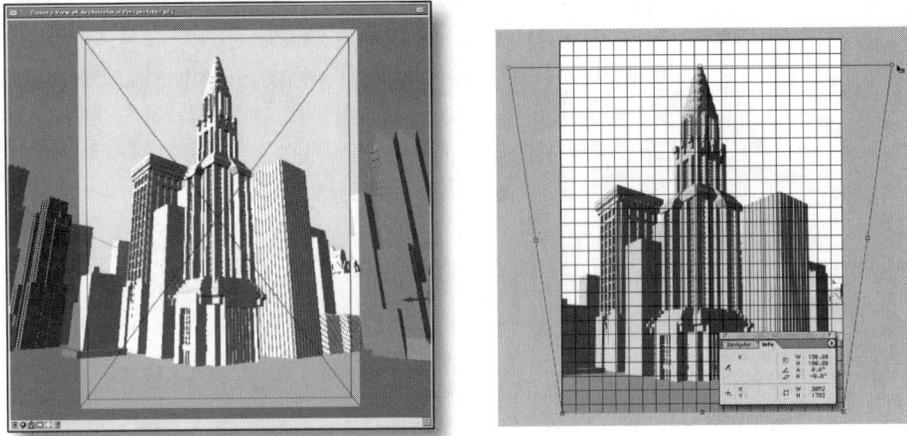

**FIGURE 12.12**   Left: The Camera window view showing the final framing. Right: The Perspective Transformation tool being applied in Photoshop.

*Photoshop's **Free Transform** is the easiest to engage because it has the **Command/Control-T** key shortcut, but it is really more of a scaling tool and not as free flowing as the **Distort** option. While in Free Transform, you can hold the **Command/Control** key down and be momentarily brought into the Distort mode, which allows any control point to be freely moved around and gives you enhanced perspective control.*

3. In the final illustration for the mock architectural project, add a sky to give it a bit more finished look. See the image on the left in Figure 12.13.

If you are still curious as to why you could not simply raise the camera and remove the perspective distortion while in Animator, look at the image on the right in Figure 12.13 where the **Position Y** for the camera body and the reference point were made the same, thus giving you a horizontal view. As you can see, it is a fine image but is certainly not the street-level view that the client requested, in fact it is more of an aerial view and thus it is not acceptable.

## Barrel Distortion

Wide-angle lenses have a lot more going on inside than other lenses because as a lens's focal length drops below the film format's diagonal, it is harder to get even exposure across the entire frame, as discussed earlier. Wide-angle lenses are significantly shorter than their film format's diago-

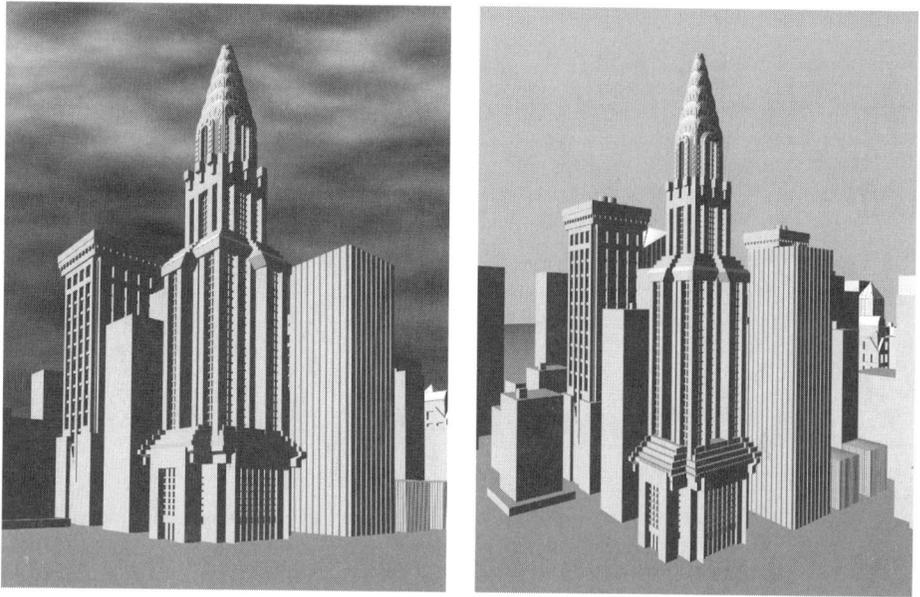

**FIGURE 12.13**   Left: The final rendering with perspective correction and a cloudy sky dropped in. Right: Correcting perspective in camera results in a fine image, but not the street-level visual that the client requested.

nal measure, so designers of these lenses had to come up with ways to correct for a variety of distortions.

*To help correct for barrel distortions in your real-world photos take a look at LensDoc from* www.andromeda.com, *and PanoTools, which is available for Windows and offers a wide range of tools. It is a free download from* www.fh-furtwangen.de/~dersch. *Both are Photoshop plug-ins.*

We have already discussed perspective distortion above; the other one that 3D artists need to think about is barrel distortion. This is the bowing outward of the image that is so typical of wide-angle lens photography. Despite improvements in lens design, as a lens gets wider, more barrel distortion is introduced. When we get to the point of a fisheye lens, we are really talking about an image that is nearly 100% barrel distorted. Real-world photographers hate this and do what they can to minimize it.

In the 3D world, barrel distortion does not exist, and if you look at an image rendered with a super-wide angle lens, all you will see is the perspective distortions, no barrel (see image on left in Figure 12.14). Normally, this would be thought of as a good thing, and it is. But, in truth,

**FIGURE 12.14** Left: Despite this image being rendered with an extremely wide-angle lens, Animator does not introduce any barrel distortions. This creates a "perfect" image, but not as realistic. Right: Synthetic barrel distortion has been added using the Spherize or Pinch distortion filter in Photoshop.

we are once again a victim of our brain and its memory. After a lifetime of seeing wide-angle images that have at least some bowing out at the edges, it is a bit unsettling to see such perfection. It does not look real to our eye. By the way, barrel distortion is not just in cameras, for those that are conscious of their peripheral vision (not everyone is), you may notice a similar effect at the edges.

Once again, you can bring your post-production tools in to help out. Both Photoshop and After Effects offer ways to add a touch of barrel distortion when needed (see image on the right in Figure 12.14). In Photoshop, you can use either the **Spherize** or the **Pinch** filters, found under **Distort**, each giving a slightly different result. Because these filters operate on a circular subset of the image, and not the entire image, you need to trick the filter by enlarging the image's canvas. This way your entire picture will rest inside the active circle area, as seen in the image on the left in Figure 12.15. Generally, doubling the canvas height and width will provide the buffer needed. For the filters, a negative setting of 10 for Pinch, and a positive setting of 40 are good starting points.

Adobe After Effects offers greater control with the use of its **Bulge** filter, which is found in the **Distort** category (see the image on the right in Figure 12.15). Bulge allows you to change the Radius settings of the filter for the vertical and horizontal axes independently. With this, you can extend the effective ellipse zone well past the frame to make sure the entire

**FIGURE 12.15**   Left: Doubling the Canvas size allows the Spherize or Pinch filters to cover the entire image (the grid over the canvas is for descriptive purposes here and does not display in Photoshop). Right: The Bulge filter in Adobe After Effects.

image is filtered evenly. The **Bulge Height** control is where you set the amount of distortion you want. This slider can be set to any value from –4 through 4.0, but for your needs a value of about +0.5 is a good place to start. There is also a **Taper Radius** control that acts basically like an edge-feathering effect, and in a gradient fashion turns the Spherize-like effect into more of a Pinch style filter. Very nice.

## Adding Distortion Lenses

An experiment: Now that EIU has Raytracing and the ability to add refraction properties to glass, what if we were to build ourselves a lens element? Could we get it to behave like a real glass lens and properly distort the light waves coming into the camera? The answer is a resounding yes, and the sample files can be found on the CD-ROM for your amusement and further refinements. A QuickTime sample animation is also provided.

**ON THE CD**

While you might first assume a standard convex lens would do the trick, this will actually give you results opposite of your goals. When replaced with a concave lens that is positioned very carefully, the results are perfect. The "glass" is made transparent—no specular, diffuse, or ambient values—and the preview level within Animator is set to **Outline** mode (**Info window > Display tab**).

Though a bit cumbersome, this does offer the advantage of quick previewing that your post-production solution does not.

### Telephoto & Orthographic Lenses

As the focal length of a lens is increased, the image it produces is increasingly compressed and flat looking, as you saw earlier in Figure 12.7 when we talked about the zoom lens. There are times when animators wish to take this effect to the extreme, even to the point of removing all perspective and thus giving an orthographic view. This can be desirable in a wide range of applications including graphic design, architecture, scientific application, and more.

Animator's camera is based on a real-world design, so it does not inherently offer this feature unless you set it up as one would a real camera. To get a telephoto lens effect, simply back your camera up—often quite far—and then narrow its FOV to *zoom* the frame back onto your subjects. This is easiest to do by setting up your scene and arranging the camera at a comfortable location for aiming. When you're happy with the angle, switch to the **Dolly** tool and use it in the Camera window view to back the camera away from the scene. Then use the **Zoom** tool to change the **FOV/Focal Length**. Once the camera is in place, its distance from the scene will make many animation moves more difficult, so use effector controls when possible.

True high-quality orthographic images can't be produced with the Camera, though lower-quality ortho images can easily be taken from any of the World window views. A very serviceable work-around is to take the camera and continue backing it away from the scene, even further than you would for a telephoto lens. This creates a lens that is so close to being orthographic that it should satisfy most needs you may have.

## DEPTH OF FIELD

Depth of field (DOF) determines how much area will be in acceptable focus, in front of and behind the objects that your lens is actually focused upon. This is another artifact of real-world lenses that you often need to simulate in 3D to avoid looking too perfect and computer generated. To understand the tools, you need to understand how real DOF works.

During exposure, a lens is controlled by the **aperture**, which determines the size of the lens opening, and the **shutter**, which controls the length of time it stays open. This is just like filling a bucket of water; a faucet is opened to a certain size, for a certain amount of time. Timed correctly, the bucket gets filled to the proper level, just as the film would get its proper exposure.

But the aperture setting also controls how much of the lens you are using, and this is what controls the DOF of your lens. The center of a lens

is the sharpest area, so when the aperture is made smaller, your DOF can be quite long. This is the principle of the old pinhole lens camera whose DOF is infinite. The downside is that exposure times become unusable, so you compromise and open the aperture to a larger diameter to let in more light. In the process we are reducing the DOF, and seeing more objects that are out of focus, as seen in Figure 12.16. This defocusing actually takes place in a circular pattern (derived from the shape of the circular lens), which is why it is referred to as "circles of confusion."

For a 3D program to create actual DOF information would require a tremendous amount of processing that is not practical, so instead we look for ways to simulate the effect. We will cover four methods here.

*Aperture is expressed in **F–Stops**, which are simply the ratio between the focal length divided by the current aperture's diameter. The math is just:*

### Focal Length/Aperture = F-Stop

*For a normal SLR lens that has a 50mm and 2.8 as it's largest F-Stop, the math would look like this: 50/X = 2.8. We can turn that around to make the math easier: 50/2.8 = 17.86. That means that when the F-Stop is set to 2.8, the aperture opens to a diameter of about 18mm.*

*Most lenses also allow us to use an F-Stop of 22 at the other side of the dial, so we get: 50/22 = 2.27mm diameter. As you can see, a lens set to F-22 has a much smaller aperture and thus has a much greater DOF.*

**FIGURE 12.16**  Depth of Field shown with a small Aperture (top), and then a large one (bottom).

## Animator's DOF

Animator has a built-in system to calculate and generate DOF. It works by rendering multiple images per frame and then combining them to create "circles of confusion," the defocusing or blur factor. In the Camera's **FOV** tab window you will see a section called Depth of Field, which only has a few controls (see Figure 12.17):

- **Enable**: Turns the feature on or off.
- **F-Stop:** Sets the virtual aperture, and in turn, the DOF. This is a very responsive control once you realize that the numbers you learned in photography may be totally useless. In many cases, you will need to use numbers in the 0.01 range or smaller to get the expected results.
- **Focal Distance:** Sets the distance of optimum focus, centered on the camera. This is only effective if the Distance pop-up menu is set to the Channel option, otherwise it has no effect.
- **Distance:** A pop-up selection menu for choosing the method of setting the camera's focus.

    **Channel**: Lets the Focal Distance value be the setting. The advantage is that, like a real world camera, no matter where the camera is moved, its focus remains unless specifically changed.

    **Reference**: Lets the camera's focal or reference arrowhead be the determining factor. This option is far more interactive—you can just drag the pointer to the object you want in focus. Even if you move the camera around in animation, the point of focus stays the same.

- **Multi-Frame Pixel Offset**: This value determines the diameter of the "circle of confusion" the process should generate. This defines what is, or is not in focus, so smaller numbers will keep more objects in focus. The default of 0.75 worked well.

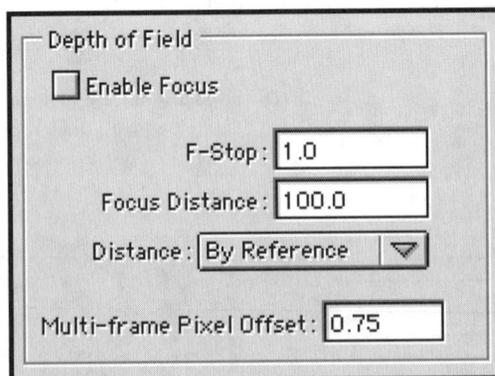

**FIGURE 12.17**    The DOF controls in the Camera's FOV tab.

Before any of this will work, you need to go into the **Render Settings** window and in the **Motion Blur** tab, enable the **Multi-Frame** toggle because this is the technology behind the process. You also have to place a number larger than 1 in the **Blur Frames** edit box to its left. This tells the system just how many frames you want to generate and blur together to make this work. The higher the number, the smoother the effect (and, of course the longer the rendering time—but you already saw that coming). Values of 5-10 are good for testing, but you will probably need to bring that up to 20 or more for the final output.

### Summary

- **Pros**: This process is an easy and fast way to set up and control a project's DOF. Being built-in helps to streamline the production, and allows for easier and faster previews of the effect than other methods. Because of its mimicry of real DOF in a few areas, this method can avoid some of the pitfalls of other methods.
- **Cons**: When it comes time to render the project, this will be the slowest option, unless you happen to also be creating motion blur effects that already require multiple frames. This method is also not very forgiving in post production, and DOF is an effect that often begs forgiveness.

*ON THE CD*

There are two files for this technique are on the CD-ROM. The first is a simple two-box setup to get your feet wet with the controls. The second is a QuickTime movie. It may look a little familiar to movie buffs, as it was inspired by Hitchcock's famous poison coffee cup scene from *Notorious*. In this shot, he was able to achieve a long DOF that physics would not allow (it was faked using an oversized cup). The goal here, on the other hand, was to shorten the DOF as seen in the frame-grabs in Figure 12.18 on the next page. Each frame combined 40 images to generate a smooth blur, and used the **Distance by Channel** option.

TUTORIAL    **DEPTH BY LAYER**

The next method is the other end of the sophistication spectrum, and relies on multi-pass renderings followed by a bit of manual compositing in Photoshop or After Effects.

**FIGURE 12.18** Two frames taken from the Hitchcock-inspired "Coffee Cup" animation are on CD-ROM. (All models from the Fact Model Disk.)

**ON THE CD**

1. Open the "**Depth by Layer.prj**" project file on the CD-ROM. You can see that it is a simple scene with models receding to the background, resting on a ground plane model.

2. **Turn off the visibility** checkmarks for all of the cylinders except for number one. Also turn off the ground plane model. (Tip: Opt-Click on Cylinder-2's toggle to turn them off down the line).

3. Take a **Full Size Snapshot** render (done by clicking on the SLR camera icon at the bottom of the camera window). It should render in a few seconds, and just show the first cylinder. When doing this, make sure the **Render Settings > Render > Image** setting is **Millions+Alpha**. Save the file.

4. Now **toggle off** the first cylinder and **toggle on** the second. Render another **Snapshot**. Continue this with each object until you have rendered and saved seven separate images.

5. Open the files in Photoshop, and combine them into one file, but with each object on its own layer. This can be accomplished quickly by opening the first layer, **Load Selection > Alpha**, and then hit **Cmd-J** for **Layer via Copy**, to raise the selection to its own layer. Open the next file and Load Selection for it, Cmd-J, and then open the **LAYER > Duplicate Layer** control. In the **Document** option select your first document, and the name should update, hit OK. Do this for the rest of the files, or open the pre-made Photoshop file on the CD-ROM to save yourself a few steps. We added an extra background layer and filled it with blue for the sky, as seen in Figure 12.19.

**ON THE CD**

**FIGURE 12.19**    The multi-layer Photoshop file combining the seven renderings.

*This technique works just as well with animation files, and can be adapted for use in After Effects or other compositing programs.*

6.    Now you can go into each layer and apply a Gaussian Blur individually, giving you absolute control over each item, as seen in the final image in Figure 12.20.

**FIGURE 12.20**    Each layer has had a progressively greater amount of Gaussian Blur applied.

When you get to the last layer that contains the ground plane, you can apply a heavy blur to it in order to soften the horizon. If we had had any detail applied to the foreground areas, such as texture, maps, or cast shadows, then the ground would need to be blurred in a more controlled fashion, as you will see next section.

## SUMMARY

- **Pros**: This technique offers control on an item-to-item basis, and is even more versatile in a program like After Effects because its filters are non-degenerative. Basically, this means that they are not applied until you **Make Movie**, allowing unlimited alterations. Many animation projects require multi-pass renderings, so the extra passes needed for this technique may not amount to much added work.
- **Cons**: If you are not doing a multi-pass render job, this can add to the workload, and it certainly can add to the number of files you need to keep track of. It also does not solve the problem with items like the ground, which have varying needs.

**TUTORIAL**

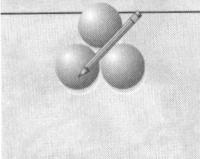

## FOG AS DEPTH OF FIELD

What if there was a way to somehow extract the distances of the models, and use it to control your blurring effects? Animators have used the Fog feature in Animator to do just this. It can be very effective, but the methods that are normally employed to accomplish this have a couple of pitfalls. Traditionally, this effect is achieved by placing the full scene rendering in the background, and then putting another version on top which has been alpha-keyed using fog, as seen in Figure 12.21. Gaussian Blur is then applied to this second keyed layer. We have provided a streamlined version of this technique on the CD-ROM in the "Traditional Fog DOF" folder so you can see how it is produced.

**ON THE CD**

The two severe limitations of this technique are that if you want to apply more than a few points of blur to the top layer, the lower layer begins to show through. This looks just awful, and limits the amount of blur you can add; in this case, the effect began to fall apart when more than 5 points of blur were added. Secondly, ground planes and non-image areas can wreak havoc with the depth map's ability to deliver a clean effect, as seen in Figure 12.22. That said, here's a modified solution that addresses these problems. Pay close attention to each step.

**FIGURE 12.21**    The traditional fog/depth technique is an easy process to set up, using only two layers.

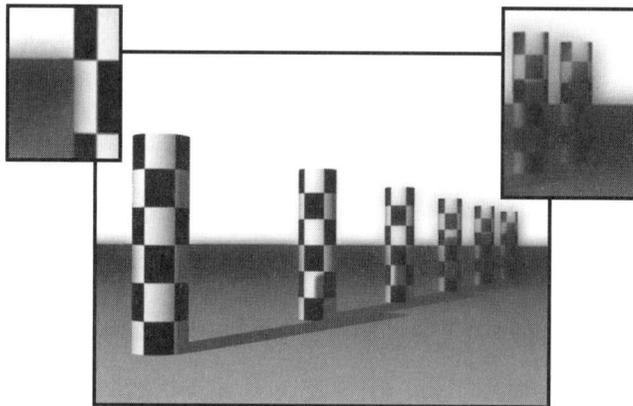

**FIGURE 12.22**    The traditional method limits the amount of blur that can be applied, and does not always apply it where needed. The result can be the "bleeding-blur" effect.

1. Open the "**Depth by Fog.prj**" project file.
2. Make the Ground Plane invisible, and make sure the Light has Shadows enabled. (Note: Steps 3, 4, and 5 have already been set in the file.)
3. Open the **Camera's Info** window and turn the **Show Fog** toggle on. It is on the far left of the window, not on a tab. Close the window. This allows you to see a wireframe preview of the fog settings in the World windows.

4. Open the **World Info** window (found at the top of the **Project** window). Toggle the **Fog** button on, and set the **Fog To** menu to **Alpha** (See Figure 12.23).

5. The two **Radius** settings control the distance from the camera that the fog starts building density, and where it reaches full density. The first box controls the items you want to remain in sharp focus, put 700 units in there as that location is just beyond your first cylinder. The **To** box should be set to the distance that you wish to achieve maximum blur—usually the furthest object in the scene, which is about **2200** units here. This value is easier to guesstimate if the rulers (**Cmd-M**) are turned on for a moment.

6. As you set these fog parameters, you will see a preview, in the Camera view, of your models getting darker to represent the fog. Remember that these darkened areas will be replaced with a blur later.

7. Do a Snapshot rendering at **Full Size**, and confirm that it matches the first image (RGB top, Alpha bottom) in Figure 12.24. To view the **Alpha**, switch views using the **Color Channel** selector (an RGB icon found along the left side of the Snapshot window). Save the image as "Cylinder.img."

8. Now we need to modify the **Amount** boxes by reversing the order of both default numbers (0.0 and 1.0, respectively) to **1.0** and **0.0**. This will invert the **Alpha** channel, but *only in the areas where the models exist*. Do another Snapshot render, which should look like the second image seen in Figure 12.24. Save it as "Cylinder Reverse.img."

9. Make the ground plane visible again.

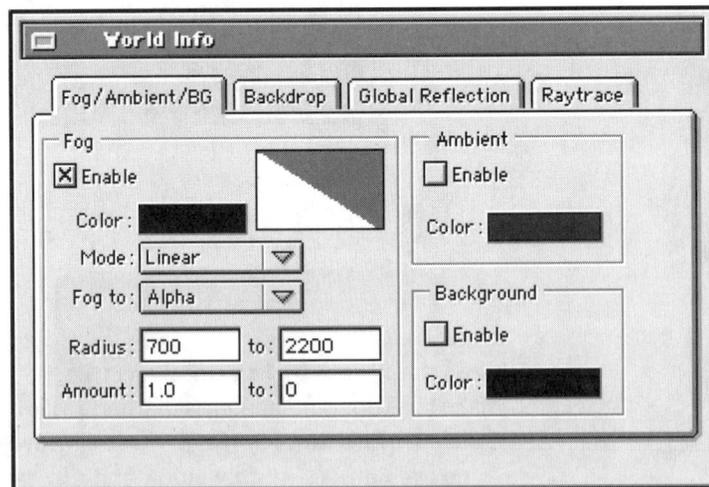

**FIGURE 12.23**  The Fog controls found in the World Object icon, in the Project window.

**FIGURE 12.24**  The four Snapshot renderings that we will make in this exercise. Previewed are the pre-multiplied RGB (top) and their Alphas (below). Left to right: Cylinders (Amount 0.0, 1.0), Cylinders (Amount 1.0, 0.0), Ground (1.0, 0,0), Ground (Amount 0.0, 1.0).

10. Toggle on **Shadow Object Only** for Cylinder-1, (**Info window > Shadow tab**). Apply this to the children cylinders by Control-clicking once again on the toggle and selecting either the **Children** or **Offspring** options. Make another Snapshot and save it as "Ground Reverse.img." It should look like the third image in Figure 12.24.

11. In the **World Info** window, **Fog** settings section, swap the **1.0** and **0.0** in the **Amount** boxes to once again read **0.0** and **1.0**, respectively. Make one last Snapshot render which should look like the fourth image in Figure 12.24, and save it as "Ground.img."

You should have saved four images at this point. Your work in Animator is finished. This would be a good time to take a break if you need one. The next section is done in After Effects, but could easily be adapted to other compositing programs. A finished After Effects project file is on the CD-ROM if you need to reference it.

**ON THE CD**

12. **Open After Effects**, which supports IMAGE files, and load the four rendered files. These are still images, but AE and the technique work with animation files as well.

13. **Create a composition** to fit the images (640 X 480) and drop all four images onto it (**Cmd-/**). The order is important and should be, from top to bottom, **Cylinder Reverse**, **Cylinder**, **Ground Reverse**, and finally **Ground** (see Figure 12.25 on the next page). Turn off visibility for the two Ground images for now.

**FIGURE 12.25** The layers loaded into After Effects, and the top Cylinder layer with both Levels and Gaussian Blur applied.

14. You now have two layers with **complimentary alpha channels.** The two images interleave very closely, but there is sure to be a subtle gap that you need to remove. To do this, you need to see it, so set the **Background Color (COMPOSITION > Background Color)** to something bright and oversaturated. Now as you look at the composition, you can see a bit of the background seeping through at the third and fourth cylinders.

15. Select the top layer and go to **EFFECT > Adjust > Levels** to add a **Levels** control to this layer. Change the **Channel** pop-up menu to **Alpha.** Now if you set the **Gamma** to about **1.4**, and the **Input White Point** to a bit below **200**, you should see that transparency gap disappear. You can accomplish this by just adjusting this layer, or by modifying both layers in tandem.

16. With the top layer still selected, add **EFFECT > Blur & Sharpen > Gaussian Blur.** This is one area where your extra efforts will start to pay off. As you dial in the blur, you will notice that you can crank it up a lot higher than when using the traditional method. This is because as the distant cylinder blurs and becomes more transparent, there is nothing behind it to create artifacts and hard edges to show through. If you want to, the **Levels** controls can be used on this, or both layers to fine-tune the blur layer's coverage. In our example, we added 10 points of blur, but we could have gone further.

17. Now you want to get the Ground images set up, so let's turn the two Cylinder layers **off,** and the Ground layers **on.**

18. You are just going to do the same thing here that you did with the top Cylinder layer, but you will instead do it to the top Ground layer. Add **Levels**, and then add **Gaussian Blur**. Note that a heavy blur applied to images that bleed off the edge of the composition can cause a bit of a problem at the edges as you can see here. Cropping can solve this. You should anticipate this before rendering and make any necessary adjustments.

19. Turn all layers on, and see how good your composition looks. See Figure 12.26.

### SUMMARY

**Pros:** the main reason to use this method is that it does what others techniques are simply not able to do. You do not get the "bleeding-blur" effect, and the Levels control gives you a lot of fine–tuning ability to get just the look you are after, even if the original rendering was a bit off.

**Cons:** requires twice as many renderings as the Traditional technique, and a small amount of extra effort to set-up in the compositing program.

**FIGURE 12.26**    The final image with Gaussian Blur and Level controls in place. Notice how we have more blur applied yet we do not see "bleeding blur" or other artifacts.

## Z-Buffer Depth of Field

Do you recall the discussion about depth-buffer information in Chapter 10? Animator actually offers a way to render this information out through a little-documented feature called **Planar Z-Depth** and **Spherical Z-Depth**. Both of these options are found in the **Render**

**Info window > Render tab > Format** pop-up menu. By setting the output to either one of these formats, we are instructing Animator to render a depth file that contains specially encoded pixel data. If you were to open this file in Animator to look at it, you would see that it looks a lot like psychedelic artwork from the '60's (see Figure 12.27).

To make use of this file, you never even need to open it. You just need to make sure that the file has a ".eiz" extension at the end of its name, and render a normal IMAGE file from the same scene. Put both files in a folder together, and when you import the IMAGE file into After Effects, the data will be available to you if you apply any of the **EFFECT > 3D Channel** filters to the imported file.

Unfortunately, testing with the Depth of Field filter showed that it suffers from many of the same shortcomings that the traditional fog technique does. However, working within those limitations, you are able to designate a focal point on the fly, and modify its DOF as well.

We found some of the other filters even more rewarding, especially the **Fog** and **Depth Matte**. As their names imply, these filters use the data to add a fog and key the image, respectively. These are a great extension of the technology and worth some exploration.

**FIGURE 12.27**    The depth file rendered using the Planar Z-Depth option.

## AUTOMATIC CAMERA MOTION

Earlier we talked about how to manually move and position the camera, now look at some of the ways Animator helps you semi-automate the process, starting with a few ways to streamline and extend the motion abilities of your camera.

### Effectors (Null)

Effectors allow you to control the camera's motion in ways that would be difficult to do with the camera on its own. The following are building blocks to more sophisticated moves.

*An Effector's icon can be hard to see on the screen, but this can be fixed by opening its **Info** window and changing the **Style** from a **Cross** to a **Box**, which is easier to see. Then in the **Special** tab, you can enlarge and re-center the box with the **Size** and **Origin** edits, respectively.*

#### Rotation

Imagine a project comes in from NASA, and requires a simple animated rotation/orbit around a planet. (This technique applies to orbiting around a car and other terrestrial objects, as well.) During the rotation, the camera needs to face Saturn the whole time. Sounds simple, right? Well surprisingly, no, because a **Rotation-Y** move on the camera can only be applied to the **camera body** and not the **reference point**. Rather, the camera body must be animated around the object. As you move it from one position to the next, you realize that creating the circle needs at least four keyframes (start, two intermediary, and final) and careful manipulation of the Beziér controls (see Figure 12.28). Oh, and if you have to re-time its speed, have fun.

**FIGURE 12.28**  Top view window shows the orbit created manually with four keyframes (left), and a cleaner solution using a Null Effector.

Now let's do it using an Effector. **OBJECT > Add Null** to the very center, at the tip of the camera's focal point arrow and make the camera its **Child**. **Enable** the Effector's animation, move the time to 3.0 seconds (in our sample project), open the Effector's **Info > X-Form** window and put *360°* in the **Rotation-Y** edit box. When you are done, press Preview in the **Top View** window to see your animation.

You only need two keyframes, no careful camera or Beziér handle placements, and if you need to change the timing, only one keyframe needs to be moved. As we talked about in Chapter 7, "The Function Curve Editor," having the least number of necessary keyframes allows you to move objects more freely. For example, you can now move the camera in a spiral just by moving the **Position** of the Effector in the **Y-axis**, something you could not do with the interference of extra KF's. You can also get the effect to repeat using **Cell Cycle Tools > Repeat** in **Keyframe** mode, or simply by **Option-Dragging** on the KF diamond in the **Time** mode.

If you are going to have the effect repeat, then you will want to have the cycle end a few degrees short of the final 360-degree position, as a full cycle would create a momentary pause in your animation. Though not perfect math, you can determine a degree position by dividing 360 degrees by the number of frames in the cycle, in this case it is 3 seconds at 30 fps, so: 360/90 = 4 degrees. You then subtract that from the 360 and find your end of cycle position to be 356 degrees. You will find everything set up in the "Rotation.prj" project file on the CD-ROM.

**ON THE CD**

### Camera Overhead

Not that you do it all the time, but occasionally you need to bring the camera directly overhead to the world zenith. Surprisingly, the camera starts to go crazy and begins doing flip-flops. In reality, the camera is actually acting upon a self-righting mechanism that does not permit it to be upside-down—much the way a Ferris wheel basket self-rights so as to not to drop its passengers. It is said that Animator's camera was designed to emulate a camera crane, which operates similar with a self-righting mechanism.

In any event, if this is not to your liking, the Effector arrangement that worked for the horizontal orbit above will do just as well for this sort of shot. You will find it already set up in the same "Rotation.prj" project.

**ON THE CD**

**Macro-Motion**

As with any other World object in Animator, an Effector can be made the Parent and used to control some of the broader animation routines. This frees you to more precisely animate the model without the macro-movements interfering. Assume you need to get the following Camera view animation.

An old cowpoke is riding the range on his faithful old horse Trigger. You need to get a shot from the perspective of the cowpoke, looking out into the desert horizon with the sounds of the horse going clippity-clop. The visual should go in an up-and-down motion, sway to the sides a bit, and move progressively forward across the terrain.

You could animate this manually, but this is faster:

1. Open the "MacroMotion.prj" file and bring up the Camera's Info window. In the **Camera to Reference Distance** box, type in about 200 units. This will make it shorter so it is more manageable. Close the window.
2. Open the Project window (**Cmd-L**) and change the view to **Frames**.
3. Enable the Camera's animation toggle.
4. Swing open the Camera's **View Channel** icons (pale purple triangle), **Camera > X-Form > Position**. In the **Y channel** do a **Command-click**, which should automatically select the entire channel.
5. Go to the **Cell Fill Tools > Jolt** and input **Amplitude: 50**, **Frequency: 5**, and **Decay: 0.** Leave the toggles unchecked. This creates a sine wave that will be applied to the camera body's **Position-Y** channel. Click **OK**, and you will see new values appear in the channel.
6. Make sure the **Render** settings are set to play **All Frames**, and go to the Side view. The Preview should show the camera body going up and down.
7. With the Y channel still selected, Copy the data and swing open the **Reference**'s **Position-Y** channel (just below). **Command-click** to select the entire channel, and **Paste** in the data. Another Preview in the Side view should show the entire camera going up and down. Close the **Channels View** icons in the Project window, and change the view back to the **Time** mode.
8. Go to **OBJECT > Add Null** and again in the Side view, **click** to place the new **Null Effector** just a bit above the camera body.
9. Using the **Parent** tool, make the Camera the **Child** of the **Effector**, and enable the Effector's animation toggle.
10. Slide the **time** to **10 seconds** and move the Effector in the **positive** direction along the **Z-axis** so that the camera is moving forward. In your sample file it starts at negative 600-700 units, and ends at positive 600-700. Play the Side view Preview and you should have the camera moving forward and up and down at the same time. Notice that unlike animating this by hand, you can easily change the Effector's **macro** positions without hav-

ing to worry about the **micro** animations going on below. But you are not done, because Effectors (just like objects themselves) can be used to stack animation.

11. Move back to **time 0.0.**
12. In the side view once again Add another Null Effector, placed just above the last one.
13. Make the new Effector the Parent to both the first Effector and the camera.
14. Open the new Effector's **Position-X** channel in **Frame** mode, select the entire channel, and open **Jolt** once again. Plug in **50, 2** and **0** respectively, and hit OK. This should make the model weave back and forth a bit from left to right from the front view.
15. Turn the **Grid** on for a moment and hit the Preview in the **Camera** window this time. It may be a bit dizzying because you are moving through the grid, but it should give you the visual feedback you need.

If you think all looks well, turn the "DesertScape" model on in the Project window, and activate the background image by clicking on the **Rotoscope** icon at the bottom of the Camera window. If you render out an animation, it should look a lot like our sample QuickTime movie on the CD-ROM (see Figure 12.29). Final project files are included for your reference. On a side note, keep in mind how you just added a simple bumpy ground plane with subtle bump-mapping, and a backdrop image, but all of a sudden you have a polished-looking scene. It doesn't always have to take too much work.

**ON THE CD**

**FIGURE 12.29**    Frame-grab from the final QuickTime movie on the CD-ROM.

### Copy Cat Motion Data

Once you have spent a lot of time getting one object to move correctly, wouldn't it be nice to be able to take advantage of it with other models? A very common event in animation is to have the camera trailing an object, following along behind, whether it is a team of marching bugs, or an action packed pod race, cameras logically follow the subject in animation and real-world films.

The beauty of this technique is that the follow-camera need not be an exact match to take advantage of the process, since it only uses the motion data as a logical place to start. The animator can then apply a variety of path altering tools and tricks so the camera feels like its own entity, apart from the model it is following. In Animator, you can apply frame-based alterations from the **Cell Fill/Blend/Cycle** menus, you can manually alter to Beziér paths in the World views, or bring the whole lot of it into the FCE to add more finesse. Don't forget that the FCE can save and import motion data files that Animator calls Envelopes, which are keyframe data files that are interpreted using easily editable Beziér controls. This is unlike the BVH format, which is a standard for motion capture and control, but also based on harder-to-edit **frame** data.

Animator also supports bringing in camera motion data to allow move–matching computer-controlled film projects, and can also bring in camera control files created in Maya and exported using "ElcanOut," a freely distributed MEL script by Chris Bernardi. It is available at *www.highend3d.com.*

### Title, Action, and Other Framings

While juggling all of the other information about camera manipulation, you must also keep in mind how the camera is framing the scene in relation to your intended delivery system. This means you often have to take your creative framing decisions and adapt them to work within the constraints of the film or video format, either of which can change your original image. Video imposes harsher limitations with its boxier format that feels somewhat old-fashioned in today's wide-format world. It also imposes a good deal of wasted image that bleeds off the screen by an amount that can vary from one TV set to another. For this reason, you need to adhere to the **Title** and **Action** safety borders that are available under the **Field Chart** icon in the Camera window. Film, multimedia, and print work do not need quite the same amount of caution, but it is still a good idea to give your images some "breathing room" whenever possible.

Another item to keep in mind is that you need not assume each shot has to be the final framing. Almost all animation relies heavily on compositing images in post, so you will often want to generate animation clips that frame floating elements, and leave proper framing until later. This same concept applies to the size of the image as well, for example, a zoom shot can often be created by rendering one 3D frame at double or triple size and faking the zoom effect in post.

# RENDERING

J ust as all roads lead to Rome, all animation efforts culminate with the rendering process.

Electric Image's rendering is handled by a standalone application called **Camera**, which has long been the fastest solution in the industry. Camera has always produced excellent image quality with its Phong renderer, and Universe has upped the ante with its new world-class Raytracing engine.

As a separate program, Camera has a very small footprint on the hard drive, and can be copied onto any number of Mac and Windows computers and controlled with its network render spooler called Renderama. For all of this power one would expect to face an onslaught of settings and controls, but to the makers' credit, Universe offers an elegant rendering toolset located inside Animator's **Render Settings** window (also called **Render Info**).

This chapter covers the ways to make best use of the rendering tools, including Raytracing, multi-pass rendering, line work, and rendering for print.

## FROM WIRES TO RAYS

The first option you are presented with in the Render Settings window is the **Camera** setting found in the **Render** tab. This is the master switch that sets the style and quality that Camera will use to perform the rendering process. Wireframe, Flat, Gouraud, Phong, and Raytrace provide increasing levels of sophistication and options, each with a distinct advantage:

- **Wireframe**: offers the classic, and often cliché 3D view of the model's mesh. This is good for effects, and is also the fastest rendering level available. The interesting thing about using Wireframe as a visual effect is that it can put a greater burden onto your modeling requirements because the mesh itself will need to look good. A Wireframe's line thickness can be adjusted in the model's **Info > Shading > Line > Line Size** edit box. You can even set the line to be shaded, which looks a lot like the Display Wireframe Shaded preview mode. For many effects, you may be better off using a higher render setting and enabling the model's **Cel/Outline Shader** controls found in the Material Editor (see Figure 13.1), which simulates Wireframe while still delivering a solid model.

- **Flat:** this offers the first level of solid model rendering, but with few polishes. Note that polygons are rendered flat—no edge or vertex smoothing is available.
- **Gouraud:** (pronounced "gurrow") is a nice step above Flat shading, and in many situations, is hard to tell apart from a Phong rendering. Its main sacrifices compared to Phong are in the smoothness of a specular reflection and shading.
- **Phong**: through most of EI's existence the Phong renderer was the best quality offered and it is still the workhorse of the program, offering exceptional quality and speed. Even when Raytracing is turned on, most of the elements are still going to be produced using Phong.

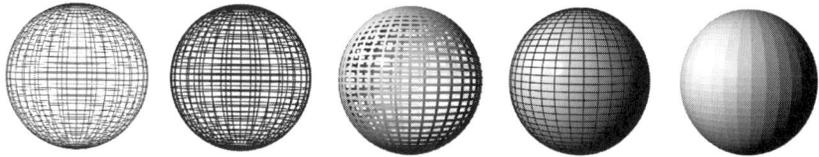

**FIGURE 13.1**  From left to right:  A default Wireframe rendering, Wireframe with the Line Sizeedit box set to 4.0 pixels, Line Size set to 12 pixels with the Shade Lines toggle enabled, a Flat rendering with the model's Cel/Outline Shaders enabled, and a plain Flat render.

## RAYTRACING

As the "top level" rendering solution in Universe, Raytracing (RT) can offer enhanced visual accuracy. Unlike many other 3D programs, Universe does not offer these enhancements blindly, and instead only uses Raytracing on elements that will actually benefit from its addition.

### How Raytracing Works

As the name implies, RT works by actually following (or *tracing*) the line of origin for every pixel (or light *ray*). The illustration in Figure 13.2 on the next page shows the way a traditional camera receives light (lens omitted), starting at the light source and bouncing off of the object, with only the rays that reflect back to the camera being recorded. The camera records the light reflected from any number of light sources in the scene, as well as any bounced lights and reflections. The physical laws of nature take care of which elements expose the film and which do not.

**FIGURE 13.2**    A simplified version of how a real world camera collects rays of light.

By comparison, a 3D program must somehow determine which rays should be traced. It does this by starting at the virtual film plane, tracing out in every direction looking for objects and lights. The Raytracer must do this from every single pixel in the image, which is why a $640 \times 480$ image can take 4 times longer to render than a quarter frame ($320 \times 240$). Phong is far more efficient, so rendering times generally do not increase more than 50% for the same increase.

The designers of EIU very cleverly realized that if they could limit the number of rays needing to be traced, then the process would start to become much more efficient. In fact, what if the only places Raytracing was available were where it would actually make a difference, and even then, only if enabled? By implementing this selection process, the 3D artist can turn RT on or off for **Reflectivity**, **Transparency**, and **Shadows**, along with a variety of sub-options that also rely on Raytracing.

## Raytracing by Channel

We will go over the channels available for RT, so that you can see the pros and cons of each one.

### Reflectivity

Before Raytraced reflections were available (which is set in the Material Editor), Animator's best reflection method was its **Environment** reflection mapping, which automatically generates and applies a reflection, usually using the Cubic configuration. The results are excellent and in most cases it is hard to tell the difference between a Raytraced image and one that has been environmentally mapped. Even when there is a noticeable difference, it is hard to say which is more "accurate," as seen in Figure 13.3. This means that the choice of which to use is often more an issue of rendering time than one of quality.

**FIGURE 13.3**   The same image rendered with the Environment Reflection using Phong (left), and Raytracing (right). It is hard to see any meaningful difference despite a bit of variation. Most scenes have even less variation than this example.

It is a long-held belief that a Phong rendering is going to be faster than a RT, but as we begin to do some testing, this truism does not always hold up, especially within Universe's highly optimized system. Our test scene consisted of 49 sphere models sitting on a plane, with only the center sphere set to 100% reflective (see Figure 13.4, left). The scene was rendered four times: Phong (using Environment) at full HDTV resolution, and again at half of that resolution. The same image was then Raytraced at both sizes. Both the Phong and RT renderings were excellent (see Table 13.1).

**Table 13.1 One Reflective Sphere**

| RENDER LEVEL | HALF (960 × 520) | HDTV (1920 × 1040) | TIME INCREASE (%) |
|---|---|---|---|
| Phong | 31 | 60 | 200% |
| Raytrace | 29 | 98 | 337% |

**FIGURE 13.4**   The first Reflectivity Raytracing test (left) consists of only one reflective sphere in the scene. The second test (right) consists of 49 reflective spheres. The visual differences between Phong Environment and RT were minor enough to not be visible in print.

Though Phong and RT take about the same time to render a smaller frame, doubling the frame size (which increases the pixel count by 400%) extends the RT time by 337%, whereas the Phong time only doubled. A good reason to stay with the older Phong renderer.

But what would happen if the scene had many reflective objects? The same reflective properties were applied to all 49 spheres (as seen in Figure 13.4, right), and another four images were rendered. Once again, the quality for both images was excellent and hard to tell apart (see Table 13.2).

**TABLE 13.2 49 REFLECTIVE SPHERES**

| RENDER LEVEL | HALF (960 × 520) | HDTV (1920 × 1040) | TIME INCREASE (%) |
|---|---|---|---|
| Phong | 17min 3 sec | 18 min 30 sec | 108% |
| Raytrace | 1 min 42 sec | 5 min 36 sec | 319% |

We expected the Phong Environment method to slow down because it now needed to generate a map for each and every one of the 49 spheres, but these results took us by surprise. As you can see by the small variation between sizes, producing the reflection maps was the consistent time drain, and the actual frame rendering was negligible. Global or per-model Bitmap reflections would speed this up considerably but would sacrifice accuracy and/or set-up time.

Raytracing in this test was the clear winner, coming in at a fraction of the time for either size rendering. It is interesting to note, though, that despite the different content of this scene, the small-to-large frame renders were consistently in the same 300+% range.

The other option found in this section is **Occlusion**, which realistically masks out areas of the reflection producing a much better rendering in most cases. The time hit for adding Occlusion is not very much, and the results are well worth it, as seen in Figure 13.5.

### Transparency

In our testing we found that a Raytraced transparency (set in the Material Editor) sometimes produces a slightly smoother transition than its Phong counterpart. Its edging effects are a bit more pronounced, but this can easily be compensated for with the addition of some Edge Density. This would probably be needed in most glass objects anyway.

The real benefit to using RT transparency is the ability to add **Refraction**, the natural bending of light rays through varying densities of glass. A Refraction Index reference can be found in this book's Appendix. Re-

**FIGURE 13.5**   Raytracing with a Occlusion off (left), and toggled on (right).

fraction does not add any appreciable time to a rendering on top of that of Raytracing, but enabling RT can be costly. In our sample images (see Figure 13.6), the RT rendering took just over one minute, compared to only 18 seconds for the Phong rendering. That is almost 400% more time spent rendering, so it had best be worth it.

If your scene involves many layers of transparent objects, lowering the **Raytrace Recursion** number from its default of ten can help speed the rendering process, but you will be compromising some level of realism along the way.

One additional point to be aware of when RTing a transparent object: Though RT will handle the transparency if enabled, most models will still retain varying degrees of density throughout the model. These sections are still handled by the traditional controls, so do not neglect the other settings just because you have RT enabled.

**FIGURE 13.6**   The Phong rendering (left) took only 18 seconds to render, compared with the Raytracing, which took 1 minute and 2 seconds. The Refraction adds no additional time.

## Raytraced Transparency and Buffer Shadows

When you have a RT transparent object that is set to cast a Buffer shadow, make sure to take a look at that shadow, both *through* the transparent model, and directly. There is a very good chance that their feathered edging will not match. Refraction has no effect on this situation; rather, the RT transparency and all elements behind it are rendered with the RT engine, and other areas are being produced with the Phong renderer (see Figure 13.7). The results of this can vary from subtle to jarring.

There are two ways to fix this. The first is to simply increase the Smoothing value in the Buffer shadows controls. Matching your Softness value is a good place to start, but you may need to reduce this a bit. A more elegant solution is to use the reduced Buffer map technique for feathering the shadow's edges rather than the Softness control. This is rendered uniformly across both RT and Phong engines. See Chapter 10 for more information on this technique.

**FIGURE 13.7**  A Buffer map's edge feathering is not treated equally by both the Raytracing and Phong engines (left). One of two solutions can fix the problem (right).

### Shadows

Raytraced Shadows are set per light in its Shadow tab window (see Figure 13.8). This feature offers many realistic qualities that are difficult to reproduce by other means. For example, Buffer Shadows allow for softened edges but they do not vary the softness appropriately, nor can they offer a natural falloff effect as the shadow extends away from the model. Raytracing offers both of these features, but the cost in rendering time is steep.

As was discussed in the Chapter 10, "Lighting," a default RT shadow is visually identical to a default Buffer (see Figure 13.9-a). There are two differences though: The RT version takes at least twice as long in our

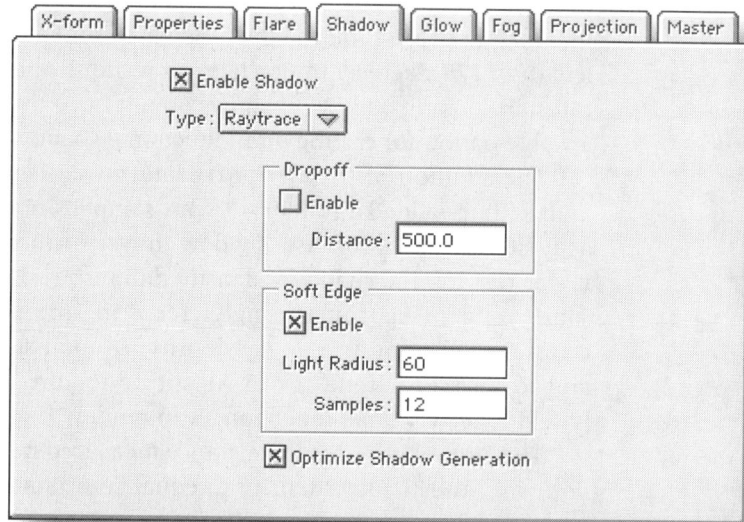

**FIGURE 13.8**   The Raytracing control tab for shadows.

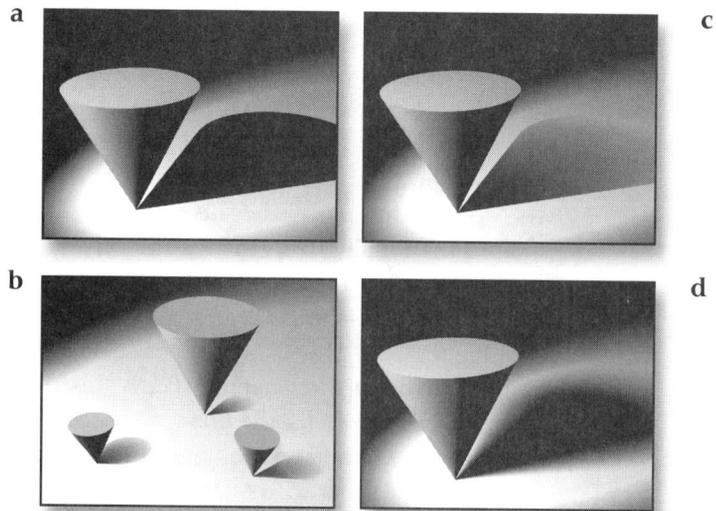

**FIGURE 13.9**   (a) The default Raytrace rendering took 42 seconds (an identical Buffer image took only 12 seconds). (b) The addition of the Dropoff feature increased that to 1 minute 3 seconds. (c) A single Dropoff light falls short of working on multiple models with varying needs. (d) Same as image "a" but with Soft Edge enabled took over 12 minutes to render, or about 6 minutes with the Optimize feature enabled.

tests, making it much less desirable, and because Buffer maps use an actual map to project the shadow, they are limited to casting at an angle of less than 179 degrees. In practice, projections of over about 100 degrees can start looking odd. RT shadows do not have this limitation and can be a viable option for casting omnidirectional shadows.

The addition of the **Dropoff** feature (see Figure 13.9-b) to the default settings added a full 50% to our sample's rendering time. What exactly does Dropoff do? As a shadow moves further away from the object it was cast by, the shadow's density diminishes. It does this for two reasons: Ambient light increasingly creeps in, and the shadow's edges increasingly blur and thus lower density. Dropoff simulates the first effect, and to a lesser extent, it can substitute for the Soft Edge feature that would otherwise take much longer to render.

The Dropoff value is the distance measured from the model to where you want the shadow density to equal zero. Since the measure is from each model, we can apply this to many models and get good results. The technique runs into problems when the lengths of cast shadows vary from one model to another. This can happen due to the angle of light (except with Parallel lights), or due to the size of the model, as seen in Figure 13.9-c.

The **Soft Edge** feature is the real reason to use RT shadows because the results can be nothing short of gorgeous; however before enabling this feature, always confirm that the Buffer Shadow option is not usable instead, as it can save you a lot of time. Check out the numerous shadow techniques found in Chapter 10, "Lighting."

Once Soft Edge is enabled with its default settings you will notice, well . . . nothing. This is because the default value setting of zero for the Radius functionally turns the feature off. We will need to put in a higher value—the larger the number, the larger the defocusing radius that is applied. This is very similar to the "Circle of Confusion" we talked about in the Chapter 12, "The Camera." It is also basically the same as the Soft Spot we made in the Chapter 10. As this number goes up, so does the time required to render the image. The test image shown in Figure 13.9-d used a value of 60 and took over 12 minutes to render.

Just below the **Radius** setting is an edit box for the **Samples** control. The default of 12 strikes a good balance with many scenes, but it can be lowered to speed the rendering. Push too far and the feathered areas of the shadow begin to exhibit a grainy noise pattern.

Another method Universe offers to help you move faster than the speed of molasses is a toggle at the very bottom labeled **Optimize Shadow Generation**. The manual warns of pixelation by-products, but we did not see any. The toggle did not speed the rendering by a factor of 16 as promised by the manual, but it did drop the time by slightly over 50%, from the 12+ minutes to just under 6. Reason enough to rejoice; unfortunately, this only benefits the Soft Edge feature and not other aspects of Raytracing.

**T U T O R I A L**

## FAST SOFT RAYTRACING

Adding over 5 minutes to a single frame's render time just for a RT shadow is a lot. Especially compared to the 10-20 seconds a soft Buffer would take. But there are times that we need the "smart softening" that RT offers. What if there was a way to get this smart softening and still keep the rendering times down? There is. First, you need to understand that the reason Soft Edge takes so long is that it is doing multiple calculations, whereas RT without these feathered edges is doing fewer calculations, and thus does not require very long rendering times (about 1 minute).

Like a magician's sleight of hand, we create two models, one that is treated normally except its **Casts Shadow** toggle is turned off (**Info > Shadow**). This is the model we see in the rendered scene. A duplicate, which is only used to generate the shadow, has its edges made transparent using the **Edge Characteristics** controls in the Transparency tab, and is set to Shadow Object Only (**Info > Shadow**).

The results can be excellent, as seen in Figure 13.10. Are they as good as doing a full RT rendering? Depending on the model, the results can be amazingly

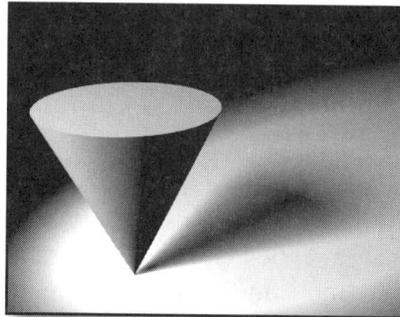

**FIGURE 13.10**   A sample of the fast soft-Raytracing technique that rendered in 1 minute and 13 seconds. Compare this to the Soft Edge sample in Figure 13.9-d.

close. There are a few additional tweaks that you need to be aware of. The Edge Characteristics work on curves but not so well on hard edges, like the tops of a cone or cylinder. So you apply a gradient image as a transparency map to that top section to feather it off. You also need to feather the edge transparency so that it is strongest at the top of the model (which casts the furthest part of the shadow that we want very soft), and weakest toward the bottom, as shown in Figure 13.11. A variety of custom transparency maps can also be used as well.

Another suggestion, though it was not used in the sample files on the CD-ROM, would be to make the shadow-casting model a few points larger in size to correct for the subtractive properties of the feathering process. Otherwise the shadows are a bit smaller than they would normally appear.

**FIGURE 13.11**   The cylinder had two gradient maps applied, one transparency (left) to the top hard edge, and another to the Edge Characteristic to taper its strength along the length of the model (right). The results at the far right Raytraced in just 58 seconds.

## Raytracing Flags

As with many features within Universe, in order to work, Raytracing must be enabled in a few places: the model's Info window Shadow tab, the Material editor's Reflectivity or Transparency tabs, the light's Shadow tab, and the Render window's master Camera setting.

In addition, there are separate and specific rendering Flags for RT Shadows, Reflections, and Transparency. These are independent of their Phong-based counterparts and can be enabled or disabled without affecting the Phong engine.

## MILLIONS+ALPHA: STRAIGHT OR PRE-MULTIPLIED

The **Image** pop-up menu sets the levels of the colors that the renderings should be saved to, however it does not dictate how the files are actually rendered, so there is no time saved by setting this to fewer colors.

Most of the time, we will want our renderings set to Millions, or Millions+Alpha. The difference, as the name implies, is the addition of an *Alpha* channel that is used to mask parts of the RGB image. This allows for much easier compositing in post production for either still or animated projects. The most common properties to be masked in the Alpha channel are areas where no model exists in the scene, transparency, and all Anti-Aliasing information. Special effect items also find their way into the Alpha channel, including the Diffuse tab's *Mask* channel and Generate Shadow Mask option.

When a Millions+Alpha image is brought into a post production application, it will need to know if the image is Straight or Pre-Multiplied in order to handle it properly. EIU's IMAGE files and Pict renderings are all saved as Straight images. A Straight image is one where the RGB channels have been saved without any of the Alpha channel's information applied, which is good because we want the Alpha information to be applied by the compositing program when it masks the image. This provides a cleaner image without the risk of the halo effect, or the danger of double masking.

If you are using **After Effects** as your compositor, it is smart enough to know that IMAGE files are Straight and can handle them automatically. These settings can also be manually changed by opening the **FILE > Interpret Footage... > Main** options. You may Ignore the Alpha, or set it to Straight or Premultiplied, along with a variety of other options.

### Render Format

The Format pop-up menu offers a variety of rendering output formats, but for general production, sticking with Electric Image's own IMAGE format offers some of the best reliability. This format supports both stills (single frame) and animations (multiple frames) in configurations that offer a reasonable amount of lossless compression. Photoshop and most animation compositing software, such as After Effects and Commotion, support this format.

Both Mac and Windows offer Apple's QuickTime as an output format, though it has proved to be less than ideal for final renderings, and is generally avoided (it is, however, very helpful as a Preview format).

### Sequential PICT Files

An alternative to the IMAGE format is to output to sequential PICT files, which can be preferable under certain workflow situations. The downside to this option is the loss of some estimate feedback information during the rendering process, and the added management that rendering out sequential files involves. Although PICT in itself is a lossless compression format, it is integrated on the Macintosh with QuickTime and offers additional QuickTime compressions that are not lossless.

Rendering to sequential files has long been a standard method for outputting professional 3D work, with advantages for both the animator and post-production staff. When an animation is rendered to a single file it becomes much harder to do any pixel-level editing without the use of specialized applications like Commotion. Even with such tools available, if a single frame happens to render with a bad polygon it is easier to open that one frame in Photoshop, edit, and save. Sequential rendering also makes simple work of adding in-between or "blending" frames when needed. When the occasional glitchy frame occurs, say frame #21, we can remove it. We could then composite frames #20 and #22 together with a 50% blend to create a new frame #21. When it plays back, the new frame #21 is a perfect bridge.

Universe will correctly number the frame files that you save into a folder. You can import this folder into After Effects as a folder and use it that way, or you can simply drag the folder from the desktop right into the footage bin. This will convert the folder into a single entity within After Effects, which makes for easier handling and allows additional options like Interpret, Replace, and Reload. Best of all, the files in the folder are still easily edited, added to, or deleted, and After Effects will simply update any changes.

### Gamma

Animations can have their overall gamma modified easily by editing the **Output Gamma** edit box found in the Render window's Render tab. This can lift or lower the overall illumination of the scene, and remove the need to re-tweak multiple light settings if the changes needed are not too severe (see Figure 13.12). These settings can also be used to help correct the rendering for use on various delivery systems, whether they are broadcast, film, or multimedia.

Although correction can usually be made in a compositing program, the quality of the image will be higher if gamma is corrected at the rendering stage, rather than later in post production.

**FIGURE 13.12**    The Output Gamma setting at 0.5, 1.0 (default), 1.5 and 2.0.

**TUTORIAL**

## Render Flags and Multipass Rendering

In the **Render** tab you will find a series of toggle switches that are referred to as **Render Flags** (see Figure 13.13). These are master switches for a variety of channels within Animator; toggling off a switch here will prevent an attribute from rendering anywhere in the scene. These are handy for speeding up test renderings by turning off items like Reflections or Shadows, but they are also useful in something called Multipass Rendering (MPR).

MPR is a technique of rendering multiple animation files from the same scene, each containing different elements from that scene. They are later reassembled in a program like After Effects, offering the animator a level of control not available in the 3D application, including the ability to do much faster modifications. Obviously the 3D elements need to be final-rendered before this step can be taken.

The variables that are most commonly used to generate the multiple animation files of a MPR are: **Channel** attributes (those controlled by the Render Flags and others), **Model Visibility** (controlled by the Visibility Flag), **Shadow Tab** attributes, and **Alpha** channel values.

In this exercise, you have a simple 3D scene with one reflective sphere model set to RT, a ground plane and a sky hemisphere (see Figure 13.14) on the next page. The plane has a grid texture map applied normally to its Diffuse channel. The hemisphere has its Diffuse sensitivity turn all the way down and an animated cloud map applied to its Luminance channel instead, so that it can be made to self-illuminate.

The scene is illuminated by one broad-angled Spot light set to cast a soft Buffer shadow. There is a touch of world Ambient lighting thrown in to puff up

**FIGURE 13.13**   The Render tab with Render Flags that are master switches for many attribute channels.

**FIGURE 13.14**   The basic scene rendered from within Universe. This looks good, but by breaking the various elements into discrete files, we have more control in the compositing stage.

the shadows and a bit of Fog, as well. Every single item just mentioned could be separated through various methods and used as an individual animation channel in our final composite. Usually, it makes more sense to limit the renders to those items most likely to need extra attention.

*The Hemisphere model has been drastically reduced on its Y-axis, as you can see in Figure 13.15. This gives you two important benefits: First, the Fog will no longer block out the sky area, something it would have done if the sky were still equidistant to the horizon. The second benefit comes when mapping the cloud texture onto the Hemisphere. Using a Cylinder or Sphere projection would have caused pinching at the corners that would have taken more time to correct. A Flat projection is more re-alistic and will exhibit only minimal smearing now that the Hemisphere is squat.*

**FIGURE 13.15**   Side view of the scene showing the altered shape of the Hemisphere and the Fog's start and stop locations.

Because we are not moving the camera in this exercise, many of the channels can be rendered as still images. The following is a breakdown on how to extract a variety of the channels you may typically need as separate elements. The output to all of these steps can be seen in Figure 13.16 on the next page, and in a composite JPEG file on the CD-ROM. Every set-up listed below has been saved as a project and is provided as a separate file on the CD-ROM for your examination. All renderings and the After Effects composite are also on the CD-ROM.

*ON THE CD*

### BACKGROUND ELEMENTS

1. **Ground Plane**: Turn off Hemisphere, Sphere, and Fog. Make sure you render to Millions+Alpha, as you should in all of the steps here.
2. **Hemisphere**: Turn off Ground Plane, Sphere, and Fog. This is an animated channel so you will want to render all appropriate frames. This is controlled in the **Render Info > Timing** tab, and is set up in the project provided.
3. **Fog**: Turn on Hemisphere and Ground Plane. Sphere stays off. Turn Fog on, and set it to Fog to Alpha. We will only be using the Alpha channel here.

**FIGURE 13.16** The resulting renderings from each of the 10 steps. Shown is the file's RGB and Alpha channel, Steps 1–5 down the left, and Steps 6–10 down the right.

### Foreground Elements

4. **Sphere**: We will want a basic Sphere render, so turn the Sphere on and the Ground Plane and Hemisphere off. The Fog should be off, though in truth, it will have no effect. Turn off extra attributes using the Render Flags. In most cases you would want to turn off Textures, Reflections, and other items, however this is a simple model so we need only toggle off the Specular flag and render.

   Realize that the rendering from Step 4 is really a composite of the Spotlight, the Diffuse color, the Ambient lighting, and the Shading tonalities. In most cases, it will be all you will need for a base layer, but this can be further divided, as you will do to a limited degree here. Steps 5 and 6 replace the rendering from Step 4.

5. **Sphere Diffuse**: Same as Step 4, set the Ambient light to full white. This will give us a rendered model of solid color with minimal highlights and no shadings. (The Spotlight will create a dull and broad highlight, which could also be separated out, though we won't do it here.)

6. **Sphere Shading**: Now that you've got the flat color in Step 5, grab the tonal gradations. Turn the Spotlight back on and the Ambient light off. Leave the Specular Render Flag off. Change the Sphere model color to white. When you render this image, it will give you the grayscale tonalities of the model, which can be set to a Multiply or other blend mode on top of Step 5.

7. **Specular Reflection**: Having the Specular reflection as a separate layer allows us to raise, lower, sharpen, or blur it in post. Turn off the Ground, Hemisphere, Fog, and Ambient light. Leave the model white, as in the last step and turn the Specular Render Flag on and the Diffuse Flag off. The rendering should be a black ball with a white Specular highlight. If you look at the composite rendering directly out of Animator, you will see that this Specular highlight gets covered up and does not actually show. Adding it back in during this process will look much better.

The next two set-ups involve the two reflections and are a bit tricky. Bitmap reflections are placed into their own channel and are easy to isolate using Render Flags, but Environment and RT reflections renderings are put into the Diffuse channel, so we can't turn off the Diffuse tab to eliminate the Sphere. We could make the Sphere a keyable color and use the Color Key plug-in in After Effects, but a better solution is simply to make the Sphere model transparent because this does not affect either specularity or reflections. "Ah!" you say, "That won't work, we will see through to the other side!" Normally you would be correct, but you will set the reflections to Raytracing, and change the **Raytrace Recursion** to 1. This limits our rendering to the first layer, which of course is the mesh facing the camera.

8. **Ground Reflections**: From the Master file, turn off the Hemisphere model, make the Sphere model fully transparent in the Material Editor, and make sure it is set to RT reflections. In the Render tab, set the Raytrace Recursion to 1. In the **Ground Plane's Info > Shading** tab, toggle on **Reflection Object Only**. We want to make sure the Ground Plane's lighting is correct because it will affect the reflection; this includes the Spotlight pattern and the Specular highlight on the Ground. Do this by creating a Selection set for the Spotlight so that it only shines on the Ground Plane. To light the Sphere, you will want to add an Ambient light to the scene and create another Selection set so that it only illuminates the Sphere. Put the Intensity of this Ambient light at 0.5. You are ready to render the file.

9. **Hemisphere Reflections**: This is almost exactly the same setup as Step 8, but without the extra credit points. Turn the Ground Plane off and the Hemisphere on. Enable its Reflection Object Only toggle. This channel is animated, so you will want to render all the frames.

10. **Cast Shadow:** The last step is to isolate the cast shadow. This is easy enough to do by going back to the Master project file, toggling on Shadow Object Only for the Sphere, and the Generate Shadow Mask for the Ground Plane. In the Render tab, toggle off Diffuse, Texture Reflections, and Luminance. And in the World Info window, turn off the Fog and Ambient light.

We are done with the Multipass renderings. If this scene had more light sources we would also want to do a separate render for each light.

The next step is to assemble all of these files in a compositing program.

### COMPOSITING A MULTI-PASS RENDER

At this point, you are starting with all your renders in a folder, ready to be imported into **After Effects** (or your choice of compositing program), as seen in Figure 13.17.

This project is not the most complex, yet you still have ten rendered layers and a Solid to deal with. This can quickly become overwhelming if you don't find some way to approach it that will allow you to keep your cool. The easiest thing to do is build a composite from the ground up—this means to start by loading and placing the background plate first (**plate** is an old term that refers to either film or printing plates). Once that is in, somehow the rest seems a lot less difficult and your mind can start to wrap around a logical plan of action. This is similar to doing a jigsaw puzzle—once the edge pieces are in place, it becomes smooth sailing. You get a little advantage because your rendered layers are already numbered. Most of them correctly too!

*After Effects numbers each layer placed on its stage, but its numbering system starts at the top layer and works its way down. This is, in effect, stacking* down *instead of* up *the way Photoshop or an old animation stand would work. This tutorial references the layer's number in its name,* not *the layer number applied in front of the name by AE.*

*Refer to the "Multipass-Sheet.jpg" on the CD-ROM for a fast visual on each layer used here.*

- **01-Ground Plane**: This gets placed first, as already discussed above. Logically, this layer contains the image of the ground plane. The fastest and easiest way to place a layer centered in AE, is to highlight the item in the main project window and select **Command** or **Control-/**.

**FIGURE 13.17**   The After Effects interface with our completed file setup.

- **02-Hemisphere**: This is the sky image, which drops in to fill the upper half of the screen.
- **03-Fog**: As you recall from your rendering setup, this layer is only used for its **Alpha** channel, which will be accessed via the Set Matte Filter applied to another layer. This filter does not need 03-Fog to actually be visible, so you can turn it off. You can also move it the bottom of the list to keep it out of the way of the layers you will need to interact with.
- **10-Cast Shadow**: Before the Sphere model goes in, you need to put the cast shadow in place, as it must rest beneath the model casting it. The Opacity is reduced to 75%.

- **Fog Solid**: No, not Frog Salad! This is a deep blue/black Solid layer created in AE, with the Set Matte filter applied. It is set to use the 03-Fog's Alpha channel as a mask. The net result is a dark fog at the horizon, which can be modified to suit our needs in ways that would be hard to impossible in 3D. Opacity should be 75%.
- **04-Sphere:** This is the layer that combines the Sphere's diffuse characteristics with its shading tonality. You are not going to use this, rather you will use the next two renders, which break these elements into discrete layers.
- **05-Sphere Diffuse**: This layer contains the Sphere model's blue color with minimal tonality. This allows you to have complete control in compositing the animation with regard to its intensity of highlights and shading.
- **06-Sphere Shading**: This layer drops in the Sphere's shading tonality, giving you the ability to lighten or darken as you see fit. In this composition, reflection layers will be dropped on top of this and will mostly obscure it. That doesn't mean this discrete layer was overkill, quite the opposite. Having an independent tonal image means you can drop it underneath *and* on top of the reflection layers, as you will soon see. Set the Transfer Mode is set to Multiply.
- **08-Ground Reflection**: This is the reflection from the reddish ground and grid pattern. Apply it with an Opacity of 90% to reduce the Sphere's Reflectivity—yes, you can control that in post!
- **09-Cloud Reflection**: This is the reflection from the sky, which could have been done at the same time as the ground, but applying it now gives you more control down the road.
- **06-Sphere Shading**: The tonal shading layer is brought back, now placed on top of all the other Sphere layers and set to the Overlay Transfer Mode, which applies both brightening and darkening attributes to the model. This helps give the Sphere a greater feeling of rounding and an overall kick. Set the Opacity to 30%—you only want just so much kick.
- **07-Specular Reflection**:  This is the Specular light that is dropped on top, like a cherry on a dessert. This is 2D, so it can easily be made brighter or darker, more opaque or less, and even blurred to appear more diffuse. And you are finished.

As you compare this image to the straight 3D version in the "Multi-pass Sheet.jpg" file on disk, you can see that the composited image not only matches, but can surpass in quality. Even if this were not the case, the ability to almost redesign an animation on the fly—turning value A up, and value B down—can be a very seductive way to work, especially to those of us who have grown up with the idea of making a change and then waiting 2 minutes to see it.

## SETTING RESOLUTION

There are two ways to set the resolution for rendering, either by using the **Resolution** pop-up menu or by manually setting the X and Y edit boxes. If you wish to retain Aspect Ratio settings, then it is important not to use the Resolution pop-up because this will override them. Instead, type your desired Horizontal resolution into the X edit box and the Y value will be updated automatically in about 2 seconds (hitting the Tab key will force an instant update).

As was discussed in the Chapter 12, "The Camera," the **Aspect Ratio** settings are most frequently used for film or print-related projects. These types of work tend to have established horizontal versus vertical ratios, but the resolution needed can vary from one job to the next, even for the same format. For example, graphics for film are often referred to as being done at 2k or 4k, which are resolutions measuring just over 2,000 or 4,000 pixels across. Print jobs also vary in resolution; for example, a newspaper job does not require the same resolution that a glossy magazine would.

### Figuring Print Resolutions

To determine the pixel resolution for a print job, you must work backwards by first establishing the halftone line screen to be used by the printer. A high-quality color magazine might use a 175 **lines per inch** (lpi) screening to print. The old rule of thumb is that you want to double that number to determine your needed **pixel per inch** (ppi) resolution, which in this case would be 350 pixels per inch. In truth, this number can be safely lowered, especially when we are talking about ultra-clean computer graphics as opposed to grainy photos. Most print jobs work well with resolutions in the 250-300ppi range. Remember that this is based on the final sizing, so if you give a magazine a 4 × 5–inch image at 300ppi, and they scale it up to 8 × 10 inches, that image will now only be 150ppi.

For print work, the Anti-Aliasing should never be set to **Oversample**, as that is too soft. Instead use **Adaptive**, or for an even crisper image, turn the Anti Aliasing off and boost the resolution to compensate (try 200%). **Resizing** the image back down to size in Photoshop (using Bicubic) will add an additional bit of edge softness. In either case, you may still want to apply a judicious amount of **Unsharp Mask** to make the image snap.

### Outputting to Film

When outputting individual images to sheet film (not for motion pictures), the resolution requirements are usually much higher, starting at about 600ppi and going into the thousands. Since film output is most commonly done for photographic blowups, the determining factor is how large the final image is going to be. Much of this work has been replaced with direct digital printing systems that go to various substrates, including photo paper.

### Setting Video Resolution

The rules change when you are doing a project that is destined for video. Because of the nature of video specifications, its formats are defined in large part by their pixel count. Its **aspect ratio** is determined by pixel resolution and **pixel ratio** (see "Pixel Ratios" below). This is why when the Resolution pop-up menu is altered, it will directly update the X and Y edit boxes, as they are hard-wired together.

The problem with video that keeps many people scratching their heads is that the video industry has too many "standard" formats. Certainly, most people reading this book are familiar with NTSC and PAL formats, but even within these camps there is a wide range to choose from. Even with standard old-fashioned NTSC broadcast, you may need to output to either 640 × 480, 648 × 486, 720 × 480, or 720 × 486 formats, depending upon which output system you use. There are, of course, different resolutions for PAL systems, a couple of HDTV standards, and others.

For all of the confusion, it really comes down to choosing the settings that match your system. In all likelihood, your system will be a match for one of the pre-sets offered in the pop-up menu. If you require a custom resolution, then just type it into the edit boxes directly.

## PIXEL RATIOS

Not to be confused with the frame's aspect ratio, pixel ratios are unique to the video world. If you are doing strictly film, Web, or print, then feel free to skip this particular headache. If not, then at some point or other, you will have to gain some understanding of the fact that even though the computer world uses square pixels, most video broadcast formats use non-square pixels. If you were to feed a square pixel image to a broadcast system, its rectangular pixels would distort the frame enough to turn spheres into ovals, and you would run the risk of having less action and title safety than you thought.

The simple concept then is to pre-distort the image, wider for NTSC (or narrower for PAL), so that when moved to video, all will look correct. The problem with doing this, however, is that we also need to be able to work on our computer systems with accurate previews.

As you can see in Figure 13.18, you have a perfectly round sphere in the middle of the scene, and one of the test images placed in the Camera's Rotoscope channels behind it. The top row shows the Camera window display and the lower row shows the rendered images displayed in After Effects. In the first column, we have set the system to the most common NTSC D-1 standard of 720 × 486 (PAL equivalent 720 × 576), but have kept the Pixel Ratio set to 1.0, which is square. Even though the preview in Animator and After Effects looks good, in reality, it is allowing us too much width, some of which would get cropped upon transfer to video.

The proper way to set this up is to use the NTSC pixel ratio of 0.9, which provides a more accurate and narrower image in Animator, as seen in the center column. However, the preview in After Effects does not fare so well and we see an elongated image that will be harder for most people to work with. One popular solution is to work in a format called NTSC Square Pixel, which is 720 × 540 at a 1.0 pixel ratio (PAL equivalent 768 × 576), which is not a preset in Animator, but is in After Effects. This format simply adds more height to the image so we square folk can work properly in both Animator and in post. When the project is

**720 X 486 Square Pixel**    **720 X 486 Non-Square Pixel**    **720 X 540 Square Pixel**

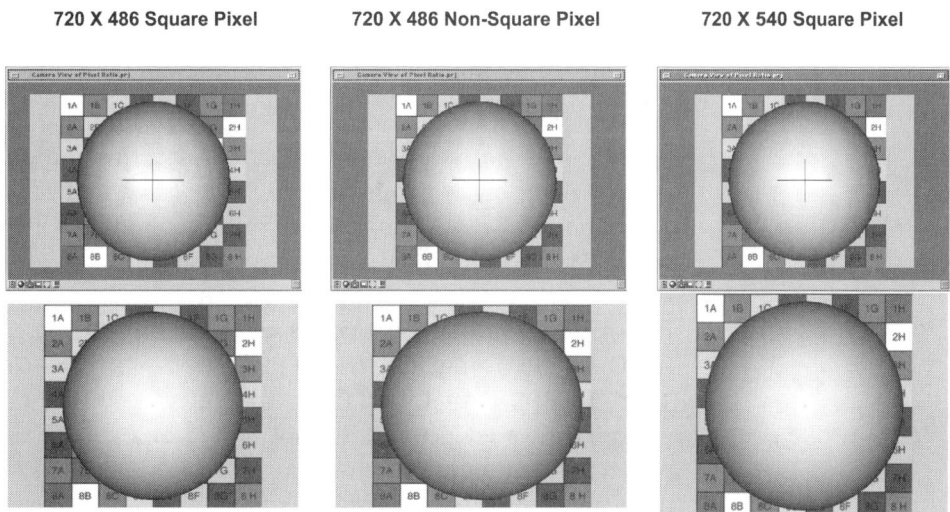

**FIGURE 13.18**    Three different output settings that deal with the issues of non-square pixel ratios to varying degrees of success. Top row shows the Camera window in Animator, and the bottom row show the imported renderings within After Effects.

ready to be rendered to video in the compositor, the vertical scale must be reduced to the proper 486-pixel count, giving us the needed distortion. Do this by dropping the final composite into a new composition window set to 720 x 486 and scaling the vertical to match. This is only one way to solve the problem, but it offers a good compromise. You must keep in mind though, that due to the vertical scaling, the image is not compatible with pre-interlaced animations.

## TIMING TAB: FRAME RATE AND INTERLACING

While film output is almost always set to 24 frames per second (fps) and multimedia is generally created at 12 or 15, video is not that simple. Technically speaking, video is generated at 29.97 fps interlaced (PAL is 25 fps). An interlaced frame is actually a blending of two frames that are called fields because each has had half of their scan lines removed. This is why video frames of a moving object look like they have a double exposure—there is visual data from two points in time combined into one frame.

The frame rate of 29.97, which runs trippingly off our tongues, is often rounded to 30fps, but this can cause a forced drop-frame every 1,000 frames. That means this convenient rounding could cause slight video stutter every 33 seconds, which is fine if you produce spots for TV that are under 30 seconds. Regardless, it is easy enough to adjust for this in post. Animator's presets are set to 30 and 25 fps, but a Custom option allows us to plug in 29.97 if desired.

The interesting thing with all of these options is that despite all the chiseled-in-stone specifications, we really have a number of options:

- **24 FPS**: We can output our animations at 24fps and do a film-to-video conversion, which is called a *3:2 Pulldown* and can be done in After Effects (the PAL equivalent is more commonly done with hardware). Many professional animation houses prefer the look and feel of this because it adds something of a cinematic look to the product. It also offers substantial savings on rendering time, reducing the frames by 20% compared to a 30 fps job.
- **29.97/30 FPS Non-Interlaced:** This offers a full frame for every video frame, a good thing. By not interlacing, you save half of the rendering time over producing an interlaced product. Most of the time, the quality is more than adequate.
- **29.97/30 FPS Interlaced:** In order to generate the two fields of an interlaced frame, Universe is really rendering both fields as full frames. This is needed for quality reasons, mostly to do with anti-

aliasing. So in reality, opting for interlacing means you are rendering out at 60fps, and having Universe toss out half of it. The advantage is that this will produce the smoothest-looking product possible, most noticeable with high action scenes that have a good deal of movement. Some animators feel this type of rendering looks too slick and polished for their tastes, so it depends on your needs. Note that you will need to choose an even or odd field dominance for this setting, and that any pixel level touch-ups will need to be done with an interlace-aware program like Commotion.

- **60 FPS**: With the plummeting cost of hard drive space, why have Universe render at 60fps and toss half of it out? By using the Custom option to manually set the render to 60fps, you can hold onto that data in case you need it. For example, there would be no need to choose a field dominance, as you could output to either or both systems in post. You can easily open frames in Photoshop for touching up, without any interlace problems. You can use the 720 × 540 Square Pixel format discussed earlier in this chapter to solve your Pixel Ratio problem. (A number of these apply to the 24fps option as well.)

It is preferable to choose your fps settings at the start of the project—changing it after keyframes and custom keys are set can cause some shifting. Animator does a good job of handling these alterations when needed. This gives you another reason to choose a 60fps setting at the start of a project, because using the **Nth Frame** control it can be altered to give you 30fps for video, 15fps for multimedia, or 10fps for testing, without ever having to worry about a shifted keyframe.

## FASTER TEST RENDERS

In animation, the old saying goes, "there is no such thing as rendering just once." We are always rendering motion and other pre-flight animation tests, so how can we make these run a bit faster? We have already discussed the Render Flags that can turn off numerous attribute channels; in addition, there are three very helpful settings you should be aware of.

The first is the **Draft** pop-up menu in the Resolution tab, that lets you reduce the frame size to a fraction of the preset rendering size. As you have learned in various parts of the book, reducing the frame size can give you a nice speed boost with Phong and lower rendering modes, and a very significant boost with Raytracing.

The second setting you will want to look at is the **Nth Frame** option in the Timing tab (also found under the Render Range Project window icon). This setting is a controlled frame drop that only renders every second, third, or fourth frame, and so on. This will of course speed the process, but because you are testing animation, there is a limit to how many frames can be dropped and the animation still be of value.

The last item is the **Anti-Alias** option, which inflicts a big hit at render time. By turning it off, you lose visual detail, but this can be fine for motion tests.

A typical proof rendering could end up with a resolution of $360 \times 243$ (1/2 of NTSC), 15fps, and a host of render flags and anti-aliasing turned off. This could easily bring the rendering time down to under 10% of a final rendering or even less, depending on the scene.

## ANTI-ALIAS

**Anti-Aliasing** (AA) is the process by which visually harsh and contrasting edges—often called "jaggies"—are made to look smooth. This is accomplished by first examining the input through *Sampling*, and then applying a controlled blur, the Anti-Aliasing. AA is easier to understand when you realize that if an image were rendered at a high enough resolution, there would be no need to use AA. This is an option sometimes used for print work, but is not possible with video.

### Sampling

This is the process of determining how closely (and slowly) Universe should examine the area to be Anti-Aliased. Although the program's default is set to a 1x1 setting in the Render window, the manual suggests that a 2x2 setting is preferable. This matches the 2x2 default set for models. The higher the setting, the higher a map's acuity, but the longer the rendering time. An Anti-Aliasing chart is on the CD-ROM and contains a variety of sample renderings at different tab settings. All renderings are presented at actual rendering size and have not been resampled in Photoshop.

**ON THE CD**

### Anti-Alias

This is what actually controls getting rid of those nasty jaggies. The larger the number, the smoother the jaggies, but this comes at a cost of image acuity that is sometimes hard to let go of. You want to use the lowest set-

ting that will still properly rid your image of the jaggies, sizzle, pop and moirés that can plague video production.

### The Adaptive Advantage

Electric Image has always offered the Oversample option, and it has done a wonderful job for video work. Print was problematic though, since Oversample delivers soft imagery that better meets the needs of animation. The addition of the **Adaptive** setting was a boon, not just to print production, but also to animators who wished to push the envelope by producing sharper/snappier footage. Adaptive's default settings are already sharper than Oversample, but you can push it even further by raising its Minimum value setting to over 200.

With all settings in this tab, there is no "perfect" formula and every scene will have its own requirements. A bit of experience, a dash of experimenting, and an understanding of what your scene needs most will be your best guides to using these tools well.

## BROADCAST COLORS

If you have ever studied color theory you will know what a color space is. Every medium has its very own color space, and even hardware like monitors and printers have their own. For print and multimedia work, we will often check our CMYK or Mac/Windows Gamut in Photoshop, and it is also a good idea to do this with texture maps that will be brought into Universe.

The obstacles are a bit more difficult when we are talking about video production because its color space is very different than that of our monitors. The video spectrum is very sensitive to bright whites and overly saturated colors, especially red. One of the best ways to ensure that you get the right colors in your work is to have an NTSC or PAL video monitor attached to your system as you work; this way, you can always drag a window over to check that its colors are correct. The realities of doing this are not always as good as the promise, because the OpenGL card you use to work in 3D may have a TV out, but how closely its colors will match that of the video output card is hard to say. However, this is a place to start and calibration software can help bridge some gaps.

Other methods to rein in your colors before they hit the magnetic tape is to use NTSC filters for Photoshop (for texture maps), or those found in After Effects. These tools are usually successful, but don't assume they will give you the best aesthetics. To get the best color may mean running a few tests to see what things will look like.

Over the last decade the quality of 3D and other video production has gone up, colors are more saturated than we thought our TVs could handle, and images often look sharper than we thought 720 × 486 would allow. So you can get the colors you want, without burning out the viewer's tubes or eyes, it may just require a bit of patience and testing.

## INITIATING A RENDER

When everything is finally set, it is time to hit that *Go* button and start your rendering on its way. Universe offers a few different ways to initiate and manage rendering, each with its own benefits.

*Renderama will be discussed in a separate section a bit further down.*

### Just Hit GO

No muss, no fuss, hit the Go button and Animator will open a Save dialog box for you to name your rendering, and choose a directory to save it to. Under OS 9, Animator quits and the Camera rendering application automatically launches to begin its work. Under OS X and Windows, Animator does not quit.

### Control–Click Go

Rather than just selecting the Go button, if we hold the Control key down on the Mac keyboard, and then use the mouse to click on the Go button (right mouse-click on Go for Windows), an **Open Application** dialog box will appear instead of the usual Save box. This brings a world of options in the form of freely distributed rendering utilities that extend the range of what we can do. As of this writing, these options are mostly available to those rendering on Mac OS 9 (work on OS X, render on an OS 9 farm), but there is no doubt that updated versions will be created in the near future that will extend the same potential to both Windows and OS X. It is with this in mind that this section is included.

### Remote Camera Launcher

In pre-Universe versions of EI, if you selected a copy of Camera over the network that was on another computer, the remote computer would launch the application and totally free the main workstation. This has unfortunately not been the case since the release of Universe, but there is

a work-around. The author's Graphlink Studio in New York developed an Applescript called **Remote Camera Launcher** that looks for a "camera.ccn" file in the remote computer's rendering folder. When it sees one appear, it will launch Camera on the local computer. This once again allows Macintosh users to initiate a render from a remote machine using the Control-Go method. The advantage of this method over using the network Renderama is that it can make more efficient use of the computer's horsepower, and you can view the rendering statistics like time and space estimates.

Remote Camera Launcher requires PsuedoCamera on OS 9, or AR PsuedoCamera if rendering from OS X to an OS 9 box (name the control file "camera.ccn"). This software is shareware and available for free download at *www.3DNY.org*.

### Other Control-Go Utilities

Here are some additional utilities that work with the Control-Go command feature. They offer various options to suit a variety of needs.

- **Pseudo Camera**: an old favorite that helps generate and collect multiple camera control files ("camera.ccn") to use later or on another computer. When you are asked to launch an app, select it and it will write the control file to disk. Double-click or drag and drop the files on Camera to initiate a rendering. This is OS 9 software.
- **AR_PseudoCamera**: written by Andres Ramirez, this is a mini-application that works like Pseudo Camera on OS 9 or OS X, but allows you to manually set the name of the saved control files. It can be downloaded for free at *http://www.pixeldream.com/EI/AR_PseudoCamera.sit*.
- **Camera Unibatcher**: written by Damian Griffin, this is an Applescript that controls the batch executions of a folder full of camera control files.

### Collect Files

Animator does not always keep track of a project's resource files as well as we might like. To ensure that you have everything you will need for both remote rendering and backup, use the Collect Files command in the

File drop-down menu. The Sub-folder option makes things organized for backup, but is not recommended for remote rendering.

## Camera: The Rendering Application

The Camera application is the rendering engine. Running it as a separate application offers a number of efficiencies of computer overhead and the freedom to install it on any number of computers without needing a dongle.

The program itself has very few controls past **Pause** and **Quit**, but its most important ability, aside from actually rendering, is its ability to offer a tremendous amount of information about the job being rendered (see Figure 13.19). The data it presents allows you to confirm your intended settings in many areas, and can also be an invaluable troubleshooting/di-

**FIGURE 13.19**   The Camera application's main interface offering a wide range of technical and visual feedback.

agnostics tool when needed. In general use, you will find the time estimates to be the most helpful tools. Be aware that no software is a fortune teller, and it can only estimate a completion time based on the complexity of frames already rendered, multiplied by how many frames are left to go. So if an animation starts out with a bouncing ball and ends with a detailed model of Rome, the early estimations will be based on the "lighter" part of the project and will not be accurate. In practice however, the system works very well.

As tempting as it is to watch the soup cook, try to avoid the temptation, and **Hide Window** when it is not needed. This will speed up your rendering computer, and also stop you from staring at the tiny preview like it was a 1950's television set. Go work on your next scene!

A defined memory partition can be set from within the application; this will ensure the program has enough memory to work efficiently when rendering on Windows or OS X. OS 9 memory partitions are set via the Get Info window in Finder.

## Renderama

This network rendering program enables automatic cross-platform rendering to almost any number of mixed computers, but will also manage the rendering of multiple animations locally on your main workstation. In either case, its operation is amazingly easy for a system that offers as many configuration options as this system does. In fact, its operation is hardly more complex than simple print spooling software used by millions of consumers (see Figure 13.20 on the next page).

The **Network** tab contains an **Enable Network Rendering** toggle switch that tells Animator you want this file to be spooled to Renderama. It also has an edit field to allow you to name the spooling file, which will appear in the Renderama queue, but it is important to realize that this does not name the actual animation file—that is done with the standard Save box. Give the spooling file and the animation similar names; it can save a lot of head-scratching later on.

As with a print queue, the Go button acts like the familiar Print button, and Animator sends the file off to the **Master** computer running the Renderama application. The Master can be any computer you wish, your main workstation or a separate box, which is a better choice. The spooled file will appear in Renderama's list box on the left, where you can see its ranking in the queue, turn it on or off, and see how much of it is completed.

Along the right side, you see any potential **Slave** rendering computers that have been added and can be made active or inactive with the toggles

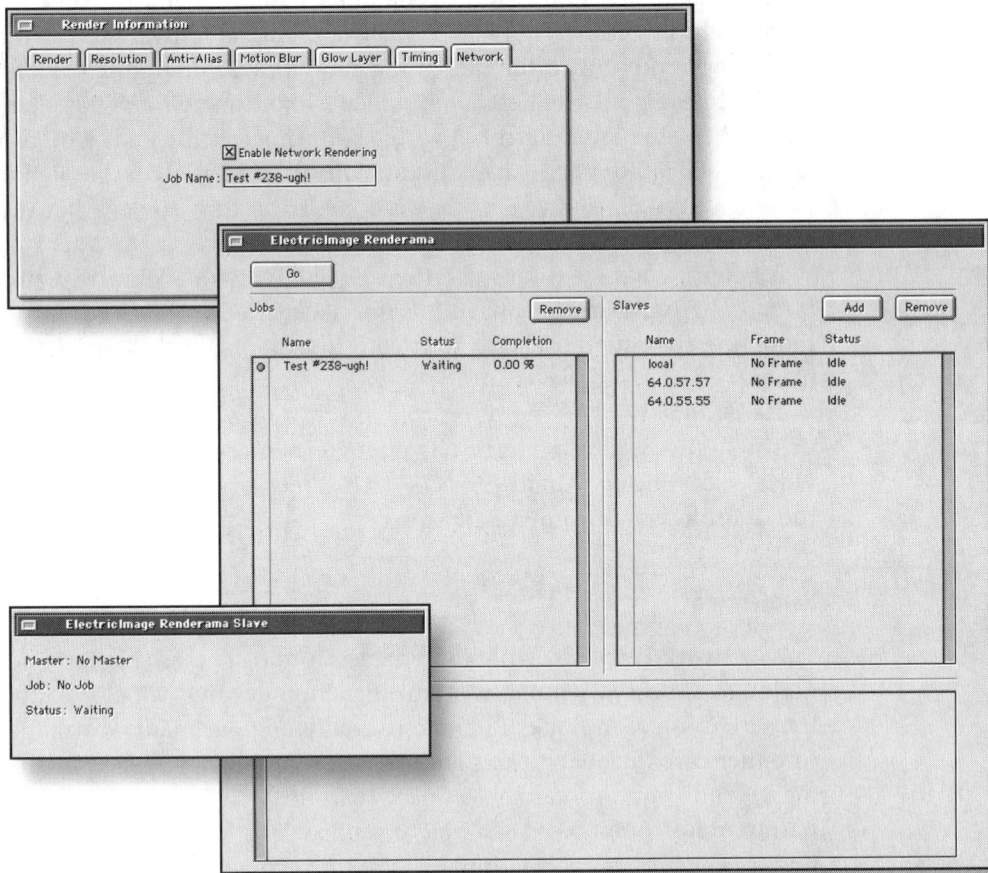

**FIGURE 13.20**   The Renderama system begins in Animator's Network tab, and spools to the main Renderama queue, which in turn doles the work out to available Slave computers.

to the left of the name. Since Renderama is built around the TCP/IP system, the leading networking system used for all local and internet traffic, this must be enabled on all Master and Slave computer for them to see and communicate with one another (see more on TCP/IP later in the section, "Renderama and TCP/IP").

For a computer to be used as a Slave unit, it must have a folder with the following items inside it: a copy of Camera, the Renderama Slave application, the full compliment of the EI Sockets and Shaders folders, and two items that where not mentioned in the manual, the EI Shared Memory Lib.bundle and EI Resources folder.

**Renderama Notes**

Here are some additional notes on setting up and making the most of Renderama:

- It is easiest to have Slave units auto-start the Renderama Slave application using an alias or shortcut when the system boots up. This is especially true of computers in a dedicated rendering farm network.
- Renderama charges additional computer power for its services causing some reduced efficiency of processor power. This is well worth it if you have enough computers in the network, but may not be if you don't. This is why many still opt for one or more of the Control-Go solutions outlined earlier. The general opinion is that at least three computers, are needed to make using Renderama beneficial as a timesaving solution.
- Renderama works by doling out single-frame render commands to each Slave, and then stitching it all back together as the finished frames are returned. Because the Master computer is always busy with this work, the process may be better served by omitting it from any rendering duties, although it may be tempting to do otherwise.
- As busy as the Master is, its job is not as processor-intensive as rendering, so the network may be most efficient if one of the slower computers is designated as the Master. (This does not mean you want to use an old 66mhz box as your Master, of course.)
- The Renderama process of rendering one frame at a time eliminates the Camera application's **Estimated Animation Time** and other technical feedback. A partial solution for this is to do a single-frame rendering of an animation and use its render time as a guide. If the frame took 2 minutes to render and there are 500 frames, then the estimate on the job is 1,000 minutes. This is the same way Camera comes up with the estimates anyway. Here is a solution that is even more accurate; render frames 1, 250, and 500, average the results, and multiply by the frame count. For example: The rendering times for the three frames are 200, 150, and 122 seconds, or a total of 472 seconds. Divide that by the number of frames in the sampling (3), and you get 157 seconds each. Now multiply this by the number of frames in the total animation. This takes into account a variety of scenes that may have vastly different rendering times.
- A more direct alternative is to let a job begin, and check its Completion percentage in some interval of time, say 10 minutes. If 13% is done, then $100/13 = X/10$, or about 77 minutes to render the whole thing.

- The render-by-frame arrangement also forces us to lose the **Calculate Shadow Only Once** option in the light's Shadow tab. For the scenes where this feature will work, it can be a big timesaver, so it may pay to just forego Renderama and initiate those manually.

### Renderama and TCP/IP

Renderama requires that each computer on your render farm have a unique IP address. There are two possible scenarios where this could be of no concern: One, Dad owns an ISP and you have a plentiful supply of static IP addresses, or two, your tech department handles all things geeky. In either case, lucky you. For those that do not have enough IP addresses to go around, there is a work-around which is fairly simple: An internal network.

The typical range of IP addresses for an internal network is 192.168.0.2 through 192.168.0.254, which gives you 253 possible IP addresses for your renderfarm network. While you can haphazardly match IP addresses to computers, it's best to come up with a naming scheme: Render2 will have the IP address of 192.168.0.2, Render3 will be 192.168.0.3, and so on. This will save you a lot of confusion later, especially if you label the computers. The IP address and network name Scotch-taped to each computer is low-tech at its best.

Start by assigning your Master computer the first IP number, 192.168.0.2, then increase the last digit by one for each additional computer. All of the computers on your Renderama network must use the subnet mask of 255.255.255.0, and all other settings (router, gateway, DNS server, etc.) must be blank unless the computer will be accessing the rest of the world through a firewall or router configured to pass traffic to and from the internal network. A DHCP server will not be used. Enter the new IP addresses into Renderama and you're ready to render.

### Animation File Get Info (Mac Only)

Hidden inside a rendered animation file's **Get Info** box is a bit more info than we normally see, and it is very welcome information. As you can see in Figure 13.21, the rendered frame numbers are listed just below the file name near the top.

In what is normally the Version line, we see the rendering level the file was created with, its dimensions in pixels, and the color level it was saved to. Just below this, we see the time it took to render this file. Very useful information in production.

**FIGURE 13.21**    The Get Info window on a Macintosh offers some important extra information about the rendered file.

## THE COST OF RENDERING

There is an awful lot of talk in this book about keeping rendering times shorter. And yet Universe Camera is the fastest rendering engine available, and today's computers are fast—what's the issue? To answer that we need only take out the calculator.

Let's not even talk about a Raytracing project, let's just talk about one that could have been optimized better. Assume it is 3 minutes of animation, and that it is going to broadcast at 30 fps. It is very reasonable to render this interlaced or at 60 fps (takes the same amount of time), and the frames are taking 3 minutes apiece to render. 60 fps ×180 seconds = 10,800 frames that need to be rendered, not counting lead-in/fade out or multi-pass needs. At 3 minutes a frame that comes to 32,400 minutes

of rendering time, that is 540 hours, or *22 and one half days!* Even if we have a render farm with 6 computers, we are looking at almost four days of continuous rendering. You can see why rendering time is an important issue.

Most scenes can be better optimized and it would probably not be hard to bring that 3-minute-per-frame rendering down to 2 minutes with a couple hours of effort. The reward for this would be a render savings of over seven days. With your 6-computer render farm, you would still save over 1.25 days—invaluable for meeting tight deadlines.

# ADVANCED TOPICS

The first Oscar Award for the new Special Effects category of 1939 went to. . . If you guessed *The Wizard of Oz* you would be wrong. Oz was beaten by *The Rains Came*, a film mostly forgotten today starring Myrna Loy and Tyron Power. Hard to imagine—even by today's lofty standards *Oz*'s effects hold up strikingly well.

Many film historians will tell you that special effects in film came into being about the same time that film itself did, with filmmaker Georges Melies' 1902 classic *A Trip to the Moon* (*Le Voyage dans la Lune*). It is probably no coincidence that before making films, Melies had been a very successful magician. There is a reason SFX teams are called the magicians of film, and I would hasten to guess that most 3D artists knew at least a few card tricks when they were young.

Character animation is often referred to as the ultimate special effect, and with good reason. It encompasses a wide range of the greatest challenges, all put into the same scene at the same time. To deal with these unique needs, Electric Image Universe has added an entire subset of tools to make character work easier and more powerful.

Both effects and character work require that the animator pull together his best talents and make them work on many levels. He must be able to figure out how to put an effect together beyond what comes out of a box or plug-in. And like all good artists, he must be eager for the obstacles of the next project.

# CHARACTER ANIMATION

If character work is your thing, Universe's expanding toolset makes this work increasingly easy, offering an ideal production environment.

## DEFINING CHARACTER

A **character** animation is the ultimate act of personification—infusing an inanimate object with a personality. Puppeteers have been doing this for thousands of years; however, 3D gives you the ability to make it far more realistic, further suspending the viewer's disbelief. Despite this, as you jump into character work, be careful to always place your emphasis on the story and emotions, rather than the technology. Remember that Danny Kay was able to create Thumbelina with just a painted hand and a handkerchief.

### Adding Character

It is common to think of character animation tools only in terms of the Bones and Inverse Kinematics controls, but one need only turn on a television to realize most character work is not produced that way. Flying M&M's and Chiclets gum have great character, and yet, often are produced with little more than Transformation controls and some Scaling. The talking toilet and similar items are done with Morphing and Deformation tools. The more specialized Bones and IK tools come into play when you need to control limb-like items, such as arms, legs, tails, and so forth.

## SACK OF FLOUR

Now, continue with the Sack of Flour concept that was started in Chapter 1, where you used the ÜberNURBS toolset to create both Anchor and Target models. Your needs are a bit different here, so you need to use a slightly modified Target model that has not had its height shortened. You can do this modification yourself, or just use the files provided in this section. You will bring these models into Animator and produce a full character animation with it.

*The final project file was time-scaled, so its keyframes have data that have been rounded and differ slightly from the instructions given here.*

**MAKING AN ENTRANCE**

In this first section, you will reproduce the QuickTime animation you saw of the Sack making its entrance into the scene. It will consist of the following stages: **Contact**, **Impact**, **Reaction**, and **Stabilize**.

1. Open the "START Sack.prj" file on the CD-ROM. The Camera, Lights, and ground plane are already in place for you. Make sure the **Time thumb** displays its location in Frames rather than seconds (set in the Time View control, in the Project window).
2. Import the "Sack Anchor.fac" model, and move it upward along the Y-axis until it is just out of the Camera view's range. This should be at a Y Position of about 2.0.

Just as some human bodies are better suited for ballet and others for football, every 3D model has its own set of dynamics. The nature of a sack of flour is bottom-heavy, slumped, and gravity-dominated. Adding character is mostly the act of liberating the sack from these weighty limitations. As such we are often moving the model in relation to the ground.

3. Open the Sack's Joint Editor and in the X-form tab, change the Position Y value to 0.0, which moves the center point to the bottom of the model.
4. **Contact**: Set the timeline to frame 21, and move the Sack down to the ground plane to a Position Y of 0.0 (see Figure 14.1, image B).
5. **Impact**: Move the timeline to frame 28 and Scale the model down in the Y-axis to 0.6. This is called a *squash* in animation, and is the same thing we did to the bouncing ball in an earlier chapter (see Figure 14.1, image C).
6. **Reaction**: At frame 33 set the Y Scale back to 1.0 (see Figure 14.1, image D).
7. **Stabilize**: Move to frame 39 and set the Y Scale to 0.8 as the resting size.
8. Preview the file in the camera window. Upon playback, you can see that you have keyframed a simple drop-bounce animation (see Figure 14.1, image E).
9. Time to add the **Morph Target**. Its full effect is not seen until **Impact** at frame 28, it but needs to be anchored at an earlier key, so go to 21 in the timeline, open the Morph Editor, and load "Sack Target.fac". Keep it set to the default of 0.0.
10. Move to your Impact frame 28. This is where your target will really kick in and give your little sack some character. You could dial-in the full 1.0 value of the target, and that would look good. But depending on what comes next in a scene, targets can usually be pushed further. Try typing 1.4 into the Morph Editor—you can see it offers more *oomph*. Many poses like this Impact position are transient and only held for a fraction of a second. They are prime candidates to push the pose past reality's boundaries. Be aware that models begin to have problems if pushed too far.

11. Move to frame 33 and reduce the Morph value to 1.0. This **Reaction** frame is the s[...] as the rubber ball bouncing back up into the air; only here the reaction is much m[...] subdued.

12. Move to the **Stabilize** frame at 39 seconds, and change the Morph value to 1.3. Thi[...] rest state that feels natural for your model, and allows a few moments pause until it s[...] some more craziness.

13. At this point, you should add the pre-made Material for the Sack, which is done by se[...] ing the Load button in the Material Editor. Choose the "Sack of Flour Material.mtr"[...] which is on the CD-ROM.

**ON THE CD**

14. To complete the effect, you want the lighting to look believable. The main light is alr[...] set as a Spot with casting Shadow. As the model falls, its shadow should start out very [...] because it is farther from the ground, and gets sharper as it descends. Accomplish th[...] setting the Main light's Shadow tab Softness value to 25 at frame number one, and [...] ering it to 5 at your Impact frame 21.

At this point, you have the model falling, an impact with reaction, and then stabilized[...] resting pose, as seen in Figure 14.1.

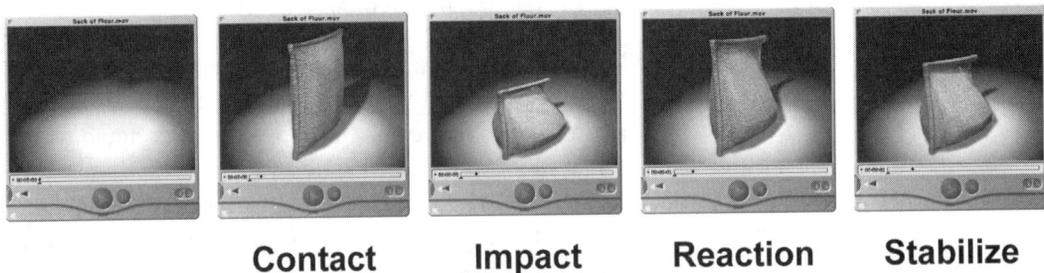

**Contact**        **Impact**        **Reaction**        **Stabilize**

**FIGURE 14.1**     Images A through E (left to right), show the Sack model making its entrance.

## ACT TWO: WHERE'D EVERYONE GO?

Now that it has arrived, your powder-filled sack hero is naturally looking for some love and attention. This next section adds some comic pantomime-like moves that convey a longing to connect with others, and then a physical depression when it realizes it is alone.

To accomplish this, you are going to use the **Deformation Editor**. When a **Deformation Region** is created, it uses the extents or boundaries of the model. If a model is resized with **Scale** (tools or X-form window), the Deformation Region knows this and can update accordingly. This is because the left hand of the program is talking to the right, as it should be. Unfortunately, there is no way for Animator to know what goes on inside a Morph model, and

this is why you had to create a modified target that did not change its overall dimensions. Instead, you will control the scaling manually, which will make using deformations and morphs at the some time much easier and give you more control.

*A few older versions of EI have some issues with mixing the Scale tool and Defor- mations on the same model (early version 2, and early Universe). This no longer appears to be an issue, but if your version has a problem, the solution is to use the Scale Deformation instead of the standard Scale operators. Make sure to place the Scale Deformer at the top of the list.*

*A **holding** keyframe is a KF that is intentionally placed in the Project window not to change any values, but rather to prevent any future KFs from changing current values. Because editing a channel's value will alter all of the 'tween frames in both directions until it runs into another KF, you can think of a holding key as an ani- mation stop sign. A holding key can be created for a single channel by making a minor edit. **Add Keyframe** (Cmd-K) can also be used, but this generates a hold- ing KF for every single channel—something you may not wish to do. So use this with care, as you will in this exercise.*

1. Move to **frame 53** and open the **Deformation Editor.** Add a **Twist** de- former with the Direction set to the Y-axis, and deforming in the X and Z axes. You need a holding KF at this point, so do this by typing a tiny value into the Twist box.
2. Move to **63** and set the Twist to **–90** degrees. Now select the command Add Keyframe (Cmd-K) (see Figure 14.2, image A).
3. Move to 89 and select Add Keyframe once again, to create a pause in the animation that will make the viewer think the sack is contemplating its situation.
4. Move to **100** and change the Position Y to 1.2, and the Scale Y to 0.35. Do not add any other keyframes here (see Figure 14.2, image B on the next page).
5. Move to **106** and change the Position Y back to 0.0, and the Scale Y to 0.8. Add Keyframe. Now change the Rotation Y value in the X-form tab to 90 degrees, and the Twist value to 0.0. The sack should be doing a twist, jump/twist, and landing, as seen in Figure 14.2, image C.

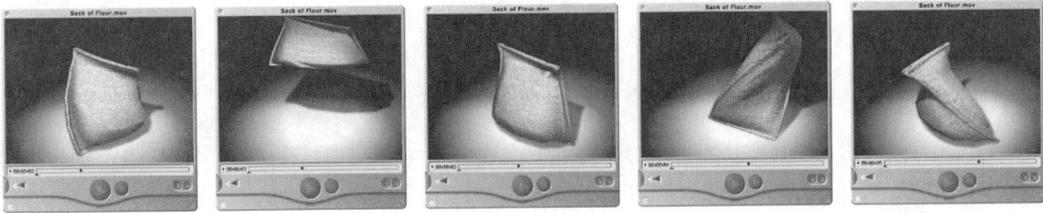

**FIGURE 14.2**    The Sack model trying out for the U.S. gymnastics team, with images A through E.

6. Move to frame **115** and Add Keyframe to create another pause. Create a new Shear deformation region, with Direction on the Y-axis, and deformations along X and Z. Set this to zero.

7. At frame **128**, set the Twist value to 120 degrees, and the Shear to 14. The Y-Scale is changed to a slightly larger 1.0, and the Morph target is given a negative value of –0.5. The negative Morph thins the bottom and puffs up the top of the model, like an expanding head or chest. These combined settings create a stretching movement as seen in Figure 14.2, image D.

8. Frame **141** is another Add Keyframe to create a hold.

9. Frame **154** changes the Twist to –90, Shear to –14, reduces the Y-Scale back to 0.8, and sets the Morph back to 1.3 (see Figure 14.2, image E).

10. Frame **169** is another hold, so Add Keyframe.

These frames have set up a series of darting poses, with our hero frantically looking for . . . well, whatever a sack would be looking for. Other sacks, perhaps? The final three keyframes wrap up the story with the character showing a realization that he is alone, and then slumping over with sadness, as seen in Figure 14.3.

11. Go to frame **196** and Add Keyframe. Twist is changed to 30 degrees, and Shear is set to 0.0, the Rotation Y is changed to 60, the Scale Y to 1.0, and the Morph is once again given a value of about –0.5. The sack now makes eye contact with the viewer (see Figure 14.3, image A).

12. Frame **235** receives another Add Keyframe, and a final Deformation is added, the Bend deformer. Its **Direction** is along the Y-axis, and **Deform** along the Z. The Region settings need to be modified, as you only want a small section to be bent. Set the Y Minimum to 0.07, and the Y Maximum to about 0.54. Set the value to 0.0.

13. In the last frame, **271**, the sack slumps over by changing the Scale Y to 0.8, Rotation Y to 100, Morph to 1.4, both Twist and Shear are set to 0.0, and the new Bend deformer is set to –125 (see Figure 14.3, image B).

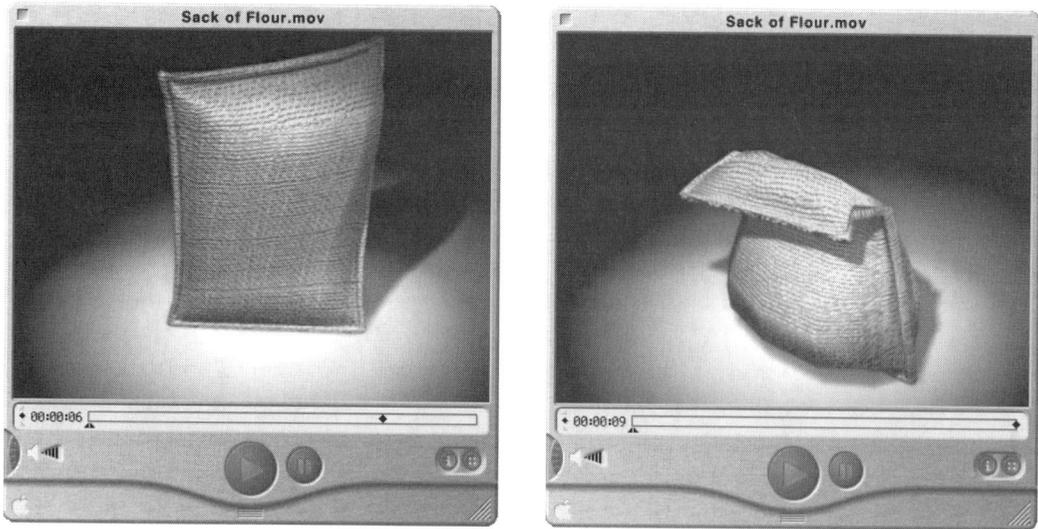

**FIGURE 14.3**    A real sad Sack (sorry, just could not resist).

ON THE CD

The basic choreography is now complete. The "Final Sack.prj" and Quick-Time movie files are provided on the CD-ROM and show the results of the project. It looks good, but there are still 2,000-plus tweaks standing between this and a finished product. Many of the channels should be brought into the Function Curve Editor for work on their timing—this helps refine the character's balance and emphasis. See how far you can take it, and enjoy, as it is a fun animation. When you have taken the project as far as you can, a new one can be started using your own choreography.

When rendering this file, make sure to set the bump map's **Sampling** level to at least 4 X 4 to ensure a smooth tonality.

## BASIC BONES AND INVERSE KINEMATICS

In the last few years, we have seen an interesting inverse reaction: As 3D tools evolve and become more plentiful, the tricks and work-arounds needed to get the job done become fewer. This is never truer than when talking about the more sophisticated tools in this category, which at this point work very well right out of the box. Don't confuse this to mean that a complex character rigging is now simple, but like building a house, improved tools can make the work more reliable, and even fun.

**CREATING A BONES CHAIN**

1. Start a new project and add an ÜberShape Cylinder/Disk with a Length of 200, Radius of 20, and a Latitude and Longitude of 20 and 40, respectively for both EI and Camera. Its Orientation should be along the Y-axis.

2. In the Front World view window, make sure the model is completely visible—move the view, not the model.

3. Go to **CHARACTER > Create Bones** (see Figure 14.4) and click on the model 4 times in the Front view, once at the top, twice in the mid-length (at the 1/3 positions), and once at the bottom. Then click the **Cancel** button. You have created a Bones chain, and a Joint End is automatically added to its endpoint. Be aware that because of the location of the model, the Bones were automatically placed in the center. This is what you want here, but that's not always the case, and new chains may often need to be moved into place along one of the axes.

4. To add the default IK rigging, before you do anything else, simply select **CHARACTER > Add IK Handle**. An icon will be added to the Project window outside of the Bones chain hierarchy; this is normal, and the Bones will be rigged with both a Handle and IK Spring Wire. See Figure 14.5.

Before moving forward, go over what you have at this point:

- The **Bones** themselves are portable deformation controls, used as a reference to setting a Region of influence, and Orientation. Bone deformations begin at the joints, where the Bones interconnect, as you would expect, but this can be feathered to give a variety of results. Bones can also be

**FIGURE 14.4**   The Character drop-down menu.

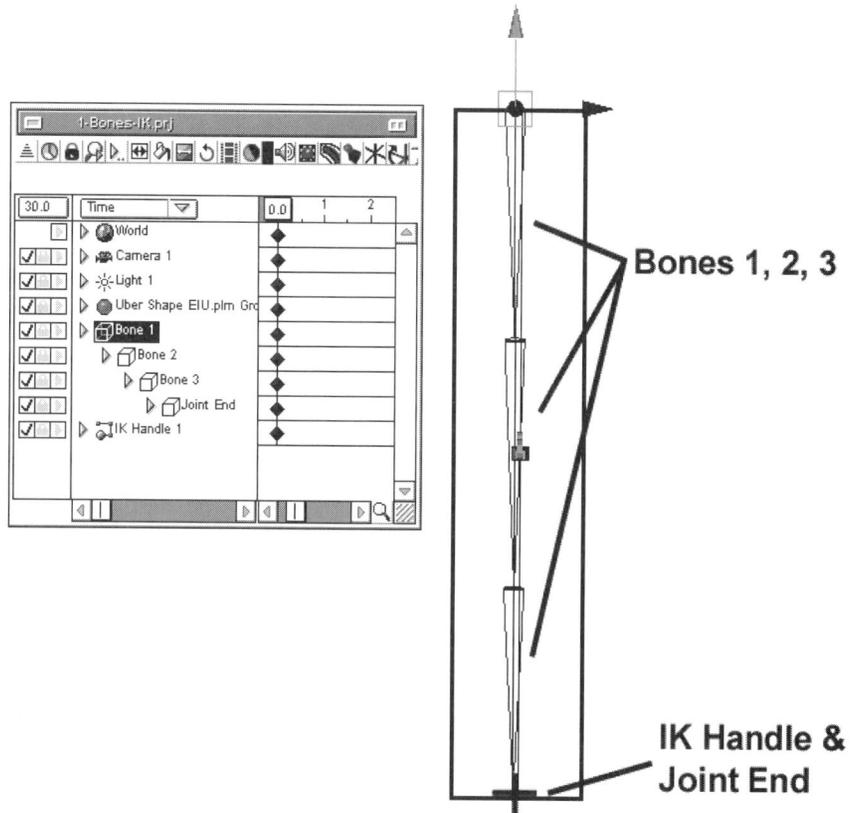

**FIGURE 14.5**    The Bones and IK elements are in place, but the model is not in the loop just yet.

used to deform by scaling them in any or all axis, which can make for some wonderful animations.

- The **Joint End** is a Null item that is used to tug at the end of the chain. This frees up the last bone to rotate freely and otherwise interact with its parent Bone. It also acts as an object for the IK Handle to anchor itself to. You will probably have little need to interact with it directly.

- The **IK Handle** and its settings control how the chain moves around as a unit. Animation can still take place without it, but the animator would have to go in manually and alter the position/rotation of each Bone individually—this is the traditional Forward Kinematics. By comparison, with Inverse Kinematics, you just drag on the Handle and the entire chain follows along.

The model is not yet connected and won't follow along, but you can click on the IK Handle and move it around to see how it moves, and how the Spring Wire connects the beginning and ending Bones in the IK chain. Notice that the IK chain and the Bones chain do not have to be the same thing. The IK chain can be a subset using fewer Bones—as is the case with a pelvis/thigh/calf/foot configuration where the IK chain excludes the pelvis.

### Adding Mesh

With the Bones and IK in place, you now need to integrate your model into the system. This process, called **Binding** allows you to use either the Bind Skin to Selected Bones, or the more common choice of Bind Skin to Skeleton, which uses the entire Bones chain.

In either case, the Bones can be assigned to any number of meshes during this process by successively choosing the meshes you want, and clicking the Cancel button when you finish. The beauty of attaching multiple meshes, or Skins, is being able to control the models separately, so that you have a body model and a separate model for the clothes. Because each model can be set to react to the Bones differently, you have a greater opportunity to get the body to move like a body, and clothing to behave more like draped fabric.

5. Click to highlight any of the Bones in your chain—only one bone needs to be selected, and then select **CHARACTER > Bind Skin to Skeleton**. You are asked to choose your mesh, so click on the ÜberShape model. You will see its icon in the Project window change to the SKIN icon. Now click on the Cancel button and voila! You are finished.

Time to try dragging the IK Handle again—this time, you will see that the model follows along beautifully (see Figure 14.6). Notice how fluidly the model moves, and how natural the folds of mesh look—just like the folds of a finger. Also realize that the model can no longer be moved directly, rather, it must be moved with the IK Handle or the Bones. Any Bone will move the model, but the child Bones will deform the shape—an interesting effect, but use the parent Bone to keep the mesh intact.

Though rigging can get very complex, with multiple attachments, branchings, and many controls, much character work can be accomplished with the tools you have just used. Walking is a good example.

### Learning to Walk

Now you will take the basic steps just learned and apply them to a human character, or at least the bottom half of one.

**IK Spring Wire**

**IK Handle**

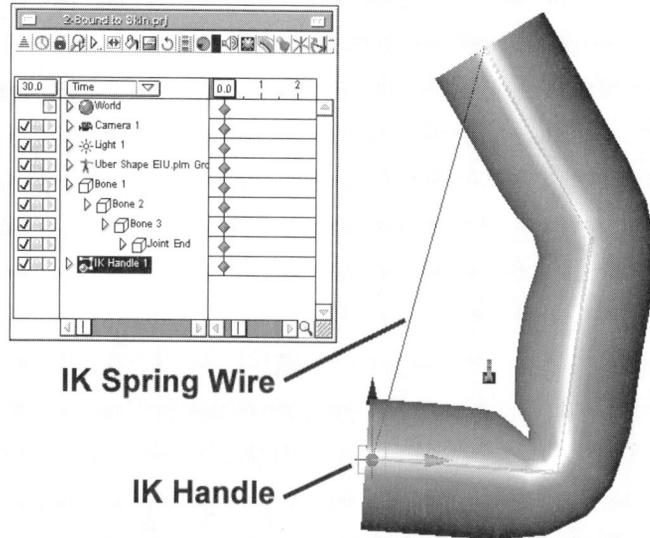

**FIGURE 14.6**    The model has been attached to the Bones and IK systems, and can be easily moved with the IK Handle.

**TUTORIAL**

*ON THE CD*

## PART I: BONES CHAIN

1. Open the "START Animated Walk.prj." The human legs and shoes model is already set up for you, as well as the lights, camera, and ground plane.
2. Make the **Front view** window fill the screen.
3. You will create Bones for the pelvis area first. **Go to CHARACTER > Create Bones** and click on the model 3 times in the Front view (in the order of top, bottom, and left), and then click Cancel, to create two Bones as seen in Figure 14.7 image A. The vertical Bone is the Spine, which you will be using as your main navigation Effector. The horizontal bone is the Right Pelvis. In the Project window, take a moment to properly name these items. While you're in the Project window, delete the **Joint End** that was also created—you will be adding to the chain, so it is not needed here.
4. Go to **CHARACTER > Create Bones** again and click at the center and then again at the right to create the Left Pelvis Bone (see Figure 14.7 image B. on the next page) Name it in the Project window, and delete the Joint End.
5. Change the screen view to **Side View**. Note that the model has its knees slightly bent. Starting in this pose helps to keep the model and its Bones chain properly oriented. The pose greatly lessens, but doesn't eliminate, the need to journey into IK, Bones, and Limitations controls.

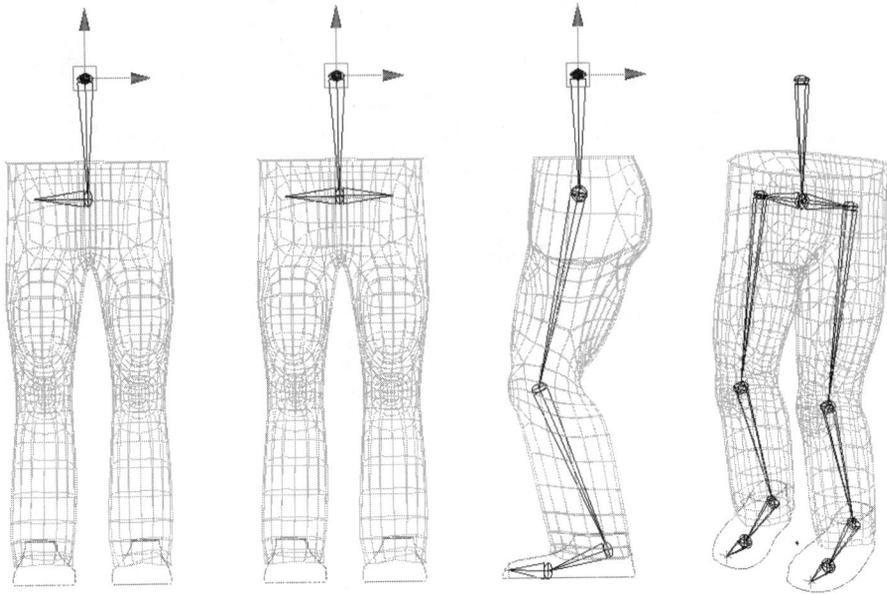

**FIGURE 14.7** Creation of the Spine and Right Pelvis (image A), creation of Left Pelvis (image B), creation of the Leg/Foot Bones chain (image C), and duplicating/placing the chains (image D).

6. Go to **CHARACTER > Create Bones** again and make your first click on the center of the Pelvis, second click is the knee, third for the heel, fourth for foot, and fifth for the toe. Click Cancel. Follow the sample in Figure 14.7 image C for placement of the joints. Notice how the Bones follow the squatting leg position with a bent knee and raised heel. You have just created the **Right Thigh**, **Right Calf**, **Right Heel**, and **Right Toe**. Name these in the Project window. In this case, you want to keep the Joint End, do not delete it.

7. In the **Front** View, highlight the first Bone created in the last step—which is the **Thigh Bone**. Now click-drag on its X-axis Transform to slide it into place under the outer end of the **Right Pelvis Bone**.

8. Using the **Duplicate** command found under the EDIT menu, Duplicate this Bones chain and slide the new chain into place under the **Left Pelvis Bone**. The result of all of this work should look like Figure 14.7 image D. Change the names of these items from "Right" to "Left."

9. Time to do a little **Parent/Child** organizing in the Project window. The Spine is the Parent Bone, both Pelvis Bones attach to it. Then each of the Leg/Foot chains attach to their associated Pelvis Bone.

### IK CHAIN AND HANDLE

1. When an IK Handle is added to a Bone, it is attached to the *starting* end. You want to create an IK relationship—or chain—for the right leg, so highlight the **Right Thigh Bone** and the **Right Heel Bone**.
2. Select **CHARACTER > Add IK Handle**. An IK Effector appears on screen at the starting side of the Heel Bone (the end of the IK chain). It will also have a Spring Wire that extends from the Heel to the starting end of the Thigh Bone (the beginning of the IK chain). An IK Handle icon shows up on the Project list, as well, outside of the hierarchy. Name it "IK Handle Right Leg."
3. Now create an IK chain for the foot—highlight the **Right Heel Bone** and the **Joint End**, and select **CHARACTER > Add IK Handle** once again. Name this "IK Handle Right Foot."
4. Select **OBJECT > Add Null,** and in the **Top View** window, click on the right heel area of the foot. A Wireframe or Outline view setting makes this easier. In the Project window list, name this Null Effector "Right Foot," and make it the Parent of the two IK Handles.
5. Repeat Steps 1 through 4 for the left leg/foot. The final expanded Project window should look like Figure 14.8, left image on the next page. But the beauty of this setup is that almost everything can be hidden away, so your actual working window looks like the image on the right. See how efficient it can be to control all of these elements with just these three Effectors? The actual mesh models are never touched, and are moved only via the Bones/IK rigging.
6. The final step is really a different category, but it is so simple, it is included here. Highlight the Spine Effector, and select **CHARACTER > Bind Skin to Skeleton,** click on the Pants, Right Shoe, Left Shoe models, and then click Cancel. The mesh is now part of the rigging, and its Project window icons are updated to confirm this fact.

### PART 2: WALK THE WALK

There are a number of ways to proceed at this point, you are going to take the keyframe approach with the Project window set to display in the **Time** mode. As with most animation, this is often the easiest way to start roughing out the motion path. You can refine this later on by switching the Project window to display in one of the spreadsheet modes, or by using the Function Curve Editor.

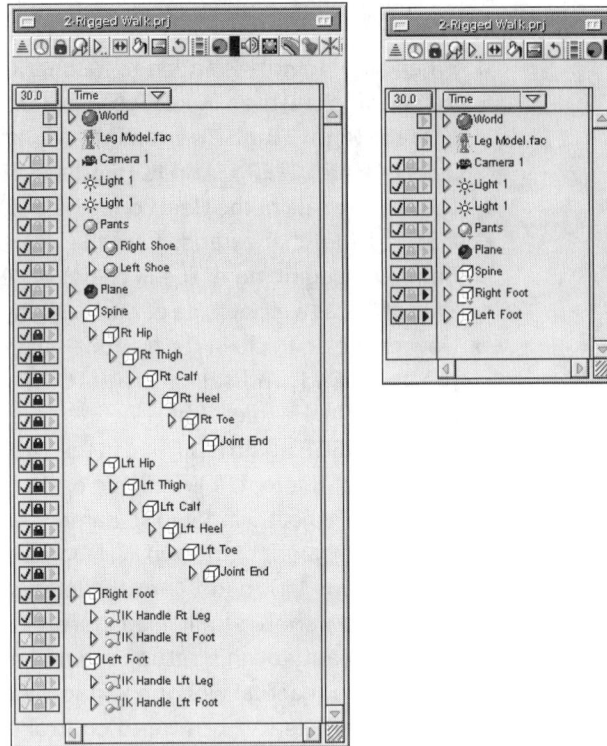

**FIGURE 14.8**    The Project window with the Bones and IK rigging complete. Image on the left shows the expanded view, and on right, the collapsed and streamlined working view.

1. Set-up the interface so that the Project window is in the upper-left corner of the screen, the Camera View window is in its normal position on the upper-right, and a Side View window is stretched across the entire width of the bottom half of your monitor (see Figure 14.9). Set the Project duration to 3.0 seconds in the Render Info window. Select **Hide Motion Path** for the three controlling Effectors for now. Although displaying Motion Paths can be very helpful, it has a habit of bopping you back to the wrong time/keyframe if you're not careful where you click.

2. Even though the Bones are hidden in the Project window, they are still visible in the World Views. You may leave them on for educational and troubleshooting purposes, but it's not necessary to do so. Turning them off leaves a cleaner image for creative work and avoids any accidental selection of the Bones (although they can be locked). Only the three controlling Effectors need to be visible.

3. At **frame 1**, select Right Foot Effector, and using its Z-axis Transform, slide it forward (to the left in the Side View) so that it is a bit in front of the body but not too far. The foot will not reach the ground, but you will remedy this soon (see Figure 14.9).

4. Still at frame 1, select the Spine Effector and perform the same Transform along the Z-axis. As you slide this back and forth, notice how natural the motion of the legs/knees, feet, and toes are. Almost too good to be real, huh? Position the Spine in the middle of the two feet to establish a balanced pose with both feet on the ground, as seen in Figure 14.9 on the next page.

5. Highlight all three Effectors and select **Add Keyframes** to lock everything down.

6. Move to **0.5 seconds** in the timeline. Highlight the **Left Foot Effector** and slide it forwards in front of the right foot by about the same distance it had been behind it—this keeps the stride consistent. And again, slide the Spine to balance the body.

7. Once more, highlight all three Effectors and select Add Keyframes to lock everything down.

8. Move to **1.0 seconds**, select the **Right Foot Effector**, and repeat Steps 3 through 7. Continue this sequence until you reach 3.0 seconds, making sure to alternate each time between the left and right feet. If you Preview the animation at this point, you should see a walk cycle of someone that is a chronic foot dragger. But you will fix that.

9. Set the time to **0.2667 seconds**, and select the **Left Foot**. Using the Y-axis Transform, slide the foot up to a height that has the bottom of the left foot a bit higher than the top of the right shoe. This can be varied, of course.

10. Go to about **0.7667** seconds and perform the same Transform with the **Right Foot**. Continue this alternating process at each empty quarter-second interval. Make sure to alternate properly. Play back a preview, and you should see a full—if not very elegant—walk cycle. Congratulations!

The process of making the walk feel more natural is one of many subtleties. As humans walk, our weight gets tossed and turned to compensate for our positions, rebalance our bodies, and stop us from toppling over. When studied closely, it makes you realize what acrobats humans are, even the least-coordinated among us. Now, you may jump into a few refinements by adjusting the Spine Effector.

11. As your character is shifting from one foot to another, the Spine/Pelvis should be adjusting to rebalance the body. So, at the same quarter second intervals you edited in Steps 9 and 10, make a subtle edit to the **Spine's Rotation-X** value, which at this point is a constant –90 degrees. At **0.2667 seconds**, change that to –100 degrees. At **0.7667 seconds**, this value should be changed to –80 degrees. Continue these alterations across the timeline. When you're done, preview the animation with a Front view.

**FIGURE 14.9**   Time lapse showing the various positions of the model during the animation. Note the final keyframe locations in the project window.

12. Another shifting that takes place while walking is an up-and-down gait: The Pelvis goes up when beginning a new step, and down when planting the descending foot. You alter this by slightly raising and lowering the Position Y value. The constant number in our sample (yours will vary depending on the exact placement of the effector) was about 63. So in **frame 1**, it was lowered to about 61. At **0.2667 seconds**, the value was increased to 64. At **0.5 seconds**, it was lowered to 61, and so on.

13. As legs move forward and back, the same side of the body must follow suit. You can simulate this by altering the **Spine's Rotation-Y**, which is currently a constant –90 degrees. This alteration is only done at the half-second points, where one leg is far forward and the other far back. At **frame 1**, change the Rotation Y to –110 degrees. At **0.5 seconds**, it becomes –70 degrees, and at **1 second**, it goes back to –110, and so on. Finish the set.

The final Project window should look something like the one in Figure 14.9. Upon playback, you should have a walk that has all the basics and is ready to be adapted to any type of personality. Play with adding channels into the FCE and altering various values—before long you will have a good understanding of how it all comes together. The final project file and QuickTime movie are on the CD-ROM.

**ON THE CD**

*To increase production speed, many animators replace the final mesh with a lower-resolution substitute model to use during the development phase. These stand-in models can be output from Modeler with lower tessellation settings, and used to replace the original model—which you will of course keep safely stored in another directory to switch back to before final rendering. If the model is the same name, and saved in the same location, reopening the project will load the stand-in. Make sure the stand-in model can be articulated in much the same way that the high-resolution model can, even if not as smoothly.*

## LIFEFORMS© AS MOTION GENERATOR

LifeForms is a product of Credo Interactive that is so unique and worthwhile that it seems to deserve a mention in any discussion of character animation work. Its sole purpose is to generate motion data for human and animal characters, which it has done now for about a decade—much longer than most 3D applications can claim.

Although major 3D applications like Electric Image Universe have gotten exceedingly good at allowing the animator to control the characters, the level of realism that is easily achieved in LifeForms is hard to match. A few minutes working in its comfortable interface (see Figure 14.10 on the next page) produces animation that looks almost like it uses motion capture data. This realism can be attributed to the software being optimized to give the models a sense of weight and buoyancy, yet it puts few if any extra technical demands on the user.

LifeForms excels in two other areas: editing existing BVH motion capture (*mocap*) files, and offering a CD library resource with literally hundreds of mocap files to use directly, or to alter at will.

LifeForms integrates well with Universe via the BVH mocap file format that Animator imports. Be aware that once imported, you will not have the normal level of controls from within Animator, so your exports from LifeForms should be final quality.

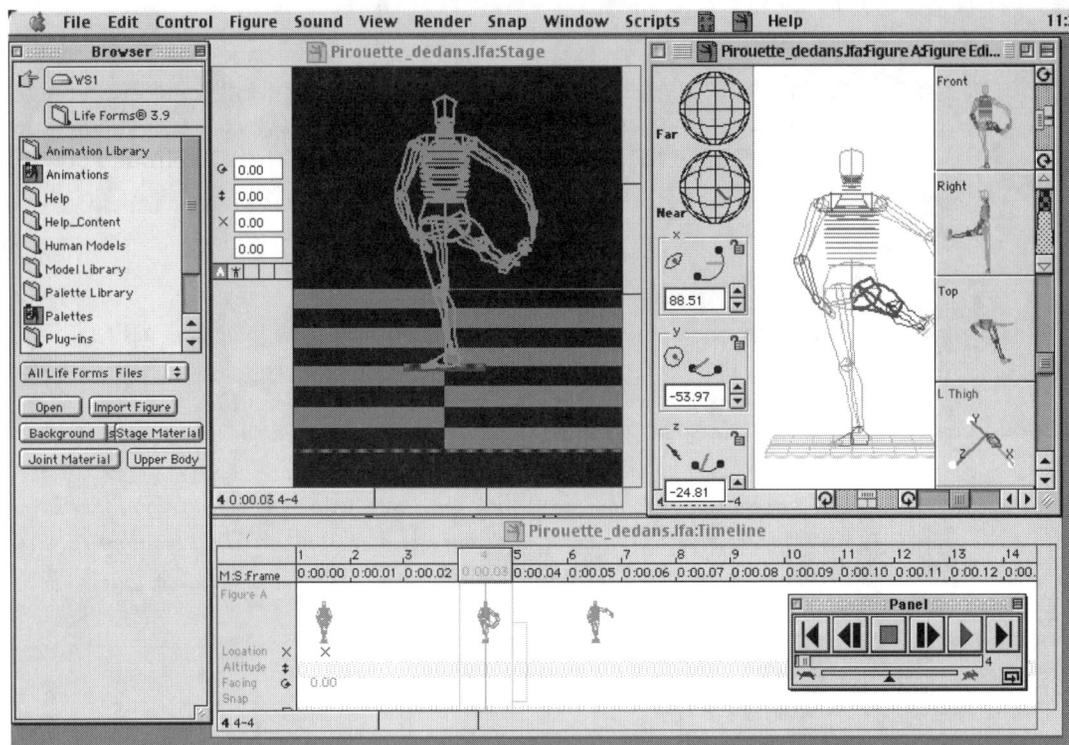

**FIGURE 14.10** LifeForms user interface.

## LIP SYNCHING & FACIAL EXPRESSIONS

Now you get to the head of the matter, or at least the head of the model. When it comes to working with the face for lip-synching projects, there is nothing that makes easier work of it than the Morph Editor (see Figure 14.11).

Depending on the quality and quantity of lip-synching work your projects require, there are a few ways to approach the subject. In all cases, it involves creating a master or **anchor** model that is imported in to Animator, and some number of Target models applied in the Morph Editor. The question becomes, how many? The most basic arrangements get by with a closed mouth model, and an open target, sliding at varying amounts between the two. For a more simplistic style of animation, this may be all that is needed.

As the bar rises, though, you realize that having at least four or five targets for lip-synching is a minimum. These target poses are modeled to look like the most common mouth positions used in everyday speech,

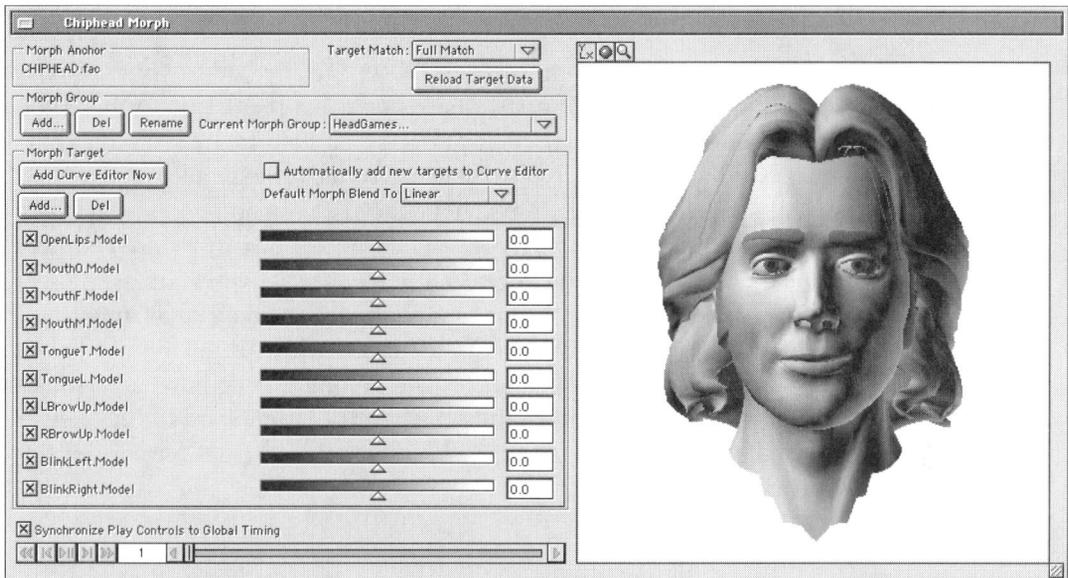

**FIGURE 14.11**    The Morph Editor setup for lip-synch work.

commonly referred to as **phonemes**. But even though there are easily hundreds of phonemes, you can practically narrow them down to the two dozen or so that the human mind/eye combo can recognize. Even better is the fact that with the weighted Morph Editor, you can take just five or six select poses that, if properly mixed, will satisfactorily reproduce most of the others. This is conceptually the same way CMYK is used to represent the full spectrum of color.

### How Important Is Lip Synching?

As the quality demands put upon animation continue to rise, so do the demands of believable-looking speech. How odd would it look to see an otherwise realistic character do only puppet-style mouth movements? We have seen it, and it is uniquely jarring to the mind. By comparison, the next time you sit down to watch *Antz*—which every animator should do now and again—pay special attention to the mouths. The lip-synch is dead-on accurate. So good, in fact, that lip readers are able to view the film and catch most of the dialogue!

## Target Models

The main target poses you want to be sure to include in your sets are: Open Mouth, O, M, F, T, and L shapes (see Figure 14.12). To these you may want to add special emphasis targets that help create a specific character's speaking personality—to depict accents, for example.

All of this is separate from general facial expression poses, which can have no direct bearing on the lip-synch poses, or can be used to help shape them. Be careful, however, to not let a facial expression overpower the speech. For example, it is a very good idea to add a small amount of Smile and Open Mouth targets to a character that is talking in a jovial mannor, perhaps telling jokes. This goes a long way to build a personality, but if you add too much, then the words become hard for the viewer to visually read on the face, which defeats the original purpose of lip-synching (see Figure 14.13).

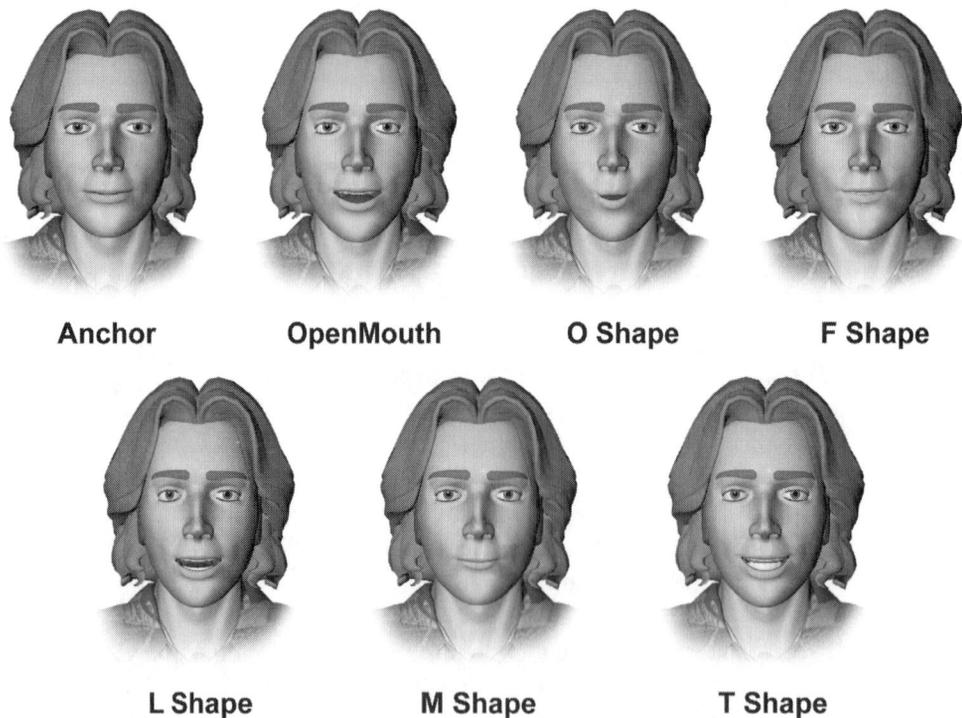

| Anchor | OpenMouth | O Shape | F Shape |

| L Shape | M Shape | T Shape |

**FIGURE 14.12** Anchor and target models for lip-sync work.

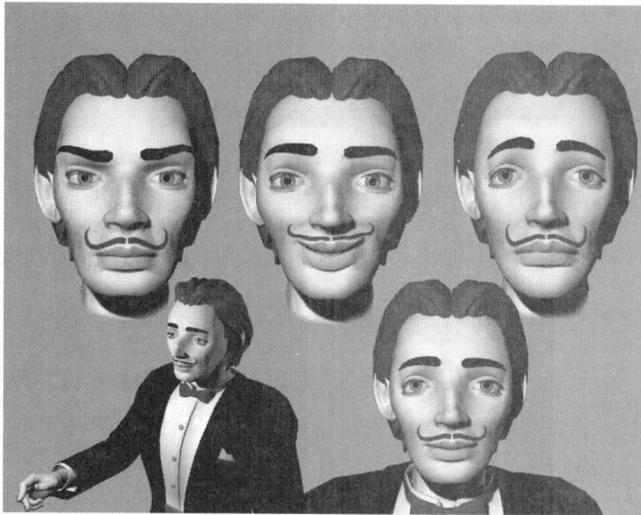

**FIGURE 14.13**    Figure 14.13 A facial expression test sheet for a character in the author's "Table for Two" animation.

## ANIMATING LIP SYNCH

The process of manually keying in the morph channel settings can be a bit arduous (see Figure 14.14 on the next page), mostly because the process involves a lot of "flying blind." You have to hit poses to match audio, but there is no way to play them back in real time to test as you go along. Even on a fast machine, mixing a number of morph channels is processor-intensive and the preview will run too slowly to keep up with an audio track.

The audio track does give you a visual waveform preview (which is larger if you flip open the **Channel Disclosure** triangle), which when combined with a few playbacks of the audio track, can go a long way to help. Practice and experience will also help, and after a few days of working at it, most animators find a better understanding setting in, as well as some increase of production. Be aware upfront that even experienced animators are only able to produce some number of seconds of lip-synching animation per day. Without the use of a specialized program (see the next section), this is always going to be slow-going work.

### Using the Function Curve Editor

As discussed in the Morph Editor chapter, the **Function Curve Editor** is a powerful ally to any Morph animation. It offers greater control in both specific areas of adjustment, as well as the ability to do broad, channel-

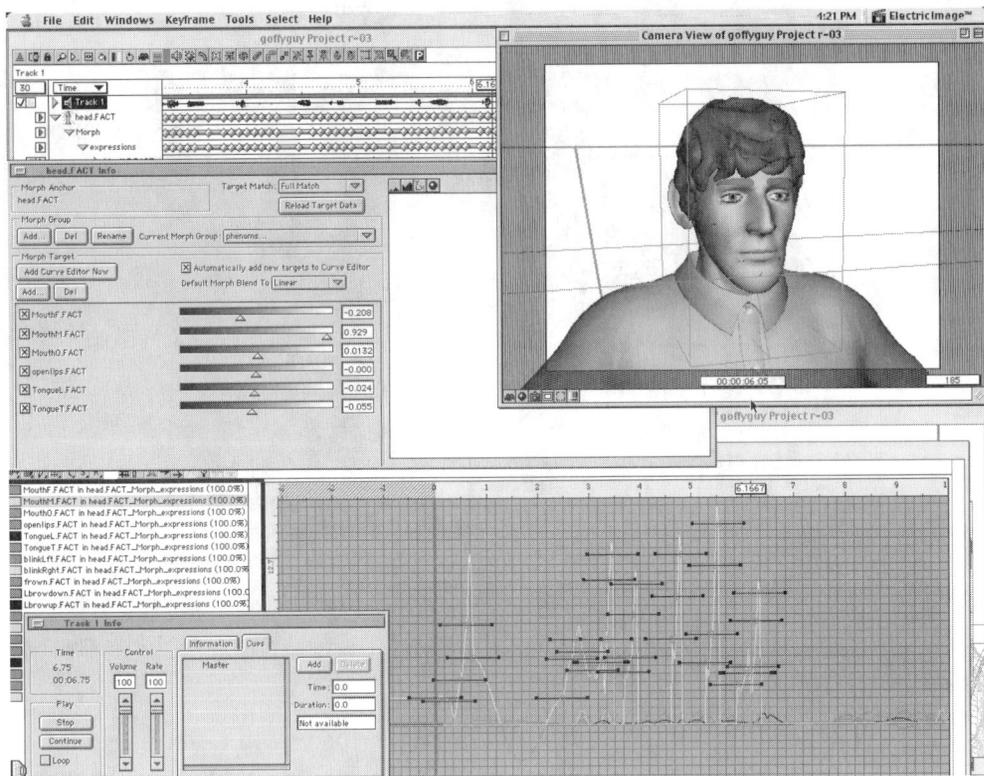

**FIGURE 14.14**    All the many windows and controls used in Lip-synch animation.

wide editing. It provides better visual feedback in the form of graphed data, which means you can see where keyframes are and avoid creating quite so many extras.

### Testing and Exporting Lip Synch Animations

When it comes time to test your work in real time, Animator offers a fast and easy option of making a Preview to QuickTime. This will include your audio track and allow for an audio/video synchronized test file.

QuickTime with audio enabled, was available in the older EIAS, and is also part of the latest Universe releases. If you happen to have a version that does not support the audio track in Preview export, it is simple enough to export the QT Preview. Just open the QT Preview and the audio file in QuickTime Pro, and copy (or add, depending on your version) the audio track to the animation.

As far as final export, it is, unfortunately, common that high-end animation programs do not have the greatest support for audio. After all, their final output is sequential frames or IMAGE files, neither of which supports an audio track. Always plan on adding audio to your animation in post production.

## HEADGAMES©: AUTOMATED LIP SYNCHING

HeadGames is a software package produced by Graphlink Studios that was designed specifically for generating lip-synch data for EIAS and Electric Image Universe. It allows the animator to use a wide range of customized lip-synching software like Magpie, Mimic, and others, which can either streamline or completely automate the process of mixing morph target models to create your phonemes. Most importantly, the files it generates are time-based and in perfect synch, so the process is plug-and-play.

The files that HeadGames exports for EIU are in Electric Image's **Envelope** format, which are imported directly into the Function Curve Editor. This means the data is non-degenerative, and offers easy editing and re-editing.

### Increased Production

Put HeadGames and EIU together with a program like Mimic, and you have the fastest automated lip-synch workstation on the planet. This is not an exaggeration. While manually generated lip-synch plods along at under a minute of animation a day (often a lot under), this suite of tools produces many minutes of good-to-excellent product in the same timeframe.

The interface and toolset are simple and easy to use (see Figures 14.15 and 14.16 on the next page), with just one main preference tab, and one conversion interface.

### MARS Technology

An added feature in HeadGames is its MARS technology—which stands for Morph As Rotation System—that allows you to import a model's automated head rotations and eye movements directly into the Morph Editor. Now the animator no longer has to jump back and forth between the Morph and Deformation Editors, and instead can produce all head-related animation from a single interface, thus, enhancing the system's ease of use, and production.

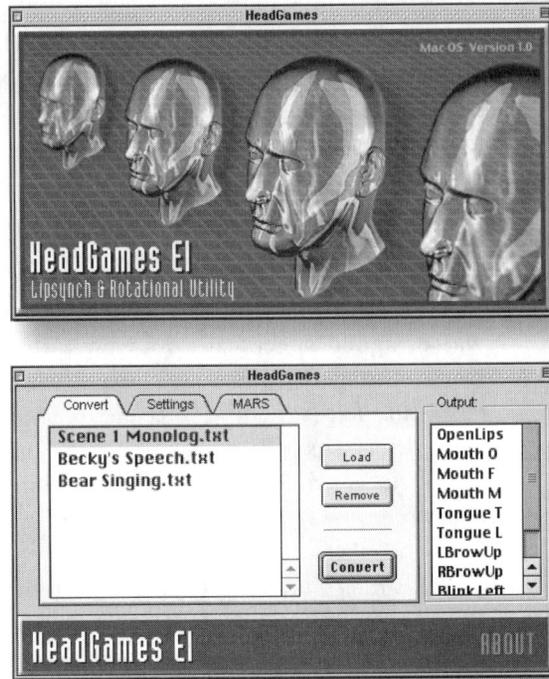

**FIGURE 14.15** HeadGames' splash page (top), and main Conversion tab (bottom).

The MARS settings tab is very simple to use, and requires only a few basic settings. HeadGames takes care of all of the math involved with the conversion and calculates the new Morph rotation channels. These data channels are produced at the same time as the lip-synch data, all of which is extremely fast. An average conversion of lip-synch and MARS rotational data for a few minutes of animation may take less than two minutes on a slow computer.

## How It Works in Universe

As Target models are added to the project, each one is automatically loaded into the Function Curve Editor by selecting the Automatically Add New Targets to the Curve Editor toggle button.

Once in the FCE, simply load each Target's channel data with the Load to Replace All button. The data comes in already created and ready to be used, saving hours or days of work, as seen in Figure 14.17. If you need to do any tweaking, you are already in the FCE, so it is fast and easy.

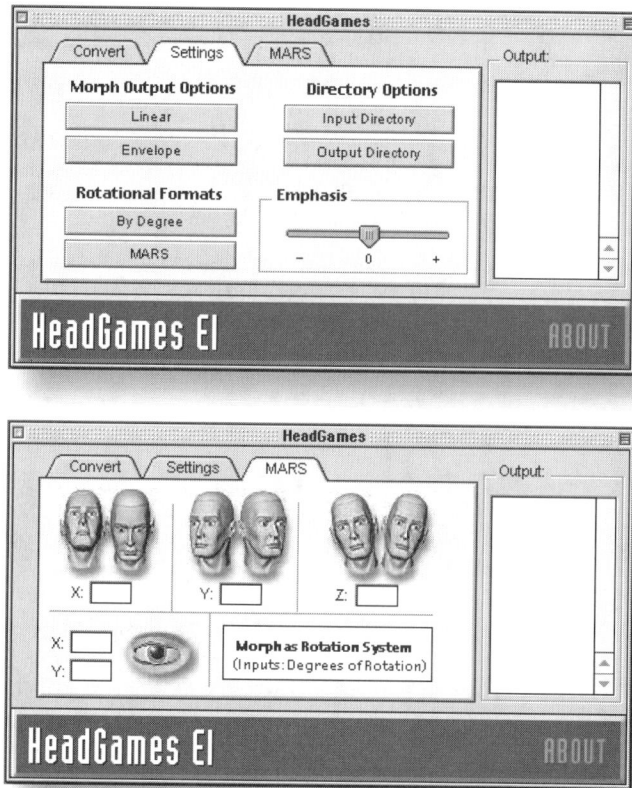

**FIGURE 14.16**    The Preferences tab (top), and MARS Technology settings tab (bottom).

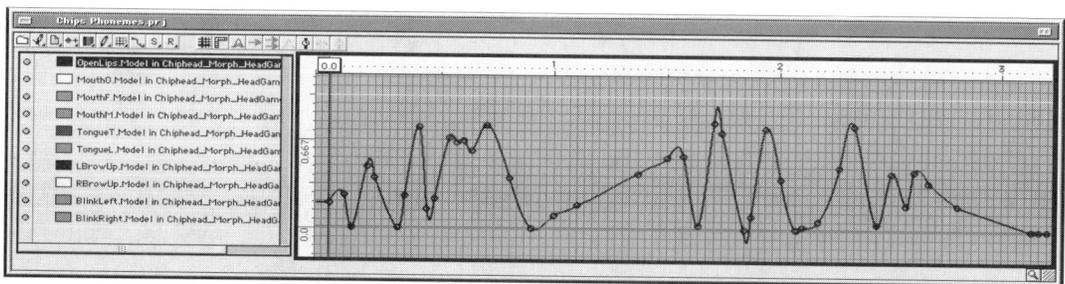

**FIGURE 14.17**    The Function Cure Editor loads up the HeadGames data, which is already animated and can be set to render.

# 15

# SPECIAL TECHNIQUES AND EFFECTS

The techniques presented here represent a range that is commonly requested by animators, artists, and their clients. Some are small, others more grand, but all offer important lessons for making your future projects better.

With only one exception, third-party tools were not used in our examples so that the tutorials could be accessible to everyone. We also want you to see what is possible using the existing toolset, and building upon it with nothing more than your imagination.

## CYCLORAMA

A subtle but very useful technique that can help set the scene is the use of a cyclorama instead of a normal flat ground plane. A **Cych** is a simple surface that is smoothly curved upward at the far side of the stage, creating the illusion that the horizon line is much higher up or nonexistent, allowing greater camera movement.

Cycloramas have been used for years in photo studios and film, and the 3D artist can obtain the same benefits, as seen in Figure 15.1, where we used a very large flat plane (10,000 units square units). But it still falls short, compared to a cyclorama that is the same size, yet more effective.

To see how much extra movement the camera is given, look at the diagram in Figure 15.2, which shows a side view of the same scene. As this is 3D, you can take this concept even further than is normally done in real life, by extending the cyclorama to make it taller or creating it as a 180-degree Revolve so that the curved wall extends to three sides instead of just one.

One more sleight of hand is the ability to create the illusion that the cych is actually a full scene. This is shown in Figure 15.3, where the same scene has been turned into a beach scene by just throwing a texture map onto the Front of the cyclorama.

**FIGURE 15.1** Both images are shot from the same camera location, yet the Cyclorama gives us an easier set-up and better-looking shot.

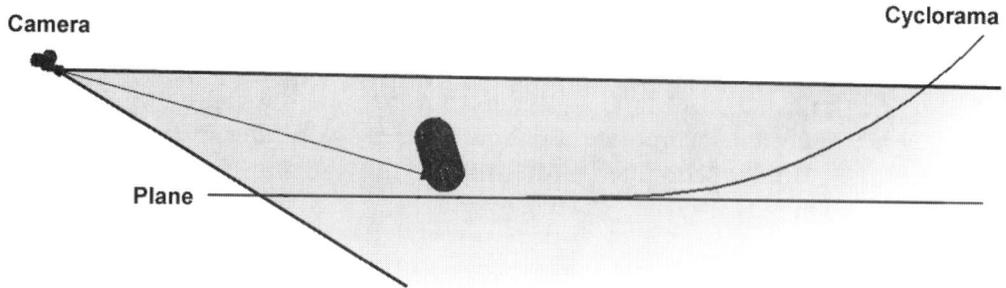

**FIGURE 15.2**    A side view of the scene in 15.2 diagrams how the Cyclorama creates its illusion.

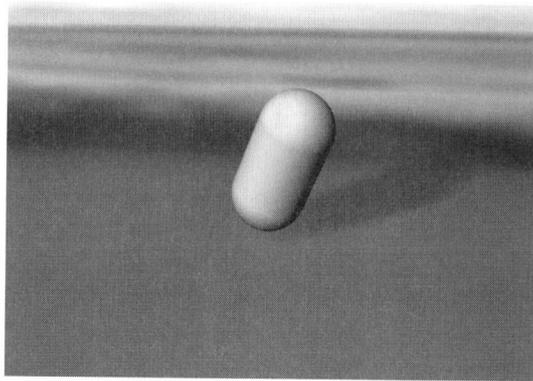

**FIGURE 15.3**    Mapping a scenic texture to the front of the Cyclorama creates the illusion of a complete environmental set where none exists.

## MOTION BLUR

Universe actually offers three distinct levels of **Motion Blur**, each suited for a different application. It is easy to get them confused, so a quick rundown will help keep it straight.

In all cases, motion blur needs to be turned on in the Render setting's Motion Blur tab, by toggling on one, two, or all three blur choices. Both **Point/Line** and **Motion Vector Blurs** will also need to be activated in the individual model's Info window's Shading tab.

The **Shutter Angle** edit box determines the length of all three of the blur options. A setting of 180 degrees is the default, but noticeable blurring does not occur until the value is increased to about 500 degrees or more. Special effects shots with dramatic sweeping blurs begin at settings of 1500 degrees and above. Keep in mind the object's velocity will also have a determining effect on the length of blur, which will generate a

very natural effect of longer trails when the model is moving faster, and shorter trails when it is moving at a slower speed.

All three options have been output as sample animations, and are on the CD-ROM in QuickTime. A fourth option was also included, which did not incorporate any blur from Universe, but instead applied the **Time > Echo** filter in After Effects. The After Effect project file is also on the CD-ROM.

**ON THE CD**

### Point & Line Blur

**Point and Line Blur** is the most basic of the three and can only be used with models that contain Points and/or Lines. (Don't confuse these with Vertices or Edges which are construction items and do not render.) Unless you specifically create a model that has these items; for example, by exporting a model from the **Transporter** model conversion utility with **Vertices as Points** or **Edges as Lines** selected (see Figure 15.4 image A), or by using ÜberShapes, few models will be able to use this option. The one notable exception is particle systems like Universe's Power Particles.

The **Blur Intensity** setting (that appears in each model's Info tab, and has a master control in the Render window) determines the visual intensity of the blur streaks. The default of zero lets Animator provide an auto-adjustment and the color of the blur is set by the color of the object.

### Motion Vector Blur

This blur option offers the smoothest rendered results (see Figure 15.4 image B), because it is created by generating a blur along the vector of the model's current motion path. This can quickly create velvety smooth blurs, but cannot adjust for curved paths, so the blurs become staccato when navigating non-straight paths.

### Multi-Frame Blur

In order to have a blur properly hug the curves of a motion path, Universe offers the **Multi-frame** option (see Figure 15.4 image C) that will generate multiple frames and then automatically blend them together to create each single final frame. The approximate break point for this to start exhibiting a smooth result is about 20 rendered frames to one final. This is a lot of extra rendering, but you can minimize this by creating a separate file for this purpose, where the scene is simplified to render faster. After all, how much detail will survive a major blur-streak anyway?

**FIGURE 15.4**   Images A thru E, left to right. Top:  Point/Line Blur, Motion Vector, and Multi-Frame. Bottom: Echo filter in After Effects, and a composited solution.

The Echo filter in After Effects offers a similar effect to Multi-frame, but it's not as smooth, and it isn't able to take into account the third dimension we get with Multi-frame blurring (see Figure 15.4 image D).

### A More Natural Blur

The one advantage the Echo filter has, is its ability to create a blur that leaves the initial object of the streak—the model—mostly intact at the front of the blur. It then decays the tail of the blur so that it trails off naturally. Both Motion Vector and Multi-frame tend to blur the forward trail as much as they do the ending trail, leaving the most recognizable part of the model in the central section. In real life, things hardly ever blur ahead of themselves! There are a few ways to correct this unnatural event; the easiest is to composite a non-blurred rendering pass underneath the heavy blurred render pass while in the compositing program. Then time-shift the top layer ahead by a few frames so that the non-blur is riding the forward cusp of the blur, as seen in Figure 15.4 image E.

**TUTORIAL**

## SOFT BODY DYNAMICS

Universe does not have all of the soft body dynamics some animators may wish for, but you can produce a lot in a pinch if you simply break the motion down into its components and apply the best tools at each stage.

The example here is a simplified re-creation of a shot from the author's *Table for Two* animation, where a tablecloth is thrown up into the air, and floats down onto a café table. Natural movement of the fabric is the goal. All project files are provided on the CD-ROM, along with a final QuickTime animation.

1. The tablecloth has two distinct shapes in this animation, flat and open in mid-air, and draped onto a table. The best way to create, control, and transition between these shapes is through morphing. In Modeler, a flat plane is brought into **ÜberMESH** mode—this is used instead of ÜberNurbs because it will give us a smoother model, which works well for this project. In Figure 15.5, you see the Über cage development on the left, and the two final models on the right.

2. When creating the Target model, make sure to only move the edges of the tablecloth down, leaving the central area untouched. This will be important later in controlling the morphing process. Export both Anchor and Target models.

3. Open the Start project file for this exercise, which has the camera, lighting, model and mapping already in place. Might as well make it easier for you, as you will be doing the hard part—animating.

4. Break down the main moves, there are actually only two (see Figure 15.6). At **Frame 1**, the tablecloth starts at the top of the screen, and at **Frame 35**,

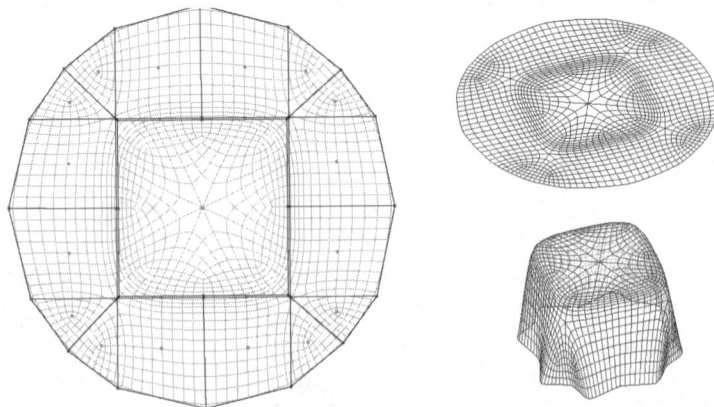

**FIGURE 15.5** The ÜberMesh (on the left) that generates the Anchor model (top right) is duplicated and modified to generate the Target model (bottom right).

a keyframe is added to bring the cloth straight down along the Y-axis to make contact with the table. Also at about Frame 35, the **Morph** channel has a **holding keyframe** created to lock the morph value at zero. The last main key is at **Frame 60**, where the Morph is brought up to a value of 1.0, which brings just the sides down to drape. Recall that you were careful to only move the sides when creating the Target model, you can see how doing this keeps your contact at Frame 35 stationary. If that area of the model moved during the morph, you would have all sorts of problems adjusting it (been there, done that, no fun).

5. The next step is to add a bit of natural fabric sway. You accomplish this easily with the **Deformation Editor** and a **Twist deformer**. A little sway is begun on the way down, but does not become significant until the Morph is in full swing. Add a couple of extra keyframes at the end for the **Reaction** (Frame 72) and **Stabilize** (Frame 84) poses. Where these keyframes are placed depends on the type of fabric you want to emulate. As the animation was being created, we kept a firm image of a vinyl café style tablecloth, which is rather stiff. You will also notice the final **Bump** texture is designed to match this material.

6. In the finished version project file on the CD-ROM, you will see that a few keyframes were shifted this way and that to improve the timing by fractions of a second. Some of the channels were also added to the Function Curve Editor for a bit of tweaking to create the final results seen in Figure 15.7 on the next page.

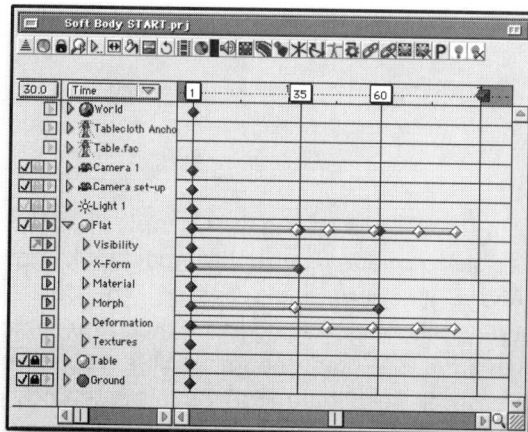

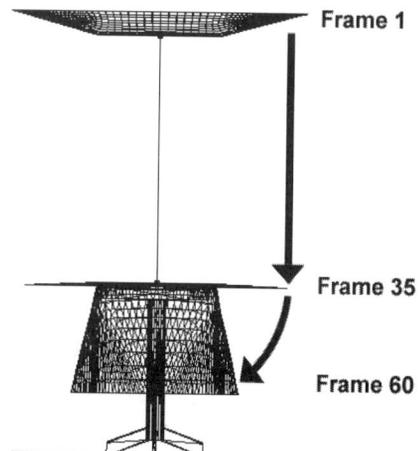

**ON THE CD**

**FIGURE 15.6**   The two main events in this animation are the movement along the Y-axis, and Morph.

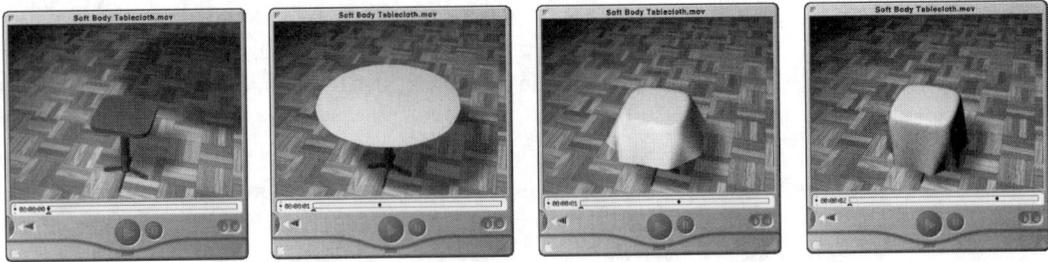

**FIGURE 15.7**   Excerpts from the final animation found on the CD-ROM.

## WATER, WATER EVERYWHERE

Creating effective and realistic water involves getting many elements working together properly. Depending on what we want the water to be doing—waves in an ocean, running tap water, and so on—there are a number of theories on how to produce the effect. Some techniques require a heavy reliance on the Mr. Blobby plug-in or one of the particle generators. In most cases, these methods can be very slow going, both in the scene building-stage, and during rendering. By comparison, the techniques put forth here are all fast setups and renders, relying on Bump/Displacements, and geometry control.

There are four watery offerings provided here: wavy open sea, running tap water, a fountain, and a water splash. They are finished to varying levels. Rather than stepping you through each one, you are provided with an introduction to how each was produced. The final project files and QuickTime animations are on the CD-ROM.

**ON THE CD**

**TUTORIAL**

## THE OPEN SEA

Starting with a simple flat plane model, and adding the **Crumple Shader** that ships with Universe, we are able to create a scene that would look right at home in the *Titanic* movie. And yet it's a surprisingly easy scene to set up.

Some of the tricks to getting this looking so good are choosing the right **High** and **Low** colors, which are a mid- and deep navy blue respectively. Other settings are important as well (see Figure 15.9), but exact settings are not actually critical, as the Crumple Shader offers a nice latitude of realistic water settings.

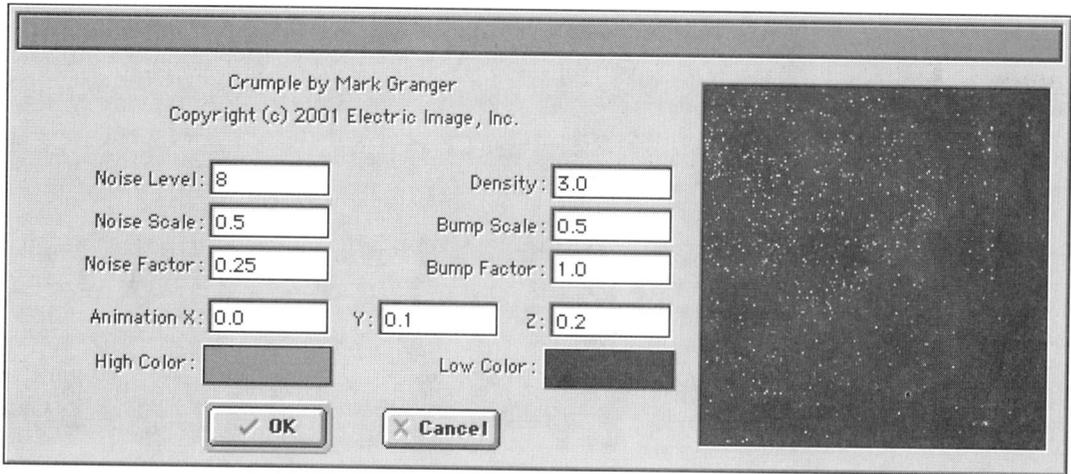

**FIGURE 15.8**    The Crumple Shader settings.

**Reflectivity** is also very important, so the model needs to be made about 50% reflective, and set to use an appropriate source of reflection, either an Environment or other map. Related to reflection is the fact that water likes to "sparkle", so a light was placed to create large amounts of **Specular** reflections. Take care here, however, because the choppy bright reflections create a good amount of sizzle in the image. Shaders cannot be set for Anti-aliasing on an individual basis, so you must do it globally by using a **Sampling** rate of at least 2 × 2 in the **Anti-Alias** tab of the Render window. The results are fast and wonderful, as seen in Figure 15.9 on the next page. You can easily add Linear Wave deformations to generate the ebb and flow of the high sea, along with some distant fog to help pull it all together.

## TUTORIAL    TAP WATER

This project relies on an animated value map placed in the **Displacement** channel. Using the kitchen set you built in Chapter 2, a simple but well-meshed cone-like model is placed under the tip of the faucet. An animated texture map, which was created in Photoshop and After Effects, is applied to this model, as seen in Figure 15.10.

When you create the original seamless graphic, a wide range of filters can be used. Despite their differences from one another, many create convincing

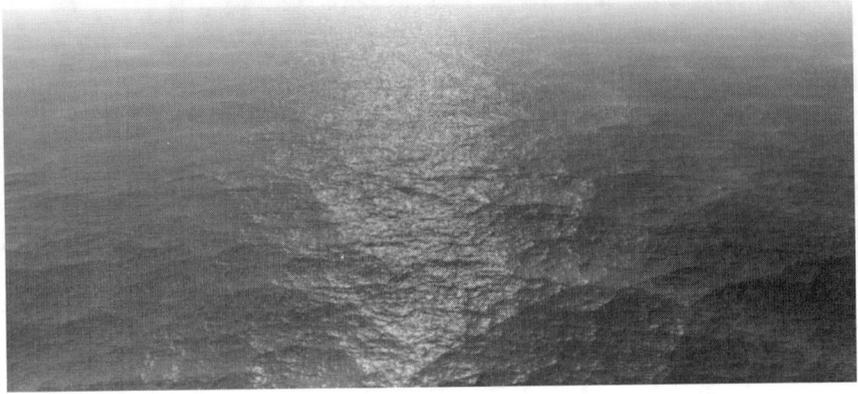

**FIGURE 15.9** A final rendering. See the color version on the CD-ROM and in the insert.

RGB          Alpha

**FIGURE 15.10** The animated texture map is created as a seamless graphic in Photoshop (left), and then brought into After Effects to be vertically animated to create a clean loop in 30 frames.

results. Make sure to apply Photoshop's **Motion Blur** filter in the same direction the map will be animated in After Effects. This smoothing is important because it helps to blend the shapes from one frame to the next, eliminating any jarring changes. When you create the loop in After Effects, keep in mind that the more frames you produce, the smoother the animation—but the longer the loop takes to cycle.

The map's Alpha channel was placed in the **Bump/Displacement** channel to create actual geometry rippling using the Displacement controls. Keep in mind that Bump and Displacement are hard-wired together, so you need to have at least a few points of Bump (1.0 works) in order for the Displacement settings to work properly. Displacement values are dependant on the model's scale, so you may need high input values or very small fractional values to get the desired results. Whatever works. The Displacement effect tends to greatly enlarge the mesh's dimensions, which is why you will see the model reduced along the X and Z axes in the project file.

The value map created the pattern of water that you wanted, while making it animated generates the appearance that water is flowing. See that effect in Figure 15.11, and in the animated QuickTime file on the CD-ROM. You can achieve even greater realism by adding additional layers of mesh—larger and smaller—with different animated maps to create more diversity and a greater sense of mass.

ON THE CD

**FIGURE 15.11**   Running tap water.

T U T O R I A L

## THE FOUNTAIN

The fountain project uses the same concept as the Tap Water scene above; in fact, it even uses the same texture map, with both depending on the Bump/Displacement channel. This project however, has the added technical problems of mapping the material onto a stream of water that is shooting *up* from a central point, spraying out, and then coming back *down* again. A normal projection mapping would not work here because the outside and the inside sections of the water have to travel in opposite directions, as seen in Figure 15.12. Three ways of doing this come to mind. It could be flat-mapped onto a plane model, which is then deformed with two Bend moves (180 degrees to fold it, and then 360 degrees to make it circular), but deformations take additional calculations which slow rendering—okay for a prime effect, but best avoided for a background element. A UV model could be generated and used. This would be fine, it would just take a bit longer to work the kinks out.

The third option seems the simplest and involves breaking the shape of the fountain's water into two separate sections, the inside and the outside. This takes no extra time, and merely involves splitting the drawn line and Revolving the two pieces separately as seen in Figure 15.12. Once inside Animator, the inside and outside model objects are mapped similarly, except the outer object is made a little more transparent, and the inner object has its map Rotated 180 degrees along the **X-axis** so that the water would appear to be going up. See the final rendering in Figure 15.13, and the QuickTime file on the CD-ROM.

ON THE CD

T U T O R I A L

## WATER SPLASH

Creating a splash of water—or one of chocolate pudding, for that matter—is an often-requested special effect that has usually involved some fairly painful and time-consuming production techniques. However, the following tutorial relies on the Morph generator and a few of the treatments discussed above to produce a smashing effect and still go home by 5pm. Well . . . maybe 6.

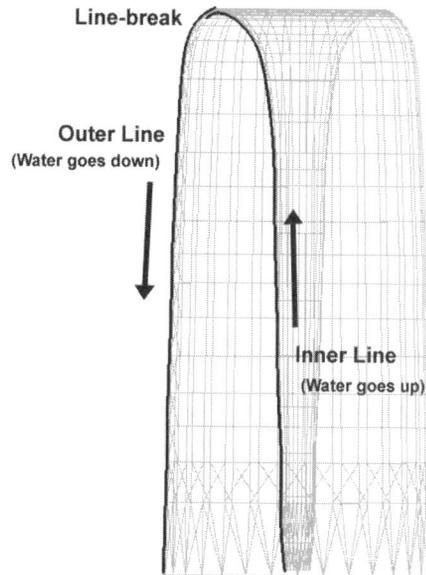

**FIGURE 15.12**    The shape of the fountain's water model, with the direction of water travel and how splitting it into two objects solved the mapping problem.

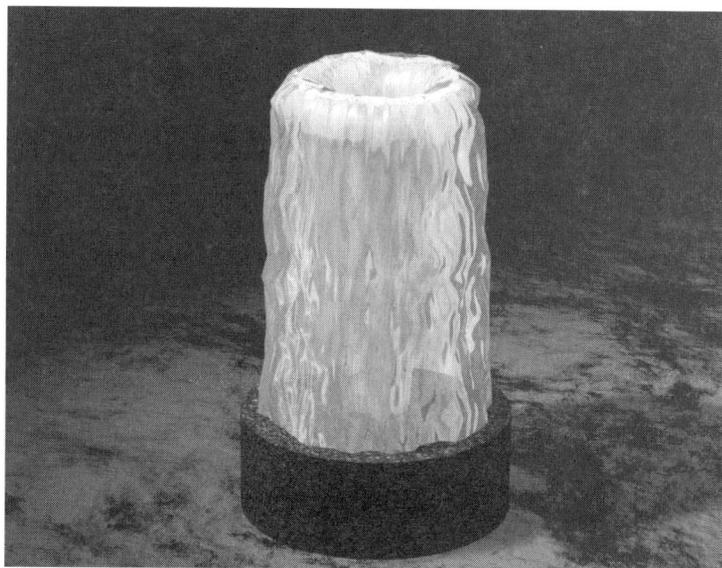

**FIGURE 15.13**    Final rendered scene.

### IN MODELER

1. Create a flat **Surface Primitive** using the **Surface Sheet** tool. This will become the water's surface and splash area. It does not have to be large enough to cover the entire scene; another plane can go underneath and be used for that.
2. Hit the plane with the **ÜberMesh/Edit Cage** tool to convert it to an Über-Nurbs object.
3. Use the ÜberNurb's **Subdivide Globally** tool to increase the mesh of the plane. Two subdivision actions were used in the sample, then the one section was further subdivided to create the model you see in Figure 15.14, image A.
4. In Step 3, you created a model with a fairly detailed cage, the associated mesh for this model looks like image B in Figure 15.14. Duplicate this object, and tuck it away to be exported as the Anchor model. Take the duplicate into **ÜberMesh** mode, and create a splash, like the one seen as image C, and its profile in the Front view, seen in Figure 15.15.
5. Not covered here is a third model that will be needed if you want the water to fall back into the sea. Unfortunately, just reversing the morph will not look right because the water needs to fall down and out. Export the models and import the Anchor into Animator.

### IN ANIMATOR

The morph is set up normally. The rest of the animation is rather straightforward, dealing with production elements that have already been covered throughout the book. You can see the final results in Figure 15.16, and the QuickTime movie file on the CD-ROM.

**ON THE CD**

**FIGURE 15.14**   The subdivided Surface Primitive with just the cage showing (left), and with its mesh displayed (middle). After a bit of working with the cage, we create a splash shape (right).

**FIGURE 15.15**    A Front profile view shows the same splash model that will be exported as a Target model.

**FIGURE 15.16**    Final render.

## CREATING FIRE & SMOKE WITH DANTE

The following tutorial was originally created by Jean-Christophe Erny (Eridia) and revised and documented by Blair M. Burtan (Northern Lights Productions). It requires the Danté plugin, not provided.

Smoke and fire are among the most difficult effects to create in computer graphics. The engineering adage "Good, Fast, and Cheap. Pick any

two." tends to apply here. To make the problem more complex, many techniques fail when the source of the fire and smoke is moving.

In this project, you're going to use the **Dante particle system** plug-in. You want to create a shot just after the associated car crashed, launching a burning tire from its fiery hulk. You'll be using an animated object as a source for the particles, and several texture-mapped objects as the particles.

All files and final animation can be found on disc.

**ON THE CD**

**TUTORIAL**

## INITIAL SETUP

1. For this project, we've already created an animation of a car tire bouncing and rolling around on the ground. Open up the starter project, the tire animation is pre-configured for you. Add Dante 2.6 to the project from the **PLUGIN** menu and configure the plug-in as follows: In the **Timing** tab, set the **Particle Lifetime** to 4.0 +/- 2.5 seconds. Start creating particles at **2.0** seconds. Set the **Emission frequency** to 40.0 +/- 30.0 per second (see Figure 15.17).

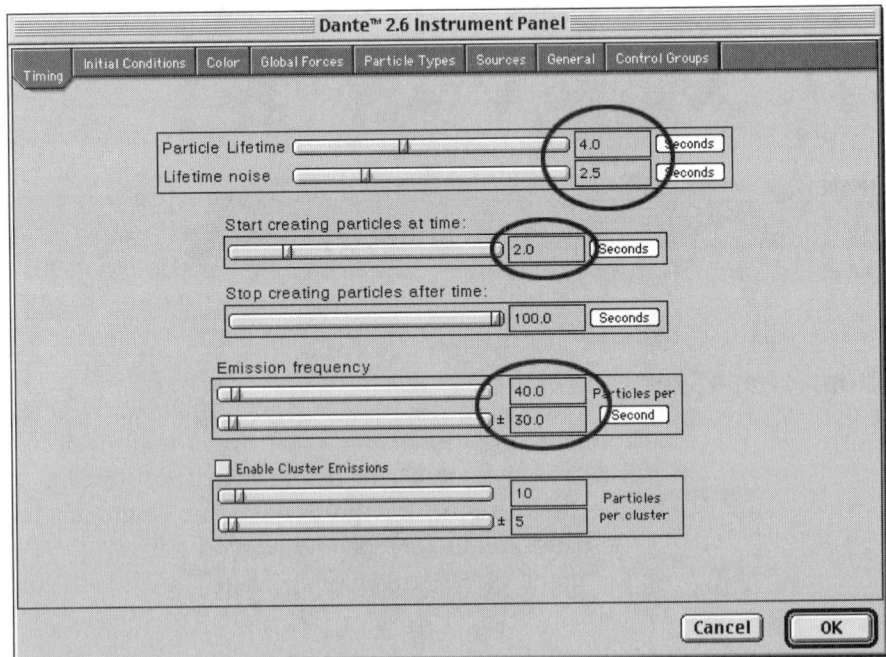

**FIGURE 15.17** Dante's Timing Tab, configuring particle settings.

2. In **Initial Conditions** tab, set the nozzle angle to 0.0 +/- 40.0 and the Initial velocity to 0.5 +/- 0.5 (see Figure 15.18).

3. In the **Global Forces** tab, set **Gravity** to Y=2.0, and **Fluid Viscosity** to 0.5, 2.0, and 0.5 (See Figure 15.19 on the next page). This should be enough to get you started. Later, you'll be using Emission surfaces and object particles.

### EMISSION SURFACE

4. Using the **Link** tool, link the **Tire Motion 1.CG** effector to Dante. Doing this reveals Tire, Emitter, and Boule in the **Available Groups** list within Dante. Select Emitter in the Available Groups list. Set the **Type** pop-up menu to **Emission Surface**. Set the pop-up to **Per surface** and click the Add button (see Figure 15.20 on the next page).

5. In the **Sources** tab, set the source to **Surface** (See Figure 15.21 on page 459). At this point, you can preview the animation, and you'll see a collection of line particles emitting from a spot on the tire. The emitter group is linked to the tire animation so it spins and moves with it. You could have used the whole tire as the emitter but a portion of it is visually more interesting. This setup also illustrates the fact that you can use a complex animation to move the particle source around.

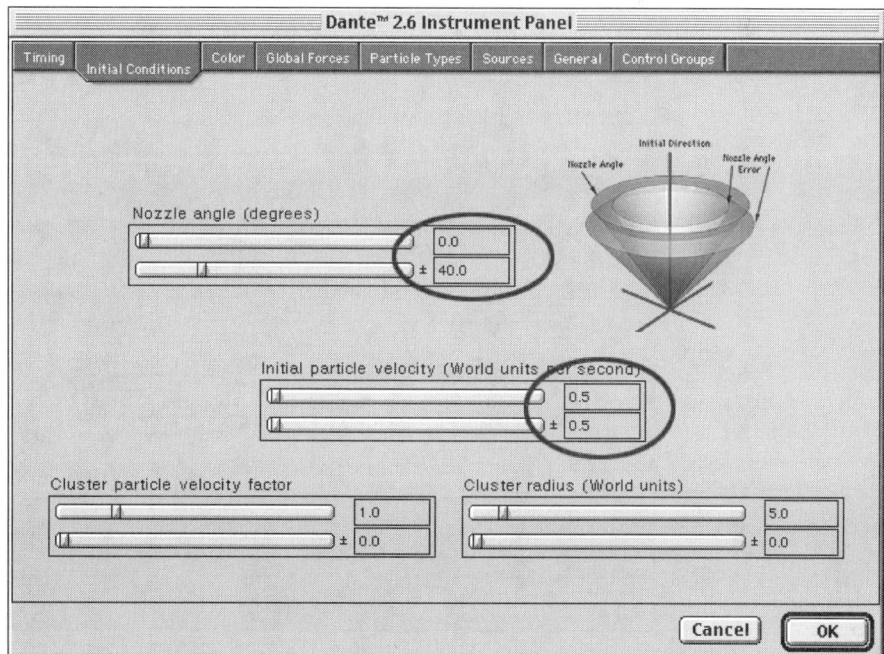

**FIGURE 15.18**   The Initial Conditions tab with the angle and velocity settings.

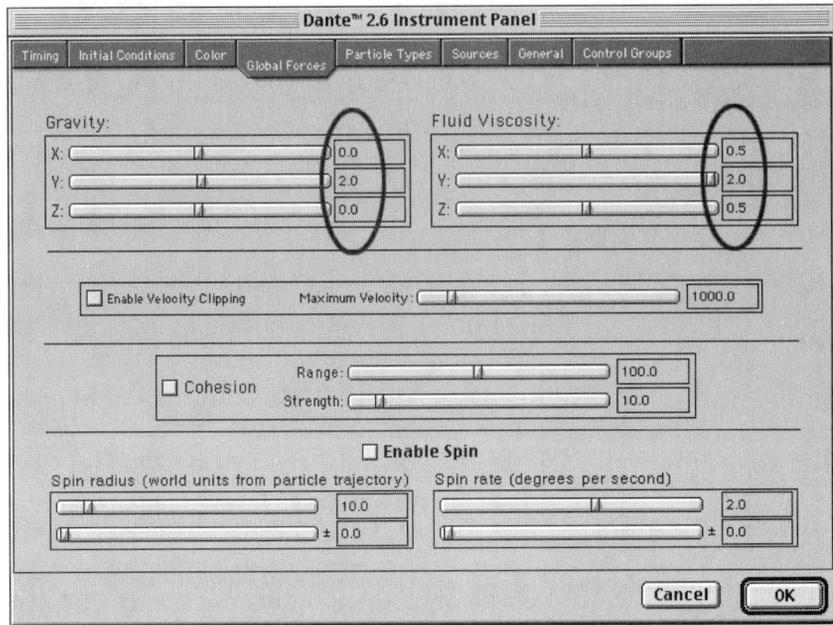

**FIGURE 15.19** The Global Forces tab, configuring Gravity and Fluid Viscosity.

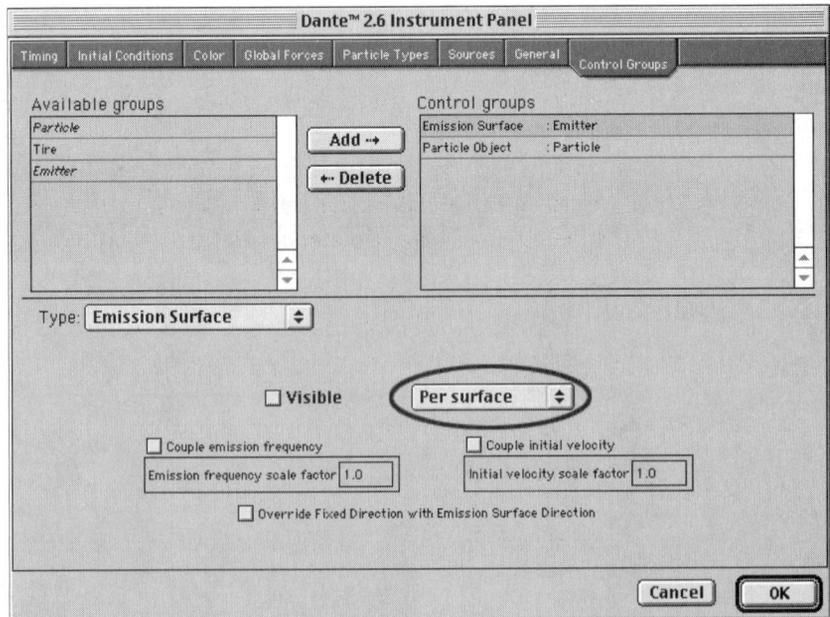

**FIGURE 15.20** The Per Surface pop-up in the Control Groups tab.

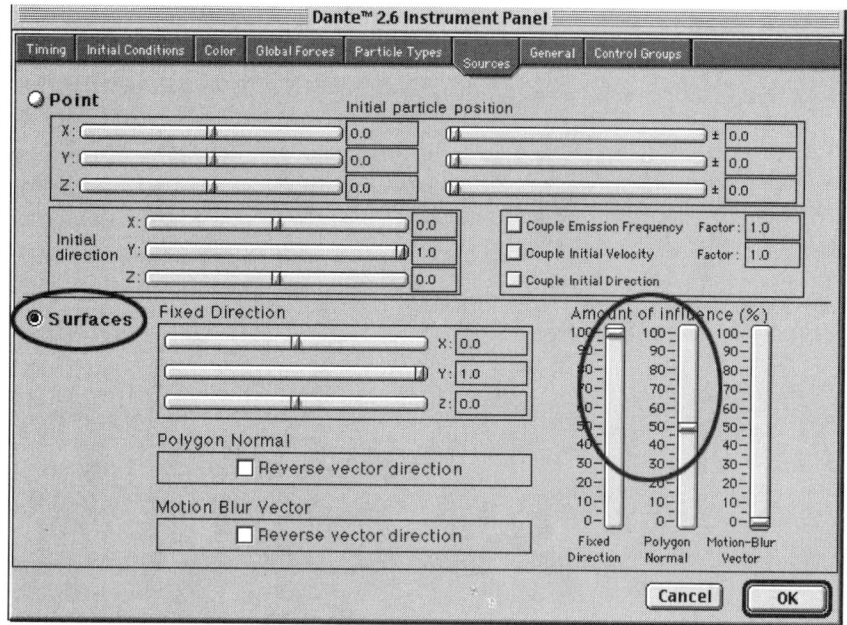

**FIGURE 15.21**   Setting the source to Surface.

### OBJECT PARTICLE

What you've got so far is a good start but doesn't look at all like smoke and fire when you render it. You need to fill the space surrounding the particles with something. This is similar to blocking in large areas of color in traditional wet-on-wet oil painting. Large areas of the canvas are filled in with one color using a large brush and the details are filled in later. Here, you're going to use simple spheres. You'll apply a material and shader later on.

6. Select the three **Particle groups** and link them to the **Dante group**. The models are identical but they're each rotated differently. The main reason for having three slightly different objects for particles is to add randomness to the final image. One would be sufficient but the results would look too uniform. In the Dante interface under the **Particle Types** tab, set the Primary Particle Type to **Objects** (see Figure 15.22 on the next page).

7. In the Control Groups tab, select **Particle** from the **Available Groups** List and switch the Type pop-up to **Particle Object**. Set the Particle Object settings as follows: X Rotation -50.0 +/- 50.0; Y Rotation 20.0 +/- 20.0; Z Rotation -50.0 +/- 50.0; Type: **Constant Rate**. Check the **Scale object** checkbox, set the start scale to 0.7 and the end scale to 5.0 (see Figure 15.23 on the next page).

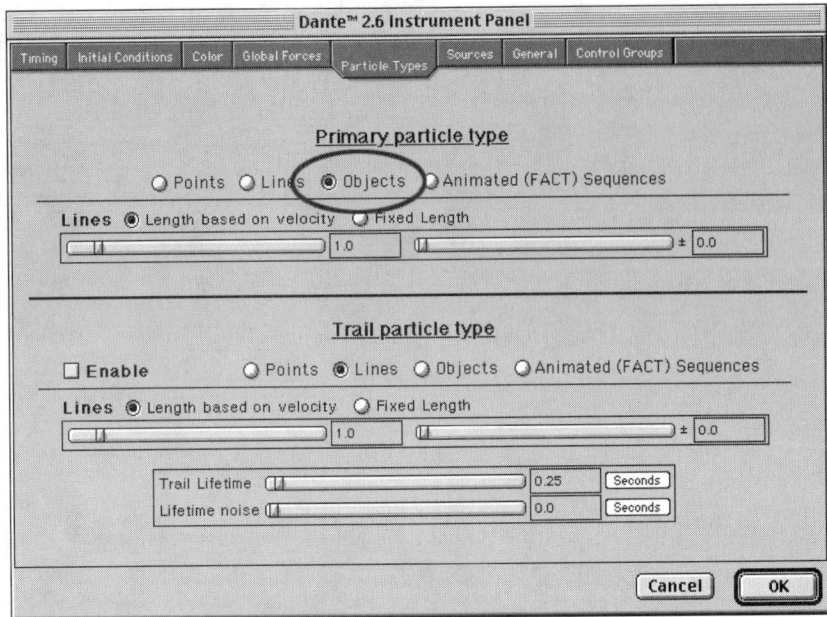

**FIGURE 15.22**   The Particle Types tab of Dante's interface.

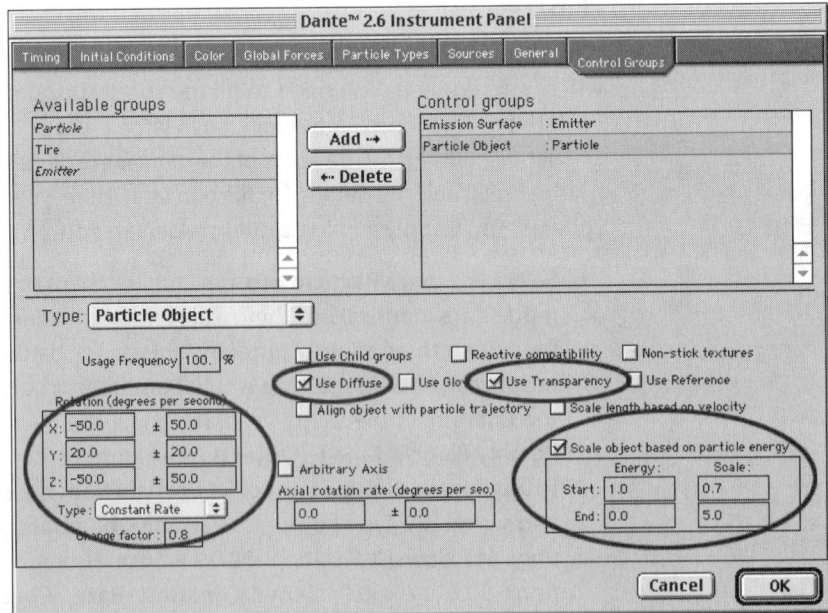

**FIGURE 15.23**   Control Groups set to Particle.

8. These settings will result in a collection of spheres that rotate randomly and increase in size over time. Check the **Use Diffuse** and the **Use Transparency** checkboxes. These will be explained later when you apply materials. Finally, click the Add button. Now preview the animation. You should see a series of spheres emanating from the tire.

## TEXTURE MAPS

If you were to render the project at this point, you'd see a lot of spheres floating around but nothing that looks like smoke or fire. For this, you need some sort of material and texture. There are a lot of ways to approach the texture question, but we've chosen to use the **Eroded** shader because it has a cloudy look to it, and the Erode Hole feature will make parts of the image transparent. As far as material settings go, the only essential component is setting Edge Transparency for transparent edges. This will effectively eliminate the edges of the spheres. A basic **Smoke Material** that has all of this configured for you is included.

## GRADIENTS

The next step will be to **colorize** the textures. Dante has a series of gradients that you can use to vary certain material components over the life of a given particle. By default, Dante has a rainbow gradient for the Diffuse. As particles age, the materials transition from the left side of the gradient to the right side. For your project, you want the **texture** to start out a fiery orange/yellow then change to smoky shades of gray. You're going to use the **Transparency gradient** for the fire part and the **Diffuse gradient** for the smoke part. You're also going to vary the **Alpha channel** of the Transparency; this will allow the texture (and thus the object particle) to fade out, mimicking the dissipation of smoke (see Figure 15.24 on the next page).

Two pre-defined gradient files are provided for you and you should spend some time making changes to these gradients to gain a better understanding of how they affect the final image.

## FINAL TOUCHES

The last thing you have to do is animate the gravity. This is a stylistic choice and not really necessary. You want the smoke and fire to be pulled upward more rapidly as the tire comes to rest. This is a nice way of faking the fact that real fire would be generating a lot more heat when it's stationary causing the

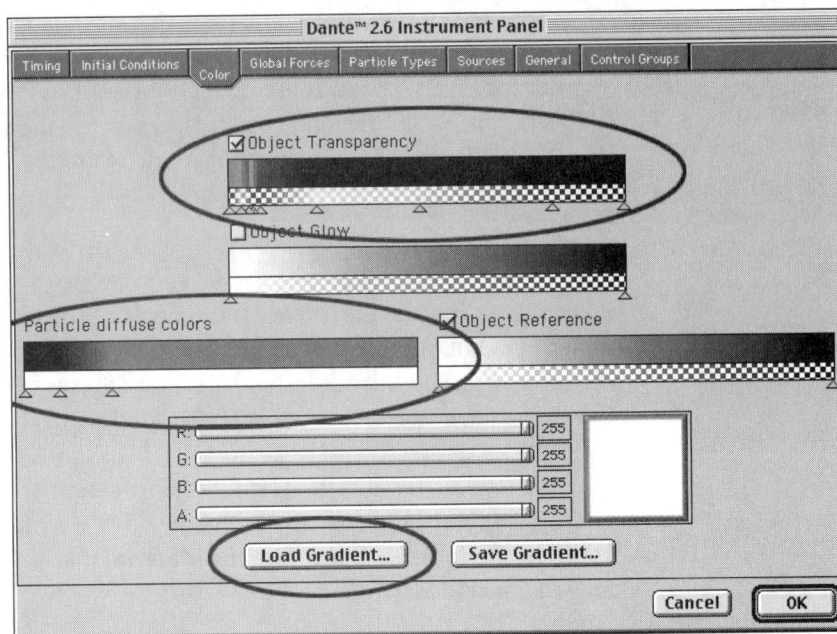

**FIGURE 15.24** Colorizing the effects: the Dante Color tab with fiery and smoky gradients.

smoke to rise more quickly. The tire begins to come to rest around **9 seconds** so we **keyframe** Dante's **gravity** setting to **5.0** (from the initial 2.0) and we'll **keyframe** it to **6.0** at the final frame.

*ON THE CD*

See the final QuckTime movie on the CD-ROM. For more information on Dante or any other Northern Lights products, visit *www.northernlights3d.com* or see the Resources Appendix.

**TUTORIAL**

## Tornado Particle Effect

Particle effects succeed best when they do not look like particles. This tutorial brings together Power Particles Basic, Mr. Nitro, and a number of great techniques that rely on standard EIU tools. The final rendering can be seen in Figure 15.25, where the tornado rips across the plains, and tears through a house that gets sucked up into the whirlwind. See the QuickTime file on the CD-ROM before you begin. This tutorial is an overview of a complex series of steps, and relies on your opening the related project files to learn more.

*ON THE CD*

**FIGURE 15.25**   A dramatic shot from the tornado tutorial.

## THE GROUND

To create the richly textured earthen environment, an uneven ground model was imported (the same one use for the desert scene in the Chapter 12, "The Camera"). The **Rust Shader** (see Figure 15.26) was applied to its **Diffuse** channel—this is one of the most versatile texturing tools, allowing control

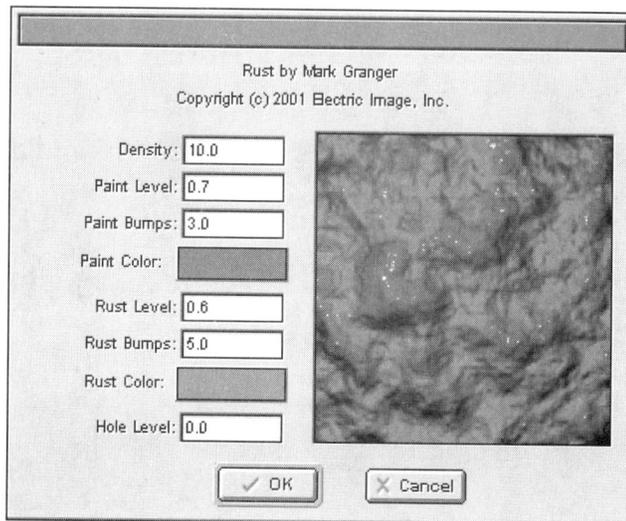

**FIGURE 15.26**   The Rust Shader settings used to generate the dry Midwest plains.

over two "layers" of organic shapes, and the color and bump qualities of each. To gain an even greater sense of dry crackling dirt with sparse foliage, a **Crumple Shader** was added to the **Bump** channel.

### PARTICLE TORNADO

A **Power Particles Basic** plug-in emitter was added to the scene. Its default settings give us the basic inverted cone shape of a tornado. Both the **End Time** and **Maximum Particles** settings were made higher to avoid unnatural limitations. The **Speed** settings were fiddled with a bit, but the important controls for this effect were **Rate Per Sec**, which controls how many particles are generated per second and needed to be increased, and **Lifespan**, which determines time-till-death of the particles. This was especially important because it is what determined where the tornado ended— how tall it would be. See Figure 15.27 for specific settings.

*Set the Preview tab's **Limit Emission** toggle to reduce the burden on Animator, and speed the working process. 10% is a good starting number.*

### SPIN & ANIMATE

The particles need to whip around in a circular fashion. This could be done by adding a fast Y-axis rotation, but a much better way is to add a **Twist Deformation**. In this case, a large 2,500-degree twist along the **Y-axis Direction** was added, so as a particle is emitted upwards it actually begins to whip around.

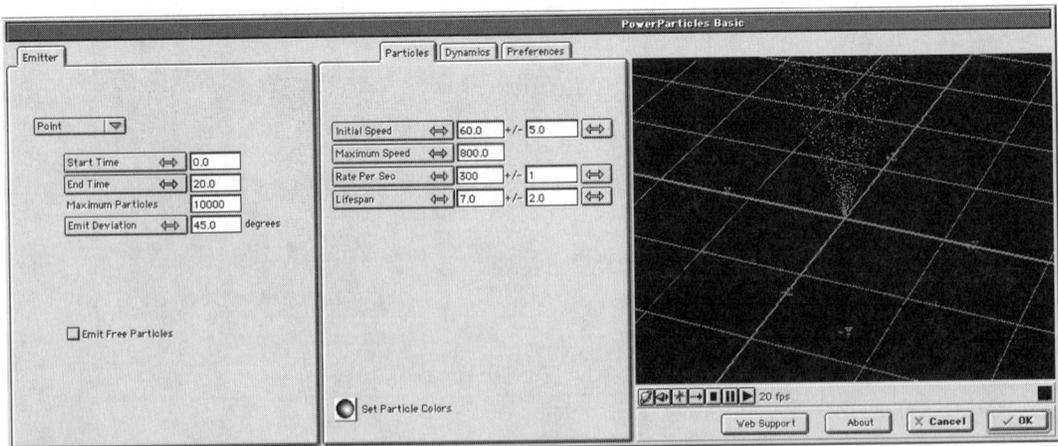

**FIGURE 15.27**   A photo-composited view of the Power Particles Basic Plug-in set for the Tornado.

This doesn't really change the shape of the tornado's profile—it will still look like Figure 15.28, image A, but using the **Deformation Editor** opens the door to a lot of additional control that you will take full advantage of. You want to create a much more natural striated, or "towel wringing" shape, as seen in Figure 15.28, image C. This is done by combining the Twist you've already added with just a few points of **Linear Wave** as seen in Figure 15-28, image B. The Linear Wave must be positioned as the FIRST deformer in the list box, thus the Twist is then applied to the wavy line—this is what creates the striation effect.

To finish the job, a **Bezier** is applied at the end (bottom of list) to give a subtle overall wave so that the tornado is not just standing upright all the time (see Figure 15.28, image D). This is the only deformer that gets animated during the project.

## ANIMATION PATH

The tornado needs to move across the screen, but if the moves were applied directly to the particle model, you could risk mixing Deformation keyframes with Transformation keyframes. This can get messy very quickly, so instead, the two actions are isolated from one another by creating a **Null Effector** and attaching the particle model to it with **Inherit Position** enabled. Now when the Effector is moved, any keyframes are applied to it and not to the particle model. The motion path is shown in Figure 15.29 on the next page.

### THE LOG CABIN

A log cabin model from the Fact Model Disk is placed in the foreground; it will shortly get destroyed by the tornado, with the help of **Mr. Nitro**. Before importing it though, this multi-part model was brought into **form•Z** and modified in

**FIGURE 15.28**  The tornado shape is formed and animated using the Deformation Editor. Tornado profile both before and after Twist (a), Linear Wave seen before Twist (b), and after (c), and with a Beziér added (d).

**FIGURE 15.29**    The Motion Paths for both the Tornado particle object and the house can be seen in this Top view.

two ways. First, it was a very detailed model and this would be taxing on Mr. Nitro, which seems to prefer doing much of its own dicing. The particle system is already using up system resources, so streamlining is important. The model's polygon count was brought down by about 50% using form•Z's **Reduce** tool. The second step was to take all the different parts and join then together into one model. Though not a necessity, this simplified model management a little.

### Mr. Nitro

Items that will receive Nitro's deadly blow must be added the Nitro object as its children, at which point the plug-in interface controls most of the effect. Unlike other interfaces, Nitro's settings are time based so there is no way—and no need—to actually animate the settings across various keyframes in the timeline (see Figure 15.30).

The actual epicenter of explosion is the center of the Nitro world icon, but this can be changed with the **Ground Zero XYZ** settings. In this animation, it is set to kick in at the edge of the house and expand. The next basic setting is the **Gravity Direction & Force XYZ,** which determines which way the debris should travel after exploding. For your needs, a positive value in the Y-axis brings the cabin remnants upwards into the tornado. The **Blast Time** of the effect needs to be set, and is often best started a short amount of time before it

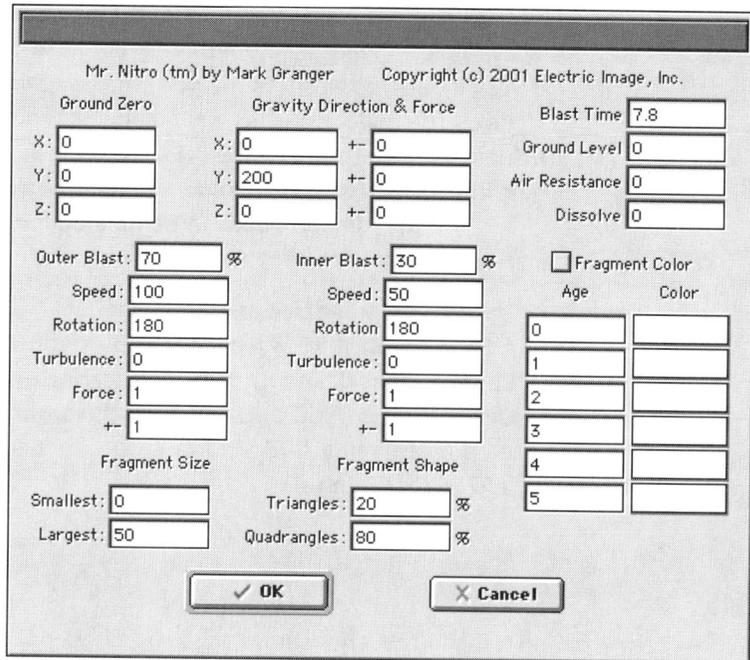

**FIGURE 15.30**   The Mr. Nitro Plug-in interface with the Tornado settings.

should be seen, as the first few frames of destruction are usually hidden behind geometry that is still intact.

The Nitro parent object can act something like an Effector and control the location of its children, or the child can move independently. The first option is well suited for a scene involving the explosion of non-moving objects, like a building, whereas the second option is ideal for something like a moving train.

To create the feeling that the cabin parts are getting sucked up into the whirlwind, as the tornado passes the cabin's location, the Nitro object is animated to follow along the same path as the particle object, with the child inheriting the position (refer to Figure 15.29). This keeps the debris in the eye of the storm, while still rising upwards from the Gravity setting. The last step is to apply a Twist Deformation similar to the one given to the particles, but much more mild. This solidifies the effect with the cabin debris whipping around in the tornado.

### RENDERING

Despite the tornado's shape working well, by their nature, particles don't have a very full-bodied look to them. (If you were using Power Particles Pro or Dante, you could substitute other geometry for each particle, and create more mass.)

And since particles are **points,** the **Point/Line** Motion Blur is the only blur option available—the results from this are not as smooth as one might like. Regardless, it gets you closer to the goal, and you can finish the job in post. The tornado, cabin, and Nitro effect were rendered together so that the debris and particles could intertwine in true 3D. If this were a full production project, you would have produced a few additional layers.

Because the tornado needs to be isolated for effects applied in post, all other elements have to be rendered separately:

- The ground is rendered as a still image.
- A **Shadow Mask** pass is rendered by setting the ground to **Generate Shadow Mask**, and the tornado/cabin debris to **Shadow Object Only**. This gave you the shadow in the Alpha channel, which could be used as an alpha selection in After Effects with the **Set Matte** filter (**EFFECT > Channel**).

### COMPOSITING

The tornado renderings have the **Echo** filter applied, which generates additional copies of the layer at slightly offset time intervals, creating a visual echo. This is an excellent filter and can often save a 3D artist from having to render motion blur in 3D. This effect works well to fill in the spinning tornado with additional "mass," but it can also add some unwanted bulk to other areas, so care has to be taken. The **Levels** filter is used to cut down some of the harsher white areas on the tornado, and then a **Color Balance** filter is applied to add a touch of color.

The ground plate is duplicated—the top version receives a **Set Matte** filter, and the shadow rendering's **Alpha** channel is chosen as the matte. The **Levels** filter is then applied and the **White Output** channel is brought down to darken the layer . . . Voila, shadow. A final blur is added to soften or "defocus" the shadow, and the animation is ready to render.

Compositing in a post-production application can generate a wide variety of results. Tear apart the Universe and After Effect project files for this tutorial found on the CD-ROM, and see what you can come up with.

**ON THE CD**

# APPENDIX A
# RESOURCES

## Index of Refraction for Common Transparent Materials

| MATERIAL | INDEX | MATERIAL | INDEX |
| --- | --- | --- | --- |
| Air | 1.00029 | Plastic (Polystyrene) | 1.55-1.59 |
| Alcohol | 1.329 | Plexiglass | 1.51 |
| Crystal | 2.00 | Quartz | 1.46 |
| Emerald | 1.57 | Ruby | 1.77 |
| Diamond | 2.417 | Salt | 1.544 |
| Flint glass (used in Prisms) | 1.57-1.75 | Sapphire | 1.77 |
| Glass | 1.5 | Vacuum | 1.000000 |
| Ice | 1.309 | Water | 1.333 |

## Value Changes

EIAS and EIU support formulas in data cells and edit boxes. Actions and percentages can be combined.

**Syntax:** @symbol amount

| SYMBOL | ACTION | EXAMPLE FORMULA | RESULT |
| --- | --- | --- | --- |
| + | Add | @+1.5 | Add 1.5 to channel |
| - | Subtract | @-1.5 | Subtract 1.5 from channel |
| * | Multiply | @*1.5 or @1.5 | Multiplies channel by 1.5 |
| / | Divide | @/1.5 | Divides channel by 1.5 |
| ^ | Exponential | @^1.5 | Channel to the power of 1.5 |
| % | Percentage | @+1.5% | Adds 1.5% to channel |

### Usage Example

A series of custom frames can have their values modified without the in-dividual values being edited. With the project window in **Keyframe** mode, highlight the series of cells that contain a value you wish to mod-ify. Choose **Fill Constant** from the toolbar and type a formula into the dialog box that appears. Click OK to apply the formula to the cells you've chosen.

## EI Shaders and Channel Mapping

Sophisticated Shaders have the ability to affect a number of channels at the same time. The following list indicates which channel a Shader is most commonly applied to, and which channels are modified by its use.

| SHADER | CHANNEL APPLIED TO | CHANNELS AFFECTED |
|---|---|---|
| Rust | Diffuse Channel | Diffuse and Bump |
| Cell Look | Diffuse Channel | Diffuse and Specular |
| Granite | Diffuse Channel | Diffuse and Specular |
| Plank | Diffuse Channel | Diffuse, Bump, and Specular |
| Bricks | Diffuse Channel | Diffuse, Bump, and Specular |
| Crumple | Any Channel | Channel applied to, and Bump |
| Crust | Any Channel | Channel applied to, and Bump |
| Eroded | Any Channel | Channel applied to, and Bump |
| Fractal Noise | Any Channel | Channel applied to, and Bump |
| Stucco | Any Channel | Channel applied to, and Bump |
| Veins | Any Channel | Channel applied to, and Bump |
| Waves | Any Channel | Channel applied to, and Bump |
| Bump Array | Any Channel | Channel Applied to, Bump, and Diffuse |
| Bumpy Noise | Any Channel | Base and Bump |
| Cammo | Any Channel | Channel applied to, never effects Bump |
| Checker Board | Any Channel | Channel applied to, never effects Bump |
| Clouds | Any Channel | Channel applied to, never effects Bump |
| Color Noise | Any Channel | Channel applied to, never effects Bump |
| Cyclone | Any Channel | Channel applied to, never effects Bump |
| Dots | Any Channel | Channel applied to, never effects Bump |
| Flame | Any Channel | Channel applied to, never effects Bump |
| Grid | Any Channel but Bump | Channel applied to, never effects Bump |
| Hex Tile | Any Channel but Bump | Channel applied to, never effects Bump |
| Marble | Any Channel but Bump | Channel applied to, never effects Bump |
| Random Dots | Any Channel but Bump | Channel applied to, never effects Bump |
| Wisp | Any Channel but Bump | Channel applied to, never effects Bump |
| Wood | Any Channel but Bump | Channel applied to, never effects Bump |

Based on work by Marie-Helene Robert

## Resources on 3dNY.org

3dNY.org hosts a free downloads page offering a tremendous library of tutorials for Electric Image. A variety of EIU shareware utilities are also available, including Remote Camera Launcher, and the drag-drop conversion utilities that convert EIU PC files into recognizable documents on the Mac.

### Full Resource Listing

**ON THE CD**

To allow for a more comprehensive listing of resources and to eliminate the need to type out long URLs, this section has been included on the CD-ROM in the associated Resources folder. In it, you will find lists of third party developers, community Web sites, the bookmarks file, and more—all with one-click links and descriptions.

### Keyboard commands

A complete list of keyboard commands can be found for both Macintosh and Windows platforms on the CD-ROM in PDF formated documents.

# APPENDIX B
# ABOUT THE CD-ROM

The CD-ROM that accompanies this book is filled with complete project files, including the models and rendered animation samples of the tutorials. This takes up a lot room because there are over 70 tutorials—both large and small—covered in this book, and with only a few exceptions, all have associated files on the CD-ROM.

In most cases, you will find that when opening projects, any supporting files, such as models or textures, will automatically load. In some situations, you may need to locate these support files in a sub or parent directory folder instead.

The tutorial folder is arranged in a logical progression that follows the book, making it easy to find the projects you seek.

## Support Files

**Support Files for Projects**: This folder contains a variety of primitive models and texture maps that are useful in general production. Many of these are *Solid* maps that open the door to power mapping within the Material Editor.

## Tutorials

**Part 1-Modeler/ Part 2-Animator/ Part 3-Advanced:** These folders contain the tutorials for their respective parts of the book. Each has subfolders named by chapter and subject. If a chapter is not represented by a folder, it is because there are no project files provided for that chapter. This is very rare, and only Chapters 4 and 6 are omitted. Most chapters have many tutorials, so within each chapter folder you will find the subjects presented in the same order as they are in the book, using topic numbering and names. This will make it easy to find the topic you seek. If numbers are skipped, it is because some rare topics do not have associated files.

## Demos

The **EIU Demoware** folder includes the demonstration versions of Electric Image Universe Version 4: a version for Macintosh entitled "Universe_406_Demo"; and a version for Windows users entitled "Universe4_05Demo.exe." Electric Image recommends the following minimal configurations for use of this program:

- **Windows**: Intel/AMD-based PC with a 500MHz or faster processor, Windows NT, 2000, or XP, QuickTime, 256MB of RAM (512MB+ recommended), 32MB Graphics Card, 120MB of available disk space required for installation. Video Card: Nvidia—All Geforce Cards 2, 3, 4, and all Quadro Cards; 3Dlabs—Oxygen Cards; Wildcat Cards; Sonicblue—FireGL Cards.
- **Macintosh**: Macintosh computer with a 300-MHz or faster PowerPC G3 or G4 processor, Mac OS 9 or Mac OS X v10.1.1, QuickTime, 256MB of RAM (512MB+ recommended), 32MB Graphics Card, 120MB of available disk space required for installation. Video Cards: ATI Radeon Series; ATI Mobility RADEON; Nvidia—All Geforce Cards 2, 3, 4.

These are good guidelines for use of the projects on this CD-ROM as well, which was produced and extensively tested on both the Macintosh and Windows XP platforms.

## Bonus Material

- **EIU Manuals:** We are fortunate to be able to include Adobe Acrobat PDF formatted files of the manuals to Electric Image Universe Modeler and Animator 3.0 and 4.0. Also included are older manuals from the pre-Universe series 2 Version of the software. These are valuable as they have many resources that did not make it into the current manuals.
- **Fact Model Disk Sampler:** The Fact Model Disk set offers over 1,200 Fact format models for use in Universe and other programs. The sample folder on the CD-ROM includes the catalog of the entire collection, and a password to download over 50 free Fact models!
- **HeadGames Lipsynch:** Sample animations of lip-synch projects are included in this folder, and in the related chapter folder, that show the results of HeadGames automated lip-synching files.
- **Resources Folder:** Includes an HTML file that lists third-party developers, community Web sites, legal resources for artists, and more (all with one-click links and descriptions). An importable bookmarks file named "bookmarks.htm" is also provided that will allow you to import this list of resources into your bookmarks/favorites folders in MSIE and Netscape.
- **Keyboard Commands Folder**: Contains PDF files listing all keyboard shortcuts for Modeler and Animator on the Macintosh and Windows platforms.

# INDEX

# C